ALBRECHT DÜRER

and the Animal and Plant Studies of the Renaissance

Fritz Koreny

ALBRECHT DÜRER

and the Animal and Plant Studies

of the Renaissance

A New York Graphic Society Book

Little, Brown and Company · Boston

This book appeared in connection with the 306th exhibition of the Graphische Sammlung Albertina, Vienna:
Albrecht Dürer and the Animal and Plant Studies of the Renaissance
April 18 to June 30, 1985

English translation copyright © 1988 by Little, Brown and Company (Inc.). Translation from the German by Pamela Marwood and Yehuda Shapiro for Lesley Bernstein Translation Service, London.

First American edition

First published in 1985 by Prestel-Verlag, Munich

Library of Congress Cataloging-in-Publication Data

Koreny, Fritz.
 Albrecht Dürer and the animal and plant studies of the Renaissance.

 Translation of: Albrecht Dürer und die Tier- und Pflanzenstudien der Renaissance.
 "A New York Graphic Society book."
 Bibliography: p.
 1. Dürer, Albrecht, 1471–1528 — Themes, motives. 2. Watercolor painting, German. 3. Watercolor painting, Renaissance — Germany. 4. Animals in art. 5. Plants in art. 6. Art, European — Themes, motives. 7. Art, Renaissance — Themes, motives. 8. Zoological illustration — Europe — History. 9. Botanical illustration — Europe — History. I. Title.
ND1954.D8K5713 1988 759.3 87-29737
ISBN 0-8212-1624-4

New York Graphic Society Books are published by
Little, Brown and Company (Inc.).
Published simultaneously in Canada by
Little, Brown & Company (Canada) Limited

PRINTED IN THE FEDERAL REPUBLIC OF GERMANY

Contents

Lending Institutions

In addition to drawings belonging to the Albertina itself, the exhibition comprised pictures lent by the following institutions:

Bamberg	Staatsbibliothek
Bayonne	Musée Bonnat
Berlin	Staatliche Museen Preußischer Kulturbesitz, Kupferstichkabinett
Bern	Universität Bern, Systematisch-geobotanisches Institut
Bremen	Kunsthalle Bremen, Kupferstichkabinett
Budapest	Museum of Fine Arts, Department of Prints and Drawings
Copenhagen	Statens Museum for Kunst, Den kongelige Kobberstiksamling
Dresden	Staatliche Kunstsammlungen, Kupferstich-Kabinett
Erlangen	Universitätsbibliothek and Graphische Sammlung der Universität
Florence	Gabinetto Disegni e Stampe degli Uffizi
Lisbon	Museu Calouste Gulbenkian
London	The Trustees of The British Museum
Los Angeles	The Armand Hammer Collection
Malibu	The J. Paul Getty Museum
New York	Ian Woodner Family Collection
Nuremberg	Germanisches Nationalmuseum, Graphische Sammlung
Nuremberg	Stadtgeschichtliche Museen
Oxford	The Ashmolean Museum of Art and Archaeology
Paris	Musée du Louvre, Cabinet des Dessins
Potsdam-Sanssouci	Staatliche Schlösser und Gärten
Providence	Museum of Art, Rhode Island School of Design
Rome	Galleria Nazionale d'Arte Antica, Palazzo Barberini
Vienna	Naturhistorisches Museum
Vienna	Österreichische Nationalbibliothek, Handschriften- und Inkunabelsammlung
Washington, D.C.	National Gallery of Art, Department of Prints and Drawings
Williamstown	Sterling and Francine Clark Art Institute
Zurich	Kunsthaus Zürich
Zollikon	Sammlung Kurt Meissner
	Also loans from Ellen Melas Kyriazi and anonymous private owners

Foreword

THERE IS NO MERIT in simply having a great past. It is much more laudable to live up to it by meeting the challenges afforded by its legacy, a legacy that has made the Albertina the proud owner of its Dürer collection. Dürer's works were assembled in the *Kunstkammer* of Emperor Rudolf II, brought there by a worldwide imperial power with an insatiable hunger for art and an enthusiastic inclination toward this particular master. Being entrusted with this exceptional treasure, the Albertina has always played an appropriately large part in Dürer research, of which this 1985 exhibition marks a high point. It has been made possible by a new method evolved by contemporary art research, that of comparison of the original works. Surveying a comprehensive lineup of all available examples is far more revealing than any amount of poring over descriptive analysis, and is indispensable for new and creative results.

Let us look briefly at the achievement of those who have brought Dürer research in the Albertina to its present level, beginning with its former director Moriz von Thausing (1838–1884), who saw it as his duty to produce a publication of Vienna that would rank alongside those of Germany and England. When he ascertained that there was a universal lack of collective survey and critical opinion based on comparison, and that the greatest problem was that scholars in all too many cases had to fall back on inadequate reproductions, he had summed up the difficulties that beset Dürer research through the remainder of the century.

After Thausing, Josef Schönbrunner (1831–1905) set himself the task of adapting the new collotype technique to the production of "facsimile" prints, a task finally fulfilled by his pupil Josef Meder (1857–1934). The resulting series of high-quality reproductions known as Schönbrunner–Meder raised professional and critical research to a new level, quite apart from the fact that they brought Dürer's works to a greater public. Meder's Dürer Exhibition of 1900, together with his major works, *Die Handzeichnung* (1919) and *Dürer-Katalog. Das graphische Werk* (1932), established the Albertina as the heart and center of Dürer research.

Further milestones were the *Beschreibender Katalog der Handzeichnungen in der Graphischen Sammlung Albertina* by Alfred Stix (1922 ff.) and *Kritisches Verzeichnis der Werke Albrecht Dürers* by Hanz Tietze and Erica Tietze-Conrat (1928 ff.), which very rightly sought to separate the kernel of authenticated works from the almost boundless jumble of attributions. The exhibition *Kaiser Maximilian I, 1959*, in which Alice Strobl was responsible for the Dürer section, continued the research tradition after the interruption of World War II. On the occasion of Dürer's five hundredth birthday in 1971, I collaborated with Alice Strobl in setting up the first exhibition of all his works in the Albertina — 139 in all.[1] The catalogue included both the history of these works and a survey of the state of individual research on each one. We felt this to be essential as the basis for a new scientific phase.

Today, if I look back over fifteen years, I can recognize with satisfaction what opportunities — such as travel and time off from other activities — we are now in a position to offer our younger colleagues when they are working on such important subjects, and I must frankly say that we carried out absolutely pioneering work under earlier, less favorable conditions. In those days it was in no way possible for us to travel to a single place in the world where Dürer's works were held. The prevailing conception of research was that it was an almost purely private activity, a spare-time hobby, so to speak. Since that time, this has completely changed.

With nothing more than photographs to go on, Dürer research had come to a full stop. Faced with this fact, we decided there was only one way forward, utterly idealistic though it seemed, and that was to gather together all, absolutely all, relevant works for direct comparison, no matter in what part of the world they were held. The forte of the Albertina's Dürer collection lies, of course, in animal and plant studies, so it was almost

1 The 225th Exhibition, *Die Dürerzeichnungen der Albertina zum 500 Geburtstag,* October 12 – December 19, 1971 (ed. by Walter Koschatzky and Alice Strobl).

7

compulsory for us to choose this particularly fascinating theme to elaborate. It soon became clear how fruitful this was, how full of new possibilities and insights. Dr. Fritz Koreny threw himself wholeheartedly into the task, and selflessly thrashed out problems and solutions with imagination and expertise. Dr. Christine Ekelhart gave him valuable assistance. Both deserve gratitude and recognition in the highest degree. Their task was made possible by our other learned colleagues of the Albertina, who must be thanked for taking over most of their normal work in addition to the everyday demands of running a large collection. Janine Kertesz and Ingrid Latour have done excellent work in preparing the typescript.

Both independently and within the context of the exhibition, this publication is particularly important. The bringing to light of hitherto unpublished material, and the assembly of other works published individually, with careful color reproduction and numerous illustrations for comparison, enable problems highlighted in the exhibition to be critically explored, and much of the unique experience to be retained.

My gratitude goes also to all those outside the Albertina whose understanding and cooperation were invaluable in helping our idealistic project to become a reality. I know very well what it means to decide to lend such costly objects. And I know too that the credit for the realization of this project is only partly ours. By far the greater share belongs to preceding generations, from whose ranks I have mentioned a few important names. We have attempted to resolve the problems bequeathed us by the past with the techniques of our own times. This is because we are convinced that science must never rest content, and that only perseverance will ensure the continuity of that which must never be lost: the urge to know the world and recognize its highest creative achievements.

Walter Koschatzky

Acknowledgments

IDEAS AND WISHES know no bounds, but there are limits to reality. The present exhibition realizes a desire that for decades seemed unrealizable, a dream of Dürer scholarship. Many obliging and cooperative people all over the world have contributed to it; it is therefore my especial concern to thank them.

First of all, I would like to express my thanks to DR. ARMAND HAMMER, whose name is firmly linked with the inception of the project; it was he who, more than five years ago, on the occasion of a visit to the Albertina, enthusiastically took up my idea, and in the most spontaneous and generous way offered his support toward its realization. His initiative first laid the foundations and encouraged me in the undertaking. Without the resources vouchsafed by him, it would have been unthinkable for us to follow up the concept of such an exhibition seriously.

Once within the realm of possibility, our project met with approval on many sides. To mount an exhibition of this size and importance, however, bringing together numerous valuable loans, also required the help of the highest government authorities. I owe especial gratitude to former President Dr. Walter Scheel, Ambassador Hans Heinrich Noebel, and the Foreign Office of the German Federal Republic for all their guaranteed backing, as well as to the vice general manager of the Creditanstalt-Bankverein, Guido Schmidt-Chiari, for doing likewise. Our thanks are directed above all to the French minister of culture, Jack Lang, for his extraordinary helpfulness. Our project also received very kind support through the directors of the Austrian Cultural Institute, Dr. Rudolf Altmüller in Paris, Dr. Bernhard Stillfried in London, and Dr. Jörg Garms in Rome; and through the initiative of the Austrian cultural attachés, Dr. Harald Kreid in Madrid and Dr. Wilhelm Lorenz in Prague, and of the cultural attaché at the Belgian Embassy in Vienna, Georges Englebert. We are indebted to the German Democratic Republic, primarily through the GDR Embassy in Vienna, for its manifold support. The Federal Ministry of Finance has considerably furthered the exhibition by its great understanding.

In the course of preparation I received particular personal help from colleagues and collectors. Their agreement, or even their disagreement, has helped to establish certain ideas, and they have had a voice in the working out of many problems. I am grateful to them for much information about important and interesting material, either published or lying hidden. I was helped toward valuable discernment above all by Fedja Anzelewsky, Peter Dreyer, Christian Dittrich, Heinrich Geissler, Hans Mielke, Andrew Robison, John Rowlands, and my teacher, Otto Pächt.

Further contributors to the success of the exhibition are Klaus Ammann, Lottlisa Behling, Maria van Berge-Gerband, Jan Białostocki, Szilvia Bodnár, Bernhard Degenhart, Gianvittorio Dillon, Judith A. Diment, Rudolf Distelberger, Vincent Ducourau, Rafael Fernandez, Erik Fischer, Eliška Fučíková, Kenneth Garlick, Gisela Goldberg, George Goldner, Richard Harprath, Herbert Haupt, Lee Hendrix, Eva Irblich, Pierrette Jean-Richard, Thomas DaCosta Kaufmann, Elisabeth Klemm, Georg Kugler, Dieter Kuhrmann, Börge Magnusson, A.W.F.M. Meij, Matthias Mende, Helen Mules, Carl Nordenfalk, Konrad Oberhuber, Peter Parenzan, Charles Parkhurst, Ursula Perucchi, Louise Richards, Alice Rössler, Martin Royalton-Kisch, María Teresa Ruiz Alcón, Werner Schade, Peter Schatborn, Bernhard Schemmel, Annegrit Schmitt, Rainer Schoch, Karl Schütz, Hana Seifertová, Maria Helena Soares Costa, Walter L. Strauss, Lorand Zentai, and Heinrich Zoller, together with the Courtauld Institute/Witt Library of London. At this point I must also express my thanks to the restoration workshops of the Staatliche Museen in Berlin, capital of the GDR, and of the Österreichische Nationalbibliothek in Vienna.

I am particularly indebted to numerous private lenders, including Ellen Melas Kyriazi, Ian Woodner, New York, and Kurt Meissner, Zurich/Zollikon, together with others

who wish to remain anonymous. They have all taken the trouble to support this exhibition, and their assistance has made it considerably easier to compile the catalogue.

I owe thanks to the advice of the art trade for valuable particulars and references to new material, above all to the great auction houses Sotheby's and Christie's; to Julien Stock and Noël Annesley; also Kate Ganz; Yvonne Koerfer-Tan Bunzl, London; Ruth-Maria Muthmann, Boerner/Düsseldorf; Paul Prouté, Paris; Kurt Meissner and August Laube, Zurich; Arnoldi-Livie, Munich; and Dr. Robert Herzig, Vienna.

For the specific identification of animals and plants, the art historian must to a great extent call on interdisciplinary help. Often very extensive checks or revisions have been selflessly undertaken by Professor Friedrich Ehrendorfer of the board of directors of the Vienna University Botany Institute, and Dr. Günther Pass, assistant at the Vienna University Zoology Institute; also the colleagues from the Vienna Natural History Museum, Dr. Herbert Schifter, and Dr. Kurt Bauer, certified engineer. We are indebted to their professional judgment for certain new pieces of knowledge. For help totally unconnected with art scholarship, to wit, the comparison by computer of certain studies, I thank Alfred Hansal, certified engineer, and IBM Austria.

This project has been considerably furthered by the Federal Ministry for Science and Research, and I thank the former head of the department Dr. Wilhelm Schlag, ministerial consultant, and Dr. Karl Blaha, ministerial consultant, for creating the necessary prerequisites through travel and study-facility concessions. The cultural agreement between the Austrian Republic and the German Democratic Republic made it possible to stay and study in Dresden, Leipzig, and Weimar.

We were able to take for granted the cordial agreement and understanding among the staff of each of the collections involved. My thanks to Director Dr. Walter Koschatzky for creating a similar possibility here, so that I could count on every imaginable support for my work. From my in-house colleagues I received help in many respects. Franz Pfeiler was responsible for the complex organization of loans. It was a pleasure for me to work with Erika Hendrych and Janine Kertesz, who looked after most of the fair-copy manuscript work. I thank Elisabeth Thobois and Karl Rücker for their constant availability, as well as Eugen Finkler, our Institute photographer — a glance at the reproductions in the catalogue made from his photographs will suffice to make plain his achievement.

Prestel-Verlag deserves infinite recognition for its excellent production and meticulous printing of the catalogue.

Finally, my colleague Dr. Christine Ekelhart deserves my particular gratitude; her collaboration has contributed more toward the success of the catalogue and the exhibition than I can possibly express in words.

Vienna, March 1985 *Fritz Koreny*

The present publication is the English translation of the catalogue that accompanied the exhibition "Albrecht Dürer and the Animal and Plant Studies of the Renaissance" at Graphische Sammlung Albertina, Vienna, in 1985. Because of the time needed to prepare the English edition, it was possible to add some new findings that resulted from a symposium held at the exhibition (June 7–10, 1985), as well as to include precise botanical identifications and changes in location and ownership. Furthermore, we were able to add two previously unpublished studies (ill. 7, p. 73, and ill. 59.2, p. 174) that have subsequently been discovered. Because the English text corresponds, page for page, with the German, expansion on the text was added to existing footnotes or in some cases placed in new footnotes.

Mr. G. Pass was helpful in examining the technical zoological terms and Messrs. M. A. Fischer and S. Segal in checking the botanical ones. I thank them, as well as the translators, for making it possible to express complex and difficult material — sometimes by capturing general sense or feeling rather than adhering to strictly literal translation. Especially I thank Professor E. Haverkamp-Begemann, who, as a favor to me, proofread difficult passages of the translation. I also thank the editors of the New York Graphic Society, in particular Lucy Lovrien and Betsy Pitha, for their care and patience in preparing this edition.

Vienna, June 1987 *F.K.*

Albrecht Dürer
and the Animal and Plant Studies
of the Renaissance

Introduction

Dann warhafftig steckt die kunst inn der natur, wer sie herauß kan reyssenn, der hat sie.
"For, verily, 'art' is embedded in nature; he who can extract it has it."

Albrecht Dürer,
aesthetic commentary in his treatise
on proportion, 1528 (translation by Erwin Panofsky)

WHEN JOSEPH HELLER, the Nestor of Dürer research, was working on the first comprehensive catalogue of Albrecht Dürer's works more than a hundred and fifty years ago, he found himself confronted by the fact that there existed replicas of certain of the artist's famous nature studies. Dürer's *Hare* in Vienna and another in Dresden — in Heller's opinion painted just as well — made him wonder which of the two might be the original. The study in his own collection of a blue roller's wing, dated 1513 and bearing the Dürer monogram, also seemed to him so similar to that in the Albertina in Vienna, and painted with just as much "originality and beauty," that he therewith suspected he also possessed a work by Dürer. Relying only on his memory, without the aid of the reproductions and photographs that we take for granted today, it was even harder for him to distinguish between original and copy; faced with the question about the originality of the Albertina *Wing of a Blue Roller* and his own, he was forced to state, "Only . . . a closer comparison of these could distinguish which might be a copy by Hans Hoffmann: for he alone would have been capable of producing such a thing."[1]

Even a century later, Friedrich Winkler, after more than twenty years' involvement with Dürer's work, had to admit that the flower and animal pictures were "by far the hardest group of Dürer's drawings to judge."[2] And like Heller before him, Winkler reached the conclusion that an accurate decision about the individual works "seems to be hardly possible without repeated and thorough examination of the originals, concentrating exclusively on this question."[3] From the comprehensive exhibition of Dürer's works mounted in Nuremberg on the occasion of the five hundredth anniversary of his birth in 1971, it again emerged clearly that hardly any other field of Dürer's creative work had received so little attention.

One would think that the work of such a central artistic figure, whose name is practically synonymous with German art, would have been intensively researched, exhibited in all facets, and exhaustively discussed. Even more amazing is the fact that whereas Dürer's prints and paintings and his drawings with pen and ink and other materials, already well discussed, keep appearing as the central point of scientific interest, his equally important and popular nature studies in watercolor and body color have nevertheless remained comparatively unexamined.

It therefore appeared to be a desirable aim, from both the material and the research point of view, to throw some light on Albrecht Dürer's animal and plant studies in relation to their sixteenth-century copies, replicas, imitations, and forgeries. A venture put off for more than a hundred and fifty years hardly needed any further justification.

Although it seemed increasingly urgent to try to organize a comprehensive assembly of the original works, in order to compare them directly, it must not be forgotten that the difficulties of realizing such a plan were apparent from the outset. The works are costly, belong among the most highly protected treasures of even the greatest museums, and furthermore are spread among numerous collections in Europe and the United States. On the basis of its own already rich holdings, the Albertina in Vienna therefore seemed predestined as no other collection to undertake the task.

We knew it was unrealistic to hope to unite every one of Dürer's animal and plant studies in one single exhibition, since no great collection would be prepared to part with all its nature studies even for a short time, so we decided that, as the Albertina held the majority of Dürer's animal and plant studies, we should make those drawings the center of the inquiry and group the relevant works around them. The idea met with approval, unprecedented helpfulness, and cooperation on all sides, which made it possible for the first time to assemble these widely scattered works in their entirety.

1 H. II, p. 118.
2 W. II, p.65.
3 W. II, p. 71.

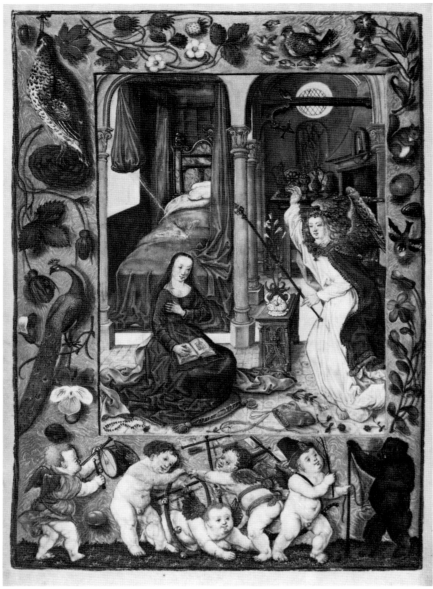

1 Prayer book of Narziss Renner, 1523, *Annunciation,* miniature painting on vellum.
Vienna, Österreichische Nationalbibliothek, Cod. 4486, fol. 35v (see Cat. 4).

Especially in a field where copy and original are so close that neither reproduction nor photograph is a valid aid to judgment, direct comparison becomes the only and indispensable way for the most objective reasoning.

This work therefore concentrates on Dürer's nature studies and their sixteenth-century imitations — which, as a result of duplication, approximation, and modification of their model, led to confusion even in the time of Emperor Rudolf II and hamper the judgment of connoisseurs and art experts today. It attempts at the same time to throw some marginal light on the influence of the nature studies on the development of still life, and to outline their effect on the evolution of scientific illustration and the like. With the opportunity to compare the questionable studies directly for the first time, the uncertainties immediately associated with these works of art stood paramount; our priority was to use the occasion to scrutinize the diversity of opinion existing in the literature in the presence of the originals themselves.

In order best to exploit this unique opportunity of comparing such rare and seldom-seen works of art in the original, a symposium took place along with the exhibition. It was concerned with nature studies both by Dürer and by other artists of his time, as well as with questions of his following and his influence in the sixteenth century, and it set out to comment on historical, botanical, and zoological matters and the history of collecting. (The lectures from the symposium were published as a special volume in *Jahrbuch der kunsthistorischen Sammlungen in Wien* 82/1986.)

The thoughts outlined below are intended only as a meager sketch or summary of certain aspects of the theme, which have already been amply set forth in other places in the extensive literature on Dürer and German drawing in the Renaissance.[4]

The Tradition of Nature Studies

If Giotto can be said to mark the beginning of modern naturalistic painting, still, more than a century and a half were to pass before Dürer's nature studies. It was first in the Renaissance that German art at last adopted imitation of the real world as an explicit artistic theme, and truth to nature as the yardstick for the validity of a work of art.[5] It followed that the nature study became the indispensable basis of creative art. Incorporated into the pattern repertoire, such studies could be referred to as needed (ill. 1). As is clear from the example of the study by Lukas Cranach the Elder, they remained in active studio use for decades and were employed in paintings on the most widely differing themes (ill. 2; see also p. 43 and Cat. 8).

While art was breaking free from craft restrictions and the constraints imposed by medieval guilds, the horizons of knowledge were widening. As representative of the *artes liberales,* filled with new self-awareness, the artist moved toward science through his visual exploration of nature. From Giotto to the turn of the fifteenth century (via Giovannino de' Grassi and Pisanello), we can observe the fidelity to nature increase steadily, until, in the beginning of the Renaissance — that is, in the work of Leonardo and Dürer — artistic statement and scientific objectivity merge into that kind of representation of nature where artistic transformation to a large extent is the manifestation of visual cognition. "That painting," declared Leonardo in his treatise on painting, "is most praiseworthy, which bears the most likeness to the object portrayed, and I say this to refute such painters as would seek to embellish natural things."[6]

Dürer's words express this thought even more directly: "But life in nature manifests the truth of these things." And, "Therefore observe it diligently, go by it and do not

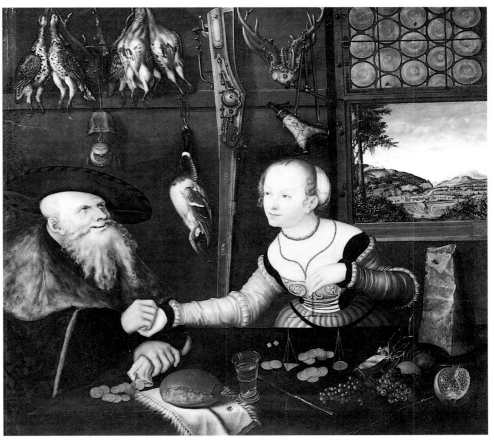

2 Lukas Cranach the Elder and studio, *The Payment*, 1532, oil on panel. Stockholm, National Museum.

4 See Kauffmann, in *AGNM* 1954, pp. 18–60; Exhibition Catalogue Münster 1979–80; Exhibition Catalogue *Dürers Verwandlung in der Skulptur zwischen Renaissance und Barock* (Frankfurt, Liebieghaus Museum alter Plastik, 1981–82), with ongoing literature.
5 Erwin Panofsky, *Idea,* 2nd ed. (Berlin, 1960), pp. 23 ff.
6 Quoted from Panofsky, *Idea,* p. 24.

depart from nature arbitrarily, imagining to find the better by thyself, for thou wouldst be misled. For, verily, 'art' [that is, knowledge] is embedded in nature; he who can extract it has it."[7] This theoretical basis gave nature study its legitimate artistic identity and was the major postulate of the Renaissance. In the way Dürer reproduces the visible world, he is at once artist and scientist. His studies from nature not only mark the peaks of German draughtsmanship, they also belong to the incunabula of scientific illustration. "In this Dürer behaved neither as a zoologist nor as an anatomist, and did not dissect and display the inner construction as Leonardo did, but observed creatures from outside and let plants remain intact."[8]

The picture of a hare, the portrayal of damp meadow ground, may appear to be, without visible development, complete and spontaneous masterpieces, and at the same time not only characteristic examples of their kind, but also individual portraits; but there is nevertheless an underlying tradition. The style of rendering that rests on close observation goes back ultimately to the conquest of the visible world in early Netherlandish painting, as shown by its founder, Jan van Eyck. Dürer's sharp, clear observation stands nearer to van Eyck's crystalline realism than one might at first suppose. Jan van Eyck's nature studies would probably not have looked very different. He comprehended reality with unbiased eyes, like the Master of Flémalle or Rogier van der Weyden. The flowers painted in the Ghent Altarpiece (ill. 4), the lifelike individualized image of the little dog in van Eyck's double portrait *Giovanni Arnolfini and His Wife* (ill. 3), the herb garden in Rogier's Frankfurt *Madonna* (ill. 5), the "millefleurs" carpets[9] by the French and Brussels weavers (ill. 6), or the plants bursting out of cracks in stones and fissures in walls in the pictures of Hugo van der Goes (ill. 7) all apparently presume exact studies of nature. This kind of realistic portrayal had been fundamental to Netherlandish art tradition for more than thirty years when it found its way into painting from Cologne and Franconia from the middle of the fifteenth century on. Both in accuracy of detail and in its formal application, like the foreground lattice work, we encounter such nature studies even among Dürer's immediate forerunners. Their German stamp can be found in Swabian and Franconian painting of the latter third of the fifteenth century, for example, in Pleydenwurff's panels *Saint Dominic* and *Saint Thomas Aquinas* (ill. 8), in the *Annunciation* of an anonymous Rothenburg master of about 1470 (ill. 9), or the *Saint Sebastian* by the Master of the Augustine Altarpiece of 1487 (ill. 10).

Against this background Dürer seems to complete as well as to innovate. Such distinct predecessors indicate that his nature studies cannot have been the very first German ones, but rather the earliest that have survived. But his studies show us the imitation of nature already at its peak.

Albrecht Dürer's studies have been constantly admired for their accuracy of observation, their assurance of drawing, and their superb execution, and thus have become almost a stock concept. When nature studies are mentioned, most people find that his *Hare, Stag Beetle, Nosegay of Violets,* or *The Large Piece of Turf* springs immediately to mind.

3 Jan van Eyck, *Giovanni Arnolfini and His Wife,* 1434, detail, oil on panel. London, National Gallery.

7 Rupprich III, p. 295; translation by Erwin Panofsky, *The Life and Art of Albrecht Dürer* (Princeton, 1955), p. 279.
8 Hans Kauffmann, "Albrecht Dürer — Umwelt und Kunst," in Exhibition Catalogue Nuremberg 1971, p. 23.
9 Exhibition Catalogue *Die Burgunderbeute und Werke Burgundischer Hofkunst* (Bern, Bernisches Historisches Museum, 1969), p. 205, no. 125.

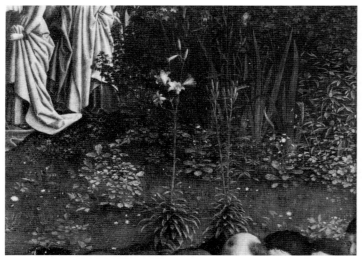

4 Jan van Eyck, Ghent Altarpiece, 1432, detail with iris and peonies, oil on panel. Ghent, St. Bavo.

5 Rogier van der Weyden, *Madonna and Child with Four Saints,* detail, oil on panel. Frankfurt, Städelsches Kunstinstitut.

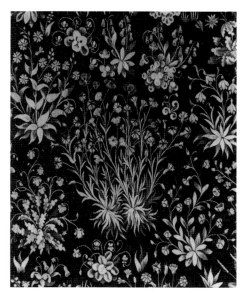

6 "Millefleurs" carpet, Brussels, 1466, detail, woven carpet. Bern, Historisches Museum.

Dürer was already famous in his lifetime, and when he died in 1528 he was mourned as the second Apelles. His extraordinary artistic personality shines forth brightly in Lambert Lombard's letter[10] to Giorgio Vasari in 1565; his fame had already spread throughout Germany; his significance was recognized even in Italy;[11] and his creative work was beginning to have an effect on art in the Netherlands. Copies and imitations were starting to appear. Half a century after Dürer's death, in the last quarter of the sixteenth century, there was such sudden and intense retrospective reaction to his work that the term "Dürer Renaissance" was coined. Exactly when this phenomenon emerged is not known, but it is certain that in Prague, Emperor Rudolf II's interest in art considerably contributed to it.

The Kunstkammer *of Emperor Rudolf II and the Dürer Renaissance*

Connoisseurship and a passion for art made Emperor Rudolf II an avid secret collector, and Hapsburg artistic aspirations culminated in his taste. During the entire sixteenth century, the Hapsburgs gave a decided stimulus to art and science. Maximilian I deserves pride of place for political propaganda and pictorial and literary documentation, but we must also be grateful to Emperor Charles V, the great-uncle of Rudolf, for furthering science, and, among others, Pier Andrea Mattiolis for his *Dioscurides* commentary. Archduke Ferdinand of Tyrol, Rudolf's uncle, was also one of the most important collectors of his time. The enthusiasm of Emperor Maximilian II, Rudolf's father, for the natural sciences led him in 1569 to acquire the *Vienna Dioscurides,* the most important example of ancient medical literature, and he was able to attract the most eminent botanists of the day, Rembertus Dodonaeus and Carolus Clusius, from the Netherlands to the Viennese court between 1573 and 1588.

The close connections between the princely courts and their exchange and promotion of artists and scholars created spiritual contacts throughout Europe and contributed to an international cultural climate that enabled Mannerism to reach full flower. Increasing cultural awareness and wide-ranging interests favored the formation of great collections; rich citizens, aristocrats, and princes competed for the acquisition of artistic, costly, remarkable, or exotic rarities. This was the beginning of "the flourishing period of the great princely cabinets of curiosities in Germany . . . the most outstanding examples of which are the collection of Ferdinand of Tyrol in the Schloß Ambras, the Rudolfian *Kunstkammer* in Prague, those of the Bavarian dukes Albrecht V and Wilhelm V in Munich, and that of the Elector of Saxony on Dresden."[12]

In 1583, Rudolf II moved his court from Vienna to Prague, and there entertained artists, scientists, and savants from the whole of Europe at his "Court of Muses." Rudolf

10 Letter of April 27, 1565, quoted in Heinz Lüdecke and Susanne Heiland, *Dürer und die Nachwelt* (Berlin, 1955), pp. 74, 75.

11 Among the body of prints we find early copies of Dürer; suffice it to mention Raimondi's engraved copies, against which Dürer himself raised protest in Venice. See Arpad Weixlgärtner, "Alberto Duro," in *Festschrift Julius von Schlosser* (Vienna, 1927), pp. 162–186.

12 Julius von Schlosser, *Kunst- und Wunderkammern der Spätrenaissance* (Leipzig, 1908), p. 35.

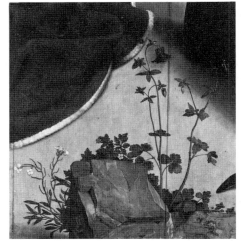

7 Hugo van der Goes, "Monforte" Altarpiece, detail, oil on panel. Berlin, Staatliche Museen Preußischer Kulturbesitz.

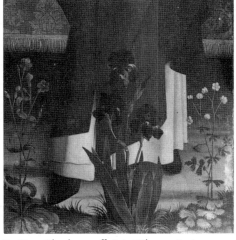

8 Hans Pleydenwurff, *Saint Thomas Aquinas,* c. 1460, detail, oil on panel. Nuremberg, Germanisches Nationalmuseum.

showed many-sided interests and was open-minded about contemporary art, but he had a particular preference for Dürer's work. And he was not alone. Nuremberg patricians had preceded him, principally Willibald Imhoff the Elder, the grandson and heir of Willibald Pirckheimer, the humanist and friend of Dürer's. In Elector Maximilian I of Bavaria, Rudolf found a powerful competitor. Art agents arranged purchases, and even royal diplomats were involved in acquisitions, as we know for a fact from Count Khevenhüller, the Austrian ambassador to the court of Madrid. It was probably he who, after monthlong negotiations on behalf of the emperor, against the interests of Philip II of Spain, succeeded in acquiring an important collection of Dürer drawings from Cardinal Granvella's heir, for which he was temporarily obliged to lay out a considerable sum of his own money.[13]

In the mounting excitement of collection fever there now became evident a retrospective trend, which revived interest in Dürer's work and led to the making of copies. A Dürer-oriented style was developed and spread, and this culminated in the phenomenon known as the Dürer Renaissance. The term was first used by the Tietzes, and although it has rather been thrust upon criticism, and the concepts "revival" or "historism"[14] have been suggested as more appropriate, the meaning is precise enough. This Dürer movement should not, however, be overvalued; of all of Rudolf's artistic enthusiasms it obviously represents only one facet, one in which the nature studies that we are concerned with here again constitute only a small part.

Historically and geographically, the phenomenon of the Dürer Renaissance — in drawings — can be clearly delimited. It coincides with the time of Emperor Rudolf's reign; it is concentrated in a few places, namely, the towns of Nuremberg, Munich, and Prague; it is associated with the names of the collector Imhoff, Emperor Rudolf II himself, and Elector Maximilian I of Bavaria; and it finds its artistic protagonists in Hans Hoffmann and Georg Hoefnagel. From the evidence of surviving examples, it lasted just over twenty years, beginning with Hoffmann's studies in the 1570s and effectively fading out with the death of Georg Hoefnagel in 1600. Successors at the Prague court, such as Roelandt Savery, turned to other exercises. We know the names of several more Dürer copyists, such as Georg Gärtner, Wolfgang Bonacker, Johann Christian Rupprecht, Johann and Georg Fischer, Jobst Harrich, and Paul Juvenel, but so far we have not been able to identify studies by their hands.

The output from this episode in Rudolfian art fashion was indeed certainly respected, along with that of the sought-after and highly valued contemporary artists and principal representatives of European Mannerism, such as Arcimboldo, Hans von Aachen, Bartholomäus Spranger, Joseph Heintz, Adriaen de Vries, and others, but doubtless it was classed more in the field of special knowledge. The fashion barely skimmed the edge of the major artistic currents of the time, but certainly it helped to fix the perception of Dürer's work and affect the way in which succeeding generations were to receive him. The Dürer-style studies made at that time were assimilated as in no other area of German art; genuine fused with imitation flatly inseparable from Dürer's own work and name. Thus there arises the question of how to distinguish among original, copy, imitation, and forgery.

9 Rothenburg Master, c. 1470, *Annunciation,* detail, oil on panel.
Nuremberg, Germanisches Nationalmuseum.

Copies, Imitations, Forgeries

The first deceptive copies of Dürer's studies were made in the 1570s, the earliest of them — Hans Hoffmann's *Stag Beetle* (Cat. 37) — dated 1574. As Hans Kauffmann has demonstrated, academism of the late sixteenth century recognized two basically different forms of copying, *imitare* and *ritrarre.* By *imitare* was meant re-creation after a given model, and it was classed as a higher function than *ritrarre,* the mere transcribing of what lay before one's eyes. *Imitatio* implied the creative combination of received factors with a personal concept, "accepting tradition and simultaneously progressing toward an improved image."[15]

Among Dürer's imitators, Hoffmann and Hoefnagel can be labeled with *imitatio.* Certainly they copied Dürer, but to a similar extent paraphrased their model and created something new by their logical development and creative rethinking of the motif.

13 See K.-Str., pp. 24 ff. On the subject of Rudolf II see Karl Vocelka, *Die politische Propaganda Kaiser Rudolfs II. (1576–1612)* (Vienna, 1981); Vocelka, *Rudolf II. und seine Zeit* (Vienna, 1985); and R. J. W. Evans, *Rudolf II., Ohnmacht und Einsamkeit* (Vienna/Graz/Cologne, 1980). On Willibald Imhoff the Elder see Ludwig Veit, in *Berühmte Nürnberger aus neun Jahrhunderten,* ed. Christoph von Imhoff (Nuremberg, 1984), pp. 136–138.
14 Exhibition Catalogue *Dürer Renaissance* (Munich, Alte Pinakothek, 1971), p. 8.
15 Kauffmann, in *AGNM* 1954, p. 30.

16 Eliška Fučíková, "Umělci na dvoře Rudolfa II. — a jejich vztah k tvorbě Albrechta Dürera," in *Umení* XX/1972, pp. 149 ff.

17 Quoted in Rosenthal, in *JPK* 49/1932, pp. 47 ff.; see also Appendix, pp. 263 ff. below.

18 See H. II, p. 72.

19 *Dieses stigklen hate mein her A D zur letze geschenck wie Ich bin von Ihme gezogen im Jar nach Christi geburt 1503 Im neuen Jartag ge . . . sen zu Nürnberg. Mortin scheffer.* And then below this: *Das ist Durirsch eigne handt. Ich hab es zu Ulm von dem alten mercklin uberkomen ein goldschmidt der alt mateus schaffrer is sein . . . anh . . . und lang bey dem Dürer gearbeit.* ("This little piece my master A D has [visibly erased and improved] as a last gift when I left him in the year of our Lord 1503. On New Year's Day to Nuremberg. Mortin scheffer." And below: "That is Dürer's own hand. I got it in Ulm from the old Mercklin a goldsmith the old mateus schaffrer is his . . . and worked a long time with Dürer.") Thieme-Becker identifies Mercklin as Elias Merckhlin, a goldsmith in Ulm, master 1584, mentioned in 1610. I am grateful to H. Krug for his help in reading these inscriptions.

20 H. Tietze, in *WJKG* 7/1930, p. 247.

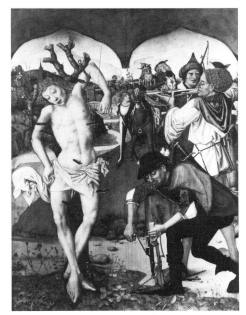

10 Master of the Augustine Altarpiece, *Saint Sebastian*, 1487, detail, oil on panel. Nuremberg, Germanisches Nationalmuseum.

Emperor Rudolf obviously did not invite Hoffmann to the Prague court simply as a Dürer copyist,[16] but rather was seeking a worthy renewer and upholder of the Dürer tradition, a proponent of his own artistic principles.

Of course, a backward-looking attitude that set out to update Dürer's art programmatically, hoping by such a stroke to enrich contemporary art, was bound to contain the seeds of forgery. As soon as the demand for Dürer originals exceeded the supply and the high regard made even copies sought after, falsifications became inevitable. The inventories in the Imhoff *Geheimbüchlein,* made by Hans Hieronymus Imhoff in the second quarter of the seventeenth century, for private family use only, give candid information about this. The circumstances surrounding sales, the asking prices and valuations, and the works still available are informatively discussed. With unconcealed satisfaction Imhoff notes about a sale made in 1633 (fol. 69r): "certainly among all the pieces sold there was not a single important one, but for the most part small items painted in watercolor, among them many where there may well be doubt whether Albrecht Dürer really did paint them." Later (1634, fol. 73v) we find a note: "A fine lion on vellum, admittedly with A. Dürer's mark underneath, but one feels that only Hans Hoffmann could have painted it," and even more clearly (fol. 73r): "III. A picture of the Virgin Mary on wood in oil paints, small. My late father had Alb. Dürer's mark painted underneath, but for all that one could not really believe that Albrecht Dürer had painted it."[17]

We shall probably never know what role Hans Hoffmann played in all this. Heller, without naming his sources, states that Hoffmann was on friendly terms with Willibald Imhoff;[18] in fact, the numerous Dürer-study replicas by Hoffmann from the Imhoff Collection leave hardly any room to doubt it. It remains unclear whether these many copies originated as plagiarisms and forgeries, and whether the Dürer monogram imitated by Hoffmann — even where the original carried none — was meant as additional information about an old tradition or added with intent to deceive.

In addition to those works identified as copies and "manipulated" by Willibald Imhoff's heirs, who had, in full knowledge of the dubious facts of the case, passed them off on credulous purchasers, there also appeared completely straightforward forgeries. These can rarely be concretely detected; one rather has the impression that Dürer's monogram and the misleading inscriptions were added only later, in order to give the appearance of authenticity to Dürer-like studies. Dürer's handwriting was often imitated with great refinement, and credibility often heightened by a text referring to the artist's period and vital circumstances (ill. 11; see also Cat. 15, where the date 1505 and the note about Trento indicate astonishing knowledge if the work comes from a seventeenth- or eighteenth-century forger!).

A study of a spider, fly, and mole-cricket (ills. 12, 12a) attempts, by several clumsy verifications written on the reverse side, to divert attention from an object not to be compared stylistically with Dürer's work. The attempt to make the attribution to Dürer a fait accompli in this way founders, however, as soon as more light is thrown on the prototypes. The study tallies closely with Georg Hoefnagel's miniatures for Emperor Rudolf II (ill. 13) and bears the characteristics of his style of drawing.

We cannot tell exactly when the inscriptions were added to the drawing,[19] which dates from the late sixteenth century. For Hans Tietze, however, they were sufficient evidence for the obvious fact of "how deep-rooted were the preconceptions that such a careful animal study must emanate from Dürer; the twentieth century was not the first to be so naive as to classify everything animal at all costs around one single artist — that one being Dürer."[20]

So basically we have to distinguish "Dürer studies":

— whether, going by the execution, a study is by Dürer or another artist;
— if the work has been done by another artist, whether the pictorial idea may be Dürer's;
— whether we are dealing with an original or a copy;
— whether we can call it an imitation in Dürer's style;
— whether we are faced with a forgery or simply a mistaken attribution.

Dürer's Studio

The problems of differentiation that occur in working on Dürer studies are further complicated by the question of the part played by Dürer's own studio, which, strange to say, is still almost unknown. We know from a series of records that at least three generations of painters and studio assistants worked around and with Dürer.[21] We know their names, but yet are faced with the fact that up to now we have not satisfactorily managed to separate their contribution from Dürer's own. Hans Baldung Grien, Hans von Kulmbach, Hans Schäufelein, and later Wolf Traut, Erhard Schoen, Hans Springinklee, and after 1520 the Beham brothers and Georg Pencz — in fact, some of the most important painters of the early sixteenth century — were in Nuremberg and evidently working alongside Dürer. Although we know of this collaboration, it has so far proved very difficult to lay hands on sufficient early drawings by these masters, and we have not as yet succeeded in ascribing even a single nature study to any specific one of these pupils or assistants.

When Dürer died, he left behind no legitimate successor. The so-called Little Masters of Nuremberg may have been working in his style, but not one of them can be labeled as a disciple in the true sense. On reflection, we have to admit that we know of no nature study either by a pupil of Dürer's or by any one of the Little Masters; apart from Cranach, this applies to German art in general in the second quarter of the sixteenth century.

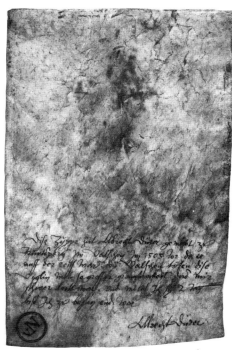

11 Forged Dürer inscription, reverse of Cat. 15.

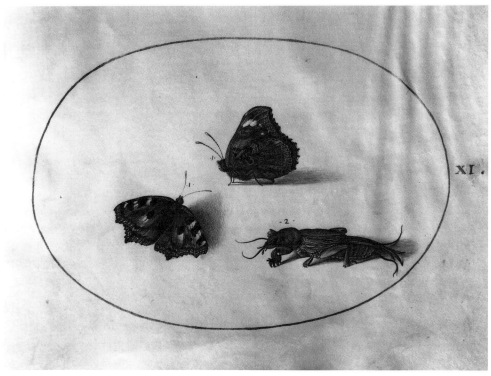

13 George Hoefnagel, *Butterflies and Mole-Cricket,* miniature painting on vellum. Washington, Collection of Mrs. Lessing J. Rosenwald, on deposit at the National Gallery of Art.

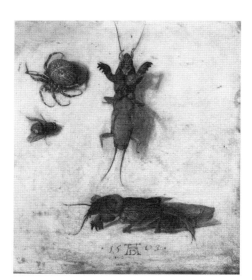

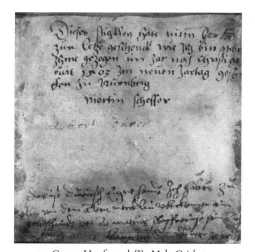

12, 12a Georg Hoefnagel (?), *Mole-Cricket, Garden Spider, and Fly,* miniature painting on vellum, with false Dürer monogram and forged inscriptions on the reverse. Paris, private collection (see note 19).

21 See, e.g., Exhibition Catalogue *Meister um Albrecht Dürer* (Nuremberg, Germanisches Nationalmuseum, 1961).

Apparently the opinion that no one else besides Dürer attempted the same sort of study[22] has hitherto suspended judgment in this area. Various lines of inquiry pursued in connection with this catalogue, however, have made us realize otherwise. Dürer's studies themselves obviously lie within a broader tradition; we are coming to know more and more comparable studies of nature from the early sixteenth century; even by Hans Baldung Grien, who was in Dürer's closest circle, some sketches are to be found that are stylistically akin to certain Dürer studies whose attribution is equivocal. Although only in the case of the *Columbine* (see Cat. 68) are concrete beginnings traceable, it must be assumed that the larger portion of the surviving studies come from the Dürer studio. Not knowing how many there are makes us hesitate to ascribe definitely to Dürer certain studies hitherto unknown or attributed to artists of the Dürer Renaissance. In the absence of more knowledge about the drawings of Kulmbach, Baldung, Springinklee, Beham, or Schoen, we cannot solve questions of attribution with total certainty.

Pictorial Tradition in the Renaissance

It is only in our own period that works of art have been extensively duplicated and popularized as a result of modern reproduction techniques based on photography, but Dürer's nature studies were already copied in the sixteenth century, obviously in full knowledge of their authenticity. Interestingly, the works accepted today as genuinely Dürer's are the very ones that were employed as models in those days. This throws even more doubt on many studies ascribed to Dürer that are of questionable origin but that are not copies.

A still almost untapped source of Dürer studies, of sixteenth-century nature study in general, and of copying methods are old albums; they usually assemble illustrations from various origins and of varying quality that are based on sometimes very diverse and often not precisely definable interests in nature. Mostly, these volumes include only average pieces that deserve little consideration as works of art, but they sometimes are not insignificant as historical evidence about collecting or are echoes of well-known works. From the frequency with which certain motifs are repeated, the extent to which an individual image was known may be deduced, and many times the fate, origin, and whereabouts of a well-known original, or even the former existence of an important model, may be revealed. Let us take as an example Dürer's *Stork,* which belongs to his early work, before 1500, and is at present in the Musée d'Ixelles (ill. 14). In the sixteenth century the study was still in Nuremberg, belonging to Willibald Imhoff the Elder, and is mentioned for the first time in the inventory of 1588.[23] A hitherto unknown copy by Hans Hoffmann, in an album now in Vienna,[24] to some extent corroborates this information (ill. 15). As already stated, Hoffmann copied many Dürer drawings in Imhoff's possession. If the inventory entry were unknown, we would guess from the fact of this copy alone that he had seen the original at Willibald Imhoff's. Furthermore, the representation of the *Stork* became known as Dürer's work to a wider circle of interested people, as is proved by an additional, long-ignored rendering in another album of animal drawings in Dresden, dating from about 1600 (ill. 16).[25]

Moreover, in the case of the *Stork* and its copies, it is possible to trace the provenance even further. The study went with other pieces from the Imhoff Collection to Emperor Rudolf II, and in 1783, together with his other Dürer drawings, it passed via the emperor's treasure chamber to his court library, and thence in 1796, to Duke Albert. In the relevant documents, the Hapsburg Dürer drawings can only be traced as bundles of papers. Only in 1829 do the sources again become concrete: at this point the piece was illustrated in Denon's *Monuments* (ill. 17).[26] Vivant Dominique Denon was Napoleon's agent, empowered to requisition the best of the art treasures belonging to defeated states and have them sent to Paris. In this capacity he appeared in Vienna in 1809[27] during the occupation by French troops. He apparently used the occasion to collect "for his own fancy."[28] It is highly likely that during these events the *Stork* came into Denon's hands and went to France with him. It then left Denon's hands and finally, via Holford and the Willems Collection, came into the possession of the town of Ixelles.

22 W. II, p. 65.
23 H. II, p. 84, no. 90.
24 Vienna, Österreichische Nationalbibliothek, Handschriften- und Inkunabelsammlung, Cod. min. 42, fol. 34r.
25 Dresden, Staatliche Kunstsammlungen, Kupferstich-Kabinett, Inv. Ca 218, fol. 51.
26 Vivant Dominique Denon, *Monuments des Arts du Dessin chez les peuples tout anciens que modernes* (Paris, 1829), vol. 4, p. 253.
27 According to K.-Str., pp. 69 ff.
28 Josef Freiherr von Hormayr, *Archiv für Geschichte . . .* (1825), no. 94, quoted in K.-Str., p. 71.

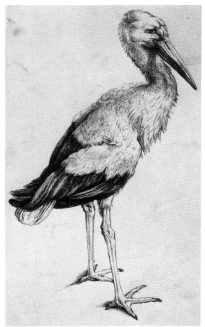

15 Hans Hoffmann, *Stork,* copy after Dürer, pen drawing. Vienna, Österreichische Nationalbibliothek.

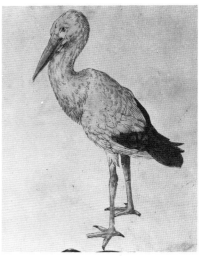

16 German, c. 1600, *Stork,* copy after Dürer, pen drawing. Dresden, Staatliche Kunstsammlungen, Kupferstich-Kabinett.

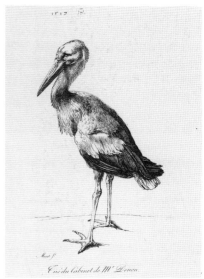

17 Lithographic reproduction of Dürer's *Stork.* Paris, 1829.

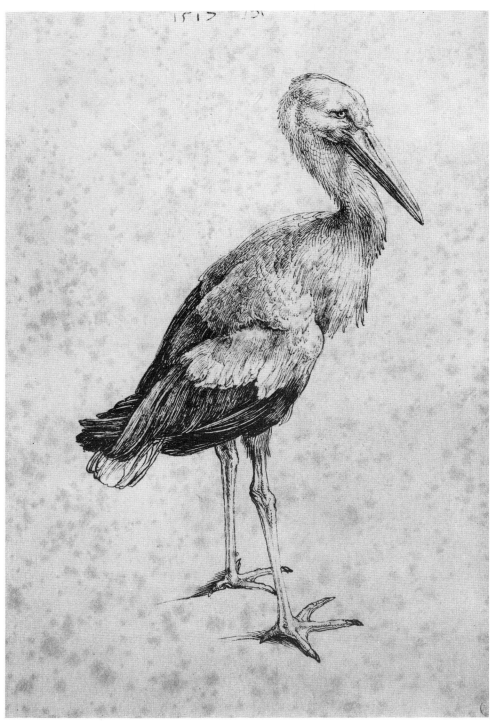

14 Albrecht Dürer, *Stork,* pen drawing (W. 240). Ixelles, Brussels.

29 Dresden, Staatliche Kunstsammlungen, Kupferstich-Kabinett, Inv. Ca 213, fol. 41; the album also includes on fol. 7 and fol. 54 copies of Dürer's pair of lions (see p. 161).
30 London, The British Museum, Department of Prints and Drawings, Inv. Sloane 5261/101 (W. 242).
31 Amsterdam, Rijksmuseum, Rijksprenten-kabinet, Inv. 587.

32 London, The British Museum, Department of Prints and Drawings, Inv. Sloane 5219/39; on the evidence of the color notes, this is the work of a Netherlandish draughtsman.
33 Berlin, Staatliche Museen Preußischer Kulturbesitz, Kupferstichkabinett, Inv. KdZ 4942 (W. 91).
34 London, The British Museum, Natural History, Zoology Library.

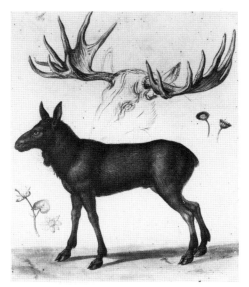

18 German, second half of the sixteenth century, *Elk Cow,* pen and brush on paper. Vienna, Österreichische Nationalbibliothek.

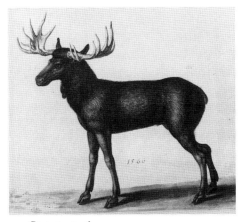

19 German, c. 1600, *Elk Bull,* pen and brush on paper. Dresden, Staatliche Kunstsammlungen, Kupferstich-Kabinett.

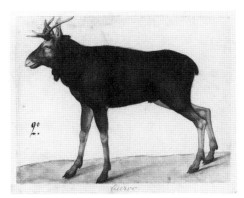

21 Netherlandish, c. 1570, *Elk,* pen and brush on paper. Amsterdam, Rijksmuseum, Rijksprentenkabinet.

So drawings of this sort, and particularly Dürer's nature studies, of course, must have attracted very many more copies than was earlier assumed. An even clearer example of this phenomenon is the drawing of an elk (ill. 18) from Cod. min. 42 in the Österreichische Nationalbibliothek in Vienna. Above the elk cow is sketched the skull of an elk bull with wide-spreading antlers. The same motif (ill. 19) appears in an album compiled in Dresden[29] only a short while later. Here the elk cow has become a bull with the skull that was only sketched in the Vienna version. The basis of both versions, though, looks different again: it is Dürer's drawing[30] of the eland (*"Heilennt,"* ill. 20), where the body shape and leg position are exactly the same.

It is by no means clear whether this speaks for the fame of the study or indicates the direct dependence of the Dresden album on the Vienna one, which is possible in the case of the elk. However, the elk of about 1570, belonging to the Lambert-Lombard Album in the Rijksprentenkabinet in Amsterdam,[31] copies Dürer's model exactly (ill. 21). We can take the connections still further, but without being able to trace their course more precisely. In London there exists a chalk drawing of a boar's head in an album in the Sloane Collection,[32] and in Vienna a similar boar's head in watercolor appears in Cod. min. 42, fol. 6r.

Even more baffling are the versions of a lobster. Dürer was probably in Venice when he drew a gigantic lobster (ill. 22), dated 1495.[33] Another version of this motif, slightly different but very nearly as large, is to be found as the only example of a crustacean, completely out of place, at the end of an album of bird pictures attributed to Giovanni da Udine (ill. 23).[34] Oddly enough, there is a very similar lobster, likewise attached at the end of the album Cod. min. 24 of the Österreichische Nationalbibliothek in Vienna (ill. 24).

These few examples give some idea of the opportunities there are to research this unknown material; we can touch on it only briefly here, since it affects our theme only indirectly.

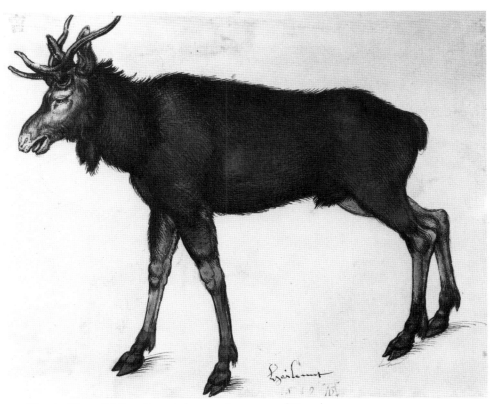

20 Albrecht Dürer, *"Heilennt,"* pen and watercolor on paper (W. 242). London, The British Museum, Department of Prints and Drawings.

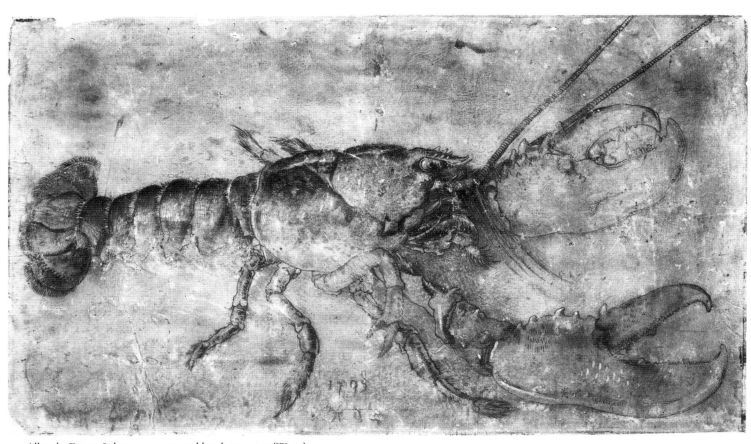

22 Albrecht Dürer, *Lobster,* 1495, pen and brush on paper (W. 91).
Berlin, Staatliche Museen Preußischer Kulturbesitz, Kupferstichkabinett.

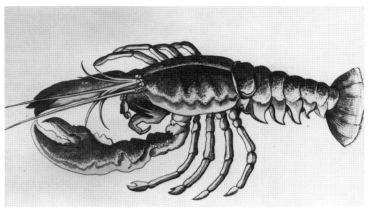

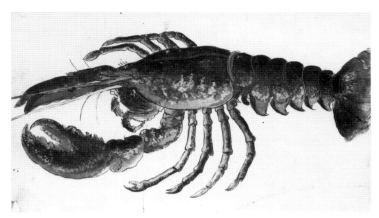

23 Italian (?), mid-sixteenth century, *Lobster,* pen and watercolor on paper. London, The British Museum, Department of Natural History.

24 German, c. 1600, *Lobster,* pen and watercolor on paper. Vienna, Österreichische Nationalbibliothek.

The Horse in Dürer's Work

Dürer's treatment of the horse also is not considered in this work, because it represents a special case among his animal studies outside our present scope — his interest here being not so much in nature study as in the examination of ideal proportion. The horse was a construction exercise for Dürer, as the human body had been since 1500. His interest in both came from Italy, aroused by Jacopo de' Barbari and Leonardo da Vinci. The Venetian de' Barbari had shown Dürer, in the latter's words, "man and woman, which he had constructed by means of measurement."[35] It was probably Dürer's friend Willibald Pirckheimer[36] who told him about Leonardo's concern[37] with classical proportion in relation to the standard build of the horse (ill. 25), since he had studied from 1488 onward in Padua and Pavia and at the University of Milan. We know from Lomazzo that Milanese contemporaries like Bramante and Foppa were also aware of a "quadrature of a horse's members."[38] Dürer worked on a grid and favored the characteristic, monumental side view, as shown in his *Rider* (ill. 26) of 1498 or the horse in *Saint Eustace* (B. 57, about 1500).

All his life, Dürer regarded the depiction of the horse as governed by basic, logical principles of form and as an exercise in theoretical abstraction. It has long been known that he had planned a treatise about the proportions of the horse. As the engraving *Adam and Eve* (B. 1, 1504) embodies Dürer's reflections about the dependence of male and female beauty on number and proportion, so his masterpiece *Knight, Death, and Devil* (B. 98, 1513; ill. 28) is the outcome of more than a decade's concern with the construction of the horse. His straight side view of horse and rider, originally used in 1498 and adhering to ideal proportions, as the grid under the Milan drawing shows (ill. 27), is here applied programmatically to achieve a pictorial realization.[39]

Scientific Illustration

Even in antiquity, drawing served as a means of scientific illustration. True-to-life drawings of plants already appear in Hellenic books, and it was particularly indispensable in medical literature. This old tradition is followed by herbals, such as the *Vienna Dioscurides,*[40] created for Anicia Juliana in the sixth century after ancient models; its late medieval variant is found in the type *Tacuinum Sanitatis.* About 1400, a new and independent way of observing nature appears in the herbal illustration of northern Italy, foreshadowing the free representation of grasses, herbs, and flowers in the Renaissance.[41] This development had its direct consequences, however, less in Italian fifteenth-century art than in Netherlandish, whence grew the autonomous nature study of the German Renaissance.

35 ". . . man vnd weib, dy er aws der mas gemacht hett." See Rupprich I, p. 103.

36 See Exhibition Catalogue *Leonardo's Horses. Studies of Horses and Other Animals by Leonardo da Vinci from the Royal Library at Windsor Castle* (Florence, Palazzo Vecchio, 1984).

37 Franz Winzinger, "Dürer und Leonardo," in *Pantheon* XXIX/1971, pp. 3–21.

38 "*Quadratura de' membri del cavallo.*" Josef Kurthen, "Zum Problem der Dürerschen Pferdekonstruktion," in *RKW* 44/1921, N.F. VIII, p. 94; Lomazzo, *Idea del Tempio della pittura* (Milan, 1590), ch. IV, p. 16.

39 Kurthen, 1921, pp. 77–106.

40 Hans Gerstinger, *Dioscurides (De materia medica),* Codex Vindobonensis, Med. Gr. I der Österreichischen Nationalbibliothek (facsimile publication, Graz, 1965–1970; commentary volume, Graz, 1970). Herbert Hunger in collaboration with Otto Kresten, *Katalog der griechischen Handschriften der Österreichischen Nationalbibliothek,* part 2 (Vienna, 1969), Med. Gr. I, pp. 37–41.

41 Otto Pächt, "Early Italian Nature Studies and the Early Calendar Landscape," in *Journal of the Warburg and Courtauld Institutes* 13/1950, pp. 13–47.

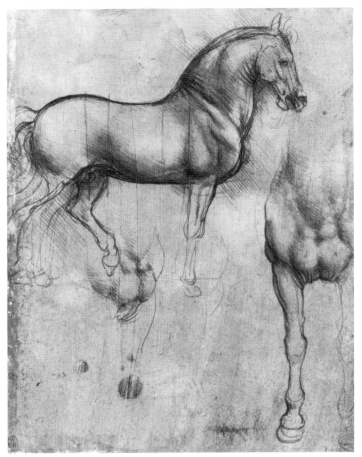

25 Leonardo da Vinci, Horse studies with proportion grid, metal stylus on blue-primed paper. Windsor Castle, Royal Library.

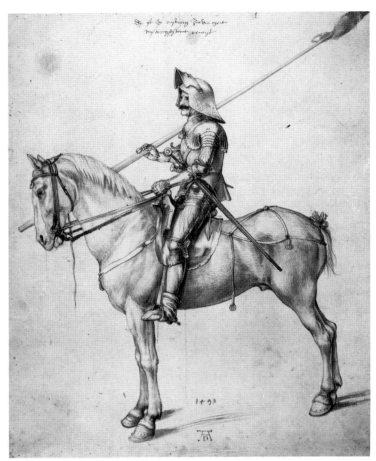

26 Albrecht Dürer, *Rider,* 1498, pen and watercolor on paper (W. 176). Vienna, Graphische Sammlung Albertina.

PICTORES OPERIS,
Heinricus Füllmaurer. Albertus Meyer.

SCVLPTOR
Vitus Rodolph. Specfle.

29 Woodcut from Leonhard Fuchs, *De historia stirpium,* Basel, 1542.

With the start of the new epoch, objective illustration became the essential tool of both science and teaching. Dürer's works, in their absolute truth to nature, correspond equally to the artistic and the scientific demands of the sixteenth century. Although Dürer, thanks to his manner of rendering reality with uncompromising fidelity, could do justice to both art and science, by the time that he approached the end of his life a specialization set in that brought about their separation.

When, in 1530, Otto Brunfels scientifically updated the herbals from their inherited late Gothic form with his *Herbarum vivae . . .* (see Cat. 82, note 1), he also revolutionized the pictorial element. He found a congenial partner in Hans Weiditz, the woodcut designer schooled in Franconian art, who evidently had worked for several years in Burgkmair's studio in Augsburg. A little later, in 1542, Leonhard Fuchs produced his *De Historia Stirpium.* Whereas the division of labor is already stressed in Brunfels's verbal text, the draughtsman and even the carver now appear in Fuchs's work in effigy (ill. 29). The gift for drawing of the artist and the dexterity of the craftsman now go hand in hand with the knowledge of the scientist.

Subject illustration soon became a specialty in its own right, aimed at scientific recognition more than simple observation of nature. It boasted an accuracy that captured even the smallest species-specific characteristic, and still permits identification that satisfies our modern botanical requirements. Illustration as an aid to identification, recognition, and knowledge, making use of additional special forms such as the enlarged, explanatory accompanying picture, from then on followed its own specific rules and went its own way.

Conrad Gessner's *Historia Plantarum* (see Cat. 84, 85) and the approximately 1,800 flower paintings carried out by Pieter van der Borcht for Carolus Clusius[42] indicate how rapidly specialization in the field of botany was progressing; here, as in other disciplines, the artistic recording of scientific particulars remained an indispensable aid until the

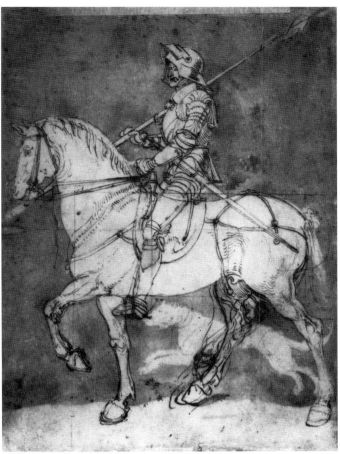

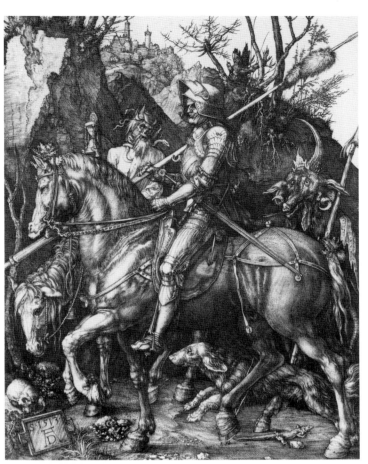

27 Albrecht Dürer, Preparatory drawing for the engraving *Knight, Death, and Devil,* with construction grid, 1513, pen drawing. Milan, Ambrosiana.

28 Albrecht Dürer, *Knight, Death, and Devil,* 1513, copper engraving (B. 98, M. 74).

invention of photography. This aspect is covered in our exhibition. We are indebted to those botany and zoology experts whose reports enabled us to discuss certain problems of art history on the basis of new hypotheses.

Still Life

The true-to-life study was important not only to the development of scientific illustration, but also to the creation of independent still life. It came to function to a certain extent as a preparatory detail of the whole.

The germ of this development can be discerned in Flemish book illustration of the late fifteenth century. The exact observation of plant details and the concrete pictorial representation of motifs such as vases of flowers or individual blooms in the miniatures and borders by the Master of Mary of Burgundy or Simon Benning anticipate *en miniature* what was to happen on a large scale in the mid-sixteenth century. The relaxation of political and religious constraints and Renaissance man's new self-awareness favored the creation of new, secular pictorial themes such as landscape and still life.[43] What had long appeared as detail in book illustration and panel painting now emerged as an independent theme. On the basis of a growing interest in nature, the step was taken from the study of a single specimen to an arbitrary composite arrangement of a new kind, the floral bouquet. The earliest known examples of the form are the flowerpieces dated 1562 by Ludger tom Ring the Younger, which predate by more than a generation the general development toward self-contained floral still lifes (see Cat. 88).

★

42 Hans Wegener, in *Zentralblatt für Bibliothekswesen* 55/1938, pp. 109 ff. I am grateful to Mrs. A. Demus for kindly drawing attention to Stephan Aumüller, in *Burgenländische Heimatblätter* 45/1983, pp. 97 ff., and informing me that the sixteen volumes of *Libri picturati* held until the war in the Prussian State Library are now in the Jagellonian Library in Cracow.

43 Compare Jan Gerrit van Gelder, "Introduction to the Study of Still-Life Painting in the Netherlands," in *Catalogue of the Collection of Dutch and Flemish Still-Life Pictures* (Oxford, Ashmolean Museum, 1950), pp. 1–23; Sterling 1952; Ingvar Bergström, *Dutch Still-Life Painting in the Seventeenth Century* (London/New York, 1956).

The almost magical power of Dürer's name, particularly in the field of nature studies, led to the attribution of numerous works to him. These attributions, however untrustworthy they were, as well as works that could easily have been recognized as imitations or falsifications, were protected by the link with Dürer as soon as this was expressed. Opinions were passed on without scrutiny, as if they were rendered immutable by the great name and confirmed by the resounding provenance — as in the case of the studies in the Albertina from the emperor's property, which proceeded from Willibald Imhoff. Many of these works have been widely popular and have enjoyed uncritical recognition even in the professional art world. Dissenting utterances, such as those of Hans and Erica Tietze, met powerful, altogether emotional objection; even cautiously formulated doubts, such as Friedrich Winkler's, were rejected.

The literature about Dürer's nature studies is abundant and often expresses conflicting opinions. It therefore seems necessary to summarize the most significant points of view before putting forward my own in order to assist the reader in understanding the specific problems. The opportunity provided here to confront the differing opinions with the very objects they concern seems well suited to clarify one or another viewpoint. For this reason, controversial opinions are quoted more exhaustively than usual, and the nature of the problem is commented on more thoroughly.

Works by artists of the Dürer Renaissance are included here in far greater number than might have been expected, with the intention of making Dürer's stylistic individuality more obvious in comparison with the specific characteristics of his followers. In addition, seeing together individual specimens from this area of German drawing makes many things clearer: with the extension of our knowledge about Dürer's influence, we not only grow more confident about distinguishing between original and copy, but we become better able to recognize the contribution of different copyists. The ingenious paraphrase of Dürer motifs, particularly the way they are varied by the use of extreme front views, can firmly be perceived as one pictorial principle of the Dürer Renaissance. Scientific illustration crystallizes as a type of drawing independent of artistic studies and subject to its own rules of representation; at the same time the importance of the autonomous nature studies for the development of still life in its own right also becomes apparent.

With the disclosure of particular nature studies by contemporaries of Dürer, we begin to set foot in an unknown territory of German art that until now was reserved only for the polar concepts of "Dürer" or "Dürer Renaissance." In the process, Dürer's exceptional, practically monopolistic position in the field of sixteenth-century German animal and plant studies in fact loses something of its dominance. But what on the one hand may be felt to be a reduction, in particular a perhaps painful cutting down of his œuvre, does not really signify a loss; on the contrary, it helps a hitherto unknown area of German art to emerge clearly — that of early Renaissance nature studies.

Animal Studies

Dürer's Predecessors and Contemporaries

The origins of the modern depiction of nature are frequently traced back to north Italian art of the quattrocento. It seems from the surviving examples of nature studies such as those of Giovannino de' Grassi or Antonio Pisanello that it is their new way of looking at the animal and plant world that informs the work of both Leonardo da Vinci and Albrecht Dürer. Although we have numerous sketchbooks and drawings[1] from Italy that give a lively image of artistic tradition and regional development there, nothing of the sort has survived from north of the Alps. Only indirectly, through book illustration and panel painting, can something be deduced. These make it clear that decisive influences on German fifteenth-century art came from the Netherlands.

Surviving works of old Netherlandish painting show that they must have been based on nature studies, but there are hardly any drawings extant, and absolutely none direct from nature. So Simon Marmion's study of a hoopoe (Cat. 1) represents the oldest known, and certainly the only surviving, example of a fifteenth-century *non*-Italian nature study up to the standard of Pisanello. Dürer might have had the opportunity, during his travels along the upper Rhine and perhaps even to the Netherlands, to become familiar with animal drawings and plant studies that must have preceded Netherlandish paintings, and that also have left some noticeable traces in French manuscript illumination.

The probably Franconian drawing of an ostrich (Cat. 5) gives us an example of how the precursors of Dürer's animal studies in Nuremberg looked. The *Dog Studies* (Cat. 3), belonging to the school of Hans Holbein the Elder, and the sketch *Performing Bear* by Hans Burgkmair the Elder (Cat. 4), on the other hand, are to be counted with the Augsburg animal studies of the Dürer period. The drawings of Dürer's contemporaries Jacopo de' Barbari, Lukas Cranach, and Hans Baldung Grien, who contribute to an understanding of the basis of Dürer's work, will be discussed later in their relative thematic connections.

These few chosen examples, each representing a tendency or an artist, are merely intended as indications of a few principal artistic possibilities that Dürer may have been involved with or built upon. At the same time, the power and originality of his own artistry clearly emerge when compared with theirs. Last but not least, after following development in Germany and glancing at the Italian pattern-book tradition, we intend to demonstrate the hardly understood influence of the Franco-Flemish and Netherlandish models on Dürer's animal and plant studies.

NOTE

1 See Bernhard Degenhart and Annegrit Schmitt, *Corpus der italienischen Zeichnungen 1300–1450;* I. *Süd- und Mittelitalien,* 4 vols. (Berlin, 1968); II. *Venedig, Addenda zu Süd- und Mittelitalien,* 4 vols. (Berlin, 1980–1982).

The illustrated section:

The literature about Dürer is so extensive that a selection has had to be made. Titles of frequently quoted works are abbreviated (see Appendix, pp. 271–272). Titles not cited in the abbreviated list or in the General Literature are given in full in the notes.

Botanical details have been checked or provided by F. Ehrendorfer and S. Segal and zoological ones by G. Pass. Zoological nomenclature is according to Grzimeks Tierleben, Enzyklopädie des Tierreichs, edited by B. Grzimek (Zurich, 1973); published in English as Grzimek's Animal Dictionary (New York/London: Van Nostrand Reinhold, 1974).

Measurements show height followed by width.

SIMON MARMION, ATTRIBUTED TO

Hoopoe

Watercolor on mildew-spotted paper
Corrections in white, brush and pen in
brown, over preliminary chalk drawing
Watermark: circle with rod and cross
(see p. 256, fig. 1)
Inscription, top right, in brown:
Simon Mormion myt der handt
Reverse: Hoopoe, black chalk; inscription,
top left, in brown:
*Man propria di M. Simon Mormion fiamengo
miniatore*
170 x 280 – 282 mm, trimmed at the top

Vienna, Österreichische Nationalbibliothek,
Handschriften- und Inkunabelsammlung,
Cod. min. 42, fol. 55r, below

PROVENANCE: Emperor Rudolf II • Kaiserliche
Schatzkammer • Kaiserliche Hofbibliothek
(1783).

BIBLIOGRAPHY: Otto Pächt, "Simon Mormion
myt der handt," in *Revue de l'Art,* 46/1979,
pp. 7–15.

This watercolor is a life-size study of a
hoopoe (*Upupa epops* L.) with raised crest. Top
right, in clearly legible old handwriting (early
sixteenth-century?) is a note meaning "Simon
Marmion with the hand." On the reverse side
is another study of the same bird, done in chalk
only (ill. 1.1), with an inscription in Italian
meaning "The own hand of Master Simon
Mormion, Flemish miniaturist."

The drawing belongs to an album[1] that in-
cludes numerous animal and plant studies by
different artists. According to the watermarks
of the paper used in the book, and the note
"1579 . . . in Praga" on fol. 161, the album

was compiled at the end of the sixteenth cen-
tury at the court of Rudolf II; in 1783 it was
moved from the emperor's treasure chamber to
the court library. Otto Pächt introduced the
drawing into the literature in 1979, and in a
thorough analysis verified the indication given
by the old inscription on the drawing that this
was a work by the painter and miniaturist
Simon Marmion, who was active at the Bur-
gundian court.

Comparison with older pictures of hoopoes
shows that there already had been independent
versions by Giovannino de' Grassi in Italy at
the end of the fourteenth century. North of the
Alps the hoopoe appears so early only in col-
lections with other types of birds.[2] In contrast
to Giovannino de' Grassi's comparatively col-
orful but rather flat, diagrammatic portrayal,[3]
a watercolor drawing ascribed to Pisanello,
from the Codex Vallardi in the Louvre,[4] shows
the hoopoe in detail from two aspects; the
drawing of the plumage and the way the bird's
outline changes with the angle of observation
indicate a deeper interest in natural subjects.
Compared with these two versions, the Vienna
piece surpasses its Italian predecessors in truth
to nature. Whereas de' Grassi overcolors the
crest, the bird's characteristic feature, with an
intense, almost glaring layer of paint, which
makes it look as though it were stuck on, Mar-
mion makes it grow organically from the head,
with each feather constructed in delicate
brown lines over a light color wash. By means
of the finest gradations from orange to brown
to black and the light white parts of the un-
touched paper base, the tone and texture of the
plumage are given their full visual value. Ob-
viously relying on direct observation of nature,
which seems to have been possible only since
Dürer made his animal studies, Simon Mar-
mion in this watercolor transcends the usual
medieval style of representation.

According to Pächt the realism of detail in
this version comes from the artist's training in

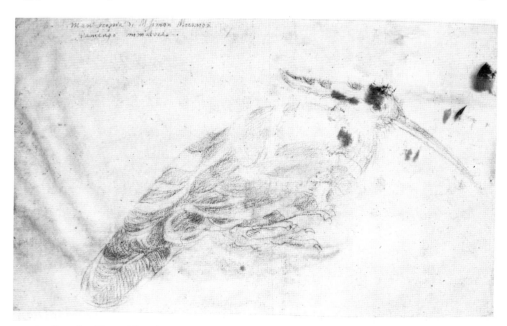

1.1 Attributed to Simon Marmion,
Hoopoe, chalk on paper (reverse of Cat. 1).

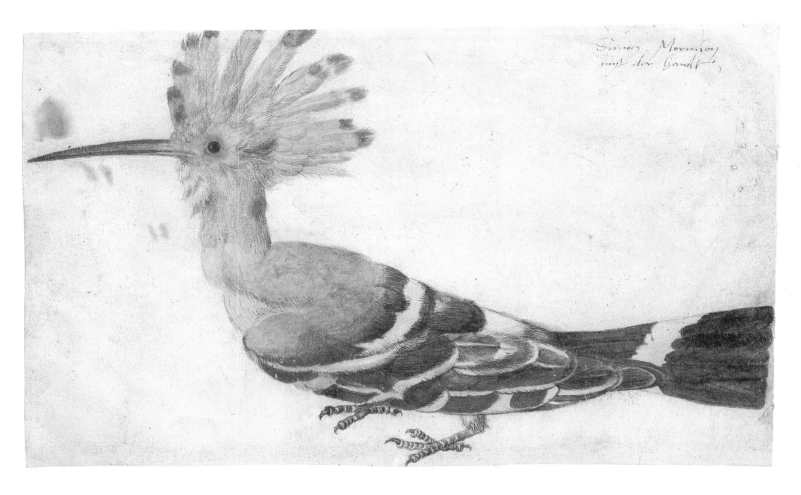

Salomon Morvian
mit der Handt

I

the Netherlands. This assumption is mainly confirmed by the highlights in the bird's eye. While in the examples of de' Grassi and Pisanello the eye is little more than a black spot ringed by a lighter border and, in the absence of shading, looks stiff and lifeless, Marmion in his study handles it like a human eye. This not only presupposes accurate observation of nature, but also indicates Netherlandish influence, as highlights in the eyes were used by the old Netherlandish masters Jan van Eyck and the Master of Flémalle for the first time since antiquity. But there is not always the same consistency between the observation of a detail and its handling. A contradiction appears in this version: the bird is shown in side view, but the tail feathers are spread out sideways to display their design better. In this respect Marmion is following a tradition that goes back to classical art, when it was applied to peacock figures. The wingtip trailing over the tail feathers, says Pächt, shows the artist's attempt to combine the classical element with a more up-to-date observation of nature.

From miniatures by Marmion and his school Otto Pächt was able to substantiate more closely the reference to Simon Marmion, written on the front of the drawing in German and repeated on the back in Italian (second half of the sixteenth century). The birds in the borders of *Histoires Romaines* by Jean Mansel, illuminated for Philip the Good between 1454 and 1460 and now in Paris,[5] show just as realistic a style of representation, particularly the light reflections in the eye. This might be an indication that there was a repertoire of models consisting of nature studies, such as this hoopoe, and that the miniatures were presumably based on them. As a further example for comparison, Pächt introduces the frontispiece of Simon Marmion's *Grandes Chroniques de France,* now in Leningrad,[6] in which Marmion has likewise inserted studies from nature among the ornamental motifs of the border decoration. Both manuscripts date from the 1450s, and we would like to assume that the hoopoe drawing also belongs to this period.

With no opportunity to make genuine comparisons, however, we must admit that no amount of meditation can do more than determine the school to which the study belongs. No convincing indication emerges that it was done by Marmion himself. But this hardly reduces its importance, and it remains nonetheless of exceptional significance as a record of an original, non-Italian nature study of the fifteenth century. As such it is not only a singular example of Franco-Flemish art, but the very earliest surviving one from north of the Alps. Moreover, in quality and in its standard of nature observation it is the only pre-Dürer animal study that can compare with his from outside Italy. As evidence of development before Dürer it is unusually important, and helps us imagine how the pattern material used in the studies looked — material that the young Dürer may have gotten to know during his years of travel on the upper Rhine and perhaps also in the Netherlands.

NOTES

1 Vienna, Österreichische Nationalbibliothek, Handschriften- und Inkunabelsammlung. Franz Unterkircher, *Inventar der illuminierten Handschriften, Inkunabeln und Frühdrucke der Österreichischen Nationalbibliothek,* part 2 (Vienna, 1959), p. 130. Cod. min. 42, "Studies of nature: 170 album sheets, paper, 487 x 361 mm; the pictures (mostly paper, some vellum) stuck on. — Netherlandish and German artists, 1530–1580." See also M. L. Hendrix, *Joris Hoefnagel and the Four Elements: A Study in Sixteenth-Century Nature Painting* (phil. diss., Princeton University, 1984), principally pp. 146 ff., where individual studies are exhaustively handled. On the removal of the Rudolfian volumes to the court library, see Heinrich Zimerman, "Inventare, Acten und Regesten aus der Schatzkammer des Allerhöchsten Kaiserhauses" (continuation), in *JKSAK* 16/1895, p. LVIII, 12658 (no. 22).

2 Jacquemart de Hesdin, *Armoiries papales* (Rome, Vatican Library), Vat. lat. 51, fol. 1. There is an illustration of this and the following mentioned works in Pächt, 1979.

3 Bergamo, Biblioteca civica, Cod. delta 7.14., fol. 12r.

4 Inv. no. 2467.

5 Bibliothèque de l'Arsenal, Ms. 5087–5088.

6 See Pächt, 1979, ill. 15.

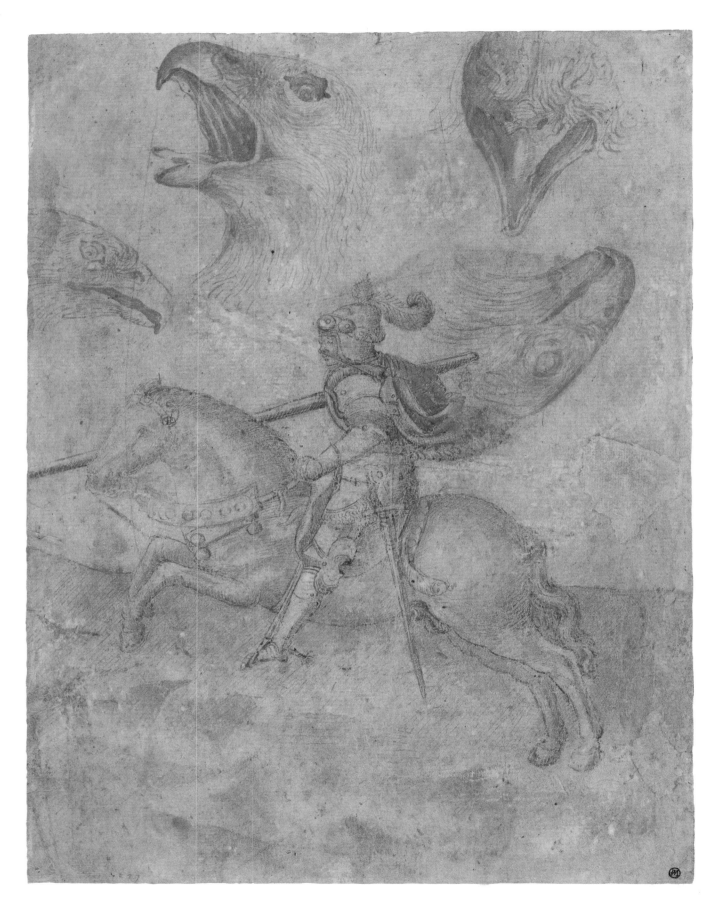

TUSCAN, SECOND AND THIRD QUARTERS
OF THE FIFTEENTH CENTURY

Knight on Horseback, with Four Eagles' Heads

(illustrated on page 31)

Pen and brush in bister, with some red chalk
(on the birds' heads),
on paper with a patchy red chalk wash
The paper has been torn in several places
and shows some mends, together with
deep scoring along the contours of the horse
Right-hand page of a pattern book; the facing
left-hand page,
now in Dijon (ill. 2.1), bears the watermark
of a triple mountain in a circle with a cross[1]
29 is written at bottom left
Reverse: lynx preying on a hare, walking ape,
leopard attacking a stag, ape with a mirror
Inscription above: *lunza ov[ero] gatto;*
below: *leopardo*
236 x 178 mm

Vienna, Graphische Sammlung Albertina, Inv.
27 (V 13)

PROVENANCE: Vasari • Mariette (L. 1852) •
Joullain • Moriz Graf Fries (L. 2903) • Duke
Albert of Saxe-Teschen (L. 174).

BIBLIOGRAPHY: Franz Wickhoff, "Die
italienischen Handzeichnungen der Albertina,"
part II: "Die römische Schule," in *JKSAK*
13/1892, p. CLXXXIII, S.R. 31 • Schönbrunner
and Meder, no. 349,555 • Albertina Catalogue I,
p. 10, no. 13 • Otto Kurz, "Giorgio Vasaris
Libro de' Disegni," in *OMD* XII/1937 (June),
p. 10, and 1937 (December), pp. 32 ff. • John
Pope-Hennessy, *The Complete Work of Paolo
Uccello* (London, 1950), p. 168 • Bernhard
Degenhart and Annegrit Schmitt, "Uccello.
Wiederherstellung einer Zeichnung," in
Albertina Studien I/1963, bk. 3, pp. 101–117 •
Degenhart and Schmitt, *Corpus der italienischen
Zeichnungen 1300–1450,* I. Süd- und Mittelitalien,
4 vols. (Berlin, 1968), vol. 2, pp. 396–402, no.
311 • Walter Koschatzky, Konrad Oberhuber,
and Eckhart Knab, *I grandi disegni italiani
dell' Albertina di Vienna* (Milan, 1972), no. 8 •
Exhibition Catalogue *Italienische Zeichnungen der
Renaissance, zum 500. Geburtstag Michelangelos,*
compiled by Eckhart Knab and Konrad
Oberhuber (Vienna, Graphische Sammlung
Albertina, 1975), p. 16, no. 3.

The front side of this pattern-book page
shows a knight on horseback and four eagles'
heads; on the reverse are four animal scenes in
the order given in the description above. The
study is half of a drawing that extends over two
pages of a pattern book, the other half being
now in Dijon (ills. 2.1, 2.3).[2] The connection
relies on the fact that the rider is galloping to
the left with leveled lance, and the weapon
finishes on the Dijon page.

The animal studies on the reverse side link
the page to the Tuscan tradition of animal pat-

tern books. They stand, as it were, at the point
of intersection with a tradition that was already
discernible in the early fifteenth century in a
pattern book now in the Rothschild Collec-
tion.[3] The lynx with the hare and the walking
ape appear there, exactly the same as our fig-
ures, and they can be seen again in Florentine
pattern books of the second quarter of the fif-
teenth century.[4] The motifs were common in
quattrocento art, and were also employed in
copper engravings[5] and *cassone* and wall paint-
ing, for example, in Benozzo Gozzoli's fres-
coes in the Camposanto of Pisa.[6]

Otto Kurz has ascertained[7] that the Vienna
drawing, together with other animal pattern
drawings (today in the Stockholm National
Museum), came from the *Libro de' Disegni* of

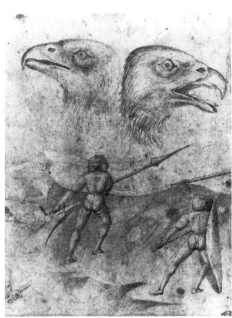

2.1 Tuscan, second and third quarter of
the fifteenth century, *Two Fighting Figures and
Two Eagles' Heads,* left half. Dijon, Musée des
Beaux-Arts.

Giorgio Vasari, who held them to be the work
of Paolo Uccello. The page, acquired from the
collection of Pierre-Jean Mariette[8] and Moriz
Graf Fries for Duke Albert of Saxe-Teschen,
was published by Wickhoff, with reference to
Mariette's note, as the work of Uccello.
Schönbrunner and Meder added a question
mark in the attribution. When Stix and
Fröhlich-Bum classified the page as north Ital-
ian in Albertina Catalogue I, and added it to
the Venetian drawings as "School of Pisanello,
mid-15th century," Uccello was practically
eliminated from the discussion. Pope-
Hennessy also excluded the studies from works
by Uccello's own hand, but he felt it was possi-
ble that they reflected a group of lost drawings
created at the same time as the Chiostro Verde
frescoes and in connection with them. The old
attribution was taken up again by Degenhart
and Schmitt.[9] In their opinion the drawing not
only resembles Uccello in form and theme, but
it even supplements our picture of the way he
worked, since it looks like a draft of the battle
scenes in the background of his painting *La*

Battaglia di San Romano. As a sort of companion
piece, similar in form and concept, they place
the galloping rider from Uccello's *Saint
George,* from the Musée Jacquemart-André in
Paris, alongside the Vienna drawing. They also
draw attention to the fighting animal groups
on the reverse side, in which they see a vital
contribution by Uccello to the Florentine
pattern-book tradition. According to them,
details here give an idea of some lost paintings
of Uccello's, those monumentally conceived
fighting animals in the Palazzo Medici that
Vasari talks about. From its connection with
the battle pictures that Uccello painted about
the middle of the century, and with the
Palazzo Medici scenes of fighting animals that
he carried out between 1450 and 1455, they

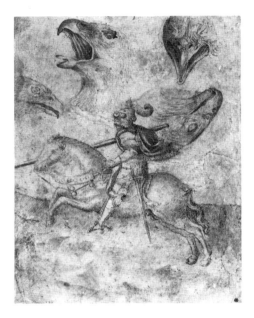

2.2 *Knight on Horseback with Four Eagles' Heads,*
right half. Vienna, Graphische Sammlung
Albertina (Cat. 2).

thought that the drawing might date from this
period.

Oberhuber, though, disagrees with Degen-
hart and Schmitt's attribution to Uccello. To
my mind rightly, he stresses the stylistic differ-
ences between the voluminous, stereometric,
abstract shapes of Uccello's Florentine rider
studies and the "dainty, sensitively drawn, but
almost jointless fairy-tale horse" that reveals
an artist of another tradition. The rider, like
the stag turning its head back, is a standard
motif in secular art, recognizable in numerous
examples of Florentine *cassone* painting; the
artist of the Vienna drawing might well be
sought among the Florentine decorative artists
of the fifteenth century. But Oberhuber's fur-
ther suggestion, to attribute the drawing to the
same hand as a pattern-book page in Lilles,[10] in
my opinion goes too far.

The four eagles' heads deserve particular at-
tention. Evidently it has not hitherto been
noted that their style — rapid sketches with
brush and pen — contrasts sharply with the
pen drawing of the rider study and the animal

figures on the reverse, shaped as they are with fine, delicate outlines and modeled with short, parallel lines of shading. The nuances of the bister inks are also different: the rider's is more reddish brown, while the birds' is grayish brown. This difference is partly veiled by the red chalk wash, which was obviously applied later. Red chalk as a drawing material, however, is found in places on the eagles' heads. In their immediacy, these heads might well be considered true nature studies, were it not, as Degenhart and Schmitt demonstrate,[11] that one of them appears in an animal pattern collection of 1460–70, from which they conclude, not that one was copied from the other, but that both are more likely to stem from a common model.

2.3 Tuscan, second quarter of the fifteenth century, *Animal Studies,* reverse of 2.1. Dijon, Musée des Beaux-Arts.

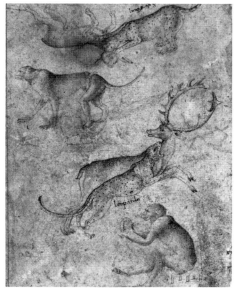

2.4 Tuscan, second quarter of the fifteenth century, *Animal Studies,* reverse of 2.2. Vienna, Graphische Sammlung Albertina.

So the addition of the eagles' heads, probably in the third quarter of the fifteenth century, indicates the continued studio use of a traditional pattern book created about 1430–40. The incongruity of the differing styles of drawing, that of the birds' heads sketched from various angles as contrasted with the neatly finished animal patterns, seems to indicate, in the focus on detail, an altered attitude toward nature. It looks at first as if we were seeing the transition from a late Gothic pattern book to a sketchbook, but since we find the bird's head repeated in another pattern sheet, it turns out in the end to be nothing more than the replenishment of an old stock of motifs from the viewpoint of a younger generation.

NOTES

1 As reported by Degenhart and Schmitt, 1968, I/2, p. 395, no. 310; but their description does not tally with the watermark shown on p. 660 as no. 111.

2 Degenhart and Schmitt, 1968, I/2, p. 395, no. 310.

3 Degenhart and Schmitt, 1968, I/1, p. 256, no. 154 (plates 185–190).

4 Degenhart and Schmitt, 1968, I/2, p. 625 (plate 442i), no. 633 (plate 443c).

5 Hind I/I, 1938, p. 94, A IV 25.

6 Degenhart and Schmitt, 1968, I/1, p. 259, ill. 367, and p. 397, ill. 528.

7 Kurz, 1937; see also the note on the reverse of the Albertina mounting: *"414 Paolo Uccello, n.n. 1389/fuit Vasari nunc Mariette,"* which was obviously copied from the old mounting paper of the drawing from Mariette's collection when it was placed in the Albertina collection.

8 Auction Catalogue Mariette/Basan 1775, p. 120, no. 775, with others (went to Joullain).

9 Degenhart and Schmitt, 1963, and 1968, I/2, no. 311.

10 Degenhart and Schmitt, 1968, I/1, p. 253, no. 148 (plate 183c), described as "Central Italian, circa 1430."

11 Degenhart and Schmitt, 1968, I/2, p. 624, no. 627 (plate 442b).

3

HANS HOLBEIN THE ELDER, SCHOOL OF

Dog Studies

Silverpoint on white-prepared paper
Reverse: sketches of two seated dogs,
one face in profile, in black chalk
Inscription, left (seventeenth century?),
in brown pen: *H. Holbein;*
right, in black chalk: *145*
140 X 202 mm
Erlangen, Graphische Sammlung
der Universität,
Inv. B. 751, I.E. 15

PROVENANCE: From the Art Chamber of the
Margrave Johann Friedrich von Brandenburg-
Ansbach (1654–1686); removed from the Castle
Library at Ansbach in 1805 by Friedrich
Wilhelm III of Prussia and presented to Erlan-
gen University.

BIBLIOGRAPHY: Alfred Woltmann, *Holbein und
seine Zeit,* 2nd ed. (Leipzig, 1876), vol. 2, p. 81,
no. 200 • Eduard His, *Hans Holbein's des Älteren
Feder- und Silberstift-Zeichnungen in den Kunst-
sammlungen zu Basel, Bamberg, Dessau, Donaue-
schingen, Erlangen, Frankfurt, Kopenhagen,
Leipzig, Sigmaringen, Weimar, Wien* (Nuremberg,
n. d.), plate LXIX • Bock, 1929, p. 183, no. 751 •
Exhibition Catalogue *Die Malerfamilie Holbein in
Basel,* drawings edited by Hanspeter Landolt
(Basel, Kunstmuseum, 1960), p. 97, no. 51 • Ex-
hibition Catalogue *Altdeutsche Zeichnungen aus
der Universitätsbibliotek Erlangen,* compiled by
Dieter Kuhrmann (Munich, Graphische
Sammlung, 1973), p. 73, no. 60, ill. 49.

This silverpoint drawing presumably came
from a sketchbook and shows various studies of
the same dog: below right we see a small, full-
figure drawing of him lying down; center, his
right hind leg; above, at either side, the head
from two different angles, with the left ear
noticeably missing (bitten off?).

The reverse side bears the old inscription *H.
Holbein.* Woltmann included the study in the
literature and indicated Holbein's authorship
as probable. Eduard His, too, included it with
the work of Hans Holbein the Elder. Glaser,[1]
on the other hand, did not mention the sketch.
According to Bock, it is hardly comparable
with the authenticated drawings of Hans Hol-
bein the Elder, which he considers in general
"much finer." Yet its technical and material
treatment seems to him in Holbein's line, "so
the old attribution may well indicate the cor-
rect school." In the Exhibition Catalogue
Basel 1960, the page size and the rather coarse,
somewhat schematic style of drawing are
named as factors that argue against Holbein,
but the portraitlike features and the painterly
treatment of the dog's coat are picked out as
typical of him. At the same time, it is pointed
out that the small, faintly traced pair of scrolls
(top center) appears in Holbein's paintings
from 1512 onward. Lieb and Stange[2] pass over

the drawing without comment. Kuhrmann
enters it as "Hans Holbein the Elder (?)."

The study cannot be unequivocally placed
by its drawing style. In addition to the charac-
teristics mentioned above, which for Landolt[3]
justify the recent attribution to Hans Holbein
the Elder, I feel that one can observe even
coarser features that it shares with several sil-
verpoint studies originally ascribed to Hol-
bein, but since recognized as Westphalian of
around 1500.[4] Despite the unquestionably
high artistic quality and the great similarity of
the strokes with Holbein's drawing, I hesitate
to ascribe the drawing to Holbein himself not
so much because of the way the drawing me-
dium is used, but rather because the layout of
the page, with studies of different sizes put
together disjointedly, would be rather odd for
Holbein.

Roughly contemporary with Dürer's animal
studies, probably dating from the beginning of
the sixteenth century, this one is a clear exam-
ple of artistic spontaneity. It is obvious that the
artist was moved to make not a scientific state-
ment, but an individual version and living like-
ness of his model.

NOTES

1 Curt Glaser, *Hans Holbein d.Ä.* (Leipzig, 1908),
 Werkverzeichnis der Handzeichnungen,
 pp. 187–210.
2 Norbert Lieb and Alfred Stange, *Hans Holbein
 d.Ä.* (Munich, Berlin, 1960).
3 Exhibition Catalogue Basel 1960.
4 These are to be found in Paris, Bayonne, and
 Basel; see Hanspeter Landolt, "Zu zwei Blättern
 mit Bildniszeichnungen," in *Öffentliche
 Kunstsammlung Basel,* Annual Reports 1964–
 1966, pp. 133–144, ills. 1, 2, 4; Friedrich
 Winkler, *Mittel-, niederrheinische und westfälische
 Handzeichnungen des XV. and XVI. Jahrhunderts*
 (Freiburg, 1932), no. 40 (*Die Meisterzeichnung,*
 vol. IV); Louis Demonts, *Inventaire général des
 dessins des Ecoles du Nord, Ecoles allemande et suisse,*
 vol. II (Paris, 1938), no. 391.

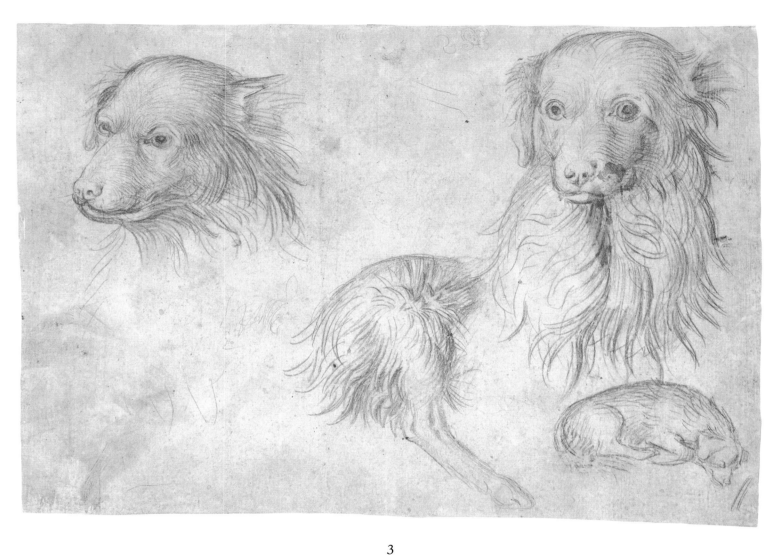

3

4

HANS BURGKMAIR THE ELDER

Performing Bear

Pen and brown ink on paper,
overdrawn in certain places with dark gray ink,
which is also used for the date *1496* at top left
The last figure is hard to decipher,
more like *6* than *8*
249 x 138 mm

Berlin, Staatliche Museen
Preußischer Kulturbesitz,
Kupferstichkabinett, Inv. 26076, 85–61 (N)

PROVENANCE: Rosenthal • L. v. Randall Esq.

BIBLIOGRAPHY: Edmund Schilling, "Hans
Burgkmair the Elder (1473–1531) — A
Performing Bear," in *OMD* XI/1936 (September), p. 36 • Exhibition Catalogue *Masterpieces of Drawing,* Philadelphia Museum
of Art 1950–51, no. 23 • Peter Halm, "Das
Gebetbuch von Narziss Renner in der Österreichischen Nationalbibliothek," in *ZKW*
VIII/1954, p. 69, ill. 3 • Auction Catalogue,
Sotheby's, May 10, 1961, p. 5, no. 3 • Tilman
Falk, "Zu Burgkmairs Zeichnung des Tanzbären," in *Berichte der Berliner Museen,* N.F.
XIII/1962, bk. I, pp. 2 ff. • Peter Halm, "*Hans
Burgkmair als Zeichner,*" in *MJBK* XIII/1962,
pp. 117, 118, ill. 50, p. 156, note 93, p. 160 •
Fedja Anzelewsky, "Hans Burgkmair," in
Apollo 1964, p. 150, ill. 5 • Franz Winzinger,
"Unbekannte Zeichnungen Hans Burgkmairs
d.Ä.," in *Pantheon* 1967, p. 17, ill. 6 • Tilman
Falk, *Hans Burgkmair, Studien zu Leben und
Werk des Augsburger Malers* (Munich, 1968),
p. 23, p. 91, notes 111, 112 • Exhibition Catalogue
*Vom späten Mittelalter bis zu Jacques Louis David,
Neuerworbene Zeichnungen im Berliner Kupferstichkabinett* (Berlin, Staatliche Museen Preußischer
Kulturbesitz, Kupferstichkabinett, 1973), pp. 17,
18, no. 18.

The brown bear (*Ursus arctos* L.) stands up on
his hind legs, supporting himself with his left
forepaw against a staff, which is chained to his
muzzle. To the right, the head of the bearmaster is briefly sketched in, not only indicating the intrinsic connection, but undoubtedly
also intending to show the mighty size of the
fully grown brown bear compared with a man.
The bear is drawn economically, "the shaggy
form circumscribed with a succession of short,
slightly curving lines, spaced out and only
rarely intersecting. Only the most essential interior details are drawn in, just enough to indicate the organic construction of the body and
the nature of the coat."[1]

It was Schilling who recognized the study as
Burgkmair the Elder's work, and his attribution has been endorsed by Halm, Falk, Winzinger, and Anzelewsky. Schilling connected
the style of the drawing with Burgkmair's earlier work, such as the *Urschelin Burgkmayrlin* in
the Louvre and the *Peasants' Tournament* in
Frankfurt, together with woodcuts, principally the *Patron Saints of Freising* of 1502 (Holl-

stein, 70), where the bear appears as the attribute of Saint Corbinian.

On the question of the date, where the last
figure is damaged and hard to read, opinions
are slightly divergent. Schilling maintained he
could decipher 1493, but also admitted that
1498 was possible. Halm[2] read 1496, and suggested that the sheet might have been cut
down and the date transferred then. According
to Falk,[3] the damaged figure should probably
be read as eight or six, but not as three.

Stylistically, too, the study accords well
with the few surviving Burgkmair drawings
from the years prior to 1500. The date is written with the same dark gray ink used to reinforce certain parts of the bear's nape, back, and
right hind leg and the tip of the staff; it might
have been done by Burgkmair himself.[4]

4.1 Hans Weiditz, Letter K from *Children's
Alphabet,* 1521, woodcut. Vienna, Graphische
Sammlung Albertina.

Falk sees the drawing as thematically connected with annual fairs and gypsy subjects,
particularly as it was mostly gypsies who appeared as bear-masters.

We have indirect confirmation that the
sketch was known in Burgkmair's studio in
Augsburg through Hans Weiditz, an artist
who was working there from about 1518 to
1522.[5] In the letter K of the woodcut for his
Children's Alphabet of 1521 (Geisberg 1548, Passavant 130; ill. 4.1), Weiditz took up Burgkmair's idea and thus contributed to the diffusion of the image. In this manner it found its
way in 1523 into the miniatures of Narziss
Renner,[6] who was working in Augsburg. We
have Falk to thank for the further observation
that Burgkmair's drawing was reproduced
as late as the mid-seventeenth century in
Johannes Johnstone's (Jonstonus) *Natural
History.*[7] There, beside the standing bear, is
a stylistically similar sitting bear, which suggests that there existed a study by Burgkmair
for him too. "It has all the signs of a nature
study done in the heat of the moment," writes
Falk.[8] So Burgkmair's portrayal of a performing bear, done only shortly before Dürer's
time, counts as one of the earliest examples of
direct observation of nature in German art.

NOTES

1 Halm, 1962.
2 Halm, 1962.
3 Falk, 1962; see also Exhibition Catalogue Berlin
 1973.
4 Compare figures in dates on other works; see
 Halm, 1962.
5 According to Falk, 1968.
6 Prayer Book of Narziss Renner, Cod. 4486,
 fol. 35v, Vienna, Österreichische Nationalbibliothek; Halm, 1954, p. 65; see also Exhibition
 Catalogue Berlin 1973.
7 Johannes Jonstonus, *Historia Naturalis de
 Quadrupedibus . . .,* ed. by M. Merian (Frankfurt, n.d. [c. 1650]), plate LV.
8 Falk, 1968.

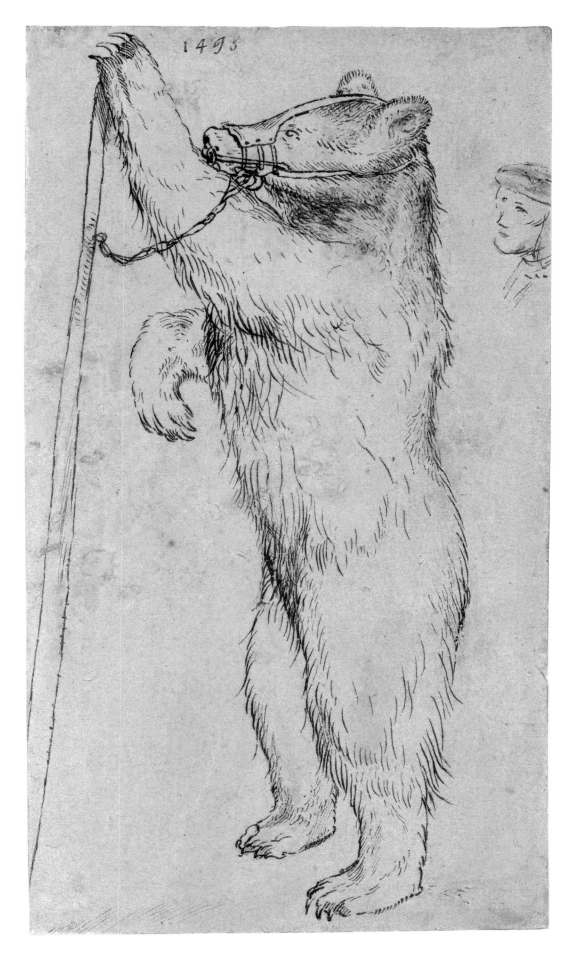

4

5

FRANCONIAN, C. 1500

Ostrich

Pen and brown ink on paper, watercolors
heightened with white, traces of preliminary
drawing (on the legs)
Watermark: bull's head with rod, flower
and pendant triangle; similar to Briquet 14 873
(see p. 256, ill. 2)
Dürer monogram and date *1508* by an unknown
hand, top center
280 x 195 mm

Berlin, Staatliche Museen
Preußischer Kulturbesitz,
Kupferstichkabinett, Inv. KdZ 50

PROVENANCE: Imhoff • Andréossy • Hulot.

BIBLIOGRAPHY: H. II, p. 84, no. 86 • Auction
Catalogue *Tableaux et Dessins anciens, Collection
de feu, M. le Général Comte Andréossy,* Paris, April
13–16, 1864, p. 18, no. 81 • Auction Catalogue
Posonyi/Montmorillon, p. 71, under no. 349 •
Exhibition Catalogue Berlin 1877, p. 24, no.
50 • Killermann, 1910, p. 63 • Bock, 1921, I,
p. 36, no. 50 • Fl. II, pp. 72, 73, 544 • Kurt
Bauch, "Dürers Lehrjahre," in *Städel-Jahrbuch*
7/8, 1932, p. 88 • W. I, pp. 12, 13, no. 8 • P. II,
p. 130, no. 1338 • Musper, 1952, pp. 125, 126,
note 11 • St. I, p. 20, no. 1486/3 • Exhibition
Catalogue Berlin 1984, pp. 124, 125, no. 121.

This picture of a male ostrich (*Struthio camelus*
L.) with decorative tail feathers was probably
intended as a natural-history illustration. Al-
beit totally different in style and technique
from Dürer's studies, it has been repeatedly
discussed in writing purely on the grounds of
the Dürer monogram and date, even though
these were added later by a foreign hand.

The attribution to Dürer is first found in the
Imhoff Inventory.[1] The drawing reached the
Berlin Kupferstichkabinett in 1877 by way of
Hulot, from the Andréossy Collection[2]—
which indicates that, like many other sheets
from this collection, it originated in Vienna.
Classified by Lippmann[3] as an "old imitation"
and described by Bock only as "in the manner
of Dürer," it looked to Flechsig as unlike
Dürer's work, but he nevertheless accepted it
among the autograph works, since "five other
drawings with the same signs . . . turned out
to be by Dürer." Bauch mentions the study
with reservations among the works belonging
to Dürer's apprentice years, and Winkler like-
wise stresses the weaknesses, but even so con-
siders Dürer's authorship possible. Doubted by
Panofsky, Musper, and Strauss, it was finally
rejected by Anzelewsky[4] too and identified as
possibly the work of Michael Wolgemut.

The discrepancy between the form of the
monogram, characteristic of Dürer's early
works, and the comparatively later date of 1508
was originally spotted by Lippmann. Bock was
the first to consider both monogram and date a
later addition, and Flechsig[5] succeeded in rec-
ognizing identical additions on a total of six

drawings. Although dated 1508, on the basis of
its style the drawing was placed earlier: by
Flechsig, Winkler, and Panofsky at 1486–
1489; Bauch thought about 1489; Musper
alone thought it possible that it was done "a
few years before the dating 1508"; Strauss
notes that the watermark appears on the paper
of drawings from the Dürer studio of 1505.
According to Anzelewsky,[6] the study repeats a
model obviously already traditional in minia-
tures by Giovannino de' Grassi and his studio
(ill. 5.1).[7]

The simple wash and brushwork in associa-
tion with the often firm, powerful pen strokes
and the almost heraldic arrangement of the
three downy feathers picked out in white pig-
ment on the back make it hard to date. The
treatment of the strawberry plant and the bird's
head shows more verve and sensitivity than
that of the body. These details suggest to
Winkler and Bauch a connection with Dürer's
early style of drawing. Flechsig feels that since
the motif of the strawberry plant, with its
crossing stems, appears in paintings by the
Wolgemut school, this is sufficient evidence
"that Dürer's model was a drawing by Wolge-
mut or his school." The specific form of this
plant should not, however, be regarded as sig-
nificant, since symmetrical overlapping be-
longs to the repertoire of the early *Hortus sani-*

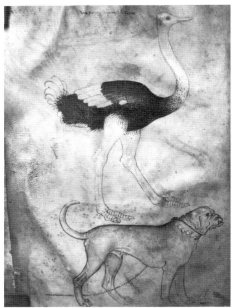

5.1 Pattern book of Giovannino de' Grassi,
Ostrich and Dog, pen and watercolor.
Bergamo, Museo Civico.

tatis illustrations[8] and was thence fairly widely
known.

Only the particular form of the Dürer
monogram — since, although it is not by his
own hand, it appears in the same form on
other, authenticated Dürer studies, for exam-
ple, the Bremen *Iris* (Cat. 66) — supports the
connection of the drawing with the Dürer
school and its placement in Nuremberg.

NOTES

1 H. II, p. 84, no. 86: *Ein Strauss. Ein Ochs. Zwo
 Kröten und Eydex* ("An Ostrich. An Ox. Two
 Toads and a Lizard"). All three works seem well
 preserved (the two others are probably identical
 with St. 1494/8 and St. 1496/9).
2 Auction Catalogue Andréossy; see Auction
 Catalogue Posonyi/Montmorillon, with further
 particulars.
3 Exhibition Catalogue Berlin 1877.
4 Exhibition Catalogue Berlin 1984.
5 See also Oehler, in *Städel-Jahrbuch,* N.F. 3/1971,
 p. 91.
6 Exhibition Catalogue Berlin 1984.
7 See also Luisa Cogliati Arano, *Miniature lombarde*
 (Milan, 1970), ill. 322 (from a *Tacuinum sanitatis*
 in the Casanatense Library, Ms. Lat. 459, in
 Rome).
8 Compare Albert Schramm, *Bilderschmuck der
 Frühdrucke,* vol. XVIII, *Nürnberger Drucker*
 (Leipzig, 1935), plate 82, no. 615 (Missale, Georg
 Stuchs, Nuremberg, 1494).

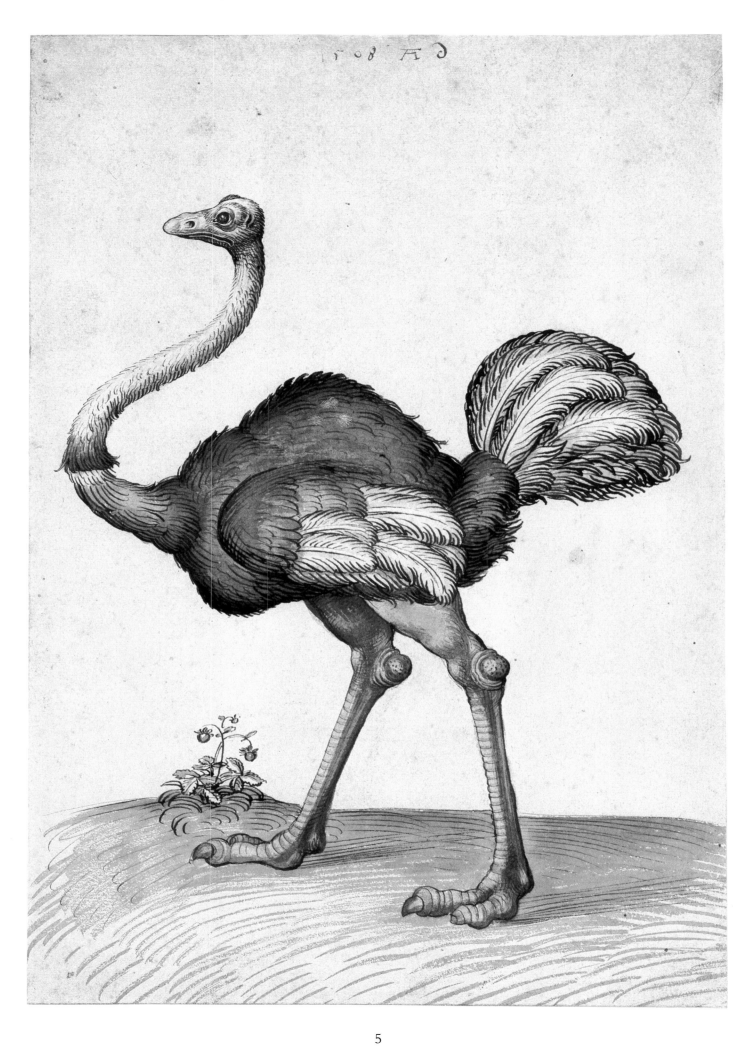

5

The Dead Bird
as a Pictorial Subject:
Jacopo de' Barbari, Albrecht Dürer,
and Lukas Cranach the Elder

The peculiarity of its subject, the virtuoso handling of the technical media, and the timeless validity of its statement make Albrecht Dürer's study *Dead Blue Roller* (Cat. 10) one of the most outstanding animal studies of the Renaissance. Its impressive, pictorially self-contained form, its almost microscopic sharpness of observation and exemplary delicacy of execution, and its restrained economy and firmness of brush drawing and pen stroke made it an ideal to be admired and emulated.

In the attempt to approach the *Dead Blue Roller* as a work of art and a prototype, the

1 Wall painting from Pompeii, detail,
Two Hanging Dead Birds,
Second Pompeian Style (first century B.C.).
Naples, Museo Nazionale.

motif itself, with its origins and precursors, has up to now been given little attention. Its extraordinariness shows first in the choice of theme; as a rule, fifteenth-century bird pictures feature living creatures, for example, Simon Marmion's *Hoopoe* (Cat. 1). Dürer, however, turned his talent to the portrayal of a dead one; with side-turned head, dangling wings, and rigid claws, this image no longer has the character of a versatile, adaptable pattern-book model, but has become an individual, realistically objective portrait of a dead bird.

The motif is not, however, limited to Dürer's *Dead Blue Roller*. The field is broader,

also including Dürer's *Dead Duck* (Cat. 7) and Lukas Cranach the Elder's bird studies — *Two Dead Waxwings Hanging from a Nail* (ill. 3), the *Bullfinches* (lost in World War II), *Four Partridges* (Cat. 8), and *Dead Mallard* (ill. 7) — together with copies in paintings and drawings from his studio. They demonstrate how popular this animal motif was with the Saxony court.[1] The field also includes works by Jacopo de' Barbari, the Venetian who was active from 1500 on in Nuremberg, and from 1503 on in Wittenberg, where he was Cranach's predecessor as court painter: namely, his painting *Still Life with Partridge, Mailed Gloves, and Crossbow Bolt,* dated 1504 and now in Munich (ill. 6.1), and the watercolor attributed to him, *Dead Partridge,* now in London (Cat. 6).

This entire complex had previously been judged in the light of Dürer's dominating artistic personality and was seen as stemming from it. Winkler[2] and Flechsig[3] were certain that Jacopo de' Barbari's still life "is hard to conceive of without a prototype by Dürer"; therefore, one had to assume the existence of similar images by Dürer from about 1500. This sequence of conclusions was indirectly strengthened by the earlier dating for the *Wing of a Blue Roller* (Cat. 22) as about 1502, as was suggested in previous years, and with that for the associated *Dead Blue Roller* itself.

A fresh approach to this question sheds new light on Jacopo de' Barbari's work in particular. It appears, in fact, that the importance of his bird studies to German Renaissance art has in the past been underestimated. The best evidence for this is his London watercolor study *Dead Partridge* (Cat. 6), which has been entirely disregarded in previous discussion, but which is much more strikingly recognizable than de' Barbari's Munich painting as the prototype for Dürer's *Dead Blue Roller*. Altogether, a survey of all the studies from de' Barbari and Dürer to

Cranach, covering a period of thirty years, makes it clear that de' Barbari's work anticipates both certain Dürer studies, such as the *Dead Blue Roller,* and also the later trompel'œil-type still lifes of Cranach.

Werner Schade has already alluded, in conversation, to late classical parallels to Lukas Cranach's bird studies in Roman pavement mosaics, and Jay Levenson indeed noticed the similarities between de' Barbari's still lifes and wall paintings at Pompeii (ill. 1) but excluded any direct connection (see Cat. 6). All the same, the relationship should be further explored, as Pompeian decorative paintings do show the same sort of hunting spoils, and try in a similar way to achieve the same illusory effect, using painterly devices to produce a naturalistic image. Both the motif of the dead bird and the illusion of its hanging on the wall represent an obvious grasp of the past in de' Barbari's work. We have no idea how he came to know of them, since Pompeii had not yet been discovered, and there is no proof that examples of such paintings from classical antiquity survived in Rome. The classical prototypes display not only a naturalistic style, however, but also the ability to create perspective and suggest space by coloristic effects, which is basic to the illusions of trompe l'œil.

The origin of the motif in the Italian past constitutes a weighty argument for Jacopo de' Barbari's precedence over Dürer and Cranach. If de' Barbari indeed deserves the credit for having prepared the way for classical imagery north of the Alps, and for having stimulated a revival of Hellenistic pictorial tradition at the start of the Renaissance, it makes him appear to have been less a pioneer than an agent of the genre. But this is not particularly surprising in a period that hailed Dürer as the second Apelles, and celebrated the achievements of its artists as against the classical *topoi*. Still, de'

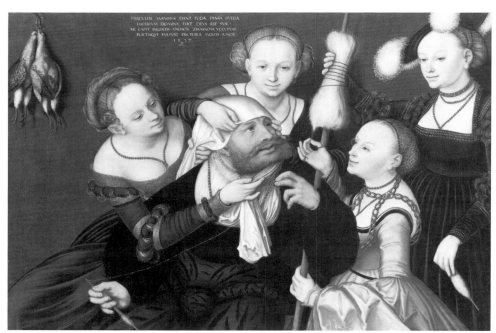

2 Lukas Cranach the Elder,
Hercules with Omphale, 1537, oil on panel.
Brunswick, Herzog Anton Ulrich-Museum.

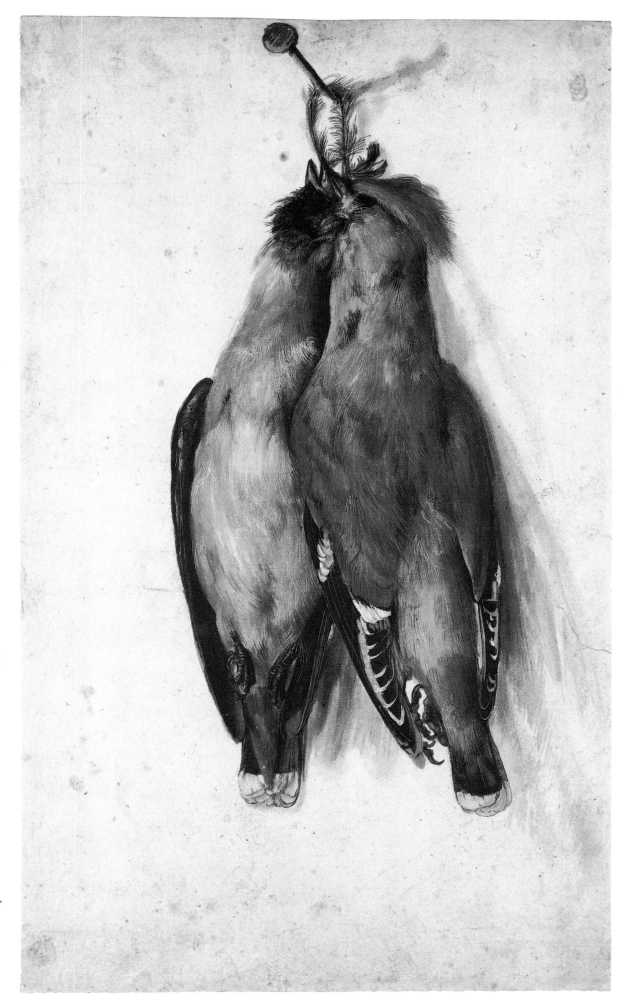

3 Lukas Cranach the Elder,
*Two Dead Waxwings
Hanging from a Nail,* c. 1530,
watercolor and body color,
pen in black, on paper.
Dresden, Staatliche
Kunstsammlungen,
Kupferstich-Kabinett.

Barbari passed on not only the motif but apparently also the knowledge of its origin in antiquity. Could Dürer likewise have known about it? In the circle of Cranach and the Humanists in Wittenberg, the classical roots of the subject were obviously known. In this respect, Cranach's use of the studies of hanging partridges in his paintings is instructive; here the motif is introduced as an attribute of the equally classical theme of Hercules and Omphale (ill. 2).

If, through their connection with Pompeian wall paintings, the studies of dead birds represent the revival of a classical tradition at the beginning of the Renaissance, they presumably meant more to educated contemporaries than mere nature studies. As their presence in the Hercules–Omphale theme shows, a generation that thought of classical art perceived them as very much more: that is, as "quotations" from the past they were modeled on.

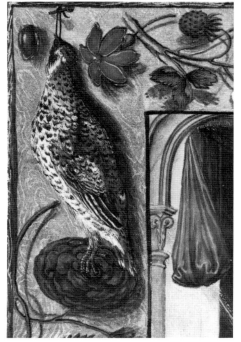

4 Prayer book of Narziss Renner, 1523, *Annunciation*, detail, miniature painting on vellum. Vienna, Österreichische Nationalbibliothek.

Copyists, Forgers, Followers

In Albrecht Dürer's *Dead Blue Roller,* the motif of the dead bird found the form that most affected the German Renaissance. It was valued as a model and frequently imitated, possibly with the intention of forgery. Four faithful copies and one variant are known:

1 Berlin, Kupferstichkabinett, unsigned (Cat. 11)
2 Paris, private collection (formerly Béhague), monogrammed AD, dated 1512 (ill. 11.2, p. 56)
3 London, British Museum, monogrammed AD, dated 1521 (Cat. 12)
4 Cleveland, Museum of Art, monogrammed Hh, dated 1583 (ill. 11.1, p. 56)
5 (Variant) London, British Museum, monogrammed Hh, dated 1583 (Cat. 13)

The study *Dead Blue Roller, Seen from the Back* (Cat. 14), to some extent the companion piece of this variant, may be included here, as it would certainly have been perceived by contemporaries as an ingenious paraphrase of the Dürer original in the spirit of the Dürer Renaissance.

All these copies narrowly coincide in coloring and drawing. However, only the copy in Cleveland and the variant in London are correctly signed, that is to say, dated 1583 and bearing the monogram of the Dürer copyist Hans Hoffmann. The Berlin copy is unsigned, while the rest, to some extent perhaps by Hoff-

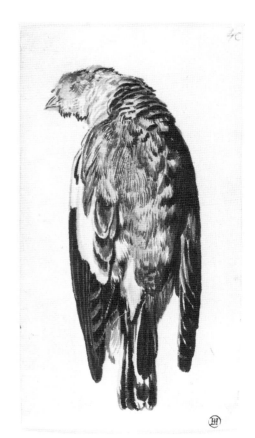

5 German, second quarter of the sixteenth century, *Dead Sparrow,* watercolor on paper. Nuremberg, Germanisches Nationalmuseum, Graphische Sammlung, Depositum Blasius-Petersen.

mann himself, misleadingly bear a Dürer monogram and different dates. In spite of the apparently different designations, which would suggest that their origins are unconnected, the copies are alike in many ways. Compared with Dürer's model, they correspond in the pale colors and the bright blue of the wingtips; the breast feathers are more yellowish green, and the modeling of the feathers is more schematic and less rich in detail. There is little variation in the outline to the right of the neck, characterized by a sharp bend of the left wing, which lies close to the body, and the plastically modeled torso looks shorter and more peg-shaped. Particularly telling is the gap between the third and fourth claws of the right foot: in Dürer's bird it is merely a V-shaped opening, whereas in Hoffmann's copies it is larger and almond-shaped. The fact that all the copies agree in size and in exactly the same deviation proves that they all share the same tracing, were all done by the same artist, and appeared at much closer intervals than the given dates indicate.

The exact copies of Dürer's *Dead Blue Roller* all date from the end of the sixteenth century. Not a single one by his direct successors is familiar, but reflections are found in Augsburg book illustration, in a prayer book by Narziss Renner dated 1523 (ill. 4) — reflections that speak for an unbroken tradition of the bird motif, to which a study, *Dead Sparrow* (ill. 5), also belongs. This watercolor study, from the Blasius-Petersen Collection, therefore deserves particular mention, as it must be one of the earliest paraphrases of the Dürer prototype, dating probably from the first half of the sixteenth century.

In the second half of the century, Dürer's influence becomes more evident: besides Hoffmann's copies, there is a *Dead Thrush* (Cat. 15), painted on vellum, that most skillfully varies the famous prototype. It gives the impression, moreover, that Dürer's example had exerted substantial influence as a conceptual and artistic starting point, even on "semi-scientific still life"; so perhaps does Daniel Fröschl's study *Two Woodpeckers* (Cat. 16) or, considerably later still, the accurately observed *Dead Bramblings,* attributed to Maria Sibylla Merian (Cat. 17), condensed into a still life of hunting spoils.

That a dead creature alone could become a pictorial subject presupposes a changed artistic attitude as a result of intellectual discussion. The studies of inanimate nature also represented the first step toward *nature morte,* self-contained still life. And it is significant that the earliest established bird study of this kind, Jacopo de' Barbari's Munich painting *Still Life with Partridge, Mailed Gloves, and Crossbow Bolt* of 1504 (ill. 6.1), simultaneously represents the very earliest pure still life of Western art. Here the hunting-spoils still life has its roots.

Without wishing to probe further into the history and development of still life and its specific character, we need refer only to the distance between Lukas Cranach the Elder's *Two Dead Waxwings* (ill. 3) and Dürer's study.

While Dürer concentrates on recording the realistic particulars of the creature with quite scientific exactitude and avoids even indicating the surroundings, Cranach transfers the accent from the subject to the situation, so that his study, in contrast to Dürer's artistic-scientific description, becomes an illusory, painterly image of picturesquely arranged hunting spoils. With the same artistic intention and the same means, Hoffmann adapted Dürer's prototype in his London variant of 1583 (Cat. 13).

Since the 1530 *Bullfinches,* belonging to the Dresden Collection, was lost in World War II, the *Two Dead Waxwings* has been the only authenticated bird study by Cranach in existence. In the development outlined here it is of particular significance, in that it draws attention beyond Dürer to the painterly widening of the theme. This is an important aspect in view of the later forgeries under Dürer's name. As we examine anonymous sixteenth-century bird studies that, perhaps like the *Dead Thrush* (Cat. 15), were furnished with Dürer's monogram and inscriptions with intent to deceive, Cranach's example helps us to realize that such works, despite apparent stylistic affinity with Dürer and often undeniable quality, must belong to a later epoch, because they allude not only to the example set by Dürer but also to the painterly progress achieved by Cranach.

Many of the motifs defined by Dürer and Cranach have turned out to be persistent and influential. Not only the original studies themselves are responsible for this, but also their mostly still-life–like use in paintings. They were further diffused by numerous replicas, especially from the Cranach studio. As is shown by the appearance of the hanging *Dead*

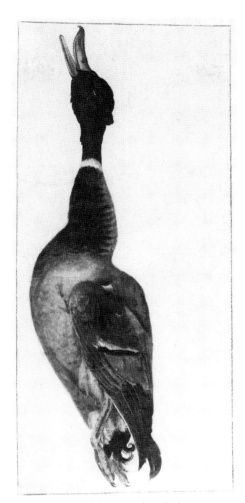

7 Cranach Workshop, *Dead Mallard,* c. 1530, watercolor and body color on paper. Dresden, Staatliche Kunstsammlungen, Kupferstich-Kabinett.

Mallard (ill. 7) in Juan Sanchez-Cotan's *Still Life* of 1602 (ill. 6), the influence of this motif from classical antiquity traveled via Jacopo de' Barbari and Cranach's pictorial forms as far as Spain.

NOTES

1 From Christoph Scheurl's dedication of 1509 it emerges, among other things, that Cranach had painted *Hasen, Fasane, Pfauen, Rebhühner, Enten, Wachteln, Krammetsvögel, Holztauben und anderes Geflügel an der Wand hängend* ("hares, pheasants, peacocks, partridges, ducks, quails, fieldfares, wood pigeons, and other wildfowl hanging on the wall") in the castle of Torgau. See also Heinz Lüdecke, *Lukas Cranach der Ältere im Spiegel seiner Zeit* (Berlin, 1953), p. 52.

2 W. III, p. 61, under no. 616.

3 Fl. II, p. 100.

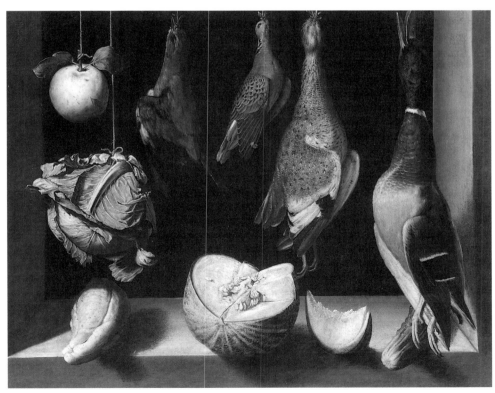

6 Juan Sanchez-Cotan, *Still Life,* 1602, oil on panel. Chicago, Art Institute.

6

JACOPO DE' BARBARI

Dead Partridge

Watercolor, brush, pen, and ink on paper
Inscribed, top right: *23*; bottom left:
g Tetras; bottom right: *Gray Partridg*
258 x 153 mm
London, The British Museum, Department of
Prints and Drawings (similarly L. 390)
Inv. 5264–23.1928–3–10–103

PROVENANCE: Sloane.

BIBLIOGRAPHY: A. E. Popham, "Jacopo de'
Barbari, *Study of a dead grey Partridge,*" in *The
Vasari Society,* Second Series IX/1928, p. 5, no. 2
(color collotype) • Hans Tietze and Erica
Tietze-Conrat, *The Drawings of the Venetian
Painters in the 15th and 16th Centuries* (New York,
1944), p. 41, no. 64 • A. E. Popham and Philip
Pouncey, *Italian Drawings in the Department of
Prints and Drawings in The British Museum.
The Fourteenth and Fifteenth Centuries,* 2 vols.
(London, 1950), vol. 1, p. 4, no. 5 • Harald
Keller, *Die Kunstlandschaften Italiens* (Munich,
1960), pp. 281, 282 • Exhibition Catalogue
London 1971, p. 51, no. 324 • Jay Alan Levenson,
*Jacopo de' Barbari and Northern Art of the Early
Sixteenth Century* (phil. diss., New York
University, 1978), pp. 210–212, no. 13,
p. 101.

This is an ink and watercolor study made with brush and pen over light washes on paper; its strokes and dots are fine, and the subtle coloration reproduces the relatively monochromatic plumage of the hen partridge (*Perdix perdix* L.). The shadings of bluish gray, brown, and brownish gray create a convincing three-dimensional effect, and although there is great graphic detail, it is never fussy. The picture is clearly different from Dürer's studies of birds without being in any way inferior to them.

This study came to be in the Sloane Collection at The British Museum and was first written about by Popham, in 1928.[1] He ascribed the work to Jacopo de' Barbari because of its formal similarity to that artist's signed and dated painting *Still Life with Partridge, Mailed Gloves, and Crossbow Bolt,* in the Alte Pinakothek, Munich (ill. 6.1),[2] which it closely resembles in details such as the drawing of the feathers and the composition of the shadow on the wall. Popham's discovery remained neglected for a long time, even though the painter's name was familiar and his works rare, and any new drawing by him should have been worthy of attention. Winkler[3] does not mention the London study when he speaks of the still life in Munich and the Venetian painter's influence on Dürer as part of the discussion of the *Dead Duck* (Cat. 7). The work is not to be found in Servolini's 1944 monograph, either.[4] In fact, the study is mentioned only in Tietze's catalogue of Venetian drawings. Harald Keller, shortly after the work was reintroduced by Popham and Pouncey, is alone in giving de' Barbari's London

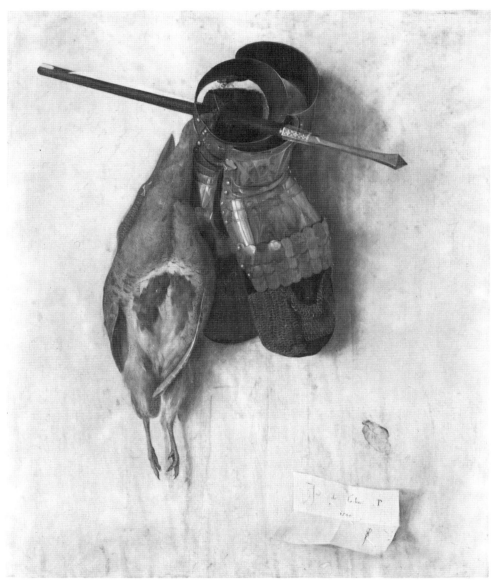

6.1 Jacopo de' Barbari, *Still Life with Partridge, Mailed Gloves, and Crossbow Bolt,* 1504, oil on panel. Munich, Alte Pinakothek.

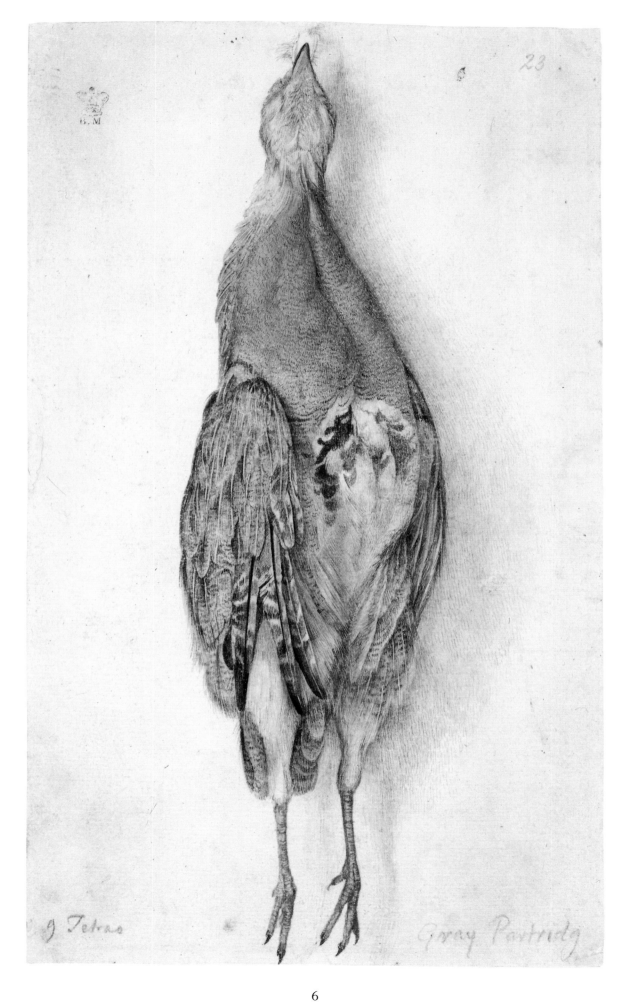

23

J Tetras

Gray Partridg

6

6.2 German, c. 1600, *Dead Bird,* watercolor. Whereabouts unknown (see note 7).

watercolor its due as a precursor of Dürer's bird studies.

Of the few drawings ascribed to de' Barbari, only the preliminary sketch for the engraving *Cleopatra*[5] is definitely by him. However, it is by definition a working drawing and cannot seriously be compared with the study of the partridge. Popham mentions another study of a bird (a jay?), on parchment, which could be by de' Barbari but which he knew only from a photograph.[6] This study disappeared, and I myself am familiar with it only from the same photograph, to be found in the Witt Library.[7] Conclusions about the composition may be drawn from it, but no judgments may be made on the style. The picture shows a bird lying dead (ill. 6.2), and parallels to it are, in my opinion, not to be found until the seventeenth century, in scientific illustrations[8] (ill. 6.3).

Popham's ascription of the *Dead Partridge* to de' Barbari is confirmed by the astonishing similarity in artistic style between the painting and the watercolor. This high degree of concordance between the two media is also found in the gentle sweep of the horizontal rows of breast plumage, drawn with short, fine strokes, and in the firm, vertical strokes on the belly and legs. These features justify the conclusion that the drawing in London is contemporaneous with the Munich still life dated 1504. However, it is too much to claim, as Keller does, that the watercolor is an actual study for the work in Munich, for all the stylistic and formal points they have in common.

With regard to Jacopo de' Barbari's painting, Keller emphasizes that still life as an independent theme was in keeping with the passive mood of Venetian art, and that the genre was developed earlier there than in other artistic centers. As Bergström and Sterling have shown,[9] this process was preceded in Italy by the flowering of the autonomous still life, which in turn had its roots in intarsia pictures of the 1470s. With this they had pointed to the basis from which, one generation later, de' Barbari was to make the still life into a real artistic theme in its own right. Bearing these

developments in Italy in mind, de' Barbari's still life becomes comprehensible; owing to its early date, his still life also demonstrates itself as forerunner for the studies by Dürer and Cranach.

One of the few reliable sources of information on the life of the Venetian painter are the imperial financial records,[10] which tell us that *"Jacoben de Barbary, maler von Venedig,"* was in the emperor's service. On April 8, 1500, he became court painter to Maximilian I, resident in Nuremberg, and in 1503 he moved to Wittenberg, where he remained until 1505 at the court of Elector Friedrich III, "The Wise."

Dürer himself tells us of his personal acquaintance with de' Barbari and of his respect for the Venetian. He had first met him in 1495, during his first trip to Venice, and was encouraged by him to make theoretical studies of human proportion. As late as 1521, as Dürer wrote in his journal of his trip to the Netherlands, he tried unsuccessfully to obtain a sketch book by "Jacob Walch"[11] from Margarethe of Austria, whose painter de' Barbari was from 1510 until his death (probably in 1515). Lukas Cranach the Elder, who in 1505 became de' Barbari's successor at the elector's court in Wittenberg, probably also knew the Italian painter, who can be traced up to 1508–1509 in the court records of Saxony, Mecklenburg, and Brandenburg.

The opinion was held for a long time that Dürer influenced de' Barbari. However, it must now be remembered that the Italians pioneered the development of the still life and that the date on de' Barbari's painting is 1504. From this we may presume that the Venetian painter's study predated Dürer's studies of dead birds, thus making it the earliest extant nature study with the characteristics of a still life. The use of a dead animal as the subject also represents the beginnings of a new genre, the still life of dead game.

Precedents for de' Barbari's nature study are not to be found in the work of Dürer and Cranach, nor in the whole repertoire of German and Italian art. Schade thus draws atten-

tion to the possibility of inspiration in classical art,[12] and he is probably right to make reference to similar themes in North African mosaic floors of the Roman era. One of the ideals of Hellenistic art was to imitate reality so as to deceive the eye. A similar concern is constantly in evidence in the *topoi* of classical literature. Classical authors praised the skill of their artists, who could reproduce details like fruit and curtains with such naturalism that they did more than simply create the illusion of reality: they occasionally surpassed it, deceiving not just men, but sometimes animals too.

The three-dimensional realistic depiction of the dead bird and the carefully studied shadow that brings it forward from the wall would seem to indicate that de' Barbari is adopting Hellenistic painterly ideals of the kind discussed above. In a vein similar to Schade's, Levenson[13] points out possible comparisons with Pompeian wall paintings but concludes that the similarity of the motifs is simply a matter of coincidence. Since no Italian contemporaries of de' Barbari painted still lifes of this kind, it may be assumed that he arrived at his forms independently of classical sources, and that the similarity was rather the result of a similar artistic intention for the shared subject.

Levenson has perhaps not chosen the best comparisons from the existing wall paintings at Pompeii and Herculaneum; better examples are the fish and birds of the Villa of Diomede[14] (see ill. 1, p. 40), which are also hanging on a nail and which are remarkably close to Cranach's studies (see ill. 3, p. 41), so much so as to suggest that the similarities arise from more than mere chance. Also, Cranach's work by itself leads to the assumption that it was not just the theme but also a knowledge of the historical context that the German painters appropriated from de' Barbari. How else can it be explained that such studies of birds — mostly partridges, which in classical times represented gifts for guests, so-called *xenia* — happened to be chosen for the classical theme of Hercules and Omphale?

This gives a new dimension to the theme

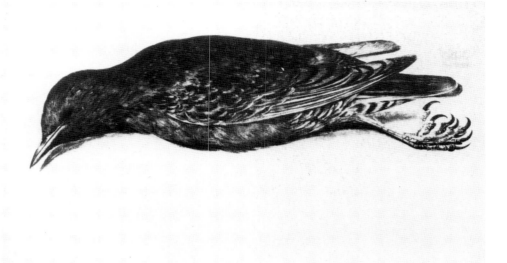

6.3 German, seventeenth century, *Dead Bird,* watercolor on paper. Dresden, Sächsische Landesbibliothek.

that Jacopo de' Barbari took from Italy to northern Europe: in the wake of the Renaissance and the sixteenth-century classical revival, excavations of Roman and Greek sites probably — and we are not able to be too specific on this — gave currency to wall paintings of the kind we now define as belonging to the Second Pompeian Style. The Italian artist, moving in humanist circles and adopting and disseminating these themes, became not only a model for the Germans but also a kind of agent to the classical past.

It is clear that Dürer's and Cranach's studies of birds were influenced by Jacopo, and it is notable, for instance, that they chose birds with a monochromatic coloration similar to the model. Few conclusions can be drawn from the considerable chronological distance between the studies of de' Barbari (c. 1504), Dürer (1512), and Cranach (c. 1530), and it certainly does not diminish the importance of the Italian; yet we must always remember that much evidence is missing and that we have knowledge of only a fragment of the material that once existed. For instance, Scheurl's report of 1509[15] mentions a wall painting by Cranach in the castle of Torgau — a painting showing game, with hares, pheasants, partridges, ducks, quails, and so on, hanging on the wall. There is also book illustration, such as that in Narziss Renner's prayer book of 1523,[16] which indicates that the motif was more widespread than we might now think.[17]

NOTES

1 Popham, 1928.
2 Signed bottom right and dated: *"Jac.de barbarj P 1504"* with a caduceus, symbol of Mercury; 520 x 425 mm; Munich, Alte Pinakothek, Inv. 5086.
3 W. III, pp. 60, 61, no. 616.
4 Luigi Servolini, *Jacopo de' Barbari* (Padua, 1944).
5 Pen and brown ink; 205 x 174 mm; London, The British Museum, Department of Prints and Drawings, Inv. 1883-8-11-35. Hind II/IV, 157, 27; Passavant III, 140, 28; Servolini, 1944, XXVIII (plate LXXXIV).
6 Popham, 1928.

7 Witt Library, London, under Jacopo de' Barbari 2, 123. According to Popham, the work was sold in 1927 to the Max Reinhart Galleries, New York.
8 Dresden, Sächsische Landesbibliothek, Msc. Dresd. B. 94, v.
9 Ingvar Bergström, *Dutch Still-Life Painting in the Seventeenth Century* (London/New York, 1956), pp. 26-30, fig. 23; Charles Sterling, *La Nature morte de l'Antiquité à nos jours* (Paris, 1952), p. 34.
10 See "Urkunden und Regesten aus dem k.k. Reichs-Finanz-Archiv," ed. by Heinrich Zimerman and Franz Kreyczi, in *JKSAK* 3/1885, p. VII, no. 2280 (Gedenkbuch 5, fol. 107'); see also no. 2550.
11 Rupprich I, p. 173 (June 7, 1521).
12 Discussed orally by Werner Schade, quoted in Exhibition Catalogue Basel 1974, I, p. 245, at no. 143; see also Exhibition Catalogue *Das Dresdner Kupferstich-Kabinett und die Albertina* (Vienna, Graphische Sammlung Albertina, 1978), p. 130, no. 124.
13 Levenson, 1978, pp. 199, 200; he refers to H. G. Beyen, *Über Stilleben aus Pompeji und Herkulaneum* (The Hague, 1928), plates IX and XI. See also Felix Eckstein, *Untersuchungen über die Stilleben aus Pompeji und Herkulaneum* (Berlin, 1957).
14 Giulio Emanuele Rizzo, *Monumenti della pittura antica scoperti in Italia,* section 3, *La Pittura di natura morta, Rom (Anno XIII E.F.).*
15 See p. 43, note 1.
16 See Cat. 4, note 6, and ill. 4, p. 42.
17 See Ingvar Bergström, "Revival of Antique Illusionistic Wall-Painting in Renaissance Art," in *Acta Universitatis Gothoburgensis* 63/1957, 1 (Goteborg, 1957). In this article, Bergström convincingly demonstrates that at the beginning of the sixteenth century, illusionistic architectural motifs were familiar through antique fresco paintings and had influenced the facade painting of the Renaissance — for example, the *Haus zum Tanz* in Basel by Hans Holbein the Younger. This contribution was made known to me only later by Mr. Bergström himself. Even though it does not directly address our subject, it does exhibit a further parallel to it and a convincing argument for recognizing that knowledge of antique wall painting existed at the beginning of the Renaissance.

7

ALBRECHT DÜRER

Dead Duck

Watercolor and body color on vellum,
brush and pen
Traces of preliminary drawing in lead pencil
(left leg and tail), traces of heightening with
gold (on the lowest tail feathers)
Moisture damage (restored in 1969)
Corners diagonally cut
Dürer monogram and the date *1515* by a foreign
hand, top center
235 x 126 mm

Lisbon, Museu Calouste Gulbenkian, Inv. I

PROVENANCE: Mariette/Boileau (?) • Andréossy
• Lawrence • Walpole (doubtful) • Max Bonn
• Colnaghi • Gulbenkian.

BIBLIOGRAPHY: Auction Catalogue Mariette/
Basan 1775, p. 138, no. 895 • Exhibition
Catalogue *The Lawrence Gallery. A Catalogue of
100 Original Drawings by Albrecht Dürer and
Tizian Vecelli, collected by Sir Thomas Lawrence*
(London, Woodburn Gallery, Eighth Exhibi-
tion, May 1836), p. 12, no. 22 • Gustav Friedrich
Waagen, *Kunstwerke und Künstler in England*,
vol. 1 (Berlin, 1837), p. 445 • Campbell
Dodgson, in *The Vasari Society* X/1914/15,
no. 19 (with collotype) • Dodgson, "Two New
Drawings by Dürer in The British Museum,"
in *TBM* 28/1915, p. 8, note 3 • Exhibition
Catalogue *A Collection of Drawings by Deceased
Masters* (London, Burlington Fine Arts Club,
1917), p. 13, no. 11 • Winkler, in *JPK* 50/1929,
p. 137 • L. VII, p. 14, no. 807 • Winkler, in *JPK*
53/1932, p. 86, note 2 • Fl. II, pp. 100, 560 •
T. II/1, p. 108, no. 632 • W. III, p. 60, no. 616,
p. 56, under no. 615 • P. II, p. 129, no. 1317 •
H. Tietze, 1951, pp. 35, 36 • Musper, 1952,
pp. 126–128, 332 • Killermann, 1953, p. 22 •
Winkler, 1957, p. 251 • Exhibition Catalogue
Paris 1967, p. 112, no. 166 • Giorgio Zampa,
L'Opera completa di Dürer (Milan, 1968), pp. 98,
99, no. 79 • St. II, p. 596, no. 1502/3, Appendix
2, 1102, under no. 8 • Exhibition Catalogue
Exposição Evocativa de Calouste Gulbenkian, XX
Anniversario da Fundação 1956/1976 (Fundação
Calouste Gulbenkian, July-October 1976),
no. 72 • Exhibition Catalogue Paris 1978, no.
150 • Strieder, 1981, p. 204, no. 239 • Piel, 1983,
p. 143, no. 62.

Dürer's study of a dead pochard drake (*Aythya
ferina* L.) hanging from a nail shows the date
and monogram on either side of the bird's bill,
but they are very faded and not in the master's
hand; according to Flechsig,[1] they were writ-
ten by Hans von Kulmbach, Dürer's studio as-
sistant and colleague.

The miniaturist delicacy of the execution
makes the *Dead Duck* one of Dürer's most
accomplished nature studies, yet Winkler
considers the drawing to be unfinished.[2] The
surface color has suffered from dampness,[3]
thus making judgment of the study more diffi-
cult. Scientific debate has never really put the
traditional attribution to Dürer in question,
but there is considerable dissent as to its dating.

Flechsig argues that since this superb work
does not bear Dürer's monogram, unlike the
Hare of 1502 (Cat. 43), it must have originated
prior to that date. Winkler, however, dates it
around 1512, together with the drawings of the
blue roller.[4] Panofsky prefers a date around
1502 over one around 1515.[5] Tietze thinks
around 1515, contrasting the *Dead Duck* with
the *Dead Blue Roller* (Cat. 10); according to
him, the duck is hung up and therefore is char-
acterized as a real thing, whereas the *Dead Blue
Roller* appeared to him as *ein Präparat in Nichts*
("a vacuous prepared specimen").[6] Musper
considers a date before 1500 to be reasonable
and suggests 1498.[7] In more recent critical
writing, preference has generally been given to
1502 as a likely date.[8] Along with the *Young
Owl* (Cat. 9) and the study *Lapwing's Wing*
(Cat. 20), the *Dead Duck* is first mentioned in
the collection of Pierre-Jean Mariette, where
Gabriel de Saint-Aubin saw and copied it (his
version now being in Boston).

Although it is not colorful — almost mono-
chromatic, in fact — the overall effect is quite
exquisite, with subtle gradations from brown
to sepia and all the shades from gray to white.
Compared with other Dürer studies, the exe-
cution is softer, more painterly, less linear; and
in this respect it cannot really be linked with
any other work we know definitely to be by
the master. The accomplishment of details,
such as the broad, quick strokes of the wash for
the feathers and the firm outline, are reminis-
cent of the *Lapwing's Wing* in Berlin. For all
the linearity of these features the total effect is
of silken delicacy, more painterly than else-
where in his studies, and distinct from the
graphic generosity and clarity of the *Dead Blue
Roller* and *Wing of a Blue Roller* (Cat. 22) of 1512.

Flechsig and Winkler draw attention to the
Dead Duck vis-à-vis Jacopo de' Barbari's still
life painted in 1504 and now in Munich, but
omit to mention the even more closely asso-
ciated example by Jacopo, the watercolor study
Dead Partridge (Cat. 6) in London. This work
should be seen in the same context as Dürer's
Duck and Lukas Cranach the Elder's drawing
of dead partridges (Cat. 8). The birds all hang
from a nail by their beaks and cast shadows on
the wall, and in theme, technique, and style are
all so closely related that one may easily con-
sider them to be interdependent and mutually
influenced. However, one should not follow
the example of Flechsig and Winkler in auto-
matically assuming that it was Dürer who set
the precedent, for Cranach's study (c. 1530) is
closer to de' Barbari's *Dead Partridge* than to
Dürer's *Dead Duck*. De' Barbari's influence on
the young Dürer was evidently great,[9] and the
Italian's study seems to be older in style than
Dürer's *Duck*. In addition, we may note the
biographical facts: de' Barbari was imperial
court painter first in Nuremberg and then in
Wittenberg, and both Dürer and Cranach
knew him personally (see Cat. 6).

The Italian painter played a more important
part than has generally been acknowledged in
the development of the ornithological study as
still life and in its transformation and incorpo-

ration into the hunting-spoils still life. De'
Barbari made these innovations during his
time at the Saxon court (the results may be seen
in the 1504 Munich still life). It was not Dürer
but rather de' Barbari who stimulated the use
of this antique pictorial theme.

Dürer also sketched a hanging duck in the
drawings in the margin of the prayer book for
Emperor Maximilian, but no immediate links
may be drawn between that picture and this
study.

NOTES

1 Fl. II, pp. 100, 54; see also W. III, p. 60, no. 616
 (in greater detail in W. I, pp. 84, 85, under no.
 112); and Oehler, in *Städel-Jahrbuch*, N.F. 3/1971,
 pp. 91 ff.
2 W. III, p. 59, under no. 615.
3 As a result of a flood in June 1967; there is an
 old reproduction (color collotype) of good
 quality to be found in *The Vasari Society*
 X/1914/15.
4 W. III, pp. 60, 61, no. 616.
5 P. II, no. 1317.
6 H. Tietze, 1951.
7 Musper, 1952.
8 St. II; Strieder, 1981.
9 For the comprehensive literature see Mende,
 1971, pp. 391–393, nos. 6589–6624.

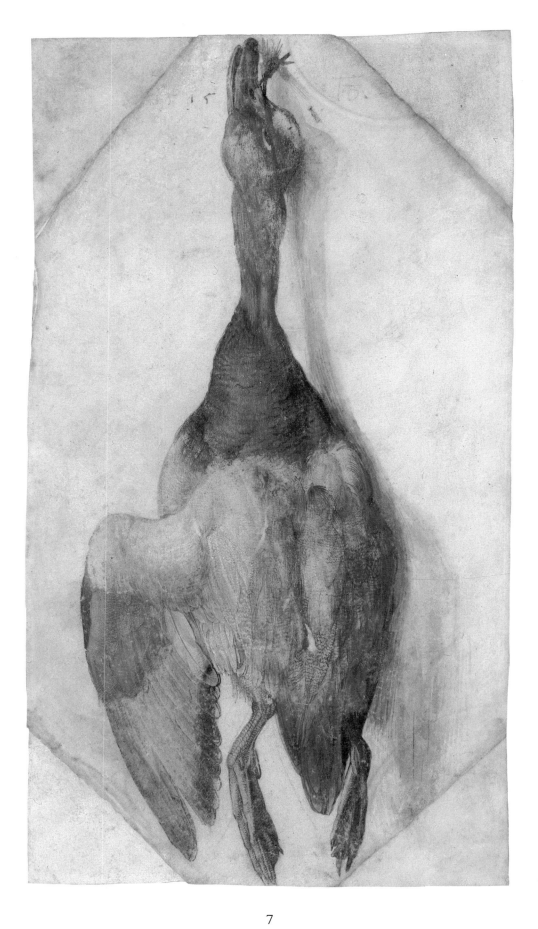

7

8

Four Partridges

Watercolor and body color on paper, which at
some stage was folded over in the middle and
has lost some color at the crease
Brush, heightened with white
Traces of light gray-brown
preparatory brush-drawing
(in evidence on the legs)
449 x 321 mm
Dresden, Staatliche Kunstsammlungen,
Kupferstich-Kabinett, Inv. C. 1193

PROVENANCE: Original Collections of the
Dresden Museums (Portfolio Ca 210, p. 26)

BIBLIOGRAPHY: Pontus Grate, "Analyse d'un
tableau," in L'Œil 78/1961, pp. 30–37, 80 •
Werner Schade, "Zum Werk der Cranach,
I. Tierzeichnungen für die Werkstatt," in *Jahr-
buch der Staatlichen Kunstsammlungen Dresden
1961/62*, pp. 29 ff., p. 48, note 3 • Exhibition
Catalogue *Altdeutsche Zeichnungen* (Staatliche
Kunstsammlungen, Dresden, 1963), p. 34, no.
77 • Exhibition Catalogue *100 Handzeichnungen
alter Meister aus dem Dresdner Kupferstich-Kabinett*
(Salzburg, 1966), p. 19, no. 19 • Exhibition
Catalogue Dresden 1971, pp. 112, 113, no. 125 •
Exhibition Catalogue Basel 1974, vol. I, p. 245,
no. 144 • Werner Schade, *Lukas Cranach d.Ä.,
Zeichnungen* (Leipzig, 1972), p. 37, color ill. 13 •
Schade, *Die Malerfamilie Cranach* (Vienna/Mu-
nich, 1977), p. 50, plate 170.

Four bagged partridges (*Perdix perdix* L.), tied
together by their beaks, hang on a nail. For a
long time this drawing was mistakenly as-
sumed to date from the seventeenth century;
then its sure hand and light brushwork were
first attributed to Lukas Cranach the Elder by
Werner Schade.[1] He dated it at some time
around 1532, linking it to Cranach's *Two Dead
Waxwings*[2] and the *Bullfinches* (dated 1530),
and also to repeated use of the model in panel
paintings by Lukas and Hans Cranach in 1532,
1535, and 1537, where similar studies of par-
tridges appear. However, it has also been sug-
gested that the picture may be by Cranach's
son Hans.[3]

The picture is carried out over a rough brush
sketch in blue-gray, which can be clearly seen
where the position of the legs was changed by
the artist. The surfaces are prepared with gray
watercolor, and some of the dark areas have
been created by placing opaque pigments on
top. The speckled feathers are drawn on this
ground with a pointed brush. The colors are
most subtly shaded, from white through gray
to brown, sepia, and black, with a touch of
yellow on the breast of the left-hand bird; the
whole is an extraordinarily realistic study, al-
most life-size.

The artistic arrangement and depiction of
the gamebirds puts the work in the tradition of
the hunting-spoils still life, a genre that was
known since Jacopo de' Barbari. As yet re-

search has not been able to separate the studies
of Lukas Cranach the Elder from those of his
sons, the situation being complicated by the
use of the same models in Lukas the Elder's
paintings[4] and in those of his sons, Lukas and
Hans;[5] the use of these models in the Cranach
studio is a further factor to be taken into ac-
count.[6] We will have to content ourselves
with acknowledging the striking contrast be-
tween the spontaneous, relaxed, and fluently
executed life-size studies of partridges and the
showpiece refinement of the painting of *Two
Dead Waxwings* and perhaps the *Bullfinches*
mentioned above. At the same time, we must
recognize that the study of partridges is of the
very highest quality, though in a very different
idiom.

Werner Schade[7] refers to two other studies,
Dead Mallard (ill. 7, p. 43) and *Two Partridges,*
which, like the *Four Partridges,* probably be-
long to a larger pool of model studies that we
know to have been used on numerous occa-
sions in pictures from the Cranach studio.
These animal motifs were variously used in
paintings[8] and had a far-reaching influence
(see p. 43). As has already been suggested, the
impulse for these bird studies that approach the
character of still life came less from Dürer than
from Jacopo de' Barbari. Schade did not sup-
port his reference[9] to a classical link in mosaics

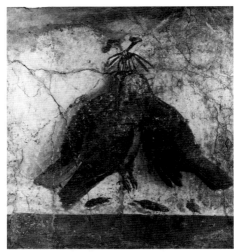

8.1 Wall painting from Pompeii, detail,
Three Partridges Hanging on a Nail,
Second Pompeian Style (first century B.C.).
Naples, Museo Nazionale.

from North Africa at the time of the Roman
Empire with any specific evidence, but con-
crete proof for the theory can be supplied by
Pompeian wall paintings (ill. 8.1). In illusion-
istic Pompeian wall painting we find still lifes
depicting customary gifts for guests (*xenia*)
that were much admired for their trompe-l'œil
effects. As in Cranach's studies and paintings
of mythological subjects, we find here birds
tied together by their beaks hanging from a
nail in the wall. The partridge was a symbol of
true love in the Middle Ages, but also of evil
and lust. It would appear that the artist, aware
of the classical origin of the motif, blended it

with the symbolism familiar in his own time to
let it partake in the theme of Hercules and
Omphale.

NOTES

1 Schade, 1961/62. It was originally attributed to
Jan Weenix.
2 Lukas Cranach the Elder, *Two Dead Waxwings,*
watercolor, brush on paper; 346 x 203 mm;
Dresden, Staatliche Kunstsammlungen,
Kupferstich-Kabinett, Inv. C 2179.
3 Exhibition Catalogue Basel 1974, vol. I.
4 See Lukas Cranach the Elder, *Hercules with
Omphale,* oil on beechwood, signed and dated
1537; 0.82 x 1.19 m; Brunswick, Herzog Anton
Ulrich-Museum, Inv. 25 (ill. 2, p. 40).
5 E.g., Hans Cranach, *Hercules among the Serving
Women of Queen Omphale,* oil on panel,
monogrammed and dated 1537; 575 x 850 mm;
Lugano-Castagnola, Thyssen-Bornemisza
Collection, ill. in Schade, 1977, no. 179.
6 Ill. in Schade, 1977, nos. 176, 177.
7 Schade, 1961/62.
8 The studies are essentially found in relation to
the Hercules – Omphale theme; according to the
animal studies included in the fifteen versions
known to me, four groups can be distinguished:
(1) with a partridge on the left; (2) with two
partridges on the left; (3) with four partridges in
the center; (4) with three groupings of
birds — a duck, two partridges, and two
pheasants.
9 Schade, in Exhibition Catalogue *Das Dresdner
Kupferstich-Kabinett und die Albertina* (Vienna,
Graphische Sammlung Albertina, 1978), p. 130,
under no. 124; and in Exhibition Catalogue
Basel 1974, I, p. 245, under no. 143.

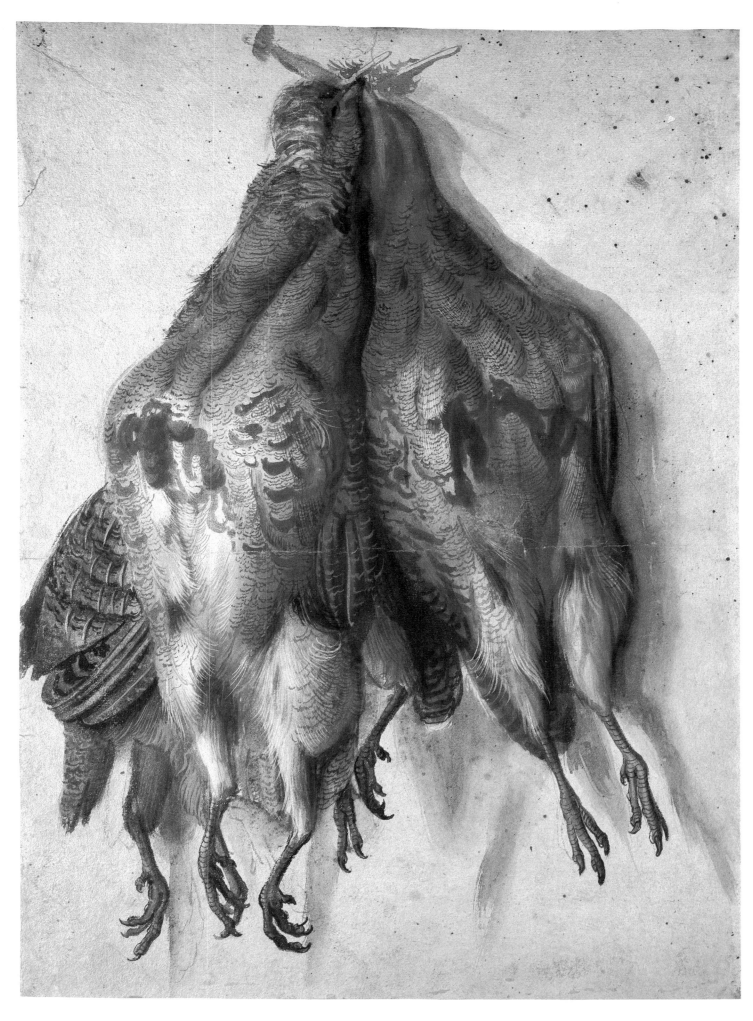

8

9

ALBRECHT DÜRER, ATTRIBUTED TO

Young Owl

Watercolor on mildewed paper with brown
wash, brush, and pen in dark brown and dark
gray ink, heightened with white
Top right-hand corner damaged
Dürer monogram and the date *1508* by a
foreign hand, bottom left
On the left, remains of a light brush drawing in
brown, subject not identifiable
192 x 140 mm
Vienna, Graphische Sammlung Albertina,
Inv. 3123 (D 165)

PROVENANCE: Mariette (L. 1852) • Prince de
Conti[1] • Duke Albert of Saxe-Teschen
(L. 174).

BIBLIOGRAPHY: Auction Catalogue Mariette/
Basan 1775, p. 138, no. 896 • H. II, p. 118,
no. 138 • Waagen, 1867, pp. 124 ff. • Exhibition
Catalogue Vienna 1871, p. 6, no. 83 • L. V,
p. 12, no. 503 • Springer, in *RKW* 29/1906,
p. 555 • Killermann, 1910, p. 64 • Albertina Cat-
alogue IV, p. 25, no. 165 • Fl. II, pp. 68, 560 •
T. II/2, p. 138, no. A 416 • P. II, p. 130,
no. 1339 • Killermann, 1953, p. 22 • Exhibition
Catalogue Paris 1967, p. 111, no. 164 • K.-Str.
p. 168, no. 25 • St. II, p. 600, no. 1502/5 • Piel,
1983, p. 143, no. 65.

This watercolor study on paper of a young
tawny owl (*Strix aluco* L.)[2] bears Dürer's
monogram and the date 1508 in the bottom
left-hand corner, but these were in fact added
later. The monogram is unusual in form and is
not to be found on any other drawing.[3] Since it
is connected with Dürer's name, the work has
become very popular through reproductions,
but it remains controversial and is often ex-
cluded from literature of the master's work.

The provenance of the drawing may be
traced back, like the Gulbenkian *Duck* (Cat. 7)
and probably also the Berlin *Wing* (Cat. 20), to
the collection of Pierre-Jean Mariette (1694–
1774), where it was attributed to Dürer, an as-
sumption later echoed by Heller and Waagen.
But in 1905 Meder stated that "the authentic-
ity of the drawing has often been doubted, and
with good reason." Its inferior quality led the
Tietzes to consider it the work of a Dürer imi-
tator from the late sixteenth century. Winkler
also did not include it in his complete cata-
logue of the artist's works, and Panofsky re-
jected it, too. Only Flechsig included it among
Dürer's works, dating it prior to 1502, and
linked it (wrongly, as the Tietzes had already
shown) with the studies for the *Madonna with a
Multitude of Animals* (Cat. 35). His thesis was
based on the appearance in this drawing of an-
other young owl, although there it is seen from
the side. Koschatzky and Strobl emphasize that
there is an immense difference in quality be-
tween the study under discussion here and au-
thenticated works such as the *Hare* (Cat. 43),
yet they ascribe it to Dürer and date it 1502.

Still, they do qualify their claim by saying that
"even a great artist, when making studies —
that is, when attempting to get closer to his
subject — in some cases may not achieve his
best."

The Tietzes suggested that the work was
perhaps originally on the same sheet of paper as
a partridge[4] ("which would ultimately go
against its authenticity"), but Koschatzky and
Strobl had already ascertained that the two
drawings were on different sorts of paper.
They did, however, point out that the *Young
Owl* was of better quality than other animal
studies excluded from the catalogue, saying
that "the brush technique in connection with
the pen drawing is not inexpressive."

Yet the wash and the draughtsmanship are
hardly in keeping with studies we know to be
by Dürer. The young tawny owl can be linked
neither to the *Hare* of 1502 (Cat. 43) nor to the
blue roller studies of 1512 (Cat. 10, 22). It is,
above all, the dark brush strokes around the
beak, eyes, wings, and feet that lack the precise
assurance characteristic of Dürer's works. The
broad, blurred strokes of the shadowing on the
ground are reminiscent of the shadows in Hans
Hoffmann's studies of lions (Cat. 59, 60).
Moreover, the three-quarter view of the bird
and the positioning of its legs on a slightly
sloping surface resemble techniques seen in
Hoffmann's squirrels (Cat. 27, 28). The brush
strokes of the plumage — soft, broad, not par-
ticularly well articulated and lacking in detail
— show some analogy with the small wing
sketches in the Metropolitan Museum, New
York (ill. 1, p. 70), which were likewise used
only for preparatory development of the paint-
ing. This cannot help us much, however, since
little is known about those sketches too.

Discussion of the *Young Owl* cannot, there-
fore, produce any convincing conclusions as to
its authenticity. Perhaps direct comparison
with works proved to be by Dürer can make
the stylistic differences clear; yet these are not
very great, being the sum of numerous small
differences in the artistic realization. Be that
as it may, the final impression seems to me
that it is further from Dürer's work rather than
closer to it, and there is an absence of hints
as to a possible date or even the attribution to
any of the Dürer disciples with whom we are
familiar.

NOTES

1 Exhibition Catalogue Paris 1967, "Collection
 prince de Conti; vente, 1777, no. 1158."
2 Not a little owl (*Athene noctua* L.), as incorrectly
 determined by Killermann, 1910.
3 A vague similarity in the numerals, particularly
 the 5, suggests Wenzel Hollar's etching of a
 reclining lion after Dürer (Parthey 2094;
 compare ill. 3, p. 161).
4 *Partridge,* brush, pen and ink, and colors on
 brown-colored paper; 132 x 141 mm; Vienna,
 Graphische Sammlung Albertina, Inv. 3110,
 D 166; Albertina Catalogue IV.

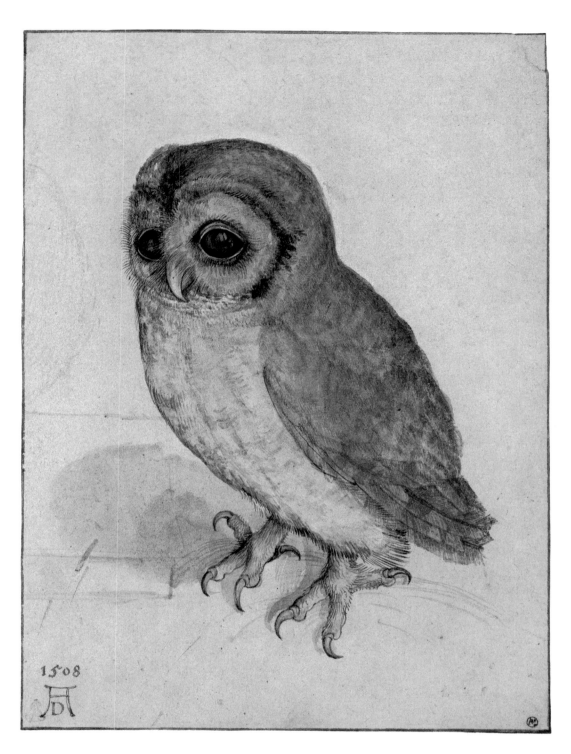

9

10

ALBRECHT DÜRER

Dead Blue Roller

Watercolor and body color on vellum, brush,
pen, heightened with white and gold
Monogram and the date *1512* in pen and dark
black-brown ink, top right
274 x 198 mm
Vienna, Graphische Sammlung Albertina,
Inv. 3133 (D 105)

PROVENANCE: Imhoff • Emperor Rudolf II •
Imperial Treasure Chamber • Imperial Court
Library (1783) • Duke Albert of Saxe-Teschen
(L. 174).

BIBLIOGRAPHY: H. II, p. 82, no. 55 and pp. 117,
118, no. 135 • E., p. 79 • Th. II, p. 56 • L. V,
p. 17, no. 256 • Springer, in *RKW* 29/1906,
p. 555 • Meder, in *RKW* 30/1907, p. 181 •
Killermann, 1910, pp. 69, 70 • Wölfflin, 1926,
p. 260 and note 1 • Fl. II, p. 372 • Albertina
Catalogue IV, p. 18, no. 105 • Winkler, in *JPK*
50/1929, pp. 137, 138 • W. II, p. 74 • T. II/2,
p. 139, no. A 419 • W. III, pp. 57, 59, no. 615 •
P. II, p. 131, no. 1350 • Francis, in *The Bulletin of
the Cleveland Museum of Art* 34/1947, pp. 13,
14 • H. Tietze, 1951, p. 36 • Musper, 1952,
p. 129 • Killermann, 1953, p. 23 • Winkler,
1957, p. 251 • K.-Str., p. 188, no. 34 • St. II,
p. 612, no. 1502/11 • Piel, 1983, p. 143, no. 61 •
Exhibition Catalogue Berlin 1984, p. 138, under
no. 141.

Dürer here captures the brilliantly colored
plumage of a young blue roller[1] (*Coracias gar-
rulus* L.) with swift, sure brush strokes and pre-
cise work with the pen; the watercolor and
body color are used to draw rather than to
paint. The way the neck stretches upward and
the wings hang down suggest that the model
Dürer used was hanging from its beak. How-
ever, the bird casts no shadows and has no spa-
tial context.

The first time the study is mentioned is in
the Imhoff Inventory,[2] and Heller praises it as
a splendid miniature painting on parchment:
"words cannot be found to describe it."[3]
Thausing was no less enthusiastic in his judg-
ment: "The masterly execution defies all de-
scription. . . . Every means is used to give
each and every feather its due, even gold in the
ruffled gray throat feathers."

The *Dead Blue Roller* has often been dis-
cussed in literature on Dürer, and it has always
been admired as one of Dürer's undisputed
masterpieces; unlike many other of the nature
studies, it has never had its authenticity seri-
ously questioned. Only Springer, the Tietzes,
and, in their wake, Panofsky have ever cast any
doubts on it. Winkler has been emphatic in his
opposition to the Tietzes' objections, finding
them feeble and completely "unfounded de-
rogatory judgments" and saying that the
Tietzes had not produced "even the faintest
evidence."

The early appreciation of this work is indi-
cated by the existence of four copies and one
variation on it, all from the hand of Hans
Hoffmann, with two of them dating from
1583. This alone should be sufficient to dis-
prove the Tietzes' hypothesis, since these
copies were made just fifty years after Dürer's
death, when the sources for the artist's work
were still reliable. If anyone could have imi-
tated his work so skillfully, Hoffmann would
have known about it and would not have cop-
ied an imitation or a forgery.

Although the authenticity of the study is,
thus, generally acknowledged, aside from a
few exceptions, there has been doubt cast on
the date in the more recent literature. The first
to do this were the authors of the Albertina
Catalogue,[4] who seemed to find the authentic-
ity of the monogram and date dubious and
linked it instead with works from 1502–03,
such as the *Hare* (Cat. 43), *Madonna with a Mul-
titude of Animals* (Cat. 35), and *The Large Piece of
Turf* (Cat. 61). Strauss follows the same line of
thought, suggesting 1502 as a possible date, but
his opinion differs in that he believes the
monogram and date to have been added by the
artist himself at the later date of 1512.

I consider that there are immense differ-
ences between the *Hare* and the *Dead Blue
Roller*. Just as the *Hare* and *The Large Piece of
Turf* share the same stylistic and technical basis,
so the *Wing of a Blue Roller* (Cat. 22) and the
Dead Blue Roller have a common — but differ-
ent — style, although the two pairs cannot, of
course, be compared with each other. The two
roller studies are so close in style that the argu-
ments for one may be valid for the other. The
Hare and *The Large Piece of Turf* both date from
1502–03 and use warm colors applied with
comparatively broad brush strokes over the
dominant base of watercolor. The *Dead Blue
Roller* study, however, is characterized by
body-color technique with strong use of the
pen and virtuoso technical refinements, the
whole effect being coolly colorful. The
graphic detail may be compared to the "mas-
ter's engravings." Wölfflin already noticed
that connection and thought "that a technique
of this kind [in the engraving *Melencolia*]
would be inexplicable if we did not know that
it was nourished by a new sensuality. . . . The
way in which Dürer conveyed the essence of
the plumage on the birds' wings and breasts in
the miniature paintings of the Albertina dating
from 1512 (L. 526, 527) is without analogy in
his work both prior to and after that date."

The monogram and date are also instructive.
Both studies, *Wing of a Blue Roller* and *Dead
Blue Roller,* carry inscriptions in very different
kinds of writing, although these are actually
quite in keeping with signatures on drawings
and paintings from the same year. The signa-
ture on the *Dead Blue Roller* may be compared
with those on drawings (W. 513, 519), while
the one on the *Wing of a Blue Roller* is typical of
those on the paintings.[5] Such characteristics
allow us to determine each of the studies with
some certainty, and since the two carry such

different types of signatures, and ones that are
typical of the time, there would seem to be an
even stronger case for dating these studies
around 1512.

NOTES

1 Recognizable as such from, for instance, the tail
feathers, which would have black tips in an
older bird.
2 H. II, p. 82, no. 55.
3 H. II, pp. 117, 118, no. 135.
4 K.-Str.
5 See Albrecht Dürer, *Adoration of the Trinity by
the Civitas Dei* (the Landauer Altarpiece, 1511),
signed and dated on the tablet held by Dürer
in the painting, Vienna, Kunsthistorisches
Museum, Inv. 838.

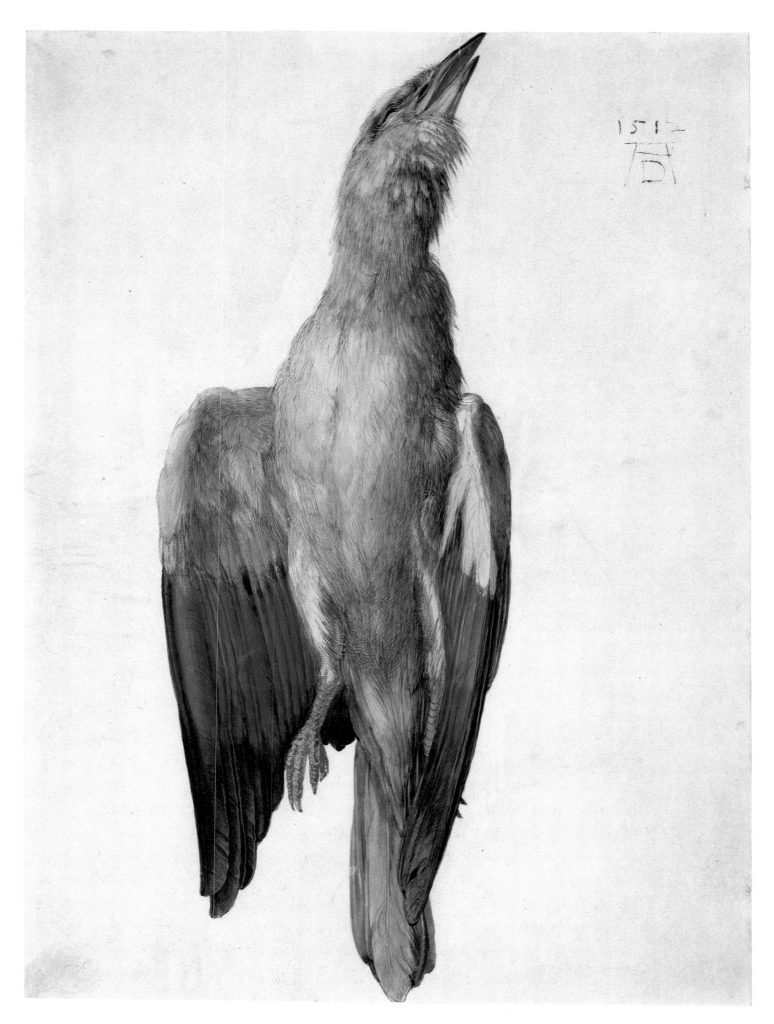

I I

<small>HANS HOFFMANN</small>

Dead Blue Roller

Watercolor and body color on vellum,
brush, pen, heightened with white and gold,
color flaking off in places
A letter crossed through (?) and the
number *142,* bottom right
On the reverse, the (nineteenth-century?)
inscription in red ink: *Eine Schnepfe. Hans
Hoffmann von Nürnberg. † zu Prag. 1600. gr.4^{to}*
293 x 190 mm

Berlin, Staatliche Museen Preußischer
Kulturbesitz, Kupferstichkabinett, Inv. KdZ 4822

PROVENANCE: Praun • Blenz (L. 264).

BIBLIOGRAPHY: Christoph Theophile de Murr,
*Description du Cabinet de Monsieur Paul de Praun
à Nuremberg* (Nuremberg, 1797), pp. 16–18, no.
142 • Bock, 1921, I, p. 47, no. 4822 • Winkler, in
JPK 53/1932, p. 81, note 1 • W. III, p. 60, under
no. 615 • K.-Str., p. 188, under no. 34 • St. II,
p. 612, under no. 1562/11, no. 2 • Exhibition
Catalogue Berlin 1984, p. 138, no. 141.

This study is a copy of Dürer's *Dead Blue
Roller* now in the Albertina Collection (Cat.
10). It differs in matters of formal detail, such as
the more noticeable spindle shape of the thigh,
the slightly stronger sweep of the left wing
(the one lying closer to the body), and the
wider gap between the third and fourth toes. It
also differs from its model in the paler, more
greenish-hued blue of the wings, and in the
yellowish green nuances of the breast plum-
age. Especially in the inner drawing, Dürer's
original is stronger on detail and more subtly
colored, while the wings in the copy are
touched in with skill, but also with compara-
tive simplicity, a pointed brush having been
used to apply white highlights in delicate con-
figurations. The overall impression conveyed
by the copy is of a lack of the dynamism that
marks the genuine artistic creation.

The features that distinguish the Berlin
copy from the original are also to be seen in the
other three copies in Cleveland[1] (ill. 11.1),
London (Cat. 12), and Paris[2] (ill. 11.2). A stylis-
tically corresponding version in London (Cat.
13), which strictly speaking is a variant, has to
be added. This one and the copy in Cleveland
carry Hoffmann's monogram and are dated
1583, which indicates that the shared features
of these studies identify them all as by Hoff-
mann. Since the Berlin study is stylistically
close to the two dated versions of the same
subject, it must also date from a time between
1580 and 1585.[3]

The Berlin version is the best preserved of
all known copies. It is executed with great care,
and as in Dürer's original, tiny golden feathers
can be seen gleaming on the neck. The striking
quality of the copying technique is evident in
the head and the ruffled neck feathers, so the
work is an excellent example of the perfection

of Hoffmann's technique. It becomes under-
standable why his copies were constantly being
mistaken for Dürer originals.

NOTES

1 Hans Hoffmann, *Dead Blue Roller,* watercolor
and body color on paper, brush, heightened
with white, traces of preliminary drawing,
monogrammed bottom center and dated 1583;
292 x 169 mm; Cleveland, Cleveland Museum of
Art, purchased by Dudley P. Allen Fund, Inv.
no. 46.217.

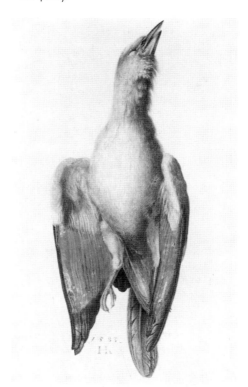

11.1 Hans Hoffmann, *Dead Blue Roller,* 1583.
Cleveland, Museum of Art (see note 1).

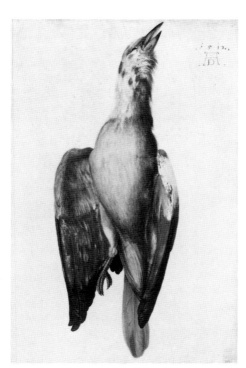

11.2 Hans Hoffmann, *Dead Blue Roller.*
Paris, private collection (see note 2).

2 Hans Hoffmann, *Dead Blue Roller,* watercolor
and body color on vellum, brush, heightened
with white, traces of preliminary drawing,
Dürer monogram top right and dated 1512;
278 x 180 mm; Paris, private collection.

3 As recognized by Katrin Achilles, the number
142 (below, right) corresponds with de Murr's
list of the Praun Collection; see Katrin Achilles,
"Naturstudien von Hans Hoffmann in der
Kunstkammer Paulus II. Praun," in *JKS*
82/1986; see also p. 267, below.

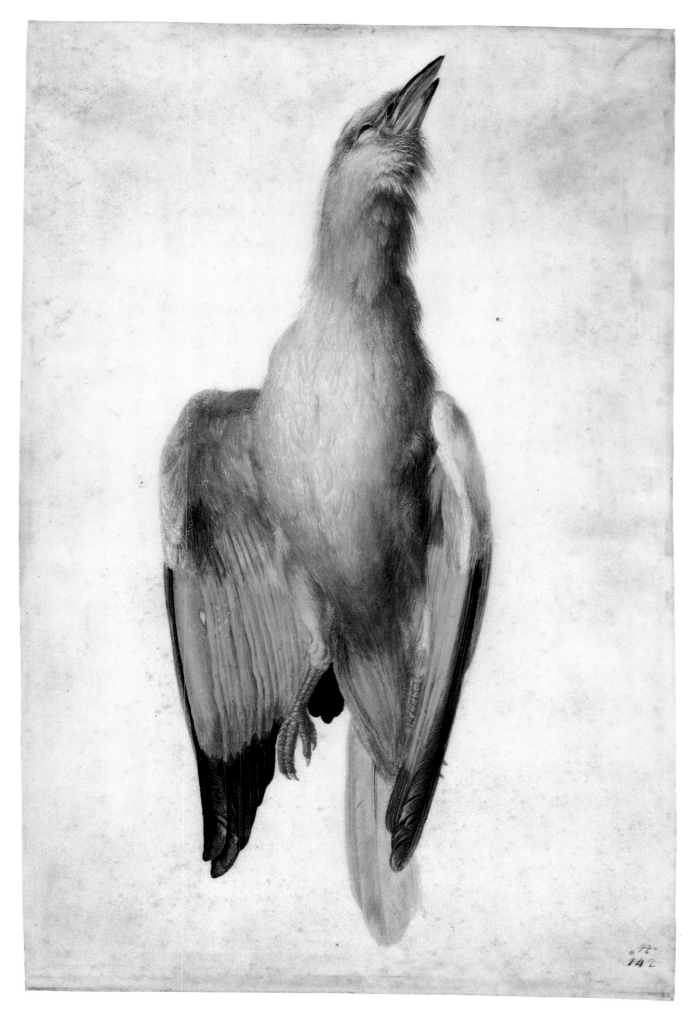

II

NOTE

1 The original monogram was quite similar in form, the date the same. Its displacement is probably linked to the effect of moisture, visible at the top and bottom of the vellum.

12

HANS HOFFMANN

Dead Blue Roller

Watercolor and body color on vellum, brush, heightened with white and gold, white partially oxidized, especially on the neck and beak Dürer monogram and the date *1521* by a foreign hand, top left; traces of an erased monogram and date, bottom right[1]
282 x 180 mm

London, The British Museum, Department of Prints and Drawings, Inv. G.g.2–220

PROVENANCE: Cracherode.

BIBLIOGRAPHY: E., p. 79 • Exhibition Catalogue London 1928, p. 31 • Winkler, in *JPK* 53/1932, p. 81, note 1 • Albertina Catalogue IV, p. 18, under no. 105 • T. II/2, p. 139, under no. A 419 • W. III, p. 60, under no. 615 • K.-Str., p. 188, under no. 34 • Exhibition Catalogue London 1971, p. 54, under no. 337 • St. II, p. 612, under no. 1502/11, no. 1.

Like the Berlin *Roller* (Cat. 11), the London version is a Hoffmann copy of the much-admired original by Dürer. Both copies differ from their model in the same details, which would suggest that they had the same tracing as their basis, and this is also the case for the copies in Cleveland and Paris (see Cat. 11).

When this study is compared directly with the one in Berlin, the great similarities are of course evident, but doing so also shows how the artist's work can vary between two examples of a piece of work. We become aware of the freedom the artist exercised, as well as of his fidelity to the model.

The attribution to Hans Hoffmann is based on a stylistic comparison with the monogrammed and dated (1583) copy in Cleveland and with the London variant (Cat. 13). Dürer's monogram and the 1521 dating, top left, have no bearing on the facts; nor does the monogram in the bottom right of the picture, which has been erased but is still faintly visible. Both of these must have been added later, and a comparison with, say, Cat. 28 (compare also ill. 11.2, p. 56) shows that they differ noticeably from the Dürer monograms that Hoffmann habitually used.

Hoffmann's copies are generally characterized by very fine, short, gentle strokes giving the surface texture, and these, in combination with the shapes largely defined by color, create an overall pictorial effect. This study displays these special features more clearly than the other *Roller* copies, particularly when contrasted with the more graphic construction of Dürer's studies. Compared with Dürer's studies, the accentuated painterly style of Hoffmann's copy is also evident in the works of other copyists of the Dürer Renaissance. It is a criterion for Dürer replicas of the late sixteenth century in general.

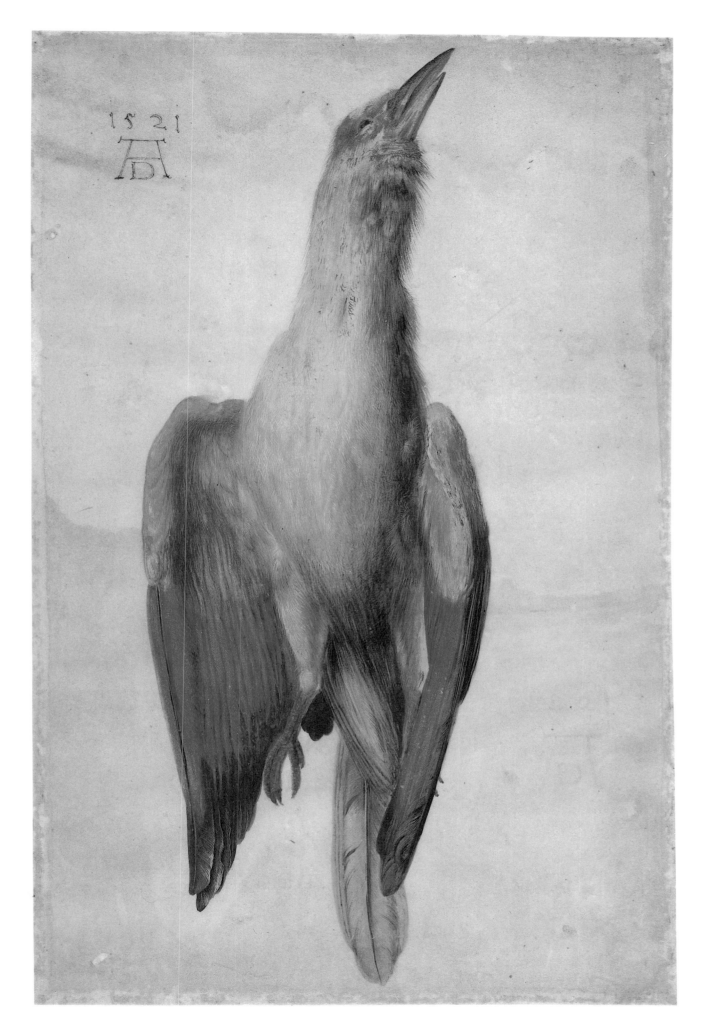

13

HANS HOFFMANN

Dead Blue Roller
Hanging on a Nail

Watercolor and body color on vellum, brush,
heightened with white
Hoffmann's monogram and the date *1583* in pen
and brown ink, top right
369 x 180 mm

London, The British Museum, Department of
Prints and Drawings, Inv. 1890 – 5 – 12 – 156

PROVENANCE: Imhoff (?) • Praun (?) • Mitchell
(L. 2638).

BIBLIOGRAPHY: E., p. 79, note 3 • Auction
Catalogue of the Mitchell Collection (Frank-
furt, F.A.C. Prestel, May 7, 1890) • Exhibition
Catalogue London 1928, p. 39, no. 335 •
Winkler, in *JPK* 53/1932, p. 81 • Pilz, in
MVGN 51/1962, p. 261, no. 24 • K.-Str.,
p. 188, under no. 34 • Exhibition Catalogue
London 1971, p. 54, no. 337 • St. II, p. 612, under
no. 1502/11, no. 3.

This bird study, monogrammed with Hoff-
mann's initials and bearing the date 1583, is a
freely conceived copy of Dürer's *Dead Blue
Roller* (Cat. 10), which, at the time Hoffmann
copied it, was in the collection of Willibald
Imhoff the Elder, to which the painter had
access.[1] Hoffmann's reproductions are nor-
mally classed as copies of Dürer's original, but
this one differs in such characteristic detail
from the model that it should correctly be
called a variant. Conspicuous differences are to
be found not only in the symmetrical place-
ment of the wings, unlike that in the original,
but also particularly in the detailed depiction of
the string threaded through the nostrils and
the nail from which the bird is hanging. The
connoisseur cannot but notice the deviations
from the famous original, but what Hoffmann
has done has created something new in the
spirit of the Dürer Renaissance. The large,
protruding nail, its shadow, and the string ac-
centuate the illusion of reality. While Dürer's
interest was mainly in reproducing the bird,
these details show the beginnings of an artistic
expansion through which Dürer's model be-
comes transformed into a still life with
trompe-l'œil effect. This shifting of emphasis
from the object to the situation is achieved by
using traditional elements, which can be traced
back from Cranach's studies of birds (see Cat.
8), via Dürer's *Dead Duck* (Cat. 7) and Jacopo
de' Barbari's study of a partridge (Cat. 6),
through to the classical period.

Hoffmann's more faithful copies of the *Dead
Blue Roller* are perhaps more convincing artis-
tically than this variant, where his own imagi-
nation was brought into play. Aside from
Dürer's example, it suggests that Hoffmann's
depictions of the roller are not just repetitions
of previous forms but are independent studies
that follow nature. This idea is further sup-
ported by another study of a blue roller (Cat.
14), where the bird is seen from behind, its
wings spread out symmetrically as if to provide
a compositional companion piece.

NOTE

1 H. II, p. 72.

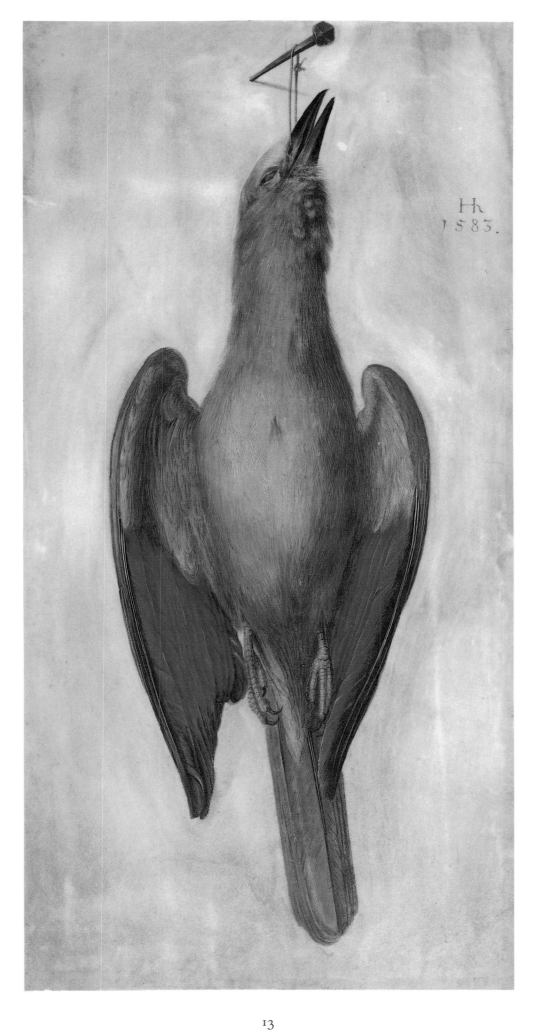

14

HANS HOFFMANN

Dead Blue Roller,
Seen from the Back

Watercolor and body color on vellum, brush,
heightened with white, partially oxidized
On the reverse of the frame the old inscription:
*Etude pour le Charles I^{er} Musee de Prado. et pour les
3 Cavaliers à Buckingham palace. Collection
Bernies-Calvière anciennnement Chevalier de la
Roque, Chateau de Vezenoles*
338 x 230 mm (overall measurement)

Paris, private collection

PROVENANCE: Esdaile (L. 2617) • Bale (?) •
Morrison • Béhague.

BIBLIOGRAPHY: Th. II, p. 56, note 2 • Winkler,
in *JPK* 53/1932, p. 86 • W. III, pp. 58, 59,
under no. 614, and appendix plate XII, bottom
right • P. II, p. 131, no. 1352 • Pilz, in *MVGN*
51/1962, p. 266, under no. 36 • St. II, appendix,
p. 1099, no. 5.

This study of a blue roller viewed from the
back with its wings slightly outstretched is nei-
ther monogrammed nor dated. Traditionally it
was associated with Dürer, and even when it
was exhibited in 1869, for the last time, by the
Burlington Fine Arts Club, it was attributed to
him.[1] In the early nineteenth century it be-
longed, as suggested by the handwritten
monogram in the bottom right-hand corner,
to the collection of William Esdaile; it was
auctioned as part of this collection along with
the *Wing of a Blue Roller* (Cat. 25), which bears
the date 1524 and Dürer's monogram.[2] Perhaps
it is simply this association that gave rise to the
attribution. Thausing included both studies in
the Dürer literature but already suspected that
they were by Hans Hoffmann. He mentions
another "very similar miniature on parch-
ment, which is, however, marked with Hoff-
mann's own monogram," in the Artaria Col-
lection, Vienna.[3]

Quite apart from this authentication, traits
of Hoffmann's style can be observed. Details of
the execution, such as the depiction of the tail
feathers with their shafts and barbs, may be
compared with the study *Dead Blue Roller
Hanging on a Nail* (Cat. 13), bearing the artist's
monogram and the date 1583, which is in Lon-
don. It is also similar to the *Wing of a Blue Roller*
of the Woodner Collection (Cat. 25) in colors
and in the precise construction and detailing of
the feathers. The theme is also closely related
to the London study, since it provides a kind of
counterpart to it viewed from the rear.

Winkler,[4] and Pilz after him, thought that
this work was the copy of a lost original by
Dürer. I would like to think, however, that
Hoffmann based it on Dürer while also study-
ing a real bird, thus creating a free paraphrase.
The composition is not taken from Dürer's
repertoire, being determined by methods
adopted from natural history: it treats the bird
like a pinned butterfly. One need not assume
that, just because it is a variant on a well-
known Dürer study that it resembles in its for-
mal vocabulary, it must spring from a lost work
by the master. Certainly creations "à la Dürer"
might have been produced at a time when
Dürer was an established example. In this con-
text it should be noted that Georg Hoefnagel's
paraphrase of the *Stag Beetle with Outspread
Wings and Scorpion* (Cat. 39) and the Mannerist
form of Hans Hoffmann's radically foreshort-
ened *Hare* (Cat. 52, 53) are characterized by a
very similar, extreme frontality. Their artistic
interest and attractiveness stem significantly
from their calculated echoing of a deliberately
modified model, a process that would have
been recognized and appreciated by the edu-
cated public. This study seems to represent a
unique and individual result, in keeping with
the spirit of the times and only to be expected
from a copyist such as Hoffmann, who was a
real artist too.

NOTES

1 Exhibition Catalogue *Albrecht Dürer and Lucas
van Leyden* (London, Burlington Fine Arts Club,
1869), no. 132.
2 Both works were probably acquired by Bale (?)
and later by Morrison.
3 According to Pilz, 1962, it was presumably
auctioned by Frederik Muller & Cie; where-
abouts unknown; watercolor and body color on
vellum; 170 x 360 mm. Pilz, apparently
working from the Artaria Catalogue 1876, lists a
Hoffmann monogram and the date 1512.
Thausing does not mention the date. The study
"*A Dead Dove*, finished watercolor, 15.5 x 36
cm, by Hans Hoffmann" is also mentioned in
Auction Catalogue Artaria (Vienna, 1896), p. 97,
as no. 1118. Pilz's identification of the work with
the horizontal format (!) study *Pigeon mort,
couché* mentioned in the Frederik Muller & Cie
catalogues (*Catalogue d'une grande vente de dessins
anciens,* Amsterdam, Sale June 15 – 18, 1908,
p. 51, no. 283, and *Catalogue des dessins anciens,*
Amsterdam, Sale June 11 – 14, 1912, p. 22, no.
128a) seems doubtful. The details, however,
would seem to indicate studies in the style of a
jay mistakenly attributed to Jacopo de' Barbari
(Photo Witt Library; ill. 6.2).
4 W. III, appendix plate XII, bottom right.

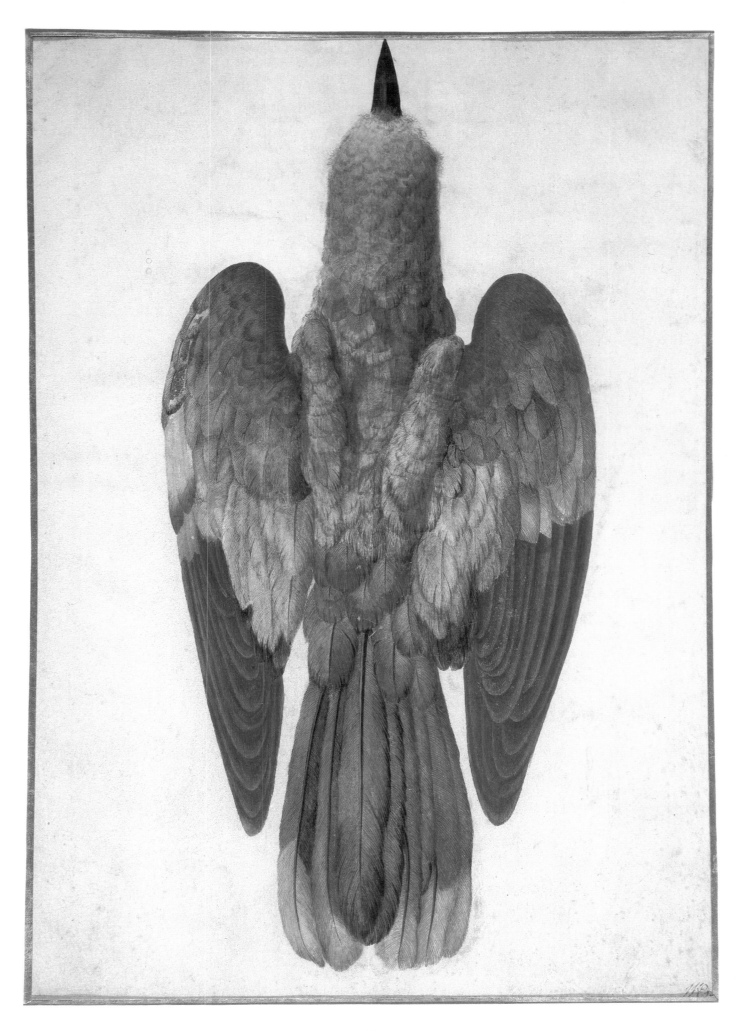

15

GERMAN, C. 1600

Dead Thrush

Watercolor and body color on vellum, brush,
heightened with white and gold
Dürer monogram and the date *1505* by a foreign
hand, bottom left
On the reverse the inscription: *Dise Zijppe hat
Albrecht Dürer gemolet zu Trintsperg im Walschen
im 1505 Jor da er auff der reiss war. Dij Valschen
töten dise voglin mit so grosser grausamkeit das mir
schwer leitt war. Und molet Ich sij 2 Tag bisg Jch zw
besten End war Albrecht Dürer.*[1]
150–155 x 97–111 mm
Private collection

PROVENANCE: Richardson? (L. 2183) • von
Nagler? (L. 2529) • Grahl (L. 1199).
BIBLIOGRAPHY: Not described.

The German term *Zippe* was formerly used
for *Singdrossel* (songthrush). This bird, how-
ever, appears to be a fieldfare (*Turdus pilaris* L.)

The *Dead Thrush,* which according to the
position of the monogram and date should be
viewed with the head pointing down, seems
very different from Dürer's *Dead Blue Roller*
(Cat. 10). Yet if the picture is turned upside
down, a close affinity between the two motifs
becomes evident. As in the *Dead Blue Roller,* the
bird's head is turned to the side and one wing is
close to its body, while the other is half spread.

The date and monogram are very different
from Dürer's own, and presumably were added
later. Like Richardson's and Grahl's collector's
stamps, and Nagler's stamp on the reverse,
they suggest old provenance as does the in-
scription on the reverse, which is quoted
above. The study is not mentioned in the liter-
ature.

Reports made in 1954 by Ludwig Baldass,[2]
Franz Kieslinger, and Robert Eigenberger
confirm the authenticity of the painting, while
the inscription was declared genuine after ex-
aminations of the handwriting on the reverse
by W. R. Muckenschnabel and R. Strebinger,
also in 1954. The study came onto the market
in 1950. Friedrich Winkler, an authority on
Dürer for more than thirty years, examined it
several times, the first being in 1954; Edmund
Schilling was also familiar with the work,[3] but
the two men do not seem to have been familiar
with the assessments mentioned. Winkler said
the monogram, date, and collector's stamps are
forgeries.[4] He considered the style to be more
painterly than Dürer's graphically oriented
technique (see p. 43). Like Schilling, he be-
lieved that the study did indeed date from the
sixteenth century, but that the inscription and
stamps were forgeries dating from the early
twentieth century.

Our understanding of the problems con-
nected with this work is aided by another study
(ill. 15.1), similar in nature and in some ways a
counterpart. It shows the same bird, but on a

larger scale and with the head pointing up;[5]
the stamps are the same, but it is dated 1512.
This, too, was put before Winkler by the Lon-
don art market in 1950. Winkler and Schilling
considered the accompanying report from El-
fried Bock a forgery. The whereabouts of this
study are unknown, and it is known to me only
from a photograph in Winkler's estate. Schill-
ing, who saw the picture,[6] considered it to be a
later work, harking back to Dürer, which had
been restored to the Imhoff Collection (per-
haps as an original?). However, there is no
concrete basis for either of these theories.

The inscriptions on the two studies are simi-
larly worded; the painting seems to have been
done by the same person, but the handwrit-
ing is different. The artist is unknown in
both cases. Winkler does not think that the
study is by Hans Hoffmann. Its motif is rem-
iniscent both of Dürer's *Dead Blue Roller* and of
the *Dead Sparrow* in the Blasius Collection (ill.
5, p. 42). Stylistically, it resembles Daniel
Fröschl's *Two Woodpeckers* (Cat. 16) or the

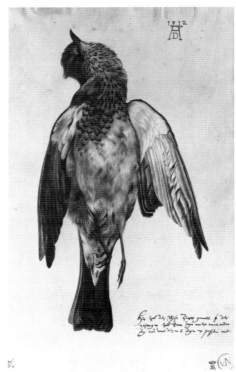

15.1 German, c. 1600, *Dead Thrush,*
body color on vellum.
Whereabouts unknown (see note 5).

studies of dead birds that were pasted into a
seventeenth-century herbal in the Sächsische
Landesbibliothek, Dresden (see ill. 6.3). Thus
Schilling's dating of the *Dead Thrush* as at the
end of the sixteenth century would seem to be
further supported.

NOTES

1 "Albrecht Dürer painted this thrush in
 Trintsberg in Walschen [a village near Trento
 in Italy] in the year 1505, when he was on his
 travels. The Walschians [i.e., Italians] kill these
 birds so gruesomely that it caused me great pain.
 And I painted it for 2 days until I came to a
 good end. Albrecht Dürer."

2 The date on the report is difficult to read; it
 could be 1954 or 1957.
3 This is taken from Winkler's correspondence,
 which has been preserved in the Berlin
 Kupferstichkabinett. My thanks to Professor
 Fedja Anzelewsky and Hans Mielke for
 allowing me access to Winkler's estate.
4 Winkler, in his assessment of May 13, 1954,
 says: "The collector's marks of Richardson and
 von Nagler would never occur together, and
 moreover, works from the Nagler Collection
 have never been sold and are unknown on the
 market" (copy in the Winkler estate, Berlin,
 Kupferstichkabinett).
5 Body color on vellum; approximately 200 x 100
 mm; on the London art market after 1950. I am
 familiar with this work only through a
 photograph in Winkler's estate. A picture of a
 similar bird study was shown me several years
 ago by a visitor to the Albertina. The work was
 on the market (Munich?) and bore the same
 collector's marks (!). I was not yet fully aware of
 the context of the piece, and I cannot remember
 whether it was the study in question here, or a
 third and different one.
6 Letter of May 16, 1950 (Berlin, Kupferstich-
 kabinett).

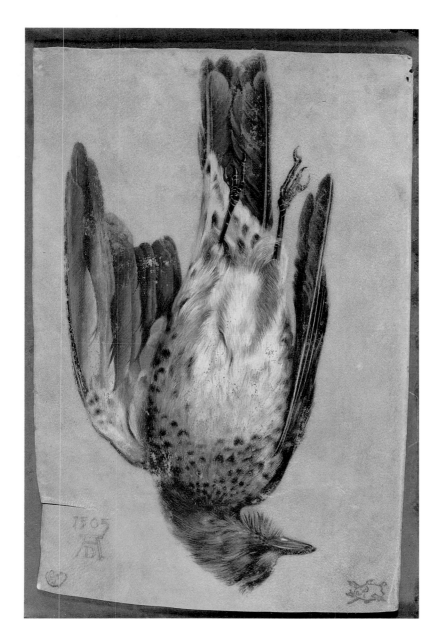

15

16

DANIEL FRÖSCHL

Two Woodpeckers

Watercolor and body color on paper, brush,
heightened with white
Signed, dated, and inscribed, center right:
*Alsterspecht od Baumheckel. ¡ᵉ Nouembris
Anno. 1589. Dan.Fröschel.f:* in pen and brown ink
195 x 255 mm
Vienna, Österreichische Nationalbibliothek,
Handschriften- und Inkunabelsammlung, Cod.
min. 42, fol. 54r (top)

PROVENANCE: Emperor Rudolf II • Imperial
Treasure Chamber • Imperial Court Library
(1783).

BIBLIOGRAPHY: Bauer and Haupt, in *JKS*
72/1976, p. XXX, fig. 14a • Lucia Tongiorgi
Tomasi, "Il Giardino dei semplici dello studio
Pisano," in *Livorno e Pisa: due città e un territorio
nella politica dei Medici* (Pisa, 1980), pp. 518, 519,
fig. 3.

The inscription on this work tells us that it
shows a spotted woodpecker, dead and lying
on its back, and another seen from the side, and
that it was drawn by Daniel Fröschl on No-
vember 1, 1589. It would seem that we have
ideally precise knowledge, through the cap-
tion, signature, and date on the piece, of the
artist and time of genesis.

Yet if we examine things more closely, the
matter becomes a great deal less clear. For a
start, the inscription refers only to one species,
whereas two birds of different species are de-
picted. Above is the great spotted woodpecker
(*Dendrocopus major* L.), while below, if one is to
judge by the pink belly and the streaked plum-
age on the breast, we have a middle spotted
woodpecker (*Dendrocopus medius* L.). More-
over, the handwriting of the signature is so
different from that of the inscription that one
is led to doubt whether the two date from the
same time, and even whether they are in the
same hand. Problems also arise from the date: it
has been read as 1580,[1] which is hardly in
keeping with Fröschl's date of birth as sug-
gested by more recent research[2] — 1573. The
date has also been read as 1589, but this would
still be surprising since it would mark the work
as that of a sixteen-year-old.

The style differs significantly from that to
be found in the Fröschl studies from the early
1600s with which we are acquainted. Those
generally show figures depicted in a pointillist
style typical of the time, while this study,
where the brush is used to draw with water-
color and body color, is in the tradition of
Cranach and Dürer. In spite of these differ-
ences of style, circumstances suggest that the
study is by Fröschl. It is pasted in an old album
in the imperial collection[3] that contained
pieces from different sources collected at some
time in the late sixteenth century. There is also
documentary proof that Fröschl made studies

of birds. He was taken into the employment of
Emperor Rudolf II in 1601 as a painter of min-
iatures, and in 1607 he was promoted to anti-
quary and curator of the imperial collections.
From then until 1611 he made an inventory of
the works.[4] Listed in it was a book of silver-
point sketches by Albrecht Dürer, which was
kept in a chest, *darein auch 3 vögel von miener
DFᶜhand, eingeklebt*[5] ("and also pasted therein
three studies of birds by my own, Daniel
Fröschl's, hand"). This would seem further to
support the case for these studies' authenticity.

There is still more evidence. The album
mentioned earlier (Cod. min. 42), in which the
study is included, was manufactured in Prague
in 1579, according to the watermark on the
backing paper and an old inscription (on folio
161); it was transferred from the imperial trea-
sure chamber to the court library (Hofbib-
liothek) only in 1783.[6] There is much to
suggest that it belonged to Rudolf's *Kunst-
kammer*,[7] one clue being the green parchment
cover. In his capacity as archivist, Fröschl
would have altered the inscriptions on the
studies if they did not correspond to require-
ments. When they are thus "authorized," it
becomes clear that the dissimilarity of style
marks the difference between early drawings
and the mature ones with which alone we were
familiar up to now. On folios 32r and 53r Cod.
min. 42 includes further studies of birds, iden-
tical in style and also carrying Fröschl's mono-
gram.[8]

NOTES

1 Bauer and Haupt, 1976.
2 Exhibition Catalogue Stuttgart 1979/80, I, p. 72.
3 See Cat. 1, note 1, for the full reference to Cod.
 min. 42; for the greatest detail on individual
 sections of the volume, see M. L. Hendrix, *Joris
 Hoefnagel and the Four Elements: A Study in
 Sixteenth-Century Nature Painting* (phil. diss.,
 Princeton University, 1984), pp. 146 ff.
4 Bauer and Haupt, p. XXVI, ill. 13, and p. 135,
 no. 2704.
5 Bauer and Haupt, p. XXIII.
6 "Inventare, Acten und Regesten aus der
 Schatzkammer des Allerhöchsten Kaiser-
 hauses," ed. by Heinrich Zimerman (continua-
 tion), in *JKSAK* 16/1895, p. LVIII, no. 12658.
7 See Otto Pächt, "Simon Mormion myt der
 handt," in *Revue de l'Art* 46/1979, p. 14, notes 3
 and 4.
8 *Kingfisher,* body color on vellum, mono-
 grammed bottom right; 130 x 165 mm; fol. 32r
 (bottom). *Two Woodpeckers and Two Butterflies,*
 watercolor, body color on paper, mono-
 grammed bottom right; 423 x 280 mm; fol.
 53r. As was later made known to me, Lucia
 Tongiorgi Tomasi had already referred (see
 bibliography, above, and Fröschl's biography in
 the appendix) to an album in the university
 library in Bologna (Aldrovandi, *Tavole di
 animali* II, p. 155) that contains among others,
 two bird illustrations from Daniel Fröschl's
 Italian period. Tongiorgi Tomasi mentions two
 other volumes, in the university library in Pisa
 (nos. 513 and 514), but among these animal
 studies there is — in my opinion — none by
 Fröschl.

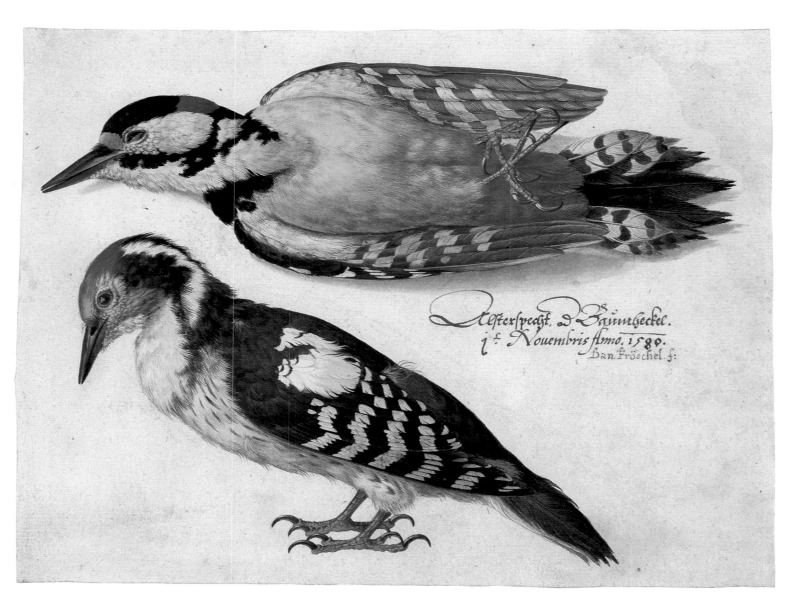

Aelsterspecht. Baumbeckel.
i.^e Nouembris Anno. 1589.
Dan. Fröschel. f:

16

17

MARIA SIBYLLA MERIAN (?)

Dead Bramblings

Body color on vellum, brush,
heightened with white
176 x 235 mm

Vienna, Graphische Sammlung Albertina,
Inv. 3708 (D 1026)

PROVENANCE: Duke Albert of Saxe-Teschen
(L. 174).

BIBLIOGRAPHY: Albertina Catalogue IV, p. 102,
no. 1026 • Gertrud Lendorff, *Maria Sibylla
Merian, 1647–1717. Ihr Leben und Werk* (Basel,
1955) • Exhibition Catalogue *Maria Sibylla
Merian* (Nuremberg, Germanisches National-
museum, 1967) • Elisabeth Rücker, *Maria Sibylla
Merian* (Bonn, 1980).

This work shows five dead bramblings (*Frin-
gilla montifringilla* L.) tied together by the
beaks, presumably bagged by a huntsman.
They would seem to have been thrown down
casually, but in fact the composition has been
artistically calculated.

Maria Sibylla Merian's reputation during
her lifetime rested primarily on her pictures of
flowers and insects, which were to an extent
based upon her own scientific studies, for in-
stance, her butterflies with detailed studies of
caterpillars and cocoons.[1] Her work tends to be
scientific in nature, and her still-life depictions
of animals are something of an exception: birds
are rare, and mammals hardly in evidence at
all. It has therefore been assumed that the artist
painted works like this *Pinselkunstücke* for
commercial purposes.[2]

It is hard to date her studies, which vary
little in form and content. The dense brush-
work and relatively bright colors suggest an
early work from some time in the 1670s, when
she was still heavily influenced by her teacher
— her stepfather, Jacob Marrel, a pupil of
Georg Flegel.

For all its arrangement as a still life, this is
yet very much a nature study. There is a con-
stant balancing between precise observation
and artistic intensity, a characteristic feature of
Merian's work that led Goethe to remark that
her style moves "to and fro between art and
science, between observation of nature and
painterly aims."[3]

It is this very quality that relates it to Flegel's
studies (see Cat. 92, 93), and its roots may be
seen to reach back beyond the scientific illus-
trations of the seventeenth century to the Re-
naissance, and to Dürer's, Cranach's, or de'
Barbari's studies of dead birds.

NOTES

1 Exhibition Catalogue Nuremberg, p. 10.
2 Albertina Catalogue IV, p. 102, no. 1026.
3 Johann Wolfgang von Goethe, *Werke,
Kunsttheoretische Schriften, Blumen-Mahlerey,* vol.
39 (Stuttgart–Tübingen, 1830), p. 233; quoted
by Elisabeth Rücker, "Maria Sibylla Merian,"
in *Fränkische Lebensbilder,* vol. I (Würzburg,
1967), p. 242.

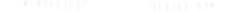

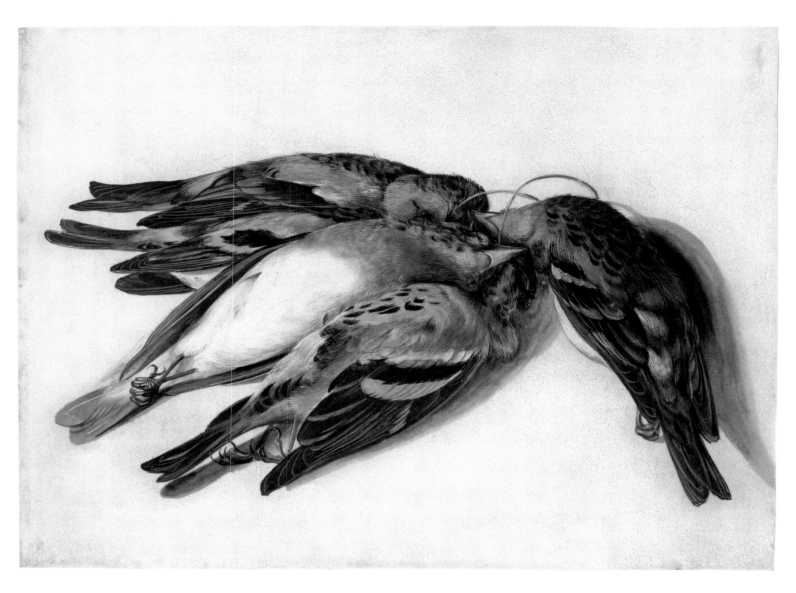

17

Wing of a Blue Roller —
Dürer's Representations of Wings

Dürer's *Wing of a Blue Roller* (Cat. 22) has always been admired as a colorful piece of virtuoso brush drawing; at the same time it has been respected as an example of the interest in nature that arose in the Renaissance. It has been recognized as a record of analytical natural science in which the investigation has been made with paint and brush. The process of discovery and its translation in graphic terms go hand in hand.

This was not the only wing to be depicted by Dürer. He made other wing studies in the period from approximately 1497 to 1514, between the *Apocalypse* and the master engravings. These can be seen in paintings and drawings as well as in woodcuts and engravings. In addition, the sixteenth century gave rise to many copies, both exact and free, of the *Wing of a Blue Roller*. The various versions Dürer produced and the numerous close imitations that followed in the course of time not only have made it more difficult for us to assess the original, but also have confused the possible connections among the different variants and muddled their chronology.

Although the Dürer wings may seem to present a complex problem, a closer examination reveals three clearly distinguishable prototypes. The differentiation among the three begins with the *Study for Nemesis* in London (Cat. 18). This drawing shows, first, the goddess of fortune with her wings folded down, while the secondary drawing next to it, a quick sketch obviously the result of compositional rethinking and correction, shows the wing already fully spread, as in the final engraving (Cat. 18a). Considering the precursors and derivations of these two arrangements, we realize that the study of a blue roller's wing in the Albertina, dated 1512 (Cat. 22), represents a distinct, third type.

For a further discussion of Dürer's representations of wings it seems useful to treat them in distinct groups, and to examine the *Nemesis* engraving before the *Wing of a Blue Roller,* although recent literature has tended to link them directly.[1] Comparisons tell us, however, that the fully spread wing in the engraving of c. 1501–02 can be derived from precedents of the 1490s. These precedents lead back, via the wing study in the *Study for Nemesis* mentioned above, to Dürer's drawing *Angel Playing a Lute* (ill. 18.1) or his woodcut *Saint Michael Fighting the Dragon* from the *Apocalypse* (ill. 18.2.).[2] According to the available comparative material, the wing first given to Nemesis in the London drawing, its feathers pointing down, represented a later stage in the development of the wing than the second one on the same sheet, although ultimately, in the engraving, the latter, with its feathers pointed upward, was substituted, for compositional reasons, for the former. The *Lapwing's Wing* in Berlin (Cat. 20) is related to that rejected wing, and so, with a

few justifications, is the study of a wing in the Escorial (ill. 4, p. 72); the wings that later were used in the engraving *The Sudarium of Saint Veronica, Displayed by Two Angels* (Cat. 21a) of 1513 can justifiably also be derived from that same rejected wing.

It was probably in relation to this group that Dürer was credited with the loosely constructed, sketchlike *Study of a Snipe's Wing* (top and underside) in the Metropolitan Museum, New York (ill. 1).[3] In spite of the effect of relative colorfulness achieved here with a monochromatic medium, the brush technique lacks grace. And even though it resembles them in form, the technique cannot be associated with the Berlin *Lapwing's Wing* or with the London *Nemesis* study; nor is there any stylistic foundation for including the *Snipe's Wing* among Dürer's works.

Both the spread and the folded wings are, then, to be seen in drawings and prints from the years around 1500, and both positions can be linked with the *Nemesis;* however, we do not know of any subsequent use of the 1512 *Wing of a Blue Roller.* There are many who would place it earlier, but in fact it would seem that the date is reliable. The detailed precision of its execution prefigures the master engravings of 1513–14, especially *Melencolia* (B. 74), although it cannot be called a forerunner of these works in the strict sense. Apparently it was conceived as an independent work of art, a thesis supported by the monogram and date, and in it Dürer brought his preoccupation with the bird's wing to both a climax and an end. As

far as is known, the work is without predecessors in his œuvre, and also without true successors.

Its aftermath has proved the more extensive for this. Concordance and appreciation have led on occasion to such deceptively exact copies and variants that some imitations are considered to be works by Dürer even today.[4]

Exact copies:	1 Bayonne, Musée Bonnat (Cat. 23)
	2 Bamberg, Staatsbibliothek (Cat. 24)
	3 Lanna Collection[5] (ill. 2)
	4 Hugelshofer Collection[6] (ill. 3)
	5 Nuremberg, Stadtgeschichtliche Museen (Cat. 26)
Variants:	6 Escorial[7] (ill. 4)
	7 New York, Woodner Collection (Cat. 25)
	8 Netherlands, private collection[8] (ill. 7)

In addition, there are the references in the Imhoff *Geheimbüchlein,* which, as far as they cannot be identified with one of the above-mentioned drawings, are included here for the sake of comprehensiveness:

Folio 71r, no. 17: *Ein schöner flügel von einem Vüß hohe, auff pergament gemahlt vom Albr. Dürer Rth. 250,* — ("A beautiful wing one

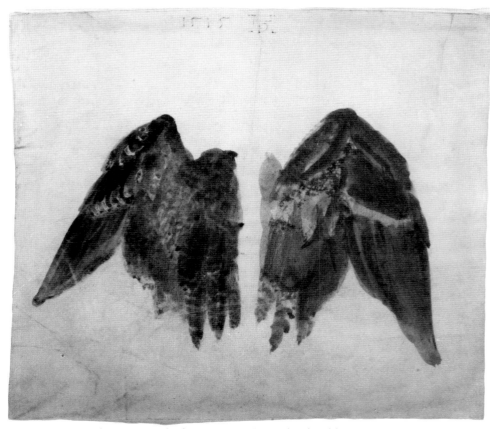

1 German, sixteenth century, *Study of a Snipe's Wing* (top and underside), watercolor on vellum. New York, Metropolitan Museum of Art (see note 3).

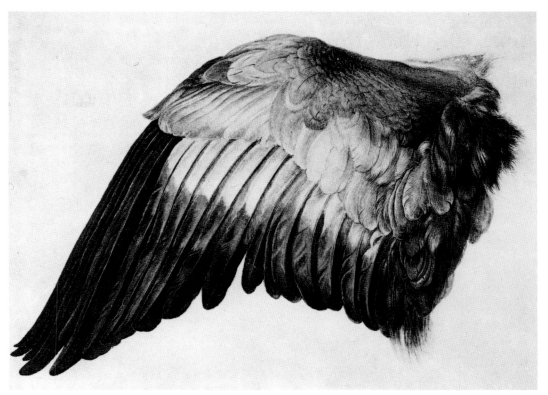

2 Hans Hoffmann (?), *Wing of a Blue Roller,* watercolor and body color on vellum.
Formerly Prague, Lanna Collection (see note 5).

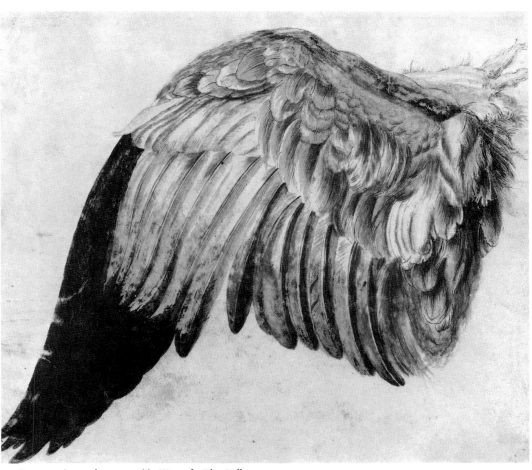

3 German, sixteenth century (?), *Wing of a Blue Roller,*
pen and watercolor on vellum. Whereabouts unknown (see note 6).

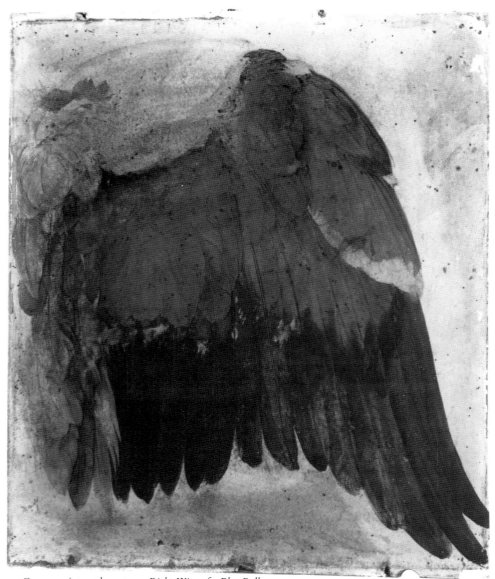

4 German, sixteenth century, *Right Wing of a Blue Roller,*
watercolor on paper. Escorial (see note 7).

foot high, painted on vellum by Albr. Dürer Rth. 250 —") (sold in 1633 by the Dutchman Abraham Blommart, not the painter!).[9]

Folio 76v: *Einen schönen auf Pergament gemahlten Flügel von einem Vus hoehe, von Hannßen Hofmans hand umb Rth. 50,* — ("A beautiful wing, one foot high, painted on vellum by Hans Hoffmann's hand for Rth. 50 —") (offered unsuccessfully in 1636 during the Imperial Diet in Regensburg; purchased in December 1637 by Matthäus Overbeck from Amsterdam).[10]

Since the stylistic differences among the individual studies are often small, significant only when viewed in terms of their total effect, we must, in regard to the opposing opinions about the original and the copies, make detailed comparisons.

In short, the copies of the *Wing of a Blue Roller* differ in the greater curvature of the primary and secondary feathers,[11] which means that they lack some of the tension and tightness of the 1512 Albertina *Wing* while gaining a

greater total breadth of form. The contours of the primary feathers are distinctive, being more concave in the Albertina original, more convex in the copies. The copies also feature a paler green and more brilliant ultramarine, and generally have stronger contrasts of shade. This is as evident in the Bamberg copy by Hans Hoffmann as it is in the Bayonne version or the one in the former Lanna Collection. These three differ from Dürer's study in the Albertina in the same details. They were, therefore, most probably taken from the same tracing, and may all be presumed to be the work of Hoffmann.

Drawn and engraved copies from this period — for instance, the copper engravings copied from Dürer's *Nemesis* or Jan Wierix's engraving after the master's *Sudarium of Saint Veronica* — convey the personalities of the artists and also display the same notable features of style: a tendency toward fluctuating light, forced chiaroscuro effects, overemphatic outlines, and a general attempt to outdo the original in density and fineness of line. These are essential features of Mannerist art, and they can

help us to make stylistic distinctions and ascribe dates to works.

NOTES

1 First by K.-Str., p. 186, no. 33; St. II, p. 610, no. 1502/10.

2 I am familiar with a study, from a photo in the Witt Library, London, that is attributed to Giovanni da Udine and that may belong to this group. It was auctioned at Christie's on November 20–21, 1958 (Skippe Collection, no. 103 [A], watercolor, paper [?]; 115 x 172 mm), as "attributed to Giovanni da Udine." The catalogue mentions an old ascription to Jacopo de' Barbari on the mount. It would be particularly interesting as an Italian view, but its whereabouts are unknown. The connection can only be of a general nature, however.

3 I am grateful to Dr. H. Schifter for the designation *Bekassine* (snipe). The bird was earlier described as a bittern (W. II, appendix plate XIV and p. 76) or else a jay (T. II/2, p. 133, no. A 394). The work: watercolor, brush on vellum; 114 x 130 mm; Dürer monogram and date (1515) by an unknown hand, top center, New York, Metropolitan Museum of Art, Inv. 19 184. From the Bale Collection (Exhibition Catalogue *Albrecht Dürer and Lucas van Leyden* [London, Burlington Fine Arts Club, 1869], p. 16, no. 137a) and the Norton Collection it reached the Metropolitan Museum in New York. It was first mentioned by Ephrussi (pp. 78, 79). The Tietzes (II/2, p. 133, no. A 394, and Hans Tietze, "Dürer in Amerika," in *AGNM* 1932/33, p. 89) are uncertain in their judgment, and after initially agreeing, go on to say that "it is probably only an imitation." Panofsky (II, p. 128, no. 1306) thinks it dubious, and if it is original would date it about 1502–03; Winkler (II, appendix plate XIV and p. 76) finds it interesting in that it shows the working method, since it is finished only as far as what seems to be the underpainting. He believes, as in the case of many other drawings, that the monogram and date are by Hans von Kulmbach; St. II, p. 1102, appendix 8.

4 W. III, p. 58, no. 614, mentions the copies known to him; the most comprehensive listing is to be found in St. II, p. 610, no. 1502/10, and supplement 2, appendix 2:7a, although it is inaccurate in many details. No. 6 should be excluded from Strauss's list; the work in question is not a wing study, but Hoffmann's copy of the *Dead Blue Roller* (Cat. 12).

5 From the Erasmus Engerth Collection, Vienna, formerly in the possession of H. v. Lanna, Prague (auctioned by Lepke, Berlin, May 19–21, 1911, no. 43, "attributed to Albrecht Dürer"; watercolor on vellum; 160 x 215 mm; collotype ill., plate 2, the basis of our illustration); then Oscar von zur Mühlen Collection (Amsler & Ruthardt, Berlin, June 5–7, 1912, under no. 278 "Hans Hoffmann," color ill., plate 1). Whereabouts unknown (not Prague, as stated in St. II, no. 1502/10, no. 5).

 H. Tietze (in *WJKG* VII/1930, p. 233) identified it wrongly with the wing in Bayonne; see also Th. II, p. 56, note 2; W. III, p. 58, under no. 614; St. II, supplement 2, appendix 2:7a, no. 5.

6 St. II, appendix 2:7, known to me only through a photograph, kindly lent me by W. Strauss. Pen, watercolor on vellum; 163 x 182 mm; from the collections of Max B. Goldstein, St.

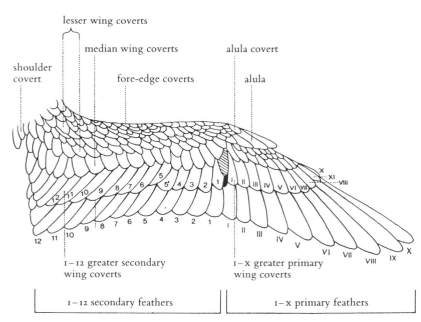

6 Diagram of a bird's wing

Labels in diagram:
lesser wing coverts
median wing coverts
alula covert
shoulder covert
fore-edge coverts
alula
1–12 greater secondary wing coverts
1–x greater primary wing coverts
1–12 secondary feathers
1–x primary feathers

5 Dead blue roller (*Coracias garrulus* L.), male, collected at Pöls near Wildon, Styria, April 26, 1883. Vienna, Naturhistorisches Museum.

Louis; Janos Scholz, New York; W. Hugelshofer, Zurich; present whereabouts unknown. It seems to be in bad condition and to have been drawn over; sixteenth century?

7 Mutual variant (?) after Dürer's model; *Right Wing of a Blue Roller,* watercolor on paper, mounted on pear or olive wood (?), restored, gone over with oil color and varnish; 186 x 158 mm; partly trimmed on the left; before restoration (1971) many of the details in the illustration were disappearing. The colors are in accordance with those in the Vienna study, while formally it is somewhere between the Berlin and Vienna *Wings.* As far as can still be judged, it was a fine sixteenth-century work, which in details of execution was close to Hans Hoffmann's copies. See Killermann, 1910, pp. 3–6 and 65–67; Winkler, in *JPK* 50/1929, pp. 128 ff., note 5 (with reference to older literature, since it is already mentioned in 1602 in the collections of Philip II); W. I, appendix, plate XXIII; P. II, p. 128, no. 1304; passed over by Strauss.

8 The study of the top side of a spread-out wing (ill. 7) was made known to me just after the Dürer exhibition. As far as I know, it is unpublished; its inclusion here in the English edition of the catalogue marks its first appearance in the literature and in the context of the wing studies.

In form, it is similar to the Woodner *Wing* (Cat. 25). It is monogrammed, dated 1524 (the black color slightly smeared), painted in watercolor and body color on thin, white vellum (195 x 262 mm), and can be described to a certain extent as the mirror-image variant of the Woodner *Wing.* It is in general well preserved; only in the upper edge of the wing,

in the ultramarine, does the surface look washed out.

The way the light accents and the contours of the feathers are applied, in body white with a fine brush, and joined with delicately waved seam lines is similar to Hoffmann's technique. Overall, however, the depiction of the feathers is not as calligraphic as it is in Hoffmann's work. In the color scheme, next to the subdued ultramarine, the colors brown, body white (in rising gradations), rose pink (applied with a quill pen), greenish blue, and especially black predominate. Herein the picture also differs from the colorful opulence of many of Hoffmann's studies.

According to the technical and stylistic characteristics, one can count this study among

the works of the Dürer Renaissance period. To attempt to connect it with Hans Hoffmann himself would be going too far, because of the above-mentioned differences. Still, until Hoffmann's stylistic development, especially in his earlier works, is completely explored, this possibility should not be wholly ruled out.

The study, which has hitherto escaped the attention of writers on Dürer, was, according to information from the former owner, auctioned in Amsterdam in the 1950s as "attributed to Hans Hoffmann." We may conclude from what remains of the French notes printed on a label on the reverse of the drawing that it was probably sold many years before that in a French (or Belgian) auction, and, according to still-readable measurements, was at that time slightly larger (202 × 270 mm).

9 Rosenthal, in *JPK* 49/1928, p. 49.
10 Rosenthal, p. 52.
11 See the picture of a dead roller (specimen from the Vienna Naturhistorisches Museum), ill. 5, and the schematic representation of a bird's wing, ill. 6. The bird, now found with any frequency only in southern Europe to central Asia, was common in central Europe in Dürer's time. (It is still occasionally found breeding in southeastern Austria.)

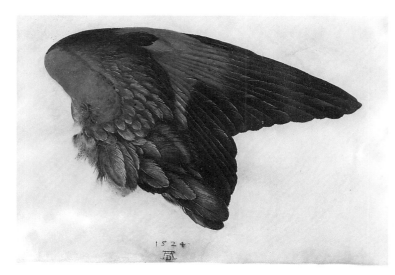

7 German, c. 1600, *Right Wing of a Blue Roller,* watercolor and body color on vellum. Private collection (see note 8).

18

ALBRECHT DÜRER

Study for Nemesis

Pen and gray-brown ink on paper
Dürer monogram by a foreign hand, bottom
center
257 x 208 mm
London, The British Museum, Department of
Prints and Drawings,
Inv. Sloane 5218–114

PROVENANCE: Sloane.

BIBLIOGRAPHY: E., pp. 33, 34, note 3 • Hausmann, 1861, p. 110, no. 96 • Th. I, p. 235, note 2 • Sylvester Rosa Koehler, *A Chronological Catalogue of the Engravings, Drypoints and Etchings of Albert Dürer as Exhibited at the Grolier Club, New York 1897*, p. 35, under no. 33 • Fl. I, p. 222 • H. Tietze and E. Tietze-Conrat, in *JKS* N.F. 6/1932, pp. 119 ff. • Tietze and Tietze-Conrat, "Dürer's First Drawings for the *Nemesis*," in *TBM* 62/1933, p. 245 • W. I, p. 186, no. 266 • T. II/1, pp. 16, 17, no. 195a • P. I, pp. 81, 82. P. II, p. 95, no. 926 • H. Tietze, 1951, p. 59, no. 20 • Hans Kauffmann, "Dürer's *Nemesis*," in *Tymbos für Wilhelm Ahlmann* (Berlin, 1951), p. 139 • Musper, 1952, p. 114 • Rupprich II, pp. 37, 38, no. 6 • Exhibition Catalogue London 1971, p. 15, no. 76 • St. II, p. 640, no. 1502/25.

This study, from The British Museum, was for a long time mistakenly believed to be a copy,[1] but now it is generally considered to be a laterally inverted preparatory sketch[2] for the figure of Nemesis in Dürer's engraving of the same name (B. 77; Cat. 18a). A nearly invisible grid drawn with a stylus was used, according to the Tietzes, in the construction of the figure. The proportions of the form are in keeping with Vitruvius's canon: the head is one-eighth the length of the whole body, which is seven times the length of the foot.[3] This would be the result of Dürer's theoretical ponderings on the ideal proportions of the human form, and is the earliest documented example of a constructed figure for one of his engravings. The corrections on the arms, legs, and head, as well as the retouching of the buttocks, stomach, and upper thigh, emphasize the conscientious control of the proportions under construction for final inclusion in the engraving.

In the engraving itself, the nude figure, a "goddess who dispenses fate, holds both the reins and the goblet: the reins for the arrogant, the goblet for the victor in life";[4] she floats over a mountainous landscape, which has been identified as Klausen in South Tyrol.[5]

Heller designated the copper engraving *The Large Fortune* as opposed to the engraving *The Small Fortune* (B. 78). Dürer himself called it *Nemesis*.[6] Giehlow[7] identified the source of the composition as Angelo Poliziano's poem *Silva in Bucolicon Virgilii pronuntiata, cui titulus Manto*, to which Dürer may have been introduced by his friend, the humanist Willibald

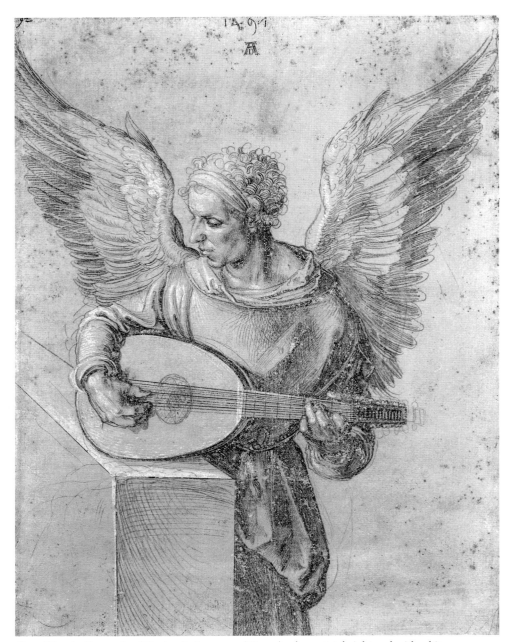

18.1 Albrecht Dürer, *Angel Playing the Lute,* 1497 (W. 144), silverpoint, heightened with white. Berlin, Staatliche Museen Preußischer Kulturbesitz, Kupferstichkabinett.

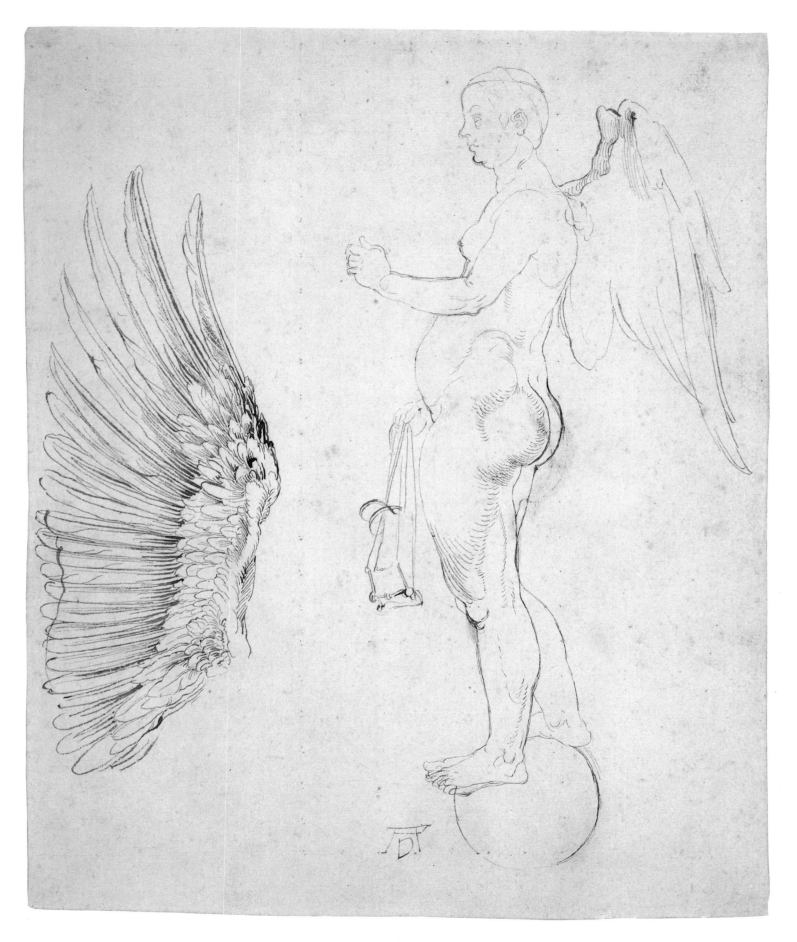

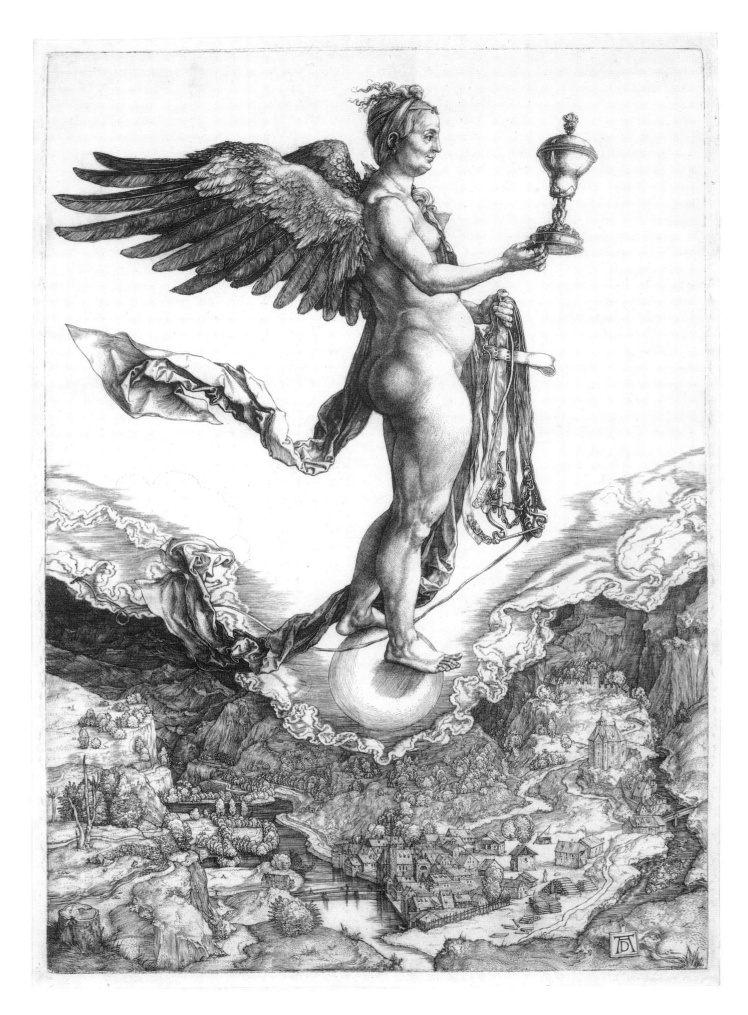

18 a

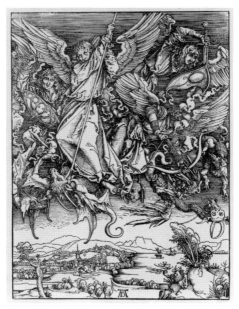

18.2 Albrecht Dürer, *Apocalypse: Saint Michael Fighting the Dragon,* woodcut (B. 72, M. 174).

18a

ALBRECHT DÜRER

Nemesis (The Large Fortune)

Copper engraving
Monogram, bottom right
Plate size 325 x 232 mm
Vienna, Graphische Sammlung Albertina,
Inv. 1930/1528

BIBLIOGRAPHY: Sandrart, 1675, p. 65 • B. 77 •
H. II, pp. 468–470, no. 71 (839) • Adolf
Rosenberg, "Dürerstudien," in *ZBK* 9/1874,
pp. 254–256 • Th. I, pp. 235 ff. • Koehler, 1897,
pp. 33–36, no. 33 • Berthold Haendcke, "Die
Chronologie der Landschaften Albrecht
Dürers," in *Studien zur deutschen Kunstgeschichte*
19/1899, pp. 12 ff. • Karl Giehlow, "Poliziano
und Dürer," in *MGVK* 2/1902, pp. 25, 26 •
Ludwig Justi, *Konstruierte Figuren und Köpfe unter
den Werken Albrecht Dürers* (Leipzig, 1902),
pp. 32 ff. • Killermann, 1910, p. 62 • Jaro
Springer, *Albrecht Dürer, Kuperstiche* (Munich,
1914), pp. 12, 13 • Max J. Friedländer, *Albrecht
Dürer, der Kupferstecher und Holzschnittzeichner*
(Berlin, 1919), pp. 49, 146 • Wölfflin, 1926,
pp. 132–136 • T. I, p. 59, no. 196 • Meder, 72 •
Fl. I, p. 222 • Waetzoldt, 1935, pp. 99–101 • P. I,
pp. 81, 82 • P. II, p. 27, no. 184 • Kauffmann,
1951, pp. 135–159 • Musper, 1952, pp. 82 ff. •
Erwin Panofsky, *"Virgo & Victrix:* A Note on
Dürer's *Nemesis,"* in *Prints,* ed. by Carl
Zigrosser (London, 1962), pp. 13–38 • Exhibition
Catalogue Nuremberg 1971, pp. 245, 246,
no. 481 • Exhibition Catalogue London 1971,
p. 15, no. 77 • Anzelewsky, 1980, p. 100.

Pirckheimer.[8] According to Thausing, the work may have originated as a commemoration of Pirckheimer's participation in Maximilian I's unsuccessful campaign against the Swiss in 1499. Thausing's historical interpretation was complemented by one based on artistic theory from Hans Kauffmann, in which the *Nemesis* is the artist's self-confession since it exemplifies Dürer's demand for balance, ideal proportions, and *die Maß* ("measure") in art as indispensable prerequisites of beauty. Consequently, this goddess of moderation symbolizes objective order in art, and "understood in this way *Nemesis* is the earliest of the conceptual images that were to find their culmination ten years later in the three master engravings."

Panofsky[9] interprets *Nemesis* as *"Virgo et Victrix";* in its interpretation he uses both Poliziano's *Manto* and Pomponius Laetus's *De Nemesi Dea,* and indicates that the formal predecessor is the goddess of victory on Roman coins of the Augustan era.

While Dürer copied the human form unaltered in transferring it to the engraving, other details were considerably changed. The most important change was in the wings: in the study they are folded down, but the mighty figure in the engraving has huge, outspread pinions. Killermann describes them as eagle's wings, but in fact their form seems to have been the product of Dürer's imagination, and it is not possible to identify them as belonging to a particular type of bird. Their role is to emphasize that the figure is floating in the air, and they provide a sense of movement in an otherwise static composition. This results in some major changes in the conception of the work: the figure is displaced from the main axis of the image, to the extent that its shadowed rear half becomes the optical middle of the picture; the drapes floating behind the goddess echo the dynamic force of the wings and suggest movement. The hand with the reins is set higher and thus adds emphasis to Nemesis's disciplinary

powers, while the drape hanging from the left shoulder and brushing against the left outer thigh provides a contour for the figure in a logical, but brilliantly effective, fashion. The parts of the body that are in shadow contrast strongly with the white of the sky, while the forms in full light are backed and outlined by the robe, providing an artistically motivated and graphically consummate juxtaposition of dark and light. Dürer thus maximizes the three-dimensional effect while letting the form appear in its full glory. This is achieved not least by the change in the position of the wings. The engraving is generally dated around 1501–02,[10] and the sketch shortly before that, probably 1500.

The London study tells us that Dürer had originally planned smaller wings with the tips hanging downward. The extended wing on the left was added with quick strokes to the sketch, and executed in full only in the engraving; it seems to have resulted from a sudden inspiration, a new step in the process of creating a form that already seemed to have reached its final conception. Dürer is recalling the mighty wings of the angels in the *Apocalypse* or the *Angel Playing the Lute*[11] from 1497 (ill. 18.1). Likewise, parallels in the composition become visible: compared with *Saint Michael Fighting the Dragon* (ill. 18.2), which depicts a religious combat in heaven, the pagan goddess floating in the air seems a secular counterpart to the slightly earlier work. Results similar in formula but changed in content embody the transition from the Gothic to the Renaissance.

With the genesis of Dürer's *Nemesis* as background, the study *Lapwing's Wing* in Berlin (Cat. 20), which is close in form to the wings as originally conceived for the figure of *Nemesis,* gains a special significance. In relation to that study, Dürer's London sketch holds a key position: both forms of the wing in it are developed as alternative solutions to the same problem, and this helps us to understand the engraving better and to make a suitable assessment of the Berlin study.

NOTES

1 As early as Ephrussi, the work was considered to be a preparatory sketch. In subsequent literature, Lippmann included, it was passed over as a copy.
2 H. Tietze and E. Tietze-Conrat, 1932.
3 Justi, 1902, pp. 32 ff.; P. I, pp. 81, 82; Rupprich II, pp. 37, 38, no. 6.
4 Wölfflin, p. 132.
5 Proved by Haendcke, 1899.
6 In "Tagebuch der niederländischen Reise"; see Rupprich I, pp. 154, 160, 162.
7 Giehlow, 1902, p. 25. Poliziano's poem, which dates from 1482, was dedicated to Lorenzo de' Medici and was reprinted several times.
8 Th. I, pp. 235–244.
9 Panofsky, 1962.
10 Friedländer, 1919; Exhibition Catalogue London 1928 (Dodgson), p. 42, no. 366; T. I; only Koehler and Springer date it 1504.
11 As already observed by Anzelewsky (Exhibition Catalogue Berlin 1984, p. 25, no. 21); this would mean that the vertical positioning in the *Nemesis* was not due just to a lack of space.

19

GERMAN, SIXTEENTH CENTURY

Study of a Bird's Wing

Pen and bister on paper, brush, with watercolor
wash in gray-brown and yellow ocher,
heightened with white (on the quills of the
feathers), black wash around it
130 x 203 – 205 mm

London, The British Museum, Department of
Prints and Drawings, Inv. Sloane 5218/72

PROVENANCE: Sloane.

BIBLIOGRAPHY: Hausmann, 1861, p. 109, no. 67
• E., p. 79 • St. II, p. 608, no. 1502/9.

This study, from an album in the Sloane Col-
lection,[1] was already known to Hausmann and
Ephrussi, who considered it to be a sketch for
the engraving (dated 1503) *Coat of Arms of
Death* (B. 101). It was not until Strauss that it
was next mentioned, but he missed the refer-
ences in earlier literature and believed that the
study had not yet been discussed. He consid-
ered that the brushwork and line work distin-
guished it as an original Dürer, whereas the
black background was possibly a later addition.
Moreover, he saw it as a preparation for the
Nemesis engraving (Cat. 18a). He also stresses
that Dürer's London preparatory sketch (Cat.
18) for this engraving shows a similar wing,[2]
which is, however, oriented the same way as in
the engraving itself, not inverted as in the
study under discussion here, an observation
that would seem to support his hypothesis.

Yet, although the quick sketch of a wing to
be found on the preparatory drawing for *Neme-
sis* corresponds to the engraving in several re-
spects, this study has nothing in common with
it, apart from the fact the wing is outstretched.
If one also compares it with the *Nemesis* en-
graving or with Dürer's *Wing of a Blue Roller*
(Cat. 22), it becomes clear that stylistically the
line is much less certain, more than a little hesi-
tant. On the basis of stylistic comparison it be-
comes impossible to support the attribution to
Dürer.

The artist who drew this sketch was work-
ing from a badly damaged wing that is missing
several primary feathers, and the initial way in
which it differs from the wing in the engrav-
ing of *Nemesis* is that it does not seem to have
belonged to the same species of bird! This
study, drawn by a somewhat unskilled hand, is
really of more interest as a piece of scientific
documentation than as a work of art, and while
the formal parallels to *Nemesis* cannot be de-
nied, it is hard to support Strauss's suggestion
of a connection between the two works. One is
tempted to assume that the similarity probably
owes more to chance than to anything else.

NOTES

1 Sir Hans Sloane (1660 – 1753) was a physicist and
an antiquarian; his collection formed the basis of
The British Museum, and this study is still to be
found in an album from the collection bearing
his name, which is the source of numerous
Dürer drawings, including many of the
zoological studies belonging to The British
Museum. According to its inscription, the album
was put together in 1637 in the Netherlands.

2 St. II; see also p. 640, no. 1502/25.

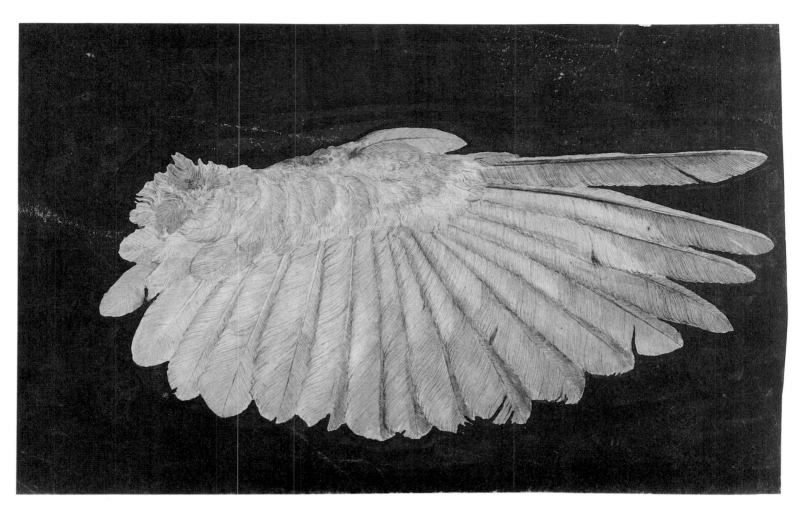

19

20

ALBRECHT DÜRER (?)

Lapwing's Wing

Brush and pen and ink on vellum, green and gray watercolor, heightened with white and gold Monogram (authentic?), top right, the date *1500* (authentic?), top center
175 x 122 mm

Berlin, Staatliche Museen Preußischer Kulturbesitz, Kupferstichkabinett, Inv. KdZ 1274

PROVENANCE: Crozat (?) • Mariette (L. 1852).

BIBLIOGRAPHY: Auction Catalogue Mariette/ Basan 1775, p. 138, under no. 896 (?) • E., p. 79, note 1 • Hausmann, 1861, pp. 115, 116 • Th. I, p. 303 • Killermann, 1910, pp. 61, 62 • Bock, 1921, I, p. 36, no. 1274 • W. I, appendix plate XXIII, top left, and pp. 166, 167 • P. II, p. 130, no. 1333 • Musper, 1952, p. 129, note 16 • Exhibition Catalogue Berlin 1984, p. 132, no. 129.

This has been considered a representation of a magpie's wing,[1] but recent investigation has shown it to be a view of the underside of the left wing of a lapwing (*Vanellus vanellus* L.).[2]

The vellum carries Dürer's monogram and the date 1500,[3] but the authenticity of both the inscription and the study itself has been questioned. It is very rarely mentioned in the literature: Ephrussi speaks about it in a footnote, and only Thausing describes this work, "carefully executed, in part with gold," as evidence for Jacopo de' Barbari's influence on Dürer's work from the years around 1500. All Bock has to say is that "it is highly unlikely that the work is by Dürer." Winkler asked whether it could possibly be based on a work by Dürer, and Panofsky also considered that it could be a copy of a lost study by Dürer. Anzelewsky stressed the finesse of the work, but nevertheless placed it among the copies after Dürer.

The state of preservation of the study is uncertain, as is the degree to which it was finished. It appears to be complete in the gray and green areas, but it is difficult to decide whether the white paint has been retouched, or whether the work was ever brought to its final state at all. A preliminary pencil sketch is partially and faintly visible, and in places, such as the tips of the wings and the shoulders, there are the remains of feathers outlined with broken pen strokes, like the ones presumed to be the outlines of a tracing in the *Pupilla Augusta* (W. 153). That it is a completed study would seem to be evident from the gold highlights, in the green (bottom), for instance.

A closer examination reveals unnoticed and instructive links with other pictures, from obvious ones such as Dürer's Albertina *Wing* (Cat. 22) and the *Nemesis* engraving (Cat. 18a) to the London preparatory sketch (Cat. 18) for the latter work, which make clear Dürer's search for the definitive form. In the sketch, the goddess of fortune, who in the final form of the engraving appears with wings out-

stretched, is seen with similar wings folded downward. There would seem to be an immediate association — not simply that both sets of wings presumably belong to the same kind of bird and have a similar outline, but also that the penultimate wing feather dominates the total shape in an analogous fashion. All of them, in fact, including Nemesis's wings as finally depicted, formally derive from the woodcuts of the *Apocalypse,* as witness the similarly powerful wings of the angel there (compare B. 66, 71, 75).

The date, 1500, should also be taken into account: according to analysis of the artist's style, it was at this time that the preparatory works for the *Nemesis* engraving were in the process of conception. As the style of the writing, date, and the specific form of the monogram are very like others to be found in engravings from the years before and shortly after 1500 (compare B. 71, 73), this Berlin study would thus suggest a knowledge of Dürer's work and of the thought behind the creation of *Nemesis* that could hardly be expected of an outsider or mere imitator. These signs support the assumption that the work is at least a reliable copy, if not a Dürer original.

Our assessment of this Berlin study may be helped by examining its relationship with the Albertina *Wing of a Blue Roller* and with copies of that work. The copies tend to be rather summary representations in comparison to the original, since they are not able to re-create the artistic inspiration; still, the Berlin and Vienna studies maintain some of the organic integrity and artistic logic that — above even the most perfect graphic accuracy — distinguish an original work of art from a copy. A mode of portrayal sharpened by personal analysis and brought to convincing clarity by a deepened understanding is noticeably different from the merely superficial, formal understanding displayed by imitations of existing works.

The detailed portrayal of the gray primary feathers and their coverts is achieved with sure, concise, and expressive strokes that capture the form and contours of the feathers, as well as the wear and tear to which they have been subjected. The depiction of the small green feathers of the mantle plumage is no less remarkable in its mastery. It becomes obvious how the precise reproduction of every feather, of each detail, contributes to turn a study of nature into a work of art.

Because of its high quality the Berlin study is superior to Hoffmann's copies. A number of facts indicate that there is much in it that speaks for Dürer himself. Care should, however, be exercised, since we know of no similar studies by Dürer's assistants, such as Hans von Kulmbach or Hans Baldung Grien, and therefore have nothing on which to base a comparison. We can hope, however, that direct comparisons may be made at the exhibition and thus aid our understanding of the questions raised.

Although Dürer finally preferred outspread wings for *Nemesis,* he did not reject completely the smaller study of wings he had made origi-

nally. It is to be found more than ten years later in the engraving *The Sudarium of Saint Veronica, Displayed by Two Angels* (Cat. 21a). Hans Hoffmann (?) is credited with making copies of sections of the engraving, including the wings (Cat. 21). With that we are given a further piece for comparison which is similar to the Berlin *Wing* and helps us to make a judgment and to limit the problems surrounding the work.

NOTES

1 Th. I; Killermann, 1910; Bock, 1921; W. I.
2 My thanks to Dr. H. Schifter for examination and rectification.
3 The date is written with small zeroes set high up; the monogram has an *A* with a high transverse stroke and slim downward strokes with no serifs at the base, and the *D* is set within it. Both the form of this monogram and the style of the handwriting are to be found in drawings (W. 224, 225) and prints (B. 71, 73) from the years leading up to 1500 and those shortly after the turn of the century.

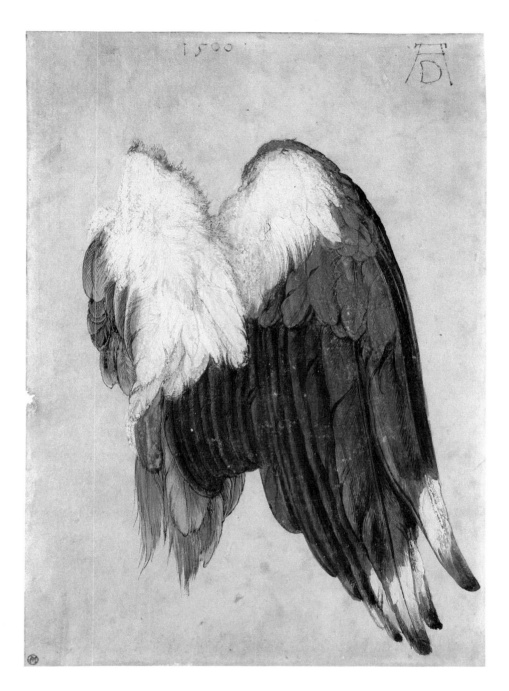

20

21

HANS HOFFMANN, ATTRIBUTED TO

Sheet of Sketches with a Bird's Wing and Other Studies

Pen and black ink on paper
135 x 117 mm
Bamberg, Staatsbibliothek, Inv. I.A.80
BIBLIOGRAPHY: Not described.

The *Sheet of Sketches with a Bird's Wing and Other Studies,* once belonging to Joseph Heller's own collection, has not previously been included in the literature. The graphic style is like Dürer's, and some of the motifs can be traced back to the master: the bird's wing is linked to the 1513 engraving, *The Sudarium of Saint Veronica, Displayed by Two Angels,* and as if to confirm this, the artist has added a detail below it of the billowing robe of the left-hand angel. The other motifs also seem to be borrowed. The hand, above left, is reminiscent of Dürer's study of a hand for the *Feast of the Rose Garlands* (W. 390); the detail of a robe, above right, is similar to the draped sleeves in, for instance, the etching *Christ on the Mount of Olives* (B. 19) and the woodcuts *The Annunciation to Joachim* (B. 78) and *The Circumcision* (B. 68). A precise identification might determine whether this is a copy of a lost sheet of sketches by Dürer, or whether it is a compilation from prints. If the latter is true, then it is informative

to see how relaxed the artist is in his reproduction of the engraving mentioned above. If one makes a direct comparison of the wing and the billowing robe, then it becomes clear that the distinctions between a copy and a free transcription are very fluid.

A copy may normally be judged only with certain reservations, since the copyist has taken it upon himself to get as close to the original as possible and will suppress features of his own personal style for the sake of fidelity. But also, the translation from one medium to another (here, engraving to pen drawing) is enough to create on its own a certain sense of alienation.

The attribution to Hoffmann arises from the analogy to similarly executed drawings found in Budapest.[1] They display similar use of the pen and a similar tendency to go beyond the model, adding shading with short strokes and dots. If the drawing is in fact by Hoffmann, it is of interest above all in relation to his copies after Dürer's *Wing of a Blue Roller* (Cat. 22). This page of sketches demonstrates improvisatorial alteration of the model, making spontaneous and pertinent modifications to Dürer's manner, and so would provide a useful commentary on the changes observed in Hoffmann's copies after Dürer's *Wing.*

NOTE

1 Approximately seventy-five pieces; they were bought from the Praun Collection in Nuremberg in 1797 by Prince Nikolaus Esterházy through the dealer Frauenholz; since 1870 they have been in Budapest at the Museum of Fine Arts (according to L. 1965, 1966). Compare particularly the pen drawings *Woman's Head* (Inv. 187) and *Moses* (Inv. 150).

21a

ALBRECHT DÜRER

The Sudarium of Saint Veronica, Displayed by Two Angels

Copper engraving, B. 25, M. 26
Monogrammed, dated *1513*
Plate size 100 x 138 mm

Vienna, Graphische Sammlung Albertina,
Inv. 1930/1476

21

22

ALBRECHT DÜRER

Wing of a Blue Roller

Watercolor and body color on vellum, brush,
pen, heightened with white
Slight flaking off of color on the wing feathers
Date *1512*, top center,
Dürer monogram, bottom center
(pen and ink, authentic)
197 x 201 mm
Vienna, Graphische Sammlung Albertina,
Inv. 4840 (D 104)

PROVENANCE: Imhoff • Emperor Rudolf II •
Imperial Treasure Chamber • Imperial Court
Library (1783) • Duke Albert of Saxe-Teschen
(L. 174).

BIBLIOGRAPHY: H. II, p. 82, no. 56 and p. 118,
no. 136 • E., pp. 79, 363 • Th. II, p. 56 •
Killermann, 1910, pp. 69, 70 • L. V, p. 18,
no. 527 • Springer, in *RKW* 29/1906, p. 555 •
Meder, in *RKW* 30/1907, pp. 180, 181 •
Albertina Catalogue IV, p. 18, no. 104 • Fl. II,
p. 372 • T. II/2, p. 140, no. A 420 • W. III,
pp. 57, 58, no. 614 • P. II, p. 131, no. 1353 • Mus-
per, 1952, p. 129 • Killermann, 1953,
p. 23 • Winkler, 1957, pp. 250, 251 • K.-Str.,
p. 186, no. 33 • Hofmann, 1971, pp. 3–6 • St. II,
p. 610, no. 1502/10 • Anzelewsky, p. 165,
no. 151 • Strieder, 1981, pp. 198, 199, no. 234 •
Auction Catalogue, Christie's, *Important Old
Master Drawings,* London, July 6, 1982, pp. 61,
62, under no. 107 • Piel, 1983, p. 143, no. 60.

This study shows the upper side of the out-
stretched left wing of a young blue roller (*Cor-
acias garrulus* L.). Its coloration is heightened
for artistic, rather than purely naturalistic,
ends. The scarlet areas at the primary joint in
the upper left section of the wing, where some
feathers have been torn out, and the similarly
colored areas at the shoulder joint and in the
lower section of the shoulder plumage, would
seem to indicate blood spilled when the wing
was plucked from the body of the bird.[1]

Like many other important Dürer works in
the Albertina, this study can be traced back to
Willibald Imhoff the Elder. "A wing on vel-
lum" was first mentioned in 1588 in an inven-
tory of Dürer works from the Imhoff Collec-
tion that were shown to Emperor Rudolf.[2]
Since these works were shortly afterward to be
found in the imperial collections, it is surpris-
ing to see included in the Imhoff *Geheimbüch-
lein* (1633) another wing by Dürer.[3] Is this an
analogous work? A 1637 reference, however,
speaks of a copy of a wing by Hans Hoffmann.[4]

In the relevant literature it is only the
Tietzes and, following them, Panofsky[5] who
do not attribute the work to Dürer. Its popular-
ity at the time of the Dürer Renaissance led the
Tietzes to look for a model by Dürer, perhaps
the head of a cherub such as he depicted in the
studies for the paintings of 1506 and 1508.
They inferred that this model would have been

painted not in heavy body color but in light
watercolor, like the *Pope's Mantle* study (W.
401). Winkler[6] rejected the Tietzes' negative
judgment as quite unfounded, and sees the
brushwork, signature, and date as convinc-
ingly genuine. Be that as it may, the Tietzes'
rejection of the work, although generally con-
tradicted, gave rise to doubts as to the accuracy
of the dating. They question the authenticity
of the inscriptions and criticize the way the
date is separated from the monogram, the
former at the top of the parchment, the latter at
the bottom. But these objections are weakened
by the observation that the proportions of the
letters and figures are almost identical to those
found on *The Engraved Passion* (e.g., B. 16) of
1507–1512, which on certain pages also fea-
tures separation of the date and monogram; the
form of the monogram itself is directly compa-
rable to that on the *Adoration of the Trinity* (see
Cat. 10).

The numerous replicas and variants of this
wing complicate rather then clarify the situa-
tion.[7] Konrad Oberhuber has put forward the
hypothesis that is currently accepted: he postu-
lates that the Bayonne study (Cat. 23) is by
Dürer himself and dates from around 1500,
whereas the Vienna *Wing* is a replication from
1512 — also by Dürer himself.[8] This seems to
clear things up, and taking Oberhuber's lead,
Koschatzky and Strobl set out to date the Al-
bertina *Wing* somewhat earlier, using as their
support Dürer's well-known nature studies
from the years shortly after 1500, such as the
Hare (Cat. 43), *The Large Piece of Turf* (Cat. 61),
the *Madonna with a Multitude of Animals* (Cat.
35), and above all the *Nemesis* engraving (Cat.
18a) from 1501–02, which made use of a simi-
lar study of a wing. Strauss and Strieder also
took up these ideas, and for Piel, too, the con-
troversies over authenticity and dating seemed
to be settled by Oberhuber's suggestion. How-
ever, the similarity between the study and the
Nemesis engraving as seen by Koschatzky and
Strobl does not withstand closer examination.
Not only do the two display considerably dif-
ferent wing forms, but also they contradict the
very different genealogy of the *Nemesis* wing:
it can be traced from the engraving back via the
London preparatory sketch (Cat. 18) directly to
predecessors like the wings in the *Angel Playing
the Lute* in Berlin (ill. 18.1) or of *Saint Michael*
in the *Apocalypse* (ill. 18.2). Even Oberhuber's
theory, when used to support the earlier dat-
ing, which sees the Bayonne *Wing* as a forerun-
ner of the Albertina study from around 1500, is
not really credible, since, as the circumstances
suggest, that study was a copy made by Hans
Hoffmann at some time around 1580 (see
Cat. 23).

If we are to understand the Albertina study
better, it is worth comparing it with its most
important copies (see Cat. 23, 24), from which
it differs just because of such basic respects as
the proportions and the positioning of certain
wing feathers. While its primary feathers
point straight down, forming a slightly con-
cave outline, Hoffmann's versions represent

this part of the wing as pulled farther to the
left, with the lower edge more jagged and con-
vex in shape. A particular difference in these
copies is one central wing feather that projects
out farther than the others.[9] The Vienna work
is very different from the later versions because
of this, and the composition is tighter, the re-
production of detail more certain and better
articulated. The total effect has a powerful ten-
sion, which is evidently lacking in the imita-
tions.

Thausing has commented tersely on the
technique and style: "The mastery of the exe-
cution defies any description." To rid the
parchment of any unevenness that could ob-
struct the brush, it was smoothed (with an
agate, perhaps) in the area of the drawing. The
technique, somewhere between drawing and
panel painting, displays exceptionally delicate
and finely disciplined brushwork. Its refined
coloration complements the clarity, precision,
and skillful shaping of fine detail in the line
work, which may be compared with the chis-
eling of Dürer's master engravings, such as
Saint Jerome in His Cell (B. 60) and *Melencolia*
(B. 74). A comparison between *Nemesis* and
Melencolia shows how much closer Dürer's
Wing of a Blue Roller is to the latter. Taking all
this into account, it becomes clear that the
monogram, date, and style of the Albertina
study are not only undoubtedly authentic, but
in fact characteristic of Dürer's work around
1512.

This study has the consummate accomplish-
ment of a finished painting, and in it Dürer
blends artistic values and scientific accuracy to
create a depiction of nature that for a long time
set a standard.

NOTES

1 First mentioned by K.-Str. and described as a
 "bleeding bullet wound."
2 H. II, p. 82, no. 56; see also p. 118, no. 136.
3 Rosenthal, in *JPK* 49/1928, p. 49, no. 17.
4 Rosenthal, p. 52, fol. 76v.
5 Albertina Catalogue IV, T. II/2, P. II.
6 W. III, p. 59, under no. 615.
7 W. III, p. 58, no. 614, mentions four replicas;
 compare p. 70 and also St. II.
8 Quoted in K.-Str.
9 Equally characteristic is the different coloration
 of the secondary feathers, which in the Vienna
 version are gradated in blue and blue-black,
 while the Bamberg and Bayonne versions are
 alike in having one half of the feather blue, the
 other reddish brown.

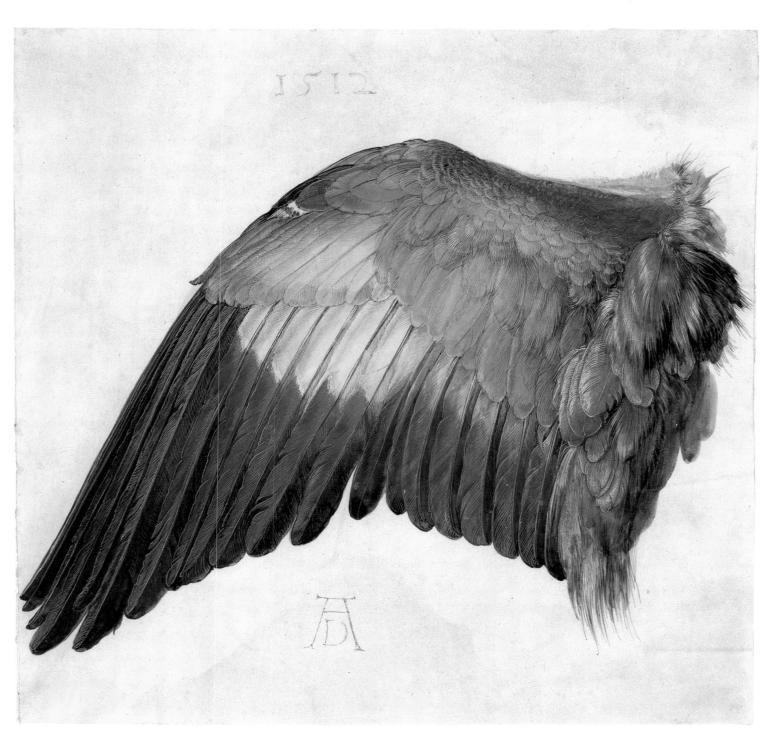

23

HANS HOFFMANN

Wing of a Blue Roller

Watercolor and body color, brush, heightened
with white, on vellum that has been smoothed
and pasted on paper
Dürer monogram by Hans Hoffmann, bottom
center, pen and brown ink, faded; above it a
correction (deleted date?)
190 x 209 mm

Bayonne, Musée Bonnat, Inv. NI 1293, AI 1522

PROVENANCE: Bonnat (L. 1714).

BIBLIOGRAPHY: H. Tietze, in *WJKG* 7/1930,
p. 233 • W. III, p. 58, under no. 614 • T. II/2,
p. 140, under no. A 420 • K.-Str., p. 186, under
no. 33 • St. II, appendix 2, p. 1100, no. 6 •
Auction Catalogue, Christie's, *Important Old
Master Drawings,* London, July 6, 1982, pp. 61,
62, no. 107 • St. Supplement 2, p. 6, appendix
2:7a, no. 3 • Exhibition Catalogue *Master Draw-
ings from the Woodner Collection,* The J. Paul
Getty Museum/Kimbell Art Museum/The Na-
tional Gallery 1983/84, p. 108, under no. 42.

Alongside Dürer's *Wing of a Blue Roller* in the
Albertina (Cat. 22), this study of a wing from
the Musée Bonnat in Bayonne is at present the
most widely discussed of all the replicas of the
piece. In fact, in the scientific discussion of
recent years it has been ascribed a key position
in relation to the assessment and dating of the
Vienna study. Our attempt to determine its
exact relation to Dürer's Vienna drawing is,
therefore, essential in the search to clarify the
question of whether the Vienna and Bayonne
studies are original Dürers, and all the others
later copies, as is currently assumed. Discussion
of this problem through direct comparison of
both drawings was made possible in the con-
text of this exhibition for the first time.[1]

It has so far been impossible to trace the ori-
gins of this study back beyond the Bonnat Col-
lection, and it is first documented with an
entry in Léon Bonnat's notebook, on page
7v: *"Albert Dürer, Aile de Geai/aquarelle
1882.2.025."*[2]

In the 1924–1926 publication of the draw-
ings in the Bonnat Collection,[3] this work has
not been included. As far as I can see, Hans
Tietze[4] was the first to mention it, although he
mistakes it for the *Wing,* formerly in the Lanna
Collection, that was first put under the ham-
mer at the Lepke auction in Berlin, 1911 (no.
43; see ill. 2, p. 71). Not only Winkler but also
the Tietzes[5] list it among the copies of the
Vienna *Wing.*

Today the predominant view is that the
Bayonne *Wing* is one of the "artistically supe-
rior variants," and that it "could be the original
from c. 1500, while the example at the Alber-
tina is perhaps a replication made by the artist
in 1512." These suppositions come from
Konrad Oberhuber and are quoted in the cata-
logue of the 1971 Albertina Dürer exhibition.[6]

This thesis has had an essential influence on all
later scientific considerations of Dürer's stud-
ies of wings. In subsequent literature, the
Bayonne study is included by everyone except
Strauss. When the *Wing of a Blue Roller* from
the Woodner Collection (Cat. 25) first became
known in 1982, the crucial arguments were
settled according to Oberhuber's thesis.

In discussion of the Bayonne *Wing* there has
always been an emphasis on the material on
which it is executed. It has been mistakenly
assumed that it is on paper. This is important
with respect to an unsupported assumption
that has been made with reference to all
Dürer's studies of plants and animals. Accord-
ing to this assumption, the use of paper sug-
gests an earlier date, up to the earliest years of
the sixteenth century, whereas vellum was
thought to suggest a later one. Nearly every
time it is discussed, errors are made with refer-
ence to the materials, size, monogram, and
date,[7] so I shall list the specifications here. The
study is on vellum, not paper; measures 190
mm x 209 mm; and bears a Dürer monogram,
bottom center, but no date. The monogram is
wider than the one on the Albertina study and
corresponds with the one on the Bamberg ver-
sion (Cat. 24). Its proportions and mode of
drawing are similar to those of the Woodner
Wing (Cat. 25) and the study *Four Feathers*
(ill. 25.1).

Until now, features of style have been ig-
nored in discussion. The study was made on a
watercolor base and applied in body color with
a very fine brush; the graphic work is bril-
liantly terse in the brown feathers on the right
and in the whole lower half of the wing, par-
ticularly the blue and black primary feathers.
The yellowish green large primary coverts
above them give the impression of being
shapeless and indistinct by comparison. The
coloration differs from the study in the Alber-
tina most conspicuously in the reddish brown
secondary feathers, where it resembles the
Bamberg wing. In its delineation it tries to be
finer than the original. Compare as a prime
instance the gentle overlapping of the small
feathers on the front edge of the wing. The
extreme gradations of color and the strong
contrast of light and dark produce considerable
optical tension. The turbulent linear structure,
the exaggerated curvature, and the rich
graphic detail create the effect of a well-worn
coat of feathers, and these effects are in keeping
with the extremely complex play of light and
the refined line work, the whole creating the
impression that this study was conceived as an
artistic "improvement" upon Dürer's original.

Notable differences are also evident in the
primary feathers; in comparison with the
Vienna study, the feathers form a more pointed
tip to the wing, while one of the inner wing
feathers projects clearly beyond the rest. The
secondary feathers are also more strongly
curved to the right. The Bayonne *Wing* thus
has a greater breadth than the Vienna study,
but also less tension. These distinctions also
apply to the Bamberg version and, as far as can

be told from a reproduction, to the one for-
merly in the Lanna Collection, Prague.

The studies of roller's wings from Bayonne,
Bamberg, and the Woodner Collection (Cat.
23, 24, 25), as well as those of dead rollers from
a private collection in Paris and from Cleve-
land and Berlin (ills. 11.2, 11.1, Cat. 11), are all
similar not only in their graphic style, but also
in their brilliant ultramarine and their dull pale
green. It would thus be illogical to single out
the Bayonne *Wing.* The common details men-
tioned above are, in fact, as we continue our
study of the works of late sixteenth-century
imitators of Dürer and know more about them,
criteria by which we more and more clearly
recognize the characteristic features of Hans
Hoffmann's work.

In the light of the demonstrable similarity to
other studies by Hans Hoffmann, we can only
reject Oberhuber's theory and recognize this
study of a wing from the Musée Bonnat as a
work by this Dürer copyist.

NOTES

1 That this direct comparison has been made
possible is thanks to the generous cooperation
of the French minister of culture, Jack Lang.
2 My thanks to E. Starcky, who, on my request,
researched Léon Bonnat's notes at the Louvre
(letter of Feb. 21, 1983).
3 *Les Dessins de la Collection Léon Bonnat au Musée
de Bayonne,* 3 vols., 1924–1926.
4 H. Tietze, 1930.
5 T. II/2, with the same erroneous information as
in *WJKG* 7/1930, p. 233.
6 K.-Str.
7 Confusing and partially erroneous information
particularly in St. II, appendix 2, p. 1100, no. 6:
"vellum" (but incorrect measurements);
"paper," however, in St. supplement 2, p. 6,
appendix 2:7a, no. 3.

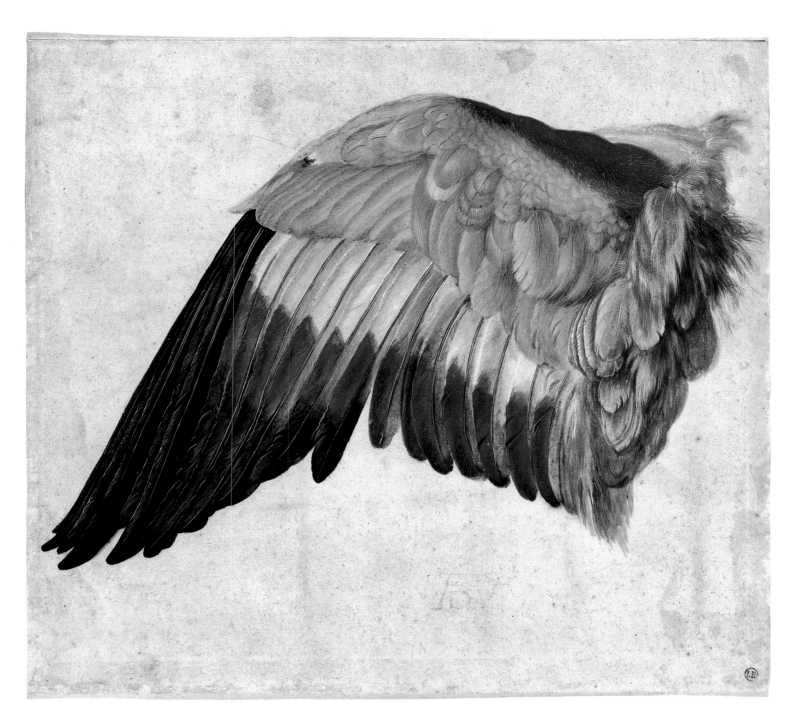

23

24

HANS HOFFMANN

Wing of a Blue Roller

Watercolor and body color on vellum,
brush, pen, heightened with white
Dürer monogram, bottom center, and the
date *1513,* top right,
both by Hans Hoffmann, pen and brown ink
190 x 213 mm

Bamberg, Staatsbibliothek, Inv. I.A.13ʰ (I.R.60)

PROVENANCE: Heller.

BIBLIOGRAPHY: H. II, p. 33, no. 78, p. 82, under
no. 56, and p. 118, under no. 136 • Hausmann,
1861, p. 117 • E., p. 79, note 2 • Th. II, p. 56,
note 2 • L. V, p. 18, under no. 527 • Albertina
Catalogue IV, p. 18, under no. 104 • T. II/2,
p. 140, under no. A 420 • W. III, p. 58, under
no. 614 • K.-Str., p. 186, under no. 33 • St. II,
p. 610, under no. 1502/10, no. 6 • St. supple-
ment 2, p. 6, appendix 2:7a, no. 2.

The Bamberg *Wing* comes from the Heller
Collection and was first documented there.[1]
Heller was convinced that he was in possession
of a Dürer, and believed this work to be the
"wing on vellum"[2] described in the Imhoff
Inventory. Yet he made the following remarks
on the Dürer drawings in the Albertina and the
example found there (Cat. 22) in relation to his
own drawing: "We likewise have this wing in
our possession, but ours has too much original-
ity and beauty to be passed off as another work.
A closer comparison could distinguish which is
a copy by Hans Hoffmann: because he alone
would have been able to achieve something
like this."[3]

Since Ephrussi, and even in the most recent
literature, the Bamberg *Wing* has been taken as
a copy, and this without any proof or more
accurate attribution. Only Thausing associates
it with Hans Hoffmann. Strauss[4] mistakenly
notes that the work is signed by Hoffmann.

The Bamberg *Wing* differs from the Alber-
tina version in its softer and rounder forms.
The front edge of the wing is more wavy; the
outline of the primary feathers runs to a
sharper point on the left, and on the lower tip is
curved slightly outward. Distinct from the
Vienna *Wing,* the coloration of the secondary
feathers is not blue-black but blue and reddish
brown (as in the Bayonne) and these feathers
are more sickle-shaped, curving to the right.
The detailing on the feathers does not have the
translucent clarity and effortless precision of
the short strokes that are features of the Alber-
tina study, where the front edge of the wing is
covered by soft feathers overlapping each
other evenly. In this study, by contrast, the
artist simply applies individual and disjointed
white highlights, which break Dürer's gentle
unity into an uneven play of light. These are
characteristics of style also to be found in the
plumage of the Berlin *Dead Blue Roller*
(Cat. 11).

These differences from the Vienna *Wing,* in
details of both form and color, are in keeping
with those to be found in the Bayonne version
(Cat. 23), which is superior only in terms of
some of the detailing. Since both are the same
size, we may assume that they were produced
by the same artist from the same tracing.

The monogram and date differ from Dürer's
model, too. A notable feature is the form of the
numeral *1,* which has a triangular "roof" on
top, above whose tip a lozenge-shaped dot is
often placed, while the shaft of the numeral
often curves to the left, ending in a point. The
numeral *5* has even stranger characteristics: the
main body of the numeral is bulbous in Dürer's
hand, while here it is reduced to a shallow *S*
shape, whose top stroke, instead of being hori-
zontal as is usual in Dürer, dips down and up in
a semicircle. In contrast to Dürer's relatively
slim, freehand monogram, this one is more
broadly proportioned, with thin single strokes
that seem to have been made with the help of a
ruler; only in the left shaft of the *A* is there a
tapering double stroke. The double lines of the
D are carefully drawn parallels.

These deviations from Dürer's monogram
are found in several other studies of wings and
works of a different nature — the *Wings* from
Bayonne and the Woodner Collection (Cat.
23, 25), and equally clearly defined in the study
Four Feathers, known only from a photograph
(ill. 25.1),[5] in the *Two Squirrels* dated 1512 (Cat.
28), in the Berlin *Hare* of 1528 (Cat. 52), and in
the copies after Dürer's *Lion* and *Lioness* (ills.
59.1, 60.1). The characteristic forms, as de-
scribed, of the *1* and *5,* as well as the virtually
circular form of the *2,* may be seen in all of
Hoffmann's dates and monograms, for in-
stance on his initialed *Peony* from Bamberg
(Cat. 76).

As the appearance of the monogram is
closely linked with drawings that show char-
acteristics significant of Hans Hoffmann, it
seems logical to ascribe works having it to him,
even if, as in the case of the Bamberg *Wing,*
they bear Dürer's monogram.

NOTES

1 H. II, p. 33, no. 78.
2 H. II, p. 82, no. 56.
3 H. II, p. 118, no. 136.
4 St. supplement 2. This remark should not go
 uncorrected. The work is not signed by
 Hoffmann, but carries Dürer's monogram (in
 Hoffmann's hand), and it is by no means certain
 that the wing "by Hans Hoffmann's hand,"
 which, according to the Imhoff *Geheimbüchlein,*
 was offered to Regensburg in 1636 and sold to
 Matthäus Overbeck in Amsterdam in 1637
 (Rosenthal, in *JPK* 49/1928, p. 52, fol. 76v), is
 identical with Heller's.
5 Imhoff *Geheimbüchlein,* Rosenthal, p. 49, under
 no. 19; St. II, p. 604, no. 1502/7a, *Three Feathers;*
 St. supplement 2, p. 10, no. 1502/7a; attributed
 to Burgkmair by Oehler, in *Städel-Jahrbuch* N.F.
 3/1971, p. 83.

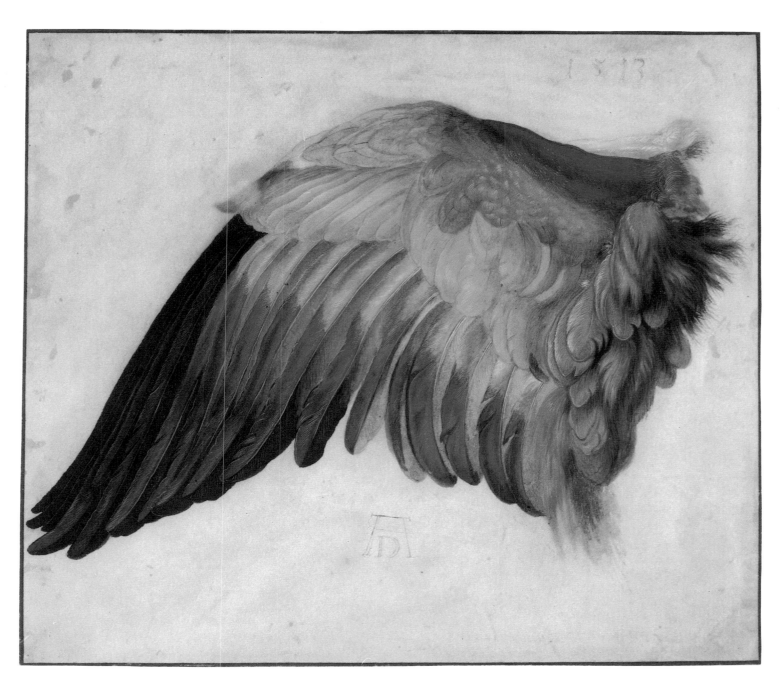

24

25

HANS HOFFMANN

Wing of a Blue Roller

Watercolor and body color on vellum, brush heightened with white, traces of preliminary drawing (still faintly visible on the second feather from the left)
Slight crease, top right
Dürer monogram and the date *1524* by Hans Hoffmann, in pen and black ink over traces of preliminary drawing, bottom right
189 x 238 mm

New York, Ian Woodner Family Collection

PROVENANCE: Esdaile (L. 2617) • Morrison • Lord Margadale of Islay.

BIBLIOGRAPHY: Auction Catalogue, Christie's, London, June 20, 1840, no. 511 • Exhibition Catalogue *Albrecht Dürer and Lucas van Leyden* (London, Burlington Fine Arts Club, 1869), no. 131 • Th. II, p. 56, note 2 • W. III, p. 58, under no. 614 • Auction Catalogue, Christie's, London, July 6, 1982, pp. 61, 62, no. 107 (color plate p. 60) • St. supplement 2, p. 6, appendix 2:7a • Exhibition Catalogue *Master Drawings from the Woodner Collection* (The J. Paul Getty Museum/ Kimbell Art Museum/ The National Gallery 1983/84), p. 108, no. 42 • Lynn R. Matteson, "Old Master Drawings from the Woodner Collection," in *Pantheon* 41/1983, p. 387 • Konrad Oberhuber, "Sur quelques dessins germaniques," in *Connaissance des arts* 376/1983, pp. 76, 77 • Exhibition Catalogues *Die Sammlung Ian Woodner:* Vienna, Graphische Sammlung Albertina, 1986, no. 50; Munich, 1986, no. 50; Madrid, 1986–1987, no. 59; London, 1987, no. 49.

The subject of this study, the outstretched left wing of a blue roller (*Coracias garrulus* L.), in conjunction with Dürer's monogram and the date 1524, link it with Dürer's Albertina *Wing* dated 1512 (Cat. 22). The two studies differ, however, not only in the date and in the positioning of the wing, but also in the model used: while the Albertina study is based on the wing of a young bird with wing feathers as yet undamaged, the Woodner study shows that of an older bird, with worn tips to the somewhat ragged primary feathers.

Although this study follows from Dürer's 1512 *Wing,* it cannot be counted as one of the copies of that earlier work[1]— which no doubt provided the stimulus — but it varies the model in a very personal manner. The more recent work has its own originality and is equally exceptional in terms of the graphic technique and the colors, being so precisely observed as to surpass Dürer's in certain aspects of its naturalism.

In the bottom right corner of the vellum is the handwritten monogram of William Esdaile (L. 2617), in whose collection it was to be found along with the study *Dead Blue Roller, Seen from the Back* (Cat. 14). Both were put up for auction in 1840 as "A parroquet and a wing

of the same,"[2] and were exhibited in 1869 at the Burlington Fine Arts Club as Dürer's work.[3] They then were mentioned by Thausing in his account of the Morrison Collection, where he listed them as copies by Hans Hoffmann, and finally were noted by Winkler as simply ascribed to Dürer. After the *Wing* could be compared with the original at the Albertina, it was auctioned in 1982 as "attributed to Albrecht Dürer."[4] Analogous to Oberhuber's and Koschatzky and Strobl's thesis on the relationship[5] between the Bayonne *Wing* (Cat. 23), the supposed original from around 1500, and the Vienna version, the artist's own replication from 1512, it was postulated shortly afterward that this wing on vellum could be a replica of a lost original on paper. According to Oberhuber,[6] the Woodner example is more

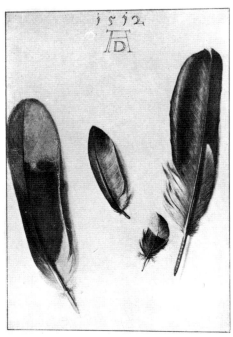

25.1 Hans Hoffmann, *Four Feathers,* probably watercolor and body color. Whereabouts unknown (see Cat. 24, note 5).

rationally organized than the Albertina one. He explains the differences in style in terms of Dürer's development toward his mature style and believes that the economy of line, the individuality of the wash technique, and the delicacy of coloration suggest either Dürer himself or a very capable assistant. Strauss questions the monogram and date as well as the authenticity of the work itself. George Goldner[7] suggests that one should not be too quick to reject the monogram and date as later additions, since there are traces of something earlier beneath, and the form of the monogram, with the numerals on either side of the initials, is, as Oberhuber has observed, also to be found on the 1511 woodcut *The Trinity* (B. 122). The study, according to Oberhuber, does not bear any relation to Hoffmann's watercolors after Dürer, especially as these are normally signed.

In order to make some sort of judgment, it is necessary to make a closer examination of Hoffmann's studies. As numerous exhibits tell

us, we know not only monogrammed works by him but also unsigned ones, and others in which he quite openly imitates Dürer's monogram. A perusal of several of his copies of Dürer allows us to compare style and monograms, both his own and the ones in Dürer's style that he added. Doing so confirms the belief that characteristic Hoffmann features are to be found in the broadly proportioned monogram drawn with pen, ink, and ruler, and in the idiosyncratic formation of the numerals on the Woodner study, which is also to be seen, incidentally, in a study, *Four Feathers*[8] (ill. 25.1), that survives only in the form of a photograph. Note the form of the *2,* which seems to be composed of an open circle and a delicate horizontal stroke, and is also to be found in Hoffmann's monogrammed *Peony* from Bamberg (Cat. 76).

The position is similar as regards style and color. What was thought of as economy of means in keeping with Dürer's late style is also to be found in the *Dead Blue Roller, Seen from the Back,* which went with the study of the wing to the Esdaile and Morrison collections. According to Thausing, a similar bird was to be found in the Artaria Collection in Vienna, although there it bore Hoffmann's monogram (see p. 62, note 3). The stylistic features of the *Dead Blue Roller, Seen from the Back* may be linked both to Hoffmann's copies of the roller and, as far as we can tell from the photograph, to the *Four Feathers* study.

The specifics of the coloring also speak for Hans Hoffmann: the brilliant ultramarine and reddish brown of the secondary feathers distinguish it from Dürer's Vienna study, but link the Woodner *Wing* to the copies in Bamberg (Cat. 24) and Bayonne (Cat. 23).

The pronounced characteristics of monogram and coloration, along with the basically irrational, rather mechanical parallel lines of the feathers, indicate that this study must be added to those by Hans Hoffmann. The brilliant colors make the Woodner *Wing* one of Hoffmann's best Dürer paraphrases.[9]

NOTES

1 See p. 70.
2 Christie's, 1840.
3 Exhibition Catalogue London 1869. In the catalogue the study of a wing is mistakenly dated 1518.
4 Christie's, 1982.
5 K.-Str., p. 186, under no. 33.
6 Quoted in Exhibition Catalogue 1983/84.
7 Exhibition Catalogue 1983/84.
8 This work has been lost since 1945, and is now known only in the form of a photograph; it may be identical with no. 19 in the Imhoff *Geheimbüchlein* (Rosenthal, in *JPK* 49/1928, p. 49, fol. 71r): *Ein Papagey und drey andere federn, auf pergament vom A. Dürer Rth. 50.* — ("A parrot and three [sic] other feathers, on vellum by A. Dürer Rth. 50. —").
9 The symposium held in Vienna June 7–10, 1985, in connection with the Dürer exhibition and catalogue made possible discussion of the problems of the various wing illustrations with Konrad Oberhuber. Confrontation of the originals and detailed comparison of the *Wings*

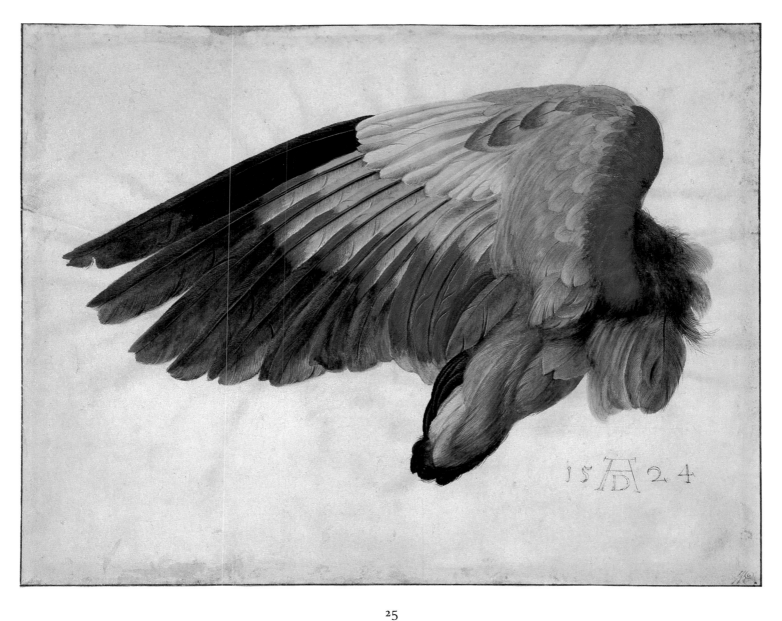

25

from Bayonne, Bamberg, Vienna, and the Woodner Collection brought Oberhuber to the conclusion that, in contrast to his prior opinion, the Woodner *Wing* was the work of Hans Hoffmann.

Meanwhile, in exhibitions of the Ian Woodner Collection, the study was being shown in Vienna, Munich, Madrid, and London labeled "Albrecht Dürer?" without the findings of our 1985 exhibition being taken into account. Instead of including new and definitive

arguments, the opinions represented in the catalogue of the Woodner exhibition overlooked those arguments and returned to the former Dürer ascription. In the face of such a difficult problem, one is hardly able to argue with the conclusion that ". . . the unique quality and outstanding beauty of the [Woodner] drawing is the surest basis for proving authorship, which would not be questioned were it anyone other than Dürer" (Exhibition Catalogue Vienna 1986, p. 123).

NOTE

1 Max J. Friedländer, "Die Madonna mit der Wickenblüte," in *ZBK* 44/1909, p. 278.

26

THEODOR JOSEF ETHOFER

Wing of a Blue Roller

Watercolor and body color on paper, brush,
heightened with white, preliminary drawing in
pencil and light pen, India ink, mounted on paper
Dürer monogram by Ethofer, in red, very
faded, bottom center
184 x 209 mm

Nuremberg, Stadtgeschichtliche Museen
(Property of the Albrecht Dürer-Haus-Stiftung)
Inv. Gr. A. 2896

PROVENANCE: Politzer, Vienna.

BIBLIOGRAPHY: Heinrich Höhn, *Das Albrecht
Dürer-Haus. Seine Geschichte und seine Sammlungen* [guidebook] (Nuremberg, 1911), p. 16 •
W. III, p. 58, under no. 614 • St. supplement 2,
p. 6, appendix 2:7a, no. 4.

This is a comparatively recent (c. 1900) copy
of the original *Wing of a Blue Roller* by Dürer
dated 1512 (Cat. 22), and no doubt Ethofer did it
out of purely academic interest, certainly not
with the intention of making a forgery. When
comparing it with the original and Hoffmann's copies, we have the opportunity of
studying the artistic hallmarks of copies from
various periods, and thus can extend our comparisons productively.

It becomes evident how every copy is
marked by the personality of the artist in question and by the artistic taste of his period, no
matter how great the influence of the original
or the effort on the part of the copyist to subordinate his own style. Side-by-side comparison
of various examples sharpens our eye for the
quality, technique, and artistic characteristics
of the original, and also increases our sensitivity to the fine distinctions between it and the
copies — which may in a sense have the same
criteria applied to them as are applicable to forgeries. Friedländer once said in such a context
that a hundred-year-old forgery is an absurdity, since every generation sees with a new
visual sense and thus views the original differently: "The history of style dictates this rule: A
forger can only dupe his contemporaries."[1]

In spite of apparent fidelity to detail, Ethofer's copy displays one inadmissible alteration: in ignorance of the natural form, and
perhaps yielding to a decorative sensibility, he
increases the number of primary feathers. The
relatively coarse detailing of his version emphasizes the delicacy of Hoffmann's brushwork in comparison with the Dürer original. It
makes clear to us those qualities whereby
Hoffmann's work, in the eyes of his contemporaries, was able even to surpass the original,
and tells us how appreciated craftsmanship and
virtuosity were as qualities and characteristics
of Mannerist art.

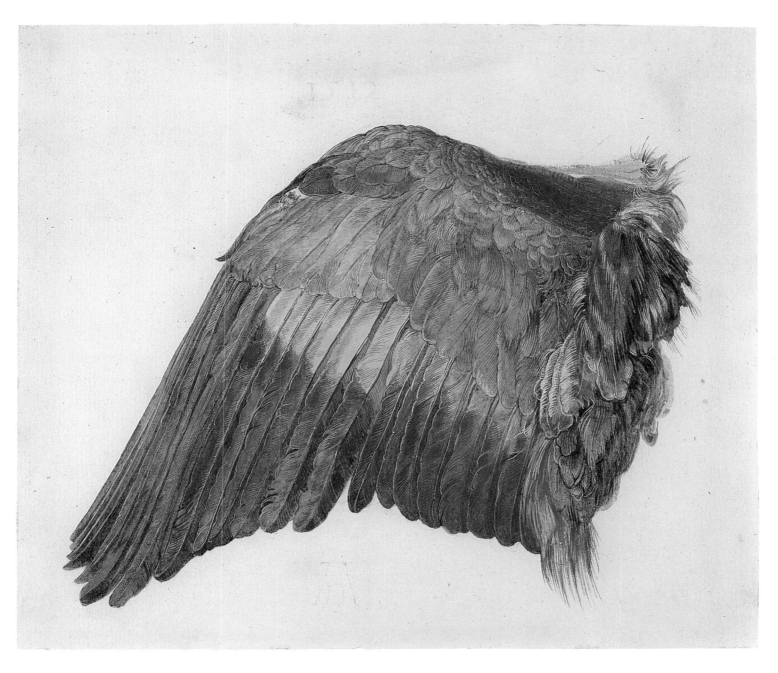

26

HANS HOFFMANN

A Squirrel

Watercolor and body color on vellum, brush,
heightened with white
Monogram and the date *1578*, bottom left
251 × 177 mm

New York, Ian Woodner Family Collection

PROVENANCE: M. A. Parker • A. Clark •
G. Rau • A. Neuhaus.

BIBLIOGRAPHY: Campbell Dodgson, "Hans
Hoffmann — A Squirrel," in *OMD* XV/1929
(December), pp. 50, 51 • Auction Catalogue,
Sotheby's, April 24, 1929, lot 287 • Winkler, in
JPK 53/1932, p. 86 • Edmund Schilling,
Altdeutsche Meisterzeichnungen, vol. 1 (Frankfurt,
1934), p. XVIII, no. 56 • Waetzoldt, 1935,
p. 279 • T. II/1, p. 144, no. W 24a • W. III, ap-
pendix, under plate XII top • P. II, p. 131,
no. 1356 • Musper, 1952, pp. 126, 127 • Pilz, in
MVGN 51/1962, pp. 254, 255, no. 10 • St. II,
p. 1098, appendix 2, no. 3 • Auction Catalogues,
Christie's, London, March 30, 1976, lot 147,
and Christie's, *Important Old Master Drawings*,
London, April 7 and 9, 1981, p. 52, no. 147 •
Exhibition Catalogues *Die Sammlung Ian
Woodner:* Vienna, Graphische Sammlung Alber-
tina, 1986, no. 56; Munich, 1986, no. 56;
Madrid, 1986–1987, no. 68; London, 1987,
no. 58.

The monogram and date on this picture of a
squirrel (*Sciurus vulgaris* L.) nibbling at a hazel-
nut identify it as by Hans Hoffmann, but its
popularity rivals that of works by Dürer. In
1929 the study was published by Dodgson as a
copy after a lost original by Dürer, and he also
referred to its link with the *Two Squirrels* (Cat.
28), which had already been familiar for some
time. He believed that the latter picture was a
complete reproduction of Dürer's original,
while the monogrammed work by Hoffmann
simply portrayed the more attractive of the
two creatures.

At first, Winkler[1] was in agreement with
Dodgson's thesis, but after studying the *Two
Squirrels,* he was led to doubt this conclusion
"in consequence of execution of detail which
is displeasingly untypical of Dürer,"[2] and later
thought it possible that it was a wholly original
work by an artist colleague of Hoffmann's.
The Tietzes, however, thought that Hoff-
mann's copy was based directly on an idea by
Dürer dating from about 1502, and thus in-
cluded it as one of the "workshop pieces." In
contrast to Dodgson and Winkler, they take
the view that Hoffmann's drawing, with its
one squirrel, was a more accurate reflection of
the lost Dürer work than the one showing two
animals. They see the addition of a second
squirrel and of nuts and nutshells lying around
as pictorial elaborations by a later imitator.
Panofsky follows the Tietzes, while Pilz com-
ments on the opinions of Dodgson and of
Winkler (1932). Musper considers the study of

the two squirrels to be Dürer's original, and
Hoffmann's emulation to be considerably infe-
rior, while Dodgson prefers Hoffmann's copy.

There are no grounds for believing that the
work came from the Paul Praun Collection in
Nuremberg.[3]

Dodgson's thesis, echoed by the Tietzes,
that the work is linked to a lost Dürer, is based
essentially on a comparison with Dürer's *Hare*
(Cat. 43),[4] to which it is related by the three-
quarter view, the white background, and the
refined portrayal of the fur, as well as by the
similar positioning and form of the monogram
and date.

There is no squirrel to be found in Dürer's
extant work that might enable us to make a
comparison. However, the animal is to be
found quite often, and notably in a similar
pose, in works by Lukas Cranach the Elder.[5] In
itself this means little. Waetzoldt already re-
ferred to a comparable squirrel in Lorenzo
Ghiberti's frame for the second door of the
Baptistry in Florence. It would seem that the
theme was widespread. Squirrels were popular
as amusing house pets in the sixteenth century,
and are often seen in this role in the works, for
instance, of Hans Holbein the Younger.[6] We
also meet the squirrel as a symbol of diligence,[7]
while Lorenzo Lotto[8] contrasts it with the in-
separable unity of marriage, making it into a
symbol of infidelity, since it is said that the
creature leaves its mate in times of need.

The extremely finely nuanced brushwork
makes this one of Hoffmann's best achieve-
ments, and the economy of the portrayal of the
fur is especially admirable. The artist is partic-
ularly astute in his observation of the varying
disposition of the hairs at the paws, nose, and
on the body, and in the differentiation of the
fluffy thighs, the tail, and the long, fine tufts
on the ear. Hoffmann revels in a technical bril-
liance that is even more refined than that of
Dürer's *Hare,* even to the extent of typically
Mannerist overemphasis. The depiction of the
fur is comparable to that of his copies of Dürer
lions. Particular parallels to the lion studies of
the previous year, 1577 (Cat. 59, 60), and the
Hare (Cat. 52) may be drawn from the several
rows of dark hairs on the back paws and the
delicate stippling on the nose.

The date placed beneath the monogram is
characteristic of Hoffmann's work from the
years in question; the same arrangement is to
be found in the imitation Dürer monograms
and dates of some of his lion studies (ills. 59.1,
60.1).

NOTES

1 Winkler, 1932.
2 W. III.
3 Auction Catalogue, Christie's, 1981.
4 T. II/1.
5 Lukas Cranach the Elder, *Cardinal Albrecht of
Brandenburg as Saint Jerome,* Sarasota, Florida,
The Ringling Museum of Art, Inv. 308; *Jerome
Repentant,* c. 1525, Innsbruck, Tiroler Landesmu-
seum Ferdinandeum, Inv. 116.
6 Hans Holbein the Younger, *Portrait of a Lady
with Squirrel and Magpie,* c. 1528, Houghton
Hall, Norfolk, Marquess of Cholmondeley, ill.

in Paul Ganz, *Hans Holbein. Die Gemälde* (Basel,
1950), p. 216, no. 43, color plate 75 with detail
of the squirrel.
7 *Reallexikon zur deutschen Kunstgeschichte,* IV
(Stuttgart, 1958), pp. 922–926; see Heinrich Al-
degrever's engraving, B. 123.
8 Lorenzo Lotto, *Double Portrait,* c. 1523,
Leningrad, Hermitage Museum, Inv. 1447, ill. in
Exhibition Catalogue *The Genius of Venice,
1500–1600* (London, Royal Academy of Arts),
pp. 176, 177, no. 44.

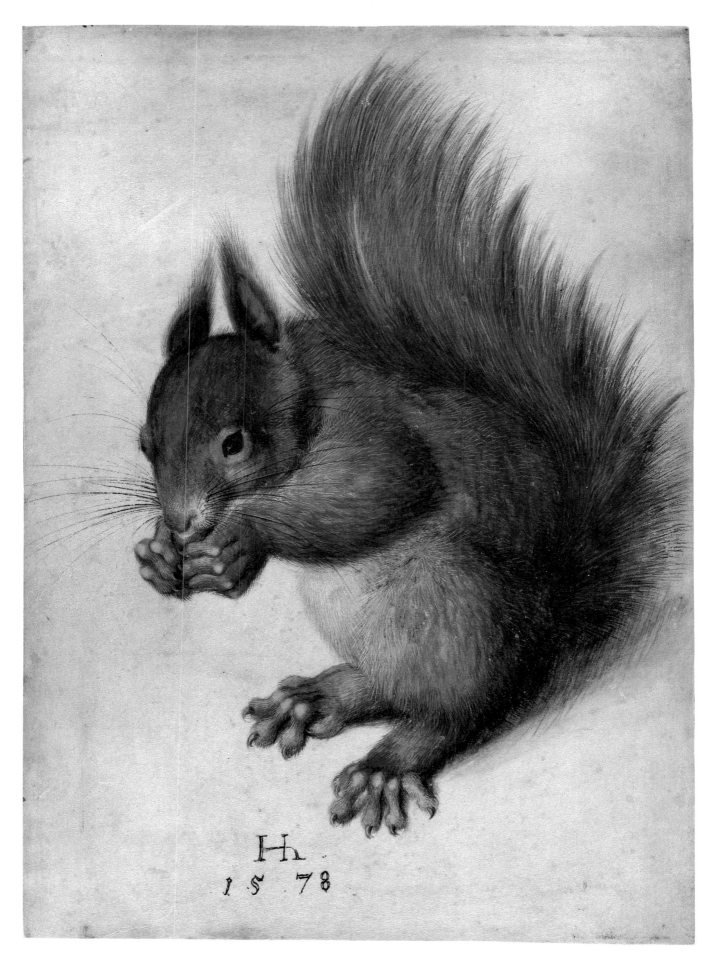

28

HANS HOFFMANN

Two Squirrels

Watercolor and body color on vellum, brush,
heightened with white, over rough (chalk?)
preliminary sketch
Torn and backed, bottom right
Dürer monogram and the date *1512* by
Hoffmann, top center
260 x 251 mm
Private collection

PROVENANCE: Bammeville • Northbrook •
Rosenthal • Randall.

BIBLIOGRAPHY: *A Descriptive Catalogue of the
Collection of Pictures Belonging to the Earl of
Northbrook* (London, 1889), p. 17, no. 18 •
Campbell Dodgson, "Hans Hoffmann —
A Squirrel," in *OMD* XV/1929 (December),
pp. 50, 51 • Winkler, in *JPK* 53/1932, p. 86 •
W. III, appendix plate XII top • T. II/1, p. 144,
under no. W 24a • P. II, p. 131, no. 1357 •
Musper, 1952, pp. 126, 127 • Killermann, 1953,
p. 21 • Exhibition Catalogue *Five Centuries of
Drawings* (Montreal, Museum of Fine Arts,
1953), no. 89 • Pilz, in *MVGN* 51/1962, pp. 254,
255, under no. 10 • St. II, p. 606, no. 1502/8 •
Exhibition Catalogue *Die Sammlung Ian
Woodner* (Vienna, Graphische Sammlung Alber-
tina, 1986), under no. 56.

The two different-colored squirrels in this
picture must be tame animals, since the one
with its back to us is clearly wearing a cherry
red collar, while the other has an unusually
large bulge of fur at the neck, which would
seem to suggest that it also is wearing one. One
is contentedly tranquil, while the other is still
busily nibbling; among the picturesquely
strewn nuts and nutshells the two animals
create an idyllic composition that exudes cozi-
ness. The drawing bears a Dürer monogram
that is untypical of the master, but "rounds
off" the composition; this is one of the most
familiar and best loved of all the nature studies
that have been associated with Dürer's name.

It is not possible to trace the provenance very
far back: in 1854 the work was acquired from
the Joly de Bammeville Collection for Lord
Northbrook. Although it was widely known
from a color reproduction, Dürer scholars took
no more notice of it until the discovery in 1929
of a repetition (Cat. 27) of the right-hand
squirrel, the one sitting sideways to the ob-
server, bearing Hans Hoffmann's monogram
and date, which caused Dodgson to introduce
it with reference to a common Dürer model for
both the pictures. Since the two pictures are
generally very similar, they are usually dis-
cussed together, and the same considerations
and arguments are to a large extent valid for
both of them.

Dodgson believed the *Two Squirrels* to be a
copy of a lost study by Dürer, which was par-
tially reproduced in the Hoffmann copy dated

1578. Winkler[1] too was initially convinced
that "the witty and amusing vivacity, the
power of the conception, and the extraordi-
nary delicacy of the technique must inevitably
be linked with the name of Dürer." The
Tietzes were of the opposite opinion, since
they considered Hoffmann's 1578 squirrel to
be closer to the Dürer original, believing there
was clear evidence of later additions in the
"genre-style arrangement and the supplemen-
tary work for pictorial effect." This idea is ba-
sically in keeping with Hoffmann's procedure
of surrounding Dürer's hare with natural ob-
jects. Winkler, having examined the picture in
detail, was no longer sure that this was indeed a
Dürer "in consequence of execution of detail
which is displeasingly untypical of Dürer."[2]
He did not rule out the possibility that it was "a
free invention by a colleague in the circle of
Hoffmann, depending upon the authentic
works by Dürer to be found at that time in the
Imhoff collection, Nuremberg." Only Musper
is categorical about the authenticity of the *Two
Squirrels*. The view has also been expressed that
the creature on the right is by Dürer, while the
one on the left was added by Hoffmann or one
of the master's contemporaries.[3] This idea,
which has no concrete basis, was revived by
Strauss. It seems to have come from a misread-
ing of the Tietzes' remark. In fact, the picture
is the work of one artist and was done at one
stroke.

The Dürer monogram, combined with the
date of 1512, was considered dubious by Dodg-
son. Winkler[4] noted that the signature was
identical with one on a copy of the *Dead Blue
Roller,* formerly in the Béhague Collection
(also 1512; ill. 11.2), that is unquestionably by
Hoffmann.[5] The fact that the signature on
Two Squirrels is Hoffmann's further supports a
comparison with the fully analogous inscrip-
tion on the Berlin *Hare* (Cat. 52). Assuming
that the squirrels are, after all, based on a Dürer
model, Winkler considers 1512 to be perfectly
possible and credible as a date, since it corre-
sponds to Dürer's "fine paintings" of that year.
This is not to forget that Hoffmann often
cheerfully used the date 1512 even on works
where it is demonstrably quite implausible. For
instance, his copies of Dürer's pair of lions (ills.
59.1, 60.1) bear this date, although Dürer him-
self first drew his lions after nature only in 1521,
during and after his trip to the Netherlands
(see Cat. 58). Two other copies of the lions
made by Hoffmann are known to us, but they
carry his own monogram and bear the date
1577, which would seem to be consistent with
the date of their execution (Cat. 59, 60). How-
ever, the Berlin *Hare,* whose monogram is sim-
ilar to that of *Two Squirrels,* and whose stylistic
character points clearly to Hoffmann, bears a
date in the same handwriting that suggests an-
other surprising date, 1528, the year of Dürer's
death. This indicates that the dates on Hoff-
mann's copies are simply not reliable enough
for significant conclusions to be drawn from
them.

Just as the characteristics of the monogram

suggest the Dürer copyist Hoffmann, so does
the style of the picture: the small, white dots
and short strokes, particularly on the head of
the right-hand squirrel, are in keeping not
only with the studies of squirrels, but also are
to be seen in the Berlin *Hare* (Cat. 52) and the
Palazzo Barberini version of the same animal
(Cat. 48). So this study of *Two Squirrels* with its
imitation Dürer monogram may be ascribed to
Hoffmann alongside *A Squirrel* authenticated
by the artist's own monogram and date.

Dodgson noted that the squirrel in the study
dated 1578 has its head turned more toward the
observer than the animal in this drawing,
which means that the right eye is visible and
the distance between the ears is more evident;
the positioning of the toes is also different, and
another notable distinction is to be observed in
the schematic and unnatural strokes of the tail
hairs. In zoological terms the squirrel in this
pictorially more elaborate study is drawn much
more organically and discriminatingly than in
the other. We do not know if this was the
result of direct observation from nature and
possibly an indication of its priority over the
study dated 1578.

None of the points discussed here helps us
determine the nature of the supposed proto-
type for the studies. There is no indication at
all that Dürer ever depicted a squirrel. Lukas
Cranach the Elder and other artists of the six-
teenth century, however, depicted squirrels on
numerous occasions, and the animal was a pop-
ular motif at this time. The question must still
remain open as to whether the two studies of
squirrels are based on a lost model by Dürer, or
whether Hoffmann, inspired by constant con-
tact with Dürer's work, came upon this happy
pictorial idea by himself.

NOTES
1 Winkler, 1932.
2 W. III.
3 Exhibition Catalogue Montreal 1953.
4 W. III.
5 W. III. Winkler was inconclusive about the link
 with Hoffmann, because he speaks of "an
 unknown, who also copied the hooded crow
 [!]." For the *Dead Blue Roller,* formerly in the
 Béhague Collection, see Cat. 11, note 2.

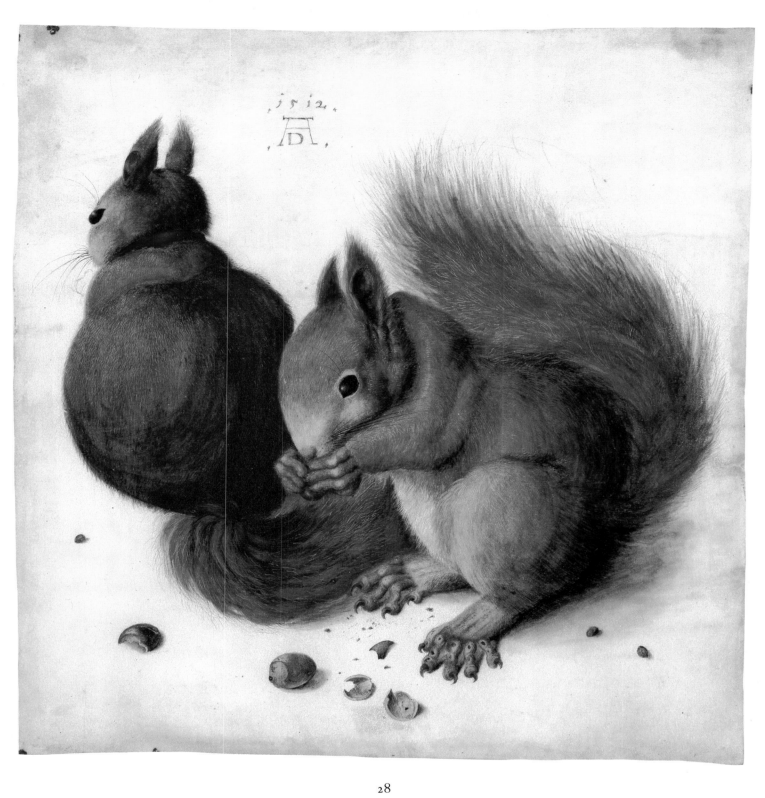

28

EIGHTEENTH-CENTURY IMITATOR OF
TOBIAS STIMMER

Squirrel

Watercolor on paper, heightened with white,
brush (isolated pinpricks)
Watermark: crowned shield with fleur-de-lis,
similar to Heawood 1824 ff. (see pp. 258, 259,
figs. 7, 7a, 7b)
Pasted on both sides are strips of paper
20–25 mm wide
Monogrammed and inscribed, bottom right:
℥ Fecit.
222 x 147 mm
Zurich, Kunsthaus Zürich, Vereinigung
Zürcher Kunstfreunde, Graphische Sammlung,
Inv. 1938/42

PROVENANCE: P. Ganz.

BIBLIOGRAPHY: Paul Ganz, "Tobias Stimmer,"
in *Pages d'Art* 12/1926, pp. 97, 98 • Exhibition
Catalogue *Tobias Stimmer* (Schaffhausen, 1926),
p. 10, no. 87 • Exhibition Catalogue *Kunstwerke
des XV.–XVIII. Jahrhunderts aus Baseler
Privatbesitz* (Kunstverein Basel, 1928), no. 50 •
Winkler, in *JPK* 53/1932, p. 86, note 3 •
Friedrich Thöne, *Tobias Stimmer, Handzeichnun-
gen* (Freiburg, 1936), pp. 66, 80, no. 21, ill. 45,
plate 15 • Exhibition Catalogue *Tobias Stimmer*
(Schaffhausen, 1939), p. 13, no. 61 • T. II/1, p.
144, under no. W 24a • W. III, appendix under
plate XII top • Max Bendel, *Tobias Stimmer,
Leben und Werk* (Zurich, 1940), p. 22, no. 22 •
Exhibition Catalogue *Swiss Drawings, Master-
pieces of Five Centuries* (Washington, Smith-
sonian Institution, 1967–68), p. 41, no. 47 •
Exhibition Catalogue *Tobias Stimmer,* drawings
compiled by Monica Stucky (Basel, Kunstmu-
seum, 1984), p. 324, no. 193.

On the basis of the old inscription, this pic-
ture of a squirrel nibbling a nut has been
ascribed to Tobias Stimmer, and has been com-
pared to similar pictures by Hans Hoffmann
(Cat. 27, 28), but since it differs from them in
many details it must be considered an indepen-
dent artistic conception.

Waetzoldt,[1] in connection with *A Squirrel*
(Cat. 27), referred to a similar squirrel in Lor-
enzo Ghiberti's bronze frame for the second
door of the Baptistry in Florence. The compar-
ison would be better suited to this drawing,
which is dated 1563, although one must not
forget that the motif of the squirrel was very
widespread in the sixteenth century, and that
the creature in profile was already often found
in medieval book illustration.[2]

The attribution to Stimmer goes back to
Paul Ganz. Winkler[3] considers the work as
further proof of a lost Dürer work, which
Stimmer would have copied even before Hoff-
mann. The Tietzes see the situation the other
way around and describe this Zurich study as
an imitation of Hoffmann's *Squirrel.* Thöne in-
cludes it in Stimmer's early œuvre, executed
about 1563, stylistically close to the Donaue-

schingen *Self-Portrait:*[4] "The light that forms
the body of the squirrel does not yet have the
degree of brightness of 1564." The authors of
the Exhibition Catalogue Basel 1984 indicate
the generally demonstrable change in artistic
attitude in relation to previous nature studies:
according to them the artists of the preceding
generation created "portraits" of the animals,
"while Stimmer and his contemporaries ex-
tend their interest in the light of, say, Gessner's
description of nature and the collecting zeal of
Platter." The monogram on the work was al-
ready recognized by Thöne as a later addition,
but the attribution was generally accepted.

It is relatively difficult to place the work in
Stimmer's œuvre. The parallel brush strokes
are notably different from his watercolor *Self-
Portrait,* which dates from the same period.
When considered in detail, there is hardly any-
thing comparable among Stimmer's drawings.
Abel Stimmer, the younger brother of Tobias
and also a painter, made the illustrations for
Felix Platter's *De Corporis Humani Structura et
usu* (published by Ambrosius Froben, Basel,
1581); in the frontispiece of *Liber tertius* there
appears, along with the portrait of Platter, a
similar squirrel (who is, however, inverted by
the printing process).

What has been hitherto overlooked is that
the paper on which the work under discussion
is drawn carries, in the top left-hand corner,
the fragment of a watermark. It is a crowned
shield with a fleur-de-lis (fig. 7b, p. 259),
which was common among paper manufac-
turers in England and Holland especially from
the end of the seventeenth century, but was not
produced in Switzerland until the latter part of
the eighteenth century.[5] As this type of water-
mark is not to be found at all in the sixteenth
century, not even in an approximation, that
means this work, until now attributed firmly
to Stimmer, must be rejected as part of his
œuvre, and considered an eighteenth-century
copy (?). This also means that it may no longer
be considered as one of the works that may
have suggested the existence and influence of a
model by Dürer.

NOTES

1 Waetzoldt, 1935, ill. 206.
2 See also Cat. 27.
3 Winkler, 1932, and W. III.
4 Tobias Stimmer, *Self-Portrait,* pen with brown
 ink, painted with watercolor, preliminary chalk
 sketch, inscribed: *Tobias Stimer von Schaffhaussen,*
 bottom left; 197 x 150 mm; Donaueschingen,
 Fürstenberg Collection, Inv. 197–150. Ill. in
 Exhibition Catalogue Basel 1984, ill. 92.
5 See Heawood, 1950, I: 1819, 1824, 1827–1831,
 1833, 1835, 1838, 1839, etc.; also Johann Lindt,
 *The Paper-Mills of Berne and Their Watermarks,
 1465–1859, Monumenta Chartae Papyraceae
 Historiam Illustrantia,* X (Hilversum, 1964), 464–
 471. Briquet, who records the watermarks from
 1282 to 1600, lists neither this form nor a similar
 one.

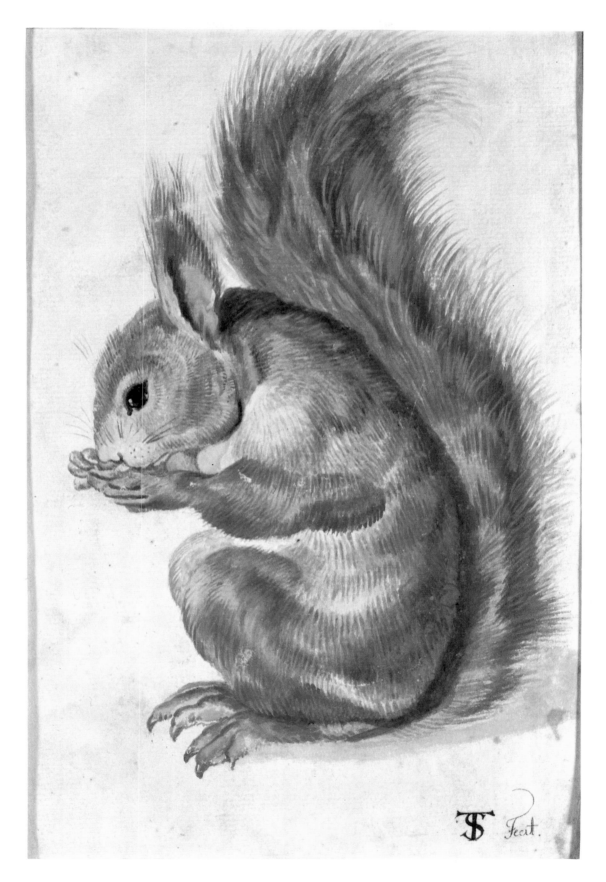

The Discovery of the Bird of Paradise and Its Depiction in the Sixteenth Century

At the beginning of the sixteenth century, explorers were leaving Europe and making a systematic geographical reconnaissance of the earth, in the process discovering flora and fauna from overseas that were previously unknown. Numerous unimagined species suddenly became known in Europe and were sometimes seen as wonders of nature. One of the most striking of these discoveries was the bird of paradise.

Its arrival in Europe may be precisely pinpointed. On September 6, 1522, the sailing ship *Victoria* anchored in Seville harbor; only eighteen of its crew were left, and it was the only ship to return out of the five that had left on September 20, 1519, under the command of Ferdinand Magellan to search out a western route to the Spice Islands (Philippines). The terrible hardships undergone and the sacrifices made had achieved more than just the first trip around the world. New lands had been discovered, and the *Victoria* was laden with a precious cargo of rare and new spices; it brought along as well the legless bodies of five small and colorful birds. No one knew that the natives had removed the bones and legs when preparing them. Captain Sebastian Delcano (de Elcano), the leader of the expedition after Magellan's death in the Philippines, had received these zoological rarities, with their silky and fabulously colored feathers, from a Moluccan ruler.[1] The islanders believed that the birds would bring victory in battle, making the possessor safe from wounds and invincible. On October 24, 1522, just a few weeks after the arrival of the ship, the privy scribe at the court of Charles V, Maximilianus Transylvanus, wrote to Bishop Lang von Wellenburg in Salzburg that he had acquired from the captain of the ship the boneless body of one of the birds for his master, "so that he may delight in its rarity and splendor."[2]

No one had seen one of these birds alive, and the Spanish naturalist Francisco Lopez de Gomara could find no legs or bones when examining the specimens. So he concluded: "We are of the opinion that these birds feed on the dew and nectar of the spice-bearing trees. But be that as it may, we may be sure that they never decay."[3] Even important scholars like Conrad Gessner[4] adopted this story and contributed to its dissemination, with the result

that, in the sixteenth century, the bird of paradise acquired the miraculous aura of a relic.

The voice of scientific criticism, wanting to put an end to the myth of the boneless, ethereal creature, was represented by men such as Antonio Pigafetta,[5] a crewman on the *Victoria,* and later Carolus Clusius,[6] but their objections were ignored. Linnaeus later gave the species the scientific designation *Paradisaea apoda,* footless bird of paradise. Only in 1824 did the French ship's apothecary, René Lesson,[7] succeed in discovering the first live bird of paradise in its habitat of New Guinea; his observations and description supplied an authentic report to replace the three-hundred-year-old tradition of fairy-tale conjecture.

Just as the fable of a footless and boneless divine bird found ready acceptance, even in scientific circles, so the depiction of the bird was long a subject of interest, as witness the numerous studies of the bird of paradise from the sixteenth and early seventeenth centuries. A specimen of the exotic bird, or at least a picture of it, became one of the favorite items for decoration and display in each natural-history collection.

It is merely an unfounded assumption that Dürer saw one of these "miraculous birds from paradise" and drew it; there is no evidence that he did so. The idea that he did is due not to an older ascription of a work to him, but to modern speculation by art historians. The idea was first suggested by Bock[8] in 1929 and later by Winkler,[9] both of whom thought it possible that Dürer was conceivably the author of the Erlangen study of a bird of paradise (Cat. 31). Although this thesis cannot be upheld, it does become clear to us how quickly a knowledge of the appearance of the wonderful bird spread around learned circles in Europe.[10] We have a silverpoint drawing by Hans Baldung Grien from the early 1520s (Cat. 30); taken from a sketchbook, it tells us that even just a few months after the arrival in Europe of the bird of paradise, this Strasbourg artist had the opportunity of drawing one. This picture is not

only an extraordinary artistic document in its own right, but also one of the earliest portrayals of one of the greatest zoological rarities of the time.

NOTES

1 Erwin Stresemann, "Die Entdeckungsgeschichte der Paradiesvögel," in *Journal für Ornithologie* 95/1954, book 3/4, pp. 263–291; the fundamental scientific presentation of this subject.

2 *Maximiliani Transyluani . . . Epistola . . . de . . . novissima Hispanorum in Orientem navigatione. Romae 1523,* quoted in Stresemann, p. 264 and note 1.

3 Francisco Lopez de Gomara, *La istoria de las Indias* (Saragossa, 1552), p. 546, quoted in Stresemann, p. 266 and note 10.

4 *Conradi Gesneri medici Tigurini Historiae Animalium,* Liber III, *De avium natura* (Zurich, Ch. Froschauer, 1555), pp. 611–614.

5 Stresemann, p. 264 and note 2.

6 Stresemann, p. 269 and note 19.

7 René Primevère Lesson (Prêtre et Oudard), *Histoire naturelle des oiseaux de paradis et des épimaques* (Paris, 1834–1835).

8 Bock, 1929, p. 53, no. 164 (see Cat. 31).

9 W. II, plate XII right (see Cat. 32).

10 The Augsburg humanist Conrad Peutinger, who died in 1547, owned a bird of paradise, as did Johann Kramer in Nuremberg; it was worth eight hundred *Joachimstaler,* as Gessner mentioned in 1555.

1 Map of the world after Battista Agnese, 1536, with the route of the *Victoria* around the world, 1519–1522. On the far right the Moluccas, an Indonesian archipelago.

Von dem Paradyßvogel/
oder Lufftvogel.
Paradisea. Paradisiauis.

Diß vogels figur ist von dem berrümpten mann und
geleerte J. E. loblicher gedächtnuß Cûnrat Peütinger /
uns mitteilt worde: welcher auch bezeüget daß er einen
sölichen vogel todt gesehen hette / als auch vil andere war-
haffte und glaubwirdige leüt vor mir söliches bezeüget
haben. Un ist unlangest ein figur diß vogels zü Nürenberg
getruckt / und mir mit disen worten zügeschickt worden:
Der Paradyßvogel / oder Apus Indica / ist in der grösse
eines Misslers / gantz leicht / mit langlechten flüglen /
welche gantz ran und durchsichtig sind / und mit zweyen
langen fäderen (wenn sy ächt mer fäderen dann burst
söllen genennt werden: dann sy kein fäderen habend /
und sind die in unserer figur nit außgetruckt) die sind eng /
schwartz / hert wie horn. Er hat keine füß / dann er flügt
stäts / und rüwet nimer anderschwo dann auff einem
baum / daran er sich mit disen langen fäderen henckt und
flichtet. Kein schiff mag so schnäll im meer / oder so weyt
vo land faren / welches er nit umbfliege. Er ist gantz hitzig /
furauß zü der speyß gebraucht. Der ist seer köstlich von
seiner seltzame wägen. Die obersten im krieg steckend dise
fäderen in jr beckelhauben als einen strauß. Disen zeigt
man zü Nürenberg bey Hans Kramer / und schetzt den
wol umb hundert taler. . . .

Deß männlins rugken hat inwendig einen winckel /
und in dise höle verbirgt (als der gmein verstand auß-
weyst) das weyblin seine eyer: dieweyl auch das weiblin
einen hole bauch hat / daß es also mit beiden hölinen die
eyer brüten un außschlöuffen mag. Dem männlin hanget
am swantz ein fade / drey zwerch hand lang / schwartz ge-
farbt / der hat die mittelst gstalt under der rúnde un vier-
eckete: er ist auch weder zü dick noch zü zart / sunder einem
schühmachertrat vast änlich: und mit disem sol das weyb-
lin / dieweyl es die eyer brütet steyff an das männlin ge-
bunden werden. Und ist kein wunder daß er stäts im lufft
sich enthaltet: dann wenn er seine flügel und den schwantz
ringsweyß außstreckt / ist es kein zweyfel / dann daß er
also on arbeit vom lufft aufgehalten werde. Sein ende-
rung und stäts abwächßlen im flug mag jm auch die müde
hinnemen. Der behilfft sich auch / als ich vermein / keiner
andere speyß dann deß himmeltaws / welches dann sein
speyß und tranck ist: darumb hat jn die natur darzü verord-
net / daß er in lüfften wonen möge. Daß er aber deß rei-
nen luffts geläben möge / oder den äße / ist der warheit nit
gleych / dieweyl der selbig vil zü zart ist. . . .

Etliche heissend disen ein Lufftvogel / eintweders da-
rumb daß er stäts im lufft flügt: oder daß er (als man
gmeinlich vermeint) deß selbigen geläbt. Nach dem ich
aber diß yetz geschribe / hat mir der wolgeleert und fleyssig
jüngling Melchior Guilandin / von Padauw einen brieff
zügeschickt / in welchem er disen vogel also beschriben hat:
Die wüssend / und habend davon geschribe / so vil bücher
von der Hispanieren schiffung in das neüwgewunnen /
und lange zeyt unbekannt land / gemacht habend / daß
namlich in den Inßlen Moluccis ein schöner vogel erbore
werde / von leyb nit schwär / aber von wägen der fäderen
(die er lang und ringsweyß außgespreitet hat / also / dz sy
einé grossen ring änlich) beduncke er einen im ersten
anblick seer groß. Diß vögelin ist von leyb und garnach
von gstalt der Wachtel änlich / mit einem ungleych gefarb-
ten umbkreiß der fäderen: doch ist der selbig gantz schön
und wol geziert / und allenthalben lieblich anzesehen. Der
kopff ist / als deß Schwalmes / großlächt / nach der grösse
seines leybs. Die fäderen so oben auff dem kopff biß zü an-
fang deß schnabels stond / sind kurtz / dick / hart / zisFrecht /
und von gäler farb / als das reinest gold / oder als die
streymen der Sonnen / glitzend. Die übrigen aber so

under dem schnabel stond / sind linder und zärter / un
schön / blawgrün gefarbt / nit ungleych denen so die En-
tenrätschen am kopff habend wenn sy sich gegen dem heite-
ren Sonnenscheyn keerend. Der schnabel ist auch etwas
lenger dann deß Schwalmens. Er hat keine füß. Die flügel-
fäderen sind von gstalt der Reiglen gleych / allein dz sy
zärter und lenger sind / grawfarb / braunglitzend. Die-
weyl aber dise fäderen all / die in flüglen und im schwantz /
rundweyß außgestreckt werdend wie ein rad (dann sy im
vogel als eyngeheffte pfeyl sstäckend / gantz unbewegt un
steyff) so ist es kein wunder daß er also stäts im lufft ent-
halten / dz er auch labendig nimer auff erdtrich gesehen
wirt / dieweyl er keine füß / so jm dann im lufft kein nutz
sind / hat . . .

Wie aber diser vogel seine eyer außbrüte / und mit was
speyß er sich erhalte / ist daoben weytlöufftig gesagt. Inn-
wendig findst du nichts lärs / sunder das gantz vögelin
überal mit feißte gespickt und außgefüllt. Diser gwüssen
und warhafften histori gebend alle neüwe gleerte kundt-
schafft / on allein Antonius Pigafeta / welcher dann gantz
falschlich und unrecht sagt / daß diser vogel einen langen
schnabel / und bein einer zwerch hand lang habe: dann ich /
so disen vogel zwey mal gehebt und gesehe / diß falsch seyn
gefunden hab. Diß schreybt der obgenennt Guilandinus /
und vermeint darbey das diß der vogel Rhyntar (welches
Plutarchus gedacht hat) seye. . . .

About the Bird of Paradise
or Bird of the Air.
Paradisea. Paradisauis.

This bird's appearance has been described to us by
the famous man and scholar, Privy Councillor Peü-
tinger of honored memory: who also declared that he
had seen such a bird dead, as have also declared before
me many other truthful and trustworthy people.
And a picture of such a bird has recently been printed
in Nuremberg, and sent to me with these words: The
Bird of Paradise, or Apus Indica, is the size of a
Mistle-Thrush, quite lightweight, with oblong
wings which are quite close and transparent, and
with two long feathers (if they should truly be called
feathers rather than bristles: for they have no vanes,
at least they are not shown in our picture) that are
narrow, black, hard as horn. He has no feet, for he
always flies, and rests never anywhere but on a tree,
on which he hangs and entwines himself with these
long feathers. No ship is as fast in the sea, or travels
as far away from land, as he can fly. He is very
toothsome, therefore used as food. He is very costly
because of his rarity. Chieftains in battle wear these
feathers in their headdresses as a crest. Such a bird
can be seen in Nuremberg at Hans Kramer's, valued
at about a hundred thalers. . . .

The male's back has within it a nook, and in this
hollow (as common sense will tell) the female hides
her eggs: meanwhile the female also has a hollow
belly, so that she may use both hollows to brood and
hatch her eggs. The male has a filament hanging on
his tail, three dwarf hands long, colored black, which

has a shape midway between round and square: it is
also neither too thick nor too delicate, but almost like
a cobbler's thread: and with this the female is most
likely firmly bound to the male while she is brooding
her eggs. And it is no wonder that he holds himself
ever in the air: for when he stretches out his wings
and his tail in a circle, there is no doubt but that he is
without effort held up by the air. His changing and
constantly alternating flight may also take away his
tiredness. Neither does he help himself, as I believe,
to any other food than the heavenly dew, which is
thus his food and drink: therefore has nature or-
dained that he shall live in the air. But that he can
live on pure air, or the ether, is not the truth, as the
same is far too thin. . . .

Some call this a Bird of the Air, either because he
is always flying in the air: or because (as is com-
monly thought) he lives off it. But after I had written
this down, the well-learned and diligent youth Mel-
chior Guilandin sent me a letter from Padua, in
which he has described the bird thus: Those knowing
and having written many books about the Span-
iards' seafaring to the newly won, and for a long time
unknown land, have said namely that on the Island
of Moluccas there exists a beautiful bird, not heavy
in body, but because of his feathers (which are long
and fanned out, so they are like a wide circle) he
appears at first glance very big. This little bird is in
body and whole form similar to the Quail, but with a
differently colored fan of feathers: which same is very
beautiful and finely patterned, and altogether lovely
to behold. The head is like a Night-Swallow's, in
proportion after the size of its body. The feathers on
top of the head down to the start of the beak, are
short, dense, firm, protruding, and of yellow color,
glistening as purest gold, or as the rays of the Sun.
The others that are under the beak, are softer and
more delicate, often colored a beautiful blue-green,
not unlike those on the head of the Drake Mallard
when he turns it against the bright sunshine. The
beak is somewhat longer than the Night-Swallow's.
He has no feet. The wing feathers are of the same
form as the heron's, only longer and more delicate,
gray colored, glistening brown. But since all these
feathers, those in the wings and the tail, are stretched
out in a wheel (sticking out of the bird like embedded
arrows, quite motionless and stiff) it is no wonder
that he always stays in the air, and that he is never
seen alive on the ground, and at the same time has no
feet, as they are no use to him in the air . . .

How this bird broods his eggs, and with what food
he nourishes himself, is amply explained above. In-
side him you find nothing empty, but the whole little
bird is plumped out and filled with fat. This detailed
and truthful description is acknowledged by all new
scholars, save only Antonius Pigafeta, who quite
falsely and wrongly says that this bird has a long
beak, and legs a dwarf's hand long: for I, who have
twice lifted and seen such a bird, have found it to be
false. Thus writes the above-named Guilandinus,
and thereby presumes this to be the Rhyntar bird
(mentioned by Plutarch). . . .

On the Bird of Paradise, from Conrad Gessner,
Vogelbuch (Book of Birds), 1557. Taken from the
German translation of the 1555 Latin edition,
fol. 185–187.

30

HANS BALDUNG GRIEN

Bird of Paradise and Studies of Heads

Silverpoint on white-prepared paper
The drawing bears descriptions of the colors,
which are now barely legible
101 x 150 mm
Copenhagen, Statens Museum for Kunst,
Den kongelige Kobberstiksamling,
Inv. Tu 93,7

PROVENANCE: Unknown.

BIBLIOGRAPHY: J. M. Thiele, *40 feuilles d'esquisses de Jean Holbein le Jeune, tirés du Cabinet Royal d'Estampes de Copenhague* (Copenhagen, 1861) • Alfred Woltmann, "Hans Holbein d.Ä. und Hans Baldung Grien unter den Handzeichnungen zu Kopenhagen," in *Jahrbuch für Kunstwissenschaft* IV/1871, p. 354 • Marc Rosenberg, *Hans Baldung Grün, Skizzenbuch im Großherzoglichen Kupferstichkabinett Karlsruhe* (Frankfurt, 1889), p. 22 • Gabriel von Térey, *Die Handzeichnungen des Hans Baldung, gen. Grien,* III (Strasbourg, 1896), p. LXI, no. 182 • Carl Koch, *Die Zeichnungen Hans Baldung Griens* (Berlin, 1941), pp. 172, 173, no. 208 • Killermann, 1953, p. 75 • Kurt Martin, ed., *Skizzenbuch des Hans Baldung Grien, "Karlsruher Skizzenbuch,"* II (Basel, 1950), p. 50, under 18r.

This silverpoint drawing, now oxidized to pale brown, shows a lesser bird of paradise (presumably the species *Paradisaea minor* Shaw) and five studies of heads, some only in very sketchy form. The description tells us that the bird is drawn with the paper in a horizontal orientation, while Baldung chose a vertical one for the heads. The bird is seen from one side and slightly from above, so that its characteristics are clearly visible. Thus the open beak with the bulbous clump of brow feathers over it, the large head, the short rump feathers, and the long tail feathers, which are partly cut off at the edge of the paper, are all recognizable. Baldung indicated the striking colors of the exotic creature with notes that are now only partly legible. The study, like other pages from sketchbooks found with it in Copenhagen, was ascribed to Hans Holbein the Elder[1] until Woltmann recognized the hand of Hans Baldung Grien and realized it was part of the Karlsruher Sketchbook.

This, as the research of Rosenberg, Koch,[2] and Martin[3] has shown, consists of various sketchbooks in similar format dating from 1511 to 1545 (the year of Baldung's death). Executed partly on vellum, partly on paper, they were only later[4] assembled in one volume. The paper, format, and style all indicate that the Copenhagen bird of paradise belongs to the third section[5] of the Karlsruher material. The paper on which it is drawn was produced in Basel and carries in several places the watermark of an ox's head, which is known to date

from the years 1514–1518. This section of the Karlsruher material also contains numerous plant studies, and is linked with works and events from the years around 1522. Martin therefore suggested that this bird of paradise was drawn in 1525 or thereabouts.

One of the features of the sensation caused by the circumnavigation of the world by Magellan's ship was the bird of paradise, which arrived in Europe only in September 1522 (see p. 100), and this makes Baldung's picture all the more remarkable; it may not look particularly spectacular, but its historical significance should not continue to be underestimated. It would certainly be most instructive to know how and where the Strasbourg artist came to study this zoological rarity so soon after its arrival, for the sketch must have been based on one of the first bodies of the bird to reach Europe.

NOTES

1 Thiele.
2 Koch, pp. 42, 43, 172, 173, no. 208.
3 Martin, pp. 25, 26, 50.
4 In 1582 by Sebold Büheler. See Martin, pp. 7 ff.
5 Martin, pp. 47 ff.

30

31

Bird of Paradise, Front and Rear View

Watercolor and body color on paper, brush,
heightened with white
Bottom right corner repaired, old crease line
in the center, about seven centimeters of
paper added below
Watermark: Nuremberg coat of arms, similar to
Briquet 917 ff. (see p. 257, figs. 4, 4a, 4b)
On the reverse the inscription in pen and ink:
*Paradeys Vogel nach . . . gru . . .
lich abcontrafeit*
598 x 375 mm
Erlangen, Graphische Sammlung
der Universität,
Inv. B. 164 II. C.4

PROVENANCE: From the collection of Margrave
Johann Friedrich von Brandenburg-Ansbach
(1654–1686); donated in 1805 by Friedrich
Wilhelm III of Prussia from the Ansbach
Schloßbibliothek to the University of Erlangen.

BIBLIOGRAPHY: Bock, 1929, p. 53, no. 164 •
Joseph Meder, review of *Elfried Bock, Die
Zeichnungen in der Universitätsbibliothek Erlangen*
in *Die Graphischen Künste* 53/1930, MGVK no.
4, p. 83 • W. II, appendix plate XIII and p. 76 •
T. II/2, p. 110, no. A 302 • P. II, p. 130, no.
1342 • Killermann, 1953, p. 75 and note 3 •
Winkler, 1957, p. 251, note 1 • St. VI, p. 3098,
No. XW. II/13.

In its informative way, this study depicts a
greater bird of paradise (*Paradisaea apoda* L.)
from both underneath and above, with the two
views placed side by side. It used to be ascribed
to Hans Hoffmann,[1] but then Bock placed it at
an earlier date, and because of the superb de-
piction of the plumage, even thought it possi-
ble that the work was by Dürer. Meder and
Winkler agreed with him on this, and the lat-
ter thought that yet another study of a bird of
paradise (Cat. 32) was also by the master. How-
ever, his verdict on the drawings was hesitant:
on the one hand he thought they may have
been copies, while on the other he could not
exclude the possibility that they were authen-
tic Dürers, dating perhaps from a time "before
the precision-works [*Kläubeleien*] of 1512."[2]

The Tietzes, however, eliminate this Erlan-
gen study, since "the artist only [reproduces]
the layout of the colors here," as is characteris-
tic of works from the end of the sixteenth cen-
tury, "making no effort to realize the physical
aspects in the way which is the essential inten-
tion in studies of this kind by Dürer." Panofsky
also rejects the drawing, but Killermann con-
siders the possibility that this double study and
the work now in the Woodner Collection
(Cat. 32) may both be works by Hans Baldung
Grien, like the silverpoint sketch from Copen-
hagen (Cat. 30). Strauss also excludes the

study, referring to the watermark of the paper
used, which never occurs in the paper of works
contemporary with Dürer, but is similar to
those of papers from the third quarter of the
sixteenth century.[3]

Although the work is obviously done by a
well-practiced hand, it appears coarse when
compared with, say, Dürer's *Dead Blue Roller*
(Cat. 10). This, in conjunction with the use of
paper that seems to have been produced only
from the middle of the sixteenth century on-
ward — similar watermarks are documented
from 1554 — defeats any argument that the
work may be by Dürer.

NOTES

1 From M. Zucker, reference in Bock, 1929.
2 Winkler, 1957, p. 251, note 1.
3 Bock already listed the watermark as a variant of
Briquet 917, 920, 924.

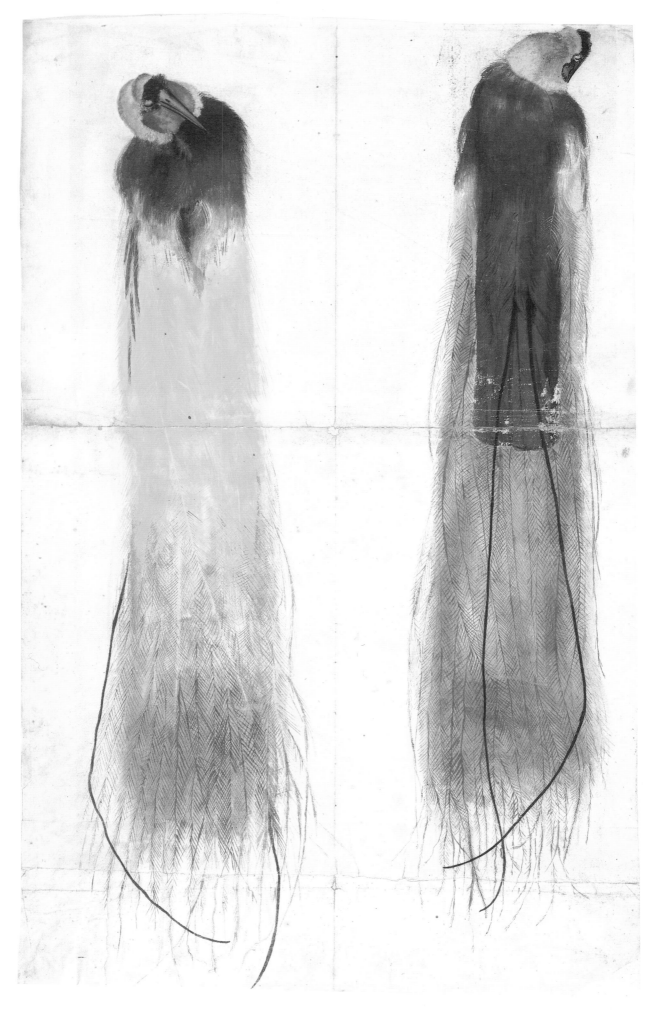

32

GERMAN, SECOND QUARTER OF THE
SEVENTEENTH CENTURY

Bird of Paradise

Watercolor and body color on paper, brush,
heightened with white; traces of preliminary
drawing on the right
Watermark: city gate; Piccard III, Section XIII,
36, 37 (see p. 257, figs. 5, 5a)
235 x 90 mm
New York, Ian Woodner Family Collection

PROVENANCE: Koch • Valls.

BIBLIOGRAPHY: W. II, appendix plate XII right
and p. 76 • P. II, p. 130, no. 1341 • Killermann,
1953, p. 75 and note 3 • Winkler, 1957, p. 251,
note 1 • St. VI, p. 3096, No. XW. II/12b •
Rafael Valls, *Stock Catalogue of Old Master Draw-
ings II* (London, undated), p. 56, no. 71, ill. p. 57.

Winkler was the first to suggest a connection
between this dorsal view of a greater bird of
paradise (*Paradisaea apoda* L.) and the work of
Dürer.[1] He considered it a work by the same
artist as the Erlangen study (Cat. 31). He was
cautious in his judgment, unsure whether the
two pieces were copies after a lost original by
Dürer, or whether they were in fact by Dürer
himself: "One should not be taken in by the
somewhat slack strokes of the feathers at the
end of the tail. Dürer changed his personal
style when he wanted to achieve particular ef-
fects, to the extent that it sometimes becomes
unrecognizable."[2] (!) Panofsky, however, con-
sidered its authenticity highly unlikely. Killer-
mann wondered whether both pictures could
be by Hans Baldung Grien, and Strauss ruled
out the work, as he had the Erlangen study.

The sketch is much smaller than the pieces
from Erlangen and from Dresden (Cat. 33) and
is skillfully painted, particularly the decorative
feathers. The feathers are shaded from purplish
brown and brown through to white, all on a
watercolor wash background, the effect of the
whole being similar to that of the Wehme bird
of paradise (Cat. 34). The body feathers are
not, perhaps, exact in reproduction, but each
one is more or less clearly outlined, and most of
them have a defined quill, features that distin-
guish this work from the other portrayals of
birds of paradise discussed here.

The watermark shows a city gate, which re-
sembles one found on papers from Dürer's
time; however, it has a special form, with four
instead of three merlons, a combination of let-
ters in the lower part, and screen lines twenty-
six millimeters apart, features that indicate
papers produced in the second quarter of the
seventeenth century.

NOTES

1 W. II.
2 W. II, p. 76; see also Winkler, 1957.

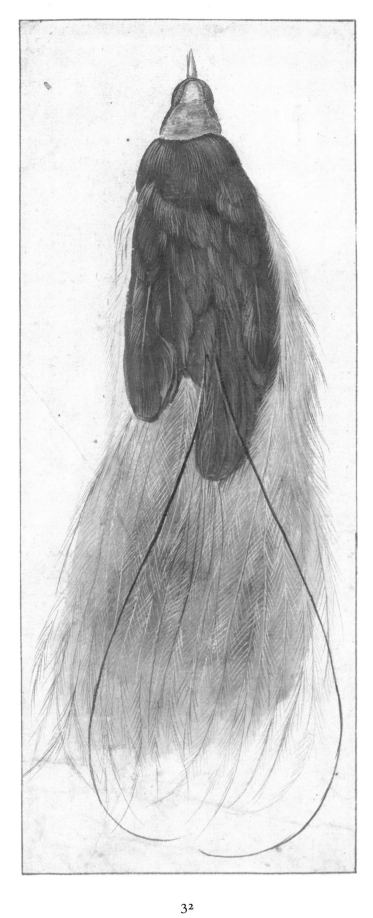

33

MONOGRAMMIST CA
(WITH THE ACORN), 1567

Bird of Paradise

Watercolor and body color on paper, brush,
heightened with white (partially oxidized),
traces of red chalk preliminary drawing
Inscription on the left: *MERALDA*
Watermark: tall crown, Piccard I,
section IX, 83/84 (see p. 259, fig. 8a)
450 x 223 mm
Dresden, Staatliche Kunstsammlungen,
Kupferstich-Kabinett, Inv. C4361, from the
album Ca 210, p. 30 (vol. no. 1232)
BIBLIOGRAPHY: Not described.

This hitherto unpublished representation of a
greater bird of paradise (*Paradisaea apoda* L.)
belonged to an album that, to judge from its
contents, was assembled at the beginning of
the seventeenth century. The study is on
paper, over a red chalk preliminary sketch col-
ored in with a brush, and carries on the left-
hand side the inscription "MERALDA." Thus
it is linked to a carefully executed, similar-size
study of two birds of paradise found in Copen-
hagen (ill. 33.2); it is obviously the sketch of
the left-hand bird, seen from the back. That
double study[1] is also unacknowledged in the
literature and is by the same artist as two other
animal studies in Copenhagen,[2] one of which
is monogrammed and dated *CA 1567,* and is
decorated with an acorn. The monogram,
which until recently was attributed to
Christoph Amberger, is now thought to be
that of an unknown painter, possibly from
Basel, by the name of Conrad Aichler.[3]

Apart from the fact that they are inverted,
the two studies are extraordinarily close to the
woodcut in Conrad Gessner's zoology.[4] If, on
the one hand, the third volume of this work,
the book of birds, had not already been pub-
lished in 1555, and the study, on the other
hand, were not associated with the date 1567,
one would think the latter the model for the
former. Or, could it be that the extraordinarily
close resemblance of the two is a result of the
use, by both Gessner's illustrator and the
Monogrammist CA with the Acorn, of the
same dead bird as a model?

NOTES

1 Watercolor, body color, and white, brush on
paper, background painted beige, inscribed
MIRALDO; 410 x 266 mm; Copenhagen,
Statens Museum for Kunst, Den kongelige Kob-
berstiksamling, Inv. II. *Garnitur der deutschen
Zeichnungen des 16. Jahrhunderts,* vol. II.
2 Copenhagen, Statens Museum for Kunst, Den
kongelige Kobberstiksamling, Inv. II. *Garni-
tur. . .,* vol. II: (1) *Ferret* (?), watercolor and body
color, brush on paper, background painted
beige, monogram and date in black chalk: *CA
1567* and an acorn. (2) *Hedgehog, Beaver, and
Mandrill* (?), watercolor, body color, and white,

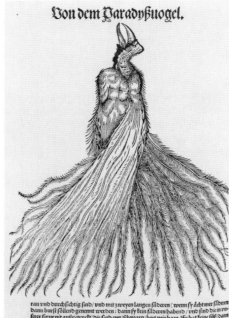

33.1 Woodcut illustration from Conrad
Gessner, *Vogelbuch,* first German edition, 1557
(see note 4).

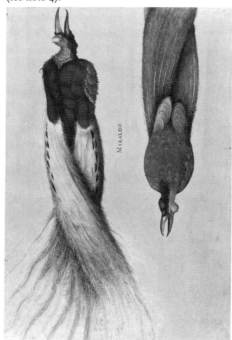

33.2 Monogrammist CA (with the acorn),
Two Birds of Paradise.
Copenhagen, Statens Museum for Kunst,
Kongelige Kobberstiksamling (see note 1).

brush on paper, background painted beige.
There is a third drawing, of a lion, which, al-
though superficially similar, is clearly different
in style.
3 Tilman Falk, inscription on mount, October 10,
1973. Falk's inscription, so I have been told, may
be traced back to a drawing in the Basel
Kupferstichkabinett that bears a similar mono-
gram and symbol: *Young Woman Wearing a Hat,
Rocking a Child,* chalk; monogram and date
bottom right: *CA 1572* with acorn; 222 x 188
mm; Basel, Kunstmuseum, Kupferstichkabinett,
Inv. U.XV.22, for which P. L. Ganz suggested

the name Conrad Aichler. (My thanks to P.
Tanner for the photograph and inventory
references.)
With regard to the identification of the
monogram, reference should be made to the
attractive thesis proposed by Tilman Falk at the
Vienna Symposium, June 7–10, 1985. Falk
pointed out that in the Augsburg painters' guild
books of 1538 "Christoph Aichele von
Salzburg" is introduced as an apprentice of
Christoph Amberger and that he is mentioned
again in 1542 after his apprenticeship was
completed. A more complete account is given in
the symposium reports: T. Falk, "Naturstudien
der Renaissance in Augsburg," *JKS* 82/1986.
4 *Conradi Gesneri medici Tigurini Historiae
Animalium,* 4 vols. and addenda (Zurich,
Ch. Froschauer, 1551–1558), Liber III (1555),
Qui est de Avium natura, "Bird of Paradise,"
pp. 611–614. Claus Nissen, *Die illustrierten Vogel-
bücher. Ihre Geschichte und Bibliographie* (Stuttgart,
1953), p. 116, no. 349.

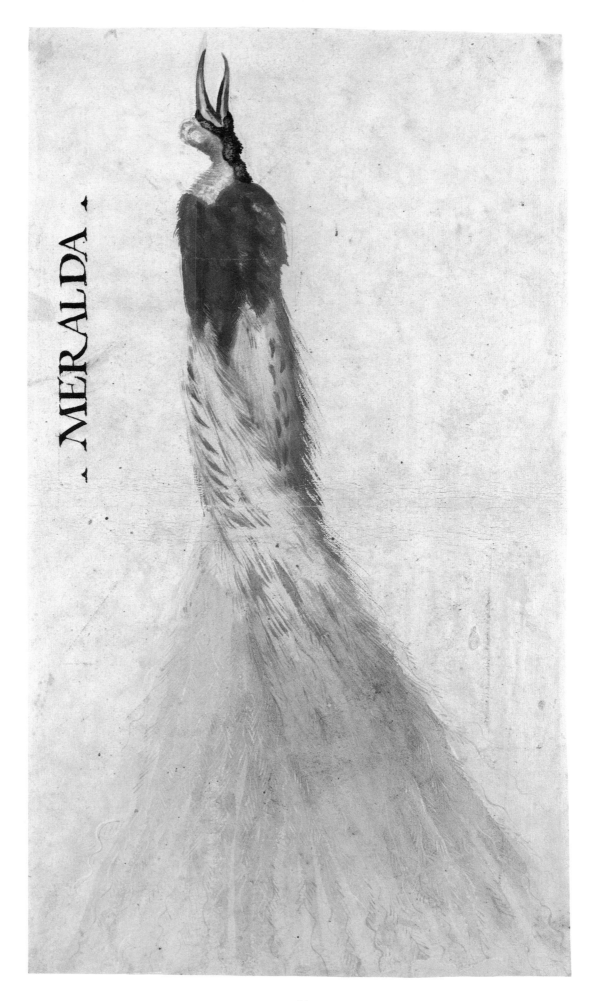

MERALDA

34

ZACHARIAS WEHME

Bird of Paradise

Watercolor and body color on paper,
brush, heightened with white,
traces of preliminary drawing
Watermark: large Saxon coat of arms
(see p. 257, fig. 6)
511 x 296 mm

Dresden, Staatliche Kunstsammlungen,
Kupferstich-Kabinett,
Inv. C 1961–86

PROVENANCE: Old Dresden estate property.

BIBLIOGRAPHY: Werner Schade, "Zum Werk
der Cranach," in *Jahrbuch der Staatlichen
Kunstsammlungen Dresden 1961/62,* pp. 39, 48,
note 8 • Exhibition Catalogue *Dresdener
Zeichnungen 1550–1650* (Dresden, Staatliche
Kunstsammlungen, Kupferstich-Kabinett,
1969), p. 112, no. 134 • Exhibition Catalogue
Das Stilleben und sein Gegenstand (Dresden,
Staatliche Kunstsammlungen Dresden, 1983),
p. 169, no. 178.

This study shows the back of a bird of para-
dise, with a supplementary picture on the left
of the bird's head seen from the side. The body
and plumage would suggest that the model
was a young male specimen of the species *Para-
disaea minor* (Shaw), since the green areas
around the beak are hardly in evidence here;
the unusual appearance of the bird may also be
due to the preparation of the corpse. The
painter displays a refined style in the way he
skillfully overlays the brown watercolor wash
with multiple shades of the same color, creat-
ing the effect of the tones of gleaming, soft
plumage.

The study was first introduced by Schade in
connection with the animal studies of the
Cranach studio,[1] and it was later identified as
the work of the Dresden court painter Zach-
arias Wehme, a pupil of Lukas Cranach the
Younger.[2] The large format shows that
Wehme adopted a tendency of the Cranach
studio, which made a habit of life-size repre-
sentations, as in *Four Partridges* (Cat. 8), *Two
Dead Waxwings Hanging from a Nail* (ill. 3,
p. 41), and *Dead Mallard* (ill. 7, p. 43). Philipp
Hainhofer, the Augsburg nobleman and art
dealer, reports in 1628 that stuffed birds of par-
adise were to be seen in the Dresden art collec-
tion, and Schade suggests that the painter for
that reason might have used one of these
corpses as a model.[3]

NOTES

1 Schade, 1961/62.
2 Exhibition Catalogue Dresden 1969; see also
Exhibition Catalogue Dresden 1983.
3 As quoted in Exhibition Catalogue Dresden 1969.

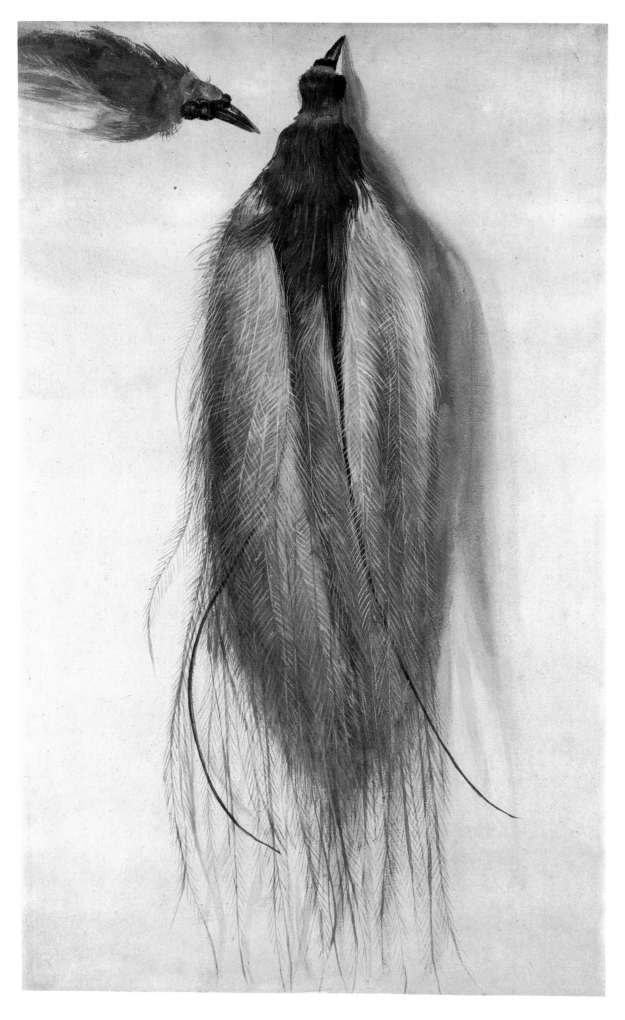

Dürer's Stag Beetle — Its Antecedents and Its Subsequent Influence

3 Prayer book of Narziss Renner, 1523, miniature painting on vellum, detail. Vienna, Österreichische Nationalbibliothek, Cod. 4486, fol. 101r.

Long before Albrecht Dürer endowed the stag beetle in *Madonna with a Multitude of Animals* (Cat. 35) and (very likely) the study of 1505 (Cat. 36) with such character that it became a leitmotiv of the Dürer Renaissance, it had already appeared in German panel painting, sometimes more as an early naturalistic ornamental device, as in Stefan Lochner's work (ill. 1),[1] sometimes as a Christ symbol, as in pictures from the Wolgemut studio.[2] Its conspicuous appearance expresses both a dawning feeling for nature and a symbolic inner meaning. As it moves from the edge of the picture into the realm of perception and significant content, there is no noteworthy difference between its use in Lochner's cathedral picture and that in Dürer's *Adoration of the Magi* (ill. 2).[3] Not until Dürer's study is the armor-plated insect taken from nature and placed on the drawing board, and so not only brought nearer to the eye of the beholder, but actually made the center of interest. Scientific nature study and artistic rendering go hand in hand: the external appearance is captured as a result of understanding its organic structure. The beetle study perfectly embodied this realization, which led it to have a far-reaching effect. It was famous in Dürer's own time, and the miniature painting in Narziss Renner's prayer book dated 1523 clearly reflects its early influence (ill. 3).

But the understanding of nature expressed in the drawing was appreciated less by Dürer's contemporaries than it was two generations later, when general interest in nature had spread. Georg Hoefnagel's example in the pictorial atlas of natural history for Emperor Rudolf II speaks for itself: at one point he copies Dürer's great model (Cat. 38), but at the same time sets up alongside it his own equally valid version, the *Stag Beetle with Outspread Wings and Scorpion* (Cat. 39). It also shows how up to date Dürer's image still was at the end of the century. For the expert it combined perfectly scientific advance and the connoisseur's taste, interest, and pleasure. Thereafter, Dürer's study became highly esteemed and recognized, copied and varied. The particular popularity of the stag beetle motif is obvious from the sheer number of copies and variations.

Hans Hoffmann and Georg Hoefnagel adhered to Dürer's prototype in keeping the beetle as the single, solitary pictorial subject. But a change takes place in the engravings of the *Archetypa studiaque patris . . .* by Jakob Hoefnagel after studies by his father, where it is accompanied by other insects, fruit, and flowers (ill. 38.1). Georg Flegel goes a step further. Whereas Hoefnagel's engraving was conceived as a pattern sheet, with as many items as possible scattered all over it, in Flegel's hands the composition is altered to still life (ill. 4).[4] The introduction of the crawling insect among inanimate things like fruit and flowers brings life into the picture.

The example of the stag beetle allows us to observe how a motif springing from late medieval roots makes its way from Albrecht Dürer's image, through Hoefnagel's *Archetypa* and Georg Flegel's studies, into the beginnings of still-life painting. Not unlike its late medieval version, with only the element of Christian symbolism removed, Dürer's example lives on in the secular world of still life.

1 Stefan Lochner, *Adoration of the Magi,* c. 1445, detail, oil on panel. Cologne Cathedral.

2 Albrecht Dürer, *Adoration of the Magi,* 1504, detail, oil on panel. Florence, Uffizi (see note 3).

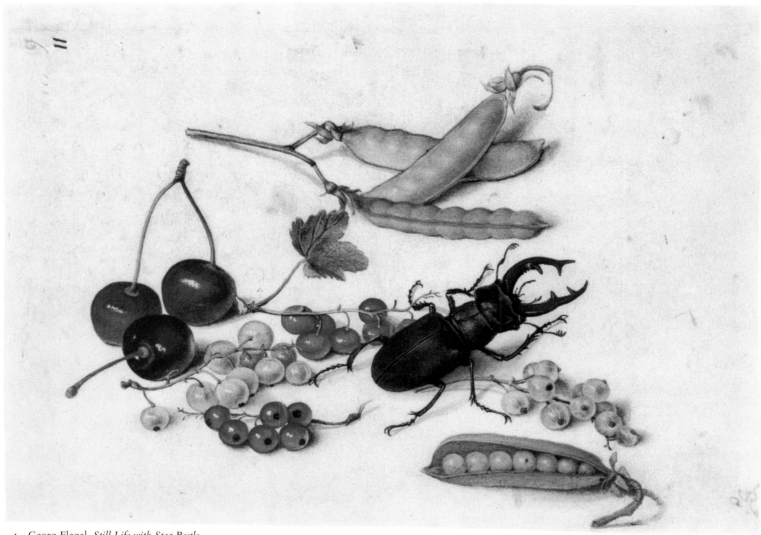

4 Georg Flegel, *Still Life with Stag Beetle,*
watercolor and body color on paper.
Formerly in Berlin, Deutsches Museum,
Kupferstichkabinett.

NOTES

1 Stefan Lochner, *Adoration of the Magi,* right
 panel, Cologne Cathedral.
2 See Alfred Stange, *Deutsche Malerei der Gotik*
 (Munich, Berlin, 1958), vol. 9, ill. 114. The stag
 beetle stands as a Christ symbol, being equated
 with the stag, which since classical times has
 been venerated as a holy animal whose horns
 could subdue the dragon.
3 Albrecht Dürer, *Adoration of the Magi,* oil on
 panel, bearing a monogram and the date 1504
 on the stone in the foreground; 1.00 x 1.14 m;
 Florence, Uffizi, Inv. no. 1434.
4 Formerly in Berlin, Kupferstichkabinett, Inv.
 KdZ 7503, watercolor and body color,
 heightened with white, brush on paper; about
 234 x 172 mm. The sheet was part of the series
 of flower watercolors once containing 110
 sheets, belonging to the Kupferstichkabinett. It
 was burned in 1945 (the illustration is taken
 from the collotype publication by Friedrich
 Winkler, *Georg Flegel, Sechs Aquarelle,* 3rd ed.,
 Berlin, 1962). Heinrich Geissler (Exhibition
 Catalogue Stuttgart 1979/80, II, pp. 66, 67)
 mentions a single, signed work to be found in
 Dresden, showing a stag beetle and a cockchafer
 among other insects, which in his opinion could
 have been one of a collection of similar pattern
 sheets. This sheet, described by him as lost, has
 reappeared in Dresden (Kupferstich-Kabinett,
 Inv. C. 2808, watercolor and body color, brush
 on paper, mounted; 156 x 129 mm; the outlines
 scored), but in my opinion it is a (seventeenth-
 century?) copy.

35

ALBRECHT DÜRER

Madonna with a Multitude of Animals

Pen and dark brown ink on paper,
watercolor, brush, fine grid in chalk
from the Madonna's head downward
Watermark (according to old data[1]):
bird in double circle, Briquet 12 223 (?)
(see p. 258, fig. 8)
Smoothed-out central fold
319–315 x 241 mm, closely trimmed,
original border still partly visible

Vienna, Graphische Sammlung Albertina, Inv.
3066(D 50)

PROVENANCE: Imhoff? • Emperor Rudolf II •
Imperial Treasure Chamber • Imperial Court
Library (1783) • Duke Albert of Saxe-Teschen
(L. 174).

BIBLIOGRAPHY: H. II, p. 80, no. 23 (?), p. 115,
no. 114 • Josef B. Nordhoff, "Dürers Bild:
Maria in der Landschaft mit vielen Tieren," in
RKW II/1879, pp. 309–311 • E., p. 54 • Th. I,
pp. 225, 226, note 1 • Ludwig Lorenz, *Die
Mariendarstellungen Albrecht Dürers, Studien zur
deutschen Kunstgeschichte,* book 55 (Strasbourg,
1904), p. 24 • Ludwig Justi, "Buchbesprechung
zu Ludwig Lorenz, Die Mariendarstellungen
Albrecht Dürers," in *Monatshefte der kunstwis-
senschaftlichen Literatur,* 1905, book 2, p. 34 •
L. V, pp. 3, 4, no. 460 • Ernst Heidrich,
Geschichte des Dürerschen Marienbildes (Leipzig,
1906), pp. 31 ff. and pp. 176–180, appendix IV •
Werner Weisbach, *Der junge Dürer* (Leipzig,
1906), pp. 58, 59 • Heinrich Alfred Schmid,
"Die oberdeutsche Kunst im Zeitalter Maxi-
milians," in *Kunstgeschichtliches Jahrbuch der k.k.
Zentralkommission* III/1909, pp. 6, 23 • Killer-
mann, 1910, pp. 42 ff. • Campbell Dodgson,
"Some of Dürer's Studies for Adam and Eve,"
in *TBM* 48/1926, pp. 308–321 • Wölfflin, 1926,
p. 110 • Elfried Bock and Max J. Friedländer,
*Handzeichnungen deutscher Meister des 15. und 16.
Jahrhunderts* (Berlin, n.d.), pp. 26, 46 • T. I,
p. 60, no. 200 • Fl. II, pp. 86, 299–301, 364,
562 • Albertina Catalogue IV, p. 12, no. 50 •
W. II, pp. 23, 24, no. 296, p. 22, under no. 295 •
P. I, pp. 36, 37 • P. II, p. 75, no. 658 •
H. Tietze, 1951, pp. 35, 47, 58, plate VI •
Musper, 1952, pp. 125, 126 • Killermann, 1953,
pp. 27, 28 • Winkler, 1957, p. 167 • Ludwig
Grote, "Dürer-Studien," in *Zeitschrift des
deutschen Vereins für Kunstwissenschaft* XIX/1965,
book 1/2, p. 167 • White, 1971, pp. 84, 85,
no. 25 • K.-Str., pp. 170–173, no. 26 • St. II,
p. 696, no. 1503/22 • Anzelewsky, 1980, p. 114,
ill. 104 • Strieder, 1981, pp. 198, 199.

Animals, plants, and small vignettes fill this
intimate devotional image with a multitude of
intellectual references. The presence of Saint
Joseph, to the right in the near background,
broadens the Madonna image to that of a Holy
Family. Over the hill in the background ap-
pears an angel announcing Christ's birth to the
shepherds. In the distance, coming through
the valleys from the sea, approach the three

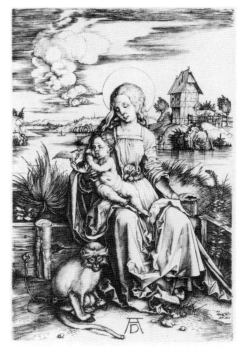

35.1 Albrecht Dürer, *Madonna with the Monkey,*
copper engraving (B. 42, M. 30).

kings from the East, with pack animals, riders,
and camels, led by the star, "till it came and
stood over where the young child was"
(Matthew 2:9).

Dürer's composition of the main figure
echoes his 1498 engraving *Madonna with the
Monkey* (ill. 35.1). Even now, a few years later,
it still seemed to him worth re-creating the
Madonna figure based on that of Lorenzo di
Credi,[2] in order to suit his new relationship to
nature, with an eye on the Netherlandish *Mary
with Child* (ill. 35.3)[3] and the *Madonna in a
Bower of Roses* from the upper Rhine.

In the *Madonna with a Multitude of Animals,*
Dürer brings together elements of the rose-
bower Madonna[4] and the theme of the *Garden
of Eden.*[5] In a "world landscape," including

35.2 Albrecht Dürer, *Madonna with
a Multitude of Animals,* detail (bottom left).

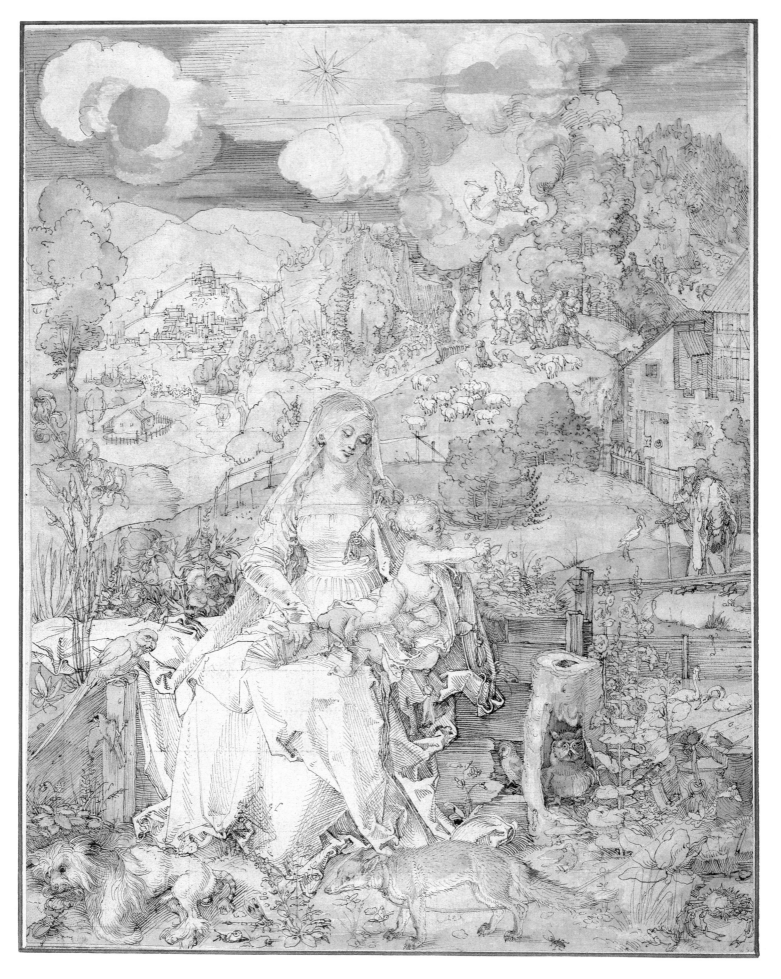

35

long vistas, Dutch hillsides, and an Italian idealized figure, he synthesizes German, Netherlandish, and Italian artistic styles and achieves a classically balanced composition: tradition and modernity, Gothic and Renaissance, religion and nature, emotion and experience, blend in perfect artistic harmony. No other artist at the turning point between the medieval and the modern age attempted a similar synthesis of traditional Christian symbols in the guise of realistic nature painting. The image of the Madonna is enriched by background scenes; thus the composition turns from a devotional religious picture to a broad, epic, narrative depiction.

Of the three known versions — a preparatory design in Berlin (ill. 35.4), a later, different variant in Paris dated 1503 (ill. 35.5),[6] and the version in the Albertina — the latter is the most outstanding. It is the result of thoughtful preparation, clarifying all the sketchiness of the Berlin rough draft, the pen strokes simply and decisively delineating every detail. The Madonna stands out in white against the smooth watercolor tints of the plants, animals, and landscape surrounding her.

There are traces of squaring over the whole width of the drawing from the head of the Madonna downward. It is hard to judge whether Dürer himself was responsible for this aid for transfer, or a later copyist. Shortly before, Dürer likewise made use of a grid over the study for the engraving *Nemesis* (see Cat. 18), but here, instead of drawing the lines, he pressed them into the paper.

As Sadeler's engraved copy and Jan Brueghel's 1604 painted version of the drawing confirm, Dürer's study belonged to Rudolf II's *Kunstkammer*.[7] Beyond that its provenance is uncertain. Possibly we should identify the watercolor with no. 23 of the Imhoff Inventory, "A watercolor panel, a picture of the Virgin Mary."[8]

The study has been the object of exhaustive analysis and extensive interpretations. It is established that the Madonna is based on an Italian prototype,[9] that the pose of the kneeling shepherd in the background relates to that of the kneeling Orpheus in a Dürer drawing in Hamburg,[10] and that the sheepdog (ills. 35.6, 8), reversed, corresponds with a dog in the engraving *Saint Eustace* (B. 57, M. 60).[11] There is a study for the stork in the Musée d' Ixelles in Brussels (ill. 14, p. 20),[12] and one for the parrot in the Ambrosiana in Milan (ill. 35.9).[13] Both also appear again in the *Adam and Eve* engraving (B. 1).[14]

The stag beetle, below left, returns in Dürer's 1504 painting *Adoration of the Magi* in Florence.[15] It is generally assumed that certain animals and plants, such as the owl, crab, toad, and iris, are connected to further studies ascribed to Dürer or suggest such connections. The peonies, we may add, are copies from Schongauer's *Madonna in a Bower of Roses* (see ills. 4, 5, pp. 210, 211). A terrier *(Visitation),* an eagle owl *(Wedding),* and a lizard *(Flight into Egypt)* all appear in the woodcut series *The Life of the Madonna,*[16] thus making the chronologi-

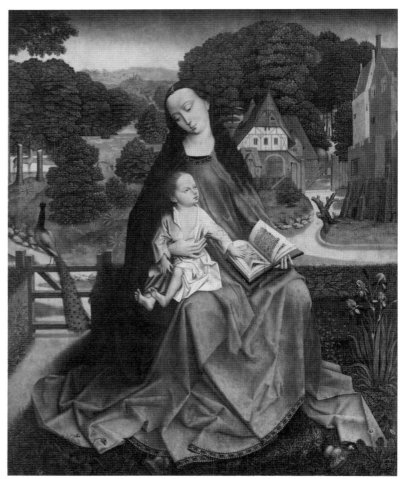

35.3 Master of the Embroidered Foliage, *Mary with Child,* c. 1500, oil on panel. Amsterdam, E. Proehl Collection (see note 3).

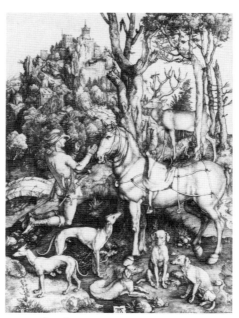

35.6 Albrecht Dürer, *Saint Eustace,* copper engraving (B. 57, M. 60).

35.7 Albrecht Dürer, *Sitting Dog,* detail from Cat. 35.

35.4 Albrecht Dürer, *Madonna with a Multitude of Animals,* pen drawing. Berlin, Staatliche Museen Preußischer Kulturbesitz, Kupferstichkabinett (see note 6).

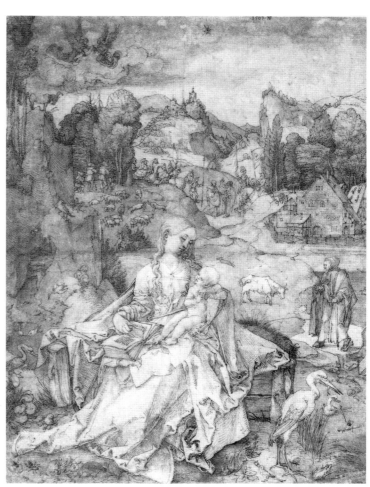

35.5 Albrecht Dürer, *Madonna with a Multitude of Animals,* 1503, pen drawing, watercolored. Paris, Musée du Louvre, Cabinet des Dessins (see note 6).

35.8 Albrecht Dürer, *Parrot,* detail from Cat. 35.

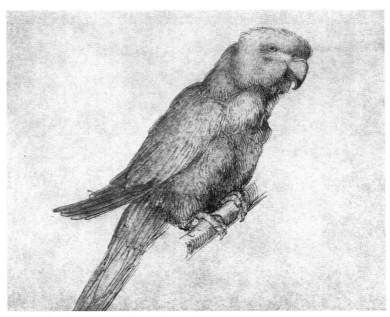

35.9 Albrecht Dürer, *Parrot,* pen drawing. Milan, Ambrosiana (see note 13).

cal relationship evident and leading to the now generally accepted dating of the drawing as "circa 1503."[17]

The animals and plants surrounding the Madonna and Child meant more to Dürer, however, than the opportunity to paint some accurate nature studies; they also held a symbolic meaning. The iconographic key is apparently the fox with collar and lead. Dürer could count on the generally widespread knowledge of Christian animal and plant symbolism and assume that everyone would recognize the fox as evil tamed, and strawberries, irises, and peonies as Madonna emblems. So what is offered as the idyll of motherhood in fact represents the Christian teaching of salvation, while the Child, to whom shepherds and kings pay homage, is not only the savior of mankind but also the master of the animal and plant world, in short, the whole of creation. Through his birth, evil is vanquished.[18]

The stag beetle sketched below left, although very small — barely 15 millimeters in the original — is carefully drawn, as the enlargement shows (ill. 35.2). In spite of its minute scale it is lively and flexible, like the beetle in the Uffizi picture (ill. 2, p. 112), and anticipates to a surprising extent everything that we find in the individual study of 1505 (Cat. 36), a good two years later.

The perfected, pared-down style of drawing and the subtle watercolor tinting of this picture are unusual both in Dürer's work and in that of his contemporaries. Whether it was conceived as a draft for a painting or whether it and the colored version in Paris should be regarded as independent works of art cannot be conclusively answered. It has also been suggested that we should see it as a fair drawing on which an engraving was to be based,[19] and this argument is strongly supported by the delicacy of the pen border lines by Dürer himself, the precision of the rough drawing, and the richness of the animal accessories — similar to the engravings *Saint Eustace* and *Adam and Eve* (B. 57, B. 1).

For a long time the connection remained unnoticed between this drawing and the *Madonna with the Iris,* known as the Richmond Madonna. This panel painting from the Dürer studio (see ill. 66.1) obviously follows from the *Madonna with a Multitude of Animals,* as can be seen from the variations of clothing and drapery in the different drawings of that subject. Starting with the Vienna version, they are progressively transformed through the Paris variant (ill. 35.5) to those of the Richmond Madonna.

It can be seen from these many points that Dürer was extensively concerned with this Madonna composition. The drawing therefore represents, to a greater extent than was previously supposed, the key to understanding his central artistic preoccupations of these years.

NOTES

1 The page is mounted, the watermark invisible to the naked eye. The identification comes from Meder (L. V). Since this paper was unusual for Dürer, who seemingly used it only once again — twenty years later — Strauss felt bound to comment apropos of the watermarks (VI, p. 3275): "there is some doubt concerning their authenticity."

2 Lorenzo di Credi, altar painting in Pistoia Cathedral, ill. in Weisbach, p. 59, ill. 24, already noticed by Thausing (I, p. 225, note 2) and not first by Weisbach, as is often stated.

3 Master of the Embroidered Foliage, *Mary with Child,* Amsterdam, E. Proehl Collection; Max J. Friedländer, *Early Netherlandish Painting* (Leyden, 1969), vol. IV, no. 84, pl. 77.

4 On the peonies drawn from Schongauer's *Madonna in a Bower of Roses,* see pp. 210, 211.

5 Compare the Frankfurt *Garden of Eden.* See also T. I, pp. 76, 77, no. 258, for interpretation of the connecting ideas behind the *Garden of Eden* and the *Adam and Eve* engraving (B. 1).

6 *Madonna with a Multitude of Animals,* pen and brown ink, monogram bottom center; 364 x 277 mm; Berlin, Kupferstichkabinett, Inv. KdZ 15387 (W. 295). *Madonna with a Multitude of Animals,* pen, brush, watercolor, monogram and date 1503, top right; 325 x 240 mm; Paris, Louvre, Cabinet des Dessins, Inv. 18.603 (W. 297).

7 It is conjectured that the copy in oils by Jan Brueghel (Rome, Galleria Doria Pamphili; 1 centimeter larger than the original all around) was commissioned by Emperor Rudolf II as a protective cover for the drawing. See Klaus Ertz, *Jan Brueghel d.Ä. — Die Gemälde* (Cologne, 1979) pp. 436, 439 ff., 575, cat. 108, 109.

8 H. II, p. 80, no. 23.

9 A Madonna prototype created in Verrocchio's studio, subsequently transformed by Leonardo and Lorenzo di Credi; see Weisbach, 1906, pp. 58, 59, note 2.

10 P. II, p. 75, no. 658: *Death of Orpheus,* pen and ink, traces of brown and sepia, monogram and date 1494 bottom center; 289 x 225 mm; Hamburg, Kunsthalle, Kupferstichkabinett, Inv. 23006 (W. 58).

11 P. II.

12 Albrecht Dürer, *Stork,* pen and brown ink, top center, Dürer monogram and date 1517 by a foreign hand; 280 x 190 mm; Brussels, Musée d'Ixelles, Inv. 136 (W. 240).

13 Albrecht Dürer, *Parrot,* pen and dark gray ink, brush, watercolor, top center, monogram and date 1513 by a foreign hand; 193 x 213 mm; Milan, Biblioteca Ambrosiana, Cod. F. 264 Inf. no. 12 (W. 244).

14 Dated 1504 (B. 1); Fl. II, pp. 86, 300; Dodgson, 1926, p. 311.

15 See p. 113, notes 2 and 3; Fl. II, p. 300.

16 Fl. II, p. 300.

17 W. II, pp. 23, 24.

18 See K.-Str., p. 173, under no. 26; Exhibition Catalogue Berlin 1984, p. 43.

19 White, 1971. Contrary to other assertions (recently, K.-Str.), the image is *not* trimmed. The border is still partly visible, which prompts White's assumption that the work was conceived as a design for an engraving. It can still clearly be seen at the bottom of the sheet that the work was extended beyond the format originally planned and bordered.

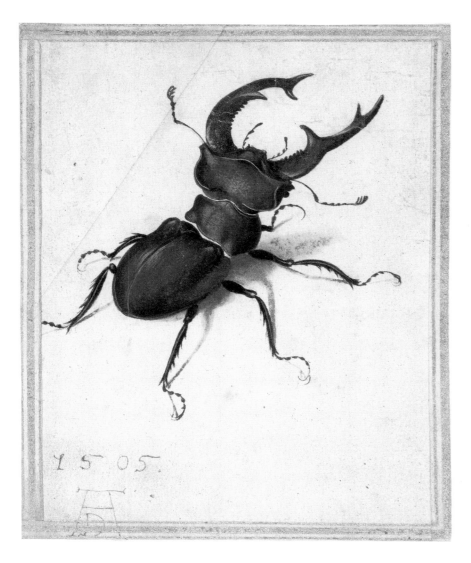

36

36

ALBRECHT DÜRER (?)

Stag Beetle

Watercolor and body color on paper,
brush, heightened with white
Traces of preliminary drawing on the mandibles
Slight flaking of color. Diagonally trimmed,
top left, and the left antenna restored
Bottom left, Dürer monogram and date *1505*
142 x 114 mm (inner gold border 131 x 103 mm)

Malibu, The J. Paul Getty Museum

PROVENANCE: Walpole • Bale • Heseltine •
Oppenheimer • Tyser • Delon.

BIBLIOGRAPHY: E., pp. 78, 80 • Th. I, p. 303 •
L. II, p. 21, no. 169 • Killermann, 1910, p. 49,
note 3 • Rudolf Wustmann, "Von einigen
Tieren und Pflanzen bei Dürer," in *ZBK* 22/1911,
p. 110 • Max Deri, "Naturalismus, Idealismus,
Expressionismus," in *Einführung in die Kunst der
Gegenwart,* by Max Deri and others (Leipzig,
1919), p. 71 • Wölfflin, 1926, p. 166, note 1 •
T. I, p. 128, no. A 140 • Gustav Pauli, "Der süd-
deutsche Dürer und die Methode der Kunstge-
schichte," in *Dürer-Festschrift* (Cicerone)
(Leipzig, Berlin, 1928), p. 71 • Campbell Dodg-
son, "Two Dürer catalogues raisonnés," in
TBM 53/1928, p. 201 • Winkler, in *JPK*
50/1929, pp. 137, 138 • H. Tietze, in *WJKG*
7/1930, pp. 246, 247 • Fl. II, pp. 9, 310 • W. II,
pp. 74, 75, 81, 82, no. 370 • P. II, p. 131,
no. 1359 • H. Tietze, 1951, pp. 35, 36 • Musper,
1952, p. 126 • Exhibition Catalogue *Drawings by
Old Masters* (London, Royal Academy of Arts,
1953), p. 60, no. 232 • Killermann, 1953, p. 24 •
Winkler, 1957, p. 182 • Auction Catalogue,
Sotheby's, London June 26, 1969, no. 53 • Hof-
mann, 1971, p. 39 • Exhibition Catalogue Paris
1978, no. 145 • St. II, p. 870, no. 1505/15.

This minutely accurate life-size portrait on
paper of a fine specimen of the male stag beetle
(*Lucanus cervus* L.) is one of Albrecht Dürer's
most popular studies. It has enjoyed practically
unqualified recognition on the part of art ex-
perts. For Ephrussi, Thausing, Lippmann,
Flechsig, Winkler, Musper, and others, the
Stag Beetle is unquestionably Dürer's work,
signed and dated in his own hand, a master-
piece on a par with the *Hare* (Cat. 43). Only the
placing of the monogram near the left edge of
the picture seemed to Winkler untypical of
Dürer; he therefore conjectured that the sheet
had originally been twice the size, then di-
vided, as another creature was drawn on the
piece obliquely cut off the top left.

When the Tietzes criticized the missing or-
ganic connection among the three separate
sections of the insect's body, labeling this a
mark of the pseudobiological interests charac-
teristic of the second half of the sixteenth cen-
tury and therefore excluding the study from
Dürer's work, they invited a storm of indigna-
tion. Pauli and Dodgson vehemently disagreed
with this. They belittled the Tietzes' critical

judgment as posing connoisseurship, but omit-
ted on their part to produce any well-founded
evidence of its unreliability. Then Panofsky, in
1943, likewise excluded the *Stag Beetle* with the
comment, "Hardly by Dürer. Date and signa-
ture in the opinion of this writer not in Dürer's
handwriting." The matter was scarcely men-
tioned again.[1]

For Hans Tietze,[2] one of the arguments for
rejection was that the stag beetle in the Floren-
tine *Adoration* (ill. 2, p. 112) was a comparatively
livelier, more organic and carefully observed
interpretation. The study, on the other hand,
he considered one of the "more or less skillful
interpretations," in which a "removal of the
organic link for the sake of the diagrammatic
clarity of the overall somatic inventory"
should be noted, in that it "so closely corre-
sponds to the mentality of the early Dürer
Renaissance around 1600." What seemed to
Tietze grounds for exclusion was for Winkler
an "original way of livening up the stark crea-
ture. It is not only presented as though physi-
cally standing out from the white ground, so
that it seems to be crawling over it, but is also
divided into three parts, each moving in a dif-
ferent direction, leaving it to the eye of the
observer to unite the body, neck, and head
across the narrow spaces separating them."[3]
Strauss's argument, that it is hard to deny
Dürer's authorship because the stag beetle also
appears in the Madonna drawing (Cat. 35) and
the *Adoration* panel, fails to recognize the far
more difficult problem.

The invention of the image, if it may be
called that at all, certainly goes back to Dürer.
The existence of such a prototype by Dürer is
adequately proved both by his own portrayals
and also by sixteenth-century copies. Opinions
are divided only as to whether this particular
study is Dürer's own work or a later copy.

Winkler[4] attempted to explain why motifs
such as the stag beetle appear frequently within
a short space of time, by making the rather
unclear suggestion that Dürer worked with a
"basic stock" of designs, augmenting it as oc-
casion offered, and then repeatedly drawing on
it for relevant works over some period. The
minute sketch of the beetle in the *Madonna
with a Multitude of Animals,* and this later, larger
study, which agrees with it even in the detail of
the leg positions, do indicate such a connec-
tion. To our way of thinking, also in accord-
ance with Dürer's usual procedure (as, for ex-
ample, in the parrot, elk, and hare for the *Adam
and Eve* engraving [ill. 42.1], which was done at
the same time), it would seem to make sense
that the studies preceded the picture rather
than followed it, as would here be the case. It is
therefore surprising that the *Stag Beetle* study is
dated later than the picture version.

According to Winkler,[5] the study bears "a
signature and dating genuine beyond any
doubt . . . which appear in identical form in
1505 itself." As a comparison he points to the
Munich drawing *Animals Attacked by Animals
of Prey* (W. 379); but this work, cited by
Winkler as evidence, was meanwhile recog-
nized by Kuhrmann[6] as dubious. The clear,
prominently placed year mark, with the char-
acteristic figure 5, bowed to the right and with
the long cross stroke, the 1 with the loop above
and the horizontal stroke below, and the pe-
riod at the end, are particulars that reappear
even more strikingly in the drawings *Head of a
Man* (W. 288), *Female Nude* (W. 343), *Christ
on the Cross,* and *The Two Thieves* (W. 324–
326). The latter had already been rejected by
the Tietzes[7] as the work of Hans Baldung
Grien, which makes Winkler's pronounce-
ment about the date appear less sound than
before.

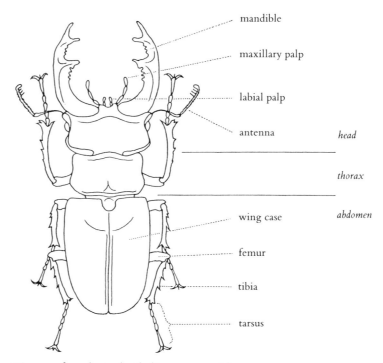

mandible

maxillary palp

labial palp

antenna

head

thorax

abdomen

wing case

femur

tibia

tarsus

36.1 Diagram of a male stag beetle (*Lucanus cervus* L.)

From the biological viewpoint, as comparison with Hoefnagel's *Stag Beetle* (Cat. 38) makes even more evident, the study displays obvious deficiencies: the incorrect structure of the maxillary palps, the varying direction of the spines on the tibiae of the legs (compare the second and third legs and the direction of the spines on the middle leg on the other side of the body), the faulty drawing of the last tarsus (without a thickening at the end), the poor modeling of the wing cases. All of these inaccuracies are surprising in view of Dürer's usual precision in observing nature.

It seems Hans Hoffmann may well have seen such a stag beetle study in the Imhoff Collection (Cat. 37). Georg Hoefnagel was also conversant with this model (Cat. 38). Surviving copies afford no further evidence for or against the Getty beetle. In overall appearance, Hoffmann's *Stag Beetle* copy certainly tends toward the Getty study, while Hoefnagel's insect is closer to the little stag beetle in the *Madonna with a Multitude of Animals.* Yet to conclude that there existed a third model, now lost, that was common to both fails to justify the trifling discrepancies.

So it remains only to weigh the pros and cons. In favor of Dürer's authorship there is the fact that very similar forms can be found in his work of 1503 and 1504, and furthermore, that the stag beetle became a leitmotiv of the Dürer Renaissance. The missing links between the body sections (for the Tietzes a grave argument against Dürer) we can observe just as clearly in the *Madonna with a Multitude of Animals.* The formal and stylistic differences between the almost contemporary beetles of the pictorial versions and the study cannot, however, be overlooked. The beetles carried out as pen drawings or oil paintings have dynamic and flexible strength, and are sharper and more angular in outline, with a lanceolate body as compared with the rounded, acorn-shaped abdomen of the Getty beetle, which also shows the defects mentioned.

Yet in our present state of knowledge, none of the arguments is conclusive. As long as no convincing affirmation emerges, judgment of this striking study will in the end always depend on subjective evaluation.

NOTES

1 The two known, stylistically different *Stag Beetle* copies (see Cat. 37) speak against Panofsky's assumption that the study is identical with one by Hoffmann noted in the Imhoff *Geheimbüchlein* (Rosenthal, in *JPK* 49/1928, p. 52, fol. 76v).
2 H. Tietze, 1930. The pen drawing *Stag Beetle* (pen and brown ink, on paper, mounted, crookedly trimmed; 88–92 x 158–159 mm; Hanover, Technische Hochschule, Inv. Mappe Kl.D.Z.61,-2-Z. Haupt: XXI², 2; ill. 36.2) is cited and reproduced in Tietze's article as record of a work from the Wolgemut studio, but seems to me certainly of a later date. The dry style of drawing corresponds more to the engraving technique of the end of the sixteenth century, seen, for example, in Jakob Hoefnagel's *Archetypa.*
3 Winkler, 1957, pp. 182, 183.
4 Winkler, 1929, pp. 137, 138.

5 W. II, p. 82, under no. 370.
6 Exhibition Catalogue *Dürer und seine Zeit, Zeichnungen und Aquarelle* (Munich, Staatliche Graphische Sammlung, 1967/68), p. 23, no. 24.
7 T. I, p. 136, nos. A 174, 175, 176. Panofsky rejects the *Head of a Man,* but accepts the *Female Nude.* In the way the date is written, however, this nude drawing corresponds to the three drawings in the Albertina (W. 324–326), which are rejected both by the Tietzes and by Koschatzky and Strobl and also seem highly

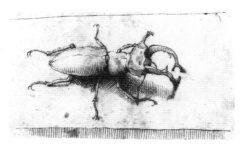

36.2 German, late sixteenth century, *Stag Beetle.* Hanover, Technische Hochschule (see note 2).

questionable to Panofsky. Such divergent opinions within so narrow a field demand a detailed examination of Dürer's 1505 dated drawings.

37

HANS HOFFMANN

Stag Beetle

Watercolor and body color on paper,
brush, heightened with white, pen and black ink
(outlining the legs and antennae)
Bottom center, monogram and date *1574*
97 x 94 mm
Budapest, Museum of Fine Arts,
Department of Prints and Drawings, Inv. 184

PROVENANCE: Praun • Esterházy, Pest.

BIBLIOGRAPHY: E., p. 80, note 3 • T. I, p. 128,
under no. A 140 • Winkler, in *JPK* 53/1932,
p. 81 • W. II, pp. 81, 82, under no. 370 • Pilz,
in *MVGN* 51/1962, p. 251, no. 5 • St. II, p. 870,
note 3, under no. 1505/15.

Hoffmann imitates the Dürer prototype,
keeping to the size of the original, but is more
hasty in the drawing and astonishingly careless
in the brushwork. He copies exactly the hair-
fine, white outline of the abdomen and faith-
fully observes the division of the parts of the
body, but feels compelled to improve on his
model by giving it a more powerful head and
stronger mandibles, and by connecting head,
thorax, and abdomen with areas of yellow.
The fine stippling technique on head and
thorax is less careful than usual in his copies.

The coarse brushwork seems a characteristic
of Hoffmann's earlier works, also visible in the
Berlin *Peonies* (Cat. 74), while the works of the
eighties are more precisely drawn. In any case,
we have to count this as one of his earliest dated
works, bearing the date 1574.[1] This copy was
known to Ephrussi, the Tietzes, Winkler, and
Pilz. Together with another copy of the same
model, now in Berlin (ill. 37.1), similarly
monogrammed but this time facing the other
way,[2] it constitutes a not unreasonable argu-
ment for the authenticity of the Getty beetle.

The reversal of the Berlin copy shows that
artists were beginning to adapt the prototype
freely. Beyond that, the relationship of the two
copies also says something about the way they
were made, namely, by tracing; they coincide
with each other in the details that vary from
Dürer, such as the more curved right mandi-
ble, the shorter head, and the turned-in maxil-
lary palps, so very likely they both were based
on the same tracing, one the same way around
and one reversed.

Hoffmann's copies were obviously the start
of a series of repetitions of this popular motif,
copied also by Georg Hoefnagel (Cat. 38) and
achieving a wider circulation through engrav-
ings by his son Jakob in *Archetypa studiaque
patris* . . . (ill. 38.1). We also meet it as a fre-
quently recurring leitmotiv[3] for more than
two decades in early seventeenth-century Ger-
man and Netherlandish still life.

NOTES

1 Pilz, 1962.
2 Hans Hoffmann, *Stag Beetle,* watercolor and
body color, brush, black bordering line, on
paper, monogram bottom center; 114 x 103 mm;
Berlin, Staatliche Museen Preußischer Kulturbe-
sitz, Kupferstichkabinett, Inv. KdZ 2046.
 Bibliography: Bock, 1921, I, p. 46, no. 2046,
pl. 60. T. I, p. 128, under no. A 140. Winkler, in
JPK 53/1932, p. 81. W. II, pp. 81, 82, under no.
370. Pilz, in *MVGN* 51/1962, p. 266, no. 33.
3 See Georg Flegel, *Still Life with Stag Beetle,* ill. 4,
p. 113, and also other still lifes by Flegel; see
Müller, 1956, plates 2, 22, 28. See also a flower
painting by Pieter Binoit in the Prague National
Gallery (Inv. 1463).

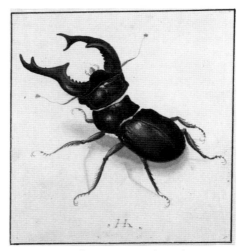

37.1 Hans Hoffmann, *Stag Beetle.* Berlin,
Staatliche Museen Preußischer Kulturbesitz,
Kupferstichkabinett (see note 2).

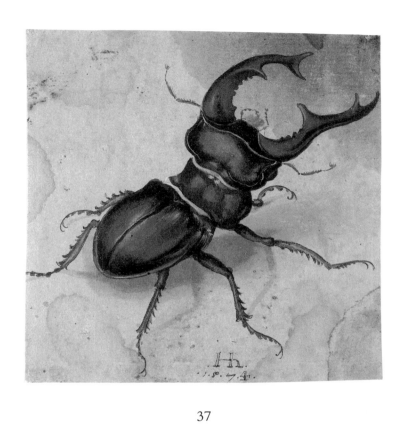

37

38

GEORG HOEFNAGEL

Stag Beetle

Watercolor and body color on vellum,
brush, pen, heightened with white,
encircled in a gold oval
Top center, the inscription: *SCARABEI
VMBRA.*

Right, the figure *V*; on the opposite page, in red,
the inscription: *Cornúbús armatus generat se
Cantharús ipsúm Christus homo suimet, solus origo
fúit. A : S.*

Page size 143 x 184 mm, maximum width of
oval 140 mm

Washington, Collection of Mrs. Lessing
J. Rosenwald, on deposit at the National
Gallery of Art,
Hoefnagel, vol. I, *Ignis*

PROVENANCE: Emperor Rudolf II • Rüpfel •
Bürgermeister Niggl • Carl August von
Brentano • F. S. Eliot • Henry Huth • J. H.
Huth • C.F.G.R. Schwerdt.[1]

BIBLIOGRAPHY: van Mander, 1617, p. 79 •
Sandrart, 1675, p. 169 • Eduard Chmelarz,
"Georg und Jacob Hoefnagel," in *JKSAK*
17/1896, pp. 285–288 • Karl Chytil, *Die Kunst
in Prag zur Zeit Rudolfs II.* 2d ed. (Berlin, 1921),
p. 46 • Eduard Kris, "Georg Hoefnagel und der
wissenschaftliche Naturalismus," in *Festschrift
Julius Schlosser zum 60. Geburtstag* (Zurich,
Leipzig, Vienna, 1927), pp. 234 ff. • C.F.G.R.
Schwerdt, *Hunting, Hawking, Shooting Illustrated
in a Catalogue of Books, Manuscripts, Prints and
Drawings, Collected by C.F.G.R. Schwerdt,* vol. 2
(London, 1928), pp. 335–339 • "Unique
Natural History Illustrations: XVIth Century
Miniatures from the Emperor Rudolf's
Manuscript," in *Illustrated London News,* March
23, 1946, pp. 328–329 • "An Eye for Nature.
Hoefnagel's Exquisite Miniatures for the
Emperor Rudolf's Natural History," *Illustrated
London News,* February 18, 1961, Suppl. • Ingvar
Bergström, "Georg Hoefnagel, le dernier des
grands miniaturistes flamands," in *L'Oeil*
101/1963, pp. 2–9, 66 • Thea Wilberg
Vignau-Schuurmann, *Die emblematischen
Elemente im Werke Joris Hoefnagels* (Leyden,
1969), vol. I, p. 9 • Jaromír Neumann, ed., *Die
Kunst der Renaissance und des Manierismus in
Böhmen* (Hanau, 1979), p. 208 • Exhibition Cat-
alogue Stuttgart 1979/80, I, p. 91 • Exhibition
Catalogue *Lessing J. Rosenwald: Tribute to a
Collector* (Washington, National Gallery, 1982),
pp. 169, 170, nos. 57a–d • Exhibition Catalogue
*Drawings from the Holy Roman Empire 1540–
1680* (Princeton, The Art Museum and other
places, 1982/83), pp. 154–157 • M. L. Hendrix,
*Joris Hoefnagel and the Four Elements: A Study in
Sixteenth-Century Nature Painting* (phil. diss.,
Princeton University, 1984). I am grateful to
Miss Hendrix for making a copy of her thesis
available to me.

Georg Hoefnagel's version of the Dürer stag
beetle is sheet *V* of an album containing eighty
miniatures with illustrations of insects. All the
paintings are executed on particularly fine,
white vellum, all encircled by the same-size

delicate gold oval, all numbered and inscribed
in Latin. The title page carries the inscriptions
Ignis and *Animalia Rationalia et Insecta qui fecit
Angelos spiritus suos: Et ministros suos Ignan ven-
tem.* This is the first of four original albums
uniformly bound in red leather, containing
274 miniatures[2] altogether, plus six empty
ovals. The creatures of the animal kingdom[3]
are classified according to the four elements,
Fire, Earth, Air, and Water. Some of the min-
iatures bear Hoefnagel's monogram, and a few
also are dated, so it may be deduced that the
albums were assembled between 1575 and
1582. Beyond any doubt, these constitute the
illustrated natural history that Carel van
Mander and Joachim von Sandrart were refer-
ring to when they said that Georg Hoefnagel
had produced four such volumes for Emperor
Rudolf II, *eines von den vierfüßigen, das andere von
den kriechenden, das dritte von den fliegenden und
das vierte von den schwimmenden Tieren, vor deren
jedes er tausend Goldcronen bekommen . . .* ("one
of four-footed, another of crawling, the third
of flying, and the fourth of swimming crea-
tures, for each of which he received a thousand
gold crowns").

Georg Hoefnagel reproduces the Dürer
model with remarkable accuracy. There is no
doubt that his version, superior to Hoffmann's
in its painting, represents one of the most care-
ful Dürer copies that we know. Critical com-
parison of all the copies reveals only minimal
similarities or differences, but the relevant de-
tails do make possible an initial grouping. So,
for example, the abdomen of Hoefnagel's bee-
tle is more spade-shaped, whereas Dürer's is
acorn-shaped, and the thorax is in a line with
the abdomen, less reared-up than the model.
Furthermore, the wing cases again vary from
Dürer's, having two dark, parallel, raised
ridges where they meet down the center of the
back, and the right antenna curves forward
while the left stretches out sideways. What is
surprising, however, is that these small, hardly
noticeable variations coincide with the minute
stag beetle, only 15 millimeters long, in
Dürer's *Madonna with a Multitude of Animals*
(Cat. 35).

Hans Hoffmann's studies (Cat. 37), on the
other hand, are more like the Getty beetle, but
vary from it in certain details that correspond

more to Hoefnagel's; namely, the more widely
flourished right mandible, the position of the
incurving labial palp between the two man-
dibles, the extended right foreleg, and the
forward-pointing tibia spines of the right mid-
dle leg, which in Dürer's version point the
other way (compare the corresponding leg on
the other side of the body). These differences
from Dürer's model look like corrections, pre-
sumably based on fresh observation. In truth to
nature, Hoefnagel's version is far superior to
Dürer's.[4]

Georg Hoefnagel's miniatures are appar-
ently based on an extensive collection of stud-
ies that, in accordance with late medieval stu-
dio tradition, constantly served as the basis and
pattern for new ones. In 1592, many years after
the natural-history picture atlas for Emperor
Rudolf II had been assembled, Hoefnagel's son
Jakob was able to produce *Archetypa studiaque
patris . . . ,*[5] obviously using the basic stock
of this pattern collection. Duplicated by cop-
per engraving, they experienced wider circula-
tion as pattern sheets for fruit, flowers, and
insects, including Dürer's stag beetle. And that
Jakob Hoefnagel could use the very same
motifs, only slightly adapted, more than thirty
years later shows how popular they were.[6]

NOTES

1 According to Exhibition Catalogue Princeton
 1982-83, p. 154.
2 Vol. I, *Ignis* — *Animalia Rationalia et Insecta,* 80
 miniatures (78 + 2); vol. II, *Terra* — *Animalia
 Quadrupedia et Reptilia,* 71 miniatures (70 + 1);
 vol. III, *Aqua* — *Animalia Aquatilia et Cóchiliata,*
 58 miniatures (57 + 1); vol. IV, *Aier* — *Animalia
 Volatilia et Amphibia,* 71 miniatures (69 + 2); see
 Schwerdt, 1928.
3 Exceptions are vol. I, ills. I and II, portraits of
 "the hairy man" Pedro Gonzales and his family.
4 I am grateful to G. Pass for indicating some of
 the gross inaccuracies from the zoological point
 of view of Dürer's study as compared with the
 real creatures.
5 *Archetypa studiaque patris Georgii Hoefnagelii
 Jacobus F. genio duce ab ipso scalpta, omnibus philo-
 musis amicé D:ac perbenigné communicat* (Frank-
 furt, 1592).
6 See his *Diversae Insectarum Volatilium . . . , bei
 Nicolao Joannis Vißcher,* Anno 1630.

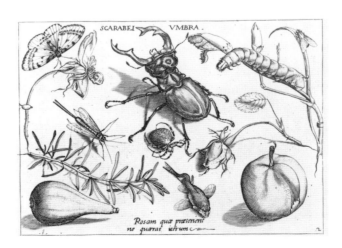

38.1 Jakob Hoefnagel, *Stag Beetle,*
copper engraving from *Archetypa
studiaque patris . . . ,* 1592, Part
two, sheet 2. Vienna, Graphische
Sammlung Albertina.

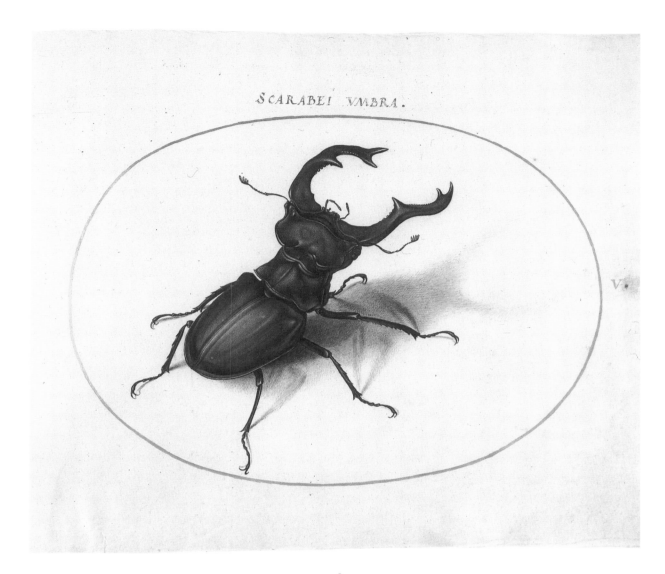

SCARABEI VMBRA.

V.

38

39

GEORG HOEFNAGEL

Stag Beetle with Outspread Wings and Scorpion

Watercolor and body color on vellum,
brush, pen, heightened with white,
encircled in a gold oval
Top and bottom, traces of inverted offprints of
inscriptions from the page originally opposite
Top center, the inscription in red:
SVB OMNI LAPÍDE DORMÍT SCORPÍVS.
Bottom center, in lilac: *OCTÍPEDEM NE
EXCÍTES.*
Right, in gold: the figure *VII.*
Above the stag beetle: the figure *1*;
in front of the scorpion: the figure *2*
Page size 143 x 196 mm, maximum width of
oval 139 mm

Berlin, Staatliche Museen Preußischer
Kulturbesitz, Kupferstichkabinett,
Inv. KdZ 4807

BIBLIOGRAPHY: Bock, 1921, I, p. 46, no. 4807 •
Exhibition Catalogue Münster 1979/80, p. 58,
no. 23.

The little study *Stag Beetle* (Cat. 36) belongs
next to the *Hare* (Cat. 43) as one of Albrecht
Dürer's most copied works. Quite inevitably
the fame of the motif invited delightful adap-
tations; like the extremely foreshortened Man-
nerist variants of the *Hare,* and the back view,
in a sense the mirror image (Cat. 14), of the
Dead Blue Roller, the *Stag Beetle with Outspread
Wings and Scorpion* is obviously one of the

39.1 Georg Hoefnagel, *Stag Beetle with Flying
Insects,* watercolor and body color on vellum.
New York, Metropolitan Museum of Art.

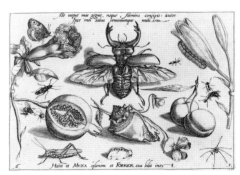

39.2 Jakob Hoefnagel, *Stag Beetle,* copper
engraving from *Archetypa studiaque patris ,*
1592, Part one, sheet 6. Vienna, Graphische
Sammlung Albertina.

metamorphoses of Dürer's motif resulting
from its resurrection and elaboration by the
artists of the Dürer Renaissance.

In this image of the stag beetle, the out-
stretched, delicate, textured hind wings are
visible below the hard wing cases, providing a
typical example of the creative adaptation of a
famous prototype in the spirit of the late Re-
naissance. To a certain extent in the style of
Dürer, but inventively varying the prototype,
the work reflects the artistic taste of an intelli-
gent public, as Carel van Mander comments in
regard to an engraving by Hendrik Goltzius.[1]

Georg Hoefnagel, in his illustrated natural
history for Emperor Rudolf II, has unmistak-
ably expressed the Dürer connection he in-
tended by placing his artistic flying beetle im-
mediately after his copy of Dürer's crawling
one. The Roman numerals alongside prove
this: the Berlin sheet bears the original figure
VII, while the one in the Rosenwald volume
once had the number *VI,* now altered to *V* by a
cruder hand.[2] The stag beetle with extended
wings occurs several times in Georg Hoefna-
gel's work. It returns, for example, as the cen-
tral figure of a miniature showing flying in-
sects (ill. 39.1),[3] an emblematic pictorial
concept such as he tended to favor.

Georg Hoefnagel felt his creation was good
enough to have his son Jakob duplicate it as an
engraving (ill. 39.2). Like the crawling stag
beetle, its flying counterpart also appears in the
already mentioned collections *Archetypa* and
Diversae Insectarum Volatilium (see Cat. 38,
notes 5, 6). Evidently, Hoefnagel's image also
influenced his contemporaries; Jacques de
Gheyn was inspired to make a very similar
study, diverging only slightly in the position
of the wings and mandibles (ill. 39.3).[4] His
variant also found followers; the draughtsman
of the Munich prayer book for Albrecht V re-
ferred to it (ill. 39.4),[5] but it seems question-
able to attribute the prayer book miniatures to
Hoefnagel himself[6] or to Flegel[7] on the
grounds of this connection. The features men-
tioned point rather in the direction of de
Gheyn.[8]

NOTES

1 van Mander, 1617, pp. 243–247.
2 This is based on the numbering, the style of
writing, and the materials used. The Rosenwald
volumes clearly show the clumsy correction.
The Roman numerals originally written in
(mussel) gold were touched up with the
alteration in oil gold (or gold bronze?), which
has oxidized, while the original numerals have
not. Bock's assumption (Bock, 1921, nos.
4805–4820) that the miniatures in the Berlin
Kupferstichkabinett have nothing to do with the
work for Emperor Rudolf II must be contra-
dicted. All the drawings are of similar size and
style, originally formed part of the work, and
were carefully removed at some time still
unknown to us.
3 New York, Metropolitan Museum of Art,
Inv. 63.200, Gift of Mrs. Darwin Morse, 1963.
4 Jacques de Gheyn Album, Fondation Custodia
(Coll. F. Lugt), Paris, Institut Néerlandais, Inv.
5655, dated 1604.
5 Munich, Bayerische Staatsbibliothek, Cod. lat.
23640, fol. 79r. See Thea Vignau-Wilberg, *Das*

*Gebetbuch Kurfürst Maximilian I. von Bayern,
Bayerische Staatsbibliothek München, Clm 23640*
(Frankfurt, 1986), pp. 88, 103, fig. 20, wherein
she shows that this prayer book copies de
Gheyn's model and was executed by an artist of
the Prague court between 1604 and 1612.
6 Hans Kauffmann, "Dürer in der Kunst und im
Kunsturteil um 1600," in *AGNM* 1940–1953,
pp. 28–29.
7 Müller, 1956, p. 158, no. 23.
8 F. Hopper Boom, "An early flower piece by
Jacques de Gheyn II," in *Simiolus,* vol. 8,
1975/76, no. 4, pp. 195–198.

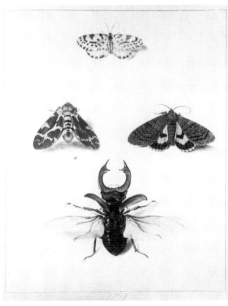

39.3 Jacques de Gheyn,
Butterflies and Stag Beetle, 1604,
watercolor and body color on vellum.
Paris, Institut Néerlandais.

39.4 German or Netherlandish, after 1604, *Stag
Beetle and Flowers,* miniature from the Prayer
Book for Albrecht V. Munich, Bayerische
Staatsbibliothek.

SVB OMNI LAPIDE DORMIT SCORPIVS.

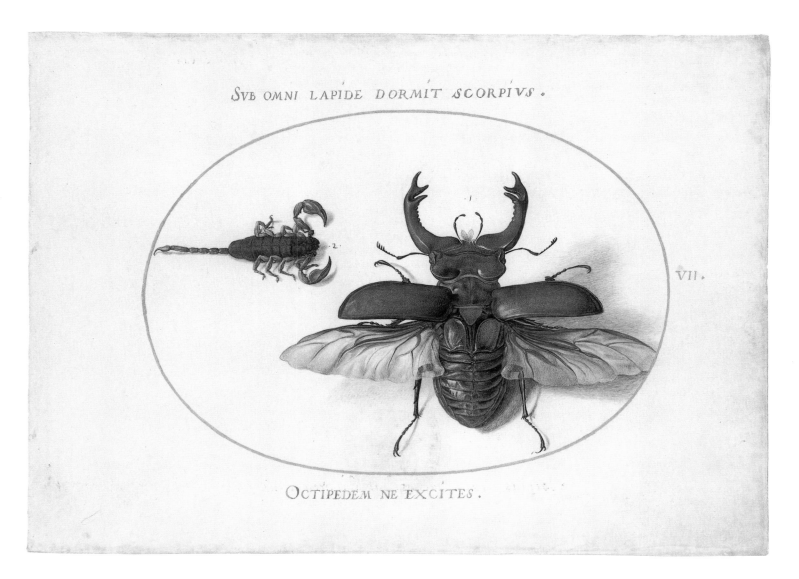

OCTIPEDEM NE EXCITES.

39

40

FRANZ BUCH

Two Weasels

Brush in gray and brown on paper,
light preliminary brush drawing in places
On the reverse the inscription:
einn Wasselkenn/frantz/b . . . 1573 18 junius.
158 x 241 mm
Berlin, Staatliche Museen Preußischer
Kulturbesitz, Kupferstichkabinett, Inv. KdZ 9

PROVENANCE: Posonyi • Posonyi-Hulot.

BIBLIOGRAPHY: Auction Catalogue Posonyi/
Montmorillon 1867, pp. 70, 71, no. 349 •
Exhibition Catalogue Berlin 1877, pp. 5, 6,
no. 9 • E., p. 79 • Killermann, 1910, p. 48 •
Bock, 1921, I, p. 36, no. 9 • W. II, pp. 78, 80,
no. 368 • P. II, p. 132, no. 1366 • Killermann,
1953, p. 22 • Winkler, 1957, p. 182 • St. II, p. 616,
no. 1502/13 • Exhibition Catalogue Berlin 1984,
pp. 50, 51, no. 48r.

The rather imprecise rendering of this mar-
tenlike beast of prey makes it hard to determine
its exact species.[1] It was originally called a
beech marten, and finally more closely identi-
fied by Killermann[2] as a great weasel or stoat
(*Mustela erminea* L.) in summer coat.

The study is first mentioned in the Posonyi
catalogue as "Dürer," and was acquired by
Lippmann for Berlin[3] as part of the Posonyi-
Hulot Collection. Still Ephrussi acknowledges
it as Dürer's work, with reference to the bold
watercoloring. Lippmann, however, did not
include it in the catalogue of Dürer's works,
and Bock also had reservations; he certainly
praised its high quality, but deemed the execu-
tion to be only "in the style" of Dürer. It was
Winkler[4] who first argued that the study had
to be "seriously taken into consideration as by
Dürer himself because of the simple, masterly
way in which the modeling, particularly of the
top animal, is worked with the brush." The
portrayal of two animals, almost the setting off
of the one study against the other, as in the
Mouth of an Ox (W. 366, 367), the *Head of a
Roebuck* (Cat. 54), and *Studies of a Hare* (Cat. 42)
seemed to him additional proof of Dürer's au-
thorship.[5]

For Panofsky the attribution to Dürer is very
questionable, even though in the main he as-
sumes the dating to be 1503. Strauss, on the
other hand, places the study with Dürer's 1502
work. Recently[6] it has been ascribed to the
Swabian artist Franz Buch on the basis of its
style and the inscription on the reverse
"*frantz/b . . . 1573*" in that painter's hand-
writing as known from his other works.[7] As
Buch's drawings are mostly copies, there may
still be the possibility that here too he used a
model, perhaps by Dürer.

The study is certainly drawn lightly and
washed in with a fluent brush, but the coloring
nevertheless gives a flat and lifeless impression.
Certain details, the back legs for example,
show remarkably hard contrasts, while others,
like the eyes, are not brought out. The attribu-
tion to Franz Buch seems to be entirely justi-
fied.

There are several artistically admirable por-
trayals of martens from the sixteenth century,
but not one of them gives the slightest hint
that it was based on a model by Dürer. The
original attribution of the *Two Weasels* to
Dürer obviously rested on faulty diagnosis of
style. Together with Georg Hoefnagel's stud-
ies *Polecat* and *Marten* (see Cat. 41, ill. 41.2), the
only thing this work dated 1573 shows is that
in the latter third of the sixteenth century,
there was a revival of animal studies in a man-
ner influenced by Dürer.

NOTES

1 I am grateful to G. Pass for this information.
2 Killermann, 1910, p. 48.
3 Exhibition Catalogue Berlin 1877.
4 W. II.
5 Winkler, 1957, p. 182.
6 Exhibition Catalogue Berlin 1984; see ill. of the
 signature on the reverse side, appendix II.
7 See W. II, p. 80, under no. 368, note 1; on
 Franz Buch, see also Exhibition Catalogue Stutt-
 gart 1979/80, I, p. 14.

40

41

HANS VERHAGEN DEN STOMMĒ VAN
ANTWERPĒ

Beech Marten

Watercolor and body color on paper, brush,
heightened and corrected in white
Watermark indistinct (shield with flower and
capital letters?)
Bottom center, the inscription:
Hans Verhagen den stommē van Antwerpē:
210–215 x 394 mm
Vienna, Österreichische Nationalbibliothek,
Handschriften- und Inkunabelsammlung, Cod.
min. 42, fol. 116r

PROVENANCE: Emperor Rudolf II • Imperial
Treasure Chamber • Imperial Court Library
(1783).

BIBLIOGRAPHY: Not described.

The characteristic appearance of the animal is
captured in a side view, with outstretched,
slightly lifted tail, on a branch that crosses the
picture plane. The artist has succeeded in re-
producing the impression of the color and the
thick, soft fur with unbroken, economical
strokes. In a neat but unusually striking way,
his portrayal offers a vivid picture of the beech
marten (*Martes foina* Erxleben),[1] using artistry
in the service of precise zoological informa-
tion.

This previously unpublished drawing from
a late sixteenth-century album introduces us to
a hitherto unknown artist. Like two other
works from the same album,[2] this one bears the
inscription *Hans Verhagen den stommē van Ant-
werpē:*. Although we know his name, we know
nearly nothing about the man. He is found
neither in artists' lexica nor in the archives of
the Rudolfian court. Further unsigned animal

studies in Berlin may well be ascribed to him,
but other work by his hand or news of him
is unknown. Stylistically, Verhagen's animal
pictures are akin to the studies in an album in
the Rijksprentenkabinet in Amsterdam, which
are grouped under the name "Lambert Lom-
bard" (ill. 41.1). However, the marten or wea-
sel studies included there also coincide for-
mally with those that we know by Georg
Hoefnagel. According to Boon,[3] the works in
his album were done only after Lambert Lom-
bard's death, probably after 1570 and before
1585, and by various artists.

The inscriptions on Verhagen's study de-
serve particular attention, showing as they do
typical features of Georg Hoefnagel's hand-
writing. Comparison with lines written by
Hoefnagel in the volumes of his natural his-
tory for Rudolf II proves this beyond ques-
tion.[4] It is to be supposed that Hoefnagel was
in possession of this and other works by this
artist, and copied some of them. His style,
above all the rendering of the fur (compare ill.
41.2), seems to have been influenced by Verha-
gen.[5] M. L. Hendrix goes into this in her dis-
sertation. She (erroneously) considers the
works to be enlarged, autograph copies by
Georg Hoefnagel of his own studies in the *Four
Elements.*

Verhagen's work bears no direct relation to
Dürer. Together with the *Two Weasels* (Cat.
40) and another study, erroneously ascribed to
Dürer but more likely by Georg Hoefnagel,
which earlier was in Paris,[6] and yet another
weasel drawing[7] associated with Cranach's
name, the work can only stand as one more
analogous example of such sixteenth-century
animal studies arising from an interest in na-
ture. The two last-named works have, for their
part, inspired a considerable following. The
beech marten pictures were ascribed to Dürer
for the first time in the nineteenth century,
which contributed to the unclear image of his
nature studies that we confront today.

NOTES

1 I am grateful to G. Pass for the identification.
2 Cod. min. 42, fol. 26r (eagle) and fol. 121r
(tortoise); see also M. L. Hendrix, *Joris Hoefnagel
and the Four Elements: A Study in Sixteenth-
Century Nature Painting* (phil. diss., Princeton
University, 1984), pp. 160 ff.
3 See K. G. Boon, *Catalogue of the Dutch and
Flemish Drawings in the Rijksmuseum, Netherland-
ish Drawings of the Fifteenth and Sixteenth
Centuries,* 2 vols. (The Hague, 1978), pp. 223,
224, nos. 559–606.
4 Particularly characteristic, for example, are the
forms of the letters *H, h, v, A,* and *w.*
5 I am grateful to Peter Dreyer for information
concerning further unsigned works in Berlin by
this artist. During the symposium organized on
the occasion of the exhibition, Dreyer demon-
strated the priority of the studies by Hans
Verhagen in comparison with works by
Hoefnagel, Hans Bol, and others. He connected
a considerable group of animal studies that stand
out by virtue of their objective observation with
this previously unknown artist whose activities
can be traced also in Antwerp sources. For the
extensive discussion of the relationships, see the
reports of the symposium in *JKS* 82/1986.
6 Art market (?). The work appears in the
catalogue of the Collection Guiraud (Paris,
Hotel Drouot, June 14, 1956, no. 47; pen and
watercolor; 85 x 180 mm) as "ascribed to
Dürer"; Hoefnagel used similar weasel images
in his miniatures for Emperor Rudolf II
(Washington, National Gallery, Rosenwald
Collection, vol. 1, fol. XXXXIV) and in the
missal for Ferdinand of Tyrol (Vienna,
Österreichische Nationalbibliothek, Cod. 1.784,
fol. 36r).
7 *Stoat,* body color, brush, on blue Venetian paper;
105 x 310 mm; ill. in *TBM* 99/1957 (Sep-
tember), p. VIII, as "formerly ascribed to Lukas
Cranach the Elder"; see also Auction Catalogue,
Sotheby's, November 18, 1982, no. 1, entered as
"Italian, 17th Cent." The composition in Cod.
min. 42, fol. 15 below, is based on the same
prototype.

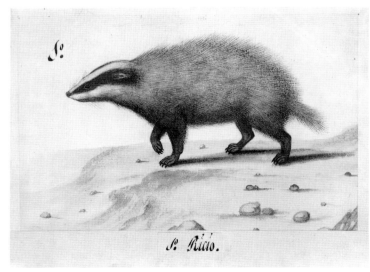

41.1 Netherlandish, c. 1570, *Badger,*
watercolor and body color on paper, Lambert Lombard Album.
Amsterdam, Rijksmuseum, Rijksprentenkabinet.

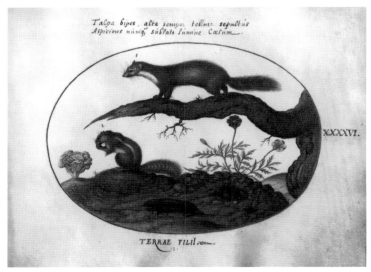

41.2 Georg Hoefnagel, *Marten,* watercolor and body color on vellum.
Washington, D.C., Collection of Mrs. Lessing J. Rosenwald,
on deposit at the National Gallery of Art (see note 6).

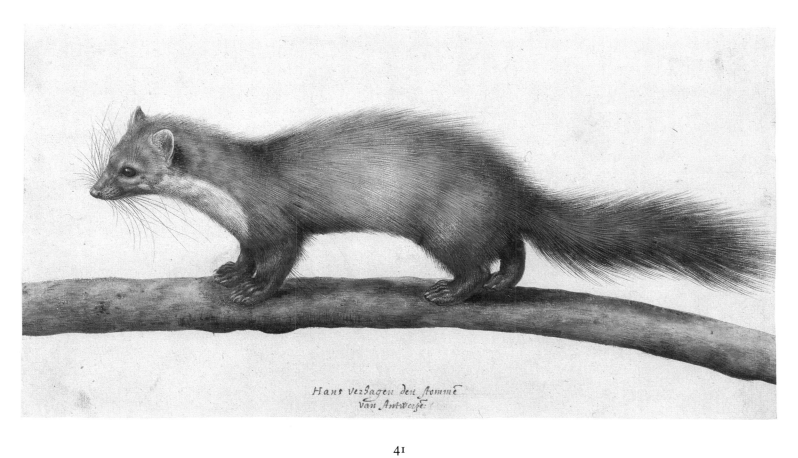

Hans verhagen den stomme
van Antwerse:

41

Dürer's Hare and Its Copies

With his watercolor *Hare* (Cat. 43), Dürer created what was probably the first example of a self-contained, figurative nature study. With typical, incomparable artistry, the image combines the physical appearance and the personality of the animal, and Dürer's pride in it as a complete entity is expressed by his carefully drafted monogram and date. His creation has proved to be of timeless validity: it became not only the leitmotiv of the Dürer Renaissance, but also, as it soon appeared, the epitome of the hare in art. This found visible expression in numerous copies in the last third of the sixteenth century. Winkler,[1] with Koschatzky and Strobl[2] and Strauss[3] in his wake, lists seven copies (numbers 1–7), to which we add a further six:

1 Berlin, 1528, Staatliche Museen Preußischer Kulturbesitz, Kupferstichkabinett (Cat. 52)
2 Bremen,[4] 1582, allegedly Kunsthalle (H. Hoffmann)
3 Dresden, Staatliche Kunstsammlungen, Kupferstich-Kabinett (Cat. 46)
4 Dublin, National Gallery of Ireland (ill. 45.1)
5 Rome, Galleria Nazionale d'Arte Antica, Palazzo Barberini (Cat. 48)
6 Weimar, Schloßmuseum (ill. 45.2)
7 Paris, Musée du Louvre, Cabinet des Dessins (Cat. 45)
8 Berlin, 1587, Staatliche Museen Preußischer Kulturbesitz, Kupferstichkabinett (ill. 53.1)
9 New York, Ian Woodner Family Collection (formerly K. Meissner, Zurich/Zollikon; Cat. 53)
10 Private collection (Cat. 47)
11 England,[5] private collection
12 New York, private collection (formerly London, Kate Ganz Gallery; ill. 46.1)
13 Here I would like to add Hans Hoffmann's *Hare among Grasses and Wildflowers in a Glade* (Cat. 49), which is in fact a panel painting, but on the grounds of preparatory studies is closely linked with the graphic œuvre.
A further example mentioned by Winkler,[6] which, according to Baldinucci, 1631, was owned by the sculptor Pietro Tacca, can be identified with no. 5.

In this connection, one should not forget the entries in the Imhoff *Geheimbüchlein*:

fol. 70r, no. 4: *Ein haasen kopff mitt 4 ohren vom Albrecht Dürer auff pergament* . . . ("Head of a hare with 4 ears by Albrecht Dürer on vellum . . . ")

fol. 70v, no. 15: *Ein haaß auf papier, so Albrecht Dürer gemalt haben soll* . . . ("A hare on paper, said to be painted by Albrecht Dürer . . . ")
fol. 71v, no. 15: *Ein Künstlicher haas, auf pergament, vom Hanns Hoffman. Ist in Ebenholtz mitt silber geziehrt eingefast* . . . ("An artistic hare, on vellum, by Hans Hoffmann. It is framed in ebony ornamented with silver . . . ")
fol. 76v: *Item einen haßen, auf papier gemahlt, in schwartz gepaist holtz eingefast, von obiger [Hannßen Hofmans] hand* . . . ("Item, a hare, painted on paper, framed in black-painted wood, by the above [Hans Hoffmann's] hand . . . ")

These copies and imitations are all of high quality and mostly unsigned, which meant that, as time went by, they became less and less known for what they were, and came to be ascribed to Dürer himself instead. Not until science became concerned with Dürer and his imitators in our own century was it discovered that many of the copies came from the Nuremberg artist Hans Hoffmann. It appears that he was friendly with Willibald Imhoff,[7] who had numerous Dürer drawings in his collection; besides the *Hare* there was also the *Dead Blue Roller* (Cat. 10) and the *Wing of a Blue Roller* (Cat. 22), which Hoffmann copied. Whereas, as Thausing[8] put it, people originally "went so far as to ascribe every watercolor hare to Dürer," now that Hoffmann has been recognized as a Dürer copyist, they go to the other extreme and subsume every one of the copies under his name.

The copies and variants from the sixteenth century show by their stylistic variety that it was not just Hoffmann but many other artists as well who had access to Imhoff's collection. Until now, this situation has not been further studied. All the indications are that not only Hoffmann, but also Georg Hoefnagel found his way to the coveted prototypes. In my opinion, however, it is not simply a case of sorting out Hoffmann's share of the surviving copies of the *Hare* from Hoefnagel's because the peculiarities of yet a third copyist are recognizable, one whose individuality has hitherto been completely overlooked. He is the painter active in the Munich court, who "completed" Hans Burgkmair the Elder's altarpiece *John the Evangelist on Patmos* (ill. 1) in the early seventeenth century,[9] and was also responsible for the copy of the *Hare* in Dresden and the one from the former Lanna Collection, now in a private collection in New York (see discussion at Cat. 46).

Certainly Hans Hoffmann is not only the most noteworthy of Dürer's imitators, but also the most individual. He did not copy Dürer's model in the strict sense, but interpreted it anew. None of his versions remains as a mere imitation; he surrounds Dürer's hare with plants, insects, and other small animals (see Cat. 49), making, as it were, a synthesis between Dürer's *Hare* and his *Large Piece of Turf* (Cat. 61); indeed, they are far less copies of

Dürer's famous study than inventive adaptations and variations inspired by it and trying to outdo it.

Of Hoffmann's copies, only one bears his monogram and the date 1582 (Cat. 47). Stylistically, however, at least four others display the same characteristic traits: they all have in common the stippling technique used for the fur on the ears, also the same way of showing the fur on the back, rhythmically organized in small tufts running to a point, which are clearly recognizable as different from the original.

The artistic handwriting of Georg Hoefnagel seems to be recognizable in the three copies that follow Dürer's drawing closely (Cat. 45, ills. 45.1, 45.2). They are so faithful that they could be taken almost as substitutes for the original. Typical of these drawings is the fine brushwork. The soft fur is composed of thickly set dots, and the surface of the head and ears is worked in rich detail. A peculiarity of these copies is the shape of the right eyelid, drawn as two consecutive arcs, while in Dürer's *Hare* it describes a simple S bend. The three drawings also display their congruity in the tumid-looking thickening along the right ear, and show that they are unequivocally by the same hand, with brushwork and drawing discernibly akin to Georg Hoefnagel's miniature work.

Belonging to neither group are the two copies dated 1502, in Dresden (Cat. 46) and in London. Their characteristics are a pointed head shape, the left ear strongly tapering at the end and oval-tipped, and the false Dürer monogram with the year to the right of it. This copyist was active at the Munich court in the early seventeenth century. He was responsible for the overpainting of Burgkmair's altar picture *John the Evangelist on Patmos* (ill. 1). His copy of the Dürer hare, inserted in the landscape — and today hidden by the frame — bears the same distinctive traits.

NOTES

1 W. I, p. 171, under no. 248.
2 K.-Str., p. 166, under no. 24.
3 St. II, p. 594, under no. 1502/2.
4 See Pilz, in *MVGN* 51/1962, p. 260, no. 21. The study mentioned only by Winkler and often cited is untraceable; it seems questionable whether it was ever in Bremen at all. Heller (II, p. 131, c), however, mentions in the Grünling Collection in Vienna: "A sitting hare, very finely painted on vellum, by Hans Hoffmann . . . whose sign Hh 1582 is above, in the center. It is an excellent copy after Dürer. Height 8Z. 3L., width 7Z." Grünling sold many of his Dürer drawings to Bremen, but there was never a hare mentioned among them. Perhaps when Winkler made his notes he mistook a memorandum referring to this transaction. The study appears neither in the old Bremen inventory nor in the list of wartime losses. Professor Busch, director of the Bremen Kunsthalle, in the course of his dealings with the Bremen Dürer drawings and related material, which go back to before World War II, assures me that he has never seen the study in question. So we assume that an error by

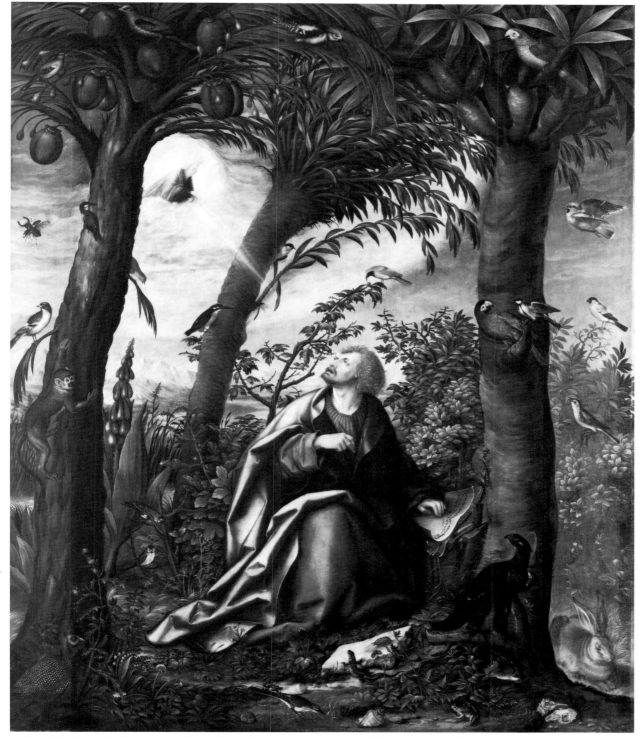

1 Hans Burgkmair the Elder, *John the Evangelist on Patmos,* 1518, center panel with early seventeenth-century additions, oil on panel. Munich, Alte Pinakothek.

Winkler, made during the wartime upheaval and not checked for a long time, was allowed to creep into the literature.

5 This copy, or secondhand copy, which is in very poor condition (like Cat. 47), I know only from the photograph in the Witt Library, London (Neg. no. B 57/888, ex 2nd Duke of Westminster).

6 W. I.

7 H. II, p. 72.

8 Th. II, p. 303, note 1.

9 Munich, Alte Pinakothek, Catalogue II, *Altdeutsche Malerei,* compiled by Christian Altgraf zu Salm and Gisela Goldberg (Munich, 1963), pp. 53, 54.

42

ALBRECHT DÜRER

Studies of a Hare

Pen and black ink on paper
Dürer monogram in a foreign hand, top center;
the number *41,* bottom center
126 x 220 mm
London, The British Museum, Department of
Prints and Drawings. Inv. Sloane 5218–157

PROVENANCE: Sloane.

BIBLIOGRAPHY: E., p. 184, note 2 • Killermann,
1910, pp. 47, 48 • Campbell Dodgson, "Some of
Dürer's Studies for Adam and Eve," in *TBM*
48/1926, pp. 308–311 • Exhibition Catalogue
London 1928, p. 22, no. 206 • T. I, p. 76,
no. 255 • L. VII, p. 10, no. 782 • Fl. II, pp. 457,
560 • W. II, pp. 75, 77, no. 359 • P. II, p. 131,
no. 1346 • H. Tietze, 1951, p. 35 • Musper, 1952,
p. 125 • Killermann, 1953, p. 21 • Winkler, 1957,
pp. 164, note 1, 181, 182 • K.-Str., p. 166, under
no. 24 • Exhibition Catalogue London 1971,
p. 18, no. 96, and p. 19, under no. 100 •
Exhibition Catalogue Nuremberg 1971, p. 308,
no. 576 • White, 1971, p. 97, no. 32 • St. II, p. 592,
no. 1502/1.

Art-history literature has always referred to
this animal as a "rabbit," but only the round
shape of its skull is typical of one; on the other
hand, the coarser fur and longer ears, black-
tipped and not round-ended, make it far more
like a hare (*Lepus europaeus* Pallas).[1]

The loose, graphic jottings of fluent, rapidly
changing momentum and typically expressive
positions demonstrate Dürer's stupendous
sureness in spontaneous capturing of the es-
sence of a natural subject. With a few strokes
he expresses the wary crouch of the animal
sketched in a back view, gives the impression
of fulfilled contentment in the animal depicted
in side view, and conveys the alert watchful-
ness of the one on the bottom left. Nor is he
shy of unusual perspective, as in the head at the
top right. The hastily jotted studies on this
sketch sheet demonstrate to perfection how
Dürer's cunning and precise hand obeys his
sensitive and observant eye.

After Ephrussi had mistakenly associated the
sketches with the Basel *Holy Family in the Hall*
of 1509 (W. 466), Dodgson recognized the
connection of the crouching animal with the
Adam and Eve engraving of 1504 (B. 1; ill. 42.1).
Since Dürer's *Hare* in the Albertina (Cat. 43) is
dated 1502, this means the sheet can be firmly
dated within a narrow span.[2]

The hare has long been symbolic of fertility.
In late medieval imagery it could also have
been understood, perhaps in the theme of the
Fall, as one of the four temperaments, namely,
the representative of "sanguine sensuality."[3]
Dürer's engraving appeared at the turning
point between the Middle Ages and modern
times. New forms of expression were being

urged for traditional meanings; Dürer sought
these in nature and, by integrating his sketches
into the engraving, expanded a spontaneous
nature study into a meaningful symbol.

NOTES

1 I am grateful to G. Pass for this information. In
some later studies of the hare by Hoffmann,
rabbits (*Oryctolagus cuniculus* L.), in fact, were
the natural models (see Cat. 53, ill. 53.1, and
especially ill. 53.2).
2 W. II, p. 77, no. 359; St. II.
3 P. I, p. 85.

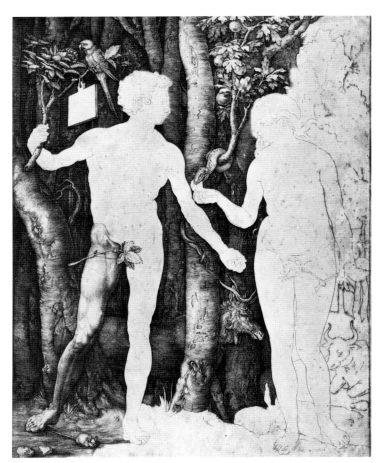

42.1 Albrecht Dürer, *Adam and Eve,* 1504, copper engraving, first state (B. 1, M. 1).
Vienna, Graphische Sammlung Albertina.

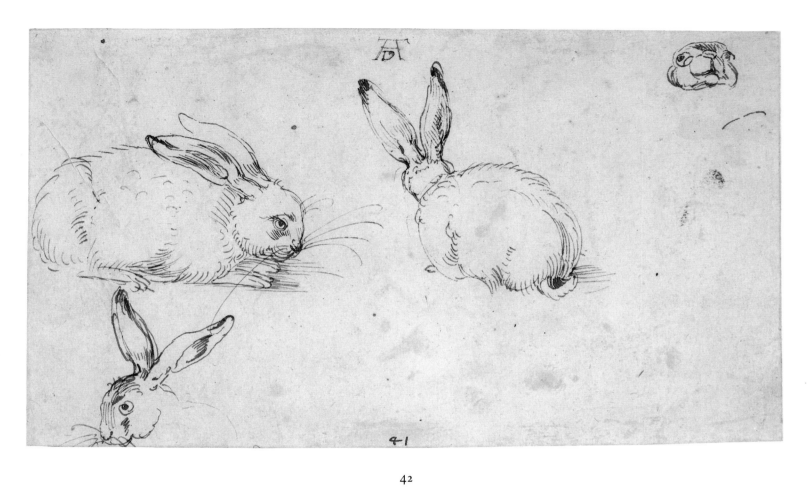

41

43

ALBRECHT DÜRER

Hare

Watercolor and body color
on very mildew-flecked paper,
brush, heightened with white,
traces of preliminary drawing on the right ear
Bottom center, monogram and the date *1502*
in pen and brown ink by the artist's own hand
250 x 225 mm
Vienna, Graphische Sammlung Albertina,
Inv. 3073 (D 49)

PROVENANCE: Imhoff • Emperor Rudolf II •
Imperial Treasure Chamber • Imperial Court
Library (1783) • Duke Albert of Saxe-Teschen
(L. 174).

BIBLIOGRAPHY: H. II, p. 82, no. 57, p. 117,
no. 134 • Eye, p. 189 • Exhibition Catalogue
Vienna 1871, p. 6, no. 79 • E., pp. 78, 80, 81 •
Th. I, p. 303 and note 1 • L. V, p. 5, no. 468 •
Springer, in *RKW* 29/1906, p. 555 • Meder, in
RKW 30/1907, pp. 180, 181, 182 • Killermann,
1910, p. 47 • Wölfflin, 1914, pp. 10, 30, no. 16 •
Max Deri, "Naturalismus, Idealismus, Expres-
sionismus," in *Einführung in die Kunst der
Gegenwart,* by Max Deri and others (Leipzig,
1919), pp. 71, 72 • Wölfflin, 1926, p. 166 • T. I,
p. 60, no. 197 • Fl. II, p. 366 • Albertina
Catalogue IV, p. 12, no. 49 • W. I, pp. 166, 167,
171, no. 248 • Helmuth Theodor Musper,
"Dürers Zeichnungen im Lichte seiner
Theorie," in *Pantheon* 21/1938, p. 106 • P. I,
p. 80 • P. II, p. 129, no. 1322 • H. Tietze, 1951,
pp. 35, 36 • Musper, 1952, pp. 124, 125 •
Killermann, 1953, pp. 8, 9, 21 • Winkler, 1957,
p. 182 • Benesch, 1964, pp. 336, 337, no. V •
White, 1971, p. 80, no. 23 • K.-Str., p. 166,
no. 24 • Hofmann, 1971, p. 39 • St. II, p. 594,
no. 1502/2 • Exhibition Catalogue Münster
1979/80, p. 51 • Anzelewsky, 1980, p. 110,
ill. 100 • Strieder, 1981, p. 203, ill. 235 • Koreny,
1984, pp. 20 ff.

Like *The Large Piece of Turf* (Cat. 61) among
the plant studies, the *Hare* (*Lepus europaeus*
Pallas) stands out among Dürer's animal stud-
ies as one that has never had its authenticity
seriously questioned.[1] It belongs, as Winkler
remarks, "to those works about which there is
really not much to be said, unless one makes a
fundamental statement. One must decidedly
reject it, or acknowledge it unreservedly as a
work of genius."

The popularity of this watercolor lies not
only in the subject and the "touching gentle-
ness of the crouching animal,"[2] in the render-
ing of its body's color and textural quality, or
the feeling of "soft fur and delicate tone struc-
ture,"[3] but also in the masterly, unsurpassable
sureness of the brushwork, which appears to
register each separate hair precisely. Only
closer inspection reveals how readily the eye
can be deceived. One becomes aware of aston-
ishing artistic economy, perceiving how the
basic color impression is established simply and
clearly, with a broad, fluent brush, in gray and

light brown, over which several layers of de-
tailed, very fine brush strokes work the optical
effect. On top of that, white is used, sometimes
mixed with yellow, or dark brown, to suggest
the hairs of the fur and the brightness of the
eyes. The many nuances of color gradations
and the differentiated brush strokes evoke the
illusion of thick, soft fur and throbbing life.
The luxurious long fur on the breast, the curly
fur on the forehead and ears, the fleecy fur on
the belly and thighs and the hairs on the back,
the whiskers on the nose, alive with tension,
and those above the eyes — each part is en-
dowed with individual expression.

The way Dürer has not just painted the
hare's portrait but also captured the animal's
personality has certainly contributed much to
the picture's fame.

Following Thausing's observation, Benesch
thinks that Dürer must have had the animal
sitting in his studio, "which is shown by the
window reflected in its pupils." According to
Białostocki, the window shape in the eye is a
classical *topos* that Dürer successfully intro-
duced into German art via Netherlandish
precedents.[4] Used to great effect for the first
time in Dürer's *Self-Portrait* of 1500, where it
has been interpreted as the "window of the
soul," it was frequently encountered from then
on, and was subsequently, as a formula, trans-
ferred to eyes of animals. For example, the
window crossbar is mirrored in the eye of the
reclining hart in Lukas Cranach the Elder's
Adam and Eve[5] of after 1537, although it is now
in the open air; and also is in Hoffmann's 1582
copy (Cat. 47) of the Dürer hare transported to
a garden.

The animal has been traditionally referred to
as a "young hare"; its body proportions, ear
length, and fur structure, however, are indica-
tive of a grown animal. Dürer probably drew it
from a live model; the sitting posture with
raised head and erect ears is completely lifelike.
Strieder's suggestion that it was a stuffed crea-
ture is out of the question. Stuffed animals
from such an early time are unknown, nor
would anyone have been capable of setting one
in such a natural pose.[6]

NOTES
1 Springer is the only exception.
2 K.-Str.
3 Benesch, 1964.
4 Jan Białostocki, "The Eye and the Window,
Realism and Symbolism of Light-Reflection in
the Art of Albrecht Dürer and His Predecessors,"
in *Festschrift Gert von der Osten* (Cologne, 1970),
pp. 159–176.
5 Lukas Cranach the Elder, *Adam and Eve,* oil on
panel: 171 x 63 cm; Dresden, Staatliche
Kunstsammlungen, Gemäldegalerie, Inv. G.
196A/AA.
6 I am grateful to G. Pass and his colleagues in the
Vienna Natural History Museum for this
information.

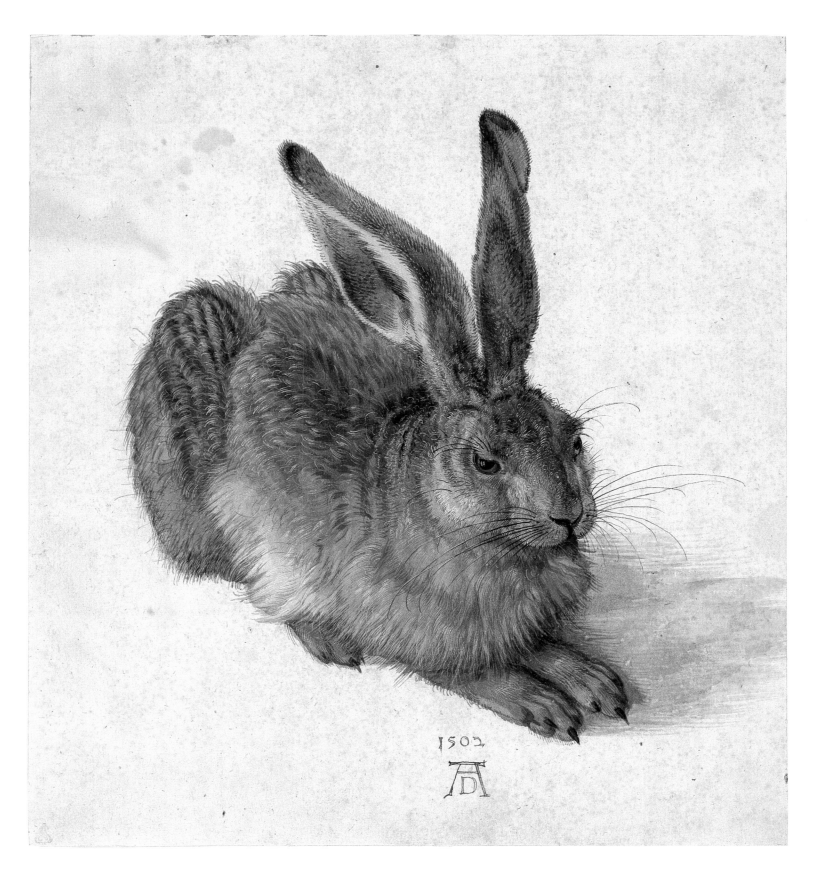

44

GEORG HOEFNAGEL

Hares, *Raurackl,* and Squirrel

Watercolor and body color on vellum,
pen, brush, heightened with white,
encircled with a gold oval
Top center, the inscription: *TVTE LEPVS
ES ET PVLPAMENTVM
QVAERIS.* Bottom center: *LEPVS DORMIT.*
Right: the figure *XXXXVII*
Above the *Raurackl,* the figure *1;*
above the right-hand hare,
the figure *2;* above the squirrel, the figure *3*
Page size 143 x 184 mm; maximum width
of oval 140 mm

Washington, Collection of Mrs. Lessing
J. Rosenwald, on deposit at the National
Gallery of Art,
Hoefnagel, vol. II, *Terra*

PROVENANCE and BIBLIOGRAPHY: See Cat. 38.

This picture of hares and a squirrel today
forms page *XXXXVII* of the second volume
(Terra — Animalia Quadrupedia et Reptilia) of
Georg Hoefnagel's four-volume illustrated
natural history for Emperor Rudolf II (see de-
scription at Cat. 38). The volume is no longer
complete, a few miniatures having been ex-
tracted in the nineteenth (?) century, including
yet another picture with hares and squirrels,
which is now in Berlin (ill. 44.1).[1]

As he did in the *Stag Beetle* (Cat. 38), Hoef-
nagel here again refers to Dürer. Inconspicu-
ous in the company of other animals, Dürer's
hare is not immediately noticeable. The other
animals are numbered, 1, 2, and 3; regrettably,
the intended captions were never written, al-
though sheets of paper for that purpose are
bound between the sheets of vellum.[2] It would
have been particularly interesting to know
what the scribe would have had to say about
the creature in the middle; this is the *Raurackl*[3]
—a hare with horns, a hybrid born of hunts-
men's tall stories, which through dissections
and pictorial remodeling was brought to syn-
thetic life.

Just as Hoefnagel placed his own back-view
variant of the *Stag Beetle* (Cat. 39) after the
three-quarter view inspired by Dürer (Cat.
38), so he inserted his straight front-view in-
terpretation of the hare (see ill. 44.1) after his
exact copy of it on this page.[4]

The rendering of the fur clearly shows
Hoefnagel's method of working: the water-
color underpainting in the palest basic color is
covered with short, rhythmically spaced little
strokes imitating the pile of the fur, overlap-
ping in progressively intense tones, concen-
trating and articulating the impression of
color. The final accent is added in white pig-
ment. Details of the coloring suggest that
Hoefnagel knew Dürer's original. He was in
ducal service in Bavaria from 1578 onward, and
he showed an interest in Dürer at the same

time as Hoffmann. As to whether he too had
access to the collection of Willibald Imhoff
the Elder, there is no proof.

In grouping the individual studies, includ-
ing the "Dürer quotation," as an ensemble,
and integrating them pictorially in the land-
scape, Hoefnagel's scientific, didactic minia-
tures foreshadow the animal still life and be-
come a forerunner of the Netherlandish
pastoral landscapes of the seventeenth century.

NOTES

1 Altogether about ten sheets must have been
taken from the volume. Of the original
miniatures, about eighty in all, it today contains
seventy, plus one empty oval. Regarding the
numbering of the miniatures, partly original (in
Berlin) and partly corrected (in Washington),
see Cat. 39, note 2.
2 Sheets of paper with colored lines demarking
the text area. Watermark: twin tower with
three crenellations, not precisely traceable in the
handbooks; similar ones appear possibly about
1600.

44.1 Georg Hoefnagel, *Hares and Squirrels,*
watercolor and body color on vellum.
Berlin, Staatliche Museen
Preußischer Kulturbesitz, Kupferstichkabinett.

3 Also known as *Wolpertinger* in Bavaria. The
writers of old zoological literature were
convinced of the existence of the horned hare,
or "stag-hare." I am grateful to the Deutsches
Jagdmuseum in Munich and Ing. J. Nussbaumer,
Vienna, for the literary information.
4 A study dating from about 1600, with various
motifs imitating Georg Hoefnagel's *Anima-
lia . . . ,* has been found in the Springell
Collection; it includes among others three illus-
trations of hares, in oil and tempera on paper.
See Auction Catalogue, Sotheby's, *Drawings from
the Springell Collection,* London, June 26, 1986,
no. 34.

TVTE LEPVS ES ET PVLPAMENTVM QVAERIS.

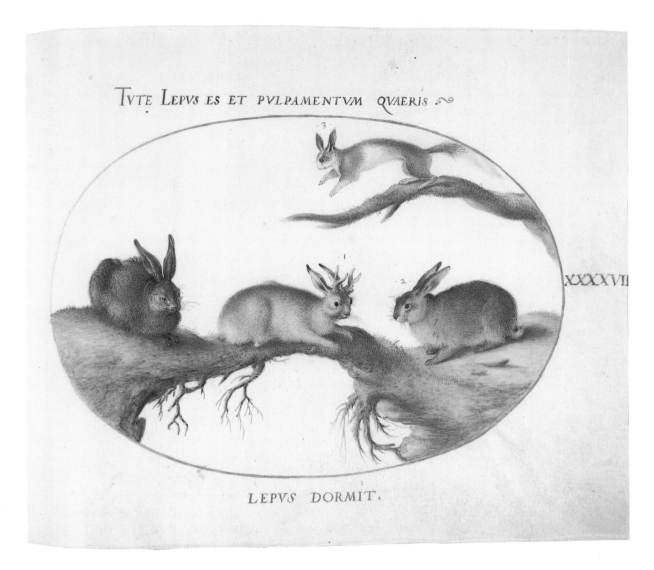

XXXXVII

LEPVS DORMIT.

44

45

GEORG HOEFNAGEL, ATTRIBUTED TO

Hare

Watercolor and body color on paper,
mounted on cardboard,
brush, heightened with white (oxidized),
damaged by damp, partly retouched
on the left ear
Bottom left center, traces of an erased
Dürer monogram
203 x 243 mm, closely trimmed
top and bottom

Paris, Musée du Louvre, Cabinet des Dessins
(L. 1886), Inv. RF 29072

PROVENANCE: Fontaine • Gay.

BIBLIOGRAPHY: T. I, p. 60, under no. 197 •
W. I, p. 171, under no. 248 and appendix pl.
XXIV above • P. II, p. 129, no. 1323 • Benesch,
1964, p. 336, under no. V • St. II, p. 594, under
no. 1502/2.

In his commentary on Dürer's *Hare,* Winkler
mentions this copy in the Louvre among those
known to him (see. p. 132), describing it as "an
effortless, fluently executed copy . . . looks
like an original by Dürer, but the work must
still be more carefully examined."[1] Placed be-
side the study in the Albertina, this watercolor
is astonishing in its remarkable fidelity to the
original. With almost no differences, they re-
semble each other in proportion and in the
faithful rendering of the fur and the long
whiskers on the nose and above the eyes. Only
careful examination reveals small discrepan-
cies. In the Paris version, the ridge of the nose
looks narrower, the contour of the forehead
between ear and eye longer. Particularly no-
ticeable, however, is the alteration to the right
eye: while the upper lid in Dürer's Vienna
study runs in an *S* shape, here it is more like a
wave, made up of two consecutive flat arcs.

Altered light values also help to differentiate
the two: in the Paris study the animal's cheeks,
ears, and flanks are a lighter color, making the
whole appearance more articulate. Compared
with the Vienna study, this one lacks the bold
confidence that transforms what is seen into a
powerfully affirmative artistic and graphic
statement. The execution is in completely dif-
ferent "handwriting"; fine brush strokes,
mainly on the head and breast, make the fur
look even more velvety and thicker than in the
Vienna prototype.

These particulars serve not only to distin-
guish between original and copy, but to link
the Paris version closely with two other copies
of Dürer's *Hare* that Winkler mentions, those
in Dublin and Weimar (ills. 45.1, 45.2). Even
though the Dublin version[2] is poorly pre-
served and thus hard to judge, and the Weimar
one[3] is carried out in a different technique,
akin to book-miniature illustration, all three
nevertheless correspond in the above points.
They have the same format, seem to have been

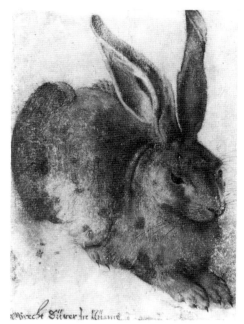

45.1 Georg Hoefnagel (?), *Hare,*
watercolor and body color on paper.
Dublin, National Gallery of Ireland.

based on the same tracing, and are without
doubt works by one and the same hand.

On the grounds of the fine brushwork used
for the fur, and also the pointillistic technique
suggested in the Paris version's treatment
of shading and employed as a principle in
the Weimar one, the works fit into the late
sixteenth-century group of Dürer copies. No
one has hitherto either noticed or looked into
their similarity in order to attribute them de-
finitively to one particular artist. Hans Hoff-
mann is too different stylistically to be consid-
ered, but there is much to be said for Georg
Hoefnagel. The way of drawing with little
dots and strokes, which can be observed partic-
ularly in the Weimar version, bears a great re-
semblance to the technique he used in his min-
iatures. His illustrations for Emperor Rudolf's
zoological picture atlas coincide closely in
some of their treatment of shadow. If I none-
theless hesitate to name him decisively as the

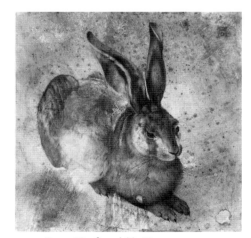

45.2 Georg Hoefnagel (?), *Hare,*
watercolor and body color on vellum.
Weimar, Staatliche Kunstsammlungen,
Schloßmuseum (see note 3).

author of these copies, it is because our knowl-
edge of the copyists of the Dürer Renaissance is
still in its early stages, and any definitive pro-
nouncement seems to me premature.

NOTES

1 W. I. The work then still belonged to the
W. Gay Collection.
2 I have not seen the original drawing and could
base my assessment only on a photograph.
3 *Hare,* watercolor and body color, brush,
heightened with white, vellum, mounted on
oak; surface partly burst away, visible damage
due to the effects of damp; top right, Dürer
monogram by a foreign hand; 221 x 216 mm;
Weimar, Staatliche Kunstsammlungen,
Schloßmuseum, Inv. G 1721. Apart from its poor
state of preservation, the best in quality of the
three copies.

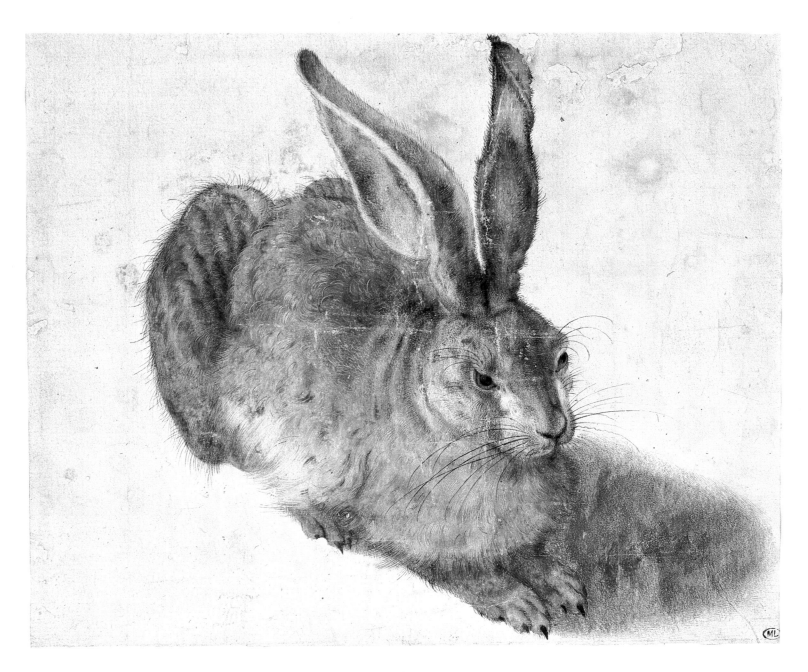

45

46

ANONYMOUS ARTIST,
ACTIVE AT THE MUNICH COURT
IN THE EARLY SEVENTEENTH CENTURY

Hare

Watercolor and body color on paper,
mounted on cardboard,
brush, heightened with white
Bottom center, Dürer monogram and
the date *1502*
in pen and drawing ink, by a foreign hand
212 × 223 mm

Dresden, Staatliche Kunstsammlungen,
Kupferstich-Kabinett, Inv. C 1976–347

PROVENANCE: Königliche Galerie, Dresden.

BIBLIOGRAPHY: Neues Sach- und Ortsver-
zeichnis der königlich-sächsischen Gemälde-
Galerie . . . , Dresden, 1822, p. 121, no. 589 •
H. II, p. 38, a), p. 117, under no. 134 • Eye,
p. 189 • Th. I, p. 303, note 1 • W. I, p. 171, under
no. 248 • K.-Str., p. 166, under no. 24.

Among the faithful copies of Dürer's *Hare*
that previously have been grouped together
under the name of Hans Hoffmann, three fur-
ther works can be selected as having certain
characteristics in common. Compared with
the Dürer prototype, the ridge of the nose is
narrower and longer, the shape of the head is
noticeably sharper, the ears are somewhat
slimmer, and there is a pronounced swelling
above the left eye; the regular pattern of
strokes showing the pale hairs in the fur is also
characteristic.

These particulars are evident first in the
copy referred to by Heller in the Dresden gal-
lery, now kept in the Kupferstich-Kabinett,
and reproduced here, which he considered so
good that he was beset by the question as to
whether it or the Albertina's *Hare* was really
the original. Secondly, the same particulars are
to be found in the copy, formerly in the Lanna
Collection,[1] which recently turned up on the
art market (ill. 46.1) after having disappeared
for a long time.[2] Finally, they can also be found
in a painting. The author of the two copies was
obviously the still anonymous painter working
at the Munich court of Maximilian I of Bavaria
in the early seventeenth century who "com-
pleted" Hans Burgkmair the Elder's *John the
Evangelist on Patmos*[3] with animals and plants,
adding Dürer's hare, among other things, to
the tropical flora and fauna surrounding the
Evangelist as he writes inspiredly amid the un-
tamed nature of Patmos (ill. 46.2 and ill. 1,
p. 133). The suggestion, originally made by
Feuchtmayr,[4] that the style of the Burgkmair
overpainting was reminiscent of the court
painter Georg Vischer, is today refuted. In any
case, the two copies are inconsistent with
Hoffmann's œuvre as well.

On the grounds of its unusually small for-
mat, scarcely larger than a postcard, the above-
mentioned copy (ill. 46.1) contrasts sharply
with the others, which are mostly the same
size as the original. It is a cabinet piece of
souvenir-like neatness, being done on so small
a scale, and precisely because it is such, it
widens our knowledge of the way the genera-
tion following Hoffmann received Dürer.

NOTES

1 Auction Catalogue, Lepke, Lanna Collection,
Prague, part 4, Berlin, May 19–21, 1911, p. 8,
no. 44; designated there as possibly by Hans
Hoffmann.
2 Auction Catalogue, Christie's, *Important Old
Master Drawings*, London, July 5, 1983, no. 11 A
(as Hans Hoffmann); the same July 4, 1984,
p. 95, no. 140 (attributed to Hoffmann);
formerly in Kate Ganz Gallery, London, now in
a private collection in New York.
3 Munich, Alte Pinakothek, center panel, Inv.
685; see Munich, Alte Pinakothek, Catalogue II,
Altdeutsche Malerei (Munich, 1963), pp. 53, 54;
finally, Gisela Goldberg, "Veränderungen von
Bildern der ersten Hälfte des 16. Jahrhunderts,"
in *Städel-Jahrbuch*, N.F. 9/1983, pp. 151 ff.
4 Exhibition Catalogue *Hans Burgkmair*, compiled
by Karl Feuchtmayr (Augsburg, Staatliche
Gemäldegalerie, 1931), pp. 13, 14, no. 8.

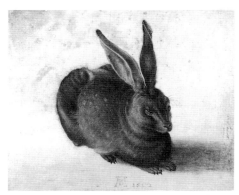

46.1 Anonymous artist active at the Munich
Court in the early seventeenth century, *Hare*,
watercolor and body color on vellum. New
York, private collection.

46.2 Hans Burgkmair the Elder, *John the
Evangelist on Patmos*, detail, with additions by an
anonymous artist active at the Munich Court in
the early seventeenth century. Munich, Alte
Pinakothek.

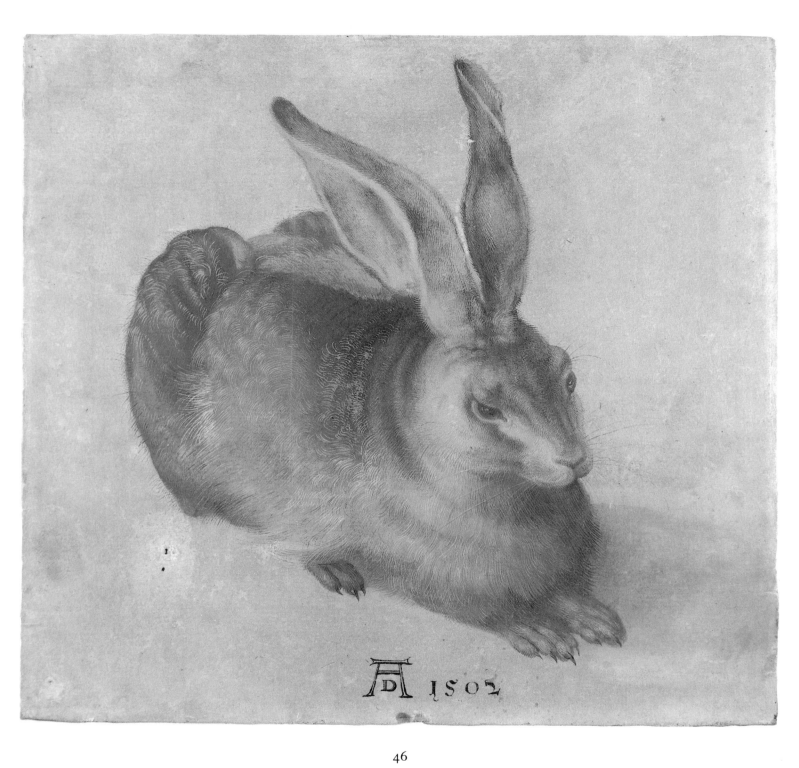

46

47

HANS HOFFMANN

Hare among Flowers

Watercolor and body color on vellum, brush,
preliminary drawing in places
Top center, Hoffmann's monogram
and date *1582*
623 x 580 mm
Private collection

PROVENANCE: Praun (?) • Berlin art market
(1937).

BIBLIOGRAPHY: Christoph Theophile de Murr,
*Description du Cabinet de Monsieur Paul de Praun
à Nuremberg* (Nuremberg, 1797), pp. 16, 17,
no. 128 • Pilz, in *MVGN* 51/1962, pp. 258, 259,
no. 20 • Exhibition Catalogue Stuttgart
1979/80, I, p. 192, no. E 6 • Auction Catalogue,
Sotheby's, *Old Master Paintings,* London,
November 30, 1983, under no. 49 • Exhibition
Catalogue Zurich 1984, p. 28, under no. 2,
note 2 • Koreny, 1984, p. 22, fig. 3.

This is the only one of Hans Hoffmann's
copies of Dürer's *Hare* to bear a monogram and
date, and therefore is of particular importance.
The work, which was first mentioned by Murr
in the Praun Collection, constitutes a reliable
basis for further attributions and the chrono-
logical arrangement of the other versions.

Unquestionably modeled on Dürer's proto-
type, but not a copy in the strict sense, the hare
sits nibbling a leaf, surrounded by numerous
insects, a sand lizard, and a frog, in the midst of
an ornamental garden full of blooming wild-
flowers and cultivated plants arranged in con-
scious diversity.

Several preparatory studies for Hoffmann's
painting of a hare (Cat. 49) are known to us,
and there must likewise have been detailed
studies for the numerous botanically accurate
plants in this picture,[1] but up to now none has
been found. We can imagine something in the
nature of the monogrammed study dated 1582
of peonies, iris, and cockchafer,[2] or the study in
Bayonne showing eight different flowers, very
much in Hoffmann's style (ill. 71.1).[3] The only
survivor is Hoffmann's detailed study of the
frog (ill. 47.1).[4] In this picture he is in the com-
pany of a lizard and a snail, just as in Burgk-
mair's altarpiece of John the Evangelist (see
Cat. 46), where the frog is astonishingly simi-
lar — a remarkable coincidence.

Hoffmann's interest in painting faded, dis-
eased, or pest-eaten foliage emerges unusually
clearly from the plants in this picture. Spider-
webs and a faded dandelion are shown with
almost exaggerated accuracy. One curious de-
tail is the window reflected large and obtru-
sively in the hare's eye, although it is sitting
out-of-doors. In Dürer's watercolor, which
was possibly done indoors, the highlight in the
eye is indicated by just two small streaks, but
here in Hoffmann's outdoor version it is stiffly

shaped, out of place, and pointlessly over-
done.[5] Still, this work, thick with plants, ani-
mals, and insects and a wealth of subtly ob-
served details spread out as if on a display table,
reveals itself not merely as a piece of artistic
bravura, but at the same time as an early exam-
ple of German still-life painting.[6]

Among the plants rendered with scientific
accuracy, the red bloom of the African mari-
gold, in the center of the picture, represented a
special rarity to Hoffmann's contemporaries,
being indigenous to Mexico and brought to
Europe only in 1573.[7] In those days there were
very few botanical collections with plants from
outside Europe. Princely courts or trade mag-
nates like the Fuggers of Augsburg rivaled
leading botanists of the time in acquiring rare
specimens and cultivating them in their own
gardens.[8]

47.1 Hans Hoffmann, *Frog,*
body color on vellum.
Budapest, Museum of Fine Arts,
Graphic Collection (see note 4).

NOTES

1 I am grateful to Professor F. Ehrendorfer, S.
Segal, and M. A. Fischer for the following
botanical identifications: below the left-hand
butterfly a chicory with blue flowers (*Cichorium
intybus* L.); to its left a hollyhock (*Althaea rosea*
cultivar); to the right of it a garden poppy
(double form of *Papaver somniferum* L.) with a
caterpillar (see below); below and to the right
African marigold (*Tagetes patula* L.); below the
right-hand butterfly a borage (*Borago officinalis*
L.); to the right of that forking larkspur
(*Consolida regalis* L.) and field poppy (*Papaver
rhoeas* L.); to the right again probably marigold
(*Calendula officinalis* L.); below it a dandelion
(*Taraxacum officinale* agg.) in fruit and a wild
strawberry (*Fragaria vesca* L.) with fruits; below
the frog probably a dock (*Rumex* spec.) or a
burdock (*Arctium* spec.); right above the hare's
head yarrow (*Achillea millefolium* L.); at the left
edge red clover (*Trifolium pratense* L.) and
raspberry; below it probably marigold again
(*Calendula officinalis* L.); to the right mullein
(*Verbascum* spec.); below that hoary plantain
(*Plantago media* L.).

I am grateful to G. Pass for the zoological
identifications: snails (*Arianta arbustorum* L.,
Cepaea spec.); insects: grasshopper, hawker drag-
onfly, "pyrrhocorid bug" (*Pyrrhoceris apterus* L.);
scorpion fly (*Panorpa* spec.?); three flies
(including flesh fly, *Sarcophaga* spec., hoverfly?);
butterflies (small white, burnet moth?); two
tiger moths (*Arctia caja* L.); swallowtail
caterpillar (*Papilio machaon* L.); sand lizard
(*Lacerta agilis* L.?); green frog (*Rana* spec.).

2 Auction Catalogue, Christie's, *Important Old
Master Drawings,* London, December 8–11, 1981,
p. 40, no. 96 (now in a private collection,
Nuremberg).

3 Sheet with eight different plant studies, body
color, brush, on vellum; 227 x 340 mm;
Bayonne, Musée Bonnat, Inv. A.I. 1525. Possibly
identical to that in the Imhoff Inventory,
entered as *ein Distel sammt vielen Blumwerk auf
Pergament* ("a thistle with many other flowers on
vellum"; H. II, p. 83, no. 64).

4 Body color, brush, on vellum; 78 x 77 mm;
Budapest, Museum of Fine Arts, Department of
Prints and Drawings, Inv. 174. I am grateful to
Szilvia Bodnár, who is preparing a work on the
drawings of Hans Hoffmann, for allowing me to
look at her photographic material.

5 Białostocki, 1970; see Cat. 43, note 4.

6 Exhibition Catalogue Stuttgart 1979/80.

7 Pilz, 1962, p. 259, according to Dr. h.c. A. Ade,
senior veterinary consultant; sometimes with
identifications that do not agree with the picture.

8 Walther Rytz, *Das Herbarium des Felix Platter.
Ein Beitrag zur Geschichte der Botanik des 16.
Jahrhunderts* (Basel, 1933), pp. 52, 53.

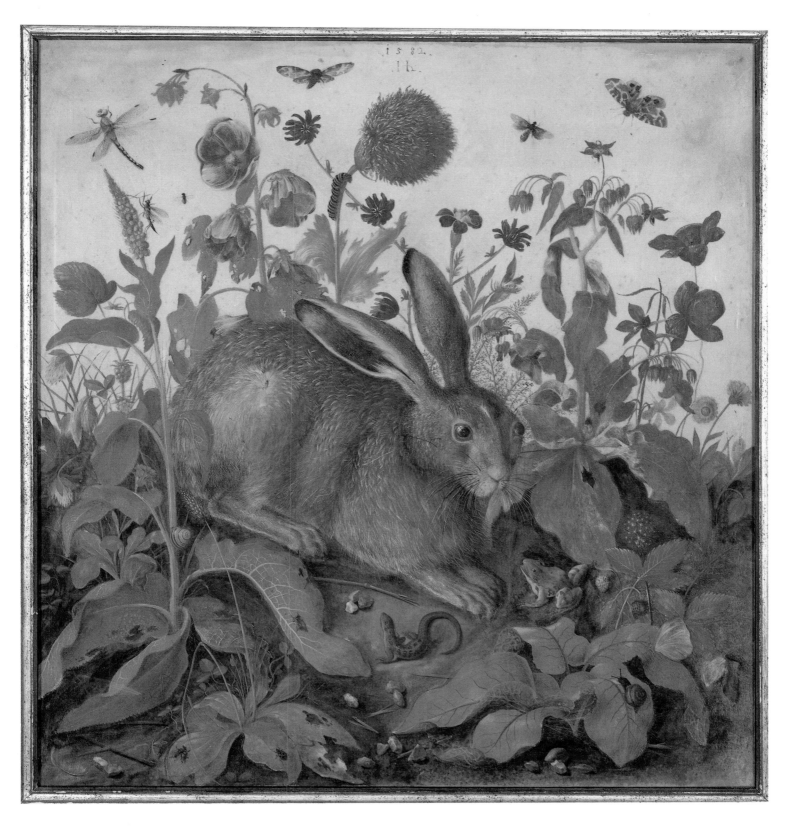

47

48

HANS HOFFMANN

Hare Surrounded by Plants

Watercolor and body color on vellum,
mounted on wood (?), brush, heightened with
white, traces of preliminary drawing,
for example, around the ears
570 x 490 mm
Rome, Galleria Nazionale d'Arte Antica,
Palazzo Barberini, Inv. 224

PROVENANCE: Pietro Tacca • Guadagni-
Tomaso Corsini • Galleria Corsini.

BIBLIOGRAPHY: Filippo Baldinucci, *Notizie dei
professori del disegno* (Florence, 1681, new edition
1846, reprinted 1974), vol. IV, p. 100 • Th. I,
p. 303, note 1 • W. I, p. 171, under no. 248 • Ex-
hibition Catalogue Bremen (Zurich, 1967/68),
p. 28, under no. 4 • K.-Str., p. 166, under
no. 24 • White, 1971, p. 80, under no. 23 • St. II,
p. 594, under no. 1502/2 • Giuseppina Magnan-
imi, "Inventari della Collezione dei Principi
Corsini," in *Bollettino d'Arte,* 1980, nos. 7, 8,
pp. 91–126, Ba. 67.

This is one of three known versions (see Cat.
47, 49) in which Hans Hoffmann returns
Dürer's *Hare* (Cat. 43) to natural surroundings.
This one copies the model more carefully than
do the other two versions, and its proportions
and outlines, especially the fur on the head and
nape, indicate a thorough acquaintance with
the original. But, diverging from his model,
Hoffmann makes his hare look at the observer.
Although the study is done like a miniature on
vellum, because it is a fair size, it pretends to be
taken as a painting.

The somewhat similar details establish a di-
rect connection with the version in a private
collection dated 1582 (Cat. 47) and the oil
painting acquired by Rudolf II in 1585
(Cat. 49). This study resembles Cat. 47 pri-
marily in the way the whole space seems tilted
forward. In both, the plants are arranged in a
semicircle around the animal, carefully spaced
so as not to overlap, silhouetted against the
light ground. The oil painting is connected
with the Barberini hare by the same plant and
animal motifs, such as dwarf mallow (*Malva
neglecta* Wallr.) and the spreading leaves of a (?)
mullein (*Verbascum* spec.; possibly *V. nigrum*
L.) or a dock (*Rumex* spec.) in the left fore-
ground, together with small twigs, straw, a
grasshopper, and a butterfly; these were done
from studies, some of which have survived,
and were evidently used in other works too.
The little hoverfly standing upright in the air
appears in the 1583 study *Musk Thistle, Heather,
and Mallow* (Cat. 50), while the bits of wood
lying in front of the hare come from the study
Thistle and Robin on a Pine Stump (Cat. 51), but
for the carthusian pink (*Dianthus carthusian-
orum* L.), top left, there is no known study.

Baldinucci, in his *Notizie dei professori del dis-
egno,* said that in 1631 Pietro Tacca[1] was in pos-
session of a version of the Dürer hare that he
valued very highly. This seems to be the same
one as that acquired by Count Corsini for his
collection and newly entered in the archive
inventory in 1827.[2] Transferred from the Pa-
lazzo Corsini to the Galleria Barberini, it is
obviously the same work that Winkler, un-
aware of the connection, mentions twice, once
as being in Tacca's possession and again as in
the Palazzo Corsini.

NOTES
1 Pietro Tacca (1577–1640), colleague of
Giovanni da Bologna and heir to his studio.
2 Magnanimi, entered under Ba. 67: *Regalo
dall'Emo Guadagni, Una Lepre di Alberto Duro*
("Gift from Guadagni, a Hare by Albrecht
Dürer").

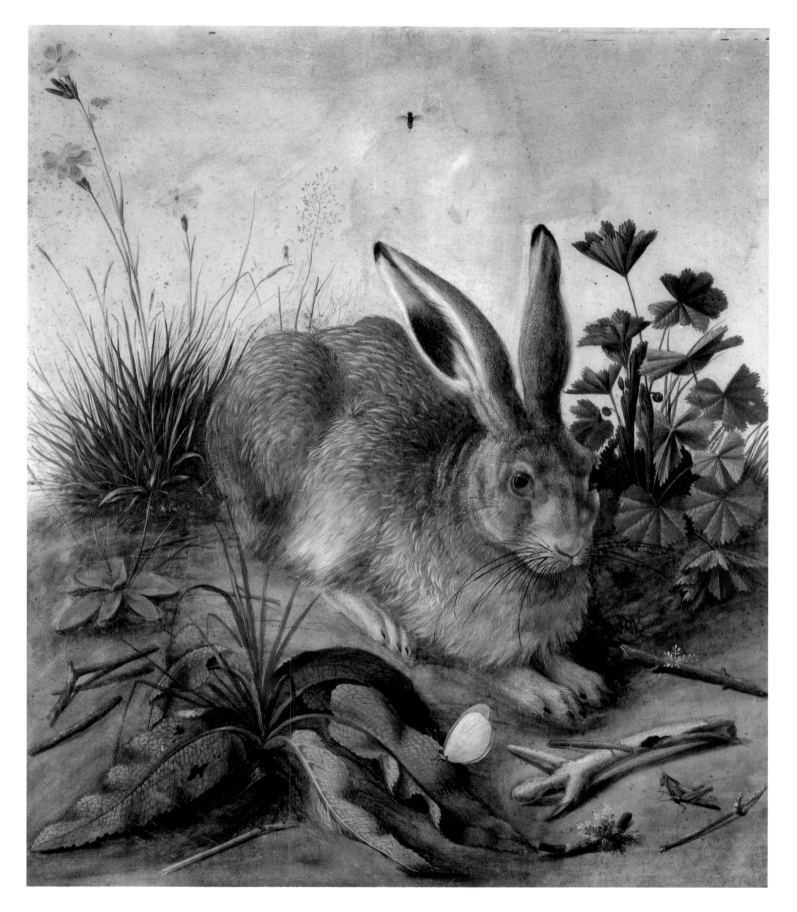

49

HANS HOFFMANN

Hare among Grasses and Wildflowers in a Glade

Oil on limewood
On the reverse the inscription:[1]

620 x 782 mm
London, private collection,
courtesy of Ellen Melas Kyriazi

PROVENANCE: Emperor Rudolf II • N. Hartas.

BIBLIOGRAPHY: Christoph Theophile de Murr, *Description du Cabinet de Monsieur Paul de Praun à Nuremberg* (Nuremberg, 1797), p. 17, under no. 130 (?) • "Urkunden und Regesten aus der k.k. Hofbibliothek," ed. by Wendelin Boeheim, in *JKSAK* 7/1888, part II, "Quellen zur Geschichte der kaiserlichen Haussammlungen von den Kunstbestrebungen des allerdurchlauchtigsten Erzhauses," p. CCXX, No. 5456 • Pilz, in *MVGN* 51/1962, p. 251, no. 4 • Exhibition Catalogue Bremen, Zurich 1967/68, p. 28, under no. 4 • Exhibition Catalogue Münster 1979/80, p. 51 • Auction Catalogue, Sotheby's, *Old Master Paintings,* London, November 30, 1983, no. 49 • Exhibition Catalogue Zurich 1984, p. 28, under no. 2 • Koreny, 1984, pp. 18–22.

There are more than a dozen surviving copies and imitations of Dürer's *Hare* (Cat. 43), no fewer than six of which are by Hans Hoffmann, but not one of them is totally faithful to the model. Either he moves the animal from its paper-white environment back to nature, surrounding it with grasses, wildflowers, insects, and little animals — Dürer's *Hare* and *The Large Piece of Turf* rolled into one, so to speak — or else he makes a free variation, stimulated by the original (see Cat. 52, 53).

Animals[2] and plants,[3] each one studied to some extent for itself alone, are artistically arranged in a semicircle around the hare, paraphrasing the model entirely within the spirit of the Dürer Renaissance. But, in his combination of Dürer's hare with its natural surroundings, Hoffmann achieves something new; it becomes a still-life–like picture, the forerunner of the "animal piece," a widespread new genre in seventeenth-century Netherlandish art.

This picture has only recently been discovered[4] and is exhibited here for the first time. We know two other variants (Cat. 47, 48) in which Hoffmann combines Dürer's hare with plants.[5] Certain identical, or even differing, details in them demonstrate his way of working from a stockpile, with no hesitation in using the same studies over and over again.

So the painting of 1582 (Cat. 47) also includes a little lizard in front of the hare, a frog, and a grasshopper, the same snails, empty snail shells, and butterflies. Even closer similarities exist between the oil painting and the body-color painting in the Palazzo Barberini (Cat. 48). In each the same grasshopper sits bottom right, the same curved twig lies near the bits of dead wood with lichen growing on them, the same mullein (or dock?) spreads its leaves on the left. Even inconsequential things reappear, like the bent blade of grass in the foreground. The mallow on the right seems to be different; in the Barberini drawing the leaves spread upward rather than sideways, adapting to the narrower space of the vertical format, yet in spite of being assembled somewhat differently, they correspond, as close inspection verifies, leaf for leaf.

Thanks to a rare accident of preservation, the study on which both pictures are based still exists. It is monogrammed and dated 1583 and shows the mallow, a few snails and pinecones, and a musk thistle (Cat. 50). Hoffmann has used these features again as a pictorial setting for the hare in the composition we are looking at, adding, however, one more twig. This in turn can be found in the study of a large thistle growing by the stump of a newly felled pine with a robin perched on it (Cat. 51). Further, Hoffmann has introduced the same tree stump here as the last feature on the right, together with some wood chips and the already mentioned twigs. The study for the frog sitting in

49.1 Hans Hoffmann, *Frog,*
watercolor on paper.
Budapest, Museum of Fine Arts,
Graphic Collection.

the left foreground survives in Budapest (ill. 49.1).[6]

These affinities among the different versions of the *Hare* and their connection with preparatory studies give a very clear picture of Hoffmann's economical, craftsmanlike method. His own observation of nature and the classical example — Dürer's model — provides freely interchangeable units of composition.

Until recently, only Hoffmann's versions in watercolor and body color were known. A variant done as a panel painting was known solely from the imperial archives. In the records of the Imperial Court Library there is an entry for October 22, 1585,[7] stating that Rudolf II's servant and court painter, Hans Hoffmann, was paid *für ainen mit ollfarb gemahlten haasen, welchen er in irer maj. aigen camer gehorsamblichen dargeben, zweihundert Gulden rheinisch* ("for a hare painted in oil colors, the which he obediently delivered to his Majesty's own chamber, two hundred Rhenish guilders"). If we add together the facts, the technique of the picture, the date of the archive entry, and that of the obviously preparatory study (1582), we have every reason to conclude that the panel reproduced here is the very oil painting that the records show as having been painted for Emperor Rudolf II.[8]

Inventively varying Albrecht Dürer's *Hare* to satisfy the taste of the time and his imperial patron's interest in natural science, Hans Hoffmann created in this interpretation a work that can stand as a paragon of the Dürer Renaissance.

NOTES

1 It has not yet been possible to decipher the inscription, written in a hand of perhaps the late seventeenth century (?), but in my opinion it represents a mark of ownership and could probably throw light on the history of the picture. I am grateful to Drs. Mikoletzky, Auer, and Koch for attempting to read the writing.

2 Animal identification by G. Pass: snails (*Arianta arbustorum* L., *Cepaea* spec.); garden spider in its web (*Araneus* spec.); grasshopper; "pyrrhocorid bug" (*Pyrrhocoris apterus* L.); wasp (?); butterflies: peacock (*Inachis io* L.), small cabbage white (*Pieris rapae* L.); two lizards (*Lacerta* spec.); green frog (*Rana* spec.).

3 Identification of the plants (which are not found together in this manner in nature) by Professor F. Ehrendorfer, S. Segal, and M. A. Fischer: left, musk thistle (*Carduus nutans* L.); below it a dandelion *(Taraxacum officinale* L); left of it (and front left) hoary plantain (*Plantago media* L.); below that a reclining spray of knotgrass (*Polygonum aviculare* L.); to the right of that the spreading leaves of a mullein (*Verbascum* spec., possibly *V. nigrum*) or a dock (*Rumex* spec.); in its middle probably a burnet saxifrage (*Pimpinella* cf. *major*), according to M. Fischer; according to S. Segal it is goose-grass (*Potentilla anserina* L.); and between them a clover (*Trifolium* spec., probably *T. repens*); between the thistle and the hare leaves of an indeterminable plant (this is not a natural combination of different plant species); in front a blade of timothy (*Phleum pratense* L.). In the center a composite rosette (?), possibly dandelion or cat's ear (*Hypochoeris glabra* L.) and a buttercup (*Ranunculus* spec.) can be recognized. At the bottom right edge of the picture is a turf protruding from which is the dead flower head of (?) a mouse-ear hawkweed (*Hieracium pilosella* L.), and above that a dwarf mallow (*Malva neglecta* Wallr.; its leaves are badly drawn and almost resemble a lady's mantle [*Alchemilla* spec.] more than mallow!); behind are harebells (*Campanula rotundifolia* L.) and

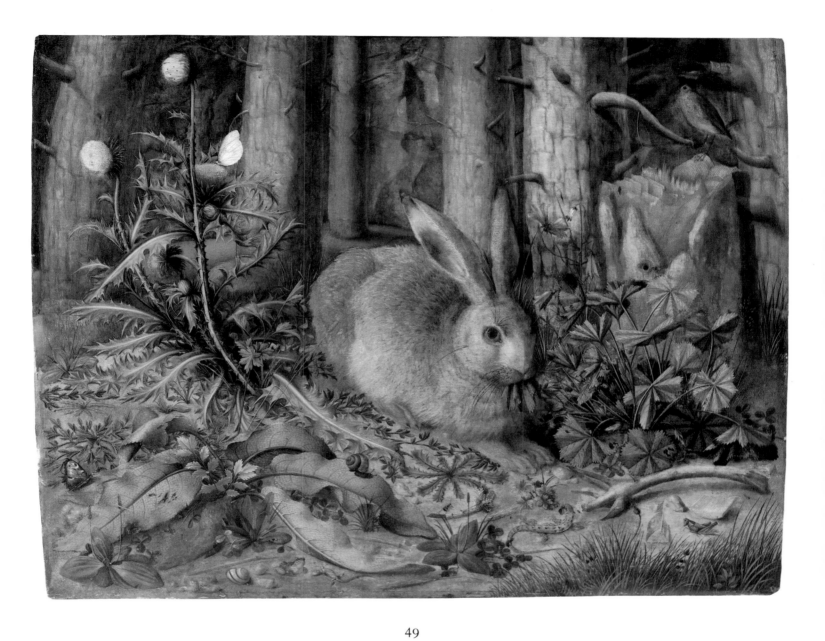

49

possibly common bent-grass *(Agrostis tenuis* L.)
and a clover *(Trifolium* spec.).

4 Auction Catalogue, Sotheby's, 1983.

5 See also "Dürer's *Hare* and Its Copies," p. 132,
no. 11 and note 5.

6 Watercolor, brush on paper; 60 x 65 mm;
Budapest, Museum of Fine Arts, Department of
Prints and Drawings, Inv. 161; see Cat. 47, note 4.

7 Boeheim, 1888.

8 Koreny, 1984. At the symposium "The Art in
the Court of Rudolf II," held in Prague June

8–13, 1987, Ingvar Bergström presented a paper
("'The Hare in a Forest' Purchased in 1585 by
Emperor Rudolf, and What Happened to It after
That") concerning further inventory references
that probably relate to this picture: attributed to
"Hems" (= Hemessen), it is cited in a Prague art
chamber inventory of 1621 (under no. 916) and is
also mentioned in an inventory of 1648 (a list
established by the Swedish troops following the
conquest of Prague) under no. 220 as *ein sissend
Haas* ("a sitting hare").

50

HANS HOFFMANN

Musk Thistle, Heather, and Mallow

Watercolor and body color on vellum, brush, heightened with white
Top center, with pen in brown, Hoffmann's monogram and the date *1583* (badly scuffed)
445 x 596 mm
Nuremberg, Germanisches Nationalmuseum, Graphische Sammlung, Inv. St. Nbg, 9640/1532 (Collection of the City of Nuremberg)

PROVENANCE: Praun(?).

BIBLIOGRAPHY: Christoph Theophile de Murr, *Description du Cabinet de Monsieur Paul de Praun à Nuremberg* (Nuremberg, 1797), p. 17, no. 129 (?) • Exhibition Catalogue Nuremberg 1952, p. 160, no. S 34 • Exhibition Catalogue Nuremberg 1962, p. 38, no. A 4 • Pilz, in *MVGN* 51/1962, p. 261, no. 23 • Koreny, 1984, p. 22.

On this monogrammed and dated sheet, Hoffmann assembles a heterogeneous set of nature studies. There are three cones from the red pine (*Pinus silvestris* L.) seen from three carefully chosen angles, top, side, and bottom; and three equally precise snails (*Arianta arbustorum* L., *Cepaea* spec.). But in the central position stand the accurately observed, detailed renderings of plants: a musk thistle (*Carduus nutans* L.) on the left, with heather, or rather, ling (*Calluna vulgaris* [L.] Hull.); and a dwarf mallow (*Malva neglecta* Wallr.) on the right. The small spray with a knobbly blue head on the far left is possibly a scabious (perhaps *Succisa pratensis* Moench).[1]

Although they appear together on one sheet, each plant is studied for itself alone, independently of the others; they are placed rather fortuitously side by side only for reasons of economy. The various outlines of their characteristic leaves and flowers stand out against the white ground, the dark soil of the earth being indicated by a few fleeting brush strokes. This style of rendering lies within the tradition introduced by Dürer's *Large Piece of Turf* (Cat. 61); but the specific style may be even better equated with that of *The Small Piece of Turf* (Cat. 62), or best of all with the *Three Medicinal Herbs* (Cat. 71) and the *Columbine* (Cat. 68); that is, the plant studies generally dated 1526.

These studies, most probably done directly from nature, were for Hoffmann a means to an end. The oil painting recently discovered (Cat. 49) — that exemplary paraphrase of the Dürer *Hare* — illustrates that fact. It includes exact repeats of the two main plants and two of the snails featured here. Apart from the picture brought to light by happy chance, for which this is a preparatory study and decidedly contributes to clarifying the connection, there are also other examples that display the versatility with which Hoffmann used these working components. The study of the mallow, for example, corresponding leaf for leaf, and the hoverfly standing upright in the air reappear unchanged in the *Hare Surrounded by Plants* (Cat. 48). Clearly, such habits reveal the craftsman's economy, in which the nature studies simply represent readily available basis material.

NOTE

1 Plant identification by F. Ehrendorfer and S. Segal (letter of May 26, 1985).

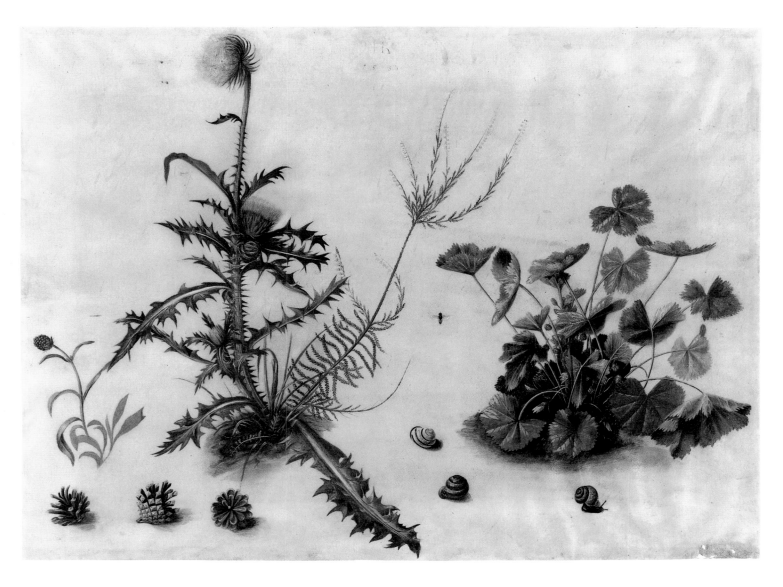

50

51

HANS HOFFMANN

Thistle and Robin on a Pine Stump

Watercolor and body color on vellum, brush,
heightened with white, traces of preliminary
pencil drawing (on tree stump and thistle heads),
mildew spots
464 x 358 mm

Nuremberg, Germanisches Nationalmuseum,
Graphische Sammlung, Inv. Hz 233/1532

PROVENANCE: Praun.

BIBLIOGRAPHY: Christoph Theophile de Murr,
*Description du Cabinet de Monsieur Paul de Praun
à Nuremberg* (Nuremberg, 1797), p. 17, no. 141 •
Exhibition Catalogue Nuremberg 1952, p. 160,
no. S 33 • Exhibition Catalogue Nuremberg
1962, p. 38, no. A 3 • Koreny, 1984, p. 22.

The attribution of this picture of a musk this-
tle (*Carduus nutans* L.) growing beside a pine
stump to Hans Hoffmann[1] rests on the coinci-
dence of style and motifs with the study *Musk
Thistle, Heather, and Mallow* (Cat. 50), mono-
grammed and dated 1583. If we need further
evidence, this is amply supplied by Hoff-
mann's oil painting (Cat. 49), where Dürer's
hare is integrated into a woodland setting and
the elements of both studies are combined. In
the painting, Hoffmann has simply put them
together afresh; the lichened tree stump and
the robin (*Erithacus rubecula* L.) are separated
from the thistle and joined with the mallow,
the chips from the newly chopped stump and
the pieces of twig are moved farther forward,
and the two thistle studies are fused into one
plant.

Concentrating on one small piece of nature,
painstakingly rendered, that occupies the
whole surface of the picture and thus becomes
a subject in itself, this picture puts us in mind of
Dürer's *Large Piece of Turf* (Cat. 61);[2] but the
way in which Hoffmann moves the thistle to
the central point, making it the main motif,
even though other elements in the picture are
treated with similar care, endows the study
with the character of a still life. Over and
above the simple portrayal of a slice of nature,
the selection and arrangement give the impres-
sion of deliberate artistry, despite apparent ca-
sualness. With the thistle at its central point,
the composition is ambivalent, broadening
into a landscape, but on the other hand con-
densing back into a still life by keeping the
plant as the center of attention. Anticipating
the form of open-air still life that was common
in seventeenth-century Netherlandish art,
Hoffmann here establishes himself as the fore-
runner of Jacob van Ruisdael (ill. 51.1) and
Mattheus Withoos.

NOTES

1 Not mentioned by Pilz, in *MVGN* 51/1962;
ascribed to Hans Hoffmann in the Germanisches
Nationalmuseum, Nuremberg.
2 Exhibition Catalogue Münster 1979/80, pp. 548,
549.

51.1 Jacob van Ruisdael, *Landscape, 1646.*
Hartford, Connecticut, Wadsworth Atheneum.

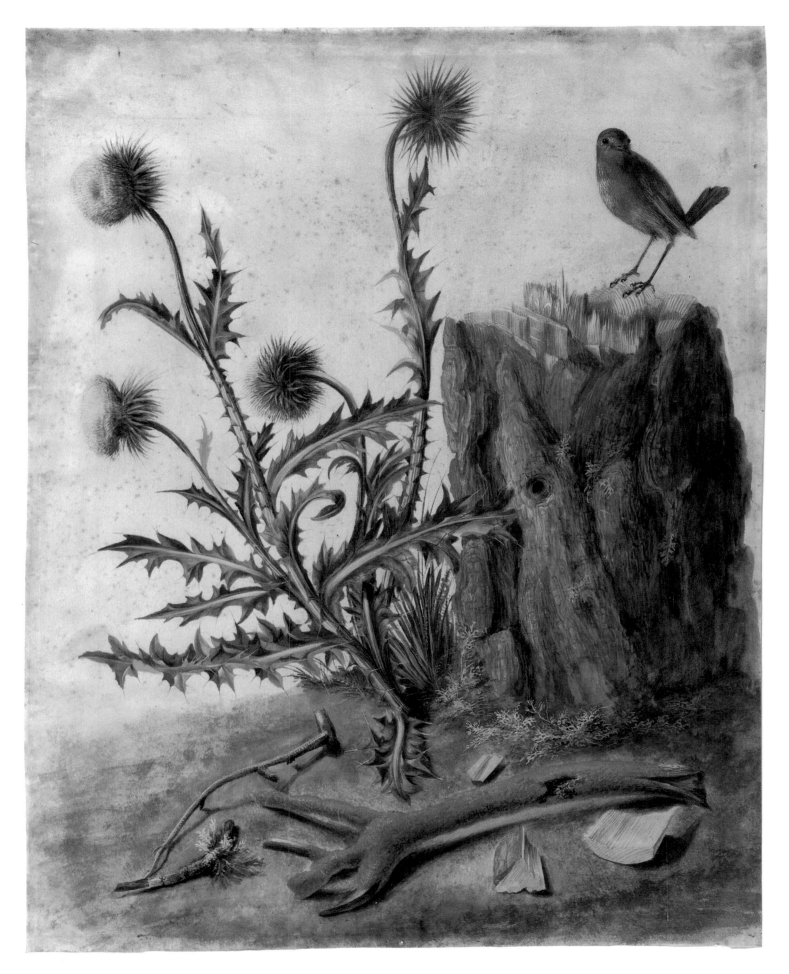

52

HANS HOFFMANN

Hare

Watercolor and body color on vellum, brush,
heightened with white
Bottom center, Dürer monogram
and the date *1528*
by Hans Hoffmann
352 x 256 mm

Berlin, Staatliche Museen
Preußischer Kulturbesitz,
Kupferstichkabinett, Inv. KdZ 1271

BIBLIOGRAPHY: Hausmann, 1861, p. 116 • Bock,
1921, I, p. 47, no. 1271 • Th. I, p. 303, note 1 •
W. I, p. 171, under no. 248 • Exhibition
Catalogue Bremen, Zurich 1967/68, p. 28,
under no. 4 • St. II, p. 594, under no. 1502/2 •
Exhibition Catalogue Münster 1979/80, p. 51,
ill. 15 • Exhibition Catalogue Zurich 1984,
p. 28, no. 2, note 2.

This crouching hare, seen from the front and
looking up at the observer, bears Dürer's
monogram and the date 1528. As Bock has al-
ready established, neither monogram and date
nor the drawing itself is authentic, but repro-
duces, he supposes, a lost work of Dürer's. In
Thausing's opinion the work has "nothing in
common" with Dürer's *Hare.*

The date, the year Dürer died, is worth no-
ticing, and is not in fact the year the work was
done. This study on vellum is far more charac-
teristic of Hoffmann's style, similar to his *Hare*
in a private collection monogrammed and
dated 1582 (Cat. 47), and to those in Rome
(Cat. 48) and London (Cat. 49). The fur, in
particular, shows his typically formal brush-
work, the hairs brought into similar rhythmi-
cally overlapping tufts. Equally characteristic
and common to all three is the way stippling is
used to render the short, soft fur on the ears.

From numerous copies of Dürer's three-
quarter-view 1502 watercolor of the hare, it is
evident that that study was already famous in
the sixteenth century. Nothing, however, in-
dicates that Dürer ever created a hare sitting
face on. One gets a much stronger impression
that the artists of the Dürer Renaissance, in-
spired by his model, created this form for
themselves. Although the motif looks com-
pletely different in the extreme perspective of
the frontal position, the work was linked to
Dürer by the clearly deliberate use of a false
monogram. The figures and initials, drawn
partly with double lines, with full stops on
both sides and a dot on the *1*, correspond to
Hoffmann's style of monogram. The style and
proportions of the monogram and figures co-
incide perfectly with those on the *Two Squirrels*
(Cat. 28) and the *Dead Blue Roller* (formerly in
the Béhague Collection, ill. 11.2).

Even as Hoffmann made several versions of
the hare among flowers and weeds (Cat. 47,
48, 49), so he varied this study. He did another

variant from a less steep viewpoint, with the
hare crouching at the foot of a tree. Yet an-
other was possibly used as an album page (ill.
53.1). This is actually ascribed to Hans Hoff-
mann, but in the rendering of the fur and the
features of the escutcheon it tends to be more
characteristic of Georg Hoefnagel.[1]

NOTE

1 Compare the hare's nose whiskers, which show
distinguishing characteristics: the whiskers are
generally drawn with a simple line, but one of
them, on the right, is strongly curved. This was
already seen in Dürer's study, but not in any of
Hoffmann's copies; Georg Hoefnagel, however,
to whom I would like to ascribe the *Hare* of Cat.
45 and its variants, has imitated it exactly.

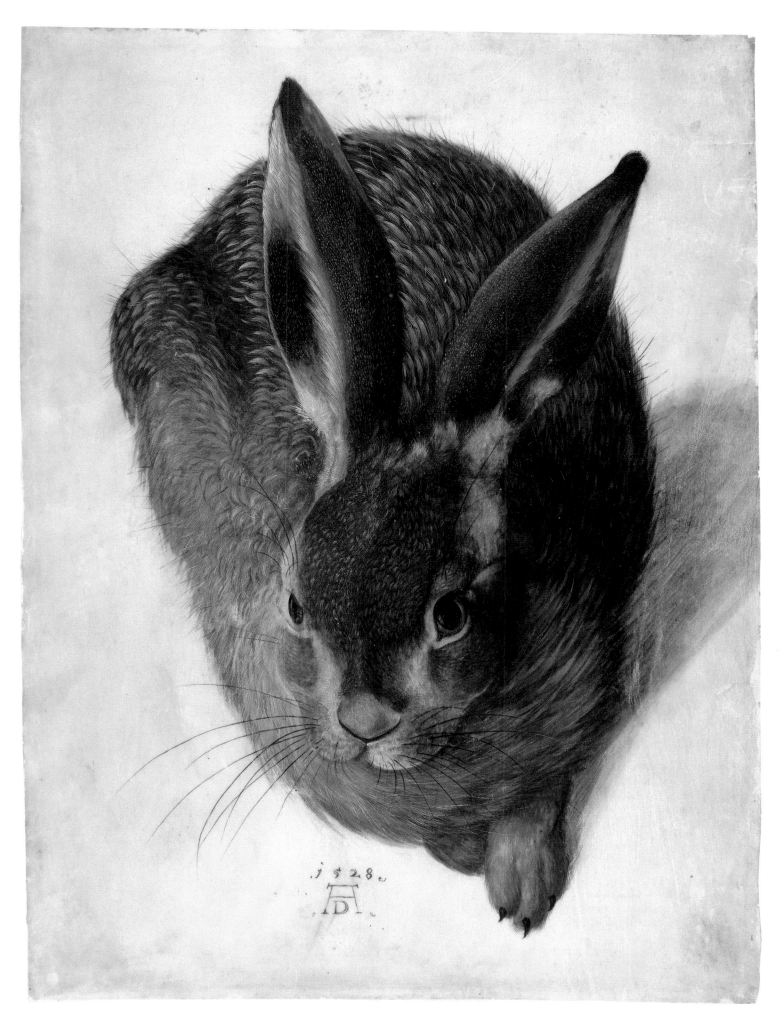

53

Hare under a Tree

Watercolor and body color on vellum,
brush, heightened with white,
mounted on wood
272 x 178 mm

New York, Ian Woodner Family Collection

PROVENANCE: Praun (?) • K. Meissner.

BIBLIOGRAPHY: Christoph Theophile de Murr,
*Description du Cabinet de Monsieur Paul de Praun
à Nuremberg* (Nuremberg, 1797), p. 17, no. 132
(?) • Exhibition Catalogue Bremen, Zurich
1967/68, p. 28, no. 4 • Exhibition Catalogue
*Old Master Drawings of the Collection of Kurt
Meissner,* Stanford Art Gallery and elsewhere,
no. 2 • Exhibition Catalogue Zurich 1984,
p. 28, no. 2 • Exhibition Catalogue *Master Draw-
ings: The Woodner Collection* (London, 1987),
no. 59.

Hans Hoffmann's variations on the Dürer
Hare, both his Berlin sheet (Cat. 52) and this
one, change the model to full frontal perspec-
tive. Thus reduced to an almost round shape
with only the animal's ears protruding, the
motif is practically no longer reminiscent of its
prototype. Yet the Dürer monogram and date
on the Berlin sheet, both in Hoffmann's hand,
surely deliberately indicate the intended con-
nection. They therefore prove that Dürer's

53.1 Attributed to Hans Hoffmann, *Rabbit,* 1587,
watercolor and body color on paper,
Berlin, Staatliche Museen Preußischer
Kulturbesitz, Kupferstichkabinett.

watercolor had raised the hare to the status of a
pictorial subject, and achieved this distinction
by his playful variation in the Mannerist style.

Whereas this hare corresponds to the Berlin
study, particularly in the treatment of the fur,
the landscape surrounding him shows unusual
characteristics. In their summary rendering,

53.2 Georg Hoefnagel, Missal for Ferdinand of
Tyrol, fol. 35v, detail, watercolor and body color
on vellum. Vienna, Österreichische National-
bibliothek, Cod. 1784.

the leaves and grasses deviate noticeably from
Hoffmann's generally detailed plant drawings.

The frequent use of this motif in the Rudol-
fian school implies that artists and connois-
seurs were aware of the alteration to a frontal
view as a paraphrase and derivative of the
Dürer *Hare.* The idea spread: in further varia-
tions in Berlin (see Cat. 52 and ill. 53.1), in
versions in Georg Hoefnagel's natural history
for Emperor Rudolf II, and in the missal for
Ferdinand of Tyrol (ills. 44.1, 53.2), the hare is
sitting before us, its exaggerated image re-
duced to its basic geometric shape, like a ball
with ears.

In principle, these modifications to full front
or back view correspond to those of the *Dead
Blue Roller, Seen from the Back* (Cat. 14) and the
Stag Beetle with Outspread Wings and Scorpion
(Cat. 39). They are all deliberately based on
Dürer prototypes, and in the way they inter-
pret these given motifs, produce new models
that typify the Dürer Renaissance.[1]

NOTE

1 The motif was not confined to the Rudolfian
 school alone: it appears again in the drawing of
 an unknown Swiss painter (old inscription:
 Hanns Asper) of the late sixteenth century; see
 Exhibition Catalogue *Hans Asper und seine Zeit,
 Züricher Kunst nach der Reformation* (Kunsthaus
 Zürich, 1981), p. 141, no. 144 with illustration.

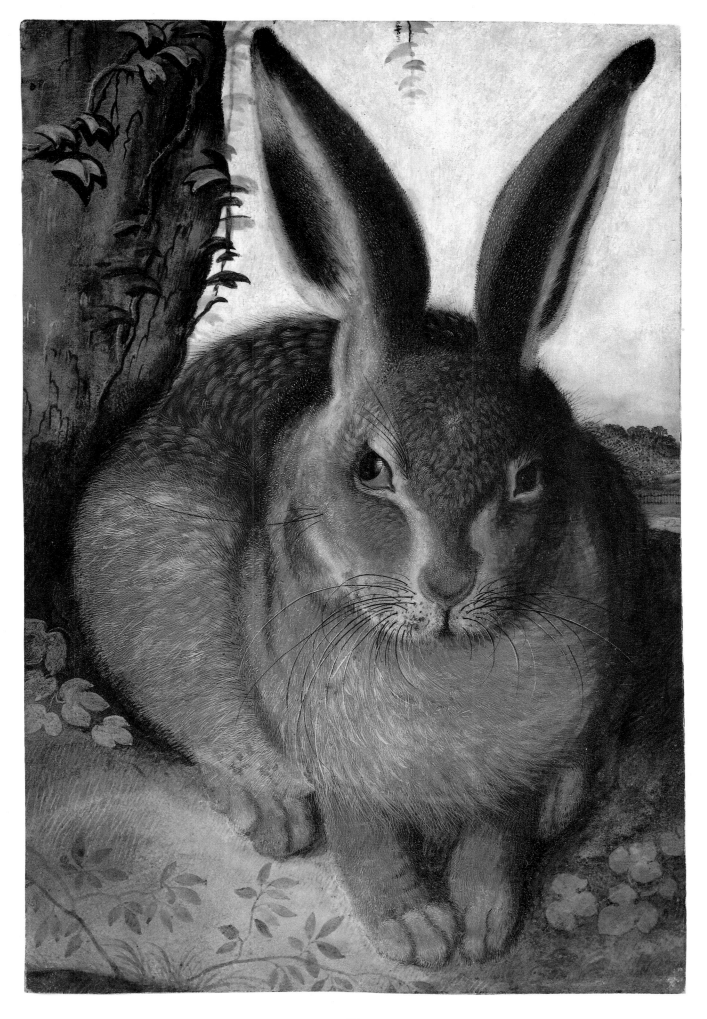

53

54

ALBRECHT DÜRER

Head of a Roebuck

Watercolor on mildew-spotted paper, brush,
heightened with white, partly oxidized
Watermark: vestiges of crown, cross,
and triangle;
Briquet 4773 (see p. 260, fig. 11)
Top right, Dürer monogram and the date *1514*
in a foreign hand; on the reverse
the inscription *34* in brown ink
227 x 167 mm

Bayonne, Musée Bonnat, Inv. N.I. 1271, A.I. 655.

PROVENANCE: Bonnat (L. 1714).

BIBLIOGRAPHY: L. IV, p. 6, no. 358 • Killermann, 1910, p. 57 • *Les Dessins de la Collection Léon Bonnat au Musée de Bayonne* (Paris, 1926), no. 30, plate 30 • Friedrich Winkler, "Der Lemberger Dürerfund," in *Der Kunstwanderer* (May 1927), p. 354 • Winkler, in *JPK* 50/1929, pp. 137 note 1, 138 • Fl. II, pp. 95, 342, 457 • T. II/1, p. 17, no. 197a • W. II, pp. 75, 78, under no. 362, p. 79, under no. 364, no. 365 • P. II, p. 131, no. 1348 • Musper, 1952, p. 126 • Killermann, 1953, p. 21 • Winkler, 1957, p. 182 • Exhibition Catalogue Washington 1971, p. 48, no. XI • White, 1971, p. 94, no. 30 • St. I, p. 354, no. 1495/47; see also nos. 1495/45, 1495/46 • Anzelewsky, 1980, p. 110, under ill. 98 • Strieder, 1981, pp. 203, 205, ill. 237.

Dürer captures the head of a grown roebuck (*Capreolus capreolus* L.) with rapid brush strokes. Opinions differ as to whether he was painting from a dead[1] or living, "probably captive" animal.[2]

The watercolor study belongs to the original contents of the Léon Bonnat Collection. There is as yet no further information about its provenance. The date 1514 and Dürer's monogram, top right, have been recognized as a later addition, Flechsig thinks by Hans von Kulmbach.

The study was first published by Lippmann, with almost no commentary. Only in 1927 did it attract renewed attention, when the drawings in the Lubomirski Museum in Lemberg became known; among them was the brush sketch of a similar roebuck's head (ill. 54.1).[3] Winkler[4] recognized the Lemberg sketch as a preparatory work for the colored study in Bayonne, and in the beginning considered about 1495 as a possible time of execution, when Dürer was traveling in Italy. Flechsig set it as around 1498. The Tietzes excluded the Lemberg drawing, and only hesitantly included the Bayonne study, which they dated 1502, in the addenda to their index of Dürer's work. Winkler[5] finally followed them, extolling the study as "one of the finest animal drawings of this period, along with the *Hare* and the *Stag's Head*,[6] almost more subtly drawn than both of these." Panofsky dates the study as around 1503; Musper, White, Anzelewsky, and Strieder put it as after 1500. In the recent

literature, Strauss is alone in putting it with the 1495 works, on the grounds of the watermark.

The Lemberg drawing, at present in the Nelson Atkins Museum, Kansas City, shows the same animal more in profile, and Winkler thinks it preceded the Bayonne study, "for after the more subtle work of the other version, Dürer would hardly have returned to the same model, and that from a less effective angle."[7] In connection with the carefully executed Bayonne study, the sketch in the Atkins Museum affords us an ideal insight into Dürer's way of working, which also applies to the *Hare* (Cat. 43). "After preliminary drawing with the brush to establish all the characteristic shapes, the work proceeded in two stages, during which Dürer was still correcting. First came an application of color over a large area, and then the fine finishing work and the addition of highlights."[8]

Since the Bayonne study is carried out in a technique almost identical to that of the *Hare* of 1502, it is revealing in many respects. Mainly, we can read from it how similarly Dürer proceeded both times, scarcely changing his method. As in the *Hare,* the pale gray and pale brown of the underpainting are left in reserve, but the white hairs, for example, around the ears, are applied with white pigment. The folds on the hare's neck and those around the roebuck's ear are rendered in an

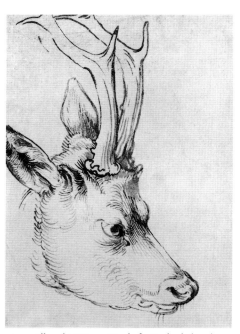

54.1 Albrecht Dürer, *Head of a Roebuck,* brush drawing. Kansas City, The Nelson Atkins Museum of Art.

entirely similar way. This analogous treatment confirms how close works of this period can be to one another.

It looks as if there was a very short time span, perhaps only a few days, between the creation of the two works. Their affinities represent valuable evidence for the continuity and the variability in the use of medium. Bearing in mind their similar technique, it becomes ever

harder to think of placing certain stylistically different studies within the same period. This applies, on the one hand, to the attempt to include the roller studies (Cat. 10, 22) here, and, on the other hand, to the effort to place alongside the flower studies on vellum *The Large Piece of Turf* (Cat. 61) and the *Iris* (Cat. 66). The *Roebuck's* stylistic affinity with the *Hare* of 1502 also makes dating it 1495, as Strauss ventures to do, a fruitless undertaking.

The *Roebuck* study makes a definite contribution to our knowledge of Dürer's style in the years 1502–1503. The remarkably close analogies in execution between this drawing and the *Hare* provide a warning not to breach the limits of variable stylistic possibilities by virtue of uncritical attempts at dating. The latter may happen, as is the case, for instance, since Meder, with the plant studies on vellum, when even the greatest differences are supposed to be attributable to the resistance of the medium, without paying attention to the fact that the *Roller* studies and *The Infant Saviour* of 1493 are also done on vellum — without the slightest difficulty.[9]

NOTES

1 Winkler, 1957.
2 Killermann, 1953.
3 Albrecht Dürer, *Head of a Roebuck,* brush sketch; 228 x 166 mm; now in Kansas City, Nelson Atkins Museum of Art (W. 364).
4 Winkler, 1929.
5 W. II, p. 79, no. 365.
6 Probably only on grounds of the similar motif and the date (1504) Winkler (II, p. 78, no. 362; 1957, p. 182), Flechsig (II, p. 95), Musper (1952, p. 126), Strauss (I, p. 354, no. 1495/47), and Strieder (1981, p. 205) refer to the study in the Bibliothèque Nationale, Paris — which, in my opinion, however, is stylistically different and deserves a thorough investigation.
7 W. II, p. 79, no. 364.
8 Anzelewsky, 1980.
9 The paper of the *Roebuck* study in Bayonne shows the lower half (rod and fastened triangle) of the watermark of a crown (p. 260, fig. 11). It runs horizontally from the middle of the right edge of the drawing to between the left eye and ear of the animal. This curtailment of the watermark allows us to presume that the work has been cut and was originally approximately twice the size.
 Similarly, the paper of the *Roebuck* study in Kansas City carries, toward the left edge of the drawing, also half a watermark — in this case the upper part of the same watermark. Both papers are of equal size. Placed side by side, Bayonne on the left and Kansas City on the right, the two parts of the watermark match (a fact previously overlooked). Apparently, both studies originally were executed on one sheet of paper that was cut in two only at a later date.
 I gave a brief statement on this subject during the symposium organized in Vienna on the occasion of the exhibition (June 7–10, 1985); one can read it in detail in the symposium report (*JKS* 82/1986).

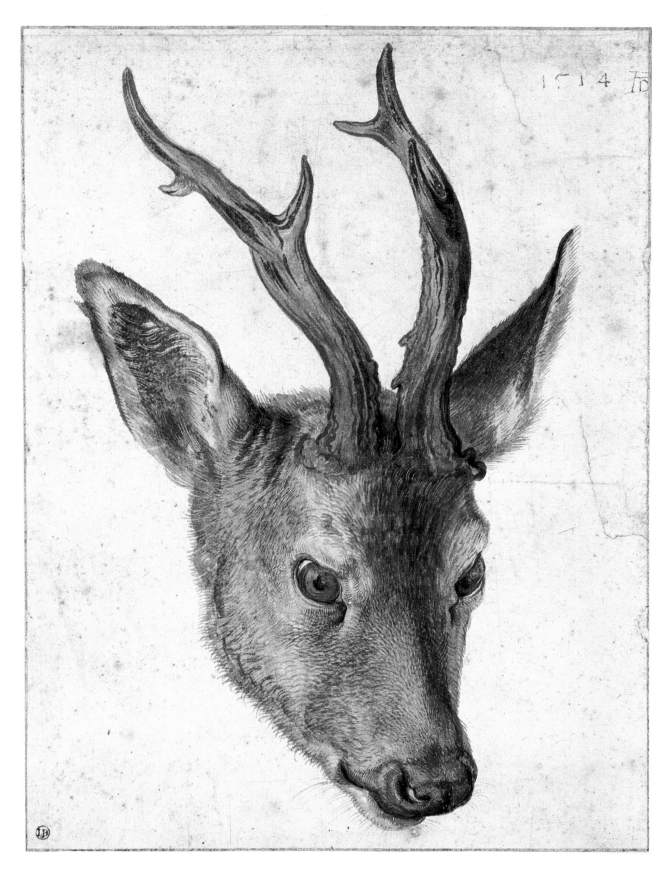

54

Dürer's Lion Studies from His Visit to the Netherlands

In all times, the lion has been a favorite subject of fine art. As an evangelist's symbol, a heraldic emblem, an allegory of power and dominion, and king of the beasts in the realm of fable, it has continually reawakened the artist's interest more than any other creature. Dürer, too, portrays it often: the lion was indispensable as an attribute of Saint Jerome. Between 1510 and 1515 alone, he made no fewer than four versions of the saint and the lion, in copper engraving (B. 60), woodcut (B. 113, 114), and drypoint (B. 59). Despite their frequency, his images of the lion show details, such as the odd shape of the nose, or an extra toe on a back paw[1] in the 1514 master engraving, that make it doubtful that he had had, at that point, opportunity to study a living model. It has been assumed that he had seen living lions on his visit to Venice in 1494–95,[2] but only from the last decade of his life, when he visited the Netherlands, do we get documentary evidence that he managed not only to see lions, but also to draw them from life.[3] This is proved by the silverpoint drawing *Reclining Lion* (Cat. 55), which carries the note *"zw gent"* and to which Dürer's entry of April 10, 1521, in his travel diary refers: *Darnach sahe ich die Löben und conterfeÿt einen mit den stefft* ("Afterward I saw the lions and counterfeited one with the stylus").[4] A further silverpoint sketch (Cat. 56) in Berlin, together with the study in the Clark Art Institute (Cat. 57), completes the list of presumably authentic lion studies surviving from this journey.

In addition, there exist a number of pacing or reclining lions that have been linked to Dürer's name:

1 Breuer lion (ill. 1), introduced in the literature by Meder as Dürer's work and judged superior to that in the Albertina.[5] It is related to an etching by Wenzel Hollar[6] (ill. 2).
2 A reclining lion, formerly in the Klinkosch Collection[7] in Vienna, now missing. This corresponds to another of Hollar's etchings (ill. 3).
3 Dürer-Haus lion[8] (ill. 4).
4 Resting lion, Detroit[9] (St. 1494/18; ill. 5).
5 The lion in the Albertina, pacing toward the left (Cat. 58); since Meder this has generally been rejected as not being Dürer's, only Winkler still listing it as authentic.

Besides these, it is appropriate to recall an entry in the Imhoff *Geheimbüchlein*, fol. 73v: *Ein Schöner löb auff pergament, stehet zwar des A. Dürers Zaichen darunter, man helt aber darfür, es habe solchen nur Hanns Hoffman gemahlt . . .* ("A fine lion [*sic*] on vellum, admittedly with A. Dürer's mark underneath, but one feels that only Hans Hoffmann could have painted it . . ."— which suggests ills. 59.1 and 60.1).

Of all the uncertainties about these lion pictures, some of which are no longer available, only those concerning the questioned study in the Albertina (Cat. 58) will be critically examined here. The studies dated 1521 invite particular interest because they are the only unauthenticated works to have been repeatedly copied more than half a century later. Some of these copies, clearly distinguishable from the Albertina *Lion,* evidently come from Hans Hoffmann (Cat. 59, 60), others from a still unknown artist, dating perhaps only from about 1600 or the early seventeenth century (ill. 6). These copies suggest two things: one, that their model was obviously a famous picture, and two, that this lion had a companion lioness. Anyone who studies the inventories of old Dürer collections carefully will soon find, in the index[10] published by Josef Heller of the Dürer works offered in 1588 from the collection of Willibald Imhoff the Elder to Emperor Rudolf II, under no. 58 a lion, and just following, as no. 59, a lioness on vellum. Here is documentary evidence of the companion deducible from the copies, in no less a place than the Imhoff Collection. Hans Hoffmann copied many of Imhoff's important Dürer studies, such as the *Dead Blue Roller* (Cat. 10), the *Wing of a Blue Roller* (Cat. 22), and the *Hare* (Cat. 43). This points to the supposition that his copies of the pair of lions were also made from the prototypes mentioned in the index after the *Roller* and the *Hare.*

Until now it has escaped scholarly interest that there is a lioness on vellum (Cat. 58a) among the Dürer drawings in the Edmond de Rothschild Collection in Paris. She has the same shape as Hoffmann's lionesses, but corresponds in treatment to the lion in the Albertina; like that lion she conforms in style to the study in the Clark Art Institute in Williamstown (Cat. 57), which is also dated 1521.

The facts come together: all the signs indicate that the *Lioness* in the Rothschild Collection is the companion piece to Dürer's *Lion,* famous and much copied in the sixteenth century. But what was previously overlooked is that both are registered in the Imhoff Collection. This, together with the *Lioness*'s stylistic affinity to Dürer's study from the Netherlands visit and the frequent copying of this drawing in the late sixteenth century, speaks strongly for its authenticity.

Besides being copied by Hoffmann, the original version found its way into natural-science illustrations too. The draughtsman of the Dresden album made use of the form traceable to Dürer (ill. 6). His example, however, not only shows the taking over of Dürer's forms even in scientific illustrations, but is also

of interest for the stylistic hallmarks it displays. It is particularly revealing in reference to some of the versions mentioned above; above all, the schematic rendering of the clearly and simply outlined paws in this drawing offers a concrete basis for judging works such as the Breuer *Lion* or the Dürer-Haus *Lion.*

NOTES

1 David, 1909, pp. 74, 75.
2 E., p. 122 and note 1; David, 1909, p. 27 ff.; W. I, p. 64, under no. 87.
3 David, 1909, p. 79.
4 Rupprich I, p. 168.
5 Formerly D. Breuer Collection, Vienna. Missing. Joseph Meder, "Eine Dürer-Zeichnung," in *Die Graphischen Künste* LII/1929, *MGVK* no. 4, pp. 65–67. Further literature: E., p. 122, note 1; Auction Catalogue, Klinkosch Collection (Wawra), Vienna, April 15, 1889, p. 33, no. 359; David, 1909, p. II; T. II/2, p. 147, no. A 440; W. IV, appendix plate IV below; P. II, p. 129, no. 1329; St. III, p. 1750, no. 1518/26.
6 Hollar reproduced this and a reclining lion (see ill. 3 and note 7). The two etchings are made from drawings that, according to Hollar's inscription, were in the collection of Lord Arundel. It is assumed that he acquired them in 1636, together with a large part of Willibald Pirckheimer's library, from the Imhoff Cabinet in Nuremberg (see Rosenthal, in *JPK* 49/1928, Supplement 1929, p. 50).
7 E., p. 122, note 1; Auction Catalogue, Klinkosch Collection (Wawra), Vienna, April 15, 1889, p. 33, no. 359; David, 1909, p. 83; W. III, appendix plate XIII above; P. II, pp. 129, 130, no. 1330; St. III, p. 1752, no. 1518/27.
8 David, 1909, p. 77.
9 Paul Wescher, "An Unnoticed Drawing in the Detroit Institute of Arts, in *The Art Quarterly* 13/1950, pp. 156–160; Winkler, 1957, p. 47; Friedrich Winkler, "Verzeichnis der seit 1939 aufgefundenen Zeichnungen Dürers," in *Festschrift E. Trautscholdt* (Hamburg, 1965), pp. 78–84; St. I, p. 234, no. 1494/18. I am not familiar with the original of this work, but from the photograph it appears to be a copy of the lion in Dürer's *Saint Jerome* (B. 61).
10 H. II, pp. 77 ff. (p. 82).

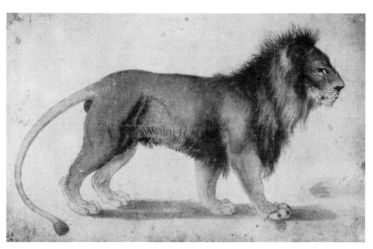

1 Probably a copy after Dürer, c. 1600 (?), *Lion*.
Formerly in Vienna, Sammlung Dora Breuer (see note 5).

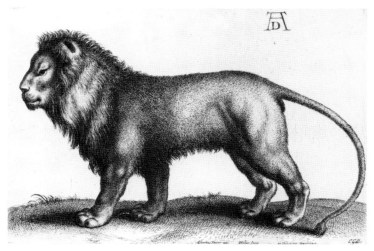

2 Wenzel Hollar, *Lion,* 1649, etching (Parthey 2095).
Vienna, Graphische Sammlung Albertina (see note 6).

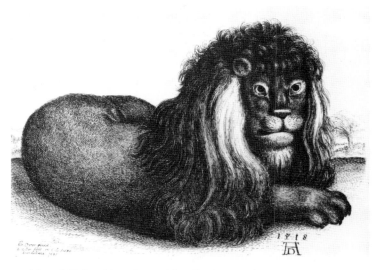

3 Wenzel Hollar, *Lion,* 1645, etching (Parthey 2094).
Vienna, Graphische Sammlung Albertina (see note 6).

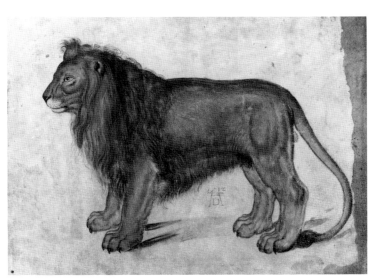

4 German, late sixteenth century, *Lion,* watercolor and body color on vellum.
Nuremberg, Albrecht Dürer-Haus-Stiftung.

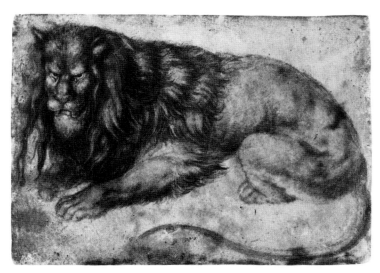

5 Attributed to Albrecht Dürer, *Resting Lion,*
watercolor on paper. Detroit, Institute of Arts (see note 9).

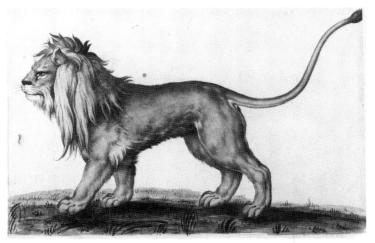

6 German, c. 1600, *Lion,* pen drawing, watercolored.
Dresden, Staatliche Kunstsammlungen, Kupferstich-Kabinett (Inv. Ca 213, p. 7).

55

ALBRECHT DÜRER

Reclining Lion

Silverpoint on white primed paper
Top right, the inscription: *zw gent*
Reverse: Cologne girl and Agnes Dürer,
inscriptions: *Cölnisch gepend* and
awff dem rin mein Weib pey popart
131 x 185 mm (overall measurement)
Vienna, Graphische Sammlung Albertina,
Inv. 23.385 (D 143)

PROVENANCE: Imperial Treasure Chamber •
Imperial Court Library (1783)? •
Österreichische Nationalbibliothek (given to
the Albertina in 1921).

BIBLIOGRAPHY: E., pp. 301, 302 • Th. II,
pp. 205, 206 • L. IV, p. 29, no. 425 • David,
1909, pp. 79, 80, 105 • Killermann, 1910, p. 75 •
Veth-Muller, I, p. 27, plate Xa and II, p. 119 •
Fl. II, p. 218 • Albertina Catalogue IV, p. 22,
no. 143 • T. II/2, p. 24, no. 812 • W. IV, p. 21,
no. 781, p. 20, under no. 779 • P. I, p. 37 • P. II,
p. 141, no. 1498 • Musper, 1952, pp. 128, 270 •
Killermann, 1953, p. 55 • Schilling, 1958, 10
recto • Goris and Marlier, 1970, pp. 92, 189,
no. 19 • K.-Str., p. 381, no. 123a • White, 1971,
p. 174, under no. 77 • St. IV, p. 2022,
no. 1521/13 • Exhibition Catalogue Berlin 1984,
pp. 102, 103, under no. 97v.

On the reverse of the page with the Barbary lion (*Panthera leo leo* L.) are the half-length portraits of a Cologne girl and Dürer's wife, Agnes. Judged by the portraits and inscriptions, the work dates from Dürer's visit to the Netherlands in 1520–21; if one takes into consideration the format, the style of drawing, and the technique, it belongs to his second sketchbook,[1] begun on the journey and mentioned in his notes. This had an oblong format, about 133 x 194 millimeters in size, and consisted of thin paper, primed on both sides in preparation for silverpoint drawing. This drawing technique was at that time particularly popular in the Netherlands, but Dürer too had occasionally used it before.

Above the lion, Dürer jotted down *"zw gent"* as if not to forget. The note can be pinpointed with the help of his diary of the Netherlands journey. Having been in the Netherlands since the autumn of 1520, on April 6, 1521, he set out from Antwerp to go via Bruges to Ghent, where he was welcomed with honor on April 9. On the following day he toured the town, visiting in particular the Ghent Altarpiece by the brothers van Eyck, and later made a further entry in his diary: *Darnach sahe ich die Löben und conterfeÿt einen mit den stefft* ("Afterward I saw the lions and counterfeited one with the stylus").[2]

This is the first lion of whom we can say with confidence that Dürer drew him from life.[3] The opportunity was obviously rare.[4] His interest was correspondingly great, as further studies in this sketchbook reveal, for after this

full-body side view of a reclining lion, he drew another in front view and profile (Cat. 56), and on a third sheet from the same sketchbook there is a fleetingly sketched head of a lion with open jaws.[5]

"Under the force of the new impressions of nature storming in on him during the journey, the fifty-year-old seems to have regained the directness and freshness of the view of nature he had in his early thirties. For the first time, Dürer now shows us the living image of the lion, and not as he lived in his imagination but in the world of reality. The animal here has neither the deadly serious, thoughtful look of the human eye, nor is he sunken to the level of the docile household pet. Dürer gives no more and no less than he actually sees before his eyes: a caged creature stultified by long imprisonment, in a resigned daze, only slightly perturbed by the attention of the artist in the daily monotony of his captive existence."[6]

A total of fifteen surviving sheets from the sketchbook are today in collections in Berlin, Chantilly, Frankfurt, London, Nuremberg, and Vienna.[7] Whether the sketchbook from Imhoff's collection reached the imperial treasure chamber is unknown. It is already mentioned in the Rudolfian inventory 1607/11.[8] Joachim von Sandrart, visiting the imperial court in Vienna in 1651, had the opportunity to see a sketchbook from the Netherlands visit in the Hapsburg art chamber.[9]

NOTES

1 Rupprich, I, p. 168.
2 Rupprich, I, p. 168.
3 David, 1909, p. 79.
4 Killermann (1953, p. 16, note 12a) indeed informs us that there were lions kept in dens even in Germany at that time.
5 Berlin, Staatliche Museen Preußischer Kulturbesitz, Kupferstichkabinett, Inv. KdZ 34v (W. 777), Exhibition Catalogue Berlin 1984, p. 101, no. 96v.
6 David, 1909, p. 80.
7 See Goris and Marlier, 1970, pp. 188, 189.
8 Bauer and Haupt, in *JKS* 72/1976, p. 135, no. 2704: *A.D.ᵈ ein zaichnusbuch in quarto, überlengt, uff baingeschwembt papir, darein er, Dürer, mit einem silbern stefft etliche conterfettl, thier, stett gezaichent, darein auch 3 vögel von mieiner D.F.ᶜ hand eingeklebt.* ("A.D.ᵈ a drawing book in quarto, oblong, on paper primed with bone wash, in which he, Dürer, with a silver stylus truly drew portraits, animals, towns, wherein also 3 birds stuck in by my D.F.ᶜ [Daniel Fröschl] hand.") Winkler's pronouncement (IV, p. 12), according to which the book was sold for lack of interest in the early nineteenth century, is already corrected by Koschatzky and Strobl (p. 381, under no. 123a): "The silverpoint sketchbook obviously never reached Duke Albert and the Albertina, but instead, probably regarded as a Court Library volume, remained there in 1796, and at least parts of it must have been stolen from there by V. D. Denon, who in 1809, as Napoleon's commissary in charge of expropriation, was not least concerned to acquire works for his own collection."
9 Sandrart, 1675, p. 67.

162

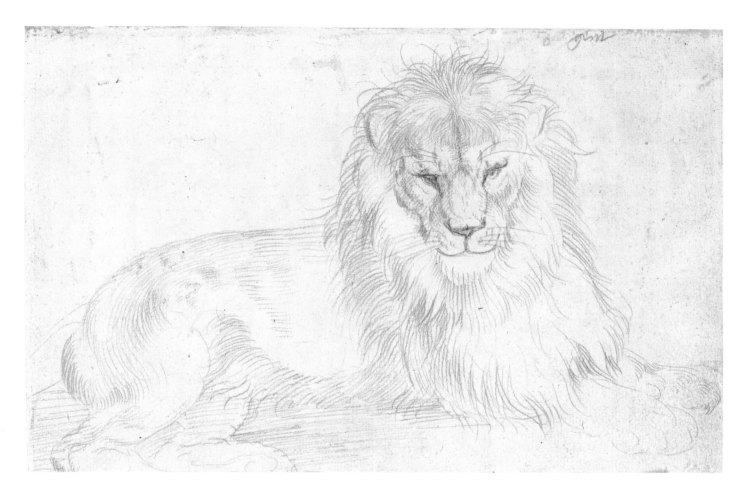

55

56

ALBRECHT DÜRER

Two Studies of a Lion

Silverpoint on white-prepared paper
Reverse: half-length portrait of a man from
Antwerp, the Krahnenberg near Andernach,
inscriptions: *zw antorff 1521* and *pey andernach am
rein*
121 x 171 mm
Berlin, Staatliche Museen Preußischer
Kulturbesitz,
Kupferstichkabinett, Inv. KdZ 33v

PROVENANCE: Anonymous collector (L. 2882) •
Firmin-Didot.

BIBLIOGRAPHY: Exhibition Catalogue Berlin
1877, p. 17, no. 33 • E., pp. 301, 302 • Friedrich
Lippmann, *Zeichnungen Alter Meister im
königlichen Kupferstichkabinett zu Berlin* (Berlin,
1882), p. 16, no. 31 • L. I, p. 13, no. 60 • Th. II,
p. 195 • David, 1909, pp. 79, 80, 81, 105 • Veth
and Muller, I, p. 27, plate XIa • Bock, 1921, I,
p. 31, no. 33v • Max J. Friedländer and Elfried
Bock, *Handzeichnungen deutscher Meister des 15.
und 16. Jahrhunderts* (Berlin, n.d.), p. 49, plate
30 • Fl. II, p. 218 • T. II/2, p. 25, no. 815 •
W. IV, p. 20, no. 779, also under no. 778 • P. I,
p. 37 • P. II, p. 141, no. 1497 • Killermann, 1953,
p. 55 • Schilling, 1958, II recto • Goris and
Marlier, 1970, p. 189, no. 18 • K.-Str., p. 381,
under no. 123a • White, 1971, p. 174, no. 77 •
St. IV, p. 2020, no. 1521/12 • Anzelewsky, 1980,
p. 220, ill. 208 • Exhibition Catalogue Berlin
1984, pp. 102, 103, no. 97v.

In this silverpoint drawing, Dürer captures
two aspects of the same lion, front view and
profile.[1] Like the foregoing study (Cat. 55), it
comes from his Netherlands sketchbook.
Opinions differ as to whether Dürer drew this
lion during his stay in Ghent from April 9 to 11,
1521, or before or after in Antwerp.[2] David
thinks that Antwerp is indicated not only by
the different physiognomy of the animal por-
trayed, but also by the reverse side of the draw-
ing, which bears a portrait and the note *"zw
antorff 1521"* ("in Antwerp 1521"). The same
note is also found on another sheet on which
Dürer sketched another lion's head beside the
study of a dog,[3] from which the Tietzes in-
ferred that it predated the finished study. In
opposition to David, the entire expert litera-
ture gives the opinion that all three studies
were done in Ghent, probably from the same
animal.

The arrangement of the two pages of studies
within the sketchbook is neither known nor to
be deduced from the drawings themselves.
While Schilling makes the Berlin lions follow
the Vienna one on a later page, Flechsig and
Goris and Marlier put them before the Vienna
study, in such a way that both pages would
have formed a double sheet in the sketchbook's
original binding.

The time between them seems minimal.
The order in which they were done is perhaps
indicated by their different finish: the Vienna
one is drawn more sketchily, and when it is
compared to the Berlin study, they look like
rough and fair copy. Despite this difference,
the very similar touch and the identity of the
model lead one to suppose that Dürer commit-
ted the same animal to paper twice in direct
succession, within the space of a few minutes.

NOTES

1 Flechsig; finally Exhibition Catalogue Berlin
1984. There is a copy of the drawing in the
Germanisches Nationalmuseum in Nuremberg,
Inv. Hz 5493, ill. in Fritz Zink, *Die deutschen
Handzeichnungen,* vol. 1, *Die Zeichnungen bis zur
Mitte des 16. Jahrhunderts* (Nuremberg, 1968),
no. 76.
2 David, 1909.
3 See Cat. 55, note 5.

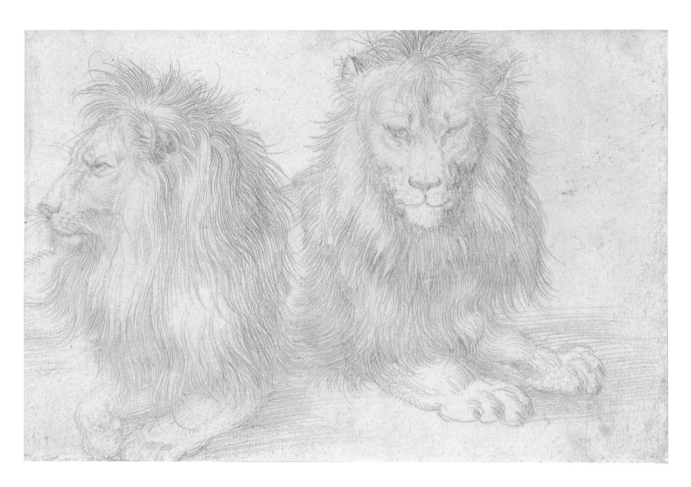

56

Studies of Animals and Landscapes

(illustrated on pages 168–169)

Pen and black ink on paper,
only the baboon tinted in pink and blue-gray
watercolor
Watermark: crown, shield, flower, and initials,
Meder 314 (see p. 259, fig. 9)
Top left corner replaced
Top right, authentic monogram and the date
1521,
also the inscription: *Ein sunder tier das/Ich . . . /*
gros anderthalben zentn[er] schw[er]
264 x 397 mm, slightly trimmed on all sides
Williamstown, Sterling and Francine Clark
Art Institute, Inv. 1848

PROVENANCE: Earl of Pembroke and Montgomery • Colnaghi • Robert Sterling Clark.

BIBLIOGRAPHY: Auction Catalogue, Sotheby's, London, July 5, 1917 (Wilton House Sale), pp. 231–233 • Campbell Dodgson, "A Sheet of Studies by Dürer," in *TBM* 30/1917, pp. 231, 232 • Veth and Muller, I, pp. 57, 58 • L. VI, p. 14, under no. 640 • W. I, p. 170, under no. 246 • W. I, appendix plate XXIII below • T. II/2, p. 20, no. 795 • Theodor Musper, "Dürers Zeichnung im Lichte seiner Theorie," in *Pantheon* 21/1938, p. 105 • W. IV, pp. 40, 41 • P. II, p. 140, no. 1475 • Killermann, 1953, p. 55 • Winkler, 1957, pp. 309, 310, 311 • *Drawings from the Clark Institute,* compiled by Charles Talbot, Egbert Haverkamp-Begemann, and Standish D. Lawder (New Haven, London, 1964), vol. I, pp. 5–7, no. 3 • Goris and Marlier, 1970, p. 192, no. 74 • Exhibition Catalogue Washington 1971, pp. 89, 90, no. XXVIII • St. IV, p. 2072, no. 1521/40.

Dürer has done several studies on this unusually large sheet. On the left are two landscapes, each of a fortress beside a bridge, on the right various animals: below, stretched out, a young Barbary lion (*Panthera leo leo* L.) with drooping eyelids; above that, left to right, a lynx (*Felix lynx* L.), the three-quarter back view of a Barbary lion with an enormous mane, and a young chamois (*Rupicapra rupicapra* L.); in the top row a dozing lioness lying next to a squatting baboon (*Papio hamadryas* L.). Dürer was particularly interested in this last exotic animal: not only did he brighten it with watercolor, but also made a note of its size and weight — although the note is now damaged and fragmented ("A curious animal that / I . . . / tall and half a hundredweight heavy"). Each animal is a separate study on its own patch of ground, and they are observed from various distances and angles. The landscapes and the lynx occupy one half of the sheet and the rest of the animals the other, which suggests that Dürer himself folded it in half.

The drawing came from the Earl of Pembroke's collection, and was stuck on the back of an engraving by Agostino Veneziano (B. 42) to reinforce it, probably in the eighteenth cen-

tury. It came to light in 1917, when it was introduced in the literature by Dodgson, associated with the Netherlands visit, and recognized as the model for the *Young Lion* in Warsaw (Cat. 57a). The latter was up to that time believed to be by Dürer himself, but then it turned out to be a partial copy.

Winkler alone initially saw the scattered arrangement of the animals[1] as the clear sign of a copy representing a compilation of Dürer motifs, but he later revised his negative opinion.[2] The Tietzes considered the sheet genuine, and countered the arrangement argument by pointing out that the sheet of Saint Christopher studies (W. 800), also dated 1521, likewise contains several juxtaposed and overlapping items. In subsequent literature, the sheet, which bears Dürer's own handwriting, has not been further questioned.

It was Dodgson who associated the 1521 drawing with Dürer's visit to the Netherlands. Dürer had left Nuremberg on July 12, 1520, arrived in Antwerp on August 2, and according to his diary, stayed in Brussels from August 27 to September 2. He wrote enthusiastically about his visit to the royal zoo,[3] and made a drawing of it (ill. 57.1). Before returning home nearly a year later, he made another stopover in Brussels, from July 3 to 12, 1521.[4] Although he does not mention the zoo this time, the drawing in the Clark Art Institute suggests a further visit to this place that he found so interesting.

Dürer used a sharp pen to hatch over the drawings with fine, flowing, regular strokes, a technique strongly reminiscent of engraving and exactly characteristic of the drawings he made on his Netherlands visit. He sketched from life, in front of his model, going all around the contours with delicate, economical strokes like guidelines, very visible around the legs of the chamois and the young lion asleep;

these either were covered in the finished drawing, or now let us see where he changed his mind. Using the paper economically, he arranged the animals side by side, as in late medieval pattern books.[5] While these animals were obviously drawn in a zoo, presumably the one in Brussels, the landscapes must have been done on the homeward journey.[6] Up to now, nobody has managed to identify the places, but one of the fortresses has been successfully detected in an etching dated 1545 by Augustin Hirschvogel (Schwarz 66).[7]

This sheet of carefully executed animal drawings in the Clark Art Institute holds a key position among the animal drawings from the Netherlands visit, since all the rest can be judged in relation to it, particularly the lions in Paris and Vienna (Cat. 58) and Hans Hoffmann's copies (Cat. 59, 60).

NOTES

1 L. VI.
2 W. IV.
3 Rupprich, I, p. 155.
4 Rupprich, I, pp. 176, 177.
5 See *Lion Studies,* Venetian, late fourteenth century, Paris, Musée du Louvre, Cabinet des Dessins, Inv. RF 1539V; or Giovannino de' Grassi's sketchbook of animal studies, Bergamo, Biblioteca Civica, fol. 16, ill. in Bernhard Degenhart and Annegrit Schmitt, *Corpus der italienischen Zeichnungen 1300–1450,* part II, vol. I (Berlin, 1980), pp. 172 ff., ills. 294–298.
6 Exhibition Catalogue Washington 1971.
7 Exhibition Catalogue Washington 1971, p. 90, note 10.

57.1 Albrecht Dürer, *Brussels Zoo,* 1520, pen drawing on paper. Vienna, Akademie der Bildenden Künste, Kupferstichkabinett.

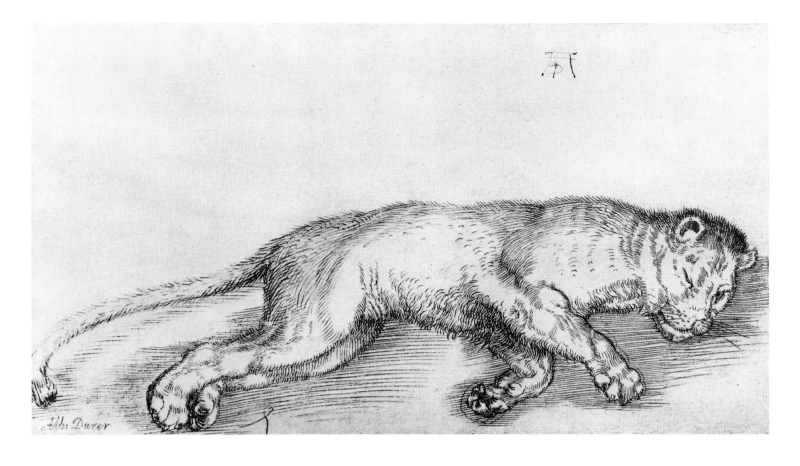

57 a

57ª

GERMAN, END OF THE SIXTEENTH
CENTURY

Young Lion

Pen and ink on paper
Watermark: Gothic *P* (according to Strauss)
Top right, Dürer monogram by a foreign hand;
bottom left, the inscription
(eighteenth century?): *Alb: Durer*
162 x 273 mm
Warsaw University Library,
missing since 1945

PROVENANCE: King Stanislaus August Ponia-
towski • Leningrad Academy until 1918 •
Warsaw University Library (Inv. Kgl. Slg.
T. 173, no. 149).

BIBLIOGRAPHY: Campbell Dodgson, in *TDS*
IV/1901, p. 13, no. XIII • David, 1909, pp. 54,
55 • Campbell Dodgson, in *TDS,* Index,
Supplementary Notes (London, 1911), p. 64,
no. IV.XIII • Campbell Dodgson, "A Sheet of
Studies by Dürer," in *TBM* 30/1917, p. 232 •
L. VI, p. 14, no. 640 • T. I, p. 134, no. A165 •
Winkler, in *JPK* 50/1929, pp. 137, 138 • Fl. II,
p. 411 • T. II/2, p. 20, under no. 795 • W. I,
pp. 166, 169, 170, no. 246 • W. IV, pp. 40, 41 •
P. II, p. 130, no. 1331, p. 140, under no. 1475 •
Musper, 1952, p. 128 and note 14 • St. IV,
p. 2074, no. 1521/41 • Exhibition Catalogue
Washington 1971, p. 89, under no. XXVIII.

When Dodgson[1] published this pen draw-
ing, formerly belonging to the Warsaw Uni-
versity Library, it was taken for a work of
Dürer's, but after the Pembroke sheet, now in
Williamstown (Cat. 57), became known, it
was recognized as a copy.[2] Winkler alone,
until 1936, still held it to be Dürer's,[3] but cor-
rected himself a little later, after having studied
the original.[4] Strauss lists it as if it were
still in the Warsaw University Library. Re-
moved after the occupation of Poland in 1939,
and last seen in the exhibition *Sichergestellte
Kunstwerke im Generalgouvernement* in Breslau
(Wroclaw) in 1940, it seems that the drawing
was lost during the wartime disturbances.[5]

Although it is now possible only to compare
a reproduction, the relation of the drawings is
revealing. It is particularly clear how the artist
reproduced the faint outlines here and there, so
managing to deceive even an expert like
Winkler for quite a long time. The fine, tenta-
tive outline is characteristic of Dürer's nature

studies, and can already be seen in his early
drawings such as the *Young Steer* (Chicago,
W. 239). But in spite of his exact reproduction
of the details mentioned, the copyist lacks
an appreciation of organic cohesion. Where
Dürer expresses the young lion's strength de-
spite its relaxation, welding together the
curved back, the muscular nape, the swelling
rump, and the powerful back legs, in the copy
these features become flat and lose all tension.

It is not possible at present to ascribe the
drawing to any Dürer copyist we know. Simi-
larities to Hans Hoffmann's pen stroke cannot
be dismissed out of hand, but this point alone is
not sufficient for an attribution.

NOTES

1 Dodgson, 1901.
2 Dodgson, 1917.
3 W. I.
4 W. IV.
5 Exhibition Catalogue *Sichergestellte Kunstwerke
im Generalgouvernement* (Breslau, 1940), p. 65,
no. 228; see also Stanisława Sawicka and Teresa
Sulerzyska; *Les pertes de dessins au Cabinet des
Estampes de la Bibliothèque de l'Université de
Varsovie 1939–1945* (Warsaw, 1960), Acta Bib-
liothecae Universitatis Varsoviensis III, p. 20. I
am grateful to Mrs. Sulerzyska for information
as to the drawing's whereabouts.

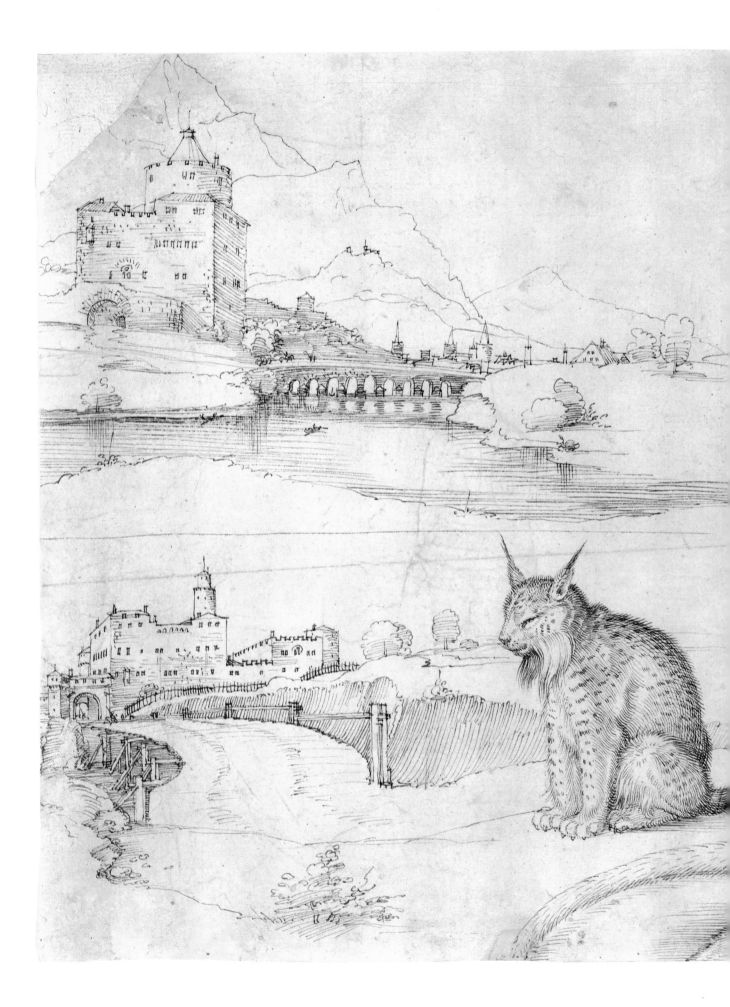

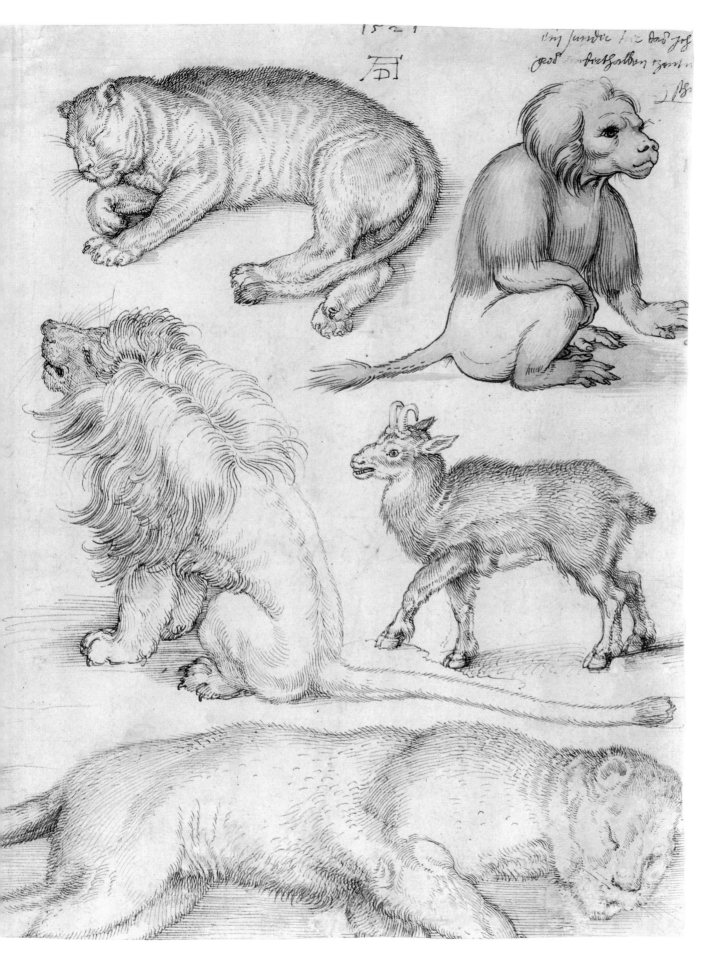

57

58

ALBRECHT DÜRER

Lion

Watercolor and body color on vellum,
mounted on cardboard, brush, pen,
traces of preliminary drawing (brush?)
Authentic monogram and the date *1521*
in pen and black ink, bottom center
177 x 283 mm
Vienna, Graphische Sammlung Albertina,
Inv. 3173 (D 173)

PROVENANCE: Imhoff • Emperor Rudolf II •
Imperial Treasure Chamber • Imperial Court
Library (1783) • Duke Albert of Saxe-Teschen.

BIBLIOGRAPHY: H. II, p. 82, no. 58 and p. 117,
no. 133 • Waagen, 1867, p. 176 • Exhibition
Catalogue Vienna 1871, p. 6, no. 78 • L. V,
p. 26, no. 567 • David, 1909, pp. 81, 82, 105,
106 • Veth and Muller, I, p. 41, no. LIII •
Killermann, 1910, p. 75 • Rosenthal, in *JPK*
49/1928, Supplement, 1929, p. 50, IV • Joseph
Meder, "Eine Dürer-Zeichnung," in *Die
Graphischen Künste* LII/1929, *MGVK* no. 4,
p. 66 • Fl. II, pp. 376, 377 • Albertina Catalogue
IV, p. 26, no. 173 • T. II/2, p. 141, no. A 424 •
W. IV, pp. 42, 43, no. 824 • P. II, p. 129,
no. 1328 • Killermann, 1953, p. 55 • Winkler,
1957, p. 311 • Pilz, in *MVGN* 51/1962, p. 252,
under no. 7/8 • K.-Str., p. 418, no. 164 • St. VI,
p. 3080, no. XW 824 • Piel, 1983, p. 143, no. 63.

58a

ALBRECHT DÜRER

Lioness

Watercolor and body color on vellum,
mounted on cardboard, pen, brush,
heightened with white (oxidized in places)
Dürer monogram and the date *1521* in
pen and black ink
by a foreign hand, bottom center
160 x 256 mm
Paris, Musée du Louvre,
Edmond de Rothschild Collection, Inv. 16 DR

PROVENANCE: Imhoff • M. Jean Gigoux
(according to Ephrussi) • E. de Rothschild.

BIBLIOGRAPHY: H. II, p. 82, no. 59 • E., p. 302,
note 2.

Dürer's monogram and the date 1521 appear between the legs of the Barbary lion[1] pacing with lifted tail toward the left of the picture. This links the picture with the works Dürer did on his visit to the Netherlands, where he saw and drew living lions several times (see Cat. 55–57).

The work is first mentioned in the Imhoff Inventory;[2] Heller[3] describes it in Duke Albert's collection, but Thausing and Ephrussi do not mention it at all. Meder[4] initially accepted it but later called it a "clumsy copy."[5] According to Veth and Muller, the study was done not from life but well before Dürer could have seen living lions in Ghent. David, on the other hand, feels that the careful execution of the study shows it to be an authentic result of Dürer's seeing lions on his visit to the Netherlands. "It was probably, however, not done on the journey, but later, after his return to Nuremberg." He excludes the possibility that the study itself or its rough draft could have been done from nature: "it is no more than a picture from memory, bearing only a loose resemblance to a direct study." David goes on to observe that when Dürer was drawing from nature, he recorded his impressions correctly with the greatest ease and confidence, but here, where he is largely using his imagination, grave errors and inaccuracies creep in, for example in the anatomy of the animal's feet.[6] Flechsig, for his part, doubts the authenticity of signature and date, as well as Dürer's authorship, but he thinks that "if the drawing is by Dürer, it is unlikely to have been done in the Netherlands, but rather after his return to Nuremberg." The Tietzes dismiss the drawing, and suggest it should be identified as the lion mentioned in the later Imhoff *Geheimbüchlein*[7] among the sales to Matthäus Overbeck, where it is said that, although bearing Dürer's mark, it was understood to be Hans Hoffmann's work. Although Winkler accepts the study as Dürer's work,[8] he still feels it possible that it is only "a very clever copy from the Dürer period," but in any case not from the second half of the century, so not belonging to the Dürer Renaissance. Pilz agrees with him in this and is the only one to make the suggestion that, on the basis of Hoffmann's copies of the lion, one might infer the existence of a companion lioness, presumably lost. Panofsky, Koschatzky and Strobl, and Strauss reject the attribution to Dürer. Recently Piel pronounced that the work can only date from before 1500, if indeed it is Dürer's at all. Flechsig bases his thoughts mainly on the writing of the date, disliking the two stops on either side of it, and on that of the monogram, which to him looks self-conscious. Comparison reveals, however, that a series of works from the Netherlands visit show the same characteristics in the writing of the figures, and the Vienna study *An Old Man of Ninety-Three* (W. 788) also has a stop before the date.

More indicative are the stylistic features of the drawing, mainly the technique, as seen particularly on the lion's back legs, reminiscent of engraving with its clusters of strokes, little hooks, and open cross-hatching. The same characteristics are found on the sheet of studies in the Clark Art Institute (Cat. 57), if one looks at the lynx or the sleeping lioness. In both works the shadows on the ground are built up in the same way: under the lion here and the baboon there, the shadows are in solid watercolor, the transition to the light indicated by a fringe of fine, parallel brush strokes.

In the discussion of this Albertina lion, a point from the Imhoff Inventory of 1588 has until now been overlooked. There is a no. 58, "A lion on vellum," and thereafter, plain and clear, is no. 59, "A lioness on vellum," indicated as a separate work.[9] This incontrovertibly documents the existence of the companion piece on which the copies by Hoffmann (who usually drew lion and lioness as companion pieces) were based long ago. It had also been overlooked that Dürer's companion piece had actually survived; mentioned in the literature only by Ephrussi, the drawing of the lioness resides in the Edmond de Rothschild Collection in the Louvre[10] (Cat. 58a). Like Dürer's *Lion* in the Albertina, she is done on vellum; they are about the same size and drawn in the same manner, and are very similar in the treatment of details. Ephrussi's suspicion that she might be a forgery is unfounded: only the monogram and date were added later.

One may be reluctantly inclined to reject the study, but, like the lion, she does have numerous shortcomings; like him, if we accept David's assumption as correct, she may well have been done from memory after his return to Nuremberg from the Netherlands. A look at the sheet of sketches in the Clark Art Institute, however — for example, the lioness's tail or the lion's half-open mouth — will also confirm the strong artistic resemblance between these two figures and the Rothschild lioness.

NOTES

1 David, p. 82, informs us that the dark stomach mane is a characteristic of the Atlas or Barbary lion (*Panthera leo leo* L.).
2 H. II, p. 82, no. 58.
3 H. II, p. 117, no. 133.
4 L. V.
5 Meder, 1929.
6 Citing discrepancies from the real animal, David points out on p. 82 that an extra joint has been inserted between the claws and the base of the foot that does not exist in reality, and that the rudimentary fifth toe-joint is missing.
7 Rosenthal.
8 W. IV.
9 H. II, p. 82, nos. 58, 59.
10 The laws governing gifts prohibit the lending of a work from the collection.

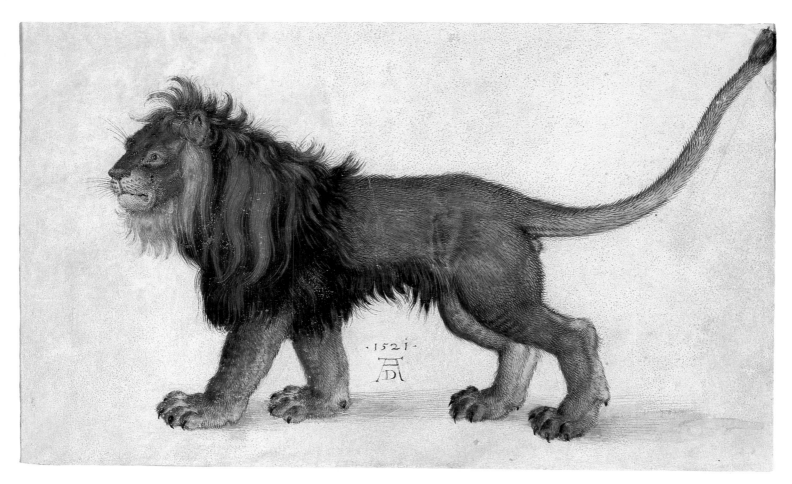

58

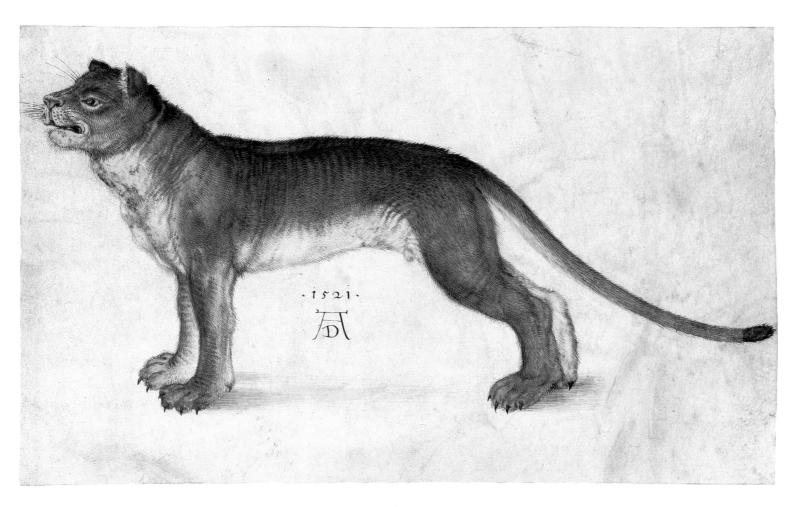

58 a

59

HANS HOFFMANN

Lion

Watercolor and body color on vellum,
brush, pen, heightened with white,
traces of preliminary drawing
with pen and pale brown ink
Bottom center, Hoffmann's monogram
and the date *1577*
172 x 277 mm

Nuremberg, Germanisches Nationalmuseum,
Graphische Sammlung, Norica 407/1534c
(property of the City of Nuremberg)

PROVENANCE: Praun • Hertel • Arnold (according to Pilz).

BIBLIOGRAPHY: Christoph Theophile de Murr, *Description du Cabinet de Monsieur Paul de Praun à Nuremberg* (Nuremberg, 1797), p. 17, no. 144 • Johann Gabriel Doppelmayer, mentioned as a handwritten addition to his author's copy in the Germanisches Nationalmuseum • Pilz, in *MVGN* 51/1962, p. 252, no. 7/8.

60

HANS HOFFMANN

Lioness

Watercolor and body color on vellum,
brush, pen, heightened with white,
traces of preliminary drawing
with pen and pale brown ink
Bottom center, Hoffmann's monogram
and the date *1577*
172 x 277 mm

Nuremberg, Germanisches Nationalmuseum,
Graphische Sammlung, Norica 408/1534c
(property of the City of Nuremberg)

PROVENANCE: Praun • Hertel • Arnold (according to Pilz).

BIBLIOGRAPHY: Christoph Theophile de Murr, *Description du Cabinet de Monsieur Paul de Praun à Nuremberg* (Nuremberg, 1797), p. 17, no. 145 • Johann Gabriel Doppelmayer, mentioned as a handwritten addition to his author's copy in the Germanisches Nationalmuseum • Pilz, in *MVGN* 51/1962, p. 252, no. 7/8.

Dürer's pair of lions (Cat. 58, 58a) was widely known, as proved by the number of times they were copied.

Hans Hoffmann made more than one copy. Those reproduced here correspond in size almost exactly to the Vienna original, and are uniformly signed with Hoffmann's monogram and dated 1577. It is highly probable that they are the paintings on vellum mentioned by de Murr as being in the Paul Praun Collection in Nuremberg, which then passed through the collections of Hertel (1782–1851) and Arnold (1811–1893) and were finally bought by the City of Nuremberg in 1896.[1]

In comparison with the Vienna *Lion,* Hoffmann's copy looks softer, the finer brushwork makes the coat look silkier, especially the mane, while the animal's head makes a more formalized, glossy impression, reinforced by the shining amber eyes, a typical feature of Hoffmann's animal paintings. A particular characteristic of his lion copies is the schematic simplification of the pelt, with individual long, dark hairs protruding in various directions, most noticeably on the belly. Another difference from the Dürer prototype is his rendering of the cast shadow: while Dürer paints patches of shadow graphically, split up into parallel streaks of watercolor, Hoffmann uses broad brush strokes.

The same characteristics, typical of Hoffmann, show up in another copy of this pair of lions (ills. 59.1, 60.1), signed, however, with a Dürer monogram and dated 1512.[2] The distinct, double-line lettering of these imitated Dürer monograms remarkably resembles the Hoffmann monograms of the 1577 lions; compare, above all, the coincidence in the way the *1* and the *5* are formed. The shape of the *2*, wide and circular, can be seen also on the *Wing of a Blue Roller* (Cat. 25) in the Woodner Collection, and on the study *Four Feathers* (ill. 25.1), known to us only from a photograph. The way the date is split up and placed on either side of the monogram is found again in Hoffmann's *Squirrel,* dated 1578 (Cat. 27).

According to oral references, such pairs of lions and lionesses are reported in the trade (London, Nuremberg, Norway); they seem to be identical to the sheets reproduced in ills. 59.1 and 60.1.

Although in both his copies Hoffmann evidently reproduces the *Lion* and *Lioness* mentioned in the Imhoff Inventory,[3] it is not clear

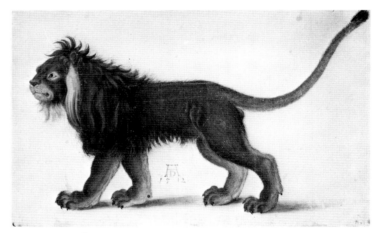

59.1 Hans Hoffmann, *Lion,*
watercolor and body color on vellum. Whereabouts unknown.

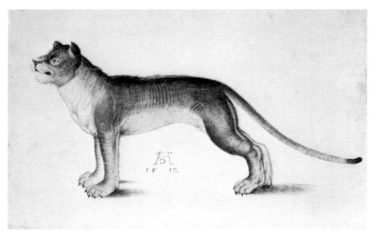

60.1 Hans Hoffmann, *Lioness,*
watercolor and body color on vellum. Whereabouts unknown.

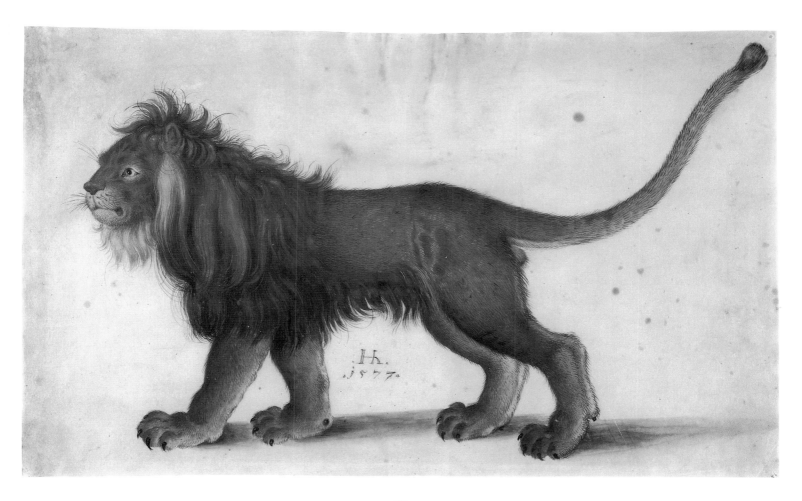

59

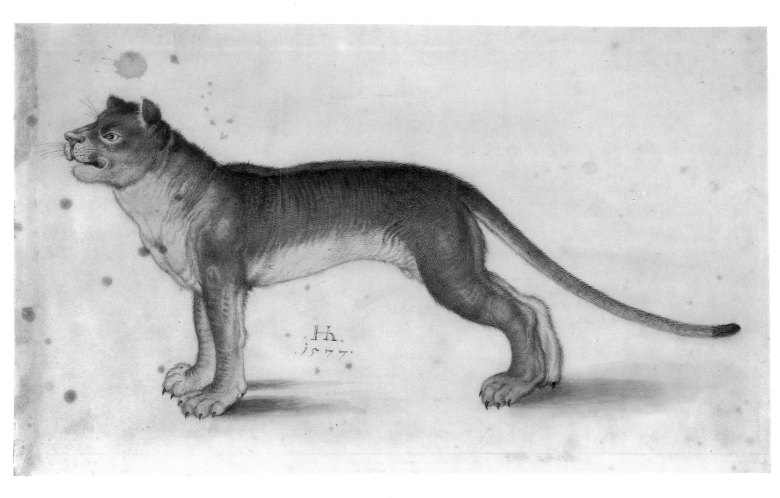

60

why he signed one pair with his own name and the indubitable date, but gave the other pair false Dürer monograms and the date 1512, in any case incorrect. Is it to be supposed that he deliberately decided to forge one pair of lions, and that is why he chose the date 1512, hopefully latching on to the popularity of Dürer's animal studies? His copies of the *Wing of a Blue Roller* (Cat. 22) and the *Dead Blue Roller* (Cat. 10), which he copied many times, are also, incidentally, dated 1512.

NOTES

1 Pilz, 1962.

2 The works shown in the illustrations are presumably those mentioned by Winkler (IV, pp. 42, 43, under no. 824) formerly in private ownership in Sweden.

 Recent information obtained at the time of production of the English edition of this catalogue indicates that the *Lion* (ill. 59.1) is now in Swiss private ownership and the *Lioness* (ill. 60.1) in (different) Swedish private ownership.

 In June 1987, I was made familiar with yet another hitherto unpublished copy of the *Lion* (ill. 59.2): watercolor and body color painted with brush on vellum; 162 x 256 mm; in Austrian private ownership. The colors are faded, the surface has been considerably rubbed and dirtied, and the white depicting the fine strands of hair has, to some extent, been oxidized.

 The shadows at the bottom were probably darkened later. Between the lion's legs there is a copied Dürer monogram over which the date 1512 appears. On the reverse, the vellum shows, at top left, Dr. Petzold's signature (L. 2024, 2025) and at bottom left, the stamp of the G. F. K. Parthey (L. 2014) Collection.

 Stylistically, the representation is closely related to Hoffmann's copies in that it deviates from Dürer's original in the same points: the more clublike form of the right front paw and the rounder contours of the right hind thigh and the left hind foot. As in Hoffmann's copies, the eye and one strand of the mane stand out in bright yellow. Also characteristic is the bottom of the mane and the clearly separated body and legs. In contrast to Dürer's image, the head of the lion is portrayed, in Hoffmann's characteristic manner, with almost doll-like features.

 All these details point to Hans Hoffmann, but the poorly preserved artistic handwriting, which would have made it possible beyond the shadow of a doubt to attribute the copy to him, is no longer clearly recognizable. (It could even be a copy after him.) One can only say that this work more closely resembles Hoffmann's copies than a Dürer original.

 The monogram, similar in position to those in the Dürer pictures, resembles those by Hoffmann, specifically in the broad proportion of the *A*, and relates to Hoffmann's copies (ills. 59.1 and 60.1) with the use of the date 1512 (rather than 1521). Nevertheless, the monogram differs from those forms familiar to us. The vellum at this spot looks scraped, as does the monogram drawn above it.

3 H. II, p. 82, nos. 58, 59.

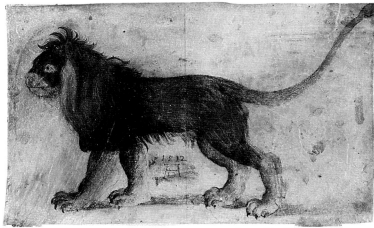

59.2 German, c. 1600 (Hoffmann?), *Lion,* watercolor and body color on vellum. Private collection (see note 2).

Plant Studies

Dürer's Large Piece of Turf:
Some Observations

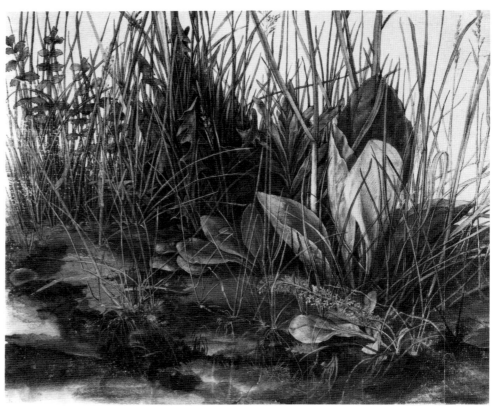

1 Albrecht Dürer, *The Large Piece of Turf,* 1503, detail. Vienna, Graphische Sammlung Albertina (see Cat. 61).

The pivotal work among Dürer's plant studies is the watercolor of a small patch of meadow with a mixture of grasses and wildflowers, known as *The Large Piece of Turf* (Cat. 61). Like the *Hare* (Cat. 43) among the animal studies, it is one of those studies after nature whose authenticity has never been questioned.[1] The seeming lack of pretense of the subject differentiates this work clearly not only from Dürer's other plant studies, but from those of fifteenth-century Frankish and German art in general.

We first encounter true-to-life flower studies in early Netherlandish painting. Their natural beauty was initially perceived and studied by Jan van Eyck and Rogier van der Weyden (ills. 4, 5, p. 14), who recognized them as worthwhile subjects, and from here they affected German art, particularly from Cologne and Franconia. Immediately before Dürer, artists schooled in Netherlandish examples, such as Hans Pleydenwurff (ill. 8, p. 15), Michael Wolgemut, or the Master of the Augustine Altarpiece (ill. 10, p. 17), introduced lifelike plant studies into their paintings. Dürer, however, took an important step forward by simplifying the motifs. His reduction from flower to grass, from the individual appearance of a plant, with its shape, color, and symbolic meaning, to the uniform, nameless thicket of green meadow grasses — to a picture of vegetation — represents a radical generalization: even the simplest thing in nature is worth painting. As a result of an altered aesthetic, of a new relationship between art and nature, attention turns from the specific to the general, to the diversity of phenomena, to the little details of reality. Inasmuch as Dürer demonstrates the potential of a modest piece of nature, he stimulates awareness of the optical sensations provided by the everyday. Only in their artistically heightened form do things that have long been accessible and visible to everyone become consciously noticed. Nature in its homeliest form, which was taken for granted by everyone and seemed not worth mentioning further, as generations of artists before him had seen but not grasped it, is transported herewith into the realm of visual consciousness, becoming, in terms of visual concept, a fully valid testimony to the powers working within it.

Although, unlike Dürer's *Hare* (Cat. 43) and the roller pictures (Cat. 10, 22), not a single copy of *The Large Piece of Turf* is known, nevertheless a few works deal with this unusual subject in a very similar way. Each one of them, however, seems to have been individually discovered and copied from nature. More than by outward form, they are linked by their fundamental idea: "One actually feels one is sensing something of the spirit of Ficino in these studies, when one compares them with its description in the *Theologia Platonica*."[2] When, in Ficino's allegory, Apelles sees and paints a field and flowers — or, as specifically mentioned, blades of grass — one after the other, he expresses in so doing the soul of the painter.[3] Neoplatonic ideas had found their way into

the Humanist circle in Nuremberg, and evidently Dürer was familiar with them.[4] Thus *The Large Piece of Turf* represents more than the result of unprejudiced observation of nature: the macrocosm of the meadow becomes simultaneously the pictorial witness to thought processes directed toward nature philosophy.

Finished, complete representations in art usually were prepared by means of studies for certain details. As such, clumps of grass also used to serve artistic craftsmanship in its striving for economy (see Cat. 49, 65). Such details were often indispensable for establishing the

3 Albrecht Dürer, *Saint Christopher with the Flight of Birds,* c. 1500, detail, woodcut (B. 104, M. 222).

4 Albrecht Dürer, *Saint Jerome in the Wilderness,* c. 1496, detail, copper engraving (B. 61, M. 57).

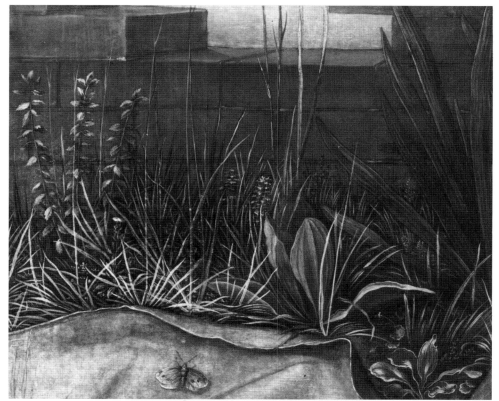

2 Dürer studio, *Madonna with the Iris,* detail, oil on panel. London, National Gallery.

does the different graphic technique separate them, however, but also their different purpose and statement, inasmuch as artistic claims are subordinated to natural-science presentation or scientific arrangements for the general public.

Furthermore, Dürer's *Large Piece of Turf* holds the seeds of a new pictorial form, which was brought to maturity only toward 1600 and later: it is a form between landscape and still life, known as "outdoor still life."[5] Its microscopic approach to the landscape, concentrating on one detail and its true-to-life rendering, established a new, ambiguous view of nature: by making the plant world the center of interest, it condensed the slice of nature into a still life, while still leaving open the possibility of seeing it as part of a landscape. Following and imitating Dürer in this sense, Hans Hoffmann not only created comparable grass studies (Cat. 65), but in the study *Thistle and Robin on a Pine Stump* (see Cat. 51), he achieved a progressive solution, preceding the development of Netherlandish still life in the seventeenth century.

NOTES

1 Except by Springer, in *RKW* 29/1906, p. 555.
2 Anzelewsky, 1980, pp. 120, 122.
3 Ernst H. Gombrich, *Symbolic Images: Studies in the Art of the Renaissance* (London, 1972), p. 77.
4 Fedja Anzelewsky, "Dürers Stellung im Geistesleben seiner Zeit," in *Dürer-Studien* (Berlin, 1983), pp. 179–216.
5 Exhibition Catalogue Münster 1979/80, p. 548.

scene of the action. The epoch-making novelty with which *The Large Piece of Turf,* without visible precedent, conveys a perfect portrait and likeness of a meadow has tended to make the study an end in itself, a self-sufficient work of art; this caused us to overlook, until now, the fact that it was also a preparatory detail drawing. In the painting from Dürer's studio *Madonna with the Iris* (ill. 66.1), not only are the iris and lily of the valley worked in from other studies (Cat. 66, 78), but we also find the leaf rosette of the plantain and the three shoots of speedwell (?) borrowed from

The Large Piece of Turf and placed on the left side of the grassy bank (ills. 1, 2). In woodcuts, engravings, paintings, and drawings (ills. 3, 4) we come across similar details, and not only in Dürer's work — take, for example, a silverpoint sketch by Hans Baldung Grien (ill. 6). Whatever technique Dürer used for such grasses and plants, leaves and blades are invariably expressed in clear, dynamic strokes of brush or stylus, and in this way alone they differ noticeably from various works ascribed to him, such as *The Small Piece of Turf* (Cat. 62) or the Potsdam *Piece of Turf* (Cat. 63). Not only

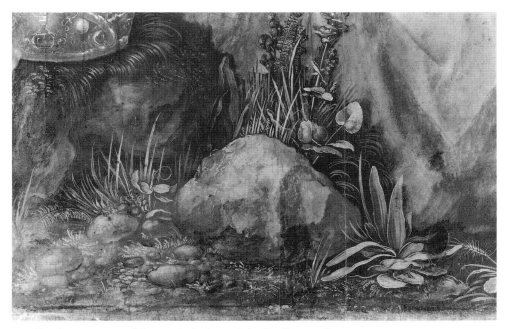

5 Albrecht Dürer, *Feast of the Rose Garlands,* 1506, detail, oil on panel. Prague, Národni Galerie.

6 Hans Baldung Grien, *Leaves,* silverpoint, c. 1522–1525, detail. Karlsruhe, Kunsthalle.

61

ALBRECHT DÜRER

The Large Piece of Turf

Watercolor and body color on paper,
mounted on cardboard, brush, pen,
heightened with white
Watermark: tower with crown and flower;
Hausmann 27, Briquet 15 863 (see p. 256, fig. 3)
Parts missing bottom center and right,
wrinkle in the middle of the sheet
Bottom right with pen in black,
probably authentic, the date *1503*

403 x 311 mm (overall measurement)
Vienna, Graphische Sammlung Albertina,
Inv. 3075 (D 54)

PROVENANCE: Imperial Treasure Chamber •
Imperial Court Library (1783) • Duke Albert of
Saxe-Teschen (L. 174).

BIBLIOGRAPHY: H. II, p. 119, no. 146 • E.,
p. 79 • Th. I, p. 303 • L. V, p. 6, no. 472 •
Springer, in *RKW* 29/1906, p. 555 • Meder, in
RKW 39/1907, pp. 180, 181 • Killermann, 1910,
p. 27 • Wölfflin, 1914, pp. 9, 10, 40 • Pauli, in
RKW 41/1919, N.F. VI, p. 25 • Wölfflin, 1926,
p. 166 • T. I, p. 71, no. 238, p. 413 • Winkler, in
JPK 50/1929, p. 135 • Fl. II, p. 366 • Albertina
Catalogue IV, p. 12, no. 54 • W. II, pp. 65, 67,
68, no. 346 • P. I, p. 80 • P. II, p. 136, no. 1422 •
Schilling, 1948, p. 16, ill. 15 • H. Tietze, 1951,
pp. 35, 36, plate VII • Musper, 1952, p. 129 •
Killermann, 1953, p. 26 and note 12 • Winkler,
1957, pp. 183, 184 • Benesch, 1964, p. 337,
no. VI • Behling, 1967, pp. 111, 112 • K.-Str.,
p. 174, no. 27 • White, 1971, p. 98, no. 33 •
St. II, p. 710, no. 1503/29 • Paul Hulton and
Lawrence Smith, *Flowers in Art from East and
West* (London, 1979), p. 13 • Anzelewsky, 1980,
pp. 112, 120, ill. 102 • Strieder, 1981, pp. 196–198.

The commonly used title of this watercolor,
The Large Piece of Turf, apparently goes back to
Meder.[1] This, the only one of Dürer's studies
of plants that is generally acknowledged as a
work of his,[2] is his crowning achievement in
this category. The date 1503 can be found in
the dark earth to the right of center under the
leaves of a daisy — an unusual place for
Dürer.[3] Since its subject was uncommon in art
and remained rare, there are neither precedents
for nor parallels to it. Its pictorial concept is
rooted in Neo-Platonism.[4]

Some soil, a lot of grasses with dandelion,
plantain, and other plants[5] among them — a
piece of simple, everyday nature — Dürer here
transforms into a "lifesize marvel of botanical
accuracy."[6] In his masterly, naturalistic treat-
ment, the modest motif has always aroused ad-
miration as a work of art and as an image of
reality. While Wölfflin[7] directed his attention
more to the graphic form, and while for him
the "impenetrable thicket of a meadow" repre-
sented the "remarkable effort of mastering an
infinity of small forms" and the "devoted at-
tempt to do justice to each individual in this
miniature-world," the Tietzes praised above
all the composition, the light that illuminated
every depth of shadow, and the "command of
the highly detailed profusion."[8] The artistic
economy is also to be admired, which, in spite
of the subtle, fine painting of many individual
features, demands "a certain method of work-
ing."[9]

It is questionable whether Dürer intended
his *Large Piece of Turf* as the model for other
works or as an end in itself. Until now the
latter has been assumed, overlooking, how-
ever, that details such as the plant near the left-
hand margin (speedwell?) and the plantain's
large leaf rosette (right) were used again in the
painting *The Madonna with the Iris.*

Of all Dürer's nature studies, *The Large Piece
of Turf* is equaled only by the *Hare,* and forms
the yardstick for judging all other plant stud-
ies. There is certainly nothing directly compa-
rable with it. The way the broad or fine brush
(and very occasionally the pen) sensitively fol-
low the sharply observant eye with painterly
boldness or draughtsmanly delicacy in water-
color and body color, in the process managing
to penetrate and clarify the context, as well as
express the dynamic, aspiring life of the vege-
tation — this exists nowhere else, even in
Dürer's work. The characteristic, crystalline
clarity of the shapes, and the light, and the
terse, vivacious lines of the grasses Dürer also
retains in his paintings, as can be observed in
details from *The Feast of the Rose Garlands*
(1506, ill. 5, p. 177) or *The Adoration of the Magi*
(1504).

In the plant studies ascribed to Dürer, with
the exception of the Bremen *Iris* (Cat. 66),
these characteristics are not found. In view of
this fact, the question arises as to why Dürer
should not have aimed at the same artistic ef-
fects in the body-color flower studies that he
had previously achieved in watercolor and oil
paintings. The explanation put forward like an
excuse since Meder, that his style was affected
by working on the unfamiliar material of vel-
lum, appears totally groundless if one com-
pares *The Infant Saviour* (1493, P. 628) or the
Wing of a Blue Roller (Cat. 22) (and see discus-
sion at Cat. 62).

The grasses in *The Large Piece of Turf* are
drawn with such precision and practically un-
surpassable fidelity to nature that almost all of
them can be botanically identified in detail,
which makes the fluid, almost casual treatment
of the foreground all the more marked. The
patchy, "cloudy" areas might be associated
with a damp roadside. It is an exercise in criti-
cal judgment to decide whether Dürer was
portraying a mature slice of actual, carefully
studied reality or presenting an artistic ar-
rangement of vegetation, his own fusion of
nature and fantasy into an ultimate artistic real-
ity. According to botanical findings, the spe-
cific assembly of plants on the sheet is repre-
sentative of the edge of a meadow with a plant
ecology typical of the Franconian area, and the
flowering period of the plants shown indicates
the month of May.

In the indissoluble fusion of art and nature,
idea and expression, reality and its artistic
transformation, *The Large Piece of Turf* is synon-
ymous with Dürer's artistic intention. When,
in his theoretical writings,[10] he advises us to be
guided by life within nature, for only out of
this can truth be created — *warhafftig steckt die
kunst inn der natur, wer sie herauß kan reyssenn,
der hat sie* — he is expressing in words the basic
principle of this nature study.

NOTES

1 L. V.
2 Except by Springer.
3 This leads to the supposition that signature and
 date may have been on a border that was cut
 off, and were copied on by a foreign hand.
4 As formulated in Ficino's *Theologia Platonica;*
 see p. 177, note 3.
5 Among the grasses are the flowering meadow
 grass (*Poa pratensis* L.); the broader-bladed
 cock's foot (*Dactylis glomerata* L.); and in the
 foreground, with tender runners, probably
 fiorin (*Agrostis stolonifera* L.); in addition
 dandelion *(Taraxacum officinale* agg.*);* left, most
 likely a speedwell (*Veronica chamaedrys* L.) (not,
 as thought earlier, burnet saxifrage leaves
 [*Pimpinella saxifraga* L.]; in the center and front
 right, leaf rosettes of daisies (*Bellis perennis* L.)
 and one of the characteristically pinnate leaves
 of yarrow (*Achillea millefolium* L.); behind that,
 center, a coarse-leaved plant, possibly hound's-
 tongue (*Cynoglossum officinale* L.), in front of
 which, to the right, is the leaf rosette of a
 plantain (*Plantago major* L.). Identification after
 Killermann, 1953, p. 26; Behling, 1967, p. 111,
 note 326; and F. Ehrendorfer. (The leaves on
 the left, saxifrage according to Behling and
 Segal, and labeled speedwell by Ehrendorfer,
 are in the opinion of M. A. Fischer unidentifi-
 able.)
6 Th. I.
7 Wölfflin, 1914.
8 T. I.
9 W. II.
10 Rupprich, III, p. 295/54.

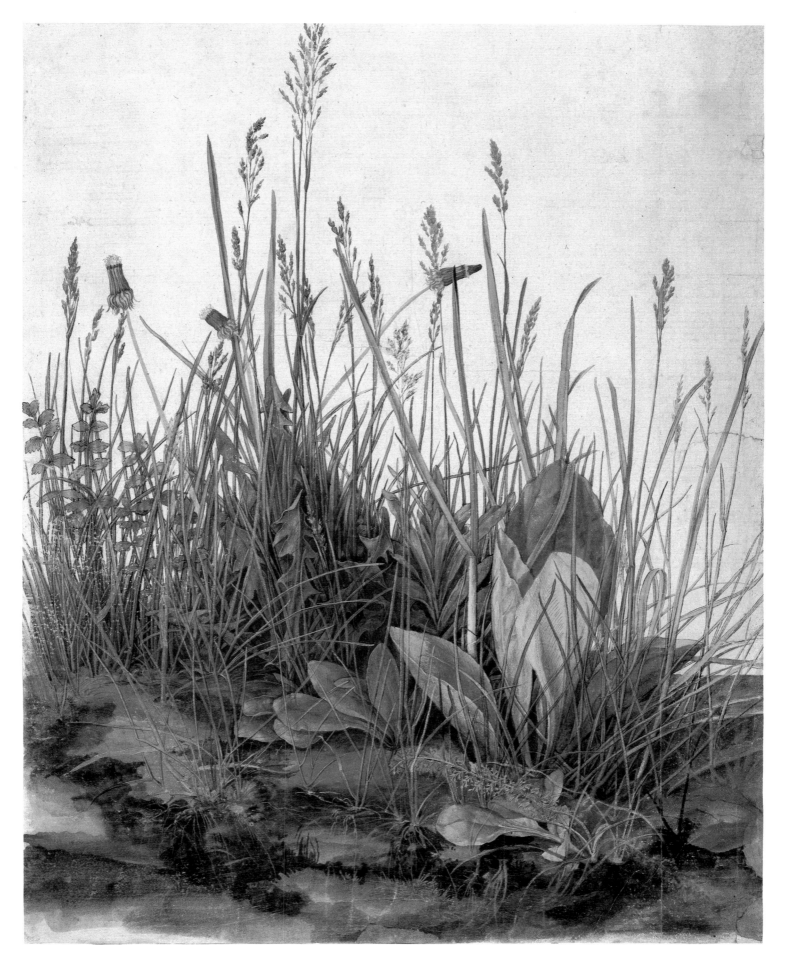

62

GERMAN, SECOND HALF OF THE
SIXTEENTH CENTURY

The Small Piece of Turf

Body color and brush on vellum,
heightened with white, mounted on cardboard
117 x 147 mm
Vienna, Graphische Sammlung Albertina,
Inv. 3077 (D 52)

PROVENANCE: Imhoff (?) • Imperial Treasure
Chamber • Imperial Court Library (1783) •
Duke Albert of Saxe-Teschen (L. 174).

BIBLIOGRAPHY: H. II, p. 118, no. 142 • L. V,
p. 6, no. 471 • Springer, in *RKW* 29/1906,
p. 555 • Meder, in *RKW* 30/1907, p. 181 •
Killermann, 1910, pp. 29, 30 • T. I, p. 137,
no. A 179, p. 413 • Fl. II, pp. 366, 559 •
Albertina Catalogue IV, p. 12, no. 52 • W. II,
pp. 66, 73, 74, no. 357 • P. II, p. 136, no. 1423 •
H. Tietze, 1951, p. 36 • Killermann, 1953, p.
26 • Benesch, 1964, p. 337, under no. VI •
Behling, 1967, pp. 114, 116 • K.-Str., p. 176, no.
28 • St. II, p. 712, no. 1503/30 • Exhibition
Catalogue Washington 1971, pp. 108, 110, under
no. XXXVI, note 3 • Piel, 1983, p. 142, no. 51.

To distinguish this small group of plants,
containing field mouse-ear chickweed (white
flowers), yarrow, clover leaves, and others,[1]
from Dürer's *Large Piece of Turf* (Cat. 61), it has
become known as *The Small Piece of Turf.*

This is one of the most problematic nature
studies that have been linked with Dürer's
name. Heller mentioned it without comment,
while neither Thausing nor Ephrussi men-
tioned it at all;[2] Meder was the first to take it
for Dürer's in the Lippmann volume he com-
piled. Only Springer contradicted him, in a
sweeping, wide-of-the-mark judgment in
which he wrote off all plant and animal stud-
ies, saying: "The animals and plants are not by
Dürer, and not even from Dürer's period."
Meder's objection was limited to blaming the
less fresh and lively effect of the flower studies
and *The Small Piece of Turf,* as compared with
The Large Piece of Turf, on the miniature tech-
nique, "that old, stiff manner of painting on
vellum, which limits artistic freedom in every
way." The Tietzes, too, exhaustively and deci-
sively rejected the *Small* by comparison with
Dürer's *Large,* commenting on the unbridge-
able differences in composition and, above all,
on the execution. Flechsig,[3] on the other hand,
stood up for the authenticity not only of this
but of all the Vienna studies, dated them about
1503, and was convinced "that a further quan-
tity of other plant studies, whose authorship
equally lacked external evidence, . . . can be
attributed to Dürer with the same justification,
particularly those of which copies by Hans
Hoffmann exist." Flechsig does not say what
he is referring to: not a single copy by Hans
Hoffmann of a Dürer plant study is known.
Winkler accepted *The Small Piece of Turf* as

Dürer's work, but commented that it had to
thank *The Large,* as whose counterpart it was
seen, for a considerable portion of its fame. He
linked it with the *Three Medicinal Herbs* (Cat.
71) and another piece in Bremen — not further
specified — in one group, and pronounced,
critically: "Much in this sheet seems to me di-
lettantish. The whole thing makes an unsatis-
factory impression . . . ," and would show
nothing reminiscent of *The Large Piece of Turf*'s
artistic creative power.

While Panofsky considered its authenticity
highly improbable, Benesch was sure that he
could recognize "unreservedly the same art-
ist's hand" in both the *Large* and *Small Piece of
Turf,* the *Columbine,* the *Buttercups, Red Clover,
and Plantain,* the *Greater Celandine,* the *Three
Medicinal Herbs,* and the *Tuft of Cowslips* (Cat.
61, 62, 68–72). As Dürer experimented with
opaque and transparent colors on vellum,
which has caused several pieces to be in a poor
state of preservation, later touching up of the
sheets should not be excluded, said Koschatzky
and Strobl, when, without going further into
the attribution problem, they left the sheet
among Dürer's work.

The Tietzes are the only commentators not
to judge *The Small Piece of Turf* together with
other plant studies, but to base their opinion on
a direct comparison with *The Large Piece of
Turf:* "A comparison seems to us at
least . . . to rule out Dürer's authorship;
whereas in that the shadows are illuminated at
every depth, in *The Small Piece of Turf* they
form a dark clot; there light plays on every
blade, a delicate bloom lies on every leaf, here
the highlights are mechanically applied, and
the leaf hairs stiff as barbed wire." They find
fault with the black ground and the artificial
arrangement of the composition.

One might have thought that Winkler's re-
flections and the Tietzes' argument would
have been sufficient basis for an ensuing criti-
cal concern with *The Small Piece of Turf.* But for
some reason their critical comments have been
belittled and set aside. The assumption ex-
pressed by Meder (and accepted by Winkler
and by Koschatzky and Strobl) that the tech-
nique of body color on vellum could possibly
inhibit an artist such as Dürer, can be coun-
tered by pointing out that in unquestioned
works such as *The Infant Saviour,*[4] an early
work done during his years of travels, and in
the later ones, like the *Dead Blue Roller* and the
Wing of a Blue Roller (Cat. 10, 22), dated 1512,
Dürer controls the technique of fine painting
on vellum with a mastery unsurpassed, or even
reached, by any of his contemporaries. Could
what he was able to do on these sheets of vel-
lum have all at once in the plant studies be-
come impossible for him? The basis of Be-
nesch's argument is questionable too, for with
the exception of *The Large Piece of Turf,* none of
the other studies can be attributed to Dürer
with any certainty.

In comparison with *The Large Piece of Turf,*
which, in the richly differentiated overall ef-
fect of a multitude of contrasting and gradu-
ated greens, brings to life "a piece of sun-

drenched nature,"[5] the *Small*'s colors look dull
and unlit, pasty in application, and the brush-
work clumsy. In every single detail, the obser-
vation and translation of the natural subject
betray an awkwardness in drawing and paint-
ing not to be found in any of Dürer's authenti-
cated paintings or studies. These facts can no
longer be ignored; the study must be struck
from the list of Dürer's authentic works. But
the question must remain open as to whether
the composition at least refers to a model of
his. Here there is nothing to go on, either to
substantiate or refute the idea.

NOTES

1 From left to right (according to F. Ehrendorfer):
white-flowered field mouse-ear chickweed
(*Cerastium arvense* L.), crown vetch (*Coronilla
varia* L.), yarrow (*Achillea millefolium* L.), hoary
plantain (*Plantago media* L.), clover (*Trifolium
spec.*), mouse-ear hawkweed (*Hieracium pilosella*
L.), species consistent with a meager dry turf.
2 Meder's quote, in L. V, may well rest on an error.
3 Fl. II, pp. 116, 366.
4 Albrecht Dürer, *The Infant Saviour,* body color
on vellum, brush, pen, heightened with white,
monogram and date 1493; 118 x 93 mm; Vienna,
Graphische Sammlung Albertina, Inv. 3059 (D
31).
5 H. Tietze, 1951, p. 36.

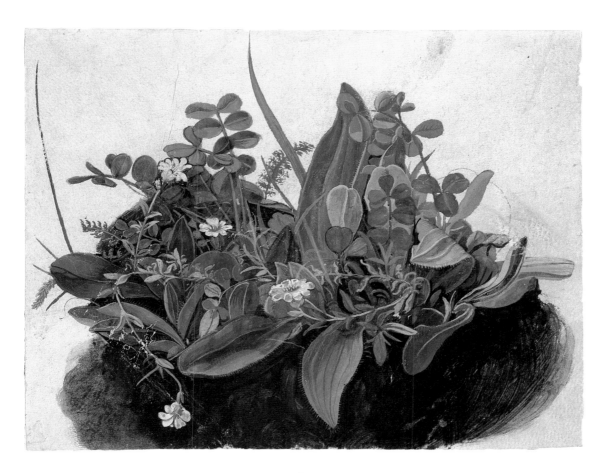

62

63

Piece of Turf

Watercolor and body color on paper,
brush, heightened with white,
autoprints of leaves (right and left lower border)
Watermark: balance in circle with star;
Piccard V, section VI, 628 (see p. 259, fig. 10)
Bottom right, Dürer monogram
by a foreign hand
320 X 217 mm, trimmed
Potsdam-Sanssouci, Staatliche Schlösser und
Gärten, Aquarellsammlung, Inv. 536b

PROVENANCE: Kassel (Wilhelmshöhe).

BIBLIOGRAPHY: Winkler, in *JPK* 53/1932,
pp. 88, note 2, 89 • Exhibition Catalogue Dresden 1971, p. 145, no. 180 • Exhibition Catalogue
Kunst der Reformationszeit (Berlin, Staatliche
Museen, Altes Museum, 1983), pp. 270, 271,
no. D 51.

Hairy rock-cress, sweet vernal-grass, ivy speedwell, and other plants[1] are portrayed life-size in a loose arrangement, side by side and broadened out rather than intertwined. The way the earthly realm is rendered in broad, dark brush strokes certainly corresponds to Dürer's art and specifically to plant studies attributed to him, but the rendering of the plants themselves shows remarkable new touches that point beyond Dürer. For instance, as if to offer the viewer a valid yardstick for comparison, the unidentified artist has included impressions of actual leaves in addition to those he drew: in green paint, placed on or near the correct places on the plant, there are two ivy-leaved speedwell leaves, and situated alone at bottom right, a leaf, in red, that does not belong to any of the plants in the group. Whereas the prints of the presumably fresh speedwell leaves have not come out clearly, that of the probably pressed and dried leaf on the right shows the fine ribs and veins with microscopic clarity.

Winkler was the first to comment on this drawing, and spoke of it as a pendant to *The Large Piece of Turf.* Following a report by Popham, he took it, together with three other plant studies (formerly in the Wilhelmshöhe in Kassel, now in Sanssouci in Potsdam), as the work of the otherwise unknown Netherlandish artist Spierincx. Schade[2] disagreed, feeling that they were the work of different artists, and that only this *Piece of Turf* could be ascribed to Dürer. According to Kroll,[3] who saw the natural size and the "cloudy treatment of the soil" as characteristics of Dürer's hand, the Potsdam drawing reproduces a direct impression of nature and was done before *The Large Piece of Turf,* which she placed later on account of its more pictorial construction.

Compared with the plant community depicted in *The Large Piece of Turf,* the rather flat line-up here is noticeable. In combination with the autoprint leaves, it gives the picture a remarkably scientific appearance. The collecting of dried plants, mostly stuck onto sheets of paper and compiled in book form in so-called herbals, which must be considered the antecedent of and prerequisite for the printing of plants, is documented no earlier than about 1530–1540,[4] while the oldest preserved herbals date from the middle of the sixteenth century. We hear of pressed plants as a vehicle of scientific information as early as 1500, but only as a novelty, received even by scholars with little sympathy.[5] Northern Italian plant books, however, reveal indirectly that the herbals began even earlier. Some of the miniatures in the Carrara herbal[6] show that pressed plants served the painter as models. But even printing from leaves or other parts of plants is considerably older, as proved by an example supposedly from the second quarter of the fifteenth century, known as the *Salzburger Naturselbstdrucke* ("Salzburg natural autoprint").[7]

That makes this *Piece of Turf* a scientifically interesting early example of the combination of nature study and natural autoprint. It is based on the same concept of combining drawing with a relevant dried leaf, which is used in some late sixteenth-century Italian herbals.[8]

The coloring, where intact, is very effective. The many finely shaded tones of green are just as distinctive as the way they are applied; on stems and leaves with strong, broadly developed areas of shadow, parallel streaks of pale green merge evenly into the dark outlines. Some parts look faded. With these particulars, added to the artist's tendency to exaggerate the already strange plant shapes, the sheet is reminiscent of *Columbine, Wild Pansy, and Alkanet* in Berlin (Cat. 79) and the *Forget-me-not* in Bamberg (Cat. 80).

This study differs from *The Large Piece of Turf* not merely in a certain artistic inferiority. In contrast to the emphasis on a complete, self-contained composition and the predominantly pictorial selection of the subject, here the botanic specimens are simply juxtaposed in an abrupt alternation of light and shade. Even though it cannot be ascribed to Dürer, the drawing represents a significant early example (c. 1500, according to the paper) of a nature study with botanical pretensions from the Dürer period, of equal interest to both art historian and botanist.

NOTES

1 From left to right (according to F. Ehrendorfer): hairy rock-cress (*Arabis hirsuta* [L.] Scop.); (common) sweet vernal-grass (*Anthoxanthum odoratum* L.); meadow grass (*Poa cf. pratensis* L.); weakly lobed ivy speedwell (*Veronica hederifolia* L. subspec. *tucorum*); autoprint of a dried leaf (probably part of the base leaf of an indigenous common umbellifera); next to it and at the bottom left margin, two autoprints of ivy-leaved speedwell leaves.

2 Exhibition Catalogue Dresden 1971.

3 Exhibition Catalogue Berlin 1983.

4 The first herbals were, as far as we know, compiled under the aegis of Luca Ghini at the universities of Pisa, Bologna, and Ferrara, whence this method of collecting rapidly spread throughout Europe. The oldest German herbal is the *Herbarium Ratzenberger* (Kassel, Naturkundemusem) begun in 1556 by the Naumburg doctor and botanist Caspar Ratzenberger; see Walther Rytz, *Das Herbarium Felix Platters* (Basel, 1933); see also Felix A. Baumann, "Das Erbario Carrarese," in *Berner Schriften zur Kunst,* ed. by Hans R. Hahnloser, vol. XII, 1974, p. 9.

5 Emilio Chiovenda, "Erbario," in *Enciclopedia Italiana di si. lett. ed arti,* XIV, 1932, pp. 186, 187 (after Rytz).

6 Baumann, 1974 (note 4, above).

7 Hermann Fischer, "Naturselbstdrucke von Pflanzen aus dem 15. Jahrhundert," in *Bericht der Oberhessischen Gesellschaft für Natur- und Heilkunde zu Gießen* 13/1929; Hermann Fischer, *Mittelalterliche Pflanzenkunde* (Munich, 1929), pp. 125, 126, plate XIX.

8 *The greater Salomons Seale, Polygonatum majus,* fol. 131r, in Sloane 5281, Inv. 1928-3-10-94, 1-205, Books 194*, d 2, London, The British Museum, Department of Prints and Drawings.

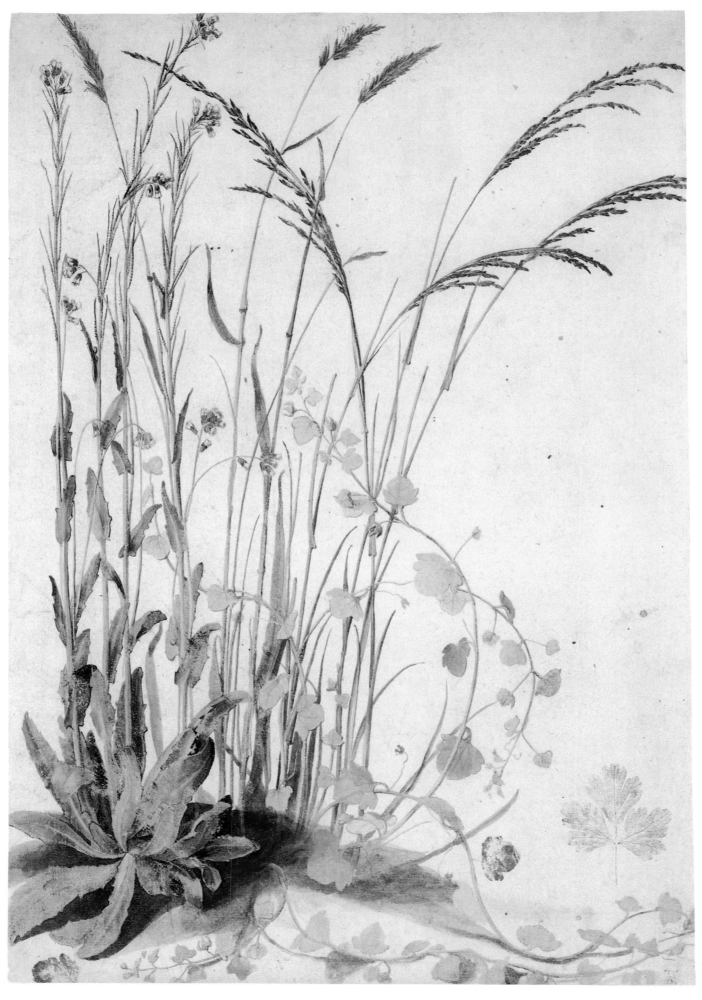

64

MATTHIAS GRÜNEWALD, SCHOOL OF (?)

Flowerbed

Body color, brush, heightened with white,
on paper prepared in gray on both sides,
brittle and torn in several places
Watermark: shield bearing three fleurs-de-lis,
flower, and initial; similar to Piccard XIII,
section III, 1677, 1685, 1695 (see p. 260,
figs. 12, 12a)
Reverse: study of a shrub and flower detail
246 x 289 mm, trimmed
Potsdam-Sanssouci, Staatliche Schlösser und
Gärten, Aquarellsammlung, Inv. 536c

PROVENANCE: Kassel (Wilhelmshöhe).

BIBLIOGRAPHY: Winkler, in *JPK* 53/1932, pp.
88, note 2, 89 • Exhibition Catalogue Dresden
1971, p. 145, under no. 180.

From a crack in a stone, perhaps in front of a
wall, spring hollyhock, ground ivy, and white
dead-nettle (?). Alongside, in a narrow flower-
bed half run wild, retained in front by a plank,
grow lilies, lavender, horseradish, and other
species.[1] The irregular juxtaposition of orna-
mental and medicinal plants suggests a small
country garden.

The execution of the study is impressive
both for its free, painterly use of the brush and
for its firm drawing. It states the shadows with
fluidity, the highlights with bravura, and
boasts a remarkable wealth of detail.

The work is done on paper, but its painterly
interpretation of the motifs obviously belongs

more to oil painting than to watercolor. The
paper bears a watermark and is prepared, but
neither fact helps very much in placing and
dating the work more closely. The use of the
thin, gray-prepared paper might place it tenta-
tively in the late sixteenth century,[2] but the
watermark points to a German paper produced
in the first quarter of the sixteenth century. If
we trust the watermark information, the study
should be dated as contemporary with *The
Large Piece of Turf* (Cat. 61).

The work is practically unpublished, as it
has hitherto been noticed only in a group.
Winkler mentions it for the first time together
with three more studies (formerly in the Wil-
helmshöhe in Kassel, now in Sanssouci in
Potsdam; see Cat. 63, 73), ascribing it, after
Popham's suggestion, to the little-known
Netherlandish draughtsman named Spierincx.
Schade[3] legitimately doubted this attribution,
together with the correlation of the three
works in general.

In the absence of comparable drawings or
watercolors, further concern with the study
and the attempt to attribute it present consider-
able difficulties. One feels obligated to bring
panel painting into play in order to discover
others approaching the same quality. In the
paintings of Matthias Grünewald we find sur-
prisingly many similarities, in the thickness
and height of the vegetation, and in the plant
forms full of internal tension and individual
movement.[4] In second-decade panel paintings,
such as the Stuppach *Madonna* and above all the
Isenheim Altarpiece,[5] Grünewald likewise
portrays lilies and hollyhocks, together with
the same sort of wild plants (ill. 64.1), places
dark silhouettes in like manner against the
paler ground, and uses a sharp light to pick out

a similarly dense pattern of grass and leaf
shapes from the darkness of the meadow back-
ground.

Should we imagine that a nature study by
Grünewald might look like this? His chalk
drawings can be compared with this study only
to a limited extent because of their different
technique, but they nevertheless have that sud-
den blinding light in common.[6] It would per-
haps be premature to make a definitive attribu-
tion of the study to Grünewald, but the
closeness described persists in justifying it. In
any case, the sharpness of observation and tal-
ent for pictorial condensation place this pre-
viously overlooked plant study among the
most significant next to Dürer's.

NOTES

1 Growing tall to the left and center are
hollyhocks (*Althaea rosea* [L.] Cavan.) and white
lilies (*Lilium candidum* L.); in addition, from left
to right: probably white dead-nettle (*Lamium
album* L.), according to S. Segal; between the
hollyhocks an unidentifiable species, (?) a
buttercup (*Ranunculus* spec.), lavender (*Lavan-
dula cf. augustifolia* Mill.), horseradish (*Armoracia
rusticana* G., M. & Sch.), (?) sage (*Salvia
officinalis* L.), and at right margin motherwort
(*Leonurus cardiaca* L.). Identification by
F. Ehrendorfer, S. Segal, and M. A. Fischer.
2 Joseph Meder, *Die Handzeichnung — Ihre
Technik und Entwicklung* (Vienna, 1923), 2d ed.,
pp. 46, 112.
3 Exhibition Catalogue Dresden 1971.
4 A conversation with Heinrich Geissler turned
my attention in this direction.
5 Stuppach *Madonna*, 1517–1519, Stuppach,
Pfarrkirche; Isenheim Altarpiece, 1512–1515,
Colmar, Musée d'Unterlinden.
6 Compare *Bearded Saint*, Vienna, Graphische
Sammlung Albertina, Inv. 3047 (D 296).

64.1 Matthias Grünewald, *Visit of Saint Anthony to Saint Paul*, c. 1512–1515, detail,
Isenheim Altarpiece, oil on panel. Colmar, Musée d'Unterlinden.

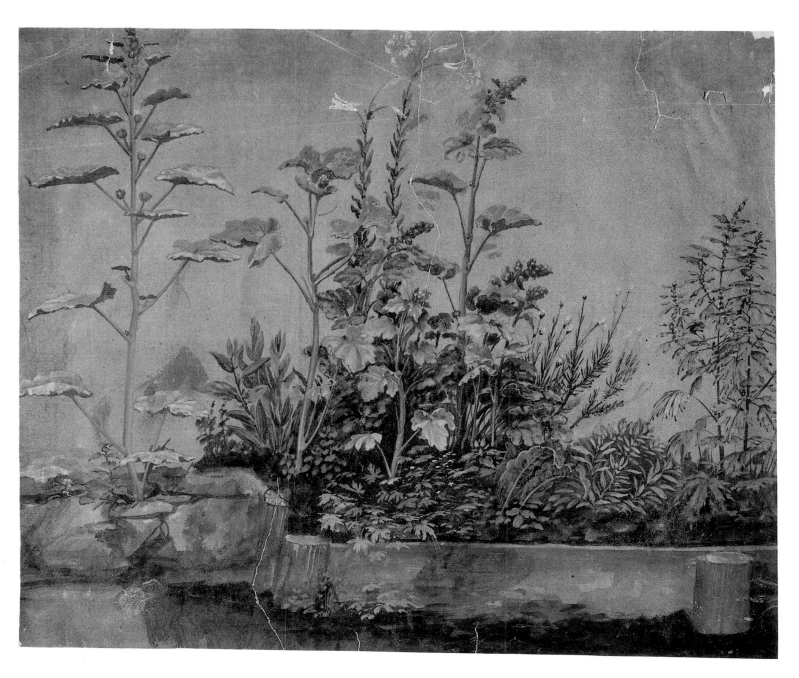

64

65

HANS HOFFMANN

Small Piece of Turf

Watercolor and body color on mildew-spotted
paper, brush, heightened with white,
traces of preliminary drawing in pencil
Bottom center, with pen in brown ink:
Hoffmann's monogram and the date *1584*
On the reverse the inscription:
J.A. Boerner 1808 R.
216 x 326 mm
Private collection

PROVENANCE: J. A. Boerner • Hertel • G. M. D.
Arnold (?, according to Pilz).

BIBLIOGRAPHY: Pilz, in *MVGN* 51/1962, p. 263,
no. 29.

Mentioned only by Pilz, this small, privately
owned turf study is practically unknown, and
its similarity in motif and concept to Dürer's
Large Piece of Turf (Cat. 61) has been virtually
unnoticed.

Various grasses and wild plants, such as yar-
row or mouse-ear hawkweed,[1] are here com-
bined into a delicate, luminous entity. Al-
though Hoffmann has not copied a single
detail from the great prototype, the work ex-
presses, more clearly than any other of his
copies from Dürer, how years of imitation had
given him understanding, and ultimately qual-
ified him for the same kind of receptive crea-
tivity. Even though it is hardly imaginable
without *The Large Piece of Turf,* Hoffmann's
own hand is visible in every detail.

In generous shades of silvery green contrast-
ing with the warmth of the luminous red
tones, the highlights applied with freedom and
verve but with precision, the brushwork of this
subtly painted sheet surpasses in finesse and
bravura that of Hoffmann's larger works in
these years. Both the artistic quality of the
study and the scientific interest it incorporates
are demonstrated by the isolated dragonfly on
the right, like a picture within a picture.[2]

Hoffmann used this study of 1584 and the
two at Cat. 50 and Cat. 51 as preparatory works
for his oil painting *Hare among Grasses and
Wildflowers in a Glade* (Cat. 49), completed in
1585 and supposedly commissioned by Em-
peror Rudolf II. There, near the bottom right
edge of the picture, we find certain grasses and
leaves from these studies used again, for exam-
ple, the goutweed (?) and the mouse-ear hawk-
weed nodding toward the left.

NOTES

1 Front left: yarrow (*Achillea millefolium* L.); beside
it, to the right, (?) goutweed (*Aegopodium
podagraria* L.) rearing up behind, the dead head
of a mouse-ear hawkweed (*Hieracium pilosella*
L.). Grasses: left (with bent blade), mat grass
(*Nardus stricta* L.); and, right, a meadow grass
(*Poa pratensis* L.). Between the grasses the leaves
of an umbellifer (?) and/or of common
tormentil (?). Identification by F. Ehrendorfer
and M. A. Fischer.

2 Hawker dragonfly, the wing position not
exactly correct (according to G. Pass).

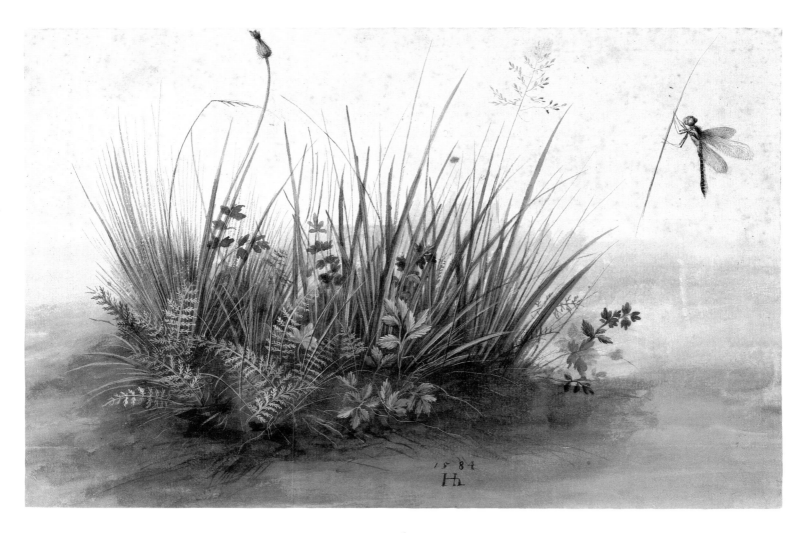

65

66

ALBRECHT DÜRER

Iris

Watercolor and body color, brush, pen,
on two sheets of paper stuck together,
mildew-spotted, creases throughout,
paint flaked off in places
Watermark: crown with pendant triangle;
Briquet 4773, Meder 24 (see p. 260, fig. 11)
Top center, by a foreign hand,
Dürer monogram and the date *1508*
Top right, the figure *89*
775 x 313 mm, trimmed top and left
Bremen, Kunsthalle, Kupferstichkabinett,
Inv. 35

PROVENANCE: Grünling (L. 1107) • Klugkist.

BIBLIOGRAPHY: H. II, p. 127, no. 35 • E., p. 80,
note 1 • Th. II, pp. 9, 57 • Killermann, 1910,
pp. 24, 25 • L. VI, pp. 13, 14, no. 637 • T. I,
p. 113, no. A 60 • Winkler, in *JPK* 50/1929,
pp. 128, note 5, 135, 144, 145 • Fl. I,
pp. 395–400 • Fl. II, pp. 71, 72, 410, 411, 550 •
T. II/1, pp. 145 ff., under no. W 51 • W. II,
pp. 65, 68, 69, no. 347 • P. I, p. 80 • P. II,
p. 136, no. 1430 • P. II (3d ed., 1948), Additions
to the Handlist, p. 169, under no. 28 • Campbell
Dodgson, "Dürer's *Virgin with Iris,*" in *TBM*
87/1945, pp. 273–276 • Kenneth R. Towndrow,
"A Note upon Dürer's *Virgin with the Iris,*" in
TBM 89/1947, p. 102 • Musper, 1952, p. 129 •
Killermann, 1953, pp. 25, 34 • Winkler, 1957,
pp. 88, 183, 184, 208, note 1 • National Gallery
Catalogues, *The German School* by Michael
Levey (London, 1959), pp. 32 ff., Inv. no. 5592 •
Behling, 1967, pp. 112, 113 • Hofmann, 1971,
p. 38 • Exhibition Catalogue Nuremberg 1971,
p. 308, no. 578 • St. I, p. 312, no. 1495/26 •
Exhibition Catalogue *Das Stilleben* (Bremen,
Kunsthalle, 1978), no. 7 • Paul Hulton and
Lawrence Smith, *Flowers in Art from East and
West* (London, 1979), p. 13 • Exhibition
Catalogue Trintperg (Bremen, Kunsthalle,
1979), no. 2.

The flower long known as *Iris germanica* was
eventually classified as *Iris trojana*.[1] The
branching stem carries three flowers and the
same number of buds in different stages of de-
velopment. The contrasts of the tepals, their
varied coloring, the petallike style, and the
nectar guides on the large tepals are rendered
with botanical accuracy.

The life-size study,[2] 77 centimeters high, on
two sheets of paper stuck together, bears the
name stamp of the Viennese dealer and collec-
tor Joseph von Grünling, at whose premises
Heller was able to see it in 1822 and so to be the
first to describe it. It is not mentioned in the
Imhoff Inventory.

The flower is frequently used in fine art
as a Madonna symbol,[3] and Thausing, and
Ephrussi after him, considered this a prepara-
tory study for the plant featured in the painting
Madonna with the Iris (ill. 66.1). Winkler con-
nected the study with Dürer's first stay in Ven-
ice, conjecturing that he did it under the influ-

ence of Jacopo Bellini, in whose Paris
sketchbook a comparable iris appears; he at
first dated it 1495,[4] but later catalogued it 1503,
together with *The Large Piece of Turf*.[5] Flechsig
is certain that the *Iris* preceded the woodcut
Holy Family with the Hare (B. 102) and that it
was painted, according to the flowering pe-
riod, in May or June 1496. The Tietzes, al-
though acknowledging that the painted copies
of the *Madonna with the Iris* vouch for such a
study, exclude the Bremen drawing as Dürer's
own work, with the remark that "its lesser or-
ganic strength in comparison with *The Large
Piece of Turf* makes its authenticity seem doubt-
ful to us." They find a dating of 1503 more
credible, however, than 1495–96. Panofsky
remarks that the semiscientific nature studies
are hard to judge, but that of these the *Iris* and
the *Turk's Cap Lily* (Cat. 67), both of which he
dates 1503, have the greatest claim to recogni-
tion. Strauss puts the watercolor with the 1495
works. It was classified in the Exhibition Cata-
logue Nuremberg 1971 as only attributed to

Dürer and dated 1503, but recently datings of
1500[6] and 1506[7] have been suggested.

In artistry and botanical accuracy, this Bre-
men *Iris* exceeds all other flower studies asso-
ciated with Dürer's name. The Tietzes' ver-
dict, generally based on admirably sharp
vision, is disappointing. They certainly com-
pare the *Iris* with *The Large Piece of Turf*, but go
no further toward substantiating their doubt.
In this case the two studies strongly suggest a
direct comparison, since they are executed
with the same means on the same material —
namely, paper. In the delicate pen outlines of
the tepals and the parallel, pale strokes that
follow the contours, looking like hems of gar-
ments, and serving to demarcate areas of simi-
lar or darker coloring, characteristics are found
that can also be observed in *The Large Piece of
Turf*. Among these similarities is, for instance,
the swelling at the base of the side axis with a
bud that appears in a strikingly similar way on
the grass blade growing up behind the plantain
in *The Large Piece of Turf*; both are characterized

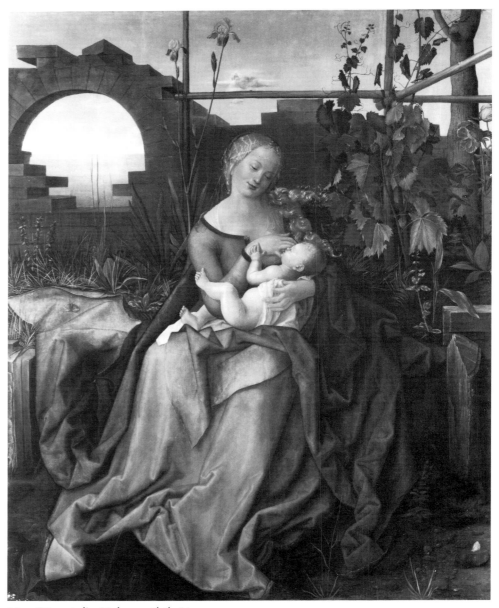

66.1 Dürer studio, *Madonna with the Iris,*
oil on panel. London, National Gallery.

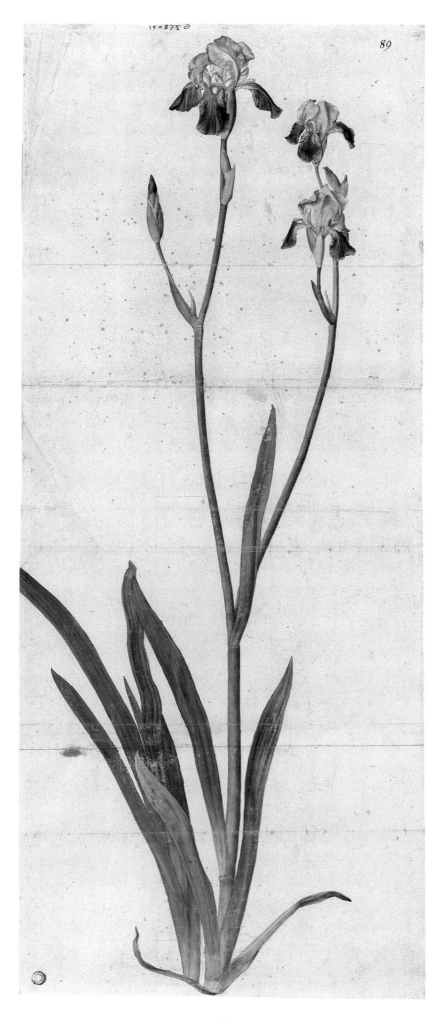

by the same discreet color gradation, and in both, fine little dashes mark the place where further down in their continuation delicate lines run down the length of the stems, like grooves. Similarly, there is a strong technical resemblance between the areas of rhythmic hatching in color on the plantain leaf backlit by the sun, enhancing its modeling and light values, and those on the bract of the lower flower on the right-hand iris stalk. So comparison between the *Iris* and *The Large Piece of Turf* reveals a high measure of conformity in both what is observed and how it is rendered artistically.

Dating the study is closely bound up with its use in the oil painting *Madonna with the Iris,* and also with the question as to where Dürer could have gotten to know and study the plant. Reproduced life-size and as an individual entity behind the Madonna sitting with her child on a grassy bank, it becomes an important component of the composition. A total of three versions of this Madonna image are known,[8] the one of highest quality being the panel in the National Gallery, London (ill. 66.1), classed as "in the style of Dürer." The London version is the only one to bear Dürer's monogram and the date 1508. If both were reliable, the panel could provide a point of reference for dating the *Iris* study. But despite its high quality, it has too many ingredients inferior to the artistic handwriting in Dürer's authenticated works. The oil painting, recognized as Dürer's work by Dodgson and Flechsig, but rejected by Winkler, who considers it a composition of the Dürer Renaissance,[9] is in recent literature generally judged to be a studio work.[10] Today it is believed that it was possibly begun by Dürer before his second journey to Venice, assisted by studies such as the *Iris* and others (see Cat. 78), and completed by his studio colleagues. The features of the Madonna are very like those in Dürer's *Virgin and Child,* monogrammed and dated 1503, in Vienna;[11] the ruin architecture recalls that in the *Adoration of the Magi,* dated 1504, in Florence;[12] the grasses on the bank presuppose *The Large Piece of Turf,* while the peony and iris are repeatedly used in other works of his from this period — all of which says much for Flechsig's suggested dating of circa 1503.

On grounds of stylistic details, Flechsig and Winkler connect the Bremen *Iris* closely with works during Dürer's first trip to Venice or shortly afterward, in 1496. Also speculative is whether Dürer did the watercolor while still in Italy or when back in Nuremberg. Towndrow's observation that the flower might be an *Iris trojana,* which was brought to central Europe only in the late nineteenth century, and in 1500 was presumably to be seen only in Venice, led him to suggest that Dürer did not do the study until 1506–07, probably with a view to the Madonna painting dated 1508. Panofsky, on the other hand, insists on its temporal proximity to *The Large Piece of Turf,* takes up Winkler's suggestion that Bellini introduced Dürer to the flower, and raises the possibility that on his first stay in Venice, when he got to

know Bellini, he was given a root of this botanic rarity to take home with him.[13] The brisk trade relationship between Venice and Nuremberg, however, makes it just as likely that such a rare plant would have found its way north without Dürer's having anything to do with it. In any case, one should not reject out of hand the possibility that he was able to study and draw the rare and therefore interesting flower in Nuremberg too.

The problem of dating also indirectly involves Dürer's *Madonna with a Multitude of Animals* of c. 1503 (Cat. 35), for of all the known versions of the iris, that Vienna drawing includes a very similar one. A link can be established between the drawing *Madonna with a Multitude of Animals* and the painting *Madonna with the Iris.* The sequence of drawings, the Paris variant being the latest, shows the step-by-step evolution of the grassy bank and the garments of the Madonna, a logical development culminating finally in the painting *Madonna with the Iris.* These links were overlooked until now; certainly they alone do not lead to any cogent conclusion, but they seem to open up new connections.

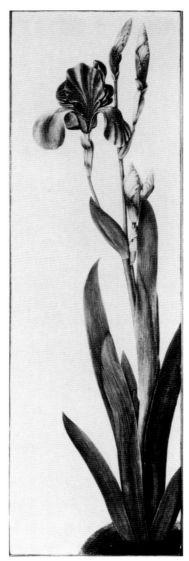

66.2 German, sixteenth century, *Iris,* watercolor and body color on paper. Escorial (see note 14).

Killermann was the first to draw attention to an analogous study of an iris, almost the same size, in the Escorial (ill. 66.2).[14] Winkler, told about this by Beenken,[15] accepted it as Dürer's work and took it as a companion piece to the Bremen *Iris,* but he never saw it in the original. Panofsky puts it with the doubtful works of possibly around 1503.[16] Strauss dated it 1495.[17]

The Escorial's study was restored in 1971, and since then, in comparison with the collotype published by Winkler, it looks very altered.[18] Judged in its present state, it has nothing in common with Dürer, only its format and motif being reminiscent of the Bremen study.

NOTES

1 Towndrow, 1947; according to F. Ehrendorfer, we are dealing with an iris of the sect. *Iris* (= sect. *Pogoniris* [Spach] Baker), that is, of the very polymorphous, extensively hybridized group of the *Iris germanica* agg., cultivated at least since the end of the sixteenth century. Ehrendorfer thinks Towndrow's suggested identification *Iris trojana* A. Kerner not very likely; this wild species from northwest Anatolia might indeed belong to the *Iris germanica* group, but it was only brought to Europe in the second half of the last century and described in 1887. The history of the origin and the taxonomy of *Iris germanica* agg. are in any case still insufficiently known and have yet to be systematically studied. Dürer's splendid rendering of a stem with flowers and leaves, cut off just above its junction with the rhizome, exceptionally portrayed and obviously with all the essential details systematically and faithfully recorded, could be an important signpost.
 According to Segal (memorandum of May 26, 1985), this is the little-known *Iris sambucina* L., described by Linnaeus first in 1759 and more fully in 1762. Redouté has illustrated it well. It is not, as stated in the literature (Dykes and *Flora Europaea*), *Iris pallida* Lam. x *I. variegata* L. (= *I. squalens* L.), but *Iris germanica* L. x *I. variegata* L. The Bremen drawing is probably the earliest documentation of this tribe. On the other hand, M. A. Fischer is of the opinion that the two different iris types were combined as one example (not occurring in nature) by the artist.
2 For the characteristics of its monogram see Oehler, in *Städel-Jahrbuch,* N.F. 3/1971, pp. 79 ff.
3 Behling, 1967.
4 Winkler, 1929.
5 W. II.
6 Exhibition Catalogue Bremen 1978.
7 Hulton and Smith, 1979.
8 (a) Dürer studio, *Madonna with the Iris,* oil on panel, false Dürer monogram and date 1508; 149.2 x 117.2 cm; London, National Gallery, Inv. 5592. (b) *Madonna with the Iris,* oil on panel; 149 x 120 cm; Prague, National Gallery. (c) *Madonna with the Iris,* oil on panel; 154 x 121 cm; Wilhering, Stift Wilhering Gallery.
9 Winkler, 1957, p. 208, note 1.
10 Levey, 1959.
11 Albrecht Dürer, *Virgin and Child,* oil on panel, top center, monogram and date 1503; 240 x 180 mm; Vienna, Kunsthistorisches Museum, Inv. 128.
12 See p. 113, note 3.
13 P. II (3rd ed., 1948).

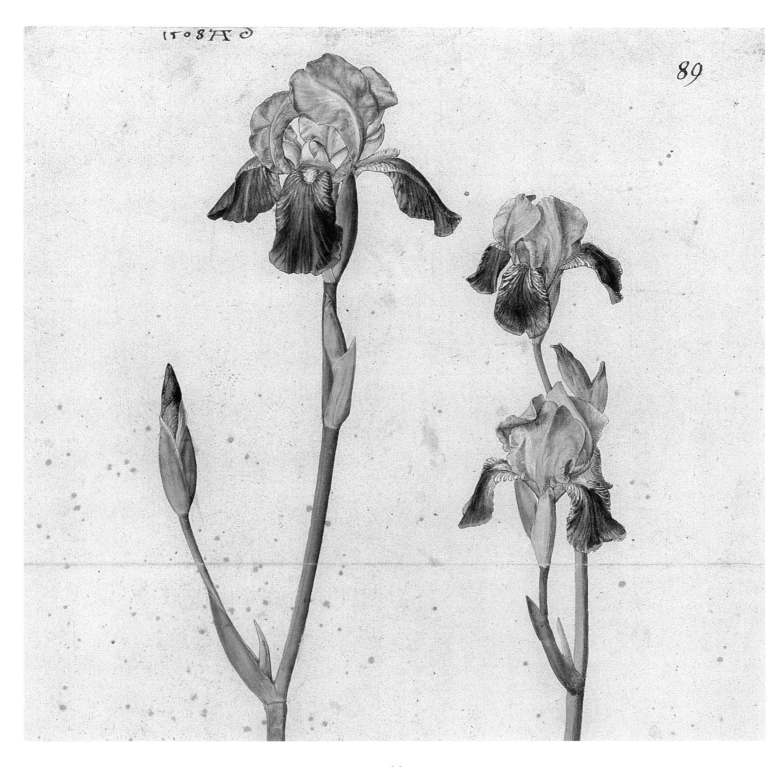

66
DETAIL

14 Watercolor and body color, brush, on paper, overpainted with oil color (?), the background paper also coated with white, varnished (partly yellowed); 576 x 174 mm (trimmed on the right); Escorial, from Philip II's death chamber. The petals are artificially wavy, today resembling an oil sketch; see Killermann, 1910, pp. 1–6.

15 W. II, p. 69, no. 348.

16 P. II, p. 136, no. 1431.

17 St. I, p. 314, no. 1495/27.

18 Winkler, in *JPK* 50/1929, plate II.

67

GERMAN, EARLY SIXTEENTH CENTURY

Turk's Cap Lily

Watercolor and body color on mildew-flecked
paper,
brush, pen, heightened with white,
oxidized in places
Watermark: crown with pendant triangle;
Briquet 4773, Meder 24 (see p. 260, fig. 11)
Creased across the middle and top,
both upper corners replaced
545 x 181 mm, bottom and sides trimmed
Bremen, Kunsthalle, Kupferstichkabinett,
Inv. 34

PROVENANCE: Grünling (L. 1107) • Klugkist.

BIBLIOGRAPHY: H. II, p. 127, no. 34 • L. VI,
p. 14, no. 638 • T. I, p. 113, no. A 61 • Winkler,
in *JPK* 50/1929, p. 126 • Fl. II, pp. 411, 550 •
W. II, pp. 65, 71, no. 353, 68, under no. 347 •
P. I, p. 80 • P. II, p. 137, no. 1439 • Musper, 1952,
p. 129 • Killermann, 1953, p. 25 • Behling, 1967,
p. 115 • Exhibition Catalogue Nuremberg 1971,
p. 308, no. 579 • St. I, p. 320, no. 1495/30 •
Exhibition Catalogue Trintperg (Bremen,
Kunsthalle, 1979), no. 3.

This is a study of a cut stem of the turk's cap
lily (*Lilium martagon* L.), with leaves noticeably
perforated by nibbling pests.

Like the *Iris* and most of the Dürer drawings
formerly in Bremen, the *Turk's Cap Lily* can be
traced back to the collection of Duke Albert.
Heller described it when it was in Grünling's
possession; Ephrussi and Thausing do not
mention it specifically, and Lippmann also
passed it over. Winkler[1] accepted the work as
Dürer's in his addenda to Lippmann. He con-
sidered the size of the sheet — similar to that
of the *Iris* — and the watermark — the same as
on two landscape studies from the first Italian
journey (W. 96, 98), formerly in Bremen —
together with the style and coloring, to be
characteristic clues for a mid-nineties dating.
Flechsig, too, dated it 1496. After further in-
quiry, Winkler[2] places the study, together
with the other flower studies, in about 1503,
commenting that, with the exception of *The
Large Piece of Turf,* none of them can be dated
with certainty. In the unusual overlapping of
the leaves, the weakness of the drawing, its
disappointing finish, and above all the careless
watercoloring, he finds "many strange fea-
tures." Without denying Dürer's authorship,
he goes on to add that if the *Turk's Cap Lily*
were not by his hand, it would have to be as-
sumed "that in Dürer's lifetime another artist
was doing similar flower studies, for which
there is as yet no evidence."[3]

On grounds of their large size and like inter-
pretation of their motifs, the *Turk's Cap Lily*
and the *Iris* have in the main been regarded in
the literature as of equal value and therefore
were described and judged together. The
Tietzes exclude both from Dürer's œuvre.

Panofsky takes them rather for authentic
works done in 1503. The compilers of the
Nuremberg Exhibition Catalogue doubt the
Turk's Cap Lily on impression. Strauss lists it
with Dürer's 1495 works.

In direct comparison with the *Iris,* the *Turk's
Cap Lily* is by a decidedly different, artistically
cruder hand. The penned outlines evince a hes-
itant, unsure touch, and the watercolor brush
does not always fill them in completely. The
gray shadow on the ground, merging into
brown toward the stem, is strange and ineffec-
tive for Dürer. Also in the awkward brush-
work and the pasty use of white pigment on
the flowers, this study is markedly different
from the *Iris* and *The Large Piece of Turf.* The
inaccurate observation of botanical details and
their careless rendering are consistent with the
clumsy touch and the clearly evident stylistic
differences from the *Iris.* Inconsistencies, such
as the faulty proportions of the flower head,
both in itself and as compared with the leaves,
and the abrupt end of the stem below, may well
be put down to this.[4] The leaf whorls, ar-
ranged at regular intervals, are drawn with pe-
culiar stiffness,[5] and the foreshortened leaves
show faulty draughtsmanship. On grounds of
these differences alone, it is impossible to con-
tinue classing the *Iris* and the *Turk's Cap Lily* as
by the same hand.

Judging these two Bremen studies, one
gains the impression that their undeniable ar-
tistic differences were hitherto ignored in def-
erence to an apparently key chain of historical
records. Considering the fact that both works
have the same watermark and the same prove-
nance — both from Duke Albert's collection
— it was too much of a temptation not to con-
clude that they had a common originator. Al-
though for Winkler there was no evidence
that other artists besides Dürer were doing
such studies, we can now produce examples
where the watermark of the paper used makes
it very probable that they were created during
Dürer's period. As we can imagine from a
glance at the numerous plant images unques-
tionably taken from nature studies in late
Gothic Netherlandish and German panel
paintings, there were surely an enormous
number of plant studies, and it is indeed aston-
ishing that we have inherited so few. But to
connect those few survivors exclusively with
Dürer is a most unreliable simplification of the
state of affairs.

The *Iris* differs from the *Turk's Cap Lily*
more than can be explained by the variations in
quality that one believes must sometimes be
conceded even a great artist.[6] Even the use of
the same paper, which in any case must have
been in normal commercial use in Dürer's
time, cannot explain away the artistic gulf be-
tween this work — perhaps Franconian, per-
haps from Dürer's circle — and that of Dürer
himself.

NOTES

1 L. VI, p. 14, no. 638.
2 W. II, p. 71, no. 353.
3 W. II, p. 65.
4 I am grateful to Professor F. Ehrendorfer for the
information.
5 Behling, 1967.
6 K.-Str., p. 168, under no. 25.

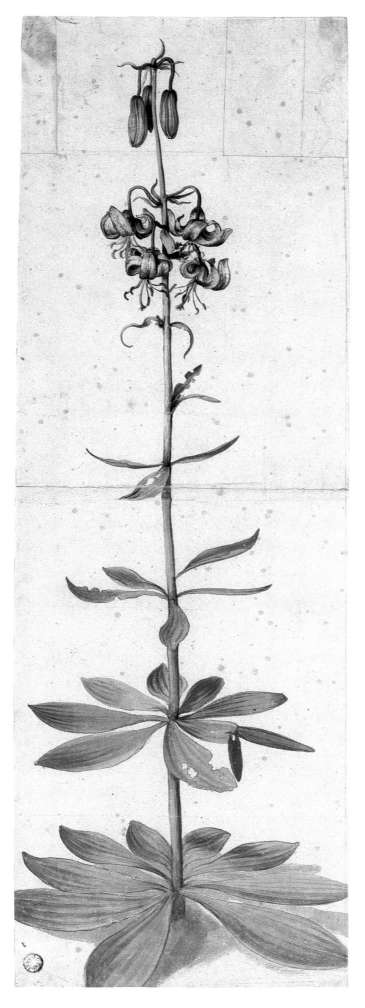

67

The Debate about the Flower Studies Dated 1526

The oldest and most important source of information about the provenance of the Dürer drawings in the Albertina, and about the plant studies, is the Imhoff Inventory.[1] In the list of works of art that Anna, widow of Willibald Imhoff the Elder, enclosed in her letter of December 30, 1588, to Rudolf II, a series of Dürer's works are named for the first time. Among the drawings there are also a number of animal and plant studies, some on paper, which is not expressly mentioned, and some on vellum, which is specifically stated. Although some are quoted with unfamiliar identification marks, this list makes it possible to identify many of the studies. The following pieces concerning flowers appear in the Imhoff Inventory:

60 *Zwo Gichtrosen auf Pergamen.* ("Two peonies on vellum." ? Cat. 74)

62 *Zwo Gichtrosen. Viel Graßwerk.* ("Two peonies. Much foliage." Cat. 75)

63 *Ein Angeli Blümlein mit sammt dem Laubwerk [a]uf Pergamen.* ("A little columbine with its foliage on vellum." Cat. 68)

64 *Ein Distel sammt vielem Blumwerk auf Pergamen.* ("A thistle with many floral works on vellum." ? ill. 71.1)

65 *Schmalzblumen und Klee auf Pergamen.* ("Buttercups and clover on vellum." Cat. 69)

66 *Lilium convallium und Ochsenzungen, weis Blümlein und Graßwerk auf Pergamen.* ("Lily of the valley and alkanet, little white flowers and foliage on vellum")

67 *Gefüllte Veil auf Pergament.* ("Double violets on vellum." Cat. 77)

The next important source of answers to our questions comes from the early nineteenth century, namely, from Joseph Heller, who in 1827 exhaustively described the Dürer drawings in the collection of Duke Albert of Saxe-Teschen,[2] including the following flower studies:

141 *Ein Veilchenstrauß, auf Pergament gemalt . . .* ("A bunch of violets, painted on vellum . . .")

142 *Gesträuch und mehrere kleine weiße Blümchen, auf Pergament, sehr schön ge-*

malt . . . ("Shrubs and several small, white flowers, on vellum, very beautifully painted . . .")

143 *Zwey Stengel von violetten Blumen; besonders schön ist der blaue Tag und Nachtschatten . . .* ("Two stems of violet flowers; particularly beautiful is the blue day- and nightshade . . .")

144 *Die blaue Glocke? Sehr vorzüglich auf Pergament gemalt, bezeichnet 1526 . . .* ("The blue bells? Very excellently painted on vellum, dated 1526 . . .")

145 *Der Stengel von einer gelben Blume, eben so schön, als das vorhergehende, auf Pergament, mit 1526 bezeichnet . . .* ("The stem of a yellow flower, as beautiful as the foregoing, on vellum, dated 1526 . . .")

146 *Eine Gruppe von verschiedenen Gras-Sorten; ein vorzügliches Stück . . .* ("A group of different grass varieties; an excellent piece . . .")

Duke Albert came into possession of these sheets through exchange in 1796; they originally formed part of Emperor Rudolf II's collection, and moved from the Hapsburg *Kunstkammer* to the Imperial Court Library only in 1783. Among them also were the Dürer drawings from the Imhoff Collection. Although we lack further information about their acquisition through the emperor, it is an established fact that many works mentioned in the Imhoff Inventory turn up again in Heller's inventory of Duke Albert of Saxe-Teschen's collection in Vienna. Numbers 63 and 67, for example, from the first inventory, are identical with 144 and 141 from the second. With less certainty, the peonies (nos. 60 and 62) in the Imhoff Inventory can be identified with those in Berlin and Bremen. Further, the description of no. 64 fits a study at present in Bayonne, and no. 65 plainly connects with the *Buttercups, Red Clover, and Plantain* (Cat. 69).

The history of the Dürer drawings in Duke Albert's collection[3] was decidedly affected by the experiences of the Napoleonic War: the occupation of Vienna by the French in 1809, and the misappropriation or sale of numerous works by the curator of the collection, François Lefèbvre, after Duke Albert's death in 1822. Among the many drawings that then passed into other hands was evidently the *Buttercups, Red Clover, and Plantain,* today in Providence. When the work came to light again in the United States in 1953, it was possible to trace its provenance from the collection of General Comte Antoine François Andréossy.[4] General Andréossy, French governor of Vienna in 1809 during the occupation of the town by Napoleon's troops, left at least seventy Dürer drawings after his death in 1829, including no. 65 from the Imhoff Inventory. It takes little to imagine that this work, like many others once in Imhoff's possession, passed through the imperial collection to Duke Albert and then found a new owner between 1809 and 1827, the year of Heller's publication. In the case of Dürer's drawings that came to

1 *Three Lime Trees,* detail. Formerly in Bremen (W. 64).

2 *Buttercup, Red Clover, and Plantain,* detail (Cat. 69).

3 *Tuft of Cowslips,* detail (Cat. 72).

4 *Columbine,* detail (Cat. 68).

5 *Greater Celandine,* detail (Cat. 70).

6 *Peonies,* detail (Cat. 74).

Bremen through the Viennese dealer Grünling, including the *Iris* (Cat. 66), the *Peonies* (Cat. 75), the *Turk's Cap Lily* (Cat. 67), the *Alkanet,* and the *Three Lime Trees,* the latter also dated 1526, we have the evidence from Grünling's own words.[5] Finally, the flower studies that reached the Berlin Kupferstichkabinett through Posonyi-Hulot also came from Vienna, passing likewise through Grünling's own hands.

Heller is the first to mention the date 1526.[6] He cites two plant studies of this year in the Albertina Collection, *Columbine* and *Greater Celandine.* We now know a total of seven with the same date: *Columbine* (Cat. 68), *Greater Celandine* (Cat. 70), *Buttercups, Red Clover, and Plantain* (Cat. 69), *Peonies* (Cat. 74), *Tuft of Cowslips* (Cat. 72), *Lily Flower* (Bayonne, ill. 7), and the *Three Lime Trees* (W. 64, formerly Bremen, missing since 1945; details showing dates on the sheets, ills. 1–6). With the exception of the *Cowslips,* the history of which is still completely in the dark, the provenance of all the sheets can be pretty well traced back to Duke Albert's collection in Vienna; for that reason they probably originally belonged in the imperial *Kunstkammer;* and because the *Buttercups* is mentioned in the Imhoff Inventory, it is likely the sheets belonged to the Imhoff Collection.

For not one of these studies is there any evidence of Dürer's authorship. No direct connection can be found between them and other authenticated works by Dürer, so judgment has to rely solely on stylistic criteria and the measure of their artistic quality. There have been various comments in the literature about the long-observed discrepancies in style between many of these studies and undoubted works by Dürer. Springer,[7] for example, denied that any, including the animal studies, were by Dürer. The Tietzes[8] decided in favor of only *The Large Piece of Turf* (Cat. 61) out of all the plants; Panofsky[9] reached the same conclusion but allowed that the *Iris* (Cat. 66) and the *Turk's Cap Lily* (Cat. 67) might perhaps be Dürer's. Winkler[10] took a less critical stand, but Flechsig was convinced "that a considerably further number of plant studies, which have just as little outside verification, such as the *Columbine* and the *Greater Celandine,* can be rightly attributed to Dürer."[11]

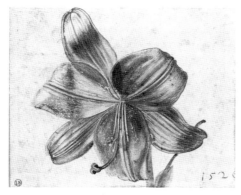

7 German, sixteenth century, *Lily Flower,* watercolor and body color on vellum. Bayonne, Musée Bonnat.

In all the deliberations concerning dating and authenticity, the fact of their being on paper or vellum became a weighty consideration. Studies on paper were generally given dates of circa 1500–1503; those on vellum later. The ones on paper are: *The Large Piece of Turf, Iris, Turk's Cap Lily, Peony, Alkanet, Columbine, Wild Pansy, and Alkanet* (Cat. 79), *Forget-me-not* (Cat. 80), and *Lily of the Valley and Bugle* (Cat. 78). Those on vellum include all those named above as dated 1526. Usually the *Three Medicinal Herbs* (Cat. 71), the *Nosegay of Violets* (Cat. 77), and *The Small Piece of Turf* (Cat. 62) are also brought into the discussion. These three are not dated; nor are they stylistically justified in being classed with the plant studies dated 1526. It is not even certain that we are looking at works by Dürer's contemporaries.

The differentiation between paper and vellum also involves a judgment of quality. In view of the quality, in every respect superior, of *The Large Piece of Turf,* which is on paper, there has been an attempt to explain the widely observed artistic weaknesses, and the more ordinary dexterity of execution of the vellum paintings, by pointing out the peculiarities and intractability of this smooth, nonabsorbent material.[12] In this connection nobody has yet mentioned that we have body color paintings by Dürer on vellum, such as *The Infant Saviour* (T. I, p. 5, no. 21) or the *Wing of a Blue Roller* (Cat. 22), that are artistically and stylistically at least as good as the watercolors on paper, in spite of their miniature technique.

Researchers have reached various conclusions about the date 1526. Thausing[13] had acknowledged the difficulty of determining the group, but made no comment about the date itself. Meder[14] took both the studies and their date to be genuine; Pauli[15] was the first to separate authorship and date, declaring the inscriptions not binding, having been added by a foreign hand. Flechsig[16] and Winkler[17] agreed with this opinion. Flechsig drew particular attention to the writing of the monogram and date. In the date *1526* he feels the figures *1, 5,* and *2* vary so much from Dürer's style "that one must quarrel with their genuineness." Comparison with dates in Dürer's paintings, drawings, and prints reveals the difference from his rhythm of writing. Where Dürer writes the year, he does so carefully, the figures, according to their shape, standing at even, optically balanced distances apart. In the *1526* of the flower studies, however, it is noticeable that the *1* and *5* are close together, but the distance between the *5* and the *2* is always a little too great and has become almost a "hole," and the *2* sits slightly lower on the line than the two previous figures.

Apart from that sort of verdict, founded on simple comparison of writing, it is mainly stylistic criteria that throw doubt on Dürer's authorship as suggested by the date. In 1526 Dürer produced *The Four Apostles,* his artistic will and testament, together with the portraits *Jakob Muffel, Hieronymus Holzschuher,* and *Johannes Kleberger*[18] and the copper engraving

Erasmus of Rotterdam (B. 107). In each one of these dated works, Dürer's creative power is unbroken. With undiminished artistic skill, without the least limitation, he expresses in them his stupendous talent for rendering the individuality of objects — fur or hair, flowers, leaves and grasses, or a bouquet of lilies of the valley. The linear dynamism and calligraphic sureness peculiar to him, which we have seen in the *Hare* (Cat. 43) and *The Large Piece of Turf,*

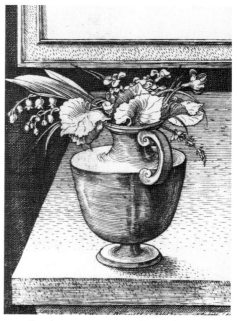

8 Albrecht Dürer, *Erasmus of Rotterdam,* detail, 1526, copper engraving (B. 107, M. 105).

appear in these later works with even terser precision, fascinating now in their chiseled clarity and accuracy of detail. It is exactly this that distinguishes them from the flower studies dated 1526. From the *Columbine, Greater Celandine,* or *Buttercups, Red Clover and Plantain* one may still pick out something of this Düreresque clarity, but the differences in execution are irreconcilable with authenticated works of these years.

The conclusion that Pauli was the first to draw from the discrepancies observed was that the date should be regarded as a later addition by a foreign hand and irrelevant as a true dating, and the sheets grouped with *The Large Piece of Turf;* but this only doubled the problem without solving anything. These studies are so different in execution from *The Large Piece of Turf* that they can no more be placed in the period around 1503 than they can in the year 1526. Added to this, and not to be overlooked, is the difference among the 1526 studies themselves: the *Columbine, Greater Celandine,* and *Buttercups, Red Clover, and Plantain* are, in my opinion, works from the same hand, but the Los Angeles *Tuft of Cowslips,* the Berlin *Peonies,* and the Bayonne *Lily Flower* are all by different artists. Moreover, the works were not necessarily done at the same time. The Berlin *Peonies,* for example, belong stylistically to the late sixteenth century and resemble the work of Hans

Hoffmann. It can therefore be suggested that these works were only later furnished with their identical, but inappropriate, dates. The question then arises: When can this have happened, why, and how was the date 1526 chosen? Has it anything to do with Dürer for some reason we do not know, was it chosen arbitrarily, or should we assume that one or more of the studies already bore it, and it was added to the rest at a later point in time by a foreign hand with the intention of simplifying the cataloguing, or creating a forgery, or both? As a glance at Baldung's silverpoint drawings in the Karlsruhe Sketchbook shows, there are further plant studies produced by other important artists in the middle twenties. Only the date on the *Columbine* seems to mark the actual time of creation, for the enlargement shows that the same pigment was used for the figures as for the plant stem above.

The state of affairs is complicated, and with the means at our disposal a solution seems not possible up to now. One must admit that there is no conclusive evidence either for or against Dürer's authorship. Nor can we get around the fact that, although the studies all bear the same date, they were done by at least two, and probably several, artists. The dates themselves, on the other hand, are not so different; on the basis of their similar style they could certainly all have been written by the same hand. So it has been suggested that the inscriptions originate from a later collector. The possibility that at least one of them, the *Peonies* (Cat. 74), is by Hoffmann, is worth thinking about.

Perhaps the true circumstances were completely different; suppose some of these flower studies, obviously by a contemporary of Dürer's, say, the *Columbine, Greater Celandine,* and *Buttercups, Red Clover, and Plantain,* bore this date, which was then copied onto other similar flower studies in the Imhoff Collection, when knowledge about their provenance was already hazy? But we are venturing into groundless speculation. In view of how little we know, and what information about Dürer has been handed down, it is understandable that the relationship of these dubious works to *The Large Piece of Turf,* as the only certain plant study by Dürer, is constantly brought up; but in the end it is not conclusive, either for their stylistic classification or for their dating. On the contrary, the longer we concern ourselves with these works, the more indications argue against attributing the group to Dürer.

All this concerns only the authorship, not the question of a prototype, and the two are quite distinct. The Tietzes[19] do not dismiss the idea that the *Columbine,* for example, which they take for a work of the Dürer Renaissance, may have been inspired by a similar original by Dürer. In the light of the latest botanical analysis (treated more fully under Cat. 68), even this seems doubtful. Furthermore, the fact that there are numerous sixteenth-century copies of Dürer's animal studies throws noteworthy light on the plants attributed to him, of which not one single copy is known. Unlike the *Hare,* the *Dead Blue Roller,* and the *Stag Beetle* (Cat.

36), nothing testifies to any general esteem and idealization of the flower studies; so, in the absence of comparable reflections, all thoughts of tracing back the studies dated 1526 to missing models by Dürer fade into mere supposition.

Winkler felt he had to reject this sort of plant study by Dürer's contemporaries. Meanwhile, we can point to flower studies on paper from the Dürer period (Cat. 63, 64) that are not his either. Furthermore, there are an increasing number of clues, for example Baldung's sketchbook and Weiditz's botanical illustrations (Cat. 82, 83), that testify to the existence of this sort of plant study in the 1520s and earlier. This possibly indicates the direction from which we may someday expect a solution to one or another of the questions raised here.

Of all the nature studies ascribed to Dürer, these flowers dated 1526 undoubtedly represent the hardest set to judge; opinions are more firmly opposed in this group of works than in any other. The studies have never been looked at side by side; for many they are known only from reproductions. Perhaps, therefore, the opportunities offered for the first time by this exhibition to make direct comparisons will allow for productive contributions in this very area toward future solutions of the problems.

NOTES

1 H. II, pp. 77 ff.; see appendix, pp. 261–262.
2 H. II, pp. 98 ff.
3 See also K.-Str., pp. 5 ff.
4 Heinrich Schwarz, "A Water-colour attributed to Dürer," in *TBM* XCV/1953, pp. 149, 150.
5 Quoted in Ernst Waldmann, *"Die Einkaufspreise für Dürers Landschaftsaquarelle in Bremen,"* in *Albrecht Dürer, Festschrift der internationalen Dürer-Forschung* (Leipzig, Berlin, 1928), pp. 103–106; see Appendix, p. 267.
6 H. II, p. 119, nos. 144, 145.
7 Springer, in *RKW* 29/1906, p. 555.
8 T. I, p. 413.
9 P. II, p. 136, no. 1430, p. 137, no. 1439.
10 W. II, pp. 65 ff.
11 Fl. II, p. 116.
12 Meder was the first, in *RKW* 30/1907, p. 181.
13 Th. II, p. 57.
14 In L. V, p. 30, nos. 585–587.
15 Pauli, in *RKW* 41/1919, p. 25.
16 Fl. II, p. 116.
17 W. II, pp. 72, 73, under nos. 354, 355.
18 *The Four Apostles,* monogram and date 1526, Munich, Bayerische Staatsgemäldesammlungen, Alte Pinakothek, Inv. 545, 540. *Jakob Muffel,* monogram and date 1526, Berlin, Staatliche Museen Preußischer Kulturbesitz, Gemäldegalerie, Inv. 557 D. *Hieronymus Holzschuher,* monogram and date 1526, Berlin, Staatliche Museen Preußischer Kulturbesitz, Gemäldegalerie, Inv. 557 E. *Johannes Kleberger,* monogram and date 1526, Vienna, Kunsthistorisches Museum, Inv. 850.
19 T. II/2, pp. 142, 143, at no. A 427.

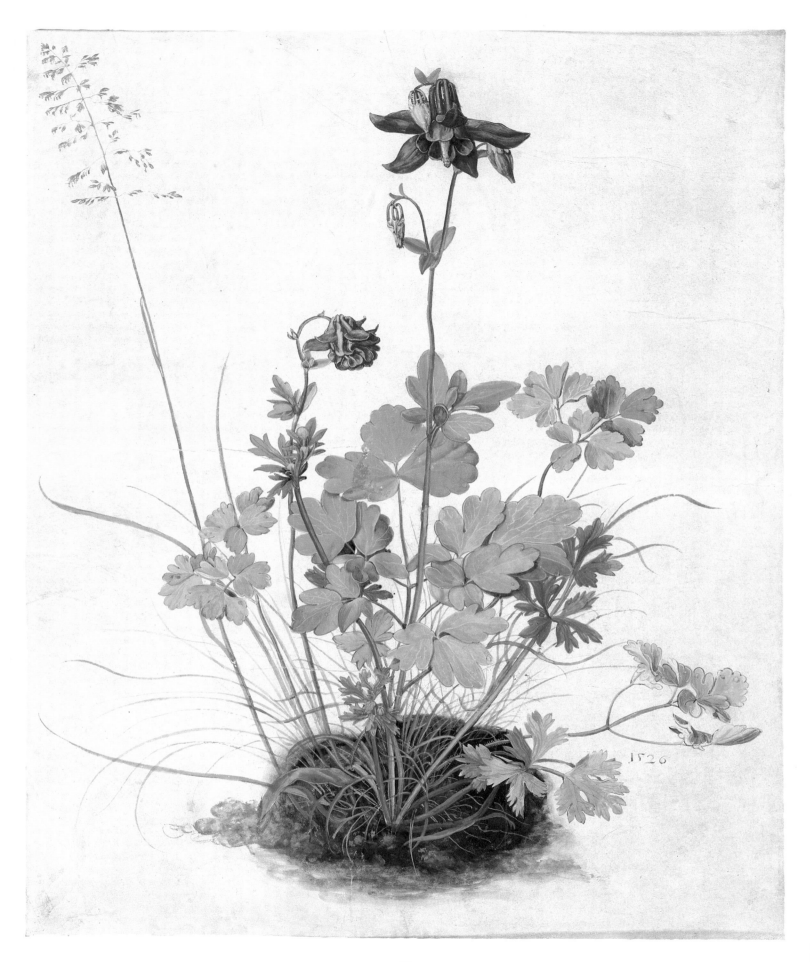

68

68

GERMAN, 1526

Columbine

Watercolor and body color, brush,
heightened with white, on vellum,
mounted on cardboard, slanting creases,
color slightly flaked off
Bottom right, in pen and brown color:
the date *1526*
356 x 287 mm
Vienna, Graphische Sammlung Albertina,
Inv. 3182 (D 159)

PROVENANCE: Imhoff • Imperial Treasure
Chamber • Imperial Court Library (1783); Duke
Albert of Saxe-Teschen (L. 174).

BIBLIOGRAPHY: H. II, p. 83, no. 63, p. 119,
no. 144 • E., p. 80 • Schönbrunner and Meder,
no. 447 • L. V, p. 30, no. 585 • Springer, in
RKW 29/1906, p. 555 • Meder, in *RKW*
30/1907, pp. 180, 181 • Luise Klebs, "Dürers
Landschaften," in *RKW* 30/1907, p. 415, note
17 • Killermann, 1910, pp. 94 ff., 103 •
Wölfflin, 1914, pp. 20, 21, 40, no. 76 • Gustav
Pauli, "Die Dürer-Literatur der letzten drei
Jahre," in *RKW* 41/1919, N.F. VI, p. 25 • Fl. II,
pp. 116, 378, 559 • Albertina Catalogue IV,
p. 24, no. 159 • W. II, pp. 65, 66, 72, 73,
no. 354 • T. II/2, pp. 142, 143, no. A 427 • P. II,
p. 136, no. 1429 • Killermann, 1953, p. 26 •
Kauffmann, in *AGNM* 1954, p. 29 • Winkler,
1957, pp. 183, 184 • Benesch, 1964, p. 337, under
no. VI • Behling, 1967, pp. 114, 116 • K.-Str.,
p. 178, no. 29 • Hofmann, 1971, p. 38 • St. II,
p. 718, no. 1503/33.

This study on white vellum shows a fan-
shaped arrangement of meadow grass (*Poa pra-
tensis* L.) and creeping-buttercup leaves (*Ran-
unculus repens* L.), together with a basal leaf and
flowering stem of columbine (*Aquilegia vul-
garis* L.), with some soil around the root balls.[1]
But they are rather too short, looking as if they
were cut off and pushed into the turf. Even
stranger is the fact that the central stem of col-
umbine belongs to a wild variety, while the
one on the left is a double garden variety,[2]
which means that both cannot possibly grow
from the same root. What looks at first like
observation of nature reveals itself, on closer
examination, to be an unnatural arrangement.

The work is entered in the Imhoff Inventory
as *ein Angeli Blümlein mit sammt dem Laubwerk
auf Pergamen* ("a little columbine with its fo-
liage on vellum").[3] Later, Heller recorded it
among Dürer's drawings in Duke Albert's col-
lection in Vienna. Thausing[4] speaks of the
plant studies only in a general way, indirectly
suggests a dating of 1515, and thinks that "its
originality cannot well be doubted," but that it
"is hard to draw the line sharply against the
quantity of falsely attributed and forged
pieces." Meder accepts the year 1526 — which
appears on five other plant studies — as genu-
ine,[5] but Pauli takes it to be by a foreign hand,

so not obligatory. Wölfflin interprets the sty-
listic difference between *The Large Piece of Turf*
(Cat. 61) and the *Columbine* as a step toward
simplification. Klebs and Killermann explain
the compositional imperfection and the lack of
the *Turf*'s freshness by saying that Dürer must
have dug up the plant, "taken it home and
drawn it on the table." Flechsig, too, doubts
the authenticity of the figure 1526, but never-
theless sees the *Columbine* and the *Greater Cel-
andine* (Cat. 70) as works of Dürer's contempo-
rary with *The Large Piece of Turf* of c. 1503.

The Tietzes suggest the study is a work of
the Dürer Renaissance, a "*Kunstkammer*" work,
inspired by a watercolor of similar content by
Dürer, but of the quality of *The Large Piece of*

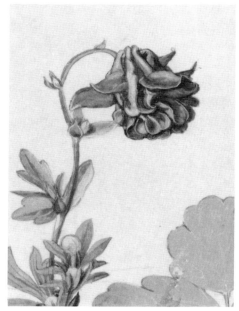

68.1 *Columbine*, detail, double garden variety.

Turf."[6] Winkler thinks he can recognize char-
acteristic details of the execution conforming
to *The Large Piece of Turf*, but adds that he is not
fully convinced of Dürer's authorship of this
and the other flower studies dated 1526: "The
rather restrained technique is hard to reconcile
with an artist who has left such exquisite work
on vellum." Winkler joins the Tietzes in the
opinion that the *Columbine*, the *Greater Celan-
dine*, and the *Three Medicinal Herbs* are techni-
cally and stylistically so close "that they are
very likely by one and the same hand."[7] Pan-
ofsky does not absolutely rule out that the
study is Dürer's, but holds it very unlikely. Ko-
schatzky and Strobl emphasize the uniformity
of the group, referring to Winkler and the
Tietzes (!) when they leave this and the two
other studies among Dürer's work. In contrast
to Springer, who excludes all the flower stud-
ies, Benesch is convinced that they all — both
Pieces of Turf, the *Buttercups, Red Clover, and
Plantain*, the *Tuft of Cowslips, Greater Celandine,
Three Medicinal Herbs*, and the *Columbine* —
show "unequivocally the same draughtsman's
hand."

With the exception of the *Three Medicinal
Herbs*, all the flower studies mentioned bear the

date 1526. The writing of the individual dates
varies. Of all these, the date of the *Columbine*,
written with a pen apparently in the paint used
for the plant stem above, appears the most reli-
able. Nevertheless, doubts arose regarding
Dürer's development and œuvre. After Pauli
and Flechsig had declared the date a later addi-
tion, the association of the *Columbine* and its
dating with *The Large Piece of Turf* of c. 1503
was generally accepted.

In spite of the basic objections mentioned to
associating the *Columbine* with *The Large Piece
of Turf*, Winkler points to certain details, par-
ticularly the reddish stem, "which are carried
out in one stroke," and the fine grass head on
the left, "most attractive in its light and grace-

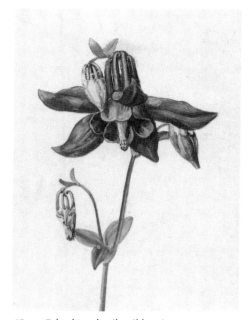

68.2 *Columbine*, detail, wild variety.

ful rendering," which in his opinion speak
"with other factors, most strongly in favor of
an execution by Dürer himself." Precisely by
comparing such details, the actual differences
become plain, paving the way for distinct pos-
sibilities for differentiating between ostensible
similarities. While on a dandelion stem in *The
Large Piece of Turf* Dürer was able to express in
a single, firm stroke specific elasticity, typical
color, light, and the characteristic shape taper-
ing toward the flower head, the stems of the
columbine, laboriously built up in several
shades of color, do not evince anything of the
former's quite playful lightness and seeming
effortlessness in formulation and expression.

In *The Large Piece of Turf*, one becomes aware
of the depth of observation and the matching
artistic interpretation that have gone into one
single, sun-infused plantain leaf. Anyone who
notices how the individual grass blades grow
from the earth, branch out, and crisscross with
clarity, evoking the space and atmosphere of
meadow ground, and then turns to the *Colum-
bine* study, will be astounded by the color sim-
plification that makes the buttercup leaf stand
out, placard-like, against the dark soil, and by
the poverty of the drawing in certain parts.

One has made it too easy for oneself, and is still doing so, if one explains the striking discrepancy in quality by the necessary demands of a different kind of technique. The inconclusiveness of this argument, advanced by Meder, is best demonstrated by the *Wing of a Blue Roller.* However we date this study, whether 1512 or earlier, the refinement and the precision of its execution on vellum totally invalidate the conclusion that the observable artistic differences between the *Columbine* and *The Large Piece of Turf* would be connected with the use of vellum and Dürer's unfamiliarity with the miniature technique.

In this flatly spread-out composition, the remarkable viewpoint itself that lets the foliage be seen from above but the central flower from below is rather disconcerting. The deliberate portrayal of various stages of growth and different varieties bears signs of a semiscientific naturalism; the nature study turns out to be a disguised art form with a didactic aspect. When Wölfflin, in his analysis of the *Columbine* and *The Large Piece of Turf,* describes the simplification whereby "the inexhaustible . . . becomes small and intelligible" as a significant step forward, he is inadvertently describing exactly what basically separates the two.

Consideration of Dürer's plant studies has hitherto been dominated by discussion of materials and technique; plant studies by his contemporaries were neglected because they were mostly done in other materials. Among these is a significant, revealing, but still hardly heeded document, the Karlsruhe Sketchbook of Hans Baldung Grien,[8] consisting of several fragments assembled as a book only after Baldung's death. One part contains accurately observed plant studies sketched in silverpoint (fol. 15r–56v). These drawings also include renderings of the columbine (fol. 15r, 39r), one of which is viewed from a similarly steep angle. As in our vellum study, a dominant spray of flowers rears up in the middle, and in both the contours of the leaves are described in lively, curving strokes. Baldung did his studies between 1522 and 1525; the *Columbine* in the Albertina is dated 1526.

These comments about Baldung's drawing are intended only to put the *Columbine* in a wider context than the reflections so far presented in the literature, and to subject it to further examination based on new premises. Given the difficulty of attributing it to Dürer, it is reasonable to ask whether its style does after all correspond to the date 1526, and whether it could not be the work of a somewhat younger contemporary of Dürer's, perhaps from the generation of Hans Baldung Grien.

NOTES

1 In medieval imagery, the columbine, along with the lily and the rose, was used as a symbol of the Virgin Mary; however, it is mainly and notably associated with the person and the suffering of Christ. As an allegory of salvation it becomes an important Christian symbol. See also Rolf Fritz, "Aquilegia. Die symbolische Bedeutung der Akelei," in *Wallraf-Richartz-Jahrbuch,* XIV/1952, pp. 99–111.

2 Identification by F. Ehrendorfer.

3 H. II, p. 83, no. 63.

4 Th. II, p. 57.

5 L. V.

6 Albertina Catalogue IV.

7 W. II, p. 72.

8 *Skizzenbuch des Hans Baldung Grien,* ed. by Kurt Martin (Basel, 1950).

68.3 Hans Baldung Grien, *Columbine and Bumblebee,* c. 1522–1525, silverpoint. Karlsruhe, Kunsthalle.

69

GERMAN, 1526

Buttercups, Red Clover, and Plantain

Watercolor and body color on vellum,
brush, heightened with white
Bottom right, in the dark soil,
the date *1526*
299 x 217 mm, slightly trimmed
at bottom edge and sides
Providence, Museum of Art,
Rhode Island School of Design,
Inv. 38053, gift of Mrs. Brockholst Smith
in memory of her mother, Jane W. Bradley

PROVENANCE: Imhoff • Andréossy • Lawrence •
Bale (L. 640, verso) • Ch. Smith Bradley •
Ch. Bradley • Jane Whitman Bradley •
Margaret Bradley.

BIBLIOGRAPHY: H. II, p. 83, no. 65 • Exhibition
Catalogue *The Lawrence Gallery, A Catalogue of
100 Original Drawings by Albrecht Dürer and
Tizian Vecelli, collected by Sir Thomas Lawrence,*
London, Woodburn Gallery, Eighth Exhibition,
May 1836, no. 41 (?) • Gustav Friedrich
Waagen, *Treasures of Art in Great Britain,* vol.
IV (London, 1857), p. 119 • Auction Catalogue
*Tableaux et Dessins anciens, Collection de feu M. Le
Général Comte Andréossy,* Paris, April 13–16,
1864, p. 18, under no. 81 • Exhibition Catalogue
Albrecht Dürer and Lucas van Leyden (London,
Burlington Fine Arts Club, 1869), no. 138 •
Auction Catalogue, Christie, Manson &
Woods, London, June 9, 1881, no. 2282 • E.,
p. 80 • W. II, pp. 66, 70, no. 350 • P. II,
p. 136, no. 1427 • Exhibition Catalogue
Watercolors by the Masters Dürer to Cézanne
(Minneapolis, Institute of Arts, 1952), no. 4 •
Bulletin, Minneapolis Institute of Arts
XLI/1952, no. 19 • Killermann, 1953, p. 25 •
Heinrich Schwarz, "A Water-colour attributed
to Dürer," in *TBM* XCV/1953, pp. 149, 150 •
Benesch, 1964, p. 337, under no. VI • Behling,
1967, pp. 114, 115 • Exhibition Catalogue
Washington 1971, pp. 108–110, no. XXXVI •
Alan Shestack, "Dürer's Graphic Work in
Washington and Boston," in *Art Quarterly,*
Autumn 1972, pp. 304, 305, note 1 • John
Rowlands, "Dürer in America, His Graphic
Work" (Washington, National Gallery of Art,
1971), in *MD* 10/1972, p. 384.

From a piece of turf, thick with grasses,
mosses, flowering red clover (*Trifolium pratense*
L.), ribwort (*Plantago lanceolata* L.), and crown
vetch (*Coronilla varia* L.), rises a bulbous but-
tercup (*Ranunculus bulbosus* L.) in full flower.[1]

The first mention of this study as *Schmalz-
blumen und Klee auf Pergamen* ("Buttercups and
clover on vellum") appears in the Imhoff In-
ventory.[2] In 1836 it was entered among the
Dürer drawings of Sir Thomas Lawrence with
a note that it came from the Andréossy Collec-
tion;[3] in 1857 it was described by Waagen in
the Charles S. Bale Collection; in 1869 it was
exhibited in the Burlington Fine Arts Club;

later, it was mentioned by Ephrussi, but still
passed over by Thausing. After being auc-
tioned in 1881, it passed into oblivion. Winkler
was the first to include in his catalogue the
photograph taken on the occasion of the Bur-
lington exhibition. The Tietzes, however, do
not mention the study.[4] For Panofsky, who
still did not know the original when he com-
piled his Dürer publication, its authenticity is
questionable. Schwarz rediscovered the study
and exhaustively set out its connection with
Dürer and the whole question of this group of
flower studies. Benesch takes it as Dürer's
work, together with all the rest of the flower
and turf pieces, while Talbot[5] discusses the at-
tribution problem but leaves the verdict open.

On grounds of form and style, the *Butter-
cups, Red Clover, and Plantain* was always
grouped with the *Columbine* (Cat. 68), the
Greater Celandine (Cat. 70), the *Three Medicinal
Herbs* (Cat. 71), *The Small Piece of Turf* (Cat. 62),
and the *Tuft of Cowslips* (Cat. 72). The connec-
tion with the Vienna flower studies, particu-
larly the *Greater Celandine,* is evident: both the
sprays are painted in a similar green, merging
into reddish brown at the edges; the little hairs
are indicated with similarly coarse brush
strokes; in like manner, the soil is not only the
base of, but also forms a dark background for,
grasses and weeds; the leaves in both are simi-
larly outlined with delicate light and dark
lines. In these ways the *Buttercups* conforms not
only to the *Greater Celandine,* but also to the
Columbine. The fact that there are buttercup
leaves in the *Columbine* assists direct compari-
son. Finally, all three drawings are based on the
same scheme of composition: each one shows a
fully grown plant with stems and leaves fan-
ning out from the middle of a lump of soil, and
with flowers in various stages of development;
spreading foliage and grass blades shift the
center of gravity to the right in a similar way.
In principles of modeling and in many com-
mon details, they turn out to be the work of the
same artist's hand. The individual criteria ad-
vanced for each one for or against Dürer's au-
thorship therefore apply reciprocally to the
others.

This group of flower studies dated 1526 does
not fit into Dürer's œuvre without difficulty,
and the problem is not diminished by declaring
the date a later addition and suggesting that the
studies were done considerably earlier, around
1503. The stylistic differences existing within
the whole group are too great for all of them to
be attributed to the same artist. *The Large Piece
of Turf* (Cat. 61) and the *Madonna with a Multi-
tude of Animals* (Cat. 35) certainly show that in
1503 Dürer was interested in such themes, but
the flower studies dated 1526 are just so diver-
gent from these works that any joint classifica-
tion involves explanatory reservations.

Anyone who tries to attribute the difference
in execution between the turf and these
flowers to Dürer's alleged unfamiliarity with
vellum painting technique[6] is overstraining
the weapon of stylistic feasibility and making
the solution too simple. Finally, there are other
examples among Dürer's works from this very

period that evince a remarkable constancy in
style. His *Hare* and *Head of a Roebuck* (Cat. 43,
54) actually demonstrate how consistent his
artistic resources can be. And that is true not
only of the animal studies: the Bremen *Iris*
(Cat. 66) can just as easily be compared with
The Large Piece of Turf. In comparison with the
latter, in fact, one notices how much less pre-
cise and well defined the grass blades are in the
Columbine and the *Buttercups, Red Clover, and
Plantain,* for example. Limp, drawn with fee-
ble, soft brush strokes, they lack the fine ner-
vousness of Dürer's characteristic artistic per-
sonality.

NOTES
1 Identification by F. Ehrendorfer.
2 H. II, p. 83, no. 65.
3 Exhibition Catalogue London 1836.
4 They have, however, presumably seen the
 photograph taken at the time of the Burlington
 exhibition, as the Albertina also has a copy.
5 Exhibition Catalogue Washington 1971.
6 Meder was the first, in *RKW* 30/1907, p. 181.

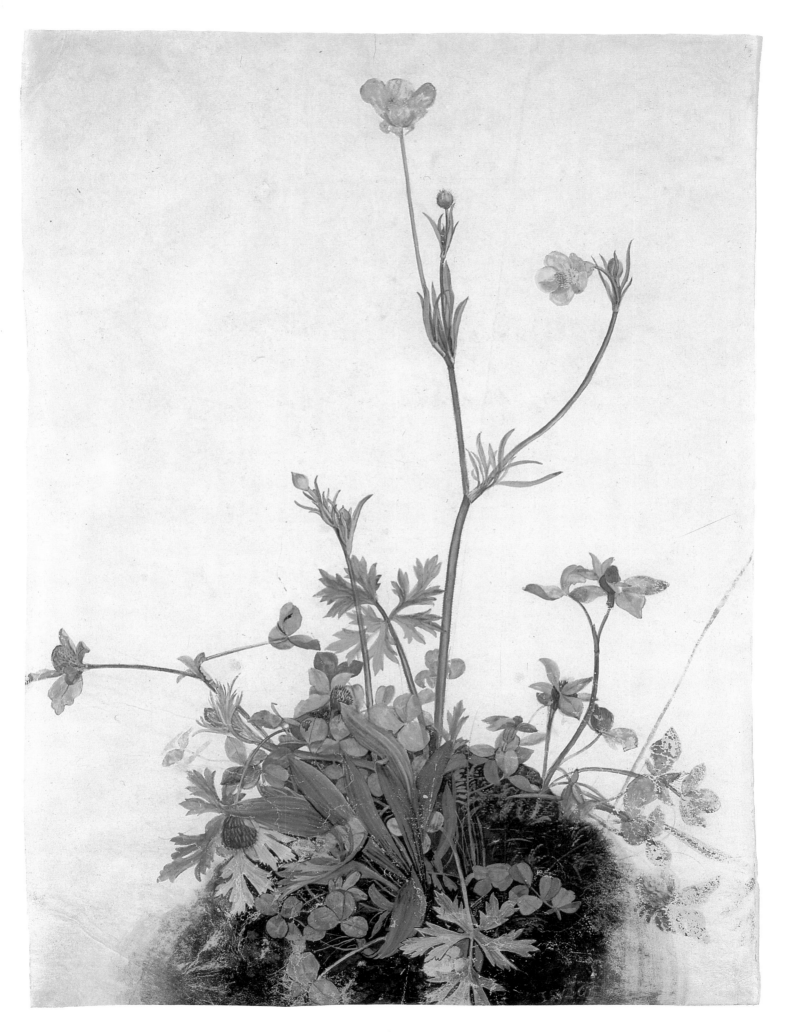

69

GERMAN, 1526

Greater Celandine

Watercolor and body color on vellum,
mounted on cardboard,
brush, heightened with white,
retouched in places on the upper leaves
Color flaked off in places, mainly from the
lower leaves and the dark soil
Bottom left, with brush in dark gray,
the date *1526*
287 x 149 mm
Vienna, Graphische Sammlung Albertina,
Inv. 3184 (D 160)

PROVENANCE: Imperial Treasure Chamber •
Imperial Court Library (1783) • Duke Albert of
Saxe-Teschen (L. 174).

BIBLIOGRAPHY: H. II, p. 119, no. 145 • E., p. 80 •
Schönbrunner and Meder, no. 456 • L. V, p. 30,
no. 586 • Springer, in *RKW* 29/1906, p. 555 •
Meder, in *RKW* 30/1907, p. 181 • Killermann,
1910, pp. 96 ff., 103 ff. • Fl. II, pp. 116, 378,
559 • Albertina Catalogue IV, p. 24, no. 160 •
W. II, pp. 66, 73, no. 355 • T. II/2, p. 143,
no. A 428 • P. II, p. 136, no. 1428 • Killermann,
1953, p. 58 • Winkler, 1957, p. 184 • Behling,
1967, pp. 74, 75, 114, 116 • Benesch, 1964,
p. 337, under no. VI • K.-Str., p. 180, no. 30 •
Str. II, p. 720, no. 1503/34.

Similar to the *Columbine* and the *Buttercups,
Red Clover, and Plantain* (Cat. 68, 69), the
Greater Celandine (*Chelidonium majus* L.) is
shown with the earth in which it is rooted.
The study clearly records the features and plac-
ing of the pinnate leaves and the budding and
flowering.[1]

The study was first mentioned by Heller,
with reference to the date 1526, in the collec-
tion of Duke Albert, and Meder still took both
study and date as original.[2] According to
Flechsig, only the *Greater Celandine* itself is by
Dürer, but Dürer's authorship of the date, here
as on the *Columbine,* is doubtful. Flechsig
thinks that one could "happily put the dating
much further back" and suggests 1503, as for
The Large Piece of Turf. Winkler puts it diplo-
matically: "Like the following [the *Three Me-
dicinal Herbs*], certainly by the hand of the mas-
ter of the foregoing sheet [*Columbine*]," but
"dated by a foreign hand." The Tietzes[3] dis-
miss it with the same arguments as for the *Col-
umbine.* They judge the study to be evidence of
the "pedantic scientific illustration style of the
Dürer imitators in the second half of the cen-
tury." For Panofsky, too, there is a close con-
nection with the *Columbine* and the *Three Me-
dicinal Herbs,* but he considers Dürer's
authorship very unlikely. Benesch's overall
verdict, that he could unquestionably recog-
nize the same draughtsman's hand in all the
plant studies, is too general to help in further
debate of the problem. Koschatzky and Strobl
contribute historical information about prede-

cessors in the development of this sort of plant
study in Netherlandish painting, such as the
Portinari Altarpiece or the *Adoration of the
Shepherds* by Hugo van der Goes, and in regard
to the dating, draw the somewhat surprising
conclusion: "If the figure 1526 on Dürer's
plant studies would be the true date, then the
many direct impressions from the Netherlands
visit could be the basis of them."

Regarding the *Greater Celandine,* these au-
thors concern themselves particularly thor-
oughly with the technique specific to the stud-
ies, namely, painting with full baby color on
vellum. The hygroscopic properties of vellum
cause its surface tension to change, so its bond
with the color slackens in the course of time,
resulting in a greater likelihood of flaking.
This has happened to the green of the leaf
below the flower head, where it is obvious that
a large piece of color is missing. It is, however,
doubtful whether the pale green patch now
visible is underpainting, as has previously been
assumed.[4] Lighter in tone, it looks more like a
restorative measure. Also, in the ground on the
right, under the faded bottom leaves, a re-
storer's hand has helped to mitigate the effect
of the loss of color by filling in with a match-
ing brown. Other places with equally notice-
able color flaking, like the stem and the base
leaves, do not show this supposed underpaint-
ing. Equally irrelevant, in my opinion, is the
suggestion that particles of the solid color were
dusted off, whereby the work's original plas-
ticity was lost. The *Greater Celandine* was never
more carefully executed; apart from isolated
missing flakes, the color surface is fully intact.
The leaf ribs applied in white, and the shading
and modeling in dark and light green mixed
with white — what corresponds to the stiff
hairs on the stem — are coarsely painted.

The color is broadly laid on, and the leaves
are vigorously outlined with a pointed brush,
with pale lines contoured against the shadows,
and thus set off against each other. Similar
characteristics are found in the *Columbine* and
the *Buttercups, Red Clover, and Plantain.* These
three studies also share the same island-like
earth form, its round shape broken up at the
sides and front. The plants do not grow out of
the middle of it but are placed well to the front,
so the dark soil acts as a foil, against which the
natural forms are displayed to greater effect.

The *Three Medicinal Herbs* is always men-
tioned in the same breath as the *Columbine* and
the *Greater Celandine,* but they differ from one
another in their distinct execution. First, the
date figures on the *Greater Celandine* look
clumsy and different compared with those on
the *Columbine.* But they have some character-
istic features in common, including the termi-
nal stroke of the *1,* moving down left, and the
small nick remaining where the two curving
strokes of the *6* meet at the bottom. The differ-
ent impression they make is probably due to
the different implement used — pen for the
Columbine, brush for the *Greater Celandine.*

As the *Columbine* and the *Greater Celandine*
are directly linked by formal, stylistic, and

technical similarities, and the date obviously
written by the same hand, the criteria for attri-
bution and dating already defined regarding
the *Columbine* (see Cat. 68) apply here too.

NOTES

1 For history and symbolic significance, see
 Behling, 1967.
2 L. V.
3 T. II/2, p. 143, under no. A 427.
4 K.-Str.

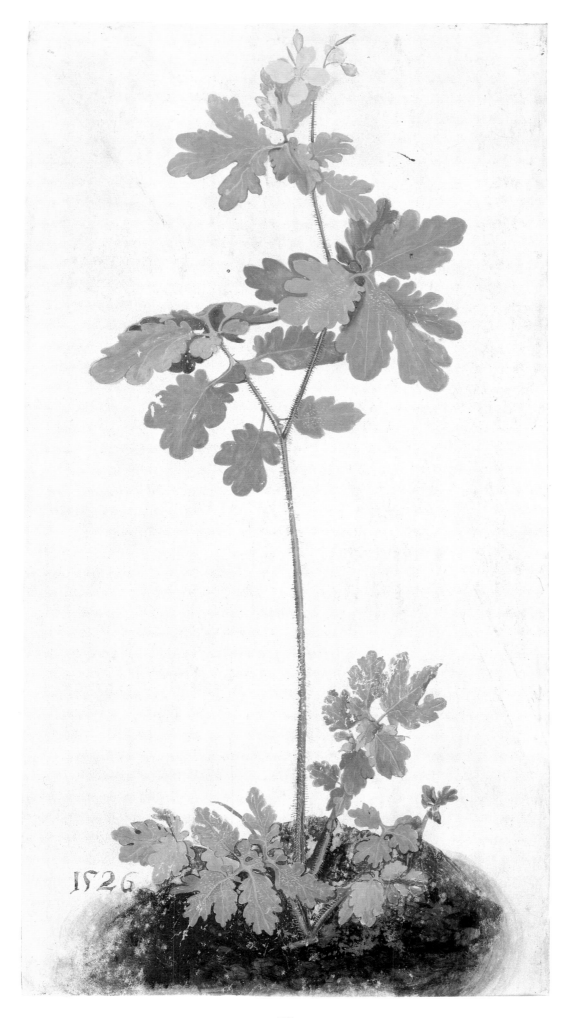

1526

GERMAN, SECOND HALF OF THE
SIXTEENTH CENTURY

Three Medicinal Herbs
(Pansy, Scarlet Pimpernel, and
Self-Heal)

Watercolor and body color on vellum,
mounted on cardboard,
brush, heightened with white,
traces of preliminary pencil drawing on the
flower of the pansy
Creases, large flakes of green
missing from parts of the leaves
288 x 148 mm, left side trimmed

Vienna, Graphische Sammlung Albertina,
Inv. 3183 (D 161)

PROVENANCE: Imperial Treasure Chamber • Imperial Court Library (1783) • Duke Albert of Saxe-Teschen (L. 174).

BIBLIOGRAPHY: H. II, p. 118, no. 143 • Schönbrunner and Meder, no. 509 • L. V, p. 30, no. 587 • Springer, in *RKW* 29/1906, p. 555 • Meder, in *RKW* 30/1907, p. 181 • Killermann, 1910, pp. 98–100, 103 ff. • Fl. II, pp. 378, 559 • Albertina Catalogue IV, p. 24, no. 161 • W. II, pp. 66, 73, no. 356 • T. II/2, p. 143, no. A 429 • P. II, pp. 136, 137, no. 1435 • Killermann, 1953, p. 58 • Winkler, 1957, p. 184 • Benesch, 1964, p. 337, under no. VI • Behling, 1967, pp. 114, 115, 117 • K.-Str., p. 182, no. 31 • St. II, p. 772, no. 1503/35 • Exhibition Catalogue *Kunst der Reformationszeit* (Berlin, Staatliche Museen, Altes Museum, 1983), p. 270, no. D 50.

This is a picture not of three plants, as one would expect from the traditional title, but of four: wild pansy (*Viola tricolor* L.), self-heal (*Prunella vulgaris* L.), scarlet pimpernel (*Anagallis arvensis* L.), and, bottom left,[1] chickweed (*Stellaria media* [L.] Vill.).

The characteristic growth form, leaf shapes, and coloring of the plants are vividly captured. The flowers, too, are shown in typical positions and various stages of development, those of the pansy from the front and the side, as if casually arranged.

The study was first mentioned by Heller. Thausing and Ephrussi do not expressly mention it. Meder[2] includes it in Lippmann's catalogue with the comment "without signature or date, because trimmed"; he is obviously thinking of the dated flower studies *Columbine* and *Greater Celandine.* The three medicinal herbs were known to late medieval pharmacists as cures for fever. Killermann therefore suggests that by no means the last purpose of these studies was a practical one: Dürer had possibly thought about illustrations for a natural-science work, or taken an interest in fever herbs for the sake of his own health, after he returned home from the Netherlands with an attack of febrile malaria. The Tietzes reject the sheet. For them it is like the *Greater Celandine* and the *Columbine,* a work of the late six-

teenth century. Panofsky, too, holds Dürer's authorship to be very unlikely. Winkler also groups the *Three Medicinal Herbs* together with the *Columbine* and the *Greater Celandine,* but says that for him it contains the most weaknesses of the three. Koschatzky and Strobl also comment on the lack of artistry but argue for Dürer, pleading the poor state of preservation, which means that it has lost the plasticity of the full-bodied color, and comparing it with the *Tuft of Cowslips* (Cat. 72) in the Hammer Collection, which still retains it.

Meder offers no evidence to support his theory that the study lost its date, 1526, when it was trimmed. Nevertheless, his suggestion was taken up in the literature and used as a reason for grouping the *Three Medicinal Herbs* with the other flower studies that actually do bear the date 1526.

The doubt expressed by Winkler can be endorsed by stylistic details. Compared with the two Albertina studies *Columbine* and *Greater Celandine* (Cat. 68, 70) and the *Buttercups, Red Clover, and Plantain* (Cat. 69), the *Three Medicinal Herbs* differs above all in the drawing of the foliage. In the first place, it lacks the sureness of the fine, unbroken strokes outlining the leaves of the *Greater Celandine,* the *Columbine,* and the *Buttercups.* Nor does it display the same characteristic sharpness and clarity of form. Although the drawing of the *Three Medicinal Herbs* is coarser, it seems to have a richer range of color, and the modeling looks more painterly. The treatment of the ground is different too: the round, almost three-dimensional lump of earth, from the middle of which grow the *Columbine,* the *Greater Celandine,* and the *Buttercups, Red Clover, and Plantain* is here reduced to a flat silhouette of a foil. It is hard to decide whether it was part of the original conception of the study or added later. The greatest difference is in the composition, with the plants lined up side by side, looking as if they were cut.

The arrangement and the specific attention to detail recall not so much the *Columbine* and the *Greater Celandine* as they do later examples, such as the flower study with eight different plants in Bayonne (ill. 71.1). Both the wide-meshed patterning of the picture surface and the painting technique are familiar. Foreshortening and overlapping are used in the same way. They are about the same height and coincide in the range of various greens, as well as in the exaggerated tendency to emphasize the damage on leaves. (In both, poor adhesion between paint and vellum has led to the flaking off of the color.) It is more than likely that scientific botanical illustration is the basis for this form of portrayal, which also characterizes the latest study to be introduced into the literature[3] as a genuine work of Dürer's, *Columbine, Wild Pansy, and Alkanet* (Cat. 79).

It is pointless to bring up again the often used argument about the different techniques of working on vellum or on paper. Even though we have as yet no further information about the true artist, the divergent factors already make it impossible to continue including this study in Dürer's œuvre.

NOTES

1 Identification by F. Ehrendorfer.
2 L. V.
3 Exhibition Catalogue Berlin 1984, pp. 34, 35, no. 31 A.

71.1 Hans Hoffmann (?), *Eight Flower Studies,*
watercolor and body color on vellum. Bayonne, Musée Bonnat.

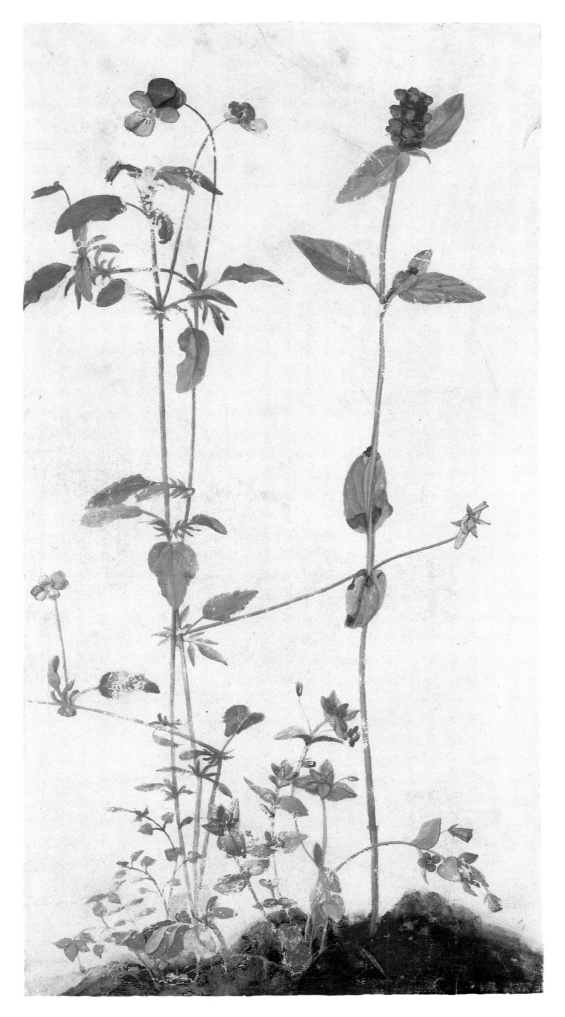

72

GERMAN, FIRST QUARTER OF THE
SIXTEENTH CENTURY

Tuft of Cowslips

Watercolor and body color on vellum,
brush, heightened with white
Bottom right, in a foreign hand,
Dürer monogram and the date *1526*
192 x 168 mm

Los Angeles, The Armand Hammer Collection

PROVENANCE: Hal O'Nians.

BIBLIOGRAPHY: Auction Catalogue, Sotheby's, *Old Master Drawings and Paintings,* London, July 11, 1956, p. 11, no. 74 • Benesch, 1964, p. 337, under no. VI • K.-Str., p. 182, under no. 31 • Exhibition Catalogue Washington 1971, p. 110, note 3 • Exhibition Catalogue *The Armand Hammer Collection* (Los Angeles County Museum, 1971/72), no. 70 (Konrad Oberhuber), and other places, e.g. (Houston Museum of Fine Arts, 1979/80), no. 64 • Alan Shestack, "Dürer's Graphic Work in Washington and Boston," in *Art Quarterly,* Autumn 1972, pp. 304, 305, note 1 • Christopher White, "The Armand Hammer Collection," in *Apollo* 95/1972, pp. 457, 458 • John Rowlands, "Dürer in America, His Graphic Work" (Washington, National Gallery of Art, 1971), in *MD* 10/1972, p. 384 • St. II, p. 726, no. 1503/37 • Exhibition Catalogue *Master Drawings from the Collection of the National Gallery of Art and Promised Gifts* (Washington, National Gallery of Art, 1978), p. 23 • Piel, 1983, p. 142, no. 50 • Exhibition Catalogue *Gothic and Renaissance Art in Nuremburg 1300–1550* (New York, Metropolitan Museum of Art, 1986), p. 300, no. 126 (and Nuremberg, 1986; the catalogue is in German).

The study shows a clump of cowslips (*Primula veris* L.)[1] isolated from its natural surroundings, with several flower stems among densely clustered leaves, together with a few blades of grass and clover leaves (*Trifolium* spec.).

The study bears a forged Dürer monogram bottom right, with the date 1526 above it. It belongs to a group with four other studies (five, counting the *Lily* in Bayonne, ill. 7, p. 195) of similar execution, all bearing the date 1526 (p. 194). Most of these sheets go back to the collection of Duke Albert of Saxe-Teschen in Vienna. Some of them are today still in the Albertina; others seem to have changed hands in the early nineteenth century. In the case of the *Buttercups, Red Clover, and Plantain* (Cat. 69), now in Providence, it was possible to follow the tracks of the study back to Duke Albert's collection.[2] Perhaps this could also be done with the cowslip study. All we know so far is that it was in private ownership (not further specified) in England before coming onto the market through Hal O'Nians in 1956 as a questionable work of Albrecht Dürer.

It was Benesch who introduced the sheet into the Dürer literature. In his opinion, the blackish garden soil was unquestionably by the

same artist's hand as that seen also in the *Buttercups, Red Clover, and Plantain,* the *Columbine,* the *Greater Celandine,* and the *Three Medicinal Herbs* (Cat. 68 – 71). After comparison with the studies in the Albertina, Koschatzky and Strobl were likewise convinced that the *Tuft of Cowslips* and *The Large Piece of Turf* were the work of the same artist. An attribution to Dürer was supported by White and Oberhuber.[3] Oberhuber makes a distinction between the carefully executed studies on paper (*Iris* and *Turf*) and those on vellum. If one assumes Dürer's authorship of both groups, he argues, the differences can be explained by the use of another technique and at another time. In his eyes, the variously shaded green conforms to *The Large Piece of Turf,* and the highlighting of the front leaves here is identical with the green heightening of the turf and with that of the violet leaves in *Nosegay of Violets* (Cat. 77). If the *Cowslips* does not have the artistic quality of the *Turf,* it still shows the same spatial depth, a similar treatment of light, and gives the same lifelike impression. Still, the rich, velvety overall texture of the sheet makes it appear to be the work of an artist of the highest quality. So since the *Tuft of Cowslips* is not quite the equal of *The Large Piece of Turf* on the one hand, but stands above many plant studies on the other, it can be seen as a connecting link. Its sense of space and life and the subtlety of its coloring bring it nearer to *The Large Piece of Turf* than any other plant in the group.

Oberhuber's positive line of argument is directly opposed to Talbot's[4] doubt about the authenticity of the cowslip study, and to its decided rejection by Shestack and Rowlands. It emerges from Friedrich Winkler's correspondence (dating back to 1956) that Edmund Schilling also knew the study and had written to him about it[5] before it was shown to him again by later owners several times. In his personal notes, Winkler ascertains connections with *The Small Piece of Turf,* the *Buttercups, Red Clover, and Plantain,* and the *Nosegay of Violets,* but sums up with the thought that "the whole does not look like Dürer." Later, when asked for a verdict, he avoided taking a position, but drew attention, for comparison, to a further cowslip study (Cat. 73).

In all judgments, the stylistic difference between *The Large Piece of Turf* and the group of works dated 1526 plays the deciding role. While there is no need to devote further discussion to *The Large Piece of Turf,* when it comes to the *Tuft of Cowslips* and the other flower studies on vellum, the question must be asked whether it is really valid to connect them to *The Large Piece of Turf* and thereby with Dürer, in view of the obvious differences.

There is a wide artistic gap between the *Cowslips* and *The Large Piece of Turf.* The parallels Oberhuber drew with the *Nosegay of Violets* have, at a glance, much to be said for them, but on closer inspection the comparison does not stand up. Not only are the violet blossoms more finely drawn than the cowslips, but the rendering of the leaves differs, despite their outwardly similar appearance. Those of the vi-

olets are modeled in a draughtsmanly manner with areas of short, dark hatching over the bluish ground, the edges reinforced by pen in green or brown color, and the leaf ribs and certain withered parts accented by brush in light ocher. The modeling of the foliage on the cowslip plant, however, is done in a painterly manner with a broad brush, the ocher-colored rims of certain leaves being particularly noticeable. Whereas these are most likely the chance remains of a watercolor underpainting not gone over carefully, the painter of the violets has deliberately added them as a final touch.

Outwardly the study may be connected by the date 1526 to the *Columbine, Greater Celandine,* and *Buttercups, Red Clover, and Plantain,* but the style is patently different. While the shapes of the other plants are more clearly rendered in a linear, graphic style, the leaves of the cowslip look soft, the grass blades against the soil lifeless, thin, and dry. The latter emerge from the darkness with no recognizable point of attachment, are composed of several brush strokes, and are twisted spirally. Brush loops, indications of a cloverleaf, and a few indefinable lines, all in green, make a transition to the soil. These details do not reappear either in *The Large Piece of Turf* or in the other flower studies dated 1526. On the other hand, parallels are to be found in the London *Madonna with the Iris* (ill. 66.1, p. 188). This oil painting corresponds strikingly, not only in the similar treatment of the grasses (ill. 2, p. 177), but also in the dots and brush twirls on the ground and in the cloverleaves sharply outlined with a fine brush, and seen through the blades of grass.

On the grounds of these similarities, the *Madonna with the Iris* and the *Tuft of Cowslips* stand closer together than the *Cowslips* and *The Large Piece of Turf;* indirectly, this comparison also clarifies the discrepancy. If we look at the results of this confrontation, bearing in mind Dürer's authenticated work, the doubts expressed about the authenticity of the study outweigh the arguments advanced in its favor.[6]

NOTES

1 Not *Primula officinalis* Jaquin (according to F. Ehrendorfer.)

2 Heinrich Schwarz, "A Water-colour attributed to Dürer," in *TBM* XCV/1953, pp. 149, 150.

3 Oberhuber, in Exhibition Catalogue Houston 1979/80.

4 Charles W. Talbot, in Exhibition Catalogue Washington 1971.

5 I am grateful to F. Anzelewsky for allowing me the opportunity to inspect those of Winkler's notes that are in the Berlin Kupferstichkabinett.

6 In the 1986 New York and Nuremberg exhibitions, the *Cowslips* was again listed with Dürer's name; the catalogue entry gave no new insights for the ascription, but pointed to the problems mentioned above (citing parts thereof inaccurately).

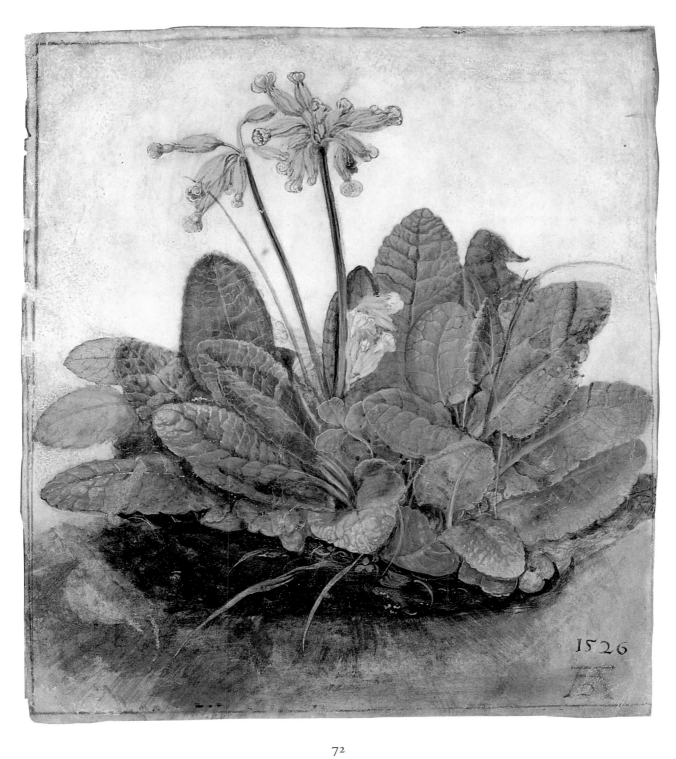

73

Cowslips with a Ladybug

Watercolor and body color on stout paper,
brush, heightened with white
Top right, the inscription:
Dieses hatt Albert Dür[er] gemacht
220–228 x 166 mm, slightly trimmed all around

Potsdam-Sanssouci, Staatliche Schlösser und
Gärten, Aquarellsammlung, Inv. 536 a

PROVENANCE: Kassel (Wilhelmshöhe).

BIBLIOGRAPHY: Winkler, in *JPK* 53/1932,
pp. 88, 89 • Arthur E. Popham, *Catalogue of
Drawings by Dutch and Flemish Artists, preserved
in the Department of Prints and Drawings in the
British Museum,* vol. V (London, 1932), p. 209 •
W. II, p. 67 • Exhibition Catalogue Dresden
1971, p. 145, no. 180.

This study, like Cat. 72, shows basal leaves
and flowering stems of the cowslip (*Primula
veris* L.), with the bright red color and black
spots of a ladybug shining out from its dark
shadow. At bottom right lies a single flower,
throwing a broad shadow. This detail rounds
off the composition and lends the nature study
the character of a still life, over and above its
nominal function (compare also ill. 88.4).

The sheet is hardly acknowledged in the lit-
erature. Only Winkler gives it a brief mention.
Commenting on the inscription, "Albert
Dür[er] has made this," he suggested, long be-
fore the *Tuft of Cowslips* in the Hammer Col-
lection (Los Angeles) became known, that this
study was perhaps based on a lost one by Dürer.
Together with three other flower studies,[1] he
attributed it to the Netherlandish painter
Spierincx, who is known only from an album
in The British Museum. This suggestion can-
not be upheld, since the drawings obviously
come from different painters.[2]

There is no need to discuss the truth of the
inscription in detail. Although it is relatively
easy to exclude Dürer's authorship, we still
have great difficulty in assigning this rather
unbalanced-looking study more accurately.

There is an unusual and harsh contrast be-
tween the brushwork of the smoothly applied
surfaces and areas of dense, systematic hatch-
ing, and the lively, decorative, calligraphic
forms of the grasses springing out in all direc-
tions. The inscription, possibly written before
1600, vaguely helps to place it.

Among sixteenth-century drawings, there is
nothing else comparable with this style; paral-
lels can be recognized, however, in paintings
by Lukas Cranach the Younger. In his panel
paintings plants may be noticed that are ob-
viously based on analogous nature studies. A
detail from his *Epitaph for the Burgomaster Mi-
chael Meyenburg* of 1558 (formerly in the Blasii-
kirche, Nordhausen, missing since 1945; see
ill. 73.1) shows similarly conceived plants with

equally calligraphic grasses filling the gaps.
This observation is in no way intended to pos-
tulate a direct connection, but merely to indi-
cate the course that further deliberation might
take.

Apart from the same motif, there is really no
link between the Potsdam and the Los Angeles
cowslip studies. Only the suggested relation to
Dürer is common to both. Their inscriptions,
although not by Dürer, are certainly old, and
could well have been added in the sixteenth
century. So there are two possible interpreta-
tions: either the sheets were connected with
Dürer's name by chance or through hazy
knowledge of his nature studies, or else there is
a grain of truth in the allusion, and the inscrip-
tions hand down an old tradition. There re-
mains the fact that both cowslip studies have
been connected with Dürer, even though they
are different plants, apparently unrelated to
each other.

This sheet will certainly not be prized for its
own sake. Its importance lies rather in its con-
nection with the Los Angeles study, and in the
renewed Dürer allusion, sufficiently strong
not to be entirely overlooked.

NOTES

1 *Piece of Turf* (Cat. 63), *Flowerbed* (Cat. 64), and
Bunch of Grapes and Jacob's Ladder (ill. in Werner
Schade, *Lucas Cranach d. Ä., Zeichnungen*
[Leipzig, 1972], ill. 30); all formerly in Kassel,
Wilhelmshöhe, today Potsdam-Sanssouci,
Staatliche Schlösser und Gärten, Aquarellsamm-
lung.
2 Exhibition Catalogue Dresden 1971 (W. Schade).

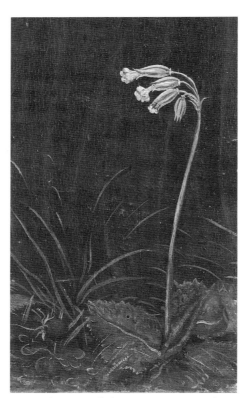

73.1 Lukas Cranach the Younger, *Raising of
Lazarus,* Epitaph for the Burgomaster of
Meyenburg, 1558, detail, oil on panel. Formerly
in Nordhausen, Blasiikirche.

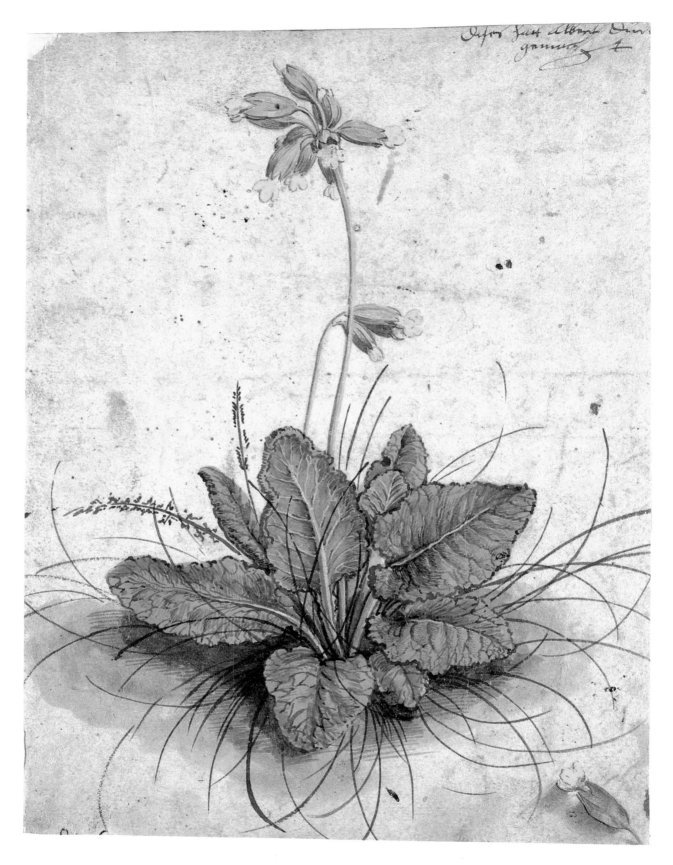

73

Peonies by Dürer and Hoffmann

It is an astonishing fact that, while there are many surviving copies of Dürer's animal studies, we know of not a single exact reproduction of any of his plant studies. The only apparent exception is the *Peony Stem* (Cat. 75),[1] attributed to Dürer. The work itself is missing, and there may be no true copy even of this, but Winkler[2] claims to find a series of reflections of it in sixteenth-century art. These include the Berlin *Peonies* (Cat. 74), with the date 1526, the two works by Hans Hoffmann in Budapest, both dated 1580, and his study in Bamberg, monogrammed and dated 1582 (Cat. 76). None of them copies another. For none is Dürer's example certain, or even that the execution of any is authentic. Winkler's attribution was a long guess, based on stylistic points.

The date 1526 on the Berlin *Peonies,* which it shares with five other flower studies ascribed to Dürer (see p. 194), does not tell us much. The figures are generally held to be a later addition to the sheets. That the date cannot be within this period is confirmed by the fact, which I consider manifest, that the Berlin sheet also was painted by Hans Hoffmann.

The only peonies firmly attributable to Dürer are those sketched in pen and wash in the *Madonna with a Multitude of Animals* (Cat. 35). In addition, those in the London *Madonna with the Iris* (ill. 66.1) can probably be linked with him, certainly with his studio. These two stand out clearly in comparison with the Bremen study (Cat. 75) and the other four. The peony plant in *Madonna with a Multitude of Animals* is in full bloom; although it is only a detail of the composition, its effective, expressive rendering corresponds to that of the *Iris* and *The Large Piece of Turf.* It sets itself noticeably apart from the morbid features of the Bremen drawing, which are slightly reminiscent of Hoffmann's examples.

The peonies in the *Madonna with a Multitude of Animals* allow no promising deduction about the studies, but it is therefore all the more interesting to trace back the history of this flower in the Madonna theme. In the process, it becomes clear that Dürer must have concerned himself with peonies. In the composition of their rich floral setting, both the *Madonna with a Multitude of Animals* and the *Madonna with the Iris* relate to fifteenth-century Upper Rhenish precursors of the type of the rosebower Madonna. Martin Schongauer's *Madonna in a Bower of Roses* of 1473, in Colmar, represents the high point of this development. Dürer, during his years of travel, intended to study

with Schongauer, although when he reached Colmar in 1492 he received news of the master's demise; anyway, he obviously knew the picture. This assumption is endorsed by comparing the peonies in Schongauer's *Madonna* and *Madonna with a Multitude of Animals.* In Schongauer's panel, a peony stem grows up from the grassy bank beside the Madonna, with a fully open flower near her elbow. Dürer introduces a flower into his drawing in exactly the same position. Both plants also conform in

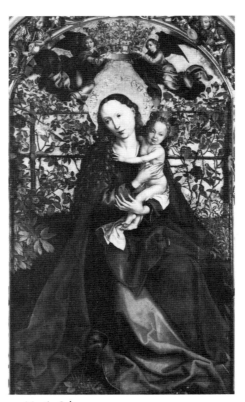

1 Martin Schongauer,
Madonna in a Bower of Roses, 1473,
oil on panel. Colmar, St. Martin.

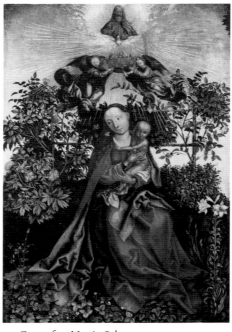

2 Copy after Martin Schongauer,
Madonna in a Bower of Roses, oil on panel.
Boston, Isabella Stewart Gardner Museum.

their stage of growth. The flowers can be individually compared, petal for petal; particularly distinctive is the slightly incurved one top right, and the one tucked like a mussel below. Every detail of Dürer's peony leads back to Schongauer's prototype.

The assumption is confirmed also by the second flower, shown in side view to the left in Dürer's drawing, as it, too, appeared first in Schongauer's work. But it can no longer be seen in the Colmar picture, for this was later heavily trimmed on the peony side. Only an old copy (ill. 2) bears witness to the former appearance of the complete composition. This shows Schongauer's peony plant in its original form, and in this the far left flower is placed a little higher and turned sideways, exactly as in Dürer's drawing *Madonna with a Multitude of Animals.* It is therefore impossible to doubt that, among the many nature studies that Dürer assembles around this Madonna, the peonies were derived from Schongauer's *Madonna in a Bower of Roses.* Looking like the result of his own observation, in the midst of numerous other plant and animal studies, it turns out, on closer inspection, to be reality at second hand.

This observation of the previously overlooked connection between Dürer and Schongauer, however, does not help to reveal Hoffmann's model. Unless chance should bring the Bremen study to light again and enable the authenticity of the original to be examined, to derive Hoffmann's peonies from a known or missing prototype by Dürer treads on the shaky ground of art-history argument based on reproductions.

NOTES

1 F. Ehrendorfer makes the general comment, regarding the identification of the peony, that along with the ordinary *Paeonia officinalis* L., other related species and evidently some hybrids were cultivated in gardens. There exact identification from drawings is hard or impossible. He classes all those in the following watercolors as *Paeonia officinalis* L. sensu lato. According to Segal, Cat. 76 shows *Paeonia mascula* (L.) Mill.

2 Winkler, in *JPK* 53/1932, p. 87.

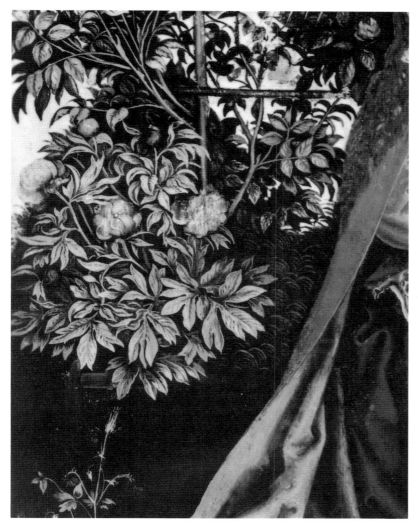

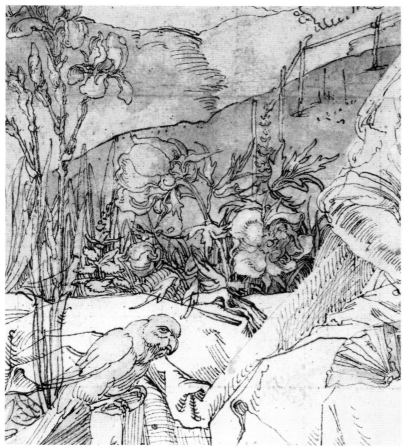

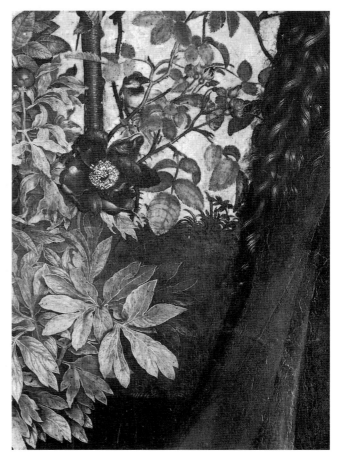

3 Copy after Martin Schongauer, *Madonna in a Bower of Roses,*
detail from ill. 2.

4 Albrecht Dürer, *Madonna with a Multitude of Animals,*
detail from Cat. 35.

5 Martin Schongauer, *Madonna in a Bower of Roses,*
detail from ill. 1.

74

HANS HOFFMANN

Peonies

Body color, brush, heightened with white,
on vellum
Bottom center, the date *1526*
232 x 321 mm
Berlin, Staatliche Museen Preußischer
Kulturbesitz,
Kupferstichkabinett, Inv. KdZ 58

PROVENANCE: Imhoff (?).

BIBLIOGRAPHY: H. II, p. 83, no. 60 (?) •
Killermann, 1910, pp. 100, 103 ff. • Bock, 1921,
I, p. 37, no. 58 • Winkler, in *JPK* 53/1932,
p. 87, note 2 • W. II, appendix plate XI below,
pp. 66, 70, 71, under no. 351 • P. II, p. 137,
no. 1436 • Killermann, 1953, p. 25 • Behling,
1967, p. 113 • Exhibition Catalogue Washington
1971, pp. 108, 109, under no. XXXVI, note 3 •
St. II, appendix, p. 1108, no. 14.

This is a study of two fully open flowers of
Paeonia officinalis L., cut off short below the top
leaves. Like the lily and the rose, the peony was
understood as a symbol of the Virgin Mary in
the late Middle Ages.

This is possibly the study entered as no. 60 in
the Imhoff Inventory.[1] Killermann was the
first to mention it, and Bock interpreted it as
"in Dürer's style . . . perhaps only the copy
of a similar study" by his hand. Winkler saw
the date 1526, which also appears, for example,
on the *Columbine* (Cat. 68) and the *Greater Cel-
andine* (Cat. 70), among others, as a reason to
connect it with Dürer. The drawing itself he
groups with four other peony studies, of which
he thinks the one in Bremen (see Cat. 75) is the
best, and possibly by Dürer himself. The Bam-
berg one (Cat. 76) and two Budapest ones (ills.
76.1,2) he definitely considers the work of
Hans Hoffmann, dated as they are 1580 and
1582, and two of them monogrammed. He
finds them so similar that they "must have
been done from a missing original by Dürer."
Because of the weaker execution of the Berlin
sheet, it can "hardly be seen as an authentic
work of Dürer."[2] Panofsky, too, rejects the
study as unlikely to be Dürer's. According to
Strauss, the writing of the date is the same as on
the *Tuft of Cowslips* (Cat. 72). Recently[3] the
study was described as late sixteenth century
on stylistic grounds, and as probably by Hans
Hoffmann, by analogy with the mono-
grammed and dated *Peony* in Bamberg.

The peculiar date, puzzling in so many ways
and appearing almost identically on six other
nature studies (see p. 194), makes renewed
comparison imperative.[4] Although the dis-
tance between the figures and their character-
istic details are the same as in the other dates in
the group, the way this one is written does not
look spontaneous, but rather carefully imi-
tated; each single figure is lightly predrawn
and then gone over with the brush.

The idea that the Berlin *Peonies* were done
by the same artist as the *Columbine* and the
Greater Celandine can be dismissed on stylistic
grounds. The suggested attribution of the
study to Hans Hoffmann, however, appears
well founded. At a glance, the *Peonies* seems
more robust than Hoffmann's parchment
paintings usually are; the works in Bamberg
and Budapest also are executed with appreci-
ably more subtlety. But the relief-like effect of
the network of veins on the underside of a
mullein (?) leaf in Hoffmann's hare study in
the Palazzo Barberini (Cat. 48), obtained with
parallel light and dark lines, resembles that of
the lower right-hand peony leaf, a convincing
point that strengthens Hoffmann's claim to
authorship. Possibly the coarser features of the
study indicate an early work.

NOTES

1 H. II.
2 W. II, p. 66.
3 Exhibition Catalogue Washington 1971.
4 I am grateful to Professor Emeritus R. Graß-
berger for a productive discussion about the
characteristic features of these figures.

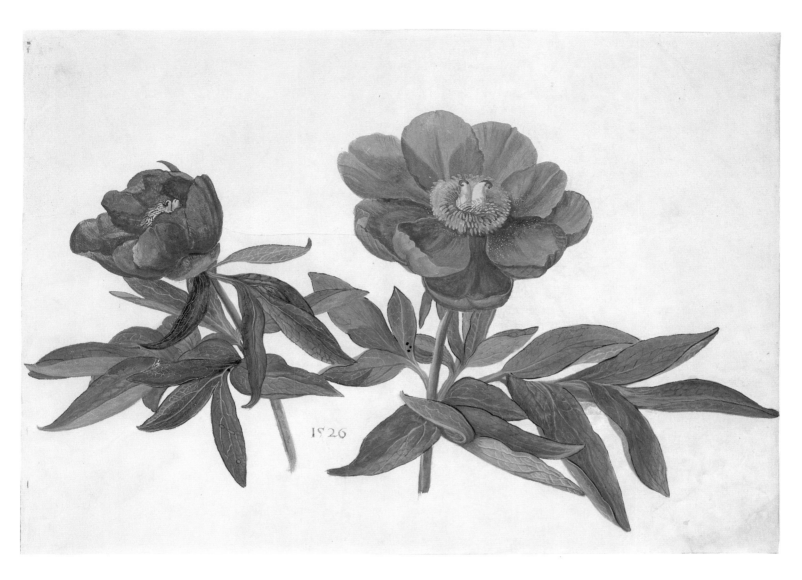

75

Peony Stem from Two Sides

Collotype
Technical particulars from Winkler (II, p. 70):
Watercolor, body color, and brush on paper
Watermark: crown with pendant triangle;
Briquet 4773, Meder 24 (see p. 260, fig. 11)
376 x 308 mm
Formerly Bremen, Kunsthalle,
missing since 1945

PROVENANCE: Imhoff (?) • Grünling (L. 1107) •
Klugkist.

BIBLIOGRAPHY: H. II, p. 83, no. 62 (?) and
p. 127, no. 36 • Fl. I, pp. 398, 399 • Winkler, in
JPK 53/1932, p. 87 and note 2 • W. II, pp. 66,
70, 71, no. 351 • P. II, p. 137, no. 1437 • Musper,
1952, p. 129 • Killermann, 1953, p. 25 • Behling,
1967, p. 113 • St. II, p. 318, no. 1495/29 •
Exhibition Catalogue Trintperg (Bremen,
Kunsthalle, 1979), no. A 20 • Piel, 1983, p. 141,
no. 44.

This watercolor study, attributed to Dürer,
has been missing since 1945. Only original-size
color reproductions have survived, a collotype
from which is the basis of our illustration and
was exhibited. Although it was contrary to the
spirit of this exhibition to include reproduc-
tions, an exception was made in this case, be-
cause the study is indispensable for coherence.

The sheet was described for the first time by
Heller, when it was among the Dürer draw-
ings of the Viennese art dealer Joseph von
Grünling: *Zwey Stämme einer Gichtrose, der eine
von vorne sichtbar, der andere schon etwas welk,
rückwärts zu sehen. Die Blumen und Blätter sind
mit ungemeinem Fleiß und Wahrheit so gegeben,
daß man dieses Gemälde eines der schönsten in seiner
Art nennen kann.* ("Two stems of a peony, one
seen from the front, the other, already some-
what wilted, seen from the back. The flowers
and leaves are rendered with such skill and
truth, that this painting can be called one of the
finest of its kind.") Sold by Grünling to the
Hamburg art dealer Ernst Georg Harzen,
along with other Dürer drawings, the sheet
came from the legacy of Senator Dr. Hierony-
mus Klugkist to the Bremen Kunsthalle.[1]
Answering Harzen's letter inquiring about the
genuineness of the offered drawings, Grünling
replied[2] that he himself had acquired them
from Duke Albert's collection through the
agency of its Inspector Lefèbvre. Since we
know that the Dürer collection assembled by
Rudolf II, which also included the drawings
from the Imhoff Collection, passed to Duke
Albert, it is possible that the Bremen *Peonies* are
the very ones mentioned in the Imhoff Inven-
tory as *Zwo Gichtrosen. Viel Graßwerk*[3] ("Two
peonies. Much foliage").

Ignored by Ephrussi, mentioned only in
general terms by Thausing,[4] the study saw its
traditional attribution finally fall into uncer-
tainty when Lippmann and then Flechsig ex-
cluded it from their critical index of Dürer's
drawings. When Winkler's attention turned
to it, its harsh, contrasty coloring looked to
him first of all like late sixteenth century.[5]
Later, however, he accepted it among Dürer's
authentic works from *The Large Piece of Turf*
period (Cat. 61), on grounds of the watermark,
which is found in the paper of other Bremen
flowerstudies and two Italian landscapes done
by Dürer in 1495. Panofsky doubts the authen-
ticity and places the study, if genuine, around
1503; according to Musper, it was done before
the *Madonna with a Multitude of Animals* (Cat.
35); on the basis of the watermark, Strauss
dates it 1495.

As already mentioned, we can now judge the
work only from the collotype reproduction,
which is only relatively reliable in these diffi-
cult matters. I would therefore like to quote
from Winkler's exhaustive commentary, based on the original from the corpus of Dürer
drawings:

"Three authenticated drawings of peonies
by Hans Hoffmann's hand, which are dated
1580, are so similar in leaf arrangement and
placing that they must have been done under
the influence of the present sheet or after a
missing original by Dürer. The rich and in-
teresting arrangement, with much intersect-
ing and a strong feeling of space, forbids at-
tribution of the drawing to Dürer copyist
Hans Hoffmann himself. In the original, the
treatment makes a very attractive impres-
sion. The stem on the left has dark yellowish
green leaves, that on the right more blue-
green. If I remember aright, the execution of
the leaves in Bamberg and Budapest is no-
ticeably harsher and more clashing in color,
without Dürer's graphic ability, so that be-
tween them and the present sheet there must
be as much difference as between the *Hare* of
1502 and Hoffmann's copy.

"Two peonies on vellum in Berlin are so
weakly executed that they cannot be com-
pared with this one here. They bear the date
1526, like the flowers nos. 354/5, also
painted on vellum, all three probably labeled
by the same hand, which does not look like
Dürer's, however, nor is it certain that he
did the studies. The same must provisionally
apply to the present drawing, but this sur-
passes all others and holds its own against
lilies and alkanet in Bremen. . . . I must
admit that it seems to me hardly possible to
judge the individual works correctly with-
out repeated and thorough scrutiny of the
original with only this question in mind."[6]

Winkler did not include in his deliberations
two more works connected with Dürer that
also portray peonies: the drawing *Madonna
with a Multitude of Animals* (Cat. 35) and the
London painting *Madonna with the Iris* (ill.
66.1). In both, a vigorous peony plant blooms
beside the Mother of God. Compared with
them, the limp stems in this study are notably
different; what is more, they are not two dif-
ferent stems but, as indicated by the leaves,
obviously one and the same, seen from both
front and, from a higher viewpoint, back.[7]
Winkler's argument that the peony studies
hold their own against the Bremen *Alkanet* can
no longer be checked, as this work too, like
other Dürer drawings in Bremen, has been
missing since the war. Since we know of a
whole series of plant studies on paper from the
Dürer period that are not by his hand, even the
watermark has lost weight in the discussion
(see, for example, Cat. 63, 64, 79). Insofar as
reproductions serve for comparisons, the Bre-
men *Peonies* can be brought side by side with
the London *Lily of the Valley and Bugle* (Cat.
78) — flowers that are copied in the *Madonna
with the Iris* and are similar to the *Peonies* in
conception and execution.

NOTES

1 Emil Waldmann, "Die Einkaufspreise für
Dürers Landschaftsaquarelle in Bremen," in
Dürer-Festschrift (Leipzig, 1928), pp. 103 ff.
2 Letter of May 16, 1827, quoted in Waldmann,
p. 104. See appendix, p. 267.
3 H. II, p. 83, no. 62.
4 Th. II, p. 57.
5 Winkler, 1932.
6 W. II, pp. 70, 71.
7 My thanks to Christine Ekelhart for this
observation.

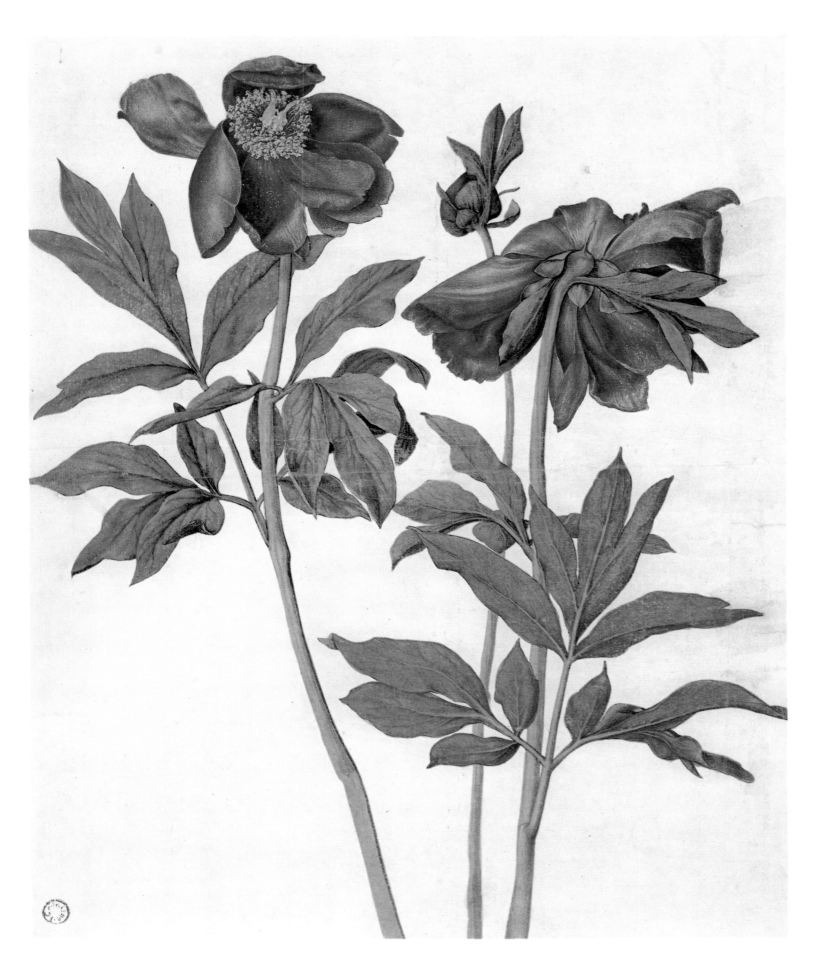

76

HANS HOFFMANN

Peony

Watercolor and body color on polished vellum,
brush, traces of preliminary drawing in pencil
Colors somewhat faded
Top center with brush in pink, monogram and
date *1582,*
bottom right, in pencil, the inscription:
Hans Hofmann N° 25
423 x 291 mm
Bamberg, Staatsbibliothek, Inv. I.Q. 20

PROVENANCE: Heller.

BIBLIOGRAPHY: Winkler, in *JPK* 53/1932,
p. 87 • W. II, appendix plate XI top right,
pp. 66, 70, 71, under no. 351 • P. II, p. 137,
no. 1438 • Killermann, 1953, p. 25 • Kauffmann,
in *AGNM* 1954, p. 29 • Pilz, in *MVGN*
51/1962, p. 257, no. 17 • Behling, 1967, p. 113 •
St. II, appendix, p. 1108, no. 13.

Hans Hoffmann captures here a flowering
spray of peony (*Paeonia mascula* [L.] Mill.)[1]
with one fully open bloom, one bud, and a few
leaves. It is presented as a typical example of its
species, simple and didactically laid out, as
though for an herbal, anticipating the form of
seventeenth-century botanical illustrations.
The study reached the Bamberg Staatsbib-
liothek with the Heller Collection. The
monogram and the date 1582 conform to those
on the *Hare among Flowers* (Cat. 47). Two
other, similar peony studies (ills. 76.1 and 76.2)
in Budapest are dated 1580, and one of them
also bears Hoffmann's monogram. On
grounds of style, the Berlin *Peonies* dated 1526
(Cat. 74) is to be included with them.

Winkler was the first to report on these
studies of Hoffmann's, together with the un-
signed studies in Berlin and in Bremen (Cat.
75), and found them so close together in motif
"that there can be no doubt about a connec-
tion."[2] As the Berlin study is so similar to the
Albertina's flowers dated 1526, one could sup-
pose that they all imitate missing prototypes by
Dürer.[3] Winkler found the Bremen peonies
the most convincing in quality, perhaps even
by Dürer himself. But Hoffmann's studies
seemed to him "so similar in leaf arrangement
and placing, that they must have been done
under the influence of the present sheet or after
missing originals by Dürer."[4] Kauffmann
raises an opposing consideration. For him,
the Bamberg study demonstrates the real dif-
ference between the Dürer original and the
Hoffmann copy, between Dürer and his late
sixteenth-century following: compared with
the individual, "wild" plant, which develops
casually and freely, a deliberate style intervenes
to produce "prepared, cut flowers of a polished
bravura of workmanship, extravagantly fin-
ished and seeming immortal."

Without disturbing intersections, curving
stems develop harmoniously into flowing

leaves, and the image looks as though poured
onto the page. In these characteristics it is like
the two Budapest sheets, and all three are de-
cidedly different in this very respect from the
one formerly in Bremen. While Hoffmann
emphasizes the typical, the artist of the Bre-
men *Peonies* captures the chance individual in
his plant portrait.

Two entirely different versions confront
each other. It seems impossible to trace both
back to Dürer, as Winkler attempts to do. The
Bamberg and Budapest peonies are motivated
by hardly more than simple stimulus from the
subject, and nothing can be seized on as having
originated from Dürer. The Bremen sheet is
missing; whether it was by Dürer evades our
judgment.

The importance of this Bamberg study lies
also in its stylistic parallel with the one in Ber-
lin dated 1526. The three-dimensional, light

vein work on the underside of the leaves is
found in the Berlin study and a mullein plant
depicted in the Palazzo Barberini *Hare* (Cat.
48), as well as in this present study. The way
the leaf ribs are drawn with dark brush strokes
accompanied by delicate white lines, and one
side of the leaf is covered with dark veining,
the other with light, indicates the work of the
same hand — that of Hans Hoffmann. Inas-
much as the Bamberg study helps to identify
the Berlin sheet and date it circa 1580, it dem-
onstrates that the date 1526 cannot be authen-
tic, thus confirming what was hitherto only
surmised.

NOTES

1 Identification by S. Segal.
2 Winkler, 1932.
3 W. II, p. 66 and appendix plate XI top right.
4 W. II, p. 70, under no. 351.

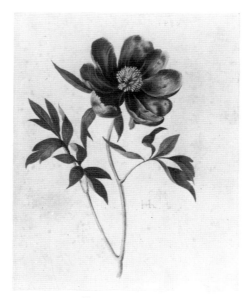

76.1 Hans Hoffmann, *Peonies,* 1580,
watercolor and body color on paper.
Budapest, Museum of Fine Arts,
Department of Prints and Drawings.

76.2 Hans Hoffmann, *Peonies,* 1580,
watercolor and body color on paper.
Budapest, Museum of Fine Arts,
Department of Prints and Drawings.

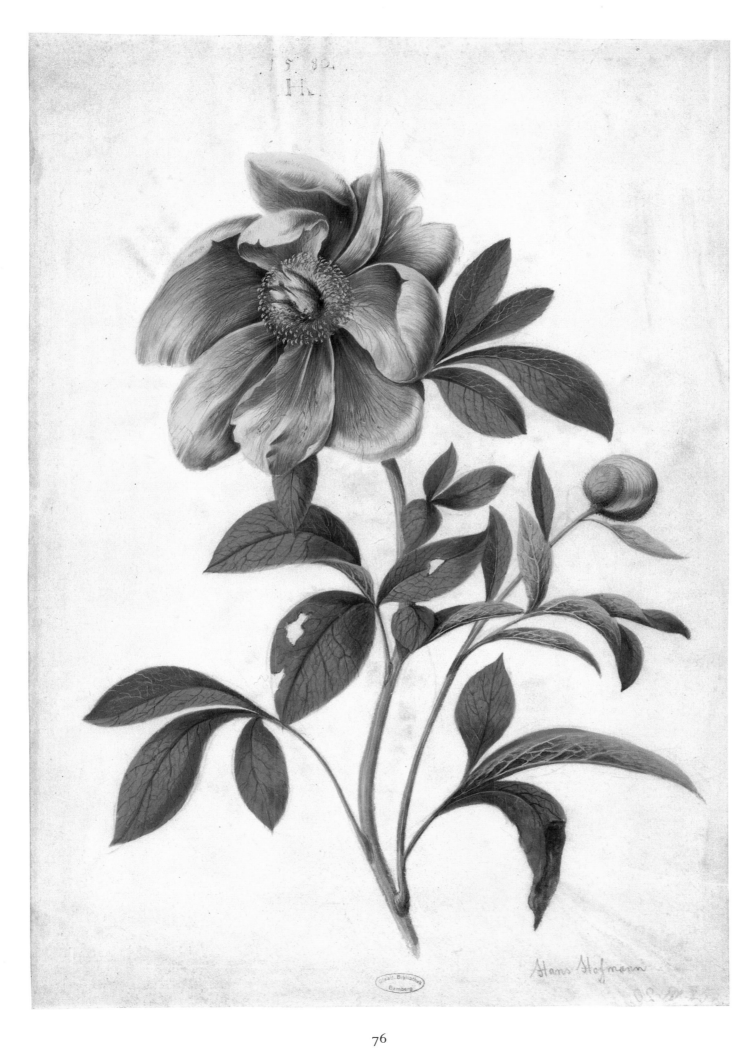

76

77

Nosegay of Violets

Watercolor and body color on vellum, brush,
heightened with white,
mounted on cardboard, creased
115 x 102 mm
Vienna, Graphische Sammlung Albertina,
Inv. 3076 (D 53)

PROVENANCE: Imhoff • Imperial Treasure
Chamber • Imperial Court Library (1783) •
Duke Albert of Saxe-Teschen (L. 174).

BIBLIOGRAPHY: H. II, p. 83, no. 67 and p. 118,
no. 141 • Th. I, p. 303 • Schönbrunner and
Meder, no. 325 • L. V, p. 6, no. 470 • Springer,
in *RKW* 29/1906, p. 555 • Meder, in *RKW*
30/1907, p. 181 • Killermann, 1910, p. 31 • T. I,
p. 137, no. A 178 • Fl. II, pp. 366, 559 •
Albertina Catalogue IV, p. 12, no. 53 • W. II,
pp. 66, 74, no. 358, under no. 357 • P. II,
p. 137, no. 1440 • Musper, 1952, p. 129 •
Killermann, 1953, p. 26 • Winkler, 1957, p. 183 •
Behling, 1967, p. 116 • K.-Str., p. 184, no. 32 •
St. II, p. 714, no. 1503/31 • Strieder, 1981,
p. 196, 198, ill. 231 • Piel, 1983, p. 142, no. 52.

The little *Nosegay of Violets* (März-Veilchen,
Viola odorata L.) enjoys great popularity be-
cause of its motif, and is already singled out
admiringly in the older literature. It is men-
tioned for the first time in the Imhoff Inven-
tory, and Heller, when describing Duke Al-
bert's collection, noted rapturously: *Ein
Veilchenstrauß, auf Pergament gemalt, welchem
nichts fehlt als der Geruch* ("A Nosegay of Vio-
lets, painted on vellum, which lacks nothing
but the scent").[1] Thausing expressed himself
similarly, but Ephrussi does not mention it.[2]
Meder dates it circa 1503,[3] and Winkler also
puts it with the studies Dürer did around 1503,
including the pieces of turf and the flowers.
Winkler had already stated that the color is
carelessly applied, which seems surprising for
Dürer. Flechsig too sees the *Nosegay of Violets*
and *The Large Piece of Turf* as contemporary,
"probably 1503." In 1957, Winkler made an-
other and more categorical statement, that
those flower studies that had for a long time
been surrounded by a halo because of their
provenance (from the imperial collection) and
their popularity with the public, were puz-
zling in the occasional clumsiness of their
technique and their rather empty grace, and
this included the violets. For the Tietzes, the
decision was clear: "Since the work . . . is
neither signed nor used in other works, it is the
quality alone that must decide, and this is too
weak for Dürer at any period. The sheet may
have been inspired by a detail study of Dürer's,
but it can only have been done in the second
half of the century, and merely in the Dürer
style." The drawing was not acknowledged by
Panofsky either.

The authors of the Albertina Catalogue[4] set
out to counter these belittling statements. For
them, "the purple blossoms . . . are excep-
tional in the quality of their artistic interpreta-
tion, and masterly in their technique of struc-
tural modeling with white lines, indeed
plainly indicative of Dürer." Only the leaves
must have been carelessly overpainted later
with turquoise green. There are certain spots
on them, as on the right, where the paint has
flaked off and the original coloring can be
seen, shading from yellowish to dark brown.
Perhaps the "rather incongruous stems" were
added on the same occasion. Strauss[5] supports
the generally accepted dating of 1503.

The violets are painted like a miniature, and
only close inspection reveals details that are
not to be found to the same extent in any other
study attributed to Dürer. First, its size con-
trasts with the life-size portrayal of other
flowers, which Winkler says is characteristic
of Dürer's studies, and in the case of the Bre-
men *Iris* (Cat. 66) has led to an unusual format.
The violets, on the contrary, whose life-size
rendering would have taken up so little space,
are very much reduced. This lends a dainty,
decorative character to the picture, which has

77.1 *Nosegay of Violets*, enlarged detail.

the quality of a concise, self-contained vi-
gnette.

Of course, every detail seems perfectly done.
Under a magnifying glass, however — with
whose help the study may well have been
painted — the hand of a hesitant, not particu-
larly skillful draughtsman becomes evident. In
a style very different from Dürer's, the outlines
are drawn and the accents placed with conspic-
uously undisciplined hatching in light or dark
color, mainly white (see ill. 77.1). Actually, the
Nosegay of Violets is less a study than a still life in
miniature. Presented for its own sake as a pleas-
ing motif, without a pictorial context or any
indication of setting, the theme itself wins at-
tention. It would be an exceptional creation for
the Dürer period, but even if it were estab-
lished as a work from the second half of the
sixteenth century, it would have no competi-
tors, apart from innovations of a different kind
by Ludger tom Ring the Younger. So, quite
independently from its connection with

Dürer, it ranks as among the earliest German
still lifes.

As to the question of authenticity, the state
of preservation plays an important part along
with considerations of style and composition.
The recent suggestion[6] that the green of the
leaves is a later addition turns out to be untrue.
The yellowish brown spots have not simply
remained clear of it, nor do they reemerge
from under it as was supposed; on the contrary,
they were deliberately added on top of it with
body color to pick out the withered patches on
certain leaves. Also, the clumsily rendered
stems, which have been pointed to as a later
addition, seem now to be original — they are
drawn in the same paint as the rims of the
leaves.

These observations fail to lead to any tangi-
ble evidence that this popular still life is by
Dürer. On reflection, it makes sense that nei-
ther the Tietzes' nor Panofsky's arguments
against Dürer's authorship were disputed, and
this fact highlights the general attitude, which
seems to need a verdict not only about Dürer's
flower studies but about his animal and plant
studies too. Considering the increasing num-
ber of objections, we have little choice but to
separate the *Nosegay of Violets* from Dürer's
name.

NOTES

1 H. II, p. 83, no. 67 and p. 118, no. 141.
2 The often quoted passage from E., p. 80,
 confuses the *Nosegay of Violets* with the
 Columbine (?) in the Albertina; Ephrussi certainly
 speaks of "violettes," but his description seems
 to apply to the *Columbine* instead.
3 L. V.
4 K.-Str.
5 St. II; Strauss (supplement 1, appendix 2:16a,
 p. 8) also refers to the study of a *Violet Plant* with
 roots but no soil (London, The British Museum,
 Department of Prints and Drawings, Inv. Sloane
 5219, fol. 12), similar in technique to the *Violet*
 and the *Cowslips* in the Hammer Collection,
 whose attribution to Dürer could not be entirely
 ruled out. As I see it, however, the nearest
 example comparable to this plant waving its
 groping feelers about is to be found in the work
 of Cranach. Compare Lukas Cranach the Elder,
 The Fall, woodcut, 1509 (Geisberg X, 21).
6 K.-Str.

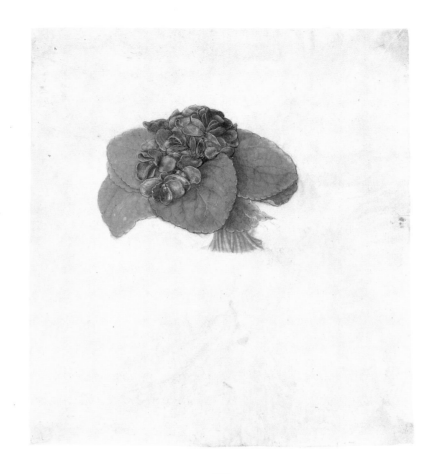

77

78

GERMAN, FIRST QUARTER OF THE
SIXTEENTH CENTURY

Lily of the Valley and Bugle

Watercolor and body color on paper,
brush, pen, heightened with white,
traces of preliminary brush drawing
near the stem of the lily of the valley
257 x 176 mm

London, The British Museum, Department of
Prints and Drawings, Inv. 1895-9-15-986

PROVENANCE: Malcolm ("JCR 530"; L. 1433).

BIBLIOGRAPHY: Exhibition Catalogue *Albrecht
Dürer and Lucas van Leyden* (London, Burlington
Fine Arts Club, 1869), no. 136 • W. II,
appendix plate XI top left and pp. 65, 69, 70,
under no. 349 • P. II, p. 136, no. 1434 •
Winkler, 1957, p. 208, note 1 • St. II, appendix,
p. 1108, no. 15.

The flower shown here springing unnaturally
out of the soil with the lily of the valley (*Con-
vallaria majalis* L.) has been referred to in art
literature as a dead-nettle, but it in fact repre-
sents a bugle (*Ajuga reptans* L.) with one flow-
ering stem and one runner.[1]

The study was introduced to the public in
1869 at the Dürer Exhibition at the Burlington
Fine Arts Club, but it was passed over by
Ephrussi and Thausing. Winkler is the first to
discuss it[2] and places it beside the *Alkanet* study
(W. 349, formerly Bremen, missing since
1945), which he ascribes to Dürer. He sums up
the verdicts both in Parker's letter rejecting it
and in Musper's statement, also in a letter, em-
bracing it. According to Panofsky, this study is
close to the *Greater Celandine, Columbine,* and
Peonies in Berlin (!), for which Dürer's author-
ship seems highly unlikely. Strauss[3] quotes
Panofsky and Winkler (the latter inaccurately,
though).

Although the partnership of the two plants
is unnatural and contrived, the study is impres-
sive in its variety of coloring and sensitive por-
trayal of the characteristic morphology. The
contours of the stems are accentuated on one
side only with delicate, dark lines. The leaf
ribs, the areas of short, fine hatching on the
bugle leaves, and the areas of shading with del-
icate, protracted, parallel lines on the silky,
shimmering lily of the valley leaves, resemble
those on the *Peony Stem* (Cat. 75), formerly in
Bremen, as far as can be judged from a repro-
duction.

As Winkler recognized,[4] the study was used
in the *Madonna with the Iris* (ill. 66.1). After the
Iris (Cat. 66) and *The Large Piece of Turf* (Cat.
61), this is the third study linked with Dürer's
name that has been integrated into that picture.
The fact that an unquestioned work like *The
Large Piece of Turf* is copied in a painting does
not, however, justify the deduction that the
present study is also a work of Dürer's, espe-
cially because heretofore even the artistic and

temporal closeness of the *Lily of the Valley and
Bugle* study to Dürer has been questioned.
Nevertheless, the temporal connection is
strengthened both by the incorporation of the
motif in the painting, and by the similarity of
the brushwork to that in *The Large Piece of Turf,*
particularly the malachite green mixed with
white heightenings.

The affinity with Dürer is close, but not
enough for an attribution. Perhaps a compari-
son with the missing Bremen *Peony Stem* and
Alkanet might have helped. If one hesitates to
exclude or to attribute to Dürer a study like
this, it is not just because the arguments seem
too weak for a definite verdict. It is rather be-
cause, in working on these problems, one real-
izes how little certainty can be achieved in
spite of decades of research in the field. Adding
to the confusion over Dürer's studies is the
often forgotten fact that nothing at all is
known about the nature studies of Dürer's stu-
dio assistants and colleagues, such as Hans von
Kulmbach, Hans Baldung Grien, Leonhard
Schäufelein, Hans Springinklee, Wolf Traut,
Erhard Schön, and Georg Pencz.

NOTES

1 Identification by F. Ehrendorfer.
2 W. II.
3 St. II; Winkler (II, p. 66) referred to the
 connections mentioned, certainly to the group
 of peonies.
4 Winkler, 1957.

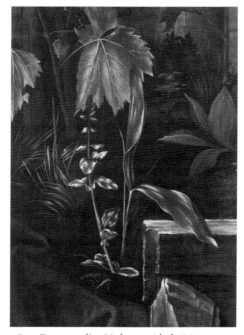

78.1 Dürer studio, *Madonna with the Iris,*
detail from ill. 66.1, oil on panel.
London, National Gallery.

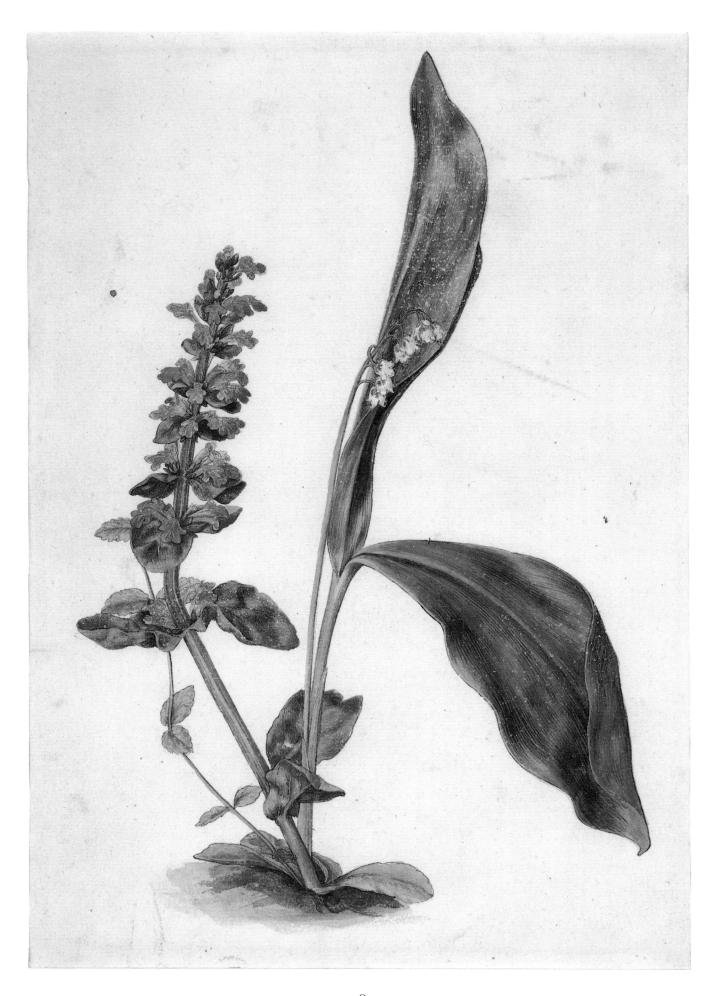

79

GERMAN, FIRST QUARTER OF THE
SIXTEENTH CENTURY

Columbine, Wild Pansy, and Alkanet

Watercolor and body color on paper, brush, pen,
heightened with white
Watermark: crown with pendant triangle;
Briquet 4773, Meder 24 (see p. 260, fig. 11)
336 x 255 mm, right-hand side trimmed

Berlin, Staatliche Museen Preußischer
Kulturbesitz,
Kupferstichkabinett, Inv. KdZ 25

PROVENANCE: Grünling • Daffinger • Festetics •
Böhm (according to Auction Catalogue
Posonyi/Montmorillon 1867) • Posonyi-Hulot.

BIBLIOGRAPHY: Auction Catalogue Posonyi/
Montmorillon 1867, p. 49, no. 310 • Exhibition
Catalogue Berlin 1877, p. 14, no. 25 • E., p. 79 •
Killermann, 1910, pp. 95, 99, 103 • Bock, 1921,
I, p. 37, no. 25 • W. II, p. 66 • Exhibition
Catalogue Berlin 1984, pp. 34, 35, no. 31A.

This watercolor study shows columbine
(*Aquilegia vulgaris* L.), wild pansy (*Viola tricolor*
L.), and alkanet (*Anchusa officinalis* L.).[1] In the
manner of natural-science illustrations, the
plants are cut off at ground level and arranged
side by side, with the flowers in typical front,
back, and side views.

The study was acquired for the Berlin Kup-
ferstichkabinett in 1877 by Lippmann, along
with the Dürer drawings from the Posonyi-
Hulot Collection, and can be traced in Vien-
nese collections back to Grünling. It shows the
same watermark as other drawings that were
evidently in his possession. As Grünling was
able to acquire from the collection of Duke
Albert, it is reasonable to suppose that all these
sheets belong to a common stock that quite
probably goes back to the Imhoff Collection.

At the time Lippmann acquired the study,
he believed it was "if not with absolute, at least
with the highest degree of certainty," by
Dürer.[2] Nevertheless, he did not include the
study in his volume of Dürer drawings in Ber-
lin, published in 1883. Ephrussi introduces it
right after *The Large Piece of Turf* (Cat. 61).
Killermann pointed out the didactic aspect of
its rendering of characteristic forms and stages
of development up to the seed-ripening stage.
Winkler includes the sheet with a group of
"cut" plants, including *Chamomile and Speed-
well* (Cat. 81) and the study *Wild Lettuce* in
Bayonne (W. 352), which, with some reserva-
tions, he considers to be by Dürer. Anze-
lewsky,[3] then, is the first to have come to terms
with the difficult problems involved in judg-
ing the plant studies. He attributes them to
Dürer, arguing that among Dürer's plant stud-
ies there are only four[4] painted on paper, in-
cluding *The Large Piece of Turf*: "Of the other
three sheets, 'Alkanet,' 'Peonies,' and 'Turk's
Cap Lily,' that belonged to the Bremen Col-

lection, only the 'Turk's Cap' survives. All
three studies were done on the same paper as
the Berlin one, and they were all together in
the Grünling Collection. It is hard to under-
stand why this connection has not been seen."

Like the question of attribution, the dating
persists in being uncertain. Winkler grouped
all the plant studies together into one period
with *The Large Piece of Turf,* "circa 1503."[5]
Strauss, who omits this Berlin sheet, dates all
the studies on paper 1495, with the exception
of *The Large Piece of Turf,* which he dates 1503,
together with all the flower studies on vellum.
Anzelewsky suggests "circa 1500" on account
of the watermark.

The artist's way of working can be observed
especially from the incomplete columbine
leaves. With amazing confidence, he contrives
to do justice to the individual characteristics of
the plant, the color gradation (for example, in
the greens), and the peculiarities of flower and
leaf shapes. It is impressive, the way he care-
fully draws the form and attitude of every sin-
gle alkanet leaf on one side, while on the other
he uses pure watercolor. The leaf ribs are either
applied with a delicate, dark brush stroke or
left as a lighter space. Contrasting flecks of
shadow suggest light, space, and the curvature
of the leaves, emphasized by sharply defined

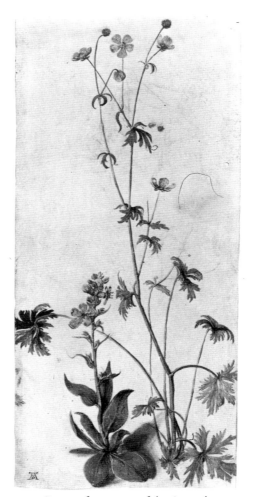

79.1 German, first quarter of the sixteenth century,
Buttercup and Mullein,
watercolor and body color on paper.
Paris, Musée du Louvre,
Collection E. de Rothschild (see note 7).

contours. In connection with the Berlin study,
the little portrait of a *Forget-me-not* in Bamberg
(Cat. 80) deserves a mention. The same stylis-
tic features characterize the composition, and
the motif is treated in the same way, as can be
seen by comparing the alkanet with the forget-
me-not,[6] both of which terminate at the bot-
tom in similarly shaped basal leaves. Despite
these similarities, which merely help to pave
the way for possible further knowledge, an at-
tribution is as far away as ever. I would like to
include two more drawings with these two,
the Potsdam *Piece of Turf* (Cat. 63) and *Butter-
cup and Mullein* (ill. 79.1), from the Rothschild
Collection in Paris.[7] There are similarities
both in the specific way of contouring the
leaves and in the broad shadows tapering to a
point. These two also are done on paper of the
Dürer period, which gives us some informa-
tion about contemporary flower studies that
are stylistically close to Dürer but not by his
hand. This represents a basic step forward, in-
asmuch as Winkler[8] still doubted the existence
of such plant studies by Dürer's contempo-
raries.

NOTES

1 Not, as previously given, hound's-tongue
 (*Cynoglossum officinalis* L.). Identification by
 F. Ehrendorfer.
2 Lippmann, in Exhibition Catalogue Berlin 1877.
3 Anzelewsky, in Exhibition Catalogue Berlin
 1984.
4 Anzelewsky must have omitted the *Iris* by
 mistake.
5 W. II, pp. 65 ff.
6 E., p. 79, note 5; Ephrussi took the alkanet in
 the Berlin drawing for a forget-me-not, and per-
 haps that is why it reminded him of the study in
 Bamberg.
7 *Buttercup and Mullein,* Paris, Musée du Louvre,
 E. de Rothschild Collection, Inv. 22 DR. It is
 somewhat cruder in execution than the Potsdam
 sheet and bears an ox-head watermark (similar
 to Meder 62). Both studies bear a Dürer
 monogram added later, with features of the
 same writing — small, with long bars, and diag-
 onal terminals on both sides — and similarly
 placed in the corner of the sheet.
8 W. II, p. 65.

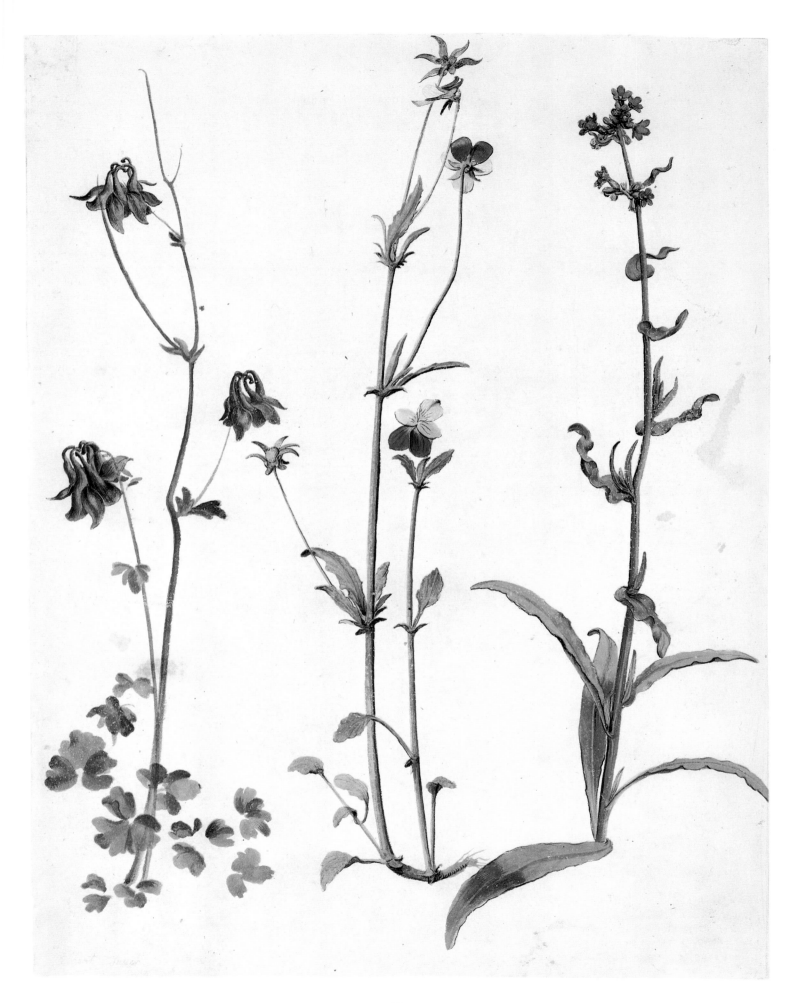

80

Forget-me-not

Watercolor, brush,
on paper heavily spotted with mildew
203 x 115 mm
Bamberg, Staatsbibliothek, Inv. I.A. 13 f.

PROVENANCE: Heller.

BIBLIOGRAPHY: H. II, p. 33, no. 77 • E., p. 79,
note 5.

The flowering spray of wood forget-me-not
(*Myosotis sylvatica* agg.) is angled in such a way
as to display its characteristically protruding
leaves. The stem is cut and shown with erro-
neous basal leaves.[1]

The study came from Heller's collection,
where it was entered under Dürer's *Wasserma-
lereyen* (watercolor paintings); it has been al-
most ignored in the literature. Only Ephrussi
refers to the Bamberg drawing as a copy after
Dürer, in connection with *Columbine, Wild
Pansy, and Alkanet* (Cat. 79), where, inciden-
tally, he mistakes the alkanet for a forget-me-
not. It has not been mentioned since.

The study shows characteristic features of
style comparable to the Berlin sheet, namely
the dainty, wiry stems tapering like needles,
their hair-fine contours, the leaves outlined
with a fine brush, mostly along one side only,
and the flecks of shadow emphasizing the cur-
vature. Both drawings exhibit the specific
traits of the same artistic personality. Similar-
ities, perhaps not so striking, can be recognized
in the Potsdam *Piece of Turf* (Cat. 63) and a
study in the Rothschild Collection (see ill.
79.1). Most obvious is the pair of opposite basal
leaves, where the stem comes to an abrupt, un-
natural end, and the leaves look like a terminal
line under the drawing. This feature occurs in
the Berlin sheet, the Rothschild study, and
Dürer's *Iris* in Bremen (Cat. 66).

This specific way of portraying plants with-
out roots and soil resembles in many respects
the botanical usage in the *herbarium vivum,* that
scientifically arranged and described collection
of plants known in the history of botany only
from the middle of the sixteenth century on-
ward.

NOTE

1 I am grateful to F. Ehrendorfer for this
information.

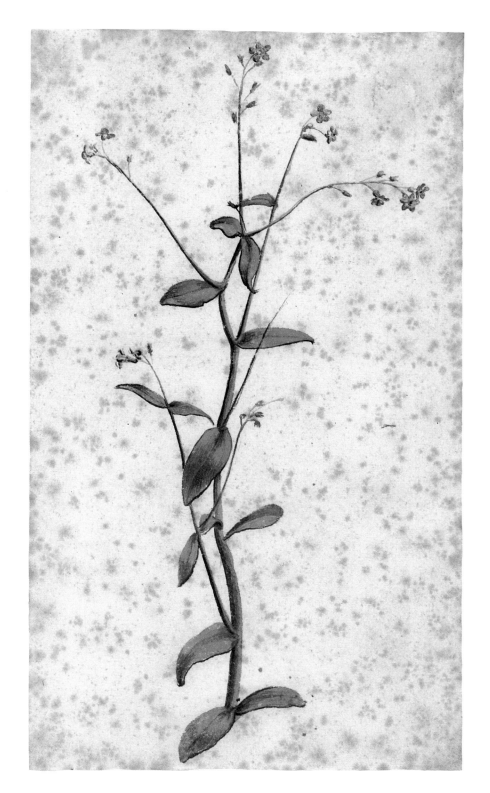

80

81

GERMAN, FIRST QUARTER OF THE
SIXTEENTH CENTURY

Chamomile and Speedwell

Watercolor and body color on paper, brush, pen
The blue flowers somewhat faded
278 x 202 mm

Berlin, Staatliche Museen Preußischer
Kulturbesitz,
Kupferstichkabinett, Inv. KdZ 26

PROVENANCE: Posonyi-Hulot.

BIBLIOGRAPHY: Auction Catalogue Posonyi/
Montmorillon 1867, p. 50, no. 311 • Exhibition
Catalogue Berlin 1877, p. 14, no. 26 • E., p. 79 •
Killermann, 1910, pp. 102, 103 • Bock, 1921, I,
p. 37, no. 26.

This is another study that came to the Berlin
Kupferstichkabinett from Vienna through the
collections of Posonyi and Hulot[1] (see also
Cat. 79). It shows, separately, two representa-
tive specimens of their species, a yellow and
white chamomile (*Anthemis austriaca* Jacqu.)
on the left and a speedwell (*Veronica teucrium*
L.) on the right.

Ephrussi mentions the drawing along with
Dürer's works of 1503. Lippmann, who in
1877 acquired the study for Berlin with the
Dürer drawings of the Posonyi-Hulot Collec-
tion, did not include it in his Dürer catalogue.
Killermann cites *Chamomile and Speedwell* as
"attributed" to Dürer. Bock catalogues it as
"in Dürer's style" under the works by pupils
and imitators.

The confident rendering of flower heads,
pinnate or dentate leaves, stipules and fore-
shortening, suggests the hand of an artist expe-
rienced in plant studies. With regularly fine,
thin strokes, the characteristic shapes and fea-
tures are captured and brought out; on top of
intricately shaded washes, areas of delicate
hatching reinforce the modeling. These are
distinctive traits of this artist's objective and
economical, yet descriptive and vivid style. In
its artistic individuality it clearly deviates from
Dürer's authenticated studies. On the other
hand, it tends toward the plant studies that
Hans Weiditz did in 1529, as models for the
woodcuts in the *Herbarium* published by Brun-
fels (see Cat. 82, 83).

The marked shapes of the leaves are deli-
cately outlined in pen, their dark contours
making a graphic contrast with the colored
wash. Both the modeling and the little chamo-
mile flower head shown on the diagonal are
similar to Weiditz's study. The most similar
characteristic is the thin, irregular, brush-
drawn line, even broken in places, outlining
the ray florets, with two conspicuous grayish,
longitudinal lines at intervals.

Only direct comparison, as offered by this
exhibition, will allow these observations to be
checked, and give better evidence as to

whether the study should be attributed to an
artist of Dürer's circle, or is one of the very first
examples of early botanical illustration, such as
we know by Weiditz from about 1530 (see Cat.
82, 83), or is one of the numerous surviving
nature studies from the second half of the six-
teenth century.

NOTE

1 Auction Catalogue Posonyi/Montmorillon 1867.

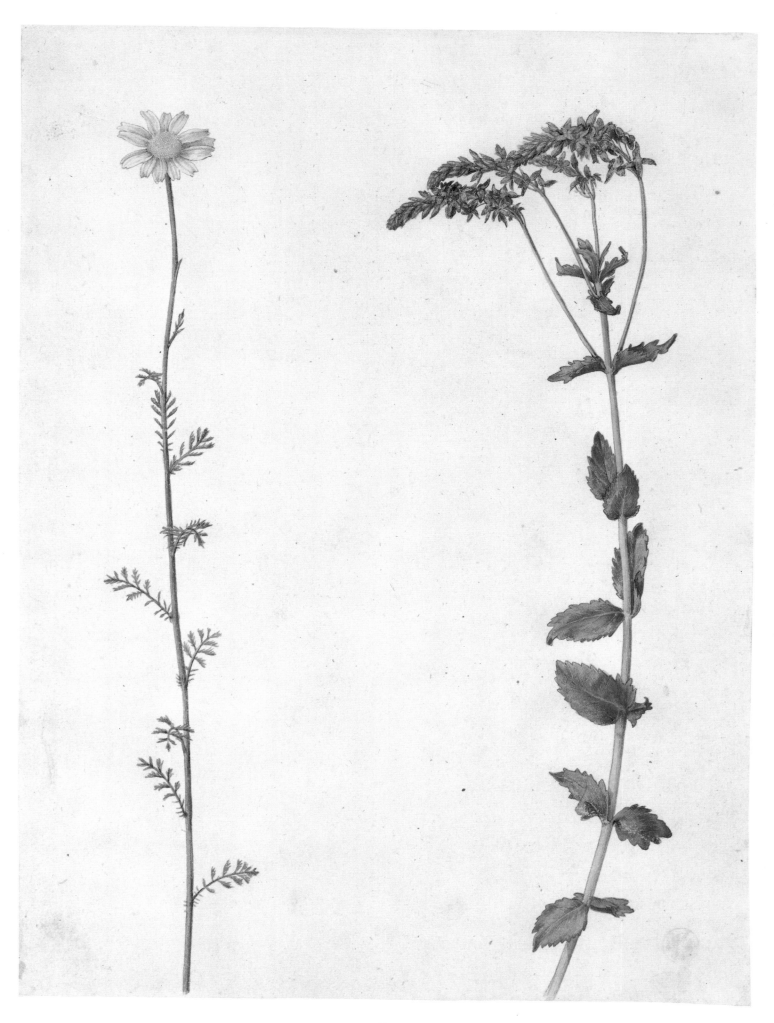

82

HANS WEIDITZ

Bugloss and Ox-Eye Daisy

Watercolor and body color on paper, brush, pen,
ink, preliminary pencil drawing
323 x c. 80 mm (bugloss), 310 x c. 75 mm
(ox-eye daisy),
cut out and mounted on paper
Bern University, Systematisch-geobotanisches
Institut, Platter Herbarium

PROVENANCE: Platter.

BIBLIOGRAPHY: Walter Rytz, "Das Herbarium
Felix Platters. Ein Beitrag zur Geschichte der
Botanik des XVI. Jahrhunderts," in *Verhandlun-
gen der Naturforschenden Gesellschaft in Basel,*
vol. XLIV, part I (Basel, 1933) • Walther Rytz,
*Pflanzenaquarelle des Hans Weiditz aus dem Jahre
1529* (Bern, 1936), plate X • Claus Nissen, *Die
botanische Buchillustration. Ihre Geschichte und
Bibliographie,* 2d ed. (Stuttgart, 1966), vol. I,
pp. 17 ff. • Elisabeth Landolt, "Materialen zu
Felix Platter als Sammler und Kunstfreund," in
*Basler Zeitschrift für Geschichte und Altertums-
kunde* 72/1972, pp. 246–306 • Heinrich Zoller,
"Konrad Gessners Historia Plantarum — Eine
Synthese von Wissenschaft und Kunst," in
*Verhandlungen der Schweizerischen Naturforschen-
den Gesellschaft* (Basel 155/1975), p. 64 • Paul
Hulton and Lawrence Smith, *Flowers in Art from
East and West* (London, 1979), pp. 128, 129, plate
50 • Exhibition Catalogue Münster 1979/80,
p. 114, no. 71.

These studies by Hans Weiditz served as
models for woodcut illustrations in the *Herbar-
ium vivae eicones . . .*[1] published by Otto
Brunfels in 1530 and printed by Johannes
Schott in Strasbourg. Not all the designs for
the approximately 140 woodcuts have sur-
vived, and not one of them in its original state
as a whole, uncut sheet. The combination here
of viper's bugloss (*Echium vulgare* L.) and ox-
eye daisy (or marguerite, *Leucanthemum vulgare*
Lam.),[2] with enlarged "insets" of root and
flower head, no longer corresponds to the ar-
rangement originally devised by Weiditz. As
nearly as we can reconstruct them, Weiditz's
designs were drawn on both sides of the paper
and provided with written notes as to size, date
of the drawing, and particulars of the plants,
such as hairs or leaf veins. Probably not until
the late sixteenth century did a number of
these drawings reach Felix Platter (1536–
1614), a doctor of medicine and a natural scien-
tist in Basel, who incorporated them into his
comprehensive herbarium. Here he arranged
pressed and dried flowers opposite correspond-
ing drawings or related woodcuts from Brun-
fels's herbarium, and especially from the plant
book of Fuchs[3] and others. For this purpose
Platter regrettably cut Weiditz's drawings out
around the outlines, in order to preserve intact
not only those on one side but also, totally or
partly, those on the other. In this way he was
able to stick the drawings from both sides onto

82.1 Hans Weiditz, *Wild ox-tongue,*
woodcut from Otto Brunfels,
Herbarium vivae eicones . . . , p. 111 (see note 1).

82.2 Hans Weiditz, *Daisy,*
woodcut from Otto Brunfels,
Herbarium vivae eicones . . . , p. 258.

the mount of his herbarium, and any parts
damaged through overtrimming were re-
touched. With Platter's herbarium, Weiditz's
drawings fell into obscurity, not to be redis-
covered until 1930, in Bern, when their impor-
tance to the history of natural-science illustra-
tion was recognized. In the course of their
editing and publication by Rytz, certain draw-
ings were detached from the herbarium and
affixed to new mounts in the form we view
them today.

Compared with the flower studies attrib-
uted to Dürer, which adhere to the appearance
of the flowers in nature and are rooted in the
soil, but are always still affected by considera-
tions of artistic composition, Weiditz's clear
and accurately observed images have unvar-
nished description as their prime considera-
tion. He grasps the unity of the plant as an
organism, with flowers, leaves, and uncovered
roots, and copies its habit faithfully. Certain
pictures have insets; and, separated from the
general representation, vegetative or repro-
ductive details of the species portrayed are
shown in enlargement. They are among the
first examples of their kind.

The clear intention of Weiditz's objective
inventory of studies, drawn solely from an art-
ist's observation, is to provide illustrations as an
aid to identification. Seen historically, their
exact rendering marks the point in time when
the examination, description, and recording of
plants became an end in itself, and scientific
methods of working were introduced. Dürer is
both an artist and scientist together in his stud-
ies. In the succeeding generation, with Hans
Weiditz, the tracks divide, and from now on
artistic interpretation and scientific illustration
as a means of visual explanatory description go
their separate ways.

NOTES

1 Otto Brunfels, *Herbarium vivae eicones ad nature
 imitationem, suma cum diligentia et artificio effigiate
 una cum effectibus earundem, in gratiam ueteris
 illius, & iam iam renascentis Herbariae Medicinae,
 per Oth. Brunf. recens editae. M.D.XXX*
 [vol. I] . . . *apud Ioannem Schottu,* vol. 2 (1532),
 vol. 3 (1536). Nissen, 1966, 257 1a.
2 According to F. Ehrendorfer, the illustration of
 Leucanthemum vulgare Lam. is so accurate that it
 can be clearly recognized as the diploid
 subspecies of this polymorphic group.
3 Leonhard Fuchs, *De historia stirpium* (Basel,
 1543). Nissen, 1966, 658.

83

HANS WEIDITZ

Orpine and Bugle

Watercolor and body color on paper, brush, pen,
ink, preliminary pencil drawing
275 x c. 65 mm (orpine), 225 x c. 70 mm (bugle),
cut out and mounted on paper

Bern University, Systematisch-geobotanisches
Institut, Platter Herbarium

PROVENANCE: Platter.

BIBLIOGRAPHY: Walther Rytz, "Das Herbarium
Felix Platters. Ein Beitrag zur Geschichte der
Botanik des XVI. Jahrhunderts," in *Verhandlun-
gen der Naturforschenden Gesellschaft in Basel,*
vol. XLIV, part I (Basel, 1933) • Walther Rytz,
*Pflanzenaquarelle des Hans Weiditz aus dem Jahre
1529* (Bern, 1936), plate V • Claus Nissen, Die
botanische Buchillustration. Ihre Geschichte
und Bibliographie, 2d ed. (Stuttgart, 1966),
vol. I, pp. 17 ff. • Elisabeth Landolt, "Materialen
zu Felix Platter als Sammler und Kunstfreund,"
in *Basler Zeitschrift für Geschichte und Altertums-
kunde* 72/1972, pp. 246–306 • Heinrich Zoller,
"Konrad Gessners Historia Plantarum — Eine
Synthese von Wissenschaft und Kunst," in
*Verhandlungen der Schweizerischen Naturforschen-
den Gesellschaft* (Basel 155/1975), p. 64 • Paul
Hulton and Lawrence Smith, *Flowers in Art from
East and West* (London, 1979), pp. 128, 129 •
Exhibition Catalogue Münster 1979/80, p. 114.

The orpine (*Sedum telephium* L. subsp. *fabaria*
[Koch] Kirchschleger) and the bugle (*Ajuga
genevensis* L.) suffered the same fate as the
viper's bugloss and the ox-eye daisy. Felix
Platter cut them out around the edges, and
they were not removed from his herbarium
until 1930, when they were rediscovered and
arranged in their present form (see Cat. 82).
With his feeling for color gradation and his
sensitivity to the various manifestations of the
plant world, Weiditz succeeded in scientifi-
cally registering the characteristics of various
species. Wherever desirable, he set artistic pre-
tensions aside in favor of scientific clarity —
see, for instance, the black background behind
the orpine flower head.[1]

The "Dürer group" of studies dated 1526
strive after artistic effect, not avoiding fore-
shortening of leaves or flowers, and showing
the plants with soil and sometimes in a com-
munity; Weiditz's pictures, in contrast, are
clearer and more factual, and he spreads his
studies out as far as possible in the interests of
visibility and identifiability. One must not
overlook this aim when appraising them.

Weiditz's primary concern is to transmit
characteristic appearances; when they serve as
scientific illustration their distinction from the
Dürer group becomes evident. The definitive,
objective style is not confined to Weiditz
alone, however, but is typical of other studies
formerly connected with Dürer, such as the
Forget-me-not, the *Columbine, Wild Pansy,* and

Alkanet, and the *Chamomile and Speedwell* (Cat.
79–81).

NOTE

1 This device of silhouetting in order to set off
delicate, pale flowers follows an old tradition
already established in the field of botanical
illustration. A century before Weiditz, the
illustrator of the *Codex Bellunensis* (London, The
British Museum, Ms. Add. 41623; ill. in
Hermann Fischer, *Mittelalterliche Pflanzenkunde*
[Munich, 1929], plate XXIV), had used it when
picturing an edelweiss.

83.1 Hans Weiditz, *Bugle,* woodcut from Otto
Brunfels, *Herbarum vivae eicones . . . ,* p. 95.

83.2 Hans Weiditz, *Orpine,* woodcut from
Otto Brunfels, *Herbarum vivae eicones . . . ,* p. 214.

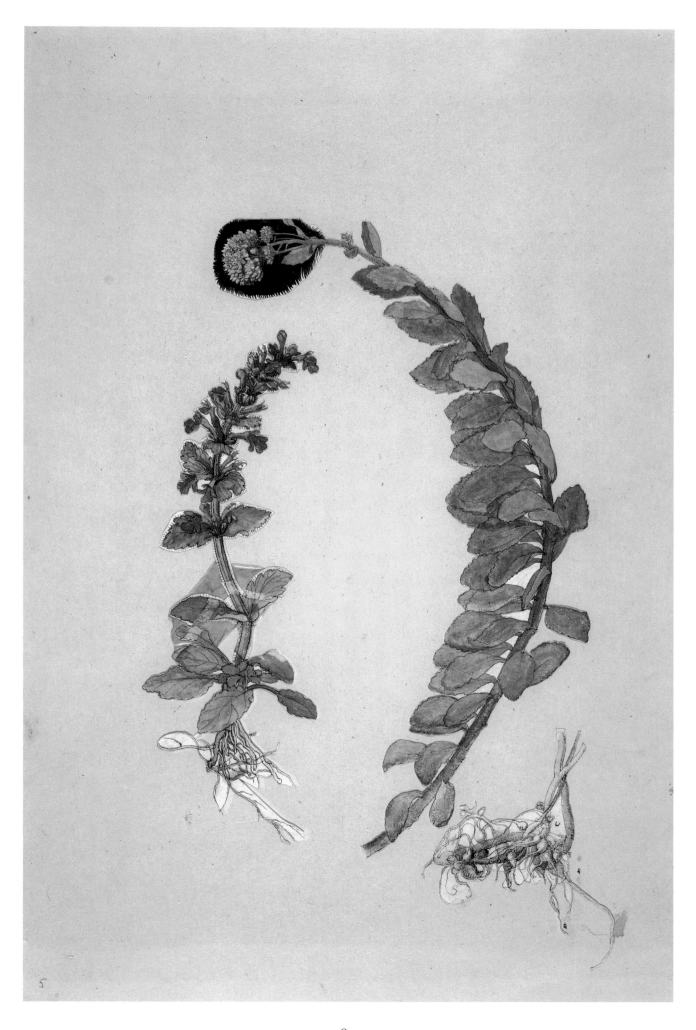

84

CONRAD GESSNER

Grass-leaved and Siberian Irises

Watercolor over pen drawing on paper, brush,
pen, ink, heightened with white,
inset in thin, mildew-spotted paper
Inscriptions in pen and ink[1]
320 x 217–221 mm (with the surrounding
paper border,
411 x 255 mm); half a folded sheet (see note 2)
Erlangen, Universitätsbibliothek, Inv. Ms. 2386,
Sheet 273v (fol. 113; 112, 125, 126)

PROVENANCE: Caspar Wolf • Joachim
Camerarius • Georg Volkamer • Christoph
Jakob Trew • Altdorf Universität • Erlangen,
Universitätsbibliothek (1818).

BIBLIOGRAPHY: *Conradi Gesneri Historia
Plantarum* — facsimile edition of the plant
watercolors from the botanical legacy of
Conrad Gessner (1516–1565) in Erlangen,
Universitätsbibliothek, ed. by Heinrich Zoller,
Martin Steinmann, and Karl Schmid, series 1–8
(Dietikon-Zurich, 1972–1980), no. 6 (1979),
pp. 62–64, plate 4, p. 18.

LITERATURE ON THE *HISTORIA PLANTARUM*:
Bernhard Milt, "Conrad Gessner's *Historia
Plantarum (Fragmenta relicta),*" in *Viertel-
jahrsschrift der Naturforschenden Gesellschaft in
Zürich* 81/1936, pp. 285–291 • Claus Nissen, *Die
botanische Buchillustration*, vol. I (Stuttgart,
1966), pp. 55 ff. • Hans Fischer, "Conrad
Gessner (26. März 1516–13. Dezember 1565).
Leben und Werk," 168th New Year's Issue of
the *Naturforschenden Gesellschaft in Zürich* for the
year 1966 (Zurich, 1966) • *Conrad Gessner
1516–1565: Universalgelehrter Naturforscher, Arzt,*
with contributions by Hans Fischer, Georges
Petit, Joachim Staedtke, Rudolf Steiger,
Heinrich Zoller (Zurich, 1967) • Heinrich
Zoller, "Konrad Gessners *Historia Plantarum* —
Eine Synthese von Wissenschaft und Kunst," in
*Verhandlungen der Schweizerischen Naturfor-
schenden Gesellschaft,* Basel 155/1975,
pp. 57–70 • Exhibition Catalogue *Zürcher
Kunst nach der Reformation, Hans Asper und seine
Zeit* (Zurich, Helmhaus, 1981), pp. 133 ff. •
Exhibition Catalogue *Tobias Stimmer* (Basel,
Kunstmuseum, 1984), pp. 144, 145, no. 40.

The study forms page 113 in Conrad Gessner's
Historia Plantarum.[2] While *Iris sibirica* L. was a
fairly common marsh plant in Gessner's day,
Iris graminea L. apparently represented a rarity
found only in gardens in the mid-sixteenth
century. The earliest illustration and descrip-
tion of it are given by Dodonaeus in his *Cruy-
deboeck* (Antwerp, 1563).[3]

As Gessner notes on the drawing, he got
his *Iris graminea* from the garden of Ulrich
Fugger,[4] presumably only a piece of rhizome.
Fugger had sent Gessner several species that
were not widely cultivated north of the Alps at
that time. In the top left-hand inscription,
Gessner mentions that the plant bloomed in
his garden in May 1565; his studies of *Iris sibir-
ica* must have been added a short time later.

With fine pen strokes and delicate water-
color brushwork, Gessner has made a wonder-
fully free-flowing study of the *Iris graminea*
(center, with additional studies below, left and
right), without roots,[5] obviously in the open
air, as it was growing in his garden. With the
Iris sibirica on the right, and further detail
drawings (middle left and middle right), he has
created an exemplary scientific study of re-
markable quality. The often drawn parallels
with Renaissance nature studies, especially
Leonardo da Vinci's, arise because Leonardo's
drawings reveal the first evidence of systematic
observation and the inclusion of inset dia-
grams.

A comparison of Gessner's study with
Dürer's Bremen *Iris* (Cat. 66) will clarify the
gap between them and the different intention
of both. Dürer's study is a natural experience
artistically condensed, faithful in every detail,
an individual portrait, but at the same time the
summary of an iris, while Gessner's is a sensi-
tively recorded diagram of two related species,
motivated by botanical curiosity and domi-
nated by morphological interest.

Against Dürer's work of art, which in its
accuracy also satisfies scientific demands,
Conrad Gessner's botanical illustration dem-
onstrates how rapidly, in the sixteenth cen-
tury, the scientific image as an independent
pursuit had broken away from the artistic
study.

For the natural scientist Gessner, the first
priority is the clear portrayal of typical features
of shape in their distinctive character, which
makes his drawings particularly interesting for
the botanist. Botanists can deduce from the
rendering of the flowers, their detail and the
way they are arranged, that Gessner had gained
insight into the pollination mechanism at a
time when its exact function was still virtually
unknown. In the enlarged detail drawings,
otherwise imperceptible details become visi-
ble, "above all the extrorse, parallel, decurrent
pollen sacs angled outward and downward,
which in irises are so positioned that the pollen
can be passed directly to the pollinator. Finally
on the lower gullet flower, the style canal run-
ning downward from the receptive point of
the stigma can be particularly well discerned.
Furthermore, the inferior ovary position of the
iris flowers is clearly visible."[6]

Gessner's studies prove that he was not only
a gifted botanist, but also possessed astonishing
artistic talent. His search for knowledge led
him to the same standard of veracity in por-
trayal that Dürer sought to reach by dedicated
fidelity to nature. But to put Dürer and
Gessner side by side would be to misconstrue
the facts. The former was no more a scientist
than the latter was worthy of a place in the
history of sixteenth-century painting. Still,
each of them, from his own position and in his
own way, has left his mark on posterity.

NOTES

1 See Zoller et al., 1979, for transcription of the
inscriptions

2 The double sheet forms pages 112, 113 and 125,
126. The illustration on page 112 shows a
mountain cranesbill, on page 125 mugwort,
thrift, and fern, on page 126 a hawkweed. I
thank Mr. Schmidt of the Nuremberg Naturhis-
torische Gesellschaft for this information. For
more on the *Historia Plantarum* see p. 275 below.

3 Page 173; it does not appear in the first edition
of 1554, nor in the French version of 1557
(according to Zoller).

4 Gessner had already visited Augsburg in 1545,
on the invitation of J. J. Fugger. The Fuggers
tried in vain to engage him as teacher and tutor.

5 The rootstock is important in order to
differentiate between *Iris sibirica* and *Iris
graminea,* so later on, obviously when the plant
had finished flowering, he made a separate,
enlarged study of it on another sheet (p. 284).

6 Zoller et al., 1979, p. 63.

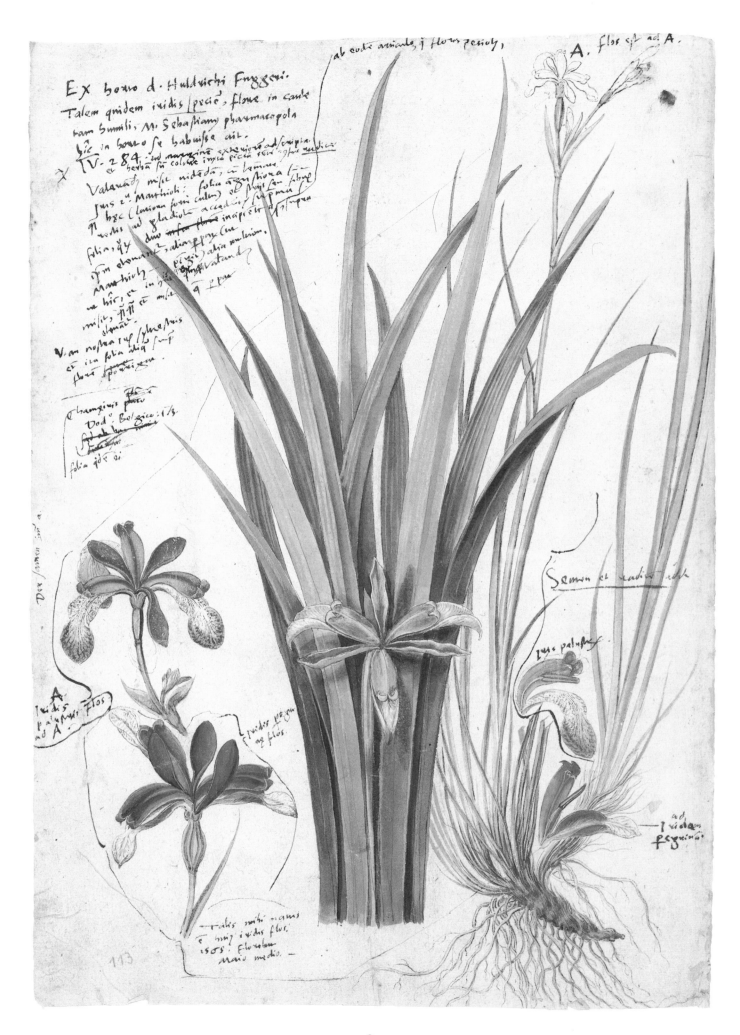

85

CONRAD GESSNER

Turk's Cap Lily

Watercolor and pen drawing on paper, brush,
pen, ink, heightened with white, inset
in thin, mildew-spotted paper
Bottom left, old text correction (by Gessner
himself)
Watermark, indistinct: standing bear
Inscriptions in pen and ink[1]
326 x 219 mm (with the surrounding paper
border,
411 x 255 mm); half a folded sheet (see note 2)
Erlangen, Universitätsbibliothek, Inv. Ms. 2386,
Sheet 379r (fol. 316; 317, 318, 319)

PROVENANCE: Caspar Wolf • Joachim
Camerarius • Georg Volkamer • Christoph
Jakob Trew • Altdorf Universität • Erlangen,
Universitätsbibliothek (1818).

BIBLIOGRAPHY: *Conradi Gesneri Historia
Plantarum* — facsimile edition of the plant
watercolors from the botanical legacy of
Conrad Gessner (1516–1565) in Erlangen,
Universitätsbibliothek, ed. by Heinrich Zoller,
Martin Steinmann, and Karl Schmid, series 7
(Dietikon-Zurich, 1979), pp. 74–76, plate 11,
p. 30 • Heinrich Zoller, "Konrad Gessners
Historia Plantarum — Eine Synthese von
Wissenschaft und Kunst," in *Verhandlungen der
Schweizerischen Naturforschenden Gesellschaft*
(Basel, 155/1975), p. 63, ill. 4.

This drawing from Conrad Gessner's *Historia
Plantarum* (page 316)[2] is regarded, even by bot-
anists, as "a timeless masterpiece of scientific
plant illustration." Gessner himself made a
note in Latin at top right: "Turk's Cap Lily,
better than Mattioli or others have portrayed
it." According to Heinrich Zoller,[3] "in none
of the illustrations in the plant books of the
fathers of botany is the trimerous, whorled
construction of the flowers presented with
such unerring clarity as in the splendid por-
trayal on page [sheet] 379 recto of the H.
[istoria] P.[lantarum], quite apart from the fact
that only with Gessner do we get a look at the
construction of the seed capsule." Gessner's
uncommon visual perspicacity can be sensed in
his precise rendering of every detail — the ac-
curately elaborate root system, with its fleshy,
annularly wrinkled anchoring and feeding
roots coming from the base of the bulb, the
fine secondary roots arranged in whorls above
the bulb, and many more. Most particularly in
the way he has shown the seed capsule, he has
perfected the art of scientific plant studies. He
draws the open seedbox, showing the arrange-
ment of the inner chambers and the position of
the seeds, with individual seeds removed and
recorded alongside. In a delicate pen sketch
below, he captures the spray of seed capsules,
each with its characteristic bent stalk, like a
candelabrum. From the note Gessner added
later, "In 1565 I had a specimen whose stem
was two ells and two spans tall" (about 1.5

meters), we can deduce that the study was
probably done in the previous year, 1564.
Three further studies on the left represent
flowering sprays of a climbing rose (*Rosa ar-
venis* Huds.). Among the Latin inscriptions ap-
pear the dates 1563 and 1565.

The *Turk's Cap Lily* (Cat. 67) in Bremen,
hitherto ascribed to Dürer, is inferior to
Gessner's example both in execution and in
accuracy of observation. The remarkably stiff
leaf whorls[4] of the Bremen study look artificial
by comparison, besides being disproportion-
ately large for the spray, and it is also notice-
able that the lower part of the spray, which
normally begins with single leaves, is missing,
whereas Gessner shows it complete.[5] In this
way, Gessner's precise drawings assist our
judgment. They indicate that the artist of the
Bremen *Iris* (Cat. 66) evidently had an unerr-
ing eye that could apprehend nature impecca-
bly, and that the artist of the Bremen *Turk's
Cap Lily* not only painted carelessly, but was
sorely deficient in observation.

NOTES

1 See Zoller et al., 1979, for transcription of the
 inscriptions.
2 The double sheet is the inner one of a spread,
 and includes the pages 316–319; page 316: turk's
 cap; on the reverse, page 317: yellow iris;
 opposite that, page 318: spiked rampion; and on
 page 319: watercress and cuckoo flower (lady's
 smock). For this information I thank Mr.
 Schmidt of the Nuremberg Naturhistorische
 Gesellschaft.
3 Zoller et al., 1979, p. 74.
4 Behling, 1967, p. 115.
5 For this information I thank F. Ehrendorfer.

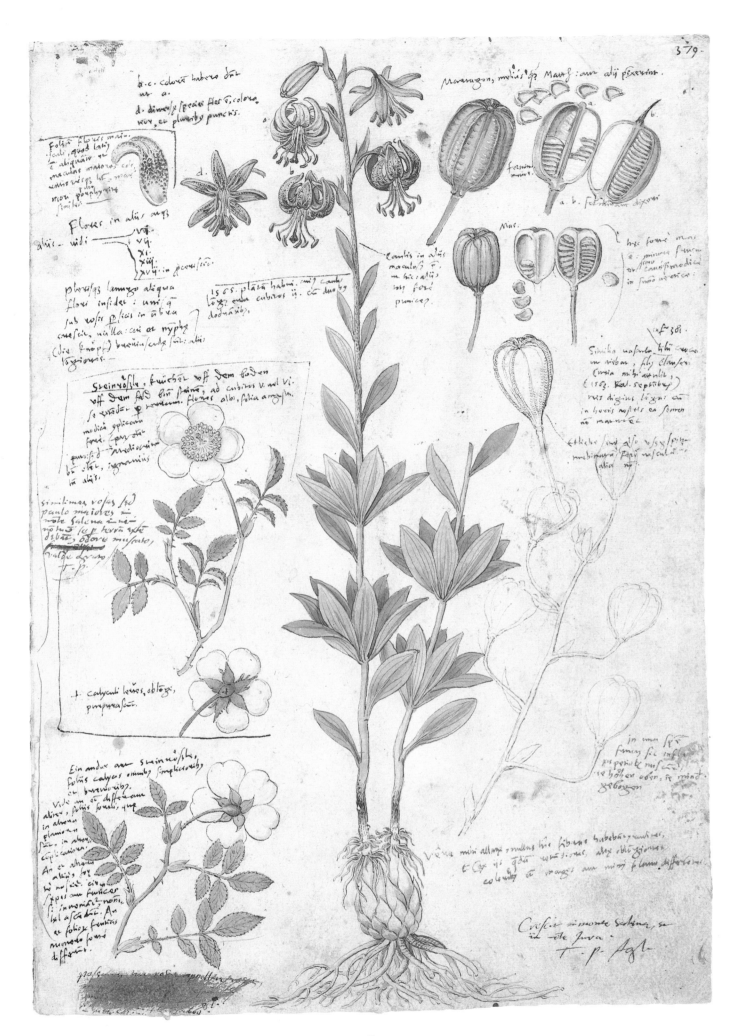

86

JACOPO LIGOZZI

Coltsfoot

Watercolor and body color on mildew-spotted
paper,
brush, pen, heightened with white oil paint (?),
traces of preliminary pencil drawing between
the stems
Fold across the middle
Watermark: shield with reclining animal;
similar to Briquet 1884 (see p. 260, figs. 13, 13a)
Top right in brown ink, the figure *17*;
below the roots, a handwritten name partially
erased; bottom left, the Latin name
677 x 453 mm
Florence, Gabinetto Disegni e Stampe degli
Uffizi
(L. 930), Inv. 1894 Orn.

PROVENANCE: Fondo Mediceo Lorenese •
"Libreria amnessa al Real Gabinetto di Fisica,"
Florence, 1779.

BIBLIOGRAPHY: Exhibition Catalogue *Mostra di
Disegni di Jacopo Ligozzi,* compiled by Mina
Bacci and Anna Forlani (Florence, Gabinetto
Disegni e Stampe degli Uffizi, 1961), no. 28 •
Exhibition Catalogue *Firenze e la Toscana dei
Medici nell'Europa del Cinquecento* (Florence,
1980), vol. 1, pp. 134 ff., vol. 2, pp. 295 ff.,
vol. 3, pp. 208 ff.

With great precision, Ligozzi, who was active as a painter at the Medici court from 1575 onward, portrays a well-developed plant of coltsfoot (*Tussilago farfara* L.), complete with roots and the remains of last year's stems. The color gradations are accurate, particularly on the newly emerging shoots that have not yet been much exposed to light. Although it shows a bushy clump of upthrusting flower stalks, the study has a clarity of composition and precision of execution reminiscent of plant studies from Dürer's time. Ligozzi reproduces the plant's habit with a masterly objectivity that satisfies the highest botanical demands. His artistic capacity for empathy and his creative power bring out the beauty of this otherwise modest plant to exemplary effect.

In contrast to botanical illustration, where usually no more than one flower spray is set out as an example, Ligozzi's study combines botanical interest with artistic imagination in a manner worthy of Dürer. Like the studies of Hans Hoffmann and Georg Hoefnagel, who adopt older solutions borrowed from Dürer and develop them further, so Ligozzi's studies reflect something of Dürer's effect and influence on Italian art of the late sixteenth century. German "specialists" in this genre were valued in Italy. There is evidence at least that Georg Hoefnagel's fine miniature flower and animal studies were known and sought after in Italy.[1] Very probably the Medici court, with its interest in natural science, knew not only about Dürer's nature studies, but also the Dürer paraphrases and plant studies of Hans Hoffmann.[2]

The preliminary drawing still visible in places gives a hint of Ligozzi's method of working. A few other, only partially completed sheets clearly show this step-by-step construction. The preliminary outline is unusually delicate, but establishes each leaf and flower precisely. Over this the watercolor is applied in flecks, then a different, gradually broader underpainting in body color follows one that already takes account of the leaf veins and light effects. After that, the study is detailed with body color and perhaps partly with oil paint (?), and finally the luminosity and shine of the paints are enhanced with albumen or thin varnish.

NOTES

1 Hoefnagel was in Italy in 1577–78; there, in Rome, he gained entry to the circle of Cardinal Alessandro Farnese, who, after the death of his court painter Giulio Clovio in 1578, tried in vain to engage Hoefnagel in his service. We know that Daniel Fröschl, from his own statement, was in the service of the Medici when he was called to the imperial court at Prague in 1601.

2 A little later, in 1631, we have evidence through Baldinucci that the sculptor Pietro Tacca (1577–1640) was in possession of a copy of the *Hare* (see Cat. 48). Pietro Tacca was the pupil and studio heir of Giovanni da Bologna, and probably, like him, had direct contact with the Prague court. Whether he acquired the study there, or from Giambologna, or from another previous owner in Italy, is beyond our knowledge.

Tussilago farfara

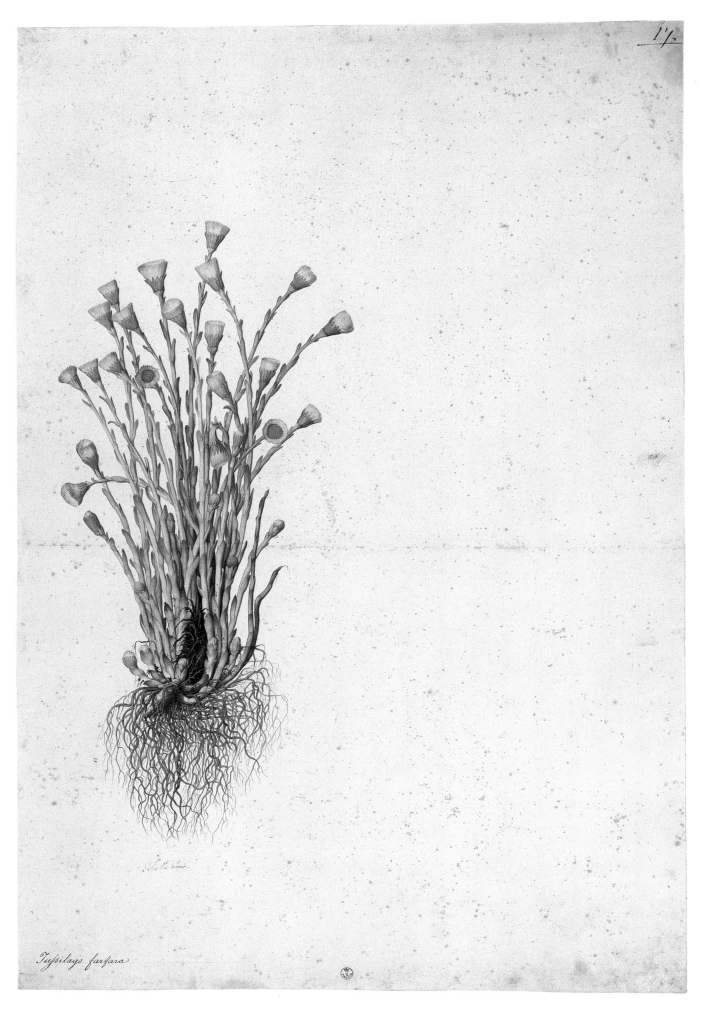

Tussilago farfara

87

JACOPO LIGOZZI

Iris susiana and Iris xiphium

Watercolor and body color on mildew-spotted
paper,
brush, heightened with white
Watermark indistinct
Bottom left, in brown ink: *Iris Susiana*
Bottom right: *Iris Xyphium*
Bottom left, the only partly erased inscription
(by Ligozzi ?): *Iris*[1]
594 x 450 mm
Florence, Gabinetto Disegni e Stampe degli
Uffizi
(L. 930), Inv. 1891 Orn.

PROVENANCE: Fondo Mediceo Lorenese •
"Libreria amnessa al Real Gabinetto di Fisica,"
Florence, 1779.

BIBLIOGRAPHY: Exhibition Catalogue *Mostra del'
500 Toscano* (Florence, Palazzo Strozzi, 1940),
p. 137 • Exhibition Catalogue *Mostra di Disegni
di Jacopo Ligozzi,* compiled by Mina Bacci and
Anna Forlani (Florence, Gabinetto Disegni e
Stampe degli Uffizi, 1961), no. 45 • Exhibition
Catalogue *Firenze e la Toscana dei Medici
nell'Europa del Cinquecento* (Florence, 1980),
vol. 1, pp. 134 ff., vol. 2, pp. 295 ff., vol. 3,
pp. 208 ff.

With both flower stalks Ligozzi captures
typical examples of iris species presumably
reared in the Medici gardens.[2] *Iris susiana,* "the
lady in mourning," according to Linnaeus was
first imported from Constantinople in 1573,
and *Iris xiphium,* indigenous to southwestern
Europe, has been cultivated since 1564.

As the Medici court painter, Ligozzi created
hundreds of plant and animal studies in his sub-
tle, precise style.[3] Despite his evidently close
relations with the polymath Ulisse Aldro-
vandi, doctor, archaeologist, zoologist, and
botanist, who was working in Bologna and
who issued a wealth of encouragement and
commissions, and despite the reciprocal esteem
of the two men, Ligozzi never engaged him-
self fully in scientific illustration. His studies
always remained a living illustration of the
natural appearance. Comparison with
Gessner's *Irises* (Cat. 84) underlines the differ-
ence; for example, unlike Gessner, Ligozzi, in
all his plant studies kept in Florence, eschewed
the use of illustrative, explanatory scientific
insets. All the more intensively, therefore, he
devoted himself to the painstaking reproduc-
tion of the overall appearance of a plant and the
individual coloring of its flowers. His stylish
portrayal, precise drawing, and meticulous ex-
ecution are reminiscent of Dürer's studies. In
his fine miniature technique, Ligozzi is similar
to his German contemporary Georg Hoefna-
gel, but in the life-size presentation of his ani-
mal and plant models, he relates to the type of
plant study pioneered by Dürer. The example
Dürer created at the start of the century with

the Bremen *Iris* (Cat. 66) still shows its validity
almost a hundred years later.

NOTES

1 At bottom left are the remains of the handwrit-
ten title "Iris" (see also Cat. 86). It looks as if
someone had intended to erase this hasty
inscription (by the artist or a botanist?) after the
title had been added by a calligrapher. Many of
the Ligozzi drawings in Florence show traces of
this procedure. Identification of the handwriting
(Ligozzi's, Aldrovandi's ?), which is still quite
visible despite the erasure, is still unresolved.
2 Odoardo H. Giglioli, "Jacopo Ligozzi
disegnatore e pittore di piante e di animali," in
Dedalo IV/1923–24, p. 562.
3 The Uffizi has 314 studies by Ligozzi. Once
Medici property, they came there by way of the
Libreria amnessa al Real Gabinetto di Fisica in
Florence. I have not examined the studies made
for Aldrovandi (seven volumes of animals, ten of
plants, flowers, and fruits, and one mixed
volume of animals and plants, in the Bologna
University Library).

Iris Susiana

Iris Xyphium

87

88

LUDGER TOM RING THE YOUNGER

Basket with Flowers

Oil colors and brush on paper, prepared in
gray-brown,
fragile and torn in places,
mounted on paper
194 x 321 mm, trimmed

Vienna, Österreichische Nationalbibliothek,
Handschriften- und Inkunabelsammlung,
Cod. min. 42, fol. 167r

PROVENANCE: Emperor Rudolf II • Imperial
Treasure Chamber • Imperial Court Library
(1783)

BIBLIOGRAPHY: Not described.

BIBLIOGRAPHY OF LUDGER TOM RING THE
YOUNGER: Exhibition Catalogue *Die Werke der
Münsterischen Malerfamilie tom Ring* (Münster,
1924). Karl Hölker, *Die Malerfamilie tom Ring*
(Münster, 1927), contributions to *Die Westfä-
lische Kunstgeschichte,* vol. 8 • Max Geisberg,
"Die tom Rings," in *Westfälische Lebensbilder,*
principal series, vol. II (Münster, 1931), p. 30 •
Ingvar Bergström, *Holländskt Stillebenmåleri
under 1600 — Talet* (Göteborg, 1947), p. 26 •
Kjell Boström, "Mededelingen van het
Rijksbureau voor Kunsthistorische Documen-
tatie, De oorspronkelijke Bestemming van
Ludger tom Rings Stillevens," in *Oud Holland*
67/1952, pp. 51–55 • Sterling, 1952, pp. 34, 128,
note 57 • Theodor Riewerts and Paul Pieper,

Die Maler tom Ring (Munich/Berlin, 1955) •
Paul Pieper, "Ludger tom Ring d.J., Die
Hochzeit zu Kanaa," in *Niederdeutsche Beiträge*
II/1962, pp. 219–238 • Paul Pieper, "Ludger
tom Ring d.J. und die Anfänge des Stillebens,"
in *MJBK* XV/1964, pp. 113–122 • Paul Pieper,
"Das Bildnis von 1564 in der Frühgeschichte
des Stillebens," in *Bulletin des Musées Royaux
des Beaux-Arts* XIV/1965, pp. 205–210 • *Katalog
des Westfälischen Landesmuseums Münster,* ed. by
P. Pieper (1968), pp. 89, 92, 93 • Peter Mitchell,
Great Flower Painters (New York, 1973), p. 17 •
Exhibition Catalogue Münster 1979/80,
pp. 28, 314 ff.

This oil study on paper, executed almost like a
painting, depicts roses, daisies, and many other
plants, ornamental ones and spices.[1] The con-
summate nature of the composition[2] makes it
into a still life in its own right.

This work belongs with twelve other stud-
ies, painted with the same technique and as yet
unpublished, in an album of animal and plant
studies that was assembled at the end of the
sixteenth century.[3] Ten of these contain de-
tails that may be shown to be preparatory stud-
ies for the large painting *The Marriage at Cana*
(ill. 88.1).[4] This painting, formerly in the
Deutsches Museum, Berlin, was destroyed in
World War II. Signed and dated 1562, it was
the masterpiece of Ludger tom Ring the
Younger and also the first kitchen still life of
sixteenth-century German painting. The stud-
ies introduced here are the first authenticated

88.1 Ludger tom Ring the Younger, *The Marriage at Cana,* 1562,
oil on panel. Formerly in Berlin, Deutsches Museum (lost in the war).

88

graphic works by this artist, who has previously been known solely as a painter.

In *The Marriage at Cana* Ludger the Younger, a member of the Westphalian tom Ring family of painters, was following Dutch models like Pieter Aertsen and Joachim Beuckelaer. More sober and objective in his conception, he captures each detail meticulously. The cumulative composition of the painting would seem to suggest detailed study for each motif,[5] and this idea is supported by the works that have now been discovered. These color sketches are far more spontaneous and free than the dryly executed painting, and they convey a much more immediate impression of nature.

The study of a basket was included in the large painting as a feature on the table in the middle. A direct comparison of the preparatory sketch and its final incarnation demonstrates the artistic license that comes into play, from the first, free depiction of the object to its calculated integration in the painting, where perspective and the choice and arrangement of the flowers are finally subordinated to the higher demands of the composition.

The rose lying in front of the basket to the left in the study was used again by Ludger in another of the works in this album, a jug with flowers (ill. 88.4).[6] The bouquet displays similarities to the still life standing on the sideboard at the left of the painting (ill. 88.3); the rose was used again some years later, in 1569, as a decorative detail in the *Portrait of Reinhard Reiners*[7] (ill. 88.6). But Ludger also turned the study itself, the bunch of flowers with the rose lying separately, into a painting: there is a flower picture ascribed to Ambrosius Brueghel, which I know only through previous literature,[8] wherein it is repeated with additional flowers (see the toadflax from Cat. 90) to create a lush bouquet (ill. 88.5). The theme and the style, as far as we can judge from a reproduction, in conjunction with the grayish coloration as described, prove beyond doubt that this lost (?) painting is a work by Ludger tom Ring the Younger, and probably was his crowning endeavor on this theme.

Ludger's bouquet study and the painting represent achievements far surpassing the prototypic independent still lifes of flowers that had been produced up till then[9] — and most of those were by him, too, which should lead us to revise his place in the history of flower painting.[10] The pictures of flowers painted by him that have been known up to now are partly symbolic and partly decorative, but this study, with its naturalness and lack of pretension, is a freely conceived, independent still life of flowers, indeed, the first of its kind surviving in European painting. Ludger tom Ring was admirably ahead of his time in the freedom of his approach and in his ability to reproduce what he was looking at; he was the first specialist in a genre that has up to now always been considered the particular achievement of the Dutch flower painters of more than a generation later.

88.2 Ludger tom Ring the Younger, *The Marriage at Cana*, basket of flowers, detail of ill. 88.1.

88.3 Ludger tom Ring the Younger, *The Marriage at Cana*, bunch of flowers, detail of ill. 88.1.

Moreover, this study with the bunch of flowers is not only of importance in the context of his paintings; its motif was also influential in the field of prints, and became widespread. It has so far not been observed that an engraving by Adriaen Collaert[11] (ill. 88.7) is also based on this model. This too sheds new light on the artistic personality of Ludger tom Ring the Younger, who evidently was an artist of higher rank and greater influence than has previously been thought.[12]

NOTES

1 In the basket from left to right: red cabbage rose (*Rosa* spec. cultivar); above, sage (*Salvia officinalis* L.), a pansy flower, and a shoot of rosemary (*Rosmarinus officinalis* L.); below these sweet william (*Dianthus barbatus* L.); farther to the right, marigolds (*Calendula officinalis* L.), white cabbage rose; in front, cultivated daisy (*Bellis perennis* L. cultivar); behind, rose campion *(Lychnis coronaria)*, red cultivated rose; a leaf of rue (*Ruta graveolens* L.). Clockwise around the basket from bottom left: white cabbage rose, cultivated daisy, rose campion, common pink (*Dianthus plumarius* L.), rosemary, sweet william, pansy (*Viola tricolor* L.), a rose petal; far right, probably the shoot of a stock (*Matthiola incana* [L.] R. Br.), an unidentifiable short shoot, a borage flower (*Borago officinalis* L.), a branch of (probably) snapdragon without flowers (*Antirrhinum majus* L.), cultivated daisy, and a rose petal. Identification by F. Ehrendorfer and M. A. Fischer.

2 Even in antiquity this mode of portrayal was admired; see Roman mosaics such as *A Basket with Flowers,* second century A.D., Rome,

Vatican Museum, ill. in Sterling, 1952, plate 6.

3 Vienna, Österreichische Nationalbibliothek, Handschriften- und Inkunabelsammlung, Cod. min. 42, fol. 17, 25, 56–58, 123, 124, 163, 166–169; for the album, see Cat. 1, note 1.

4 A comprehensive edition of all the works, only some of which can be introduced here, is planned.

5 Pieper, 1864.

6 Oil, brush, on brown-prepared paper; 290 x 200 mm; Cod. min. 42, fol. 169.

7 *Portrait of Reinhard Reiners,* dated 1569 on the vase and bearing Ludger's mark; Brunswick, Herzog Anton Ulrich-Museum.

8 Ill. in Ralph Warner, *Dutch and Flemish Flower and Fruit Painters of the XVIIth and XVIIIth Centuries* (London, 1928), p. 40, plate 15c (the basis of our illustration). I am acquainted with a copy from the art market: oil, wood; 360 x 265 mm; ill. in the catalogue *Old Master Paintings* (Vienna, Galerie Sanct Lucas, Winter 1977–78), no. 4.

9 Pieper, in Exhibition Catalogue Münster 1979/80, pp. 314 ff. (especially 322).

10 Bergström, 1947, p. 26; Sterling, 1952, p. 34; Pieper, 1965, pp. 205–210.

11 *Vase of Flowers,* from *Liber Florilegium,* copper engraving, Hollstein 679–702; the intermediate stages may also be traced in tom Ring's work. See note 4.

12 These comments indicate how very much the basket study at that time was perceived as an independent still life; a flower still life by Ambrosius Bosschaert (see Auction Catalogue, Christie's, *Old Master Paintings,* London, December 2, 1983, no. 122) and a very similar oil painting attributed to Johannes Bosschaert in Rotterdam (ill. 88.8) are obvious examples.

88.4 Ludger tom Ring the Younger, *Jug with Flowers,* c. 1562, oil study on paper prepared in brown. Vienna, Österreichische Nationalbibliothek.

88.5 Ludger tom Ring the Younger, *Jug with Flowers,* oil on panel. Whereabouts unknown (see note 8).

88.6 Ludger tom Ring the Younger, *Portrait of Reinhard Reiners,* 1569, oil on panel. Brunswick, Herzog Anton Ulrich-Museum.

88.7 Adriaen Collaert, *Liber Florilegium, Vase with Flowers,* copper engraving. Vienna, Graphische Sammlung Albertina.

88.8 Attributed to Johannes Bosschaert, *Basket with Flowers,* oil on panel. Rotterdam, Museum Boymans-van Beuningen (Inv. 2417).

89

LUDGER TOM RING THE YOUNGER

Daffodils and Other Flowers

Oil colors and brush on paper prepared in
gray-brown,
mounted on paper
280–284 x 284 mm, trimmed

Vienna, Österreichische Nationalbibliothek,
Handschriften- und Inkunabelsammlung,
Cod. min. 42, fol. 166r

For provenance and bibliography, see Cat. 88.

The blooms of various spring flowers —
Christmas roses, violets, daffodils, spring
snowdrops, and others[1] — are placed close to
one another, covering two-thirds of the paper;
the remaining section is empty, as if wait-
ing for other flowers to be painted on it.
With their bright or dark outlines, the rather
leathery-looking leaves are rendered with
striking clarity. Like the oil sketch *Basket with
Flowers* (Cat. 88 and ill. 88.4), this and the fol-
lowing study come from an album assembled
at the end of the sixteenth century.[2] In their
materials, technique, execution, and style, they
belong to a group linked with Ludger tom
Ring's painting *The Marriage at Cana* (ill 88.1).
The connection with this painting, dated 1562,
establishes the period of the study and its au-
thorship by the Westphalian master.

The composition is significant in itself: in
order to have as versatile a repertoire as possible
for later use, tom Ring painted the flowers
from more than one angle, showing them
from several sides and at various stages of
growth. These efforts may make one think of
scientific drawings, but his aim was not didac-
tic — he was taking an economical approach
to having a useful source for future reference.

NOTES

1 Beginning from bottom left: daffodils (*Narcissus
 pseudonarcissus* L.), to the right sweet violets
 (*Viola odorata* L.); above them spring snowdrops
 (*Leucojum vernum* L.), cultivated daisies (*Bellis
 perennis* L. cultivar), and the flowering shoot of
 a stock (*Matthiola incana* [L.] R. Br.); then to the
 right a spray of pot marigold (*Calendula
 officinalis* L.), liverwort (*Hepatica nobilis* Schreb.),
 Christmas roses (*Helleborus niger* L.); below,
 probably a purple hellebore (*Helleborus cf.
 purpurascens* Waldst & Kit), beside it a grape
 hyacinth (*Muscari racemosum* [L.] Mill.); above, a
 peony (*Paeonia officinalis* L.); and to the right an
 oxlip (*Primula elatior* [L.] Hill.). Identification by
 F. Ehrendorfer.
2 See Cat. 1, note 1.

89

90

LUDGER TOM RING THE YOUNGER

Poppy and
Other Field Flowers

Oil colors and brush with preliminary brush
drawing
on paper prepared in gray-brown, mounted
on paper
315 x 420 mm, trimmed
Vienna, Österreichische Nationalbibliothek,
Handschriften-und Inkunabelsammlung,
Cod. min. 42, fol. 163r

For provenance and bibliography, see Cat. 88.

This study uses the same technique as the previous ones; it shows flowers that bloom only in the summer, most of them field flowers like the field poppy, cornflower, and corn-cockle.[1] The scale is not completely consistent. For the dating of this study — published here for the first time — and its attribution to Ludger tom Ring the Younger, see Cat. 88, 89.

Of course, no one particular bloom out of the many can be conclusively traced to flower paintings by tom Ring, but the formation, in terms of both the drawing and the painting, may be considered as analogous. Pieper[2] already supposed that there must have been studies to act as models for tom Ring's paintings: "One must assume that the painter relied for each individual form upon studies that he would have had on hand as needed. By continually making new combinations of the individual studies, he formed his pictures. While in doing so the individual forms correspond, the whole takes on a different shape each time." The studies shown here, of a kind previously unknown from the painter, must be part of the store of these models, which were presumed to have existed at some stage and then to have been lost.

The frequency with which floral still lifes, either as autonomous works or within the context of a larger work, appear in paintings by Ludger tom Ring, and their execution on the basis of model sheets that allowed him to compose still lifes as he wanted, independently of the time of year, indicate that floral painting became a genre in its own right. As a practical anthology, tom Ring's sheets of studies represent the immediate precursors of the collections of prints like Adriaen Collaert's *Florilegium* or Jakob Hoefnagel's *Archetypa studiaque patris* (see Cat. 39).

NOTES

1 The picture shows: bottom left, toadflax (*Linaria vulgaris* Mill.); above it, red clover (*Trifolium pratense* L.), meadow bellflower (*Campanula patula* L.), and field poppy (*Papaver rhoeas* L.). On the left, in front, herb Robert (*Geranium robertianum* L.). Next to the poppy, a thistle (*Cirsium* or *Carduus* spec.); at the very bottom, soapwort (*Saponaria officinalis* L.). In the center,
meadow buttercup (*Ranunculus acris* L.) and cornflower (*Centaurea cyanus* L.); below them, snapdragon (*Antirrhinum majus* L.); sketched in to its right, foxglove (*Digitalis purpurea* L.). Next to it a corn-cockle (*Agrostemma githago* L.); behind this, above, corn chamomile (*Anthemis arvensis* L.). Next to it on the right, wild radish (*Raphanus raphanistrum* L.); the yellow flowers beneath it, wallflowers (*Erysimum cheiri* [L.] Cr.); farther down, with red star-shaped flowers, a red campion (*Silene dioica* [L.] Clairv.); at the very bottom, on the right, larkspur (*Consolida ajacis* [L.] Schur.). Identification by F. Ehrendorfer. S. Segal (in a memorandum of May 26, 1985) takes the wild radish for a night violet (*Hesperis matronalis*).

2 Pieper, 1964, p. 119.

90

91

GEORG HOEFNAGEL

Flowerpiece with Insects

Watercolor and body color on vellum, brush,
pen, heightened with gold
On the blue ribs of the vase, Hoefnagel's
monogram and the date *1594*
161 x 120 mm

Oxford, lent by the Visitors of the Ashmolean
Museum, Oxford, Inv. 56e

PROVENANCE: N. M. Calmann.

BIBLIOGRAPHY: Ashmolean Museum Annual
Report 1951, p. 63 • Ingvar Bergström, *Maestros
Espanoles de Bodegones y Floreros del Siglo XVII*
(Madrid, 1970), p. 49, fig. 34 • Ingvar
Bergström, "Flower-pieces of Radial Composi-
tion in European 16th and 17th Century Art,"
in *Album Amicorum J.G. van Gelder* (The Hague,
1973), pp. 22–26 • Exhibition Catalogue
Münster 1979/80, pp. 26, 556, no. 3.

Tulips, columbine, and roses,[1] a caterpillar,
butterflies, a dragonfly, and a dead cock-
chafer,[2] each an individual study, are arranged
into a composition like a still life. This *Flower-
piece with Insects,* dated 1594, is one of the few
surviving early Dutch examples of this genre.
Bergström mentions a very similar work, dated
1592, by Hoefnagel, that was on the Italian art
market in 1961.[3] Carel van Mander[4] claims
that flower and fruit paintings of this kind had
existed even before Hoefnagel, but there is no
surviving evidence of them.

The title pages of the *Archetypa studiaque
patris* (dated 1592), parts II and IV, by Jakob
Hoefnagel after his father's collection of speci-
men works, contain compositional precursors
to this study. These show similarly composed
arrangements of flowers and vases balanced on
balls, the latter demonstrating the "artfulness"
and inner symmetry of the picture. The dead
cockchafer also returns, laterally inverted, in
the third part of the work (fol. 7), which sug-
gests that it was part of the same repertoire of
images. But specific precursors are already
found in book illustration of the later Middle
Ages, in the work of Jean Bourdichon and
others in France, and of the Master of Mary of
Burgundy in the Netherlands.

Book illustration in the Middle Ages was
surprisingly innovative, with new material
often appearing in a consummate form. Spe-
cific motifs often move from the margins of
miniatures to the center of the page, an exam-
ple being the unadorned nature study of a but-
terfly from a fifteenth-century French book of
hours (ill. 91.1). Although he followed nearly a
century later, Georg Hoefnagel can be seen as
one of the last legitimate representatives of the
great late fifteenth-century Bruges tradition of
book illustration, inasmuch as he takes as his
point of departure its technique of miniature
painting on vellum as well as the still-life–like
representation of reality.

Unlike other miniature still lifes by Hoefna-
gel, this work is not embellished with allegori-
cal allusions. The careful arrangement of the
botanical and zoological specimens, however,
suggests overlapping relationships: in contrast
to the beauty of the flower, the caterpillar, but-
terfly, and dead cockchafer convey incisively
genesis, splendor, and consummation — the
unfolding, prime, and frailty of all being.

In this pictorial blend of scientifically exact
studies of insects and plants on the formal basis
of simple Renaissance decorative patterns,[5]
Hoefnagel created a type of decorative, flat,
picturelike object that satisfied the taste and
interest of educated bourgeoisie and aristocrats
alike. He was able to unite in it scientific pre-
tensions and visual appeal, adding an artistic
gloss to his didactic aims, and providing vari-
ety in his virtuoso presentation.

Bergström[6] cites Georg Hoefnagel as hav-
ing initiated this form of floral painting with
its "radiate composition," which was then de-
veloped in the work of Georg Flegel, and dis-
semid by "the most important painters of

91.1 *Book of Hours,* Rouen, c. 1450,
miniature painting on vellum.
Whereabouts unknown.

flowers in countries like Germany, Holland,
Flanders, France and Italy."[7]

NOTES

1 F. Ehrendorfer lists the following in the
painting: a cultivated form of the columbine
(*Aquilegia vulgaris* L.) at top left and right, with
the tulip (*Tulipa gesneriana* agg.) between; on
either side of the tulip, roses (*Rosa* spec.); lying
at bottom right, probably a cultivated double
form of liverwort (*Hepatica nobilis* Schreb.).

2 According to G. Pass: painted lady (*Vanessa
cavolui* L.) in the center; a Bath white (*Pontia
daplicide* L.) and a butterfly caterpillar to the left;
below it, the cockchafer (*Melolontha melolontha*
L.), and a small dragonfly to the right.

3 Bergström, in Exhibition Catalogue Münster
1979/80, p. 556, ill.; see also Bjurström, *Vase of
Flowers,* watercolor on vellum; 230 x 170 mm;
in Exhibition Catalogue Bergamo, Galleria
Lorenzelli, 1971.

4 Van Mander, 1617, I, pp. 143, 425, note 196.

5 See Rudolf Berliner, *Ornamentale Vorlageblätter
des 15. bis 18. Jahrhunderts, Mappe I, Gotik und
Renaissance etwa 1450 bis 1550* (Leipzig, 1925),
plates 66, no. 4 and 185, no. 1.

6 Bergström, 1973, and Exhibition Catalogue
Münster 1979/80, p. 556.

7 On the subject "Georg Hoefnagel und seine
Beziehungen zur Gent-Brügger Buchmalerei,"
Dagmar Thoss was able to show interesting new
material during the June 7–10, 1985, sympo-
sium held in connection with the Dürer
exhibition; see her article in *JKS* 82/1986.

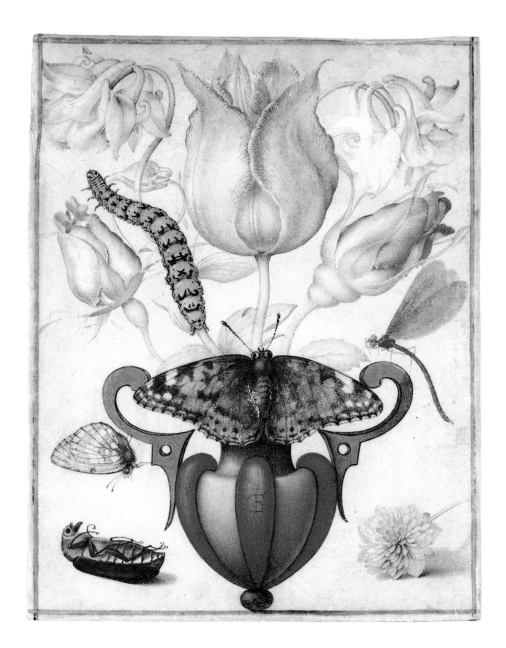

92

GEORG FLEGEL

Fritillaria, Iris, Narcissus, and Hornet

Watercolor and body color on mildew-spotted
paper,
brush, heightened with white,
traces of preliminary pencil drawing
Watermark: crowned coat of arms with a horn
and pendant AS, Piccard VII, section IX, 233
(see p. 260, fig. 14)
Bottom left, the number 36 and a curlicue
233 X 173 mm

Berlin, Staatliche Museen Preußischer
Kulturbesitz,
Kupferstichkabinett, Inv. KdZ 7525

BIBLIOGRAPHY: Bock, 1921, I, p. 356, no. 7525
(as Conrad Wagener?) • Lottlisa Behling,
"Zeichnungen Georg Flegels im Berliner Kup-
ferstichkabinett," in "Berliner Museen," insert
in *JPK* 60/1939, pp. 46–50 • Exhibition
Catalogue Nuremberg 1952, p. 160, no. S 25 •
Müller, 1956, p. 152, Cat. 5, plate 15 • Friedrich
Winkler, *Georg Flegel, Sechs Aquarelle*, 3d ed.
(Berlin, 1962), ill. 4 • Exhibition Catalogue
Deutsche Maler und Zeichner des 17. Jahrhunderts
(Berlin, Orangerie des Schlosses Charlotten-
burg, 1966), p. 144, no. 143 • Exhibition
Catalogue Stuttgart 1979/80, II, p. 67, no. K 10.

This picture shows the following plants:[1] iris
(*Iris lutescens* Lam.), narcissus (*Narcissus jon-
quilla* [L.] agg.), and fritillaria (*Fritillaria melea-
gris* L.). The last of these was a favorite theme
in art and was particularly popular at Flegel's
time.

This work and the following drawing be-
long to a collection that once included more
than a hundred studies of flowers, animals, and
fruit.[2] Four of these drawings, including the
frontispiece with Flegel's self-portrait, were
monogrammed,[3] and three bore dates — 1627,
1629, and 1630. One may assume that Flegel
saw this collection of studies as models for
paintings, and possibly also as a "catalogue" for
prospective clients.

The three flowers are presented almost as a
small bouquet, each retaining its natural
beauty and character, although their stems are
curtailed with surprising abruptness. Next to
them crawls an oversized hornet (*Vespa crabro*
L.);[4] it is seen obliquely, is foreshortened, and
casts a shadow on the surface, all of which give
it an appearance of physical reality that is
passed on to the flowers, although they cast no
shadows themselves. The flowers become the
environment for the hornet, and by this the
simple flower study turns into a still life. With
the placement of the insect next to the plants,
vegetable life is enriched, so to speak, by a fur-
ther dimension of natural existence.

In so doing, Flegel is picking up visual ideas
from earlier painters. What in the consum-
mate form of his work seems to represent the
beginning of a new genre in art can be traced

back via Hans Baldung Grien to Italian herbal
illustration of the latter half of the fifteenth
century.

NOTES

1 Identifications by F. Ehrendorfer and S. Segal
(memorandum of May 26, 1985).

2 The series originally consisted of at least 117
sheets, as may be inferred from the numbering,
done by hand and usually found in the bottom
left-hand part of the page. In 1921, when Bock
made his catalogue, seven works were missing;
of the 110 studies listed by him, thirty-one were
lost in a fire at the end of World War II (six of
these are to be found in color collotypes in
Winkler's book). For their identification as
works by Georg Flegel, see Behling, 1939.

3 In addition, many of the works bear a virtually
indecipherable curlicue "which appears to be an
owner's mark rather than a Flg (Flegel)
signature" (Geissler, in Exhibition Catalogue
Stuttgart 1979/80, I, pp. 66, 67). Bock
interpreted this sign as the "letter P and a
flourish" (Bock, p. 356). It would seem possible
that the curlicue consists of S and P joined
together and a g.

4 Previous literature has always described it as a
wasp. My thanks to G. Pass for checking it and
providing the new identification.

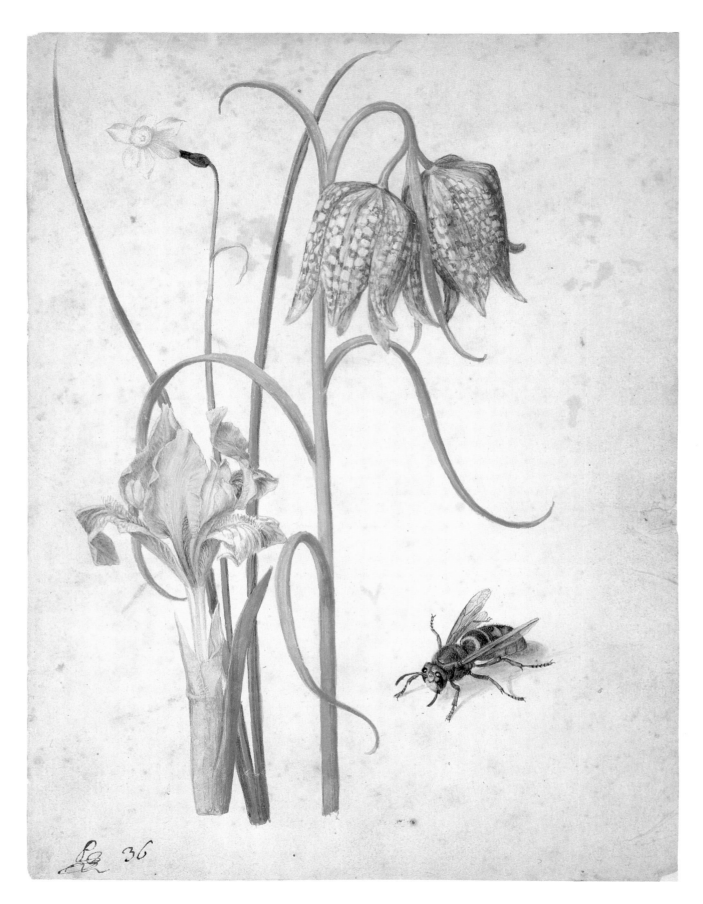

36

93

GEORG FLEGEL

Iris, Bindweed, Cherries

Watercolor and body color on paper, brush,
heightened with white, traces of
preliminary pencil drawing
Bottom left, the number 60 and a curlicue
232 x 172 mm

Berlin, Staatliche Museen Preußischer
Kulturbesitz,
Kupferstichkabinett, Inv. KdZ 7549

BIBLIOGRAPHY: Bock, 1921, I, p. 356, no. 7549
(as Conrad Wagener?) • Lottlisa Behling,
"Zeichnungen Georg Flegels im Berliner
Kupferstichkabinett," in "Berliner Museen,"
insert in *JPK* 60/1939, pp. 46–50 • Exhibition
Catalogue Nuremberg 1952, p. 160, no. S 28 •
Müller, 1956, p. 152, cat. 5, plate 16 • Ingvar
Bergström, "Flegel," in *L'Œil* 102/1963, pp. 3,
5 • Exhibition Catalogue *Deutsche Maler und
Zeichner des 17. Jahrhunderts* (Berlin, Orangerie
des Schlosses Charlottenburg, 1966), p. 114,
no. 141 • Exhibition Catalogue Stuttgart
1979/80, II, p. 66, no. K 9 • Exhibition Cata-
logue Münster 1979/80, p. 65, no. 34.

Portrayed here are an iris, tricolor bindweed,
and various cultivated forms of the sweet and
sour cherry.[1] Each detail is carefully observed.
While the natural forms, each one captured as
a separate entity, appear at first as simply the
artistic depiction of observed botanical reality,
standing out in objective naturalism against
the neutral white of the paper, a change of idea
and conception takes place through selection
and arrangement. New values are created by
the glassy gleam of the variously colored cher-
ries juxtaposed between the flowers, their con-
trasting surface textures playing off against one
another, their stalks projecting into space, and
their shadows, suggesting corporeality. The
accent is shifted from the detail to the ensem-
ble. From a simple recording of iris and bind-
weed there emerges a spatial counterbalance
that transports a descriptive study into the inti-
mate little world of a still life.

With the exception of Ludger tom Ring the
Younger, whose still lifes were exceptional
and far ahead of their time, Flegel was one of
the first German artists to be painting indepen-
dent still lifes of flowers and fruit at this time,
around 1600. Through his detailed studies, de-
signed as preparation for other works, he draws
our attention to the beauty of simple form and
color. Flegel thus was continuing a tradition
that leads back to the allegorical form of Jacob
Hoefnagel's *Archetypa* and is ultimately based
in fifteenth-century Flemish book illustration
(see Cat. 91). Through light and perspective,
and by going beyond the objects while por-
traying them in close-up, Flegel successfully
opens up progressive layers of space. These
studies thus show clearly what Georg Flegel

was able to contribute to the development of
the German still life, among whose pioneers
he belongs.

NOTE

1 Flesh-colored cultivated variant of *Iris spuria* L.
(Segal: *Iris latifolia* [Mill.] Voss), tricolor
bindweed (*Convolvulus tricolor* L.), cultivated
forms of the sweet and the sour cherry (*Prunus
avium* L., *Prunus cerasus* L.). Identifications by F.
Ehrendorfer and S. Segal.

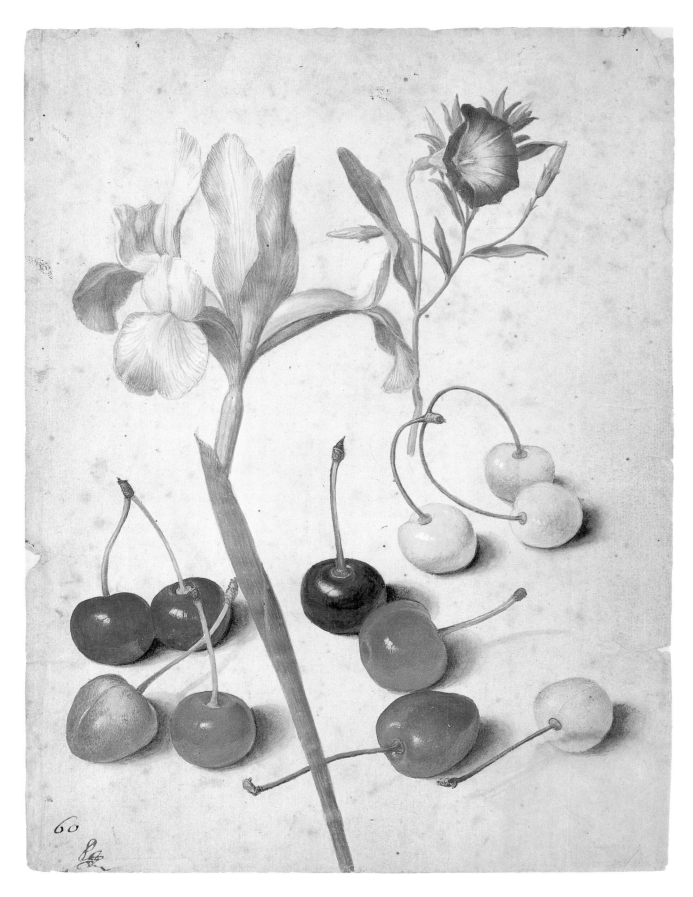

60

93

Appendix

Fig. 1, Cat. 1,
after O. Pächt, in *Revue de l'Art,*
46/1979, p. 14

Fig. 2, Cat. 5,
after Briquet 14 873:
Leipzig 1483

Fig. 3, Cat. 61,
after Briquet 15 863:
Augsburg 1473, 1477,
Nuremberg 1511

Fig. 4, Cat. 31,
drawn from Cat. 31

Fig. 4a, Cat. 31,
after Briquet 924

Fig. 4b, Cat. 31,
after Briquet 917

Fig. 5, Cat. 32,
drawn from Cat. 32

Fig. 5a, Cat. 32,
after Piccard III, Section XIII, 37:
Bamberg, Würzburg 1636–1641

Fig. 6, Cat. 34,
drawn from Cat. 34

Fig. 7, Cat. 29,
after Heawood 1824

Fig. 8, Cat. 35,
after Briquet 12 223:
Naples 1502, Florence 1507

Fig. 7a, Cat. 29,
drawn from Cat. 29

Fig. 7b, Cat. 29,
photographed from Cat. 29

Fig. 8a, Cat. 33,
similar to Piccard I, Section IX, 83/84:
Frankfurt, Münster, Brunswick 1535–1551

Fig. 9, Cat. 57,
after Meder 314

Fig. 10, Cat. 63,
after Piccard V, Section VI, 628:
Rattenberg c. 1500

Fig. 11, Cat. 54, 66, 67, 75, 79,
after Briquet 4773 and Meder 24:
Würzburg, Innsbruck c. 1500

Fig. 12, Cat. 64,
after Piccard XIII, Section III, 1685:
Frankfurt 1502

Fig. 12a, Cat. 64,
rubbed from Cat. 64

Fig. 13, Cat. 86,
drawn from Cat. 86

Fig. 13a, Cat. 86,
after Briquet 1884

Fig. 14, Cat. 92,
after Piccard VII, Section IX, 233:
Strasbourg 1624

The Principal Sources
for Animal and Plant Studies
by Albrecht Dürer and His
Sixteenth-Century Followers

The Imhoff Inventory
(after H. II, pp. 77 ff.)

[p. 77]
EXTRACT.

Mistress Willibald Imhoff's reply
to His Imperial Majesty.
Most Serene, Almighty, and Invincible
Roman Emperor.
Gracious Sir!

First I offer Your Imperial Roman Majesty my poor but ardent prayer to God for his blessed and long-lasting reign together with my humble obedience. And I have these recent days in humble reverence and obedience received Your Imperial Majesty's most gracious letter dated Dec. 21 through my son Philip Imhoff, and taken note of its contents, regarding Your Imperial Majesty's gracious desire that I, together with my sons, should agree most humbly to have you see the seven painted works of art and have them sent forthwith.

May I also say how much I appreciate His Imperial Majesty's having honored me by writing to me about this transaction that had been arranged only by word of mouth between my son and His Majesty and I thank Him most humbly. May I respectfully ask His Majesty to understand that matters like these not only touch myself, who am at the end of my days and concerned with other things and not competent in these matters, but were the fruits of my dear deceased lord and husband's many years of diligence and labor, and brought together at great cost, and over many long years, and for which he was often offered large sums and great honors by Electors and Princes and even Foreign Potentates; but he preferred his art, and considered these pieces his most precious treasure; and in his last
[p. 78]
will he ordained that these should remain forever in the house of the Imhoff family and to their honor and never to be moved from there. Several of his sons, those who were at home at the time, had to give their hands and word of honor to it.

But setting aside all this, since His Imperial Majesty shows gracious interest in these pieces, we do not wish to withhold them from him, and have decided, after friendly discusson among ourselves, to send them to him immediately. The artbook will be sent separately with our dear friend, the Hon. Joachim König, who is instantly prepared to go to Prague and

will deliver it to Your Imperial Majesty himself. The other panel paintings we have had very well packed and secured, and as König did not have opportunity or space to carry them as well, we have given them to a carrier who will be leaving today, and they will be delivered to König in Prague, and by his hand Your Imperial Majesty shall at last graciously be able to receive them.

Date Nuremberg Monday the 30th Dec. A. 88.

> Your Roman Imperial Majesty's
> most obedient and most humble
> Anna, the late Willibald Imhoff's
> bereaved widow, née Harsdörferin.

HEREWITH INVENTORIED THE ITEMS IN OUR POSSESSION

1) A portrait of the Virgin Mary by Albrecht Dürer, considered the best piece he ever did, for which a cardinal offered 500 ducats many years ago.
[p. 79]
2) A Saviour, the last piece he made. Dürer left it unfinished, and in 1650 it was still in Hans Imhoff's possession.
3) Christ's Descent from the Cross, a large panel, and Christ's Resurrection from the Grave in oil paints.
4) Sodom and Gomorrah.
5) The Burial of the Fugger Gentlemen, gray in gray.
6) A little child, gray oil paint.
7) An Ecce Homo.
8) An Ecce Homo exceptionally fine.
9) Kleeberger's portrait, a good likeness. Is now in the Vienna Gallery (see there).
10) St. Jerome, small, watercolor.
10) Albrecht Dürer's portrait, watercolor. Bacchus and Diana by Pordana.* Saint Sebastian by Lucian.** Quintilonius by Stabschireu.***
11) A book containing a variety of designs by Albrecht Dürer and other good masters, of which His Majesty shall have our share.

INVENTORY OF DÜRER'S PIECES

12) Our Lady's picture in oils with a cover in watercolors, also by Albrecht Dürer. Hans Cleeberger's portrait in oils. (See above.) Item a Saviour in oils. (See above.)
13) A panel by Albrecht Dürer depicting Christ being led out.
[p. 80]
About 1650 this was in Hans Imhoff's possession. See further below.
14) A small panel in gray, showing a little child lying naked. A panel showing

* Paris Bordone was one of Titian's best pupils, born c. 1500, died 1570.
** Probably Bernardin Licinio, a Venetian painter working around 1540.
*** This name, unknown to art historians, was probably distorted in copying.

Sodom and Gomorrah in flames. (See above, p. 78.)
15) A panel with fine golden frame, containing a picture of Holy Mary.
16) Item Emperor Maximilian in watercolors.
17) A self-portrait in watercolors painted in his twenty-sixth year. Eustace, illuminated by Dürer's hand. Melancholia, illuminated by Albrecht Dürer.
18–19) Two panels, Albrecht Dürer's father on one, his mother on the other.
20) A small panel with a picture of Veronica.
21) A small panel with a picture of a woman.
22) A small folding panel in black painted by Dürer with small figures, the story of Samson, and the Ascenscion of the Lord Christ.
23) A watercolor panel, a picture of the Virgin Mary.
24) Saint Simon in watercolors on cloth.
25) On a small panel Albrecht Dürer's self-portrait, wearing an old cap. Two small panels in watercolors on cloth, coming from Albrecht Dürer's studio.
26) A panel in oil colors Veronica.
27) A Christmas painting.
29) A long naked man, drawn by Albrecht Dürer in 1501.
30) A large panel in oils with a sailor.
31) A large panel with a curtain in oils, showing Christ being lifted down from the Cross. A large Triumph. Maximilian I illuminated (woodcut).
32) A medium-sized book in a green cover containing admirably drawn and illuminated pieces, painted by Dürer.
[p. 81]
A medium-sized book bound in red leather, containing all printed pieces by Albrecht Dürer.
A book in green cover, containing 12 of the largest copper engravings of Albrecht Dürer's pieces, together with medium and small pieces cut in wood.
A medium book bound in green taffeta, containing Albrecht Dürer's medium-sized pieces engraved on copper, bound together with other assorted good pieces more.
A medium book, containing his medium pieces and others more.
A booklet in green taffeta, containing his small works together with the passion.
A book containing the 12 large pieces on copper, together with a number of others.
Assorted pieces engraved in copper unbound.
Albrecht Dürer's large woodcuts, bound together in white parchment.
Mr. Willibald Birkheimer's portrait engraved in copper.
(This could mean the copper plate).
33) Two wooden panels made of several

boards, drawn by hand with a silver engraver.

36) On cloth, the drawing of a dead man, supposed to be Albrecht Dürer's wife's father. (Who was Hans Frey. S. 1 § 20.) A book, which contains the following works by Dürer:

37) First Emperor Maximilian, a charcoal drawing.

38) Landauer, charitable founder, in charcoal.
Matheus Landauer, who was a smith and metal caster, had knowledge of alchemy, and in 1501 founded together with Erasmus Schiltlerot the so-called House of 12 Brothers in Nuremberg, with a chapel, for which Dürer painted an altarpiece, the Trinity, now in Vienna. (See § 39, under Vienna.)

39) Dürer's mother in charcoal.

40) Albrecht Dürer's wife in silverpoint.
[p. 82]

41) Albrecht Dürer's wife in Netherlandish costume done in gray.

42) Self-portrait of Albrecht Dürer done when still a child, in silverpoint.
This is in the Albertina Collection in Vienna.

43) A picture of a woman with a veil.
A piece showing two naked men by Raphael Urbino in red chalk.
Now in Vienna in the Albertina Collection. See under Vienna.

44) A portrait in silverpoint.

45) A portrait of Albrecht Dürer's brother.
This is a portrait of Andreas. See under Vienna in the Albertina Collection.

46) A small child weeping, gray in gray.

47) A head of Mary in gray.

49) Portrait of the Abbot of St. Ægidius in gray.
This is the portrait of the famous Friedrich Pistorius, the monastery's last abbot.

50) Lucretia in gray.

51) Mary and John in gray.

52) A man's head in gray, gazing toward Heaven.

53) Christ together with two hands in gray.

54) An old man, gray in gray.

55) A nutcracker on vellum.
Now in the Albertina Collection. See Vienna.

56) A wing on vellum.
(Now in the author's collection. See above under Bamberg p. 33. There is a similar one in the Albertina Collection. See under Vienna.)

57) A leveret.
In the Albertina Kabinet. See under Vienna or Dresden. See above p. 38.

58) A lion on vellum.

59) A lioness on vellum.
[p. 83]
Dürer probably drew these in Ghent, for he said in his diary of the journey (see above p. 47): "I saw the lions and counterfeited one with the stylus."

60) Two peonies on vellum.

61) A lion on vellum with a piece of turf.

62) Two peonies. Much foliage.

63) A little columbine with its foliage on vellum.

64) A thistle with many floral works on vellum.

65) Buttercups and clover on vellum.

66) Lily of the valley and alkanet, little white flowers and foliage on vellum.

67) Double violets on vellum.
In the Albertina Collection in Vienna.

68) A female nude, gray in gray.

69) Two female nudes on vellum.

70) Two nudes and other figures drawn by Albrecht Dürer.

71) Drawing of a drinking-vessel. (A monstrance?)

72) A little child on vellum.

73) Drawing of soldiers in Ireland.

74) Three old Stürz women.

75) A Sturz woman going to church.
Now in the Albertina Collection, Vienna.

76) A woman dressed as one would go dancing in olden times.

77) A piece showing how young girls would go dancing years ago.
In the Albertina Collection, Vienna.

78) An old woman, as one would dress in houses years ago.
In the Albertina Collection, Vienna.

79) How the fashionable women dress in Iceland.

80) Two small pictures of women, as the powerful women dress in Iceland.

81) Two costumes as worn by ordinary women in Iceland.
[p. 84]

82) Sketch of the bridge by the Little Gate at the Haller-Thürlein.
In the Albertina Collection, Vienna.

83–85) Three sketches of three horses.

86) An ostrich. An ox. Two toads and a lizard.

87) A sketch for an altar, made by Dürer in Frankfurt.
This magnificent altar, which was constructed from the drawing, was still in Frankfurt in 1650. (See below.)

88) A Petronica on cloth.

89) An old cuirassier in silverpoint.

90) A stork. Several riders, male and female.

91) Several old mounted soldiers.

92) A sketch for Adam and Eve that Dürer engraved on copper.

93) Two hands in red chalk.

94) Drawing of four figures together.

95) A well, drawn on vellum.

96) Drawing of a Roman emperor and king.

97) Emperor Charlemagne's crown.

98) Emperor Charlemagne in his habit.

99) Emperor Charlemagne's sword. His glove. His orb.

100) Drawing of various drinking vessels.

101) Virgin Mary. A stag's head.

102) Saint John on parchment.

103) A holy picture with a dragon.

104) Drawing of Christ on the Cross.

105) Drawing showing the Slaying of the Innocents.

106) Four men's heads, one behind the other.

107) An old mounted soldier on his horse.

108) Saint Sebastian. An old sketch.

109) Two men.

110) Christ's Crucifixion.

111) A small picture of a man.
[p. 85]

112) Christ being led out.

113) Several nudes.

114) A fantasy drawn by Dürer's hand.

115) Four nudes.

116) A small picture of the Virgin. A woman.

117) Portrait of a town. Two little children grown together. Assorted animals.

118) Again assorted animals.

119) Various birds and heads.

120) Strange fantasies.

121) A bagpipe player on a donkey.

122) A woman — picture.

123) Drawing of the two Marys, as engraved on copper by Dürer.

124) Sketch of a painting as in the Town Hall.

125) Four sketches together.

126) Further assorted drawings.

128) Several more drawings.

129) Several drawings of bottles and beakers by Dürer's hand.

130) Triumphal chariot of Emperor Maximilian I, drawn by Dürer and later made into a woodcut by him, of which this is the first sketch.

The Imhoff *Geheimbüchlein*

(confidential notebook)
Stadtbibliothek Nürnberg, Amb. 63, 4°

The English translation that follows is based on the transcription in JPK 49/1928, Supplement 1929, pp. 47–54, by Erwin Rosenthal. The German transcription followed the original as closely as possible, preserving certain idiosyncrasies, but correcting punctuation to assist the reader. The English does the same in regard to punctuation and also makes the spellings of proper names consistent.

Kunst Cammer

[f. 67r] Although my dear father was often willing to indicate how his art chamber was to be preserved after his passing away, and he desired such conversations with all his heart and urgently advised his sons about this, still, when he was reminded of the matter during his last illness by his two sisters, Mistress Tobias Tucherin and Mistress Carol Tetzlin, he then did not have the desire anymore, but rather answered that his children would surely know themselves how to make the best use out of this or that item. He did not mention his earlier plans concerning the art chamber in the least, but intimated instead to his sister-in-law, Mistress Tobias Hallerin, that none of these things brought him any more joy, and that he very much regretted the fact that he had sunk so much money into it; out of this conversation one does not get the feeling that he wanted to bind his heirs to an agreement not to alter the art chamber in any way, but instead he gave them free rein to do as they pleased. Nevertheless, in spite of his liberty, we two brothers have had no desire to remove anything from it, but wished to keep it together, intact, in shared ownership. And although we recently [f. 67v] had a request from Mr. Lucas Friedrich Beheim, by command of His Highness the Elector of Bavaria, that we should send each and every piece by Dürer to Munich for him, with greatest care, as he pleased to travel there on business, and his Serene Highness had a great desire to see these, and was disposed to purchase what was acceptable to him, yet we initially gave the aforementioned Mr. Beheim a negative answer, as we did not wish our goods to be sent such a long way overland. But as his request was made with such fervor, I did at last agree to pack the desired pieces by Dürer and, since I was somewhat sick at the time, let Brother Paul offer them to His Serene Highness for a certain price. But when His Highness the Elector was shown them, he had no desire for them, and considered many of them not to be originals, and returned them all (except for a small Saint Jerome and a small panel, on which A. Dürer, before he became a painter, had drawn three little faces, for which he paid 200 Reichsthaler, and honored both my brother and myself with a penny allowance, and my brother and Mr. Behaim left the inn and were graciously dismissed) [f. 68r] and made no offer for them. In March in the year 1633, comes Abraham Blommart, a Netherlander and local inhabitant, to Friederich von Berck, and shows him a commission he has got from a noble merchant of Amsterdam to purchase some pieces by Dürer for him; but because he did not know where the like were to be found, he asked him to make inquiries where one might obtain such things. To which the said von Berck replies, he knew of nothing of the sort around, except in possession of the late Hans Imhoff's heirs, but he did not think that they would sell their things, but would talk to me about it and inquire how things stood, and would let Blommart know my answer. When the said Berck gave me to understand this, I promised to confer with the guardians of my late brother's children and heirs, the which I did; and they unanimously decided that, since our late father left no instruction in his will regarding his Art Chamber, although reminded to do so by his two sisters when he was in his last illness, we therefore have a free hand and [f. 68v] in these present hard times, when all our income is blocked, both in the business in which our late father sank all his capital, and on the land because of the ruination of the partnership, no sensible man could blame us if, to our better maintenance, we should decide to make some silver out of these totally useless art pieces, among which are many watercolor paintings, which are already rather damaged and in time will probably be moth-eaten and totally ruined, and they therefore intently begged me to negotiate so that if possible a bargain may be struck with each and every one of Dürer's pieces, good and bad together. After the desired agreement was reached, I made out a list of all our Dürer pieces pricing each one separately and gave it to Blommart himself, who sent it to his client in Amsterdam, from whom he had an answer within 3 weeks, authorizing him to deal with us on the best terms he could. He then sent a knowledgeable painter Michael Herr to inspect the pieces, and on May twentieth[1] concluded a purchase with me for a sum of 3400 Reichsthaler in cash, he however retaining 100 Rth. for his [f. 69r] trouble, and because it depended on him to pursue or abandon the purchase. So, praise and thanks to God, we made a better deal than we could ever have imagined, for certainly among all the pieces sold there was not a single important one, but for the most part small items painted in watercolor, among them many where there may well be doubt whether Albrecht Dürer really did paint them. To our great good fortune, this purchase was made with such pleasure and speed, that another Netherlander is come from Leyden during the transaction, by the name of Mattheus von Overbeck, who also applied to buy our things, which I gave Blommart to understand, whereupon he quickly dealt with us and only deducted 120 Rth. from the total sum of the sale; but we gave him with the purchase the beautiful little Popish prayer book that Holbein had painted in Basel, and all the more readily permitted the deduction of the above-mentioned 100 Rth., because he promised that he would do his best to recommend our other art objects to his employer, and ensure that he would buy further noteworthy pieces, to which purpose we have made out a detailed list for him of all the remaining pieces, in the hope that yet another transaction may be arranged.

[f. 69v]
Here follows the description and prices of the items sold.

1. A picture of the Virgin Mary in the Garden, oil colors on vellum, in a large gilt frame for Rth. 300 —
My grandfather Mr. Willibald Imhoff noted in the booklet where he recorded his antiques and paintings that this piece was supposed to have been painted by Albrecht Dürer and bought by him from Frantz Spengler for fl. 9; in the inventory of his Art Chamber, my father, however, values it very highly at fl. 400 —. Many other art experts consider it not to be from Dürer's hand.

2. A small panel painted on vellum, framed in ebony and silver, showing Mistress Pirckheimer on her deathbed,[2] by Dürer's own hand Rth. 200 —
Our late father valued it at about fl. 150 —.

3. A beautiful panel of the same size by Dürer's own hand, therein a landscape, a hunt and beautiful foliage together with two women holding the Pirckheimer and Rieter coats-of-arms in their hands, on vellum Rth. 200 —
Our late father valued it at fl. 150 —.

[f. 70r]
4. Head of a hare with 4 ears by Albrecht Dürer on vellum Rth. 150 —
My late father valued it at fl. 100 —.

5. A small panel, therein 4 different Pirckheimer coats-of-arms, as cut out of books, in watercolors [*Gummifarben*] Rth. 60 —
Our late father valued it at fl. 40 —.

6. A small wooden panel, showing a young man painted by Albrecht Dürer's hand Anno 1507, in oil colors Rth. 160 —
My late father valued it at fl. 200 —.
My grandfather, however, only at fl. 16 —.

7. A small wooden panel in oil colors, Adam and Eve, is all worm-eaten Rth. 100.—
My late father bought it at Lyon as by Albrecht Dürer's hand for 40 fl., but values it at fl. 100 —.

8. A large panel on cloth, watercolors, the birth of Christ by A. Dürer Rth. 300.—
My late grandfather valued it only at fl. 3 —, but my late father at fl. 100 —.

9. A panel on cloth, watercolors, wherein A. Dürer painted himself when he was 26 years old Rth. 150.—
My grandfather put it at about fl. 120, but my father at fl. 50 —. It is already rather damaged.

1 In the margin: A.C. 1633.
2 Rosenthal refers to two paintings, in Vienna (Rothschild Collection) and Bremen (Kunsthalle). According to Anzelewsky, 1971, pp. 182–184, No. 81K, we know of at least five versions.

10. A picture of the Virgin Mary on cloth, watercolor, very damaged, by A. Dürer Rth. 150.—

My grandfather puts it at about fl. 4, but my late father about 50.

11. Saint Simon on cloth in watercolors, A. Dürer's hand, is very damaged and faded Rth. 150.—

My late grandfather puts it at about fl. 3 —, but my late father about fl. 50 —.

12. Albrecht Dürer's mother, on wood in oil colors; many hold it not to be Dürer's work Rth. 150.—

My grandfather put it at about fl. 10 —, but my father at about fl. 40— .

13. A panel, Christ being led out, on wood in oil colors, gray in gray, said to have come from A. Dürer's workshop Rth. 130.—

It cost my late grandfather fl. 80, but he values it at fl. 120, and my late father decided to leave it at that.

14. A man on parchment, was Albr. Dürer's master in Strasbourg Rth. 50.—

My late grandfather estimated about fl. 4. My late father, however, about 50 fl.

15. A hare on paper, said to be painted by Albrecht Dürer Rth. 30.—

16. A very small Ecce Homo, the Mistress Pirckheimerin kneeling in front of it, on parchment Rth. 50.—

My late father put it at about fl. 25 —.

[f. 71r]

17. A beautiful wing one foot high (!), painted on vellum by Albr. Dürer Rth. 250.—

My father valued it at about fl. 200 —.

18. A leopard painted on vellum by Albrecht Dürer Rth. 50.—

My late father's estimate fl. 20

19. A parrot and three other feathers, on vellum by A. Dürer Rth. 50.—

My late father puts it at about fl. 40.—

20. Three beautiful sketches on paper, gray, Saint Peter and Saint Paul by Albrecht Dürer and Saint John's head by Hans Hoffmann, together at Rth. 150.—

My late father estimates about fl. 100 —.

21. Portrait of Herr Willibald Pirckheimer and his housewife, drawn by A. Dürer on paper with charcoal Rth. 40.—

My late father valued it at about fl. 40 —.

22. Dürer's prints from copper and wood plates, very neatly put together in a fine book, but a number of pieces are missing Rth. 200.—

23. A small panel framed in ebony, the Crucifixion of Christ with the whole passion, surrounded by small golden ornaments [Klein von golt herum geziehrt], by Lucas von Leyden on parchment Rth. 200.—

My late grandfather estimated it at fl. 12, but my late father at about fl. 100 —.

[f. 71v]

24. A small panel in oil paints on wood; it is a Crucifix with a landscape by Albrecht Altdorfer's hand Rth. 100.—

My late grandfather held it to be by Andreas Amberger's hand and valued it at fl. 16 —, but my father about fl. 100 —.

25. An artistic hare, on parchment, by Hans Hoffmann. It is framed in ebony ornamented with silver Rth. 100.—

My late father put this piece at about fl. 100 —.

26. A small panel with a picture of a man on vellum, by Holbein in Basel Rth. 50.—

My late father valued it at about fl. 40 —, but my grandfather only about fl. 3 —.

All told the complete estimate for these pieces Rth. 3520.—

[f. 72r]

The following pieces were sold in the year 1634 to Mattheus von Overbeck of Leyden in Holland.

I. 14 books from the Pirckheimer Library as follows: I. Appollonius in quarto. Below the book title 2 little naked boys with wings, holding the Pirckheimer and Rieter coats-of-arms in their hands, painted in watercolors by Albrecht Dürer's hand. II. Luciani opera et multa alia graecè; pictura: a landscape with 4 satyrs, one with a fiddle, another with a flute, the third with a bow, the fourth, a young female, has the Pirckheimer [sic] coat-of-arms in her hands. III. Dioscorides et Nicander graecè. Pictura: A satyr with the Pirckheimer coat-of-arms hanging from a lance on his back, who is giving a man in a blue coat some herbs. IV. Thucidides graecè. Pictura: Three satyr women and a man, who sit on whales that seem to be swimming in the sea, and are striving with each other, they have the Pirckheimer and Rieter coats-of-arms in their hands. V. Libri Ethicorum et Politicorum Aristotelis graecè; pictura: 2 Swiss with halberds holding the Pirckheimer coat-of-arms in their hands. VI. Julius Pollux graecè; pictura: Two whales with two naked little boys kneeling on them, who have the heads of two Romanic statues in their hands, on the tail of one of the whales sits a cockerel, on the [f. 72v] other a rabbit, in the center the Pirckheimer coat-of-arms encircled by a little wreath. VII. Aristotelis Organon graecè. Pictura: Also two whales swimming in the sea, on which sit two armed boys, fighting with each other. VIII. Simplicius in decem Categorias Aristotelis graecè. Pictura: On a pole or half a tree hang two festoons and the Pirckheimer and Rieter coats-of-arms, on the festoons sit two angels playing the violin. IX. Aesopi Vita a Maximo Planude composita et alia multa graecè et latinè. In the first capital letter sits an owl, but under the title of the book a wild man and woman; they hold the Pirckheimer coat-of-arms in their hands. X. Thesaurus Cornucopiae graecus. Pictura: In a wreath stand two angels, one has a trumpet and the other the Pirckheimer coat-of-arms in his hands. XI. Theophrasti historia Plantarum. Item de causis Plantarum, Aristotelis et Alexandri proplemata. Item Aristotelis Metaphysica graecè. Pictura: Two naked half-boys with long ears and the lower halves of their bodies shaped like a fish, each one holding a little basket of grapes, on which sit two birds, likewise holding the Pirckheimer coat-of-arms in their hands. XII. Theocriti Eclogae triginta et alia multa eiusdem authoris. Pictura: A beautiful landscape, [f. 73r] with two shepherds minding their sheep; one shepherd fiddles, the other pipes, and the Pirckheimer and Rieter coats-of-arms hang from two trees. NB. This is the best painting and most comprehensive work. XIII. Carmina Gregorii Nazianceni graecè et latinè. Two small boys fencing with each other, having the Rieter and Pirckheimer coats-of-arms painted on shields in their hands. XIV. Lexicon graecolatinum, an old dilapidated book. Pictura: Below the title the Pirckheimer coat-of-arms very small on a little shield. These 14 books, each with something painted below its title by Albrecht Dürer's own hand, have been made over to the buyer Overbeck for Rth. 300. —

NB. Our late father had in his lifetime cut the best pieces out of the other books, and given away some as presents, but had some neatly framed and made into small pictures.

II. A picture of the Virgin Mary with her Child, painted on vellum. Small, the size of quarter of a sheet of paper; Hans Imhoff, my late great-grandfather, had this painted at Antwerp. I made out to Overbeck that it was by Lucas van Leyden; an sit, dubiatur a multis; it is valued at Rth. 100.—

III. A picture of the Virgin Mary on wood in oil paints, small. My late father had Alb. Dürer's mark painted underneath, but for all that one could not really believe that Albrecht Dürer had painted it, for Rth. 50.—

[f. 73v]

IV. A fine lion [!] on vellum, admittedly with A. Dürer's mark underneath, but one feels that only Hans Hoffmann could have painted it, for Rth. 40.—

V. A small Ecce Homo on wood, a copy after Dürer, my late father sold the original to Augsburg for 100 gold fl. a long time ago, for Rth. 40.—

VI. A dead man (!) on cloth, watercolor, it is certainly a really Dürerish piece, but very repulsive to look at, up to now no one has wanted to buy it Rth. 40.—

VII. Four sketches, to wit a Scotswoman, also a small lion drawn in charcoal, a man with a violin, a young fellow and a girl, drawn by Anthoni Dürer, brother of Alb. Dürer, Albrecht Dürer's mark is nowhere except under the lion, all together come to Rth. 60.—

VIII. Portrait of Willibald Pirckheimer, very small, cut in stone (!) by Dürer, for Rth. 30.—

[f. 74r]
IX. The great Triumphal Arch by Dürer, is illuminated and has been rather patched, for Rth. 40.—

X. The horns of a hare with its pan [*Raurackl*], as brought in the year 1525 from Spain, for Rth. 30.—

Total Rth. 730.—

Further[1] I have a small neat piece by Dürer, which my late father cut out of a book and bestowed on Heinrich Müllegg, it was bought back from Müllegg and sold together with the above pieces to Mattheus von Overbeck for Rth. 26.—

Total of all these pieces Rth. 756.—

And although the said total of 756 Rth. had been agreed and concluded by various exchanges of letters, meanwhile von Overbeck had not seen the things, but bought the same solely on my recommendation, and since after receipt they did not altogether please him, he almost wished to let the whole purchase be returned, and reduced the buying price by 56 Rth. and paid no more than Rth. 700 —

1636.

[f. 74v]
When[2] in May the English Ambassador Milord Arundel was sent to see their Imperial Majesty about the restitution of the Electorate of Pfalz, he came to Nuremburg and stayed some considerable time here, and among other things visited our Art Chamber for the third time and promptly made an offer for the Pirckheimer Library. Although I for my part was not disposed to sell the said library, but to keep it for the sons, the guardians of my brother's children considered it expedient not to let slip from our hands this good opportunity, which would probably never present itself again, because the said library was very old and many books, particularly the manuscripts, were in such a state that they were hard to read, and nowadays such books can mostly be obtained new and in good editions, which in time will be much more useful to our young people than such cumbersome old editions. Albeit I was very unwilling to change my mind about disposing of [f. 75r] the aforesaid library, I was in fact content to concede, because at this time I was finding it very hard to gain a livelihood, since for 5 years I had not enjoyed a pennyworth of profit from my estates at Lonerstatt, and my garden was demolished, the interest from the money at the accounts office [*Losungstuben*] had not been paid, and God Almighty had first afflicted my wife with severe illness for a year and a day, and finally visited a high fever upon myself too, at the very time when this purchase was going forward, and for this I was greatly in need of money. After that the

oft-mentioned Pirckheimer Library was sold after tedious negotiation and debate for 350 Rth. And although I made keen efforts to raise the sum to 400 Rth., it was not to be, as this gentleman takes care to shop wisely indeed. When one adds in the 300 Rth. that Mattheus von Overbeck paid for the 14 books previously sold, the Library has been disposed of for fl. 975 and that is[3] fl. 175 — more than my late father paid his brother Carl Imhoff for it.[4] The said gentleman has bought more from our Art Chamber, as follows

14 particularly fine roebuck antlers, among them one of a Red-Indian goat, in which antlers nature has created wonders, for Rth. 50. —

[f. 75v]
2 bowls and 2 saltcellars of Limousin work for Rth. 20.—

Portrait of Pirckheimer, engraved by Dürer on copper Rth. 40.—

With the purchase we also had to give 2 quite large cut jasper stones, which Milord dropped and broke while he was inspecting them, but in fact they were of no particular antiquity; also 3 old vases, rather bad ones, 2 of clay [? *daen*] and one of copper.

This gentleman has bought with exceeding frugality and exactitude, so we have made no profit from him, and had I not been in such great need of money, he should not have got these things for so little a sum. But one must reckon one thing against another, and if I have sometimes disposed of a piece a little more cheaply than my late father valued it, one has on the other hand made a handsome profit on the first two deals with the Netherlander.

1636. 1637.

[f. 76r]
During the above years, a highly respected assembly of electoral and princely personages were in Regensburg, among them even their Majesty the Holy Roman Emperor, king of Bohemia and Hungary, where at that time the Roman King [*sic*] was also chosen and crowned, and various people sent all kinds of costly goods and works of art and offered them for sale there, so with the consent of the guardians of my late brother's children I too dispatched a number of things from our Art Chamber to Conrad Paulus Fürleger for him to sell for a fixed commission; but he managed to sell few, as people wanted to give almost nothing or very little for even the best pieces.

Would I had sent nothing to Regensburg, because of the great expenses of customs duty, commission, carriers, wagons, and so forth, against such mean takings.

The following were sold.

19 pieces of old Roman earthenware vessels, one should have been an urn, most of them became damaged, for Rth. 30.—

4 small female heads painted in oil colors on parchment by a very old, good, but unknown master, set in a neat little black frame, for Rth. 16.—

[f. 76v]
Judith carved into a stone of white marble, by a good but unknown master, for Rth. 16.—

Saint Sebastian, small woodcut, supposed to have been done by Dürer, but no art expert is willing to accept it as such, for Rth. 8.—

Also at this time sold to Fürleger a small Birth of Christ by L. von Cranach, for Rth. 10.—

Item in December in the year 1637 Mattheus von Overbeck in Amsterdam bought from Friederich von Berck some of the works of art we had sent to him:

A beautiful wing, one foot high, painted on vellum by Hans Hoffmann's hand for Rth. 50.—

Item, a hare, painted on paper, framed in black-painted wood, by the above hand for Rth. 25.—

Item[5] several beetles [*?Schöter = Schröter*] painted on paper also by this hand for Rth. 12.—

On March 27, in the year 1638, Baron B. Jörger bought:

Two small heads sketched on paper and mounted on cloth, not completely finished (?), by an unknown master Rth. 4.—

[f. 77r]
Item two small pictures drawn on parchment, one by the old Master Langen, the other by an unknown hand, both together for Rth. 4.—

These pieces appear to have been bought.

Again the above Mr. Jerger [*sic*] bought a small head of a man in ink on paper by a good but unknown master for Rth. 5.—

On April 13, in the year 1638, Paulus Conrad Fürleger bought the following pieces from our Art Chamber, to be paid for in copies within 6 months:

Titius in marble, an excellently artistic piece for Rth. 100.—

20 small cast metal pictures, many of them damaged, several of them only casts, for Rth. 62.—

A gladiator cast in metal, a good piece, said to be the work of Jean di Bologna, for Rth. 50.—

The conversion of Saint Paul, oil colors on wood, by Zibett, for Rth. 40.—

Saint Sebastian, oil colors on wood, a very fine copy by Friederich von Falckenburg [*Valckenborgh*] after the original by Raphael d'Urbino, for Rth. 40.—

1 The following to the end of the page is written in different ink and was probably added some time later.

2 The following (to folio 75v incl.) is written in different ink and another handwriting, therefore later.

3 From "and that is" to the end of the sentence there is a later addition in a different ink.

4 The following postscript appears in the side and bottom margins: "This Library has also been offered to von Overbeck, as he has been a great admirer of these studies and has various stipends at Leyden in Holland. He has said nothing about it, however, as also since my late father's death no one has desired to see or to buy the things. But when they have been disposed of, many have alleged they would have bought them at a higher price; if this be true I cannot know."

5 In the margin of this and the two foregoing entries the note: "Probably bought just like that."

An old portrait on wood in oil colors by an unknown master, for Rth. 25.—

Another portrait on wood by Sebald Behaim for Rth. 25.—

An Ecce Homo by Lucas von Cranach Rth. 8.—

On July 19, 1639, M. Schwanner glazier bought a very small panel painted by Gollen (?) for Rth. 8.—

By August of the same year, Friederich von Berck of Amsterdam, to whom I had sent the following pieces during the Lenten Mass in Frankfurt, had not been able to sell several of them, to wit

Books by Dürer and Lucas von Leyden, that, being last prints, were bad and incomplete; item a piece on paper in pencil and ink, the Resurrection of Christ by an unknown master; item Dürer's portrait, small on wood, rather crude; a small head of a man in ink, rather good; a Bionia stallion; 3 lilies of the valley by Hans Hoffmann, 3 very small pieces sketched by Martin Schön, and 4 more small pieces sketched by Israel van Mecheln all together and all told Rth. 100.— It can be presumed that Berck will have looked for some advantage for himself from these sales; I was quite disposed to have the above-mentioned pieces brought back here, only shrank from the great expense.

1637

[f. 78r]
Last February Heinrich Müllegg sent to Earl Lesler of Regensburg: Orpheus, a good copy of the original by Paris Rectoris (?), the Beheading of St. Maurice by Hans Kircher (?), the Birth of Christ by Lucas von Cranach and a picture of the Virgin Mary by the same master, with a small panel, which belonged to my children, the which all together were sold to him for 200 Rth. We however had to solicit for this money over 4 years,[1] and it was finally transferred to us on deduction of 50 Rth. at the accounts chambers [*Losungstuben*] of E. E. Rath Rth. 150.—

NB. My children's panel was valued at[2]

1646

On September 9 Georg Schwanhardt bought the following pieces, to wit:

The Crucifixion of Christ painted on cloth by the old Prügel [?Brueghel] for Rth. 30.—

Two small landscapes, one painted on wood, the other on paper for Rth. 10.—

A small panel of marble for Rth. 4.—

1649.[3]

[f. 78v]
It is now many years ago that we began selling our Art Chamber, and for several years we

1 Marginal note in different ink: "finally even had to sue."
2 Price not entered.
3 The following (up to f. 79r below) in a different hand.

have been looking about for a buyer for the marble statues, 56 of them, large and small, good and bad, most of which have been patched, also for the 6 cases of Roman and Greek coins and medallions, to wit a small one with gold, 4 with silver, and a large one with copper, all rather overpriced by our late grandfather.[4] In all this considerable time, however, no buyer has yet been found. At last Heinrich Müllegg approached us on behalf of an unnamed stranger, but offered no more than 1200 Rth. for all the above-indicated things. As I could not by a long way liken this offer to the above-indicated estimate by my grandfather, [f. 79r] I could not consider it advisable or responsible toward my young cousins to throw away such talked-of rarities at such a low price, although my brothers and sisters and their sons' guardians and also my own coguardian Hanns Moritz Füerer thought highly of this price, until finally I was defeated by my avaricious relatives, so still against my will, and after long thinking over and customary bargaining, was obliged to conclude the deal with the oft-named Müllegg for 1925 fl. in cash. Another consideration affecting the outcome of this transaction concerned my foster son Johannes Pauluss Imhoff, who was determined perforce to continue his peregrinations, irrespective of the fact that no means for this would be available unless this sale took place. Concluded on March 5 in the above year.

For my pains I managed to squeeze 6 fl. out of the sale for my little daughter.

NB. I promised the aforementioned Müllegg 50 Rth. if he would name the person for whom he wants to buy these rarities, for I would have liked to deal with him myself. But I was able to get nothing from this bargain-broker.

The[5] statues appear to have been bought for Duke Augustus of Braunschweig and Lüneburg. Forstenhaußer paid the money.

4 The following passage has been added in the top margin: "These coins, also the statues, had been offered for sale to Arundel, also to H. von Overbeck. And lastly to Archduke Leopold Wilhelm by letter. Item to the Elector of Bavaria."
5 This section is a later addition.
The manner in which these records were made may be summed up as follows. The first part is written in one continuous flow with the same ink up to the top of f. 74r, that is to say after the conclusion of the deal with Overbeck, but before the settlement of the bill, which is recorded in two later entries that follow on f. 74r. These parts are therefore composed retrospectively as a relatively fair copy, taking into account other notes and documents, which is evident from the lack of postscripts, etc. All following entries have been made piecemeal, as differences in ink and handwriting show, so presumably each sale was recorded as it was made; here we find various corrections, postscripts, and marginal notes. The description of the 1649 sale has not been written by H. H. Imhoff himself, but (presumably at his dictation) by another hand of rather younger style; the marginal notes and additions to this section, however, also the 1658 entries, are written by himself in ever-deteriorating handwriting.

[f. 79v]
From all the things here specified and sold, my late brother's sons have properly received their half share in cash, as the reckonings sent to them at all times can show.

1658.

On September 9 the art dealer Frantz Rößel paid fl. 12.— for a piece painted on glass, King Belshazzar's Feast, Augsburg work. As long ago as 1659 [*sic*] the above Rößel was given several different items from the relics of our Art Chamber to sell in Prague. But since he had not been able to sell a single piece, after a long time he handed them back, but the above piece he said he had sold in Frankfurt for 15 fl., but for his pains, risk, and freight charge he desired a recompense, for the which he was honored with 3 fl. of the 15 fl. remitted.

Extract from the correspondence between the Viennese collector and dealer Joseph von Grünling and the Hamburg art dealer Ernst Georg Harzen dated May 16, 1827

"I can reliably assure you that the goods are very beautiful and completely genuine; I have a good understanding of these things as you well know. Bear in mind that I made the purchase under very favorable circumstances; and when you are sent the account from the former Duke Albert Gallery Director Le Febre, you may see for yourself that about 40 pieces from this collection for around 460 Fr. cash was a fair bargain. Nearly all of them seemed to be removed and included with the works passed to Le Febre by the deceased Duke, who had gotten the Maximilian legacy, since the Duke received so much and probably did not wish at that time to accept and keep repeated copies of the same drawing. If my works are compared with the aforementioned gallery's drawings, even the layman may see that the former are in no way inferior to the latter; this and Heller's notes are all that I can in truth and honesty guarantee you about these drawings."

———

Quoted from Emil Waldmann, "Die Einkaufspreise für Dürers Landschaftsaquarelle in Bremen," in *Albrecht Dürer, Festschrift der internationalen Dürer-Forschung* (Berlin, 1928), from the papers of the Bremen Kunstverein.

Bremen War Losses

Mentioned in the literature, no copies or photographs extant; from old card-index records:

OSTENSIBLY ALBRECHT DÜRER 31A

Alkanet (*Anchusa officinalis* L.)

Viper's Bugloss (*Echium vulgare*)
Unsigned, 262 x 205 mm, body color, W. 349
Lippmann • Winkler, vol. VII, no. 840, there still referred to as Viper's Bugloss
Watermark: tall crown, Hausmann No. 21

OSTENSIBLY ALBRECHT DÜRER 32A

Various Plant Studies

Left stem, leaves, and one flower of the wild poppy (*Papaver rhoeas*) in watercolor. Also in the same manner peas (*Pisum sativum*), vetch (*Vicia sepium*), hairy vetch (*Ervum hirsutum*), and a single flower of monkshood (*Aconitum napellus*). Lastly an entire bush in silverpoint. Unsigned, 138 x 185 mm, silverpoint, tinted in places with watercolor.
Ephrussi, p. 80; also W.

ALBRECHT DÜRER 33A

Plant Studies

Left, a nipplewort (*Lapsana communis*) showing the whole plant. Likewise a hedge mustard (*Erysimum virgatum*). Upper right stem and lower leaves with detached flower and feathery seed head of dandelion (*Leontodon taraxacum*). Below, a whole plant of cranesbill (*Geranium pusillum*). Unsigned, 268 x 340 mm, body color on vellum.
The paint has flaked off in places, namely below left and right.
Ephrussi, p. 80.

ALBRECHT DÜRER (?) 36B

Two Stems of a Wild Peony
(*Paeonia corallina*)

Unsigned, 377 x 303 mm, body color, watercolor, fold splits, and isolated mildew spots
Ephrussi, p. 80, W. 351.
Watermark: tall crown, Hausmann No. 4.

Inventory of Studies by Hans Hoffmann described as Paintings in the Paul Praun Collection

Copied from Christoph Theophile de Murr, Description du Cabinet de M. Paul de Praun à Nuremberg (Nuremberg 1797), pp. 16–18

	Haut.		Larg.	
	Pouces.	Pieds.	Pouces.	Pieds.
HANNS HOFMANN, jusqu'au Num. 134.				
128. Un Liévre au gîte entre plusieurs herbes, fleurs et insectes, peint en détrempe, *sur vélin.* 1582.	I	10	I	8
129. Deux chardons et quelques herbes et fruits. 1580.	I	6		2
130. Un Liévre mort pendant à un clou. *Hans Hofmann acheva ce tableau en* 1586 *à Prague, où il travailloit pour l'Empereur* Rodolphe II. Il commençoit ce tableau en 1583. et faisoit un autre d'après en huile pour ce Monarque, qui le denomma pour. son Peintre. Ce Liévre est peint si admirable qu'on le peut mettre en parallèle avec celui du fameux Peintre *Polygnote.* Apostolii Centur. XVI, Paroemia 39. Πολυγνωτου λαγως, Le Liévre de Polygnote. Sur vélin, comme les suivans.	2	9		9
131. Un petit liévre. 1582.		9		8
132. Un liévre au gîte sous un arbre.	I	9	I	9
133. Quelques Fleurs. 1582.	I		I	3
134. Tête d'un enfant, lavée en bistre.		7		5
HANNS HOEFNAGEL.				
135. Quelques Insectes. *Sur vélin, comme les suivans.*		4		6
136. Quelques Fleurs et Insectes, du même.		6		5
HANNS HOFMANN, jusqu'au Num. 148. *Sur vélin.*				
137. Un chien. 1585.		5½		4
138. Un cheval.		6½		6½
139. Un oiseau. 1583.	I	2		7
140. Six oiseaux.	I	3	I	I
141. Un oiseau réposant sur le tronc d'un arbre.	I	6	I	2
142. Un autre.		11		8
143. Un Rhinocéros.		9		11
144. Un Lion. 1577.		7		11
145. Une Lionne. 1577.		7		11
146. Un Elefant.	I	3		11
147. La grue du Brésil. Grus Cariama *Marc-grauii.*	I	I		8
148. Quelques Fleurs. 1578.	I		I	7

Bibliography

General Literature

Adel, Kurt
Konrad Celtis. Vienna, 1956.

Anzelewsky, Fedja
"A propos de la topographie du parc de Bruxelles et du quai de L'Escaut à Anvers de Dürer," in *Bulletin des Musées Royaux des Beaux-Arts.* Brussels, 1957, pp. 87–107.

Anzelewsky, Fedja
Dürer-Studien, Untersuchungen zu den ikonographischen und geistesgeschichtlichen Grundlagen seiner Werke zwischen den beiden Italienreisen. Berlin, 1983.

Baldacci, Antonio
"Leonardo da Vinci als Botaniker," in *Festschrift der Mostra Leonardo da Vinci,* edited by Sandro Piantanida and Costantino Baroni. Milan, 1939, Berlin, 1940, pp. 448–454.

Baldass, Ludwig
Jan van Eyck. London, Cologne, 1952.

Battersby, Martin
Trompe-l'œil: The Eye Deceived. London, 1974.

Baum, Julius
Martin Schongauer. Vienna, 1948.

Baumgart, Fritz
Grünewald, tutti i disegni. Florence, 1974.

Beenken, Hermann
"Dürers Kunsturteil und die Struktur des Renaissance-Individualismus," in *Festschrift Heinrich Wölfflin.* Munich, 1924, pp. 183–193.

Beenken, Hermann
"Dürer-Fälschungen ?" in *RKW* 50/1929, pp. 112–129.

Behling, Lottlisa
"Betrachtungen zu einigen Dürer-Pflanzen," in *Pantheon* 23/1965, pp. 279–291.

Behling, Lottlisa
"Eine 'ampel'-artige Pflanze von Albrecht Dürer: Cucurbita lagenaria L. auf dem Hieronymus-Stich von 1514," in *Pantheon* 30/1972, pp. 396–400.

Bergström, Ingvar
"Disguised Symbolism in 'Madonna' Pictures and Still-life," in *TBM* 97/1955, pp. 303–308 and 342–349.

Bergström, Ingvar
"Revival of Antique Illusionistic Wall-Painting in Renaissance Art," in *Acta Universitatis Gothoburgensis* 63/1957, Göteborg, 1957.

Bergström, Ingvar
"Georg Hoefnagel, le dernier des grands miniaturistes flamands," in *L'Œil* 101/1963, pp. 2–9, 66.

Bergström, Ingvar
"Georg Flegel als Meister des Blumenstücks," in *Westfalen* 55/1977, pp. 135–146 (Mitteilungen des Vereins für Geschichte und Altertumskunde Westfalens).

Bergström, Ingvar, and others
Natura in Posa. Milan, 1977.

Bernt, Walther
Die niederländischen Maler des 17. Jahrhunderts. Vols. 1–3, Munich, 1948; vol. 4, Munich, 1962.

Bernt, Walther
Die niederländischen Zeichner des 17. Jahrhunderts. 2 vols., Munich, 1957–58.

Białostocki, Jan
"The Renaissance concept of nature and antiquity," in *The Renaissance and Mannerism. Studies in Western Art.* Vol. 2, Acts of the 20th International Congress of the History of Art. Princeton, N.J., 1963.

Biese, Alfred
Die Entwicklung des Naturgefühls im Mittelalter und in der Neuzeit. Leipzig, 1888.

Bol, Laurens J.
The Bosschaert Dynasty: Painters of Flowers and Fruit. Leigh-on-Sea, 1960.

Bol, Laurens J.
Holländische Maler des 17. Jahrhunderts nahe den groß en Meistern, Landschaften und Stilleben. Brunswick, 1969.

Bott, Gerhard
"Stillebenmaler des 17. Jahrhunderts, Isaak Soreau, Peter Binoit," in *Kunst in Hessen und am Mittelrhein,* 1–2/1962, pp. 27–93.

Brande, Renilda van den
Die Stilentwicklung im graphischen Werk des Aegidius Sadeler. Phil. diss., Vienna, 1950.

Burkhard, Anton
Hans Burgkmair d. Ä. Leipzig, 1934.

Busch, Günther
"Das Schicksal der Bremer Dürer-Aquarelle," in *Museum-Heute, Ein Querschnitt.* Kunsthalle Bremen, 1948, pp. 23–31.

Carstensen, Jens
Über das Nachleben antiker Kunst und Kunstliteratur insbesondere bei Albrecht Dürer. Phil. diss., Freiburg im Breisgau, 1982.

Cassirer, Ernst
Individuum und Kosmos in der Philosophie der Renaissance. Studies from the Warburg Library. Vol. 10, Leipzig, Berlin, 1927.

Cetto, Anna Maria
Animal Drawings of Eight Centuries. London, 1951.

Chastel, André
Marsile Ficin et l'art. Geneva, Lille, 1954.

Chastel, André, and Klein, Robert
Die Welt des Humanismus, Europa 1480 bis 1530. Munich, 1963.

Chmelarz, Eduard
"Georg und Jakob Hoefnagel," in *JKSAK* 17/1896, pp. 175–290.

Christensen, Carl C.
The Nuernberg City Council as a Patron of the Fine Arts, 1500–1550. Phil. diss., Ohio State University, 1965.

Curtius, Ernst Robert
Europäische Literatur und lateinisches Mittelalter. Bern, 5th edition, Munich, 1965.

Cust, Lionel
"Jacopo de' Barbari und Lukas Cranach d. J.," in *JPK* 13/1892, pp. 142–145.

David, Harry
"Dürers Tierdarstellungen," in *Sitzungsberichte der kunstgeschichtlichen Gesellschaft.* Berlin, 1910, pp. 37–40.

David, Harry
"Zum Problem der Dürerschen Pferdekonstruktion," in *RKW* 33/1910, pp. 310–317.

Degenhart, Bernhard
"Ein Beitrag zu den Zeichnungen Gentile und Giovanni Bellinis und Dürers erstem Aufenthalt in Venedig," in *JPK* 61/1940, pp. 37 ff.

Degenhart, Bernhard, and Schmitt, Annegrit, eds.
Jacopo Bellini: Der Zeichnungsband des Louvre. Munich, 1984.

Dhanens, Elisabeth
Hubert und Jan van Eyck. Cologne, 1980.

Dodgson, Campbell
"Two Dürer catalogues raisonnés," in *TBM* 53/1928, pp. 201–203.

Dudík, Beda
"Die Rudolfinische Kunst- und Raritätenkammer in Prag," in *Mitteilungen der k.k. Central-Commission zur Erforschung und Erhaltung der Baudenkmale* 12/1867, pp. XXXIII ff.

Dvořák, Max
"Betrachtungen über die Entstehung der neuzeitlichen Kabinettmalerei," edited and enlarged by Ludwig Baldass, in *JKS* 36/1923, pp. 1 ff.

Ehlers, Ernst
"Bemerkungen zu den Tierabbildungen im Gebetbuch des Kaisers Maximilian," in *JPK* 38/1917, pp. 151–176.

Ehlers, Ernst
"Ephrussis 'Etude de fleurs' von Dürer," in *RKW* 40/1917, pp. 252–254.

Ertz, Klaus
Jan Brueghel der Ältere: Die Gemälde, Cologne, 1979.

Exhibition Catalogue *Niederländische Stilleben von Brueghel bis van Gogh.* Amsterdam, Fine-Arts Dealers P. de Boer, and Brunswick, Herzog Anton Ulrich–Museum, 1983.

Exhibition Catalogue *Nuremberg, A Renaissance City, 1500–1618,* compiled by Jeffrey Chipps Smith. Austin, Archer M. Huntington Art Gallery, University of Texas, 1983.

Exhibition Catalogue *Pieter Bruegel d. Ä. als Zeichner.* Berlin, Staatliche Museen Preußischer Kulturbesitz, Kupferstichkabinett, 1975.

Exhibition Catalogue *Künstler sehen Tiere.* Brunswick, Herzog Anton Ulrich–Museum, 1977.

Exhibition Catalogue *Albert Dürer aux Pays-Bas.* Brussels, Palais des Beaux-Arts, 1977.

Exhibition Catalogue *Fleurs et Jardins dans l'Art flamand.* Ghent, Musée des Beaux-Arts, 1960.

Exhibition Catalogue *Dürerrenaissance um 1600.* Hanover, Niedersächsische Landesgalerie, 1978/79.

Exhibition Catalogue *Old Master Drawings from Chatsworth.* London, The Arts Council, 1949.

Exhibition Catalogue *Meister um Albrecht Dürer.* Nuremberg, Germanisches Nationalmuseum, 1961.

Exhibition Catalogue *Martin Luther und die Reformation in Deutschland.* Nuremberg, Germanisches Nationalmuseum, 1983.

Exhibition Catalogue *Albrecht Dürer Jubiläumsausstellung.* Vienna, Graphische Sammlung Albertina, 1928.

Exhibition Catalogue *Künstlerische Überlieferung in der niederländischen und deutschen Malerei des 16. und 17. Jahrhunderts.* Vienna, Akademie der bildenden Künste, 1966.

Exhibition Catalogue *Renaissance Drawings from the Ambrosiana*. Washington, National Gallery, and elsewhere, 1984.

Exhibition Catalogue *Das italienische Stilleben von den Anfängen bis zur Gegenwart*. Zurich, Kunsthaus, and elsewhere, 1965.

Exhibition Catalogue *Leonardo da Vinci, Naturstudien aus der Königlichen Bibliothek in Windsor Castle*. Zurich, Kunsthaus, 1984.

Fossi Todorow, Maria
I disegni del Pisanello e della sua cerchia. Florence, 1966.

Fraenger, Wilhelm
Matthias Grünewald. Munich, 1983.

Friedländer, Max J.
Albrecht Dürer, Der Kupferstecher und Holzschnittzeichner. Berlin, 1919.

Friedländer, Max J.
Von Kunst und Kennerschaft. Oxford, 1946.

Friedländer, Max J.
Early Netherlandish Painting. 14 vols., Leyden, Brussels, 1967–1976.

Fučíková, Eliška
"Der Dürer-Stil und seine Vertreter am Hofe Rudolfs II," in *Umění* XX/1972, pp. 149–166.

Garas, Klara
"Zur Geschichte der Kunstsammlungen Rudolfs II," in *Umění* XVIII/1970, pp. 134–141.

Gerstenberg, Kurt
Albrecht Dürer, Blumen und Tiere. Berlin, 1936.

Gerstenberg, Kurt
"Die naturwissenschaftliche Richtung in der deutschen Blumenmalerei des 18. Jahrhunderts," in *ZKW* 7/1953, pp. 85–94.

Giehlow, Karl
"Dürers Stich 'Melencolia I' und der maximilianische Humanistenkreis," in *MGVK* 4/1904, pp. 57 ff.

Giesen, Josef
Dürers Proportionsstudien im Rahmen der allgemeinen Proportionsentwicklung. Phil. diss., Bonn, 1930.

Glück, Gustav
"Fälschungen auf Dürers Namen aus der Sammlung Erzherzog Leopold Wilhelms," in *JKSAK* 28/1909/10, pp. 1–25.

Goldberg, Gisela
"Zur Ausprägung der Dürer-Renaissance in München," in *MJBK* 3. Folge, XXXI/1980, pp. 129–175.

Gombrich, Ernst Hans
Symbolic Images: Studies in the Art of the Renaissance. London, 1972.

Gombrich, Ernst Hans
The Heritage of Apelles: Studies in the Art of the Renaissance. Oxford, 1976.

Grote, Ludwig
"Vom Handwerker zum Künstler," in *Festschrift Hans Liermann*. Erlangen, 1964, pp. 26–47.

Grote, Ludwig
"Dürer-Studien," in *Zeitschrift des Deutschen Vereins für Kunstwissenschaft* 19/1965, pp. 151–169.

Gwynne-Jones, Allan
Introduction to Still Life. London, New York, 1954.

Haendcke, Berthold
"Dürers Beziehungen zu Jacopo de' Barbari, Pollaiuolo und Bellini," in *JPK* 19/1898, pp. 161 ff.

Hampe, Theodor
"Kunstfreunde im alten Nürnberg und ihre Sammlungen," in *MVGN* 16/1904, pp. 57 ff.

Hauser, Arnold
Der Manierismus, Die Krise der Renaissance und der Ursprung der modernen Kunst. Munich, 1964.

Heinz, Günther
"Geistliches Blumenbild und dekoratives Stilleben in der Geschichte der kaiserlichen Gemäldesammlungen," in *JKS* 69, N.F. XXXIII/1973, pp. 7–54.

Held, Julius
Dürers Wirkung auf die niederländische Kunst seiner Zeit. The Hague, 1931.

Henkel, Arthur, and Schöne, Albrecht, eds.
Emblemata, Handbuch zur Sinnbildkunst des 16. und 17. Jahrhunderts. Stuttgart, 1967; Supplement, Stuttgart, 1976.

Hermann-Fiore, Kristina
Dürers Landschaftsaquarelle. Frankfurt, Bern, 1972; *Kieler Kunsthistorische Studien*, vol. I.

Hetzer, Theodor
Die Bildkunst Dürers. Stuttgart, 1982.

Hindman, Sandra
"The Case of Simon Marmion: Attributions and Documents," in *ZKG* 40/1977, pp. 185–204.

Hollstein, Friedrich Wilhelm Heinrich
Dutch and Flemish Etchings, Engravings and Woodcuts, ca. 1450–1700. Vol. I. Amsterdam, 1949 ff.

Hopper Boom, Florence
"An early flower piece by Jacques de Gheyn II," in *Simiolus* 8/1975/76, pp. 195–198.

Horn-Prickartz, Paula
Die Entwicklung der Blumenmalerei bis zur Entstehung des Blumenstillebens. Phil. diss., Göttingen, 1947.

Huizinga, Johan
Das Problem der Renaissance. Tübingen, 1953.

Imhoff, Carl Freiherr von
"Die Imhoff — Handelsherren und Kunstliebhaber," in *MVGN* 62/1957, pp. 1–42.

Justi, Ludwig
Jacopo de' Barbari und Albrecht Dürer. Phil. diss., Bonn, 1898.

Justi, Ludwig
"Jacopo de' Barbari und Albrecht Dürer," in *RKW* 21/1898, pp. 346–374, 439–458.

Justi, Ludwig
Konstruierte Figuren und Köpfe unter den Werken Albrecht Dürers. Leipzig, 1902.

Justi, Ludwig
"Über Dürers künstlerisches Schaffen," in *RKW* 26/1903, pp. 447 ff.

Kaufmann, Thomas DaCosta
"Arcimboldo's Imperial Allegories, G. B. Fonteo and the Interpretation of Arcimboldo's Painting," in *ZKG* 39/1976, pp. 275–296.

Kaufmann, Thomas DaCosta
"Remarks on the Collections of Rudolf II.: The Kunstkammer as a Form of *Representatio*," in *Art Journal* 38/1978, pp. 22–28.

Kaufmann, Thomas DaCosta
L'Ecole de Prague: La Peinture à la Cour de Rodolphe II." Paris, 1983.

Khevenhüller-Metsch, Georg
"H. Khevenhüllers diplomatische Korrespondenz und Tagebuch," in *Mitteilungen des Österreichischen Staatsarchivs* 22/1969, pp. 21 ff.

Killermann, Sebastian
"Albrecht Dürer's Rasen- und Blumenstücke," in *Naturwissenschaftliche Wochenschrift*, N.F. 5/1906, pp. 481–486.

Killermann, Sebastian
"Feldhase und Hermelin: Ein neues Dürerbild?" in *Natur und Kultur* 14/1916/17, pp. 176–178.

Kirchner, Albrecht
Deutsche Kaiser in Nürnberg: Eine Studie zur Geschichte der Reichsstadt Nürnberg von 1500–1612. Nuremberg, 1955.

Klauner, Friderike
"Dürers Werke in der Kopie," in *Alte und moderne Kunst* 16/1971, pp. 14–18.

Köhler, Wilhelm
"Aktenstücke zur Geschichte der Wiener Kunstkammer in der herzoglichen Bibliothek zu Wolfenbüttel," Quellen zur Geschichte der kaiserlichen Haussammlungen und der Kunstbestrebungen des Allerdurchlauchtigsten Erzhauses, in *JKSAK* 26/1906/07, Part 2, pp. 1 ff.

Kohlhaußen, Heinrich
Nürnberger Goldschmiedekunst des Mittelalters und der Dürerzeit 1240–1540. Berlin, 1968.

Koschatzky, Walter
Albrecht Dürer: Die Landschaftsaquarelle. Vienna, 1971.

Kris, Ernst, and Kurz, Otto
Die Legende vom Künstler: Ein geschichtlicher Versuch. Vienna, 1934.

Kristeller, Paul Oskar
Humanismus und Renaissance. 2 vols. Munich, 1974–1976.

Kurthen, Josef
"Zum Problem der Dürerschen Pferdekonstruktion: Ein Beitrag zur Dürer- und Behamforschung," in *RKW* 44/1924, pp. 77–106.

Kuspit, Donald B.
"Dürer's Scientific Side," in *Art Journal* 32/1972, pp. 163–171.

Lange, Konrad, and Fuhse, Franz
Dürers schriftlicher Nachlaß. Halle an der Saale, 1893.

Leids Kunsthistorisch Jaarboek 1/1982
"Rudolf II and his Court."

Lendorff, Gertrud
Maria Sibylla Merian: Leben und Werk. Basel, 1955.

Lhotsky, Alphons
Festschrift des Kunsthistorischen Museums in Wien 1891–1941. 2 vols. Vienna, 1941–1945.

Lüdecke, Heinz
Albrecht Dürer, Leipzig, 1970.

Marle, Raimond van
The Development of the Italian Schools of Painting, vol. XVIII. The Hague, 1936.

Mielke, Georg
Das Naturstudium Albrecht Dürers. Das Verhältnis des Künstlers zum Objekt. Eine entwicklungsgeschichtliche Untersuchung. Phil. diss., Berlin, 1956.

Mitchell, Peter
Great Flower Painters: Four Centuries of Floral Art. New York, 1973.

Musper, Theodor
"Dürers Zeichnung im Lichte seiner Theorie," in *Pantheon* 21/1938, pp. 103–110.

Neubert, Eberhard, and Reimann, Georg
Albrecht Dürer, Pflanzen und Tiere. Leipzig, 1960.

Neuwirth, Josef
"Rudolf II. als Dürer-Sammler," in *Xenia Austriaca, Festschrift der deutschen Mittelschulen zur 42. Versammlung der Philologen und Schulmänner in Wien,* vol. I, section 4, article 5. Vienna, 1893, pp. 185–225.

Nissen, Claus
Die zoologische Buchillustration, ihre Bibliographie und Geschichte. 2 vols. Stuttgart 1966, 1971.

Nordhoff, Josef
"Dürers Bild 'Maria in der Landschaft mit den vielen Tieren'," in *RKW* 2/1879, pp. 309–311.

Oehler, Lisa
"Das 'geschleuderte' Dürer-Monogramm," in *Marburger Jahrbuch für Kunstwissenschaft* 17/1959, pp. 57–191.

Oettinger, Karl, and Knappe, Karl Adolf
Hans Baldung Grien und Albrecht Dürer in Nürnberg. Nuremberg, 1963.

Osten, Gert von der
Hans Baldung Grien, Gemälde und Dokumente. Berlin, 1983.

Ottino della Chiesa, Angela, and Zampa, Giorgio
L'Opera completa di Dürer. Milan, 1968.

Pächt, Otto
The Master of Mary of Burgundy. London, 1947.

Panofsky, Erwin
Dürers Kunsttheorie vornehmlich in ihrem Verhältnis zur Kunsttheorie der Italiener. Berlin, 1915.

Panofsky, Erwin
"Albrecht Dürer and Classical Antiquity," in *Meaning in the Visual Arts.* Garden City, New York, 1955, pp. 236–294.

Panofsky, Erwin
Die Renaissancen der europäischen Kunst. 3rd ed. Frankfurt am Main, 1984.

Pauli, Gustav
"Verschollene Dürerzeichnungen in Radierungen Wenzel Hollars," in *Jahrbuch für Kunstsammler* 1/1921, pp. 15–22.

Pfister-Burkhalter, Margarethe
Maria Sibylla Merian, Leben und Werk 1647–1717. Basel, 1980.

Pirckheimer, Willibald 1470/1970. Documents, studies, views, on the 500th anniversary of his birth, published by the Willibald Pirckheimer Kuratorium. Nuremberg, 1970.

Puyvelde, Leo van
La Peinture Flamande au siècle de Bosch et Breughel. Paris, 1962.

Regteren Altena, Johan Quirin van
The Drawings of Jacques de Gheyn I. Amsterdam, 1936.

Regteren Altena, Johan Quirin van
Jacques de Gheyn: Three Generations. 3 vols. The Hague, Boston, London, 1983.

Reichel, Anton
"Zur Geschichte der Dürer-Zeichnungen in der Albertina," in *Festschrift Josef Strzygowski.* Klugenfurt, 1932, pp. 141–144.

Salvini, Roberto
Albrecht Dürer: Disegni. Florence, 1973.

Scheja, Georg
"Über einige Zeichnungen Grünewalds und Dürers," in *Festschrift Hubert Schrade.* Stuttgart, 1960, pp. 199–211.

Schilling, Edmund
"Beitrag zu Dürers Handzeichnungen: Übersehene und verschollene Werke," in *Städel-Jahrbuch* 1/1921, pp. 118 ff.

Schilling, Edmund
Nürnberger Handzeichnungen des XV. und XVI. Jahrhunderts. Vol. 3 of *Die Meisterzeichnung* series. Freiburg im Breisgau, 1929.

Schilling, Heidemarie
Studien zu Jacopo de' Barbaris graphischem Werke. Phil. diss., Graz, 1969.

Schlitter, Hanns
"Die Zurückstellung der von den Franzosen im Jahre 1809 aus Wien entführten Archive, Bibliotheken und Kunstsammlungen," in *Mitteilungen des Instituts für österreichische Geschichtsforschung* 22/1911, pp. 108 ff.

Schlosser, Julius
Die Kunstliteratur: Ein Handbuch zur Quellenkunde der neueren Kunstgeschichte. Vienna, 1924.

Schöndorf, Hildegard
Plotins Umformung der platonischen Lehre vom Schönen. Bonn, 1974.

Seifertová, Hana
"Georg Flegel — Malíř trompe l'œil," in *Umění* XXVI/1978, pp. 248–261.

Springer, Anton
"Inventare der Imhoff'schen Kunstkammer zu Nürnberg," in *Mitteilungen der k.k. Central-Commission zur Erforschung und Erhaltung der Baudenkmale* 5/1860, pp. 352–357.

Springer, Jaro
Albrecht Dürer: Kupferstiche. Munich, 1914.

Stadler, Franz J.
Michael Wolgemut und der Nürnberger Holzschnitt im letzten Drittel des 15. Jahrhunderts. Strasbourg, 1913. Vol. 161 of *Studien zur deutschen Kunstgeschichte.*

Stechow, Wolfgang
Northern Renaissance Art, 1400–1600: Sources and Documents. Englewood Cliffs, New Jersey, 1966.

Strauss, Gerald
Nuremberg in the Sixteenth Century. London, 1976.

Suida, Wilhelm E.
Leonardo und sein Kreis. Munich, 1929.

Talbot, Charles
"Recent Literature on Drawings by Dürer," in *MD* 14/1976, pp. 287–313.

Tietze, Hans
Genuine and False: Copies, Imitations, Forgeries. London, 1948.

Unterkircher, Franz, and Schryver, Antoine de
Gebetbuch Karls des Kühnen vel potius, Stundenbuch der Maria von Burgund, Codex Vindobonensis 1857 der Österreichischen Nationalbibliothek, Kommentar. Graz, 1969.

Veit, Ludwig
"Die Imhoff, Handelsherren und Mäzene des ausgehenden Mittelalters und der beginnenden Neuzeit," in *Das Schatzhaus der deutschen Geschichte,* edited by Rudolf Pörtner. Düsseldorf, 1982, pp. 503–531.

Venturi, Adolfo
"Zur Geschichte der Kunstsammlungen Kaiser Rudolfs II.," in *RKW* 8/1885, pp. 1–23.

Vocelka, Karl
Die politische Propaganda Kaiser Rudolfs II. Vienna, 1981, Österreichische Akademie der Wissenschaften, publications of the Kommission für die Geschichte Österreichs, vol. 9.

Weinberger, Martin
Nürnberger Malerei an der Wende zur Renaissance und die Anfänge der Dürer-Schule. Strasbourg, 1921.

Weise, Georg
Dürer und die Ideale der Humanisten. Tübingen, 1953. Vol. 6 of the series *Tübinger Forschungen zur Kunstgeschichte.*

Willnau, Carl, and Giessler, Rudolf
"Ein Beitrag zur Pflanzensymbolik bei Dürer," in *ZBK* 64/1930/31, pp. 47–48.

Winkler, Friedrich
Die Flämische Buchmalerei des XV. und XVI. Jahrhunderts. Leipzig, 1925.

Winkler, Friedrich
Die Zeichnungen Hans Süss von Kulmbachs und Hans Leonhard Schäufeleins. Berlin, 1942.

Winkler, Friedrich
Albrecht Dürer, Pflanzen und Tiere. Berlin, 1949.

Winkler, Friedrich
"Verzeichnis der seit 1939 aufgefundenen Zeichnungen Dürers," in *Festschrift E. Trautscholdt.* Hamburg, 1965, pp. 78–84.

Winzinger, Franz
"Dürer und Leonardo," in *Pantheon* 29/1971, pp. 3–21.

Würtenberger, Franzsepp
Der Manierismus: Der europäische Stil des sechzehnten Jahrhunderts. Vienna, Munich, 1962.

Zimmer, Jürgen
"Zum Stil in der Rudolfinischen Kunst," in *Umění* XVIII/1970, pp. 110 ff.

Zintzen, Clemens, ed.
Die Philosophie des Neuplatonismus. Darmstadt, 1977. Vol. CDXXXVI of the series *Wege der Forschung.*

Abbreviated Periodicals

AGNM
Anzeiger des Germanischen Nationalmuseums.

JKS
Jahrbuch der Kunsthistorischen Sammlungen in Wien.

JKSAK
Jahrbuch der Kunsthistorischen Sammlungen des Allerhöchsten Kaiserhauses.

JPK
Jahrbuch der Preußischen Kunstsammlungen.

MD
Master Drawings.

MGVK
Mitteilungen der Gesellschaft für vervielfältigende Kunst (Supplement to "Die Graphischen Künste").

MJBK
Münchner Jahrbuch der Bildenden Kunst.

MVGN
Mitteilungen des Vereins für Geschichte der Stadt Nürnberg.

OMD
Old Master Drawings.

RKW
Repertorium für Kunstwissenschaft.

TBM
The Burlington Magazine.

WJKG
Wiener Jahrbuch für Kunstgeschichte.

ZBK
Zeitschrift für Bildende Kunst.

ZKG
Zeitschrift für Kunstgeschichte.

ZKW
Zeitschrift für Kunstwissenschaft.

Abbreviated Literature

Albertina Catalogue I
Die Zeichnungen der venezianischen Schule. Compiled by Alfred Stix and L. Fröhlich-Bum. Descriptive catalogue of the drawings in the Graphische Sammlung Albertina, edited by Alfred Stix, vol. I. Vienna, 1926.

Albertina Catalogue IV
Die Zeichnungen der deutschen Schulen bis zum Beginn des Klassizismus. Compiled by Hans Tietze, E. Tietze-Conrat, Otto Benesch, Karl Garzarolli-Thurnlack. Descriptive catalogue of the drawings in the Graphische Sammlung Albertina, edited by Alfred Stix, vol. IV. Vienna, 1933.

Anzelewsky, 1971
Fedja Anzelewsky. *Albrecht Dürer — Das malerische Werk.* Berlin, 1971.

Anzelewsky, 1980
Fedja Anzelewsky. *Dürer — Leben und Wirkung.* Stuttgart, 1980.

Auction Catalogue Mariette/Basan 1775
Catalogue raisonné des différens objets de curiosités dans les sciences et arts qui composoient le Cabinet de feu Mʳ Mariette . . . par F. Basan, Graveur à Paris . . . 1775.

Auction Catalogue Posonyi/Montmorillon 1867
Catalog der überaus kostbaren von Alexander Posonyi in Wien zusammengestellten Albrecht Dürer-Sammlung . . . Monday, November 11, 1867, in the Montmorillon Art and Antiques Auction Rooms in Munich.

B.
Adam Bartsch. *Le Peintre Graveur.* 21 vols. Vienna, 1803–1821.

Bauer and Haupt, in JKS 72/1976
"Das Kunstkammerinventar Kaiser Rudolfs II., 1607–1611," edited by Rotraud Bauer and Herbert Haupt, in *JKS* 72/1976, N.F. XXXVI, pp. xi–191.

Behling, 1967
Lottlisa Behling. *Die Pflanze in der mittelalterlichen Tafelmalerei.* 2nd ed., Cologne, Graz, 1967.

Benesch, 1964
Otto Benesch. *Meisterzeichnungen der Albertina — Europäische Schulen von der Gotik bis zum Klassizismus.* Salzburg, 1964.

Bock, 1921, I
Elfried Bock. *Die deutsche Meister.* Descriptive catalogue of all the drawings in the Berlin Staatliche Museen. Vol. 1, text, vol. 2, plates, edited by Max J. Friedländer. Berlin, 1921.

Bock, 1929
Elfried Bock. *Die Zeichnungen in der Universitätsbibliothek Erlangen.* Frankfurt am Main, 1929.

Briquet
Charles-Moïse Briquet. *Les Filigranes — Dictionnaire historique des Marques du papier dès leur apparition vers 1282 jusqu'en 1600.* 4 vols. 2nd ed., Leipzig, 1923.

David, 1909
Harry David. *Die Darstellung des Löwen bei Albrecht Dürer — Zur Geschichte der deutschen Tiermalerei.* Phil. diss., Halle, 1909.

E.
Charles Ephrussi. *Albrecht Dürer et ses dessins.* Paris, 1882.

Exhibition Catalogue Basel 1974
Lukas Cranach — Gemälde, Zeichnungen, Druckgraphik. 2 vols. Basel, Kunstmuseum, 1974.

Exhibition Catalogue Berlin 1877
Catalog der Ausstellung neu erworbener Zeichnungen von Albrecht Dürer. Berlin, Königliche Museen, Kupferstich-Cabinet, 1877.

Exhibition Catalogue Berlin 1984
Albrecht Dürer — Kritischer Katalog der Zeichnungen. Berlin, Staatliche Museen Preußischer Kulturbesitz, Kupferstichkabinett, 1984.

Exhibition Catalogue Bremen, Zurich 1967/68
Handzeichnungen alter Meister aus Schweizer Privatbesitz. Bremen, Kunsthalle; Zurich, Kunsthaus; Münster, Westfälisches Landesmuseum für Kunst und Kulturgeschichte; Baden-Baden, Staatliche Kunsthalle, 1967/68.

Exhibition Catalogue Dresden 1971
Deutsche Kunst der Dürer-Zeit. Staatliche Kunstsammlungen Dresden, Albertinum, 1971.

Exhibition Catalogue London 1928
Guide to the Woodcuts, Drawings and Engravings of Albrecht Dürer in the Department of Prints and Drawings exhibited in commemoration of the fourth centenary of the artist's death on April 6th, 1528. London, The British Museum, 1928.

Exhibition Catalogue London 1948
Old Master Drawings from the Albertina Collection, Vienna. London, The Arts Council of Great Britain, 1948.

Exhibition Catalogue London 1971
The Graphic Work of Albrecht Dürer. London, The British Museum, Department of Prints and Drawings, 1971.

Exhibition Catalogue Münster 1979/80
Stilleben in Europa. Münster, Westfälisches Landesmuseum für Kunst und Kulturgeschichte, 1979/80; Baden-Baden, Staatliche Kunsthalle, 1980.

Exhibition Catalogue Nuremberg 1952
Aufgang der Neuzeit — Deutsche Kunst und Kultur von Dürers Tod bis zum Dreißigjährigen Kriege 1530–1650. Nuremberg, Germanisches Nationalmuseum, 1952.

Exhibition Catalogue Nuremberg 1962
Barock in Nürnberg 1600–1750. Nuremberg, Germanisches Nationalmuseum, 1962.

Exhibition Catalogue Nuremberg 1971
Albrecht Dürer 1471/1971. Nuremberg, Germanisches Nationalmuseum, 1971.

Exhibition Catalogue Paris 1950
Cent cinquante chefs-d'œuvre de l'Albertina de Vienne. Paris, Bibliothèque Nationale, 1950.

Exhibition Catalogue Paris 1967
Le Cabinet d'un Grand Amateur, P.-J. Mariette 1694–1774, Dessins du XVᵉ au XVIIIᵉ siècle. Paris, Musée du Louvre, Galerie Molien, 1967.

Exhibition Catalogue Paris 1978
Albrecht Dürer 1471–1528, Gravures, Dessins. Paris, Centre Culturel du Marais, 1978.

Exhibition Catalogue Stuttgart 1979/80
Zeichnungen in Deutschland — Deutsche Zeichner 1540–1640. 2 vols. Stuttgart, Staatsgalerie, Graphische Sammlung, 1979/80.

Exhibition Catalogue Vienna 1871
Dürer-Jubiläum. Vienna, k.k. Österreichisches Museum für Kunst und Industrie, 1871.

Exhibition Catalogue Washington 1971
Dürer in America — His Graphic Work. Washington, National Gallery of Art, 1971.

Exhibition Catalogue Zurich 1946/47
Meisterwerke aus Österreich. Zurich, Kunsthaus, 1946/47.

Exhibition Catalogue Zurich 1984
Hundert Zeichnungen aus fünf Jahrhunderten. Zurich, Galerie Kurt Meissner, 1984.

Eye
August von Eye. *Leben und Werk Albrecht Dürer's.* Nördlingen, 1860.

Fl. I, II
Eduard Flechsig. *Albrecht Dürer — Sein Leben und seine künstlerische Entwicklung.* Vol. 1, Berlin, 1928; vol. 2, Berlin, 1936.

Francis, in The Bulletin of the Cleveland Museum of Art 34/1947
Henry S. Francis. "Drawing of a dead blue jay by Hans Hoffmann," in *The Bulletin of the Cleveland Museum of Art* 34/1947, pp. 13, 14.

Geisberg
Max Geisberg. *The German Single-Leaf Woodcut 1500–1550.* 4 vols., edited by Walter L. Strauss. New York, 1974.

Goris and Marlier, 1970
Jan Albert Goris and Georges Marlier. *Albrecht Dürer — Das Tagebuch der niederländischen Reise.* Brussels, 1970.

H. II
Joseph Heller. *Das Leben und die Werke Albrecht Dürer's.* Vol. 2, Part 1, *Dürer's Zeichnungen, Gemälde, Plastische Arbeiten.* Bamberg, 1827.

Hausmann, 1861
Bernhard Hausmann. *Albrecht Dürer's Kupferstiche, Radirungen, Holzschnitte und Zeichnungen unter besonderer Berücksichtigung der dazu verwandten Papiere und deren Wasserzeichen.* Hanover, 1861.

Heawood, 1950, I
Edward Heawood. *Watermarks, Mainly of the 17th and 18th centuries.* Monumenta Chartae Papyraceae Historiam Illustrantia I. Hilversum, 1950.

Hind I/I
Arthur M. Hind. *Early Italian Engraving.* Part I, *Florentine Engravings and Anonymous Prints of Other Schools,* vol. I. Vols. I–IV, London, 1938.

Hind II/V
Arthur M. Hind. *Early Italian Engraving.* Part II, *Known Masters Other than Florentine Monogrammists and Anonymous,* vol. V. Vols. V–VII, London, 1948.

Hofmann, 1971
Walter Jürgen Hofmann. *Über Dürers Farbe, Erlanger Beiträge zur Sprach- und Kunstwissenschaft.* Vol. 42. Nuremberg, 1971.

Hollstein
Friedrich Wilhelm Heinrich Hollstein. *German Engravings, Etchings and Woodcuts, ca. 1400–1700.* Vols. I ff. Amsterdam, 1954 ff.

Kauffmann, in AGNM 1954
Hans Kauffmann. "Dürer in der Kunst und im Kunsturteil um 1600," in *AGNM* 1940–1953; Vom Nachleben Dürers, Beiträge zur Kunst der Epoche von 1530 bis 1650. Berlin, 1954, pp. 18–60.

K.-Str.
Walter Koschatzky and Alice Strobl. *Die Dürerzeichnungen der Albertina Zum 500 Geburtstag.* Salzburg, 1971.

Killermann, 1910
Sebastian Killermann. *Dürers Pflanzen- und Tierzeichnungen und ihre Bedeutung für die Naturgeschichte. Studien zur deutschen Kunstgeschichte,* vol. 119, Strasbourg, 1910.

Killermann, 1953
Sebastian Killermann. *A. Dürers Werk — Eine natur- und kulturgeschichtliche Untersuchung.* Regensburg, 1953.

Koreny, 1984
Fritz Koreny. "A Hare among Plants by Hans Hoffmann," in *Art at Auction,* edited by Tim Ayers. London, 1984.

L.
Frits Lugt. *Les Marques de collections de dessins et d'estampes.* Amsterdam, 1921; supplement, The Hague, 1956.

L. I
Friedrich Lippmann. *Zeichnungen von Albrecht Dürer in Nachbildungen.* Vol. I, edited by F. Lippmann. Berlin, 1883.

L. IV
Friedrich Lippmann. *Zeichnungen von Albrecht Dürer in Nachbildungen.* Vol. IV, edited by F. Lippmann. Berlin, 1896.

L. V
Friedrich Lippmann. *Zeichnungen von Albrecht Dürer.* Edited by F. Lippmann. Vol. V, *Zeichnungen Albrecht Dürers in der Albertina zu Wien in Nachbildungen,* in collaboration with Josef Edler von Schönbrunner, edited and revised by Dr. Joseph Meder. Berlin, 1905.

L. VI
Friedrich Lippmann. *Zeichnungen von Albrecht Dürer in Nachbildungen.* Initiated by F. Lippmann. Vol. VI, edited by Friedrich Winkler. Berlin, 1927.

L. VII
Friedrich Lippmann. *Zeichnungen von Albrecht Dürer in Nachbildungen.* Initiated by F. Lippmann. Vol. VII, edited by Friedrich Winkler. Berlin, 1929.

van Mander, 1617
Carel van Mander. *Das Leben der niederländischen und deutschen Maler.* Facsimile of the 1617 edition. Translation and notes by Hanns Floerke. 2 vols. Munich, Leipzig, 1906. *Kunstgeschichtliche Studien, Galeriestudien.* 4th installment, edited by Theodor von Frimmel.

M., Meder
Joseph Meder. *Dürer-Katalog — Ein Handbuch über Albrecht Dürers Stiche, Radierungen, Holzschnitte, deren Zustände, Ausgaben und Wasserzeichen.* Vienna, 1932.

Meder, in *RKW* 30/1907
Joseph Meder. "Die grüne Passion und die Tier- und Pflanzenstudien Albrecht Dürers in der Albertina," in *RKW* 30/1907, pp. 173–182.

Mende, 1971
Matthias Mende. *Dürer-Bibliographie.* Wiesbaden, 1971.

Müller, 1956
Wolfgang J. Müller. *Der Maler Georg Flegel und die Anfänge des Stillebens.* Frankfurt, 1956.

Musper, 1952
Helmuth Theodor Musper. *Albrecht Dürer — Der gegenwärtige Stand der Forschung.* Stuttgart, 1952.

Neubert and Reimann, 1960
Eberhard Neubert and Georg J. Reimann. *Albrecht Dürer, Pflanzen und Tiere.* Leipzig, 1960.

Oehler, in *Städel-Jahrbuch,* N.F. 3/1971
Lisa Oehler. "Das Dürermonogramm auf Werken der Dürerzeit," in *Städel-Jahrbuch,* N.F. 3/1971, pp. 79–108.

P. I, II
Erwin Panofsky. *Albrecht Dürer.* 2 vols., Princeton, New Jersey, 1943; 3rd ed., 1948.

Parthey
Gustav Parthey. *Wenzel Hollar — Beschreibendes Verzeichnis seiner Kupferstiche.* Berlin, 1853; enlarged and revised, Berlin, 1858.

Passavant III
Johann David Passavant. *Le Peintre-Graveur.* Vol. III, *Les maîtres néerlandais et allemands du XVI siècle.* Leipzig, 1862.

Pauli, in *RKW* 41/1919
Gustav Pauli. "Die Dürer-Literatur der letzten drei Jahre," in *RKW* 41/1919, N.F. VI, pp. 1–34.

Piccard
Findbücher der Wasserzeichenkartei im Hauptstaatsarchiv Stuttgart. Compiled by Gerhard Piccard. 14 vols., Stuttgart, 1961–1983.

Piel, 1983
Friedrich Piel. *Albrecht Dürer — Aquarelle und Zeichnungen.* Cologne, 1983.

Pilz, in *MVGN* 51/1962
Kurt Pilz. "Hans Hoffmann — Ein Nürnberger Dürer-Nachahmer aus der 2. Hälfte des 16. Jahrhunderts," in *MVGN* 51/1962, pp. 236–272.

Rosenthal, in *JPK* 49/1928
Erwin Rosenthal. "Dürers Buchmalereien für Pirckheimers Bibliothek," in *JPK* 49/1928, supplement (1929), pp. 1–54.

Rupprich I–III
Dürer — Schriftlicher Nachlaß. Edited by Hans Rupprich. Vol. I, Berlin, 1956; vol. II, Berlin, 1966; vol. III, Berlin, 1969.

Sandrart, 1675
Joachim von Sandrarts Academie der Bau-, Bild- und Mahlerey-Künste von 1675, Leben der berühmten Maler, Bildhauer und Baumeister. Edited and annotated by Arthur Rudolf Peltzer. Munich, 1925.

Schilling, 1948
Albrecht Dürer — Zeichnungen und Aquarelle. Selected and introduced by Edmund Schilling. Basel, 1948.

Schilling, 1958
Albrecht Dürer — Skizzenbuch der Reise nach den Niederlanden (1520–1521). Edited by Edmund Schilling. 2nd ed., Basel, 1958.

Schönbrunner and Meder
Handzeichnungen aus der Albertina und anderen Sammlungen. Edited by Joseph Schönbrunner and Joseph Meder. 12 vols., Vienna, 1896–1908.

Schwarz
Karl Schwarz. *Augustin Hirschvogel.* 2 vols., Berlin, 1917.

Springer, in *RKW* 29/1906
Jaro Springer. "Dürers Zeichnungen in neuen Publikationen," in *RKW* 29/1906, pp. 553–570.

St. I–VI
Walter L. Strauss. *The Complete Drawings of Albrecht Dürer.* 6 vols., New York, 1974.

St. supplement 1, 2
Walter L. Strauss. *The Complete Drawings of Albrecht Dürer.* Supplement 1, New York, 1977; supplement 2, New York, 1982.

Sterling, 1952
Charles Sterling. *La Nature Morte de l'Antiquité à nos jours.* Paris, 1952.

Strieder, 1981
Peter Strieder. *Dürer.* With contributions by Gisela Goldberg, Joseph Harnest, Matthias Mende. Königstein im Taunus, 1981.

T. I
Hans Tietze and Erica Tietze-Conrat. *Kritisches Verzeichnis der Werke Albrecht Dürers.* Vol. I, *Verzeichnis der Werke bis zur Venezianischen Reise im Jahre 1505.* Augsburg, 1928.

T. II/1
Hans Tietze and Erica Tietze-Conrat. *Kritisches Verzeichnis der Werke Albrecht Dürers.* Vol. II, *Der reife Dürer.* 1st half-volume, 1505–1520. Basel, Leipzig, 1937.

T. II/2
Hans Tietze and Erica Tietze-Conrat. *Kritisches Verzeichnis der Werke Albrecht Dürers.* Vol. II, *Der reife Dürer.* 2nd half-volume, 1520–1528. Basel, Leipzig, 1938.

TDS
The Dürer Society. 12 vols., London, 1898–1911.

Th. I, II
Moriz Thausing. *Dürer — Geschichte seines Lebens und seiner Kunst.* 2 vols., 2nd ed., Leipzig, 1884.

Thieme and Becker
Allgemeines Lexikon der bildenden Künste von der Antike bis zur Gegenwart. Edited by Ulrich Thieme and Felix Becker. 37 vols., Leipzig 1907–1950.

H. Tietze, in *WJKG* 7/1930
Hans Tietze. "Dürerliteratur und Dürerprobleme im Jubiläumsjahr," in *WJKG* 7/1930, pp. 232–259.

H. Tietze and E. Tietze-Conrat, in *JKS,* N.F. 6/1932
Hans Tietze and Erica Tietze-Conrat. "Neue Beiträge zur Dürer-Forschung," in *JKS,* N.F. 6/1932, pp. 115–139.

H. Tietze, 1951
Hans Tietze. *Dürer als Zeichner und Aquarellist.* Vienna, 1951.

Veth and Muller I, II
Jan Veth and Samuel Muller. *Albrecht Dürers niederländische Reise.* Vol. I, *Die Urkunden über die Reise;* vol. II, *Geschichte der Reise.* Berlin, Utrecht, 1918.

W. I–IV
Friedrich Winkler. *Die Zeichnungen Albrecht Dürers.* 4 vols., Berlin, 1936–1939.

Waagen, 1867
Gustav Friedrich Waagen. *Die vornehmsten Kunstdenkmäler Wiens.* 2 vols., Vienna, 1867.

Waetzoldt, 1935
Wilhelm Waetzoldt. *Dürer und seine Zeit.* Vienna, 1935.

White, 1971
Christopher White. *Albrecht Dürer — Die schönsten Zeichnungen.* Cologne, 1971.

Winkler, in *JPK* 50/1929
Friedrich Winkler. "Dürerstudien, I. Dürers Zeichnungen von seiner ersten italienischen Reise (1494/95)," in *JPK* 50/1929, pp. 123–166.

Winkler, in *JPK* 53/1932
Friedrich Winkler. "Dürerstudien, III. Verschollene Meisterzeichnungen Dürers," in *JPK* 53/1932, pp. 68–89.

Winkler, 1957
Friedrich Winkler. *Albrecht Dürer — Leben und Werk.* Berlin, 1957.

Wölfflin, 1914
Albrecht Dürer — Handzeichnungen. Edited by Heinrich Wölfflin. Munich, 1914.

Wölfflin, 1926
Heinrich Wölfflin. *Die Kunst Albrecht Dürers.* 5th ed., Munich, 1926.

Artists' Biographies

HANS BALDUNG, CALLED GRIEN

Born 1484–85 in Schwäbisch-Gmünd (?),
died 1545 in Strasbourg

Hans Baldung was probably born into a family of scholars in Schwäbisch-Gmünd between the spring of 1484 and the summer of 1485. It appears that the family moved to Strasbourg around 1492, since his father served as procurator to the bishop of Strasbourg. Baldung must have received his early training about 1499–1500, very likely in Strasbourg or with a Swabian artist. From 1503 to 1506 he worked as assistant in Albrecht Dürer's Nuremberg studio, where he probably got his nickname Grien, from his predilection for the color green; the G appears in his monogram from about 1510. In 1509 Baldung applied for Strasbourg citizenship, and in 1510 he married Margarethe Herlin, set up a studio of his own, and became a member of the guild *zur Steltz,* to which painters, printers, goldsmiths, and glass painters belonged. In 1512 Baldung went to Freiburg in Breisgau, where he was commissioned with the execution of the altar for the newly built choir of the minster. In 1517 he returned to Strasbourg. He died in September 1545.

JACOPO DE' BARBARI

Born c. 1440–50 in Venice,
died before 1516 in Brussels (?)

Little information has been handed down about Jacopo de' Barbari's training or early work. He was probably born in Venice about the middle of the century, and trained in Vivarini's studio. Dürer met him in Venice in 1495, and through him became interested in the study of human proportion; in 1523, in the draft for the dedication of his textbook on proportion, he refers to him as *"einen man Jacobus genennt, von Venedig geporn, ein liblicher moler"* ("a man called Jacobus, born in Venice, a lovely painter").[1]

There are no reliable sources of information about de' Barbari before 1500; in that year in Augsburg Emperor Maximilian I signed the contract appointing "Jacoben von Barbari" as *"Contrafeter und Illuministen"* (counterfeiter, i.e., portrait artist, and illuminator), resident in Nuremberg.[2] About 1503–04, de' Barbari entered the service of Elector Friedrich III of Saxony, known as the Wise, to whom he had written while he was still working for Maximilian I. During these years he also stayed in the courts of Lochau, Torgau, Weimar, Leipzig, Nuremberg, and Wittenberg. He maintained regular contact with the highly influential humanists and professors at Wittenberg University. After the outbreak of an epidemic in 1506, de' Barbari left Wittenberg and subsequently worked for Duke Heinrich the Peaceable of Mecklenburg. In 1508 he moved to the Brandenburg court of Elector Joachim I in Frankfurt-an-der-Oder, and was subsequently employed by Philip of Burgundy.

From 1510 until his death in 1515 or 1516, de' Barbari was court painter to Margarethe of Austria in Mecheln, Antwerp, and Brussels, and received a sort of pension from her from 1512 onward, on the grounds of his ill health.

Jacopo de' Barbari's painterly *œuvre* is small; *Still Life with Partridge, Mailed Gloves, and Crossbow Bolt* (ill. 6.1), signed and dated 1503, in the Munich Pinakothek can be considered his masterpiece. He became famous for his woodcut map of Venice, created in 1500. Evidently his engravings influenced Dürer. Hans von Kulmbach was a direct pupil of his.

NOTES

1 Rupprich I, p. 102.
2 *Inventare, Acten und Regesten aus der Schatzkammer des Allerhöchsten Kaiserhauses,* in *JKSAK* 16/1895, p. VII, 2280.

FRANZ BUCH

Active 1546–1573

Franz Buch seems to have been active as a draughtsman in Ulm or Munich between 1546 and 1573; however, he is not mentioned in any documents. We know his name only from some drawings signed on the back, some of which are also dated: 1546 (London, British Museum); 1549 (Frankfurt, Städelsches Kunstinstitut); 1553 and 1568 (Budapest, Museum of Fine Arts); 1573 (Berlin, Kupferstichkabinett). In addition there are some undated works, most of which are in Budapest.

HANS BURGKMAIR THE ELDER

Born 1473 in Augsburg,
died 1531 in Augsburg

Hans Burgkmair was born before May 10, 1473, in Augsburg, the son of the painter and "scribe" Thoman Burgkmair, who gave him his early training. After his apprenticeship he worked with Martin Schongauer in Colmar, probably from 1488 to 1490. He seems to have been back in Augsburg by 1490 at the latest. On July 3, 1498, he married Anna Allerley, the daughter of a furrier, was immediately afterward (July 29) taken on as a master by Augsburg's guild of painters, glass painters, and woodcarvers, and set up his own studio. There is evidence from his drawings that about 1503 Burgkmair undertook a journey in the lower Rhineland and the Netherlands, and in 1507 he stayed for a short while in northern Italy. In 1508 he created the first colored woodcuts using color blocks.

At the Augsburg Diet of 1500, and probably through the good offices of Konrad Peutinger, the Augsburg town clerk and imperial councillor, he met Emperor Maximilian I, who was to become his most important patron and employer. Between 1512 and 1518 we worked on the woodcut illustrations for Maximilian's *Weisskunig,* the *Theuerdank,* and the *Triumphzug* (the Great Triumphal Car). In 1516, as a mark of special recognition, the emperor granted him a coat-of-arms. Other influential employers of Burgkmair's were the Fugger family and the humanists Konrad Peutinger and Konrad Celtis. In 1526 he bought a pension from the town as old-age security for himself and his wife. He died between mid-May and mid-August 1531 in the town where he was born.

MONOGRAMMIST CA WITH THE ACORN

The attempt to link the initials CA with Christoph Amberger (1500/10–1561/62) is inconsistent with his dates, and cannot be supported on stylistic grounds. Paul Ganz resolved the monogram as "Conrad Aichler" without substantiating the identification. It has so far been impossible to trace any artist of this name. Until recently only one drawing with this monogram, dated 1572 in Basel, was known. Now we have three more in Copenhagen, one of which is monogrammed and dated 1567, and there is a sketch in Dresden with stylistic affinities (see Cat. 33). Tilman Falk recently suggested that the monogrammist who is mentioned in the Augsburger painters' guild books might be the painter "Christoph Aichele of Salzburg," who emerged from the school of Christoph Amberger. For more information regarding this identification, see Cat. 33.

LUKAS CRANACH THE ELDER

Born 1472 in Kronach,
died October 16, 1553, in Weimar

Lukas Cranach, who called himself after his place of birth in upper Franconia, was the son of the painter Hans Maler, who presumably gave him his early training. We know he was active in Coburg in 1501, probably on behalf of Elector of Saxony Frederick III the Wise, to whom he later became court painter. In 1502 he made a journey to Vienna, probably via Budapest, and was active there until 1504–05. In 1504 he signed a work *LC* for the first time. In 1505 he furthered his career as successor to Jacopo de' Barbari at the Saxon court. From 1505 on he maintained a studio in Wittenberg, and was active in Coburg, Torgau, and Lochau. In 1508 the elector granted him a coat-of-arms with the device of a winged snake, which he used from then on as his signature. A journey through the Netherlands in the summer of

1508 led him to Emperor Maximilian I. His wedding to Barbara Brengbier, daughter of the Gotha burgomaster, seems to have taken place in 1512–13. In 1515 he worked alongside Dürer, Baldung, and Burgkmair on Emperor Maximilian's prayer book. In 1517 he was active in Dresden at the court of George, Duke of Saxony.

From 1519 to 1545 Cranach was on the Town Council of Wittenberg and was its burgomaster, on and off, between 1537 and 1544. In 1520 the duke granted him an apothecary's patent, since he seems to have had a shop since 1513.

Cranach was a personal friend of Luther's, and a follower of the Reformation. In 1517–18 he created the first woodcut titleframes for Luther's writings, and Luther's translation of the New Testament with woodcuts by him appeared in 1522. With his council colleague Christian Döring, a goldsmith, and the printer Joseph Klug, he issued reformatory pamphlets from his own press. From 1537 onward, he adopted a new form of signature with a snake and bird's wing dormant.

In 1532 Cranach entered the service of Johann Friedrich I the Magnanimous, the new elector of Saxony, who, like his predecessor, supported the Reformation. He was defeated in 1547 at the Battle of Mühlberg against the Emperor Charles V, taken prisoner, and deprived of his title. As a result, Cranach lost his paid position as court painter, but remained active for Johann Friedrich and in 1550 followed him into captivity in Augsburg, and then to Innsbruck in 1551, where he continued working for him. In the autumn of 1552 he returned with the regent, reinstated as duke, not elector, to the new residence in Weimar, where Cranach died on October 16, 1553.

ALBRECHT DÜRER

*Born May 21, 1471, in Nuremberg,
died April 6, 1528, in Nuremberg*

Albrecht Dürer, son of the goldsmith Albrecht Dürer, came into the world as the third of eighteen children. At first he studied from 1484 to 1486 in his father's workshop. Subsequently he was apprenticed to the painter Michael Wolgemut until 1489. At Easter 1490 he began his travels which took him to southwest Germany, and perhaps the Netherlands too, but there are records of only a few stops along the route. In 1492 he arrived in Colmar, hoping to study with Martin Schongauer, only to learn that he had died on February 2, 1491; he then stayed in Basel, and in 1493 he visited Strasbourg. After Pentecost in 1494 he returned to Nuremberg, and married the wife his father had found for him, Agnes Frey. That same autumn he appeared in Venice, where he met, among others, Gentile Bellini and Jacopo de' Barbari, who got him interested in the study of proportion. Early in 1495 he opened his own studio back in Nuremberg. His friendship with the patrician Willibald Pirckheimer

gained him entry into the Nuremberg humanist circle. In 1496 he seems to have received his first commission for a painting from Elector Frederick the Wise of Saxony, who was staying in Nuremberg in April that year. In 1498 Dürer published his woodcut series The Apocalypse, and two years later he started his designs for the Life of the Virgin woodcuts.

From 1505 to 1507 he undertook a second journey to Italy, with another long stay in Venice, from where he probably visited Bologna, Florence, and Rome. On commission from the German merchants in Venice, he painted *The Feast of the Rose Garlands* in 1506. In 1511 the woodcut series the Large Passion and the small woodcut Passion were published in Nuremberg. Emperor Maximilian I's stay in Nuremberg in 1512 brought him further important commissions such as the *Triumphal Arch* and the *Triumphal Procession,* and the border designs for Emperor Maximilian's prayer book. In 1513–14 came the master engravings *Knight, Death, and Devil, Saint Jerome in His Study,* and *Melencolia.* From September 6, 1515, on, Dürer drew a pension from the emperor of a hundred guilders a year.

He made shorter journeys in 1517 to Bamberg, in 1518 to the Imperial Diet in Augsburg, and in 1519, with Willibald Pirckheimer and Martin Tucher, to Switzerland. He undertook his last long journey from July 1520 to July 1521, in the company of his wife, to the Netherlands, in order to have his annual pension confirmed by Maximilian I's successor, Charles V, when he was crowned emperor at Aachen. Dürer was able to attend the coronation on October 23, 1520, and have his petition ratified finally in Cologne. Before and after, he visited Antwerp, Bruges, Ghent, and Brussels. He met eminent personalities, including Erasmus of Rotterdam, Lucas van Leyden, Jan Provost, and Joachim Patinier, saw the works of great Netherlanders, such as the Ghent Altarpiece by the Brothers van Eyck, made animal studies at the bear pit in Ghent, was received by Margarethe of Austria, the Netherlands head of state [*Statthalterin*], and acquired rare, mostly foreign, natural curiosities.

In the last years of his life, Dürer concentrated mainly on publishing his theoretical writings. His treatise on fortification appeared in 1527, and his four volumes on proportion came out posthumously in the autumn of 1528.

THEODOR JOSEF ETHOFER

*Born December 29, 1849, in Vienna,
died October 24, 1915, in Baden, near Vienna*

Theodor Josef Ethofer studied at the Vienna Academy under Professor Carl Wurzinger. He lived in Italy from 1872 to 1887; after Venice, where he was influenced by August von Pettenkofen, his favorite places were Florence, Rome, and Naples. He made journeys to Tunis and Spain. From 1898 on he settled in Salzburg. He was known for genre pictures, water-

colors of Italy and Salzburg, portraits, and religious murals.

GEORG FLEGEL

*Born c. 1566 in Olmütz,
died 1638 in Frankfurt*

This painter was born in Olmütz, and when he had finished his studies, probably at about the age of twenty, he left home and set out on his travels. It is likely that he arrived in 1592 or 1593 in Frankfurt; we have no documentary evidence of him there until November 14, 1594, when his son Michael was baptized. The Netherlandish painter Marten van Valckenborch is named as godfather, which suggests that the two families were friendly. Possibly Flegel worked as assistant in Valckenborch's studio, where he would have had to do still-life details such as flowers and fruit in the paintings. Lucas van Valckenborch provided him with a good reference when he applied for Frankfurt citizenship, which he was granted on April 28, 1597. In the following years Flegel's mounting reputation was not limited to Frankfurt, where, according to Sandrart, most of his clients were Netherlandish immigrants. A note from the Augsburg art dealer Philipp Hainhofer, advising Duke Philipp II of Pommern-Stettin of a consignment of works of art on June 28, 1611, includes *eine hüpsche collation tafel [Frühstückstilleben] vom Spiegel gemahlet* ("a pretty collation table [breakfast still life] painted by Spiegel"), showing that Flegel, who began to date his still lifes only in the last years of his life, had distinguished himself in this genre considerably earlier. In 1627 Jacob Marrel became apprenticed to Flegel. Flegel's burial is registered on March 23, 1638, in the Frankfurt town register of deaths.

DANIEL FRÖSCHL

*Born 1573 in Augsburg,
died October 15, 1613, in Prague*

Daniel Fröschl of Augsburg was the son of the graduate lawyer Hieronymus Fröschl. Nothing is known about his training. From about 1597 to 1603 he was working in Florence for the grand dukes of Tuscany, although he had already been confirmed as a miniature painter by Emperor Rudolf II on December 28, 1601. Later, Fröschl worked as court miniaturist in Prague. From May 1, 1607, he held office there as antiquary and curator to Rudolf II, which, according to Hainhofer (1610), left him very little time for painting. In the years 1607 to 1611 he compiled an inventory of the Rudolfian *Kunstkammer.*[1] After the death of Rudolf II in the year 1612 Fröschl was accused of misappropriating objects from the treasure chamber. He died in Prague on October 15, 1613.

NOTE

1 Bauer and Haupt, in *JKS* 72/1976. For Fröschl's activity in Florence and Pisa, Italy, see also

Lucia Tongiorgi Tomasi, "Immagine della natura e Collezionismo Scientifico nella Pisa Medicea," in *Firenze e la Toscana dei Medici nell'Europa del 1500* (Florence, 1983), vol. I, pp. 95–108. See also Cat. 16.

CONRAD GESSNER

Born March 16, 1516, in Zurich,
died December 13, 1565 in Zurich

Conrad Gessner was a humanist, doctor, and botanist, educated at the School of Theology of the Great Minster in Zurich. In 1532 he was amanuensis to the preacher Wolfgang Capito in Strasbourg, from 1532 to 1534 he studied theology and medicine at the universities of Bourges and Paris, in 1535 he married Barbara Singysen, in 1536 a scholarship enabled him to study medicine in Basel and anatomy in Montpellier, from 1537 to 1540 he was professor of Greek at the Lausanne Academy, and in 1541 he graduated in Basel as doctor of pharmaceutics. In the same year he received a professorship of natural history at the Carolinum in Zurich. In 1554 he became town doctor of Zurich.

Besides his profession as a doctor, Gessner was active as a writer in a wide variety of fields: philology, medicine, theology, zoology, and botany. Without exception, his works were brought out by Christoph Froschauer in Zurich. The most important include:

1542 *Catalogus plantarum*
1545 *Bibliotheca universalis*
1546 *Die Kirchenväterausgabe*
1553 *Icones animalium quadrupedum; De thermis medicatis Helvetiae et Germaniae*
1554 *Historia quadrupedum oviparorum*
1555 *De avium natura*
1558 *De piscium aquatilium animantium natura*
1561 *Horti Germaniae*
1565 *De rerum fossilium figuris*

Many of his works were translated into German and appeared in many editions. Gessner was in correspondence with the most eminent scholars of Germany, France, Italy, and England. Emperor Ferdinand I marked his contribution to science in 1564 by granting him a coat-of-arms.

The Story of the Historia plantarum

In the spring of 1555, encouraged by Johannes Kentmann, Gessner made plans to write a universal, illustrated history of plant life, *Historia plantarum*. Professional painters, and he himself, prepared the true-to-life illustrations for it. Through Caspar Wolf, the heir to his scientific legacy, we know that he personally contributed about 150 plant studies, but as none of them are signed or monogrammed, they can be recognized only by style, supported by the occasional inscription.[1]

In his history of plant life, Gessner did not just deal with the medical use of plants, but went on from the herbaral tradition and concentrated on plant morphology, thereby rais-

ing botany to a genuine science. The *Historia plantarum* was never finished, as Gessner died of the plague in Zurich on December 13, 1565. Nor did its publication by Caspar Wolf come about as he had intended. The work remained unpublished, and his achievement, which could have given a vital impulse to scientific botany, remained unknown.

From Caspar Wolf, the legacy passed to the Nuremberg botanist Joachim Camerarius, and in 1658 to the Nuremberg doctor and nature scholar Georg Volckamer. In 1744 it was acquired by the Nuremberg doctor Christoph Jakob Trew, who commissioned the Erlangen professor of botany, Casimir Christoph Schmiedel, to make an engraved edition of the *Historia plantarum*. Trew's legacy fell to the University of Altdorf, and was taken from there to the Universitätsbibliothek, Erlangen, where it lay for a long time in obscurity, until it was rediscovered in 1929 by the medical historian Bernhard Milt.[2]

NOTES

1 Cited from *Conradi Gesneri Historia plantarum*, facsimile edition, ed. by Heinrich Zoller, Martin Steinmann, and Karl Schmid, series 2 (Zurich, 1972), pp. 11, 12; Caspar Wolf, *De Conradi Gesneri stirpium historia ad Ion. cratonem pollicitatis* (Zurich, March 14, 1566, reprinted in Josias Simmler, *Vita Conradi Gesneri, Froschauer 1566* Zurich), fol. 45 ff.
2 After Exhibition Catalogue *Züricher Kunst nach der Reformation, Hans Asper und seine Zeit* (Zurich, Helmhaus, 1981), pp. 133 ff.

GEORG (JORIS) HOEFNAGEL

Born 1542 in Antwerp,
died September 9, 1600, in Vienna

Georg Hoefnagel was the son of a wealthy family, and his parents wanted him to pursue a career in commerce. During the years 1560 to 1567 he traveled in France and Spain, and drew townscapes, which show us the route he took. In 1567 he returned to Antwerp, and in 1568–69 visited England. There, in 1569, he created his first allegorical work, entitled *Patientia,* which incorporated twenty-four drawings. Back in Antwerp, in 1571 he married Susanna van Onsen, the daughter of a diamond merchant. In this period he took lessons from the painter Hans Bol, but was not for long influenced by his master's work; in fact, Hoefnagel described himself as *Autodidaktos* on a drawing dated 1578. As a partner in his father-in-law's jewel business, he lost his capital through the Spanish uprising of 1576. In June 1577 he went off in the company of the humanist and cartographer Abraham Ortelius, via Augsburg and Munich, to Italy, where he sketched landscapes and townscapes, elaborating them somewhat afterward in Munich. In Rome he gained entry to the circle of Cardinal Allessandro Farnese, but had to decline his offer to replace the court painter, Giulio Clovio, who died in 1578, because Hoefnagel was already under contract to Duke Albrecht V of

Bavaria, whose service he entered in 1578. In the years 1581–82 to 1590 he was busy with the miniatures for a missal for Archduke Ferdinand of Tyrol, but collaborated at the same time with Georg Braun and Franz Hogenberg on *Civitatis Orbis Terrarum,* a book of towns that had been appearing since 1574. Between 1575 and 1582 he had been active for Emperor Rudolf II; a four-volume work of animal studies (see Cat. 38, note 2) and two script pattern books date from this period. In 1590 Hoefnagel entered the emperor's service for good. In 1591 he moved to Frankfurt, where he rejoined many of his compatriots who had fled from the Netherlands on religious grounds, among them artists such as Johannes, Ägidius, and Raphael Sadeler, or Marten and Lucas van Valckenborch. In 1594 Hoefnagel returned to Vienna, where he died in 1600.

HANS HOFFMANN

Born c. 1530 in Nuremberg (?),
died 1591–92 in Prague

Little is known of Hans Hoffmann's background and beginnings, but it can be assumed that he is the same Hans Hoffmann who on August 19, 1557, was permitted by the Nuremberg Town Council to have his *"gemalte Tücher [=Leinwandbilder] undterm rathaus fail zu haben"* ("Painted cloths [paintings on linen] on sale under the Town Hall"). He is described in the document as a Netherlander, which does not necessarily mean he came from there, but could also be explained by a previous stay in the Netherlands, probably during his journeyman years.[1] About 1570 he seems to have been a pupil of Nikolaus Neufchatel.[2] The baptism of his son Matthias is registered in the year 1572. Hoffmann is named in a document of 1576 as painter and citizen of Nuremberg. Throughout 1584 he worked at the Munich court of Duke Wilhelm V the Pious. Finally, probably through the introduction of Willibald Imhoff, he entered the service of Emperor Rudolf II in Prague, and from July 1, 1585, he drew an annual salary of a hundred thalers as imperial court painter. In the same year he received two hundred guilders from the pay office of the Prague court *"für ainen mit ollfarb gemahlten haasen"* ("for a hare painted in oil colors") for Rudolf II's *Kunstkammer.* Hoffmann is mentioned in documents, for example, as being several times in Prague, so in 1589, in addition to a raise in salary, he received a gratuity of another hundred thalers. He must have died, presumably in Prague, between October 14, 1591, the date of his last written mention, and June 12, 1592, when the pension for his widow and children was fixed.

Hoffmann is considered the main representative of the Dürer Renaissance.

NOTES

1 Pilz, in *MVGN* 51/1962, p. 237.
2 Fritz Zink, in Exhibition Catalogue Nuremberg 1962, p. 38.

JACOPO LIGOZZI

Born 1547 in Verona,
died March 26, 1626, in Florence

Jacopo Ligozzi came from a family of artisans — painters, silk embroiderers, and weapon smiths — who were active at the Innsbruck court, among other places. It can be assumed that he received his training within the family circle of craftworkers. In 1578 he enrolled at the Academia del Disegno in Florence. From 1577 until his death in 1626, apart from short stays in Verona and Mantua, he lived in Florence as court painter to the Medicis. His friend, the nature scholar Ulisse Aldrovandi from Bologna, describes him in a letter of recommendation as *"l'eccellentissimo pittore del Granduca di Toscana"* ("the most excellent painter of the Grand Duke of Tuscany").[1] Ligozzi's range of commissions was comprehensive; he did portraits, records of official occasions, small-format devotional pictures, and also altarpieces and frescoes in Florence and Tuscany. He produced designs for embroidery, inlaid work, and festival decorations. He was director of the art gallery and the studio attached to it, which also made copies. However, his fame rests mainly on his detailed scientific animal and plant studies, based on the most careful observation of nature, and executed with a fine, miniaturelike technique.

NOTE

1 Quoted in Odoardo H. Giglioli, "Jacopo Ligozzi disegnatore e pittore di piante e di animali," in *Dedalo* IV/1929, p. 554.

SIMON MARMION

Born c. 1420 – 25,
died 1489 in Valenciennes

Simon Marmion was probably born in Amiens, son of the painter and sculptor Jean Marmion; there is news of his father's activity between 1426 and 1444, and he gave Simon his early training as a panel painter. He seems to have learned miniature painting in the studio of the so-called Master of Mansel. After 1458, Simon Marmion evidently lived and worked in Valenciennes. In 1468 he was accepted into the Lukas Guild of Tournai. He worked for the Burgundian dukes Philipp the Good and Charles the Bold, and for high dignitaries in Burgundy. The œuvre he produced in over forty creative years earned him the admiring nickname of *Prince de l'enluminure.* Although there are reports that Simon Marmion also did panel paintings, festive decorations, and probably murals too, his artistic personality can be known only from his book illustrations.

MARIA SIBYLLA MERIAN

Born April 2, 1647, in Frankfurt am Main,
died January 13, 1717, in Amsterdam

Maria Sibylla Merian was the daughter of the engraver and publisher Matthäus Merian the Elder. After the death of her father in 1650, and her mother's remarriage to the flower-piece painter Jacob Marrel, who had been a pupil of Georg Flegel and the Utrecht flower painter Jan Davidsz de Heem, she received her first instruction in drawing and painting from her stepfather. Among Marrel's pupils were Abraham Mignon, her later teacher, and Johann Andreas Graff, whom she married in Frankfurt on May 16, 1665. Their daughter Johanna Helena was born in 1668, and a second child, Dorothea Maria, in 1678. From 1670 the family resided in Nuremberg. Maria Sibylla Merian specialized exclusively in studies of flowers, fruit, and insects, for which she did thorough scientific research. She separated from her husband in 1685, and went back to her mother in Frankfurt. (The marriage was later dissolved between 1692 and 1694.) Later, she took her two daughters to West Friesland, where she lived in the castle of Walta-State and joined the "Labadists" sect. In 1691 she moved to Amsterdam and returned to her interrupted artistic activity. Financial help from the Amsterdam authorities enabled her to travel to Suriname (Dutch Guiana) to study exotic flora and fauna. An illness forced her to return sooner than planned, in the summer of 1701, but she had already assembled a wealth of material: studies on large sheets of parchment, comprehensive notes, preserved butterflies, and flower bulbs. Her work on the insects of Suriname was published in 1705.

Her most important illustrated books include *Florum Fasciculi tres,* first series, 1675; *Der Raupen wunderbare Verwandlung und sonderbare Blumennahrung,* first edition, 1679–83; *Metamorphosis insectorum Surinamensium,* first edition, 1705.

LUDGER TOM RING THE YOUNGER

Born November 19(?), 1522, in Münster,
died early in 1584 in Brunswick

Ludger tom Ring the Younger was the son of the painter Ludger tom Ring the Elder, in whose studio he received his training. After traveling in the Netherlands, and after his father's death, he must have collaborated with his brother Hermann. About 1550 he undertook a journey to England because he had to leave Münster, possibly on religious grounds — he had joined the Protestants. This was probably also the reason for his move to Brunswick in 1569, where he obtained citizenship in 1572. His wife, Ilse, came from the patrician Bardenwerper family of Brunswick. Ludger tom Ring the Younger earned great respect in Brunswick as a portrait painter and still-life artist.

"HANS VERHAGEN DEN STOMMĒ VAN ANTWERPĒ"

The clearly legible inscription on the *Beech Marten* study (Cat. 41), found on three illustrations (a fourth, a peacock on page 118, looks like a copy) in an album compiled at the end of the sixteenth century (Cod. min. 42) among the manuscripts and early printed books of the Österreichische Nationalbibliothek in Vienna, refers to the illustrator Hans Verhagen of Antwerp. His name does not appear in any artists' lexica nor in the archives of the Rudolfian court. However, through Peter Dreyer's recently published research results,[1] his "person" becomes more real: thus the artist could have been born between 1540 and 1545; in the Antwerp Artists' Guild a Verhagen is mentioned twice — once in 1554 and again in 1555 — as an apprentice to the artist A. Bessemers; on July 5 or 15, 1572, an artist of this name married Janneken Aelbrechs in O. L. Vrow (the Cathedral of Our Lady) in Antwerp.

The inscription on the drawing bears the characteristic traits of Georg Hoefnagel's handwriting and is undoubtedly written by him. Stylistically, the Verhagen drawings are close to Hoefnagel's and, according to Dreyer, precede them. It is possible that Hoefnagel knew the author of these animal studies, who may have been, like Hoefnagel himself, in the service of Emperor Rudolf II.

M. L. Hendrix's views,[2] that the name should be read as Versagen, and that the studies so signed are considered to be enlarged copies, by Hoefnagel himself, of older models already used in his illustrations for Emperor Rudolf II, seem to be superseded by Peter Dreyer's conclusions.

NOTES

1 See Peter Dreyer's commentaries from the Dürer symposium (June 7–10, 1985, Vienna), in *JKS* 82/1986.
2 M. L. Hendrix, *Joris Hoefnagel and the Four Elements: A Study in Sixteenth-Century Nature Painting* (phil. diss., Princeton University, 1984).

ZACHARIAS WEHME

Born c. 1558 in Dresden,
died 1606 in Dresden

Zacharias Wehme was the son of Hans Wehme, the elector's cabinetmaker and master gunner at the Dresden court. After his father's death, he obtained a scholarship (1571–1580) from Elector August of Saxony to study under Lukas Cranach the Younger in Wittenberg. When he came back to Dresden, he certainly received commissions from the court, but it was apparently not until 1592 — other sources suggest 1605 — that he was salaried as court painter to Christian I, the successor to Elector August. But since he had not been a journeyman and had not taken a master's examination, the Dresden guild was hostile to him. For the court he was principally active as a

painter of portraits and miniatures for books and maps; in addition, Wehme painted hunting spoils, biblical scenes, and murals. There are authenticated works in the Dresden Stallhof and Colditz Castle.

HANS WEIDITZ

Born before 1500 in Freiburg,
died probably c. 1536

Hans Weiditz was probably the son of the wood-carver Hans Weiditz in Freiburg in the Breisgau region. After a period of study in Strasbourg that began about 1514, and subsequent journeyman experience, he seems to have worked as a colleague in Hans Burgkmair's studio, where he was mainly concerned with book illustration as a draughtsman. In 1522 he went back to Strasbourg. In 1529 he produced the drawings for the woodcut illustrations of the *Herbarium vivae eicones,* edited by Schott, for which Otto Brunfels, the botanist and town doctor of Bern, prepared the text, and which appeared in three folio volumes in 1530, 1532, and 1536, together with a German edition with a total of 230 illustrations under the title *Contrafayt Kreuterbuch.* In both the dedicatory poem of the Latin version and chapter XXXII of the German version it is recorded that the illustrations were *"durch den hochberümpten meyster Hans Weiditz von Strassburg gerissen und contrafayt"* ("devised and counterfeited by the highly famed master Hans Weiditz of Strasbourg"). The attempt to identify his artistic personality with the Petrarch Master[1] on grounds of stylistic affinity is disputed.[2]

NOTES

1 Hans Röttinger, "Hans Weiditz, der Petrarkameister," in *Studien zur Kunst,* book 50 (Strasbourg, 1904); Max J. Friedländer, *Holzschnitte von Hans Weiditz* (Berlin, 1922).
2 Ernst Buchner, "Der Petrarkameister als Maler, Miniator und Zeichner," in *Festschrift Heinrich Wölfflin* (Munich, 1924); Theodor Musper, *Die Holzschnitte des Petrarkameisters* (Munich, 1929).

Illustration Credits

Amsterdam	Ills. 21 p. 21, 35.3, 41.1: Rijksmuseum
Bamberg	Color plates 21, 24, 76, 80: Staatsbibliothek
Bayonne	Ills. 7 p. 195, 71.1: Paris, Musées Nationaux Color plates 23, 54: Ets. Giraudon
Bergamo	Ill. 5.1: Photothek Degenhart, Munich
Berlin	Ill. 15.1: Staatliche Museen Preußischer Kulturbesitz, Kupferstichkabinett Color plates 4, 5, 11, 20, 39, 40, 52, 56, 74, 79, 81, 92, 93, ills. 22 p. 22, 18.1, 37.1, 44.1, 53.1: Jörg P. Anders Ill. 7 p. 15: Gemäldegalerie, Kunsthistorisches Institut der Universität Wien
Berlin GDR	Ills. 73.1, 88.1: Staatliche Museen zu Berlin
Bern	Ill. 6 p. 15: Historisches Museum Bern Color plates 82, 83: Universität, Systematisch-geobotanisches Institut, Peter Lauri
Boston	Ills. 2 p. 210, 3 p. 211: Isabella Stewart Gardner Museum
Bremen	Color plates 66, 67: Kunsthalle
Brunswick	Ills. 2 p. 40, 88.6: Herzog Anton Ulrich-Museum
Budapest	Ills. 47.1, 49.1, 76.1, 76.2: The Budapest Museum of Fine Arts Color plate 37: Szelényi Károly
Chicago	Ill. 6 p. 43: The Art Institute of Chicago
Cleveland	Ill. 11.1: The Cleveland Museum of Art
Colmar	Ill. 64.1: Musée d'Unterlinden Ills. 1 p. 210, 5 p. 211: St. Martin
Cologne	Ill. 1 p. 112; Rheinisches Bildarchiv
Copenhagen	Color plate 30, ill. 33.2: Hans Petersen
Dijon	Ills. 2.1, 2.3: Musée des Beaux-Arts de Dijon
Dresden	Ill. 6.3: Sächsische Landesbibliothek Color plates 8, 33, 34, 46, ill. 3 p. 41: Reinhold (Leipzig-Mölkau) Ills. 16 p. 20, 19 p. 21, 7 p. 43, 6 p. 161: Staatliche Kunstsammlungen Dresden, Kupferstich-Kabinett
Dublin	Ill. 45.1: National Gallery of Ireland
Erlangen	Color plates 3, 31, 84, 85: Universitätsbibliothek
Florence	Color plates 86, 87: Gabinetto Disegni e Stampe degli Uffizi, Stefano Giraldi Ill. 2 p. 112: Galleria degli Uffizi
Frankfurt	Ill. 5 p. 14: Städelsches Kunstinstitut
Ghent	Ill. 4 p. 14: Kunsthistorisches Institut der Universität Wien
The Hague	Ill. 25.1: Rijksbureau
Hanover	Ill. 36.2: Technische Hochschule
Hartford	Ill. 51.1: The Wadsworth Atheneum
Karlsruhe	Ills. 6 p. 177, 68.3: Staatliche Kunsthalle Karlsruhe, Kupferstichkabinett
Lisbon	Color plate 7: Museu Calouste Gulbenkian, Reinaldo Viegas
London	Color plates 6, 12, 13, 18, 19, 42, 78, ill. 20 p. 21: The British Museum Ill. 23 p. 23: The British Museum of Natural History Color plate 49: Prudence Cuming Associates Ltd. Ill. 46.1: Gallery Kate Ganz Ills. 3 p. 14, 2 p. 177, 66.1, 78.1: National Gallery of Art Ill. 6.2: Witt Library
Los Angeles	Color plate 72: The Armand Hammer Foundation
Madrid	Ills. 4 p. 72, 66.2: Escorial
Malibu	Color plate 36: The J. Paul Getty Museum
Milan	Ill. 27 p. 25: Ambrosiana
Montreal	Color plate 28: Brian Merrett et Jennifer Harper Inc.
Munich	Ill. 39.4: Bayerische Staatsbibliothek Ills. 6.1, 1 p. 133, 46.2: Bayerische Staatsgemäldesammlungen
Naples	Ill. 8.1: Deutsches Archäologisches Institut — Rome
New York	Ills. 1 p. 70, 39.1: Metropolitan Museum of Art Ill. 3 p. 71: Collection Janos Scholz Color plates 25, 27, 32: Ian Woodner Family Collection
Nordhausen	Ill. 73.1: [formerly] Staatliche Museen zu Berlin, Berlin GDR
Nuremberg	Color plates 50, 51, 59, 60, ills. 8 p. 15, 9 p. 16, 10 p. 17, 5 p. 42: Germanisches Nationalmuseum Color plate 26, ill. 4 p. 161: Stadtgeschichtliche Museen Nürnberg
Oxford	Color plate 91: Ashmolean Museum
Paris	Ill. 39.3: Fondation Custodia (Coll. F. Lugt), Institut Néerlandais Color plates 45, 58a: Musées Nationaux Color plate 14, ills. 12, 12a p. 18, 11.2: private ownership
Potsdam-Sanssouci	Color plates 63, 64, 73: Staatliche Schlösser und Gärten
Prague	Ill. 5 p. 177: Narodni Galerie v Praze
Private ownership	Ill. 7 p. 73
Providence	Color plate 69: Museum of Art, Rhode Island School of Design
Rome	Color plate 48: Galleria Nazionale d'Arte Antica, Palazzo Barberini
Rotterdam	Ill. 88.8
Stockholm	Ill. 2 p. 13: Statens Konstmuseet
Vienna	Ill. 57.1: Akademie der bildenden Künste Ill. 59.2 Peter Ertl Color plates 2, 9, 10, 15, 17, 22, 35, 43, 55, 58, 61, 62, 68, 70, 71, 75, 77, ill. 4 p. 113, and all illustrations not otherwise specified: Graphische Sammlung Albertina, Eugen Finkler Color plates 1, 16, 41, 88, 89, 90: Alfred Jànderka Ills. 4 p. 14, 7 p. 15: Kunsthistorisches Institut der Universität Wien Ill. 5 p. 73: Naturhistorisches Museum Ills. 1 p. 12, 15 p. 20, 18 p. 21, 24 p. 23, 1.1, 4 p. 42, 3 p. 112, 53.2, 88.4: Österreichische Nationalbibliothek
Washington, D.C.	Color plates 38, 44, ills. 13 p. 18, 41.2: National Gallery, Department of Prints and Drawings
Weimar	Ill. 45.2: Kunstsammlungen zu Weimar
Williamstown	Color plate 57: Sterling and Francine Clark Art Institute
Windsor	Ill. 25 p. 24: Royal Library Windsor Castle
Zollikon	Color plate 53: Sammlung Kurt Meissner
Zurich	Color plate 29, ill. 7b p. 259: Kunsthaus